DONALD CAMMELL
A LIFE ON THE WILD SIDE

First edition published by FAB Press, May 2006

FAB Press
7 Farleigh
Ramsden Road
Godalming
Surrey
GU7 1QE
England, UK

www.fabpress.com

This book reproduces illustrations by Donald Cammell which originally appeared in the book *King Arthur and the Round Table* by Alice Mary Hadfield, published by J.M. Dent & Sons Ltd. All attempts at tracing the copyright holder of *King Arthur and the Round Table* were unsuccessful. Illustrations in these pages marked 'courtesy David Del Valle' were generously supplied by the Del Valle archive. Copyright of film stills and promotional artwork is the property of the production or distribution companies concerned. These illustrations are reproduced here in the spirit of publicity, and whilst every effort has been made to trace the copyright owners, the authors and publishers apologise for any omissions and will undertake to make any appropriate changes in future editions of this book if necessary. All personal photographs and behind the scenes photographs are reproduced here with the gracious permission of the duly credited owners.

Front cover illustration:
Donald Cammell, *Self-Portrait,* ca. 1952, age 18.

Frontispiece illustration:
Donald Cammell, *Beat Generation,* 1958, originally published in *Lilliput* magazine, January 1959.

A CIP catalogue record for this book is available from the British Library

hardback: ISBN 1903254280
paperback: ISBN 1903254299

FAB PRESS
A PUBLICATION

DONALD CAMMELL

A LIFE ON THE WILD SIDE

REBECCA AND SAM UMLAND

Acknowledgements

We have, of course, benefited by those whose work has preceded ours. In the years immediately following his suicide in 1996, there were two important books about Donald Cammell published, both of which focused primarily on *Performance* but which also contained biographical material. Colin MacCabe's book on *Performance*, published by the BFI in 1998, holds pride of place as the first book published about Cammell after his death, followed by a documentary by Kevin Macdonald and Chris Rodley, *Donald Cammell: The Ultimate Performance* (1998). Subsequently, in 1999 Mick Brown published a book on *Performance*, containing additional material not included in either MacCabe's book or the documentary. We have read and re-read (and re-viewed) these works many times and profited from them, although both books contain factual errors about Cammell's life that we have corrected in the following pages, while the documentary contains biographical omissions and conclusions about the circumstances of his death that we have found to be unconvincing. Indeed, in all instances regarding factual matters of his biography, our book should take precedence. We have clearly labelled any speculations as our own.

Among his important contributions, Mick Brown, a London journalist, conducted two interviews which for a number of reasons we were unable to conduct ourselves, both of them filling in some major gaps in our knowledge. Much has been written about the effect of *Performance* on James Fox, perhaps because his reaction was so extreme. Yet Brown is the only author, to our knowledge, who has ever interviewed Michèle Breton about *her* experience working on *Performance*, others ignoring it as if it were of little consequence, and his book made an important contribution to our knowledge of her particular circumstances. However, he and others aver that *Performance* was Breton's only film role, but as we shall see, this is incorrect. Brown also spoke to Anthony Valentine, who in *Performance* plays the crucial role of Joey Maddocks. So far as we have been able to determine, prior to Mick Brown's interview he had never given his account of his experiences working on *Performance*, despite the importance of his role. We tried unsuccessfully to contact him, and hence Brown's interview is again the only insight we have from Valentine about the making of *Performance*. The interview contained several comments by Valentine confirming our suspicion that he fundamentally disliked the experience of making the film, and didn't like the film, either: "I don't think 'like' is a word I could use about *Performance*." We learned during our interview with Anita Pallenberg, who was both candid and generous with her memories of making the film, that her experience was not particularly a happy one, either, despite her friendship with Donald.

Although some spoke to us anonymously, we have many others to thank. Several people close to Donald gave us not only many hours but many days of their time, and frequently put long telephone conversations on their own nickel. We are grateful to Frank Mazzola, Donald's creative associate for many years whose re-edit was responsible for getting *Performance* released. He gave us much of his time and energy; we thank him and Catherine Mazzola for their friendship, conversation, and candour. In a very real sense, we could not have written this without them. We are also grateful to Donald's family. David Cammell has spent many hours and days with us, and we thank him for his friendship and support of this project. Donald's half-sister Lili Cammell supplied us with many details of her father's life, as did Charly and Helga Cammell, who also provided us with some pictures. Among the very first individuals we contacted when we began this book was David Del Valle, and we thank him, too, for his many years of encouragement and friendship. David also provided us with several of the stills included in this book, most of which were given to him by Donald himself, including a number

of heretofore unseen production snaps of *Performance*. At a critical juncture, film scholar Dr. Sally Shafto helped us complete our research. A film historian and a specialist in French cinema, especially on the work of Jean-Luc Godard, she shared with us much of her expertise on the French film scene of the 1960s and conducted crucial interviews for us with former friends and acquaintances of Donald's still living in Paris. We are most grateful to her for her expert help.

Many other individuals played essential roles, and we wish to thank them as well, for their expertise, their kindness, their time, and their insights: Maggie Abbott; Maria Andipa; Kenneth Anger; Dr. Joe Auch Moedy (a forensics expert); Patrick Bauchau and Mijanou Bardot Bauchau, who opened their garden to us; Francie Bradley; Andrew Braunsberg; David Brownstein; Dr. Kevin Byrd of the Department of Psychology at the University of Nebraska at Kearney, who read key chapters of our manuscript and helped us formulate the BPD hypothesis; Pierre-Richard Bré; Michael Butler; China Kong Cammell; John Charles; Vartkes Cholakian; Debbi Collard; Tim Deegan; Rudy Durand; Cassian Elwes; Dr. Barbara Emrys; Glenn Erickson; Ken Finkleman; Myriam Gibril; Julian Grainger; Bill Gray; Drew Hammond; Barbara Hall, Research Archivist, Margaret Herrick Library, at the Academy of Motion Picture Arts and Sciences; Rob Hyman; David Irving; Lukas Kendall; Zalman King; Stanislas ("Stash") Klossowski; Sonja Kropp; J.F. Lawton; Craig Ledbetter; Tim and Donna Lucas; China Machado; David McCallum; Libby McCord; Cathy Moriarty; Marc Morris; Chris Neill; Anita Pallenberg; Peter Playdon, who kindly obtained materials for us in the UK we couldn't otherwise obtain, and who wrote a brilliant dissertation on *Performance*; Roman Polanski; Daniel Pommereulle; Mark Pomeroy, Archivist, Royal Academy of Arts; Nick Redman; Mrs. Deborah (Dixon) Roberts; Jack Rovner; Nicky Samuel; Steven Jay Schneider; Fr. Benedict Seed; Carol Staswick; Barbara Steele; Brad Stevens; Anna Swadling; David Thomson; Stephen Thrower; Michael T.R.B. Turnbull; Peter Watkins; Stephen Weeks; Karl Wessel; Brad Wyman; Peter Young; Zouzou. We also wish to thank Dr. Ken Nikels of the Graduate Office at the University of Nebraska at Kearney as well as the UNK Research Services Council, for financial assistance during the writing of this book. We thank our children, Lauren, Andrew, and John, for patience while we spent the interminable hours on this project. We must especially thank our son John for enduring hundreds of hours on jet airplanes, certainly more than a boy under age ten ought, but we hope he enjoyed seeing some of the world and meeting a few of its interesting people. Thanks also to Harvey Fenton and Francis Brewster at FAB Press, whose attention to detail, extensive research, and discoveries made this book better than we'd ever imagined. To all those individuals who have been omitted at their insistence or by our unconscious neglect, thanks to you all.

*One of a series of pen and ink illustrations by Donald Cammell, which accompanied a short story by David Garnett entitled "An Old Master," in the March 1959 issue of **Lilliput** magazine.*

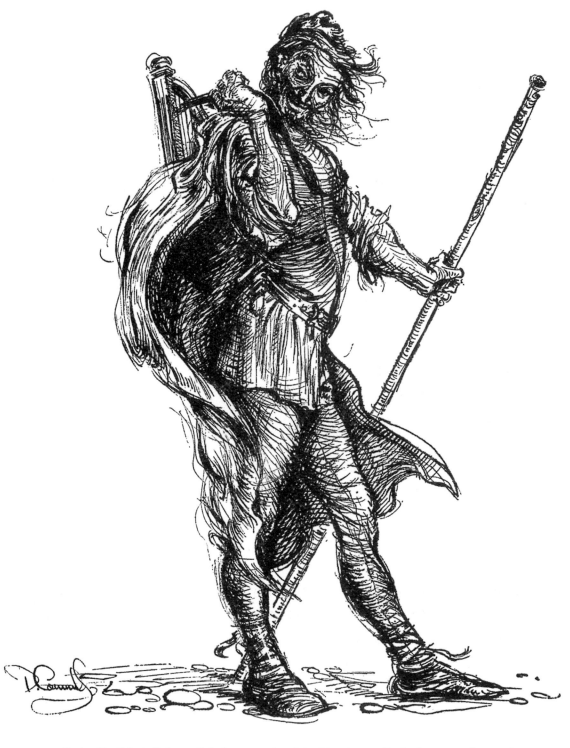

*The foundling, Taliessin, his harp on his back, represents the artistic spirit as the revered bard and mage in an illustration for Alice Mary Hadfield's re-telling of the King Arthur legend for young readers, **King Arthur and the Round Table** (1953).*
- Donald Cammell, pen and ink, 1952.

Table of Contents

Foreword by Frank Mazzola 8

Preface "The Faultless Painter": A Parable 9

PART I: **HIGHLANDER** (1934-1970) **13**

Chapter 1 The Heart of Midlothian, 1934-1941 15

Chapter 2 Fort Augustus, 1942-1943 31

Chapter 3 Portraits, 1944-1959 37

Intermezzo Circus 53

Chapter 4 Parisian Scenes, 1960-1967 59

Chapter 5 *Performance*, 1967-1970 87

PART II: **SEA-CHANGE** (1970-1996) **145**

Chapter 6 Entr'acte, 1970-1974 147

Chapter 7 *Demon Seed*, 1975-1979 169

Chapter 8 *White of the Eye*, 1980-1988 203

Chapter 9 *Wild Side*, 1989-1995 229

Chapter 10 Blood of a Poet, 1995-1996 247

Aftermath 259

Appendix i Donald Cammell Filmography 273

Appendix ii Other Works by Donald Cammell 284

Appendix iii Unproduced Scripts 285

Appendix iv Selected Bibliography 286

Notes 290

Index 297

Foreword

Working as a film editor with Donald Cammell was creative freedom without rules, as opposed to the imposition of intellectual pretension based on learned techniques. His improvisational considerations gave me the license to work outside the realm of convention and exercise the full potential of my own expression. From *Performance* through *Wild Side* the films took on a life of their own. As they ran through my hands in the Moviola, I could feel the creative energy of the films' artists. It was as if that energy was being synthesized onto the emulsion of the film stock. At times I could feel the electricity in my hands and teeth.

In late April, 1996, after the madness of *Wild Side*, I was working on a film that Donald had recommended me for. While I was editing on the Moviola, I heard my assistant crying in the hallway. She had just received the news that Donald had taken his life. *Impossible*… I had seen Donald recently and all he talked about was getting *Wild Side* back from Nu Image and finishing it the way we had intended.

I left the studio and drove in the hills above Hollywood. I remembered when we first screened *Performance* at Warner Brothers, and the instant rapport and film sense that Donald and I had shared. I remembered working at Goldwyn Studio and the incredible energy that surrounded us and how that energy worked its magic into the re-editing of *Performance*.

I thought about the last time we saw each other and how beautifully innocent he was in his demeanour, revealing a soul filled with the spirit of hope as he talked about getting back the producer's tasteless version of *Wild Side* and reconstructing the film into our original cut.

He also expressed his feeling about wanting to do certain projects that we were involved with through the years, and how we were going to do them without the interference of the studios. Our intention was to form an independent production company with certain members of the community that we knew, and whose work we respected. A film consortium of artists who would exchange roles: writer, cameraman, actor, editor one time - director next. And we would contribute our own expertise, lending strength and unity to the end result of each project. What difference did it make what role we played as long as we could achieve independence; to avoid the inevitable frustration, the pain and disillusionment of still-born projects ending up in the hands of those who had the power to take away the breath of life from the artist's vision and creation?

With the potential of restoring Donald's definitive director's cut of *Performance*, the completed restoration of *Wild Side - The Director's Cut*, and the restoration of *The Argument*, a short film that I produced for Donald in 1972, I believe this is the best I can do for Donald, with fond memories of the high times, the creative time, and the battles we fought together.

In this book, Sam and Rebecca Umland's approach to Donald's life and work brings to light the many facets of this gifted artist who left behind a complex legacy which they have unravelled with scholarly detail.

- Frank Mazzola

"The Faultless Painter": A Parable

In this world, who can do a thing, will not;
And who would do it, cannot, I perceive.

- Robert Browning, "Andrea del Sarto"

There is an old adage about being one's own worst enemy. Surely there is some truth to it: how often do we see or hear of people who - despite talent, resources, and opportunity - fail to realize their full potential? It is, at first, perplexing: sometimes "bad luck" or "fate" is blamed, but more often, upon closer scrutiny, there exists a hidden flaw, a crack in the character of the under-achiever. When this person is an artist, he is frequently at war with his own time, his own art, or himself, his obstacles, then, self-imposed.

This pattern of willed failure is the determining factor in the life and careers of Donald Cammell, whose professional life began as a classically trained painter of considerable repute (he attended the much touted Royal Academy of Arts and took lessons from the famous Italian painter, Annigoni), after which he became a talented filmmaker. When success was in his grasp, he repeatedly, one might even say systematically, set about to guarantee his own failure, either by abandoning a project or by setting himself at odds with his patrons. His is not a unique case, although the reasons for it are both complex and compelling, and are one of the true subjects of this book. Donald Cammell's troubled relationship with his own talent needs to be accounted for, not excused or defended. Moreover, it is our view that the reasons for this deliberate artistic undercutting are not rooted in culture, but are highly idiosyncratic and personal, and are thus all the more important, albeit more difficult to uncover.

Such was the case of Andrea del Sarto (1486-1531), a classical painter of the Italian Renaissance, whose biography was composed by his student, Giorgio Vasari, in *The Lives of the Most Eminent Painters, Sculptors and Architects* (trans). Vasari asserts that in Andrea "art and nature combined to show all that may be done in painting," but that there existed a "diffidence and want of force in his nature, which are proper to the more exalted character" and which, if "added to the advantages wherewith he was endowed, would have rendered him a truly divine painter." In other words, Andrea's ability to paint well was at odds with his desire to do so. The explanation for Andrea's will to fail is difficult to discern from Vasari's discussion of Andrea's life, but the psychology of it is probed by poet Robert Browning, in his 1855 poem, "Andrea del Sarto: (Called 'The Faultless Painter')." Browning's portrait of Andrea is what critic Harold Bloom calls a "deep study of a deliberate artistic self-crippling," choosing a wife, the beautiful Lucrezia, whom he knows will be unfaithful to him and thus undercut his vocation as an artist.

In Browning's poem, a wearied Andrea addresses his faithless wife, attempting to delay her inevitable rendezvous with her lover. He recalls his past opportunities to achieve a greatness equal to that of Rafael (Raphael) and Michel Agnolo (Michelangelo). Indeed, his patron was once Francis I, King of France, but Andrea readily and wrongfully abandoned his work and absconded with the monarch's money when Lucrezia recalled him from the French court back to Italy. The impediment to greatness is

Lucrezia's infidelity, yet Andrea is content in the knowledge that he himself lacks the will to fulfil his potential, and that the desire for wealth, praise, and fame that drives others does not motivate him. Rather, he paints to make a heaven for himself, setting his own satisfaction above that of all others:

> Their works drop groundward, but themselves, I know,
> Reach many a time a heaven that's shut to me,
> Enter and take their place there sure enough,
> Though they come back and cannot tell the world.
> My works are nearer heaven, but I sit here.
> The sudden blood of these men! at a word—
> Praise them, it boils, or blame them, it boils too.
> I, painting from myself and to myself,
> Know what I do, am unmoved by men's blame
> Or their praise either... (83-92)

Yet, Andrea divines that man should aspire to greatness: "Ah, but a man's reach should exceed his grasp,/Or what's a heaven for?" (97-98), even though he cannot will himself to do so. Browning thus conveys a portrait of the artist who systematically undermines his own efforts, possesses the requisite insight to know that he does so, but tragically cannot prevent himself from orchestrating his own artistic demise.

Donald Cammell's father, Charles Richard Cammell, a learned man of letters with a passion for art, shared Browning's enthusiasm for Vasari's *Lives* and, in truth, there is an uncanny resemblance between his son and Andrea. Like Andrea, Donald Cammell recognized his own talent, yet refused to use it to his full advantage. Like Andrea, too, his personal life involved tragedy and loss: Browning's ageing Andrea believes, on the one hand, that with Lucrezia as an artistic "partner," of sorts, it is still not too late to achieve greatness, yet he knows that she has abandoned him for another. (In fact, as Vasari reports, Andrea did die of the plague, abandoned by his wife and everyone else.) Donald Cammell also engaged in the fantasy that he could derive strength from a joint artistic effort with a younger wife, who also, finally, abandoned him.

It is our hope that, in this book, Browning's penetrating study of Andrea del Sarto will provide us with the paradigm of the self-sabotaged artist that will shed light on the problem of Donald Cammell's thwarted careers as a painter and filmmaker. "Andrea del Sarto" attempts to provide a psychology of art - and the obstacles to art - that, no doubt, spoke to Browning himself, but which also invite the reader to think about the questions we will attempt to address in relation to Donald Cammell. This is not an attempt to justify his insistence on failure, either in his art or in his notorious and sensational personal life, but to account for it. Our concern is not only with *what* Cammell did in his professional and personal life, but *why* and, in doing so, we will examine the difficult questions that Browning himself intuits: Where does art come from or, more precisely, how is an artist shaped? What is the connection between the personal and the artistic? To what degree does the artist express his own idiosyncratic view of the world, and to what extent does his art represent his time?

The enmity between the artist and his own time has always existed: the antique Roman poet, Ovid, was banished to a northern barbarian outpost; medieval Italian sage and composer of *The Divine Comedy* (trans), Dante Alighieri spent his life in exile from his beloved city, Florence. Among the High Romantics, French writer Victor Hugo joined Ovid and Dante, and British poet, Percy Bysshe Shelley, spent the last years of his short but illustrious life in self-imposed exile in Italy (a pattern that Browning himself tried to imitate, eloping with a literary luminary, like his precursor, Shelley). As Shelley asserts

in his famous treatise, "A Defence of Poetry," artists speak to their own time but are also always - as visionaries - ahead of it and, therefore, at odds with it. ("Poets are the unacknowledged legislators of the world.") The real question for Shelley is the degree to which they are "conscious of the distinction which must have subsisted in their minds between their own creeds and that of the people." In part a product of a particular historical and cultural moment, the highest art is, finally, Shelley suggests, subversive, at odds with its own time and not merely an expression of it, an idea that, filtered through Genet and others, Cammell himself embraced. This book hopes to uncover how and why Donald Cammell became an artist, why he repeatedly refused to bring his talented visions to fruition, and what his films, in particular, tell us about his life and his relationship to his own time. It is our hope that our study will open up new avenues of inquiry about Cammell's life and art, even as we strive to resolve what, in our mind, drove this modern Andrea del Sarto - our contemporary - to engineer his own ruin. Often the obstacles to art are as fascinating as the art itself.

As might be expected, we explore the issue of Donald's infamous sexual life, but readers expecting an organ recital ("Who banged, blew or buggered whom, when?") will very likely be disappointed. A number of individuals spoke to us only under the condition of strict anonymity and insisted also that certain information be withheld from publication - one of those unexpected obstacles we mentioned earlier, i.e., we could have the information but, paradoxically, couldn't use it - and, true to our word, we have honoured their wishes. Still, the information we were able to obtain contributed to our overall understanding of Donald's character and personality, and in that sense was quite valuable. On the other hand, we think our book contains one or two revelations that will satisfy even the most jaded reader.

If our book presents some controversial theories, it seeks to dispel a number of myths as well. For instance, to cite a particularly egregious example, there was a story widely disseminated in the media after his death that Cammell had lived for forty-five minutes after shooting himself in the head, during which time he supposedly hallucinated the picture of Borges as seen in *Performance*. This fabled story taxes one's credibility, yet has been faithfully repeated, without corroboratory evidence, in numerous articles. We are of the opinion that the story is false: our recreation of the event, based on police reports and the coroner's office report, and its analysis by a forensics expert, is scarcely so mystical or romantic. In place of this romanticized version, we can only offer the stark existential reality, to use Andrew Solomon's phrase, of "the loneliness of self-annihilation."

"It is always easy to be logical. It is impossible to be logical to the bitter end." So wrote Albert Camus in "The Myth of Sisyphus," the essay in which he explored the question of suicide. We discovered this statement uncannily reflected our mood as we completed this book which, though primarily concerned with Donald Cammell, is necessarily indirectly about suicide also. This study took us well over six years from start to finish, not a huge part of one's life, but much longer than we had anticipated. When we began researching the life of Donald Cammell years ago, in our naiveté we had not thoroughly considered the obstacles to such a project, nor had we fully grasped the formidable issue of suicide. For these and other reasons, this book has been delayed for more than four years. We have not considered the question of suicide as Camus did, using categories derived from existential philosophy. Rather, we approached the problem of suicide as a psychologist might, and conclude, based on our study of current psychiatric research and the evidence we have gathered, that Donald Cammell suffered from what is called Borderline Personality Disorder (BPD), a particularly daunting psychological condition, the features of which include depressive episodes, dissociative states, and frequent suicidal threats. For reasons to be explained in this book, we do not believe he was bipolar or manic-depressive, although he claimed he was. We fully expect our thesis to be controversial, in part because psychological explanations of the sort we shall present challenge our cherished notions of individual volition, free will, and moral culpability.

The notion of a unitary subjectivity, referred to as the "Cartesian ego" - following Descartes's famous formulation about the certitude of his own consciousness, *cogito ergo sum*, "I think therefore I am" - is one of the cherished myths of Western culture. The Cartesian ego presents a seamless face to the world, but it is an illusion, nonetheless. Every day, each of us experiences the conflict of internal forces, and when it comes to others, we are often puzzled why they behave the way they do. In a world supposedly haunted by ghosts and evil spirits, and purportedly visited by mysterious alien beings from outer space who may or may not be benign in their intentions, human beings find other human beings the most mysterious thing of all, incalculably strange and impenetrable. For most of us, though, thankfully, our internal conflicts seldom emerge in the form of a full-blown dissociation of consciousness, volition, or identity, which appears to be true in Donald Cammell's case. What was called Romanticism in the nineteenth century became known as Modernism in the twentieth, and our culture still cherishes certain Romantic, or Modernist, myths of the "tortured artist," particularly notions about the artist's heightened sensitivity and physical and/or emotional fragility, which, to follow the usual story, in some especially sensitive individuals possessed of a singular genius, culminates in suicide. We have tried to ignore such myths, writing about Donald Cammell under the cold, harsh light of contemporary psychology. That he was a "tortured" individual and possessed a singular genius is true, but we believe that his suicide wasn't caused by his extreme sensitivity or inability to withstand the blows of harsh, misguided critics or the Philistinism of studio executives. There are limits to our understanding of suicide, certainly, but one thing is very certain - we must avoid simple cause-and-effect scenarios or banal chicken-or-egg dialectics to explain it. Thus we must reiterate: "It is always easy to be logical. It is impossible to be logical to the bitter end."

Pencil drawing by Donald Cammell, which originally appeared in **Lilliput***, June 1959, one of four illustrations Donald made for the story "Natural Child," by Tom Sterling.*

HIGHLANDER
(1934-1970)

THE GUARDIAN ANGEL
For Donald Seton Cammell

Angel unto whom in Heaven
Charge to watch this child was given:
 Lately he from God is come.
Oh! make smooth for him, I pray,
Through the world his pilgrim way,
That his feet may never stray
 Far from his celestial home.

He hath brought such lovely dreams
From the meadows and the streams
 And the hills of Paradise!
On his silken cheek repose
Beauties of an earthless rose,
Budded in Heaven's garden-close;
 And the stars are in his eyes.

Guide him, guard him, Wingèd Sprite,
Suffer not the Homeland's light
 Ever to grow faint or dim.
Watch his steps, lest he should fall;
Listen, lest for help he call;
Be his playmate, be his All,
 Still with love surrounding him.

- Charles Richard Cammell, 1934

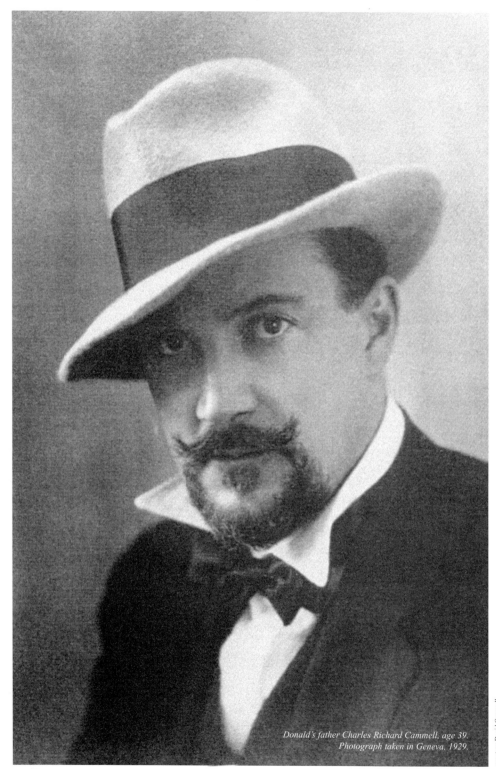

Donald's father Charles Richard Cammell, age 39.
Photograph taken in Geneva, 1929.

1　The Heart of Midlothian

1934-1941

Donald Cammell is a mythic figure. For some, such an assertion will smack of hyperbole: How can a person known only to relatively few *cognoscenti* be called mythic? We are not using "mythic" to suggest "larger than life," however, in the sense of "demigod." Nor are we using "myth" in the vulgar sense, to mean misperceptions, half-truths and falsehoods, although it is indisputably true that misperceptions and falsehoods about his life abound. Rather, he is a mythic figure because such figures are deeply divided, embodying irreconcilable contradictions.

Among these contradictions is his curious artistic legacy. Although by training he was a painter and by dint of personality a bohemian intellectual, he ironically achieved his greatest artistic success in a mass art form, yet none of his few films, even his most famous, could be in any way called popularly successful. Just the opposite. Idiosyncratic, strange - at best impenetrably hermetic - they are stubbornly non-commercial, yet they feature popular stars, often cast in popular cinematic genres.

He was a Scotsman educated in British schools, but following the Scottish tradition, he opted to form an alliance with France. He became a French citizen but lived the fewest number of years of his life in that country, instead residing for over a third of his life in the United States. His lifestyle was an anti-utopian version of the sort of monastic bohemianism exemplified by certain expatriate American Beatniks of the 1950s. He was not too old to have been a rocker, but he no more had that sensibility than that of a mod or a folkie. He was born only a year before Elvis Presley, and was just two years older than the oldest Rolling Stone, Bill Wyman. He didn't come from a working class background, although he was never particularly rich. He never had vast sums of money - it was generally feast or famine - but he possessed that stereotypical Scottish thriftiness which, along with great personal charm, made him appear better off, economically speaking, than he really was.

He was proud of his Scottish heritage; it was one of the few features of his background he generally mentioned in interviews - that, and the assertion that Paris was his true home. But Donald Seton Cammell was actually born in Scotland. At the time of his birth, 17 January 1934, George V, grandson of Queen Victoria, was still King of England. George V was a monarch who had witnessed tumultuous times: the outbreak of World War I, the rise to power of the British Labour Party, and, in 1931, when the economy had virtually collapsed, the formation of a coalition government under the leadership of Ramsay MacDonald. In Scotland, the worldwide economic depression had closed factories and left embittered veterans questioning the worth of their military service to "Great Britain" in the First World War. Antagonism towards British rule had increased in the decade following World War I, resulting in the formation of what would become the Scottish National Party in 1928.

One figure in the movement for modern Scottish independence, at least as it took its parlour form of expression in the 1930s, was poet and critic Charles Richard Cammell, Donald Cammell's father. Like George V, for whose Silver Jubilee in 1935 he was to write an occasional poem, Charles Richard Cammell despised the modern world, and was much more comfortable in that of the nineteenth century, the century of his birth. Donald's mother, Iona Macdonald Cammell, was Scottish born and raised in the Highlands near the shores of Loch Ness. She married Charles Richard Cammell in 1932. The Celt heritage was thus strong in Donald Cammell.

Because he became a strong advocate of the Scottish Nationalist movement, Charles Richard Cammell was in his later life to emphasize his ancestry and cherish all things Scot, even though his mother's family was actually English. It is generally accepted that the name Cammell is an older form of Campbell, the latter spelling representing its English transformation. Most sources we researched indicate that "Campbell" derives from the Gaelic, "Caimbeul," meaning "wry mouth" (Cam beul), most likely referring to a specific dialect. Charles Richard Cammell claimed the name derived from Caimeal, the name of an ancient Celtic god. Other sources refer to the name Camulos, a god of war. This may be right, as Charles Richard Cammell rather audaciously argued that Cammell is the root of Camelot, mythical home of King Arthur, a claim that reveals his own love of literature and learning, but which also oddly prefigures Donald Cammell's illustrations for Alice Mary Hadfield's edition of *King Arthur and the Round Table* in 1953.

Charles Richard Cammell was born into great wealth, and as a result was able to nurture his love of art and literature and develop his skills as a poet. Moreover, he was of one of the last generations to be able to foster a life of learning and leisure that resulted in a "man of letters," a collocation which fits him accurately. Among his other accomplishments (a result of the fact that he was a bibliophile), was the compilation of a fine rare book library containing many volumes of *incunabulae*. In addition to being an art critic, he was also a poet, playwright, and translator, as well as a highly-skilled, expert fencer, the epee champion of Scotland in 1934. A cultured, sensitive man, from whom Donald and his two younger brothers no doubt inherited their disarming charm and personality, no one seems to have an unkind word to speak of Charles Richard Cammell; only remembrances of admiration and respect. "I think he really didn't live in the contemporary world," observes Mrs. Deborah Roberts, née Dixon, Donald's romantic companion for about eight years. "He didn't want anything to do with it," a characterization with which David Cammell, his son, would strongly agree.[1] Charles Richard Cammell had little sympathy for modern poetry. He especially admired the British Romantic poets and his interest in poetry rarely extended beyond the works of pre-Raphaelite poet and painter Dante Gabriel Rossetti (1828-1882), an overt Romantic ideologist. With one significant exception - his son, Donald - all who knew him regarded him highly, and the animosity between Charles Richard and Donald, according to Donald's first wife, Maria Andipa, resulted from Charles Richard's disapproval of Donald's decision to abandon painting, for which he displayed such an auspicious talent.

Donald's father was born on 29 December 1890, in London. When she met him in London in the early 1960s, Deborah Roberts says that he was still a "very handsome" man and "a charming old gentleman."[2] The location of his birth was, Charles Richard was later to claim in his memoirs, "accidental," because "with the British Babylon I have no blood-kinship or family association of any kind. My father took my mother to London so that she might be in the care of a celebrated *accoucheur* on the occasion of my birth; for she had suffered from serious complications at the births of my two sisters."[3] He avers in his memoirs that he is a descendent of Archibald Campbell, seventh Earl of Argyle. Archibald Campbell's son, also named Archibald, became the eighth Earl and first Marquess and was (this again according to Charles Richard Cammell), "ancestor of all the subsequent Earls, Marquesses and Dukes of Argyle."[4] David Cammell, however, states that it was not Archibald's son of the same name, but a younger son, Eustace, from whom they are directly descended.

Charles Richard Cammell's grandfather, Charles Cammell, was born in 1810, the youngest of his family. In 1837 - the year of Queen Victoria's accession to the throne - he co-founded a steel-foundry in Sheffield, and within three decades it had become a world leader in the field. Charles Cammell subsequently became the first Chairman of Charles Cammell and Co. Ltd. In the early years of the twentieth century, the firm became Cammell Laird & Co., famous as shipbuilders.[5]

When Charles Cammell died, in December 1879 at the age of 69, he left his heirs over a million pounds in stock and three beautiful estates - a staggering fortune in those days.

Donald Cammell's paternal grandfather, Charles David Wilson Cammell, was born in 1847. He died in 1905, many years before Donald's birth. Because Charles David Wilson was the oldest child, at his father's death, he was given first choice among the three landed estates. At a mere 22 years of age, he chose Ditcham Park in Hampshire because he was an accomplished yachtsman and the estate was in close proximity to a harbour. According to Charles Richard Cammell, his father lived "the life of a country-gentleman, holding always a Directorship in the Cammell firm."[6] His father was to sell Ditcham Park before his birth.

The first marriage of Charles David Wilson Cammell ended in divorce, although he retained custody of his three daughters. Donald's paternal grandmother, who became Charles David Wilson Cammell's second wife, in 1884, was Geraldine Theresa Haworth-Booth. Her father, Colonel Haworth-Booth, was a noted scholar and a close personal friend of Queen Victoria's favourite prime minister, Gladstone. In addition to three half-sisters, Charles Richard Cammell had two sisters, Meta, born ca. 1886 (d. ca. 1941) and Cordelia Violet Katherine ("Eila") born ca. 1888 (d. unknown). Charles Richard was thus the only son and the youngest child, and like his father, his first marriage would end in divorce, and he would have three children with his second wife.

Like his siblings, Charles Richard Cammell inherited an enormous fortune. His early life is one that is difficult to imagine, with its opulent luxury. As a small boy he recalls the family resettling on a country estate, Hutton Hall, a few miles outside of York. His description of the household suggests the degree of wealth his family enjoyed at the time:

> The staff consisted of fifteen servants in the house (Cressy the butler, a footman and an odd-job man: Nanny and a nurse-maid; two lady's maids, three housemaids, a cook and two kitchenmaids, and two laundry-maids) with nine men outside (Cox, the coachman and two grooms in the stable; three gardeners and three gamekeepers) not to speak of boys to help in all departments, and the wives and children of the married retainers. It was not a very large establishment for those days: just a comfortable gentleman's home; but it was a little world in itself, in which everyone was happy, everyone cared for, with the assurance of security when old age came.[7]

Memory has clearly idealized his recollection of his early life, but what it suggests is Charles Richard Cammell's own view of it as a perfect arrangement for the family and its servants alike - one that hearkens back to an antiquated past, when the "laird" of the manor viewed his servants as extended family and a co-dependence existed between classes. This memory exerted considerable power over Charles Richard Cammell, with its utopian dimensions largely the cause for his idealization of the nineteenth century; he was described, in the promotional material included on the dust-jacket of his book *Castles in the Air* as, "the last of the Romantics," an apt description that no doubt pleased him as well.

Like many literary luminaries before him, the most famous of which might be the Romantic poet Percy Bysshe Shelley, Charles Richard Cammell began his formal education at Eton, in his case at the age of thirteen, in 1904. Stricken with a "serious affection of the optic nerves" - some sort of severe eye strain - he was given three tutors to help him complete his studies.[8] Despite the unusual affliction, he nonetheless finished at Eton in three years rather than the usual five.

During the summer of 1909, at the age of 18, he met and began an affair with a beautiful actress he has named "Maud" (no doubt a pseudonym). Apparently, by mutual agreement, she followed him to Cambridge in the fall, where he began his university career. Unfortunately, he chose untrustworthy confidantes to tell about the affair, who maliciously made it known to his relatives

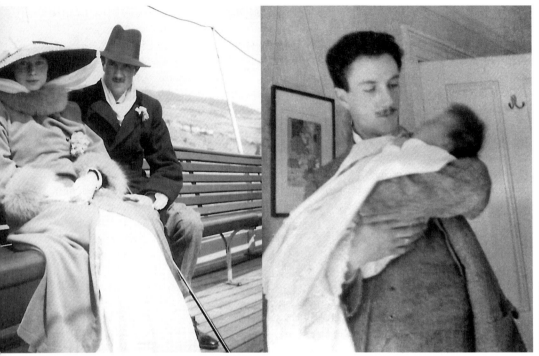

Left: *Donald's father, Charles Richard Cammell, with his first wife, Elizabeth (Macalester) Cammell, in 1911.*
Right: *Charles Richard Cammell with his oldest son, Charly, in his arms in October 1911. Charly was born 30 September 1911.*

and created a family scandal. Public morals being what they were in the early Edwardian age, Charles Richard was forced to leave Cambridge after only one term. In his memoirs, he looked back upon this episode as a particular disaster:

> In retrospect few incidents in my life fill me with so much indignation as the meddlesome activities of those misguided relations. Certain it is that their behaviour towards me at that time determined largely the course of my future life. It wrecked my university career, which might otherwise have been brilliant; it estranged me for many years from most of my kindred; and it alienated me from my country for a quarter of a century.[9]

In December 1909, during the winter holiday at Cambridge University - to which he was never to return - Charles Richard fell in love with a young American woman, Elizabeth Lathrop Macalester (born 1888), whom he had actually met in Geneva, Switzerland the previous year. She was the youngest daughter of Dr. R.K. Macalester, of Philadelphia. The Macalesters of Philadelphia, Charles Richard says, "were counted among the wealthiest and most distinguished families of the old Scottish aristocracy who had migrated to America." He goes on to say Elizabeth was actually born in Switzerland and educated in France; "she was altogether cosmopolitan in culture."[10] He and Elizabeth met a second time in 1910 and declared their love. They married at the British Vice-Consulate, and later at St. John's Church, Menton, France, on 29 March 1910. He was very young at the time of this rather impulsive marriage, a mere nineteen years old. Interestingly, his son Donald was to also to marry at a young age, twenty, and his first marriage, too, would end in divorce.

The first child born to Charles Richard and Elizabeth Macalester Cammell was a son, Charles George Macalester ("Charly") Cammell, born at Oxbourne, Shoreham, Kent on 30 September 1911. Two other children would be born to them: Elizabeth Geraldine ("Lili") Cammell, born at 30 Redcliffe Gardens, Kensington, London on 12 May 1914; and Christopher Benvenuto Cammell - named after the poet Marlowe and the sculptor Cellini, both of whom Charles Richard admired - who was born at the Château de Chevigny-St. Sauveur in Burgundy, near Dijon, on 14 January 1916.

The Château de Chevigny-St. Sauveur was discovered by Charles Richard in January 1912, while travelling with his wife and sister, Meta. Elizabeth had caught a cold, and the three were required to remain at Amiens until she recovered. One day while out for a walk, he and his sister Meta came upon the Château, which was for sale at the time. Apparently Elizabeth was as taken with it as Charles Richard, and the couple subsequently purchased the property on 29 January 1912. The Château itself was built in the Queen Anne style, between the years 1643 and 1652, and was erected on the former site of a twelfth-century castle. A good many of the rare books and *incunabulae* that Charles Richard was to own and cherish came with the purchase of this property.

Charles Richard and Elizabeth Cammell spent enormous sums of money on the Château's restoration - even to the extent of completely renovating its collapsed moat - settling there in the early spring of 1912. In the midst of the harsh winter of 1916 (when Donald's half-brother Christopher Benvenuto was born), fuel oil became scarce as a result of the war in Europe. Charles Richard and Elizabeth were forced to abandon the Château because it became impossible to heat it. They took up residence in Geneva, Switzerland, never to return to the home upon which they had lavished so much money. Charles Richard's first son, Charly, recalls that the empty Château was subsequently used to house French troops and that by the end of the First World War, "everything was smashed." In 1919, Charly recalls, the French government "paid very little money" to his father for it.[11] David Cammell reports that in about 1969, the last time he passed by, the Château had become "a school for naughty boys."[12]

The marriage of Charles Richard and Elizabeth was destined not to last. One has to read between the lines of Charles Richard's memoirs to discern why, although he is quite forthcoming about his extramarital affairs during his first marriage, and his obsession with a French peasant girl, Lucienne-Gabrielle, whom he rescued from an enforced elopement with a rakish cousin of Elizabeth. Charles Richard devoted his poetic endeavours to Lucienne-Gabrielle, and averred that she "was destined in years to come to exalt and wreck me, to awaken in me that kind of love which Plato and Dante and Petrarch have taught us is the most divine emotion in the soul."[13] Most certainly this contributed to the strain on his marriage, although he and Elizabeth were still travelling together as late as 1928, the year he most likely met Iona Macdonald, who would become his second wife.[14]

Donald's half-brother, Charly Cammell, photographed in 1937 with his Aunt Olga, sister of his mother, Elizabeth.

Iona - By Moonlight

Iona Katherine Lamont Macdonald, Donald's mother, was born on 6 April 1903 in her parents' house, Kilmichael, near Glenurquhart, Invernessshire, in the Highlands of Scotland. Kilmichael is a fine stone house, located a short distance up the glen from Drumnadrochit on the north shore of the famous water, Loch Ness. "Kil" is Gaelic for church, and thus "Kilmichael," means "Church of Michael." Donald's maternal grandfather was Dr. David Macdonald, a revered local doctor who died young from anaemia in December 1925. Iona's mother, Anne Jane Cameron Macdonald, who died in 1952, was called affectionately by the grandchildren "Neenie." She had, according to Charles Richard Cammell, "a commanding dignity" and was "the bravest woman" he ever met.[15] Her strength of character has been acknowledged by her grandson, David Cammell as well, who has fond childhood memories of her from the time he and Donald stayed at Kilmichael during the wartime bombing raids on London. Neenie "unofficially ruled Glenurquhart, by virtue of her personality," says David, but also because her son, Dr. William Francis Macdonald ("Willie Frank"), succeeded to his father's local medical practice.[16] It is alleged that his was the most extensive practice, geographically speaking, in Britain at the time. Charles Richard Cammell writes fondly of Kilmichael, and visited there often - he, Iona and the young Donald and David were visiting there, for instance, on that historic day in 1939 when it was announced on the radio that Britain had declared war on Germany. Francie Bradley, daughter of Willie Frank Macdonald and hence Donald's first cousin, says that Neenie ruled Kilmichael "with an iron fist."[17] She was "a strong woman with strong religious beliefs," says Francie. She recalls as a child, at "no more than 4 years old, I would have to sing hymns to her. She would hold my hand and look directly into my eyes with her very bright blue ones," to make sure the hymns were sung correctly. "I have no doubt [that] her other grandchildren would have been subjected to this rather frightening ordeal," she says, meaning Donald as well and, presumably, Iona and her siblings before them.[18]

Myriam Gibril, Donald's companion in the years immediately following *Performance*, remembers Iona as a small, fiercely independent woman in her late 60s who doted over her son Donald, and worried about whether Myriam was clothing and feeding him properly. Deborah Roberts says that Iona had an "elfin" quality about her. "I was very fond of both of them [Donald's parents]," Deborah says, especially Iona, with whom she continued to be friends even after she and Donald parted in late 1967.[19] Francie Bradley, too, remembers her aunt Iona's independence of mind, but also that she was the "wild one," her brothers "often being called in to 'talk' to her. Donald may have inherited his wild streak from her," Francie speculates.[20]

Iona was taught French, learned to paint, and play the piano, was very well read, and had a formidable knowledge of many ancient Scottish traditions, including that of dyes and the weaving of plaid tartans. Before she met Charles Richard Cammell, while in her twenties, Iona demonstrated the fierce independence of spirit that those who knew her are compelled to mention. By her early twenties, "she had a shop on Bond Street," says David Cammell, "which is the smartest shopping street in London, selling tweeds. She had them hand-woven and dyed in the [Scottish] Western Isles. All the dyes were taken from local plants. I know the Queen Mother bought from her."[21] Charles Richard Cammell found Iona's role in maintaining the ancient Scottish traditions "truly patriotic work." He maintained that she was "an authority on Highland weaving" who employed "a number of the most expert women-weavers at Portnolong in Skye to produce cloths in every variety of weight, weave and colour, including some lengths of soft-tartan of exceptional beauty. Of these homespuns she gave several exhibitions in England, both in London and in the provinces, thereby assisting the maintenance of this ancient craft in the Highlands."[22] She was not to continue in her business for long, however. "She gave it all up after she married my father," says David Cammell.[23]

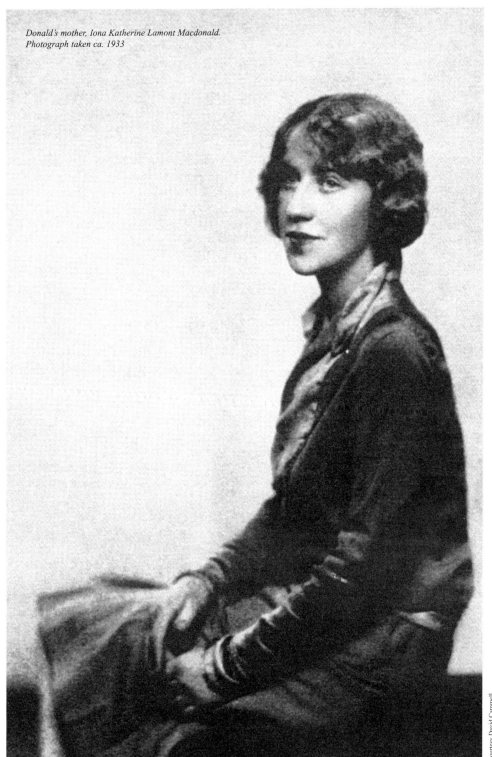

Donald's mother, Iona Katherine Lamont Macdonald.
Photograph taken ca. 1933

courtesy David Cammell

One of two versions of the circumstances by which Charles and Iona met was provided by "Charly" Cammell - eighty-nine years old when we spoke with him - who says that his father met Iona in Geneva "when Iona became our nanny," specifically when she was hired as the "governess for my sister, Lili."[24] Lili, born in 1914, would have been fourteen years old in 1928, the likely year Iona and Charles met; Iona would have been about twenty-five. In an alternate, more romantic family version, David Cammell recalls being told his future parents met at the "Fête des Fleurs" celebration in Geneva, Switzerland, which "as a child struck me as a suitably romantic occasion for our parents to meet."[25] Both accounts agree on the point that their meeting occurred sometime after the death of Iona's father, David Macdonald (December 1925), because in his memoirs Charles Richard indicates that he never met him.[26] Fortunately, Charles Richard Cammell was a poet (and memoirist), and one of his poems provides a clue about the approximate time he and his soon-to-be bride met, or at least the approximate time he fell in love with her. In his collected *Poems* (published in London, 1930), there is a verse dated June 1928, titled "By Moonlight," that appears to be the first of many love poems he was to write to Iona Macdonald. The poem employs a deliberately antiquated diction suggesting the sources of his inspiration - Romantic poetry. It should be pointed out that Charles Richard Cammell and T.S. Eliot, for instance, were of the same generation, and virtually the same age. The form and diction of "By Moonlight," written six years after the publication of Eliot's famous Modernist poem, *The Waste Land* (1922), suggests why his rather anachronistic poetry (in terms of both style and substance) is not more widely known. In any case, he was to compose other poems in 1928 that by inference are addressed to Iona: "Song" (July 1928), "Her Roses" (October 1928), and "Iona" (1929).

According to his memoirs, he and Iona seem to have been travelling in Europe together before Charles Richard's divorce was final, which, as their son David observed years later, "must have been unorthodox at the time."[27] However, by the spring of 1931, when he left Geneva for London, and London for Edinburgh, Charles Richard Cammell and Elizabeth Macalester were divorced. His first marriage, which lasted long after the love had vanished, stands in stark contrast to his second marriage, which was marked by fidelity and, if sometimes stressful, lasting mutual affection.

There were other concerns for Charles Richard during this period of marital upheaval, as the Wall Street crash had depleted the remainder of his fortune, already reduced by his rather extravagant expenditures on the restoration of the Château de Chevigny-St. Saveur. "I was caught by the disastrous financial crisis of that autumn, 1931: to few more disastrous than to me. Had I remained in Geneva, I might have weathered the storm, but it was not to be."[28]

Heart of Scotland

By his own account, Charles Richard Cammell crossed the border into Scotland one day in the spring of 1931, as was his wont commemorating the event with a poem, "The Return."[29] At the beginning of his second volume of memoirs, he claims that he was prompted to do so by the spirit of his deceased godmother, "Min," Miss Anne Davidson who, he insists, during her lifetime had "the strange gift of 'the second sight'," by virtue of the fact that she was the seventh child of fourteen, and that her parents were both seventh children as well. To her, his "second mother," Charles Richard pays great tribute: "She taught me to read and to write, to love poetry, to love history, to love books, to love Scotland."[30] No mention of his fiancée, Iona, is made, so presumably she remained in London with her business until shortly before the marriage. It is at this juncture that the long-time expatriot became a fervid supporter of the National Party of Scotland, which had been formed in 1928.

The Edinburgh to which Charles Richard Cammell returned, where he was to marry Iona Macdonald and live for the next four years, was a vital, historic, and beautiful city - as it still is today.

During the eighteenth century it had undergone of period of enlightenment, which had earned it the title 'Athens of the North', and it had become home to many important artists, intellectuals, and scientists. Among the many famous residents of Edinburgh are author Robert Louis Stevenson, economist Adam Smith, philosopher David Hume, and pioneering surgeon Joseph Lister (after whom the antiseptic Listerine is named). Edinburgh still had a lively intellectual and artistic scene in the early 1930s. Charles Richard and Iona were to make some interesting acquaintances during their time in the city. For instance, they knew Canon John Gray - then the local parish priest at St. Peter's Church in Edinburgh - upon whom Oscar Wilde loosely modelled his famous character, Dorian Gray.*31*

According to the family Bible, Charles Richard Cammell and Iona Katherine Lamont Macdonald were married in Edinburgh on 2 April 1932. The marriage of a Cammell (Campbell) and a Macdonald was a rarity, given the deep-seated animosity between the Campbell and Macdonald clans that dates back to the infamous Glencoe Massacre of 1692. One of the darker episodes in Scotland's troubled history, the Glencoe Massacre in Scotland to this day is considered the ultimate example of villainy and treachery. The Lowland Campbells, to advance their own political allegiance with the English, slaughtered 38 members - including women and children - of the Highland Macdonald clan, who were their hosts. Not only was this an act of cowardly treachery, but also a violation of the Scottish code of hospitality. Among the Scots, the name "Campbell" retained the tinge of treachery for many generations.

Given this longstanding hatred between the clans, the marital union of a Macdonald and Campbell, even 240 years after the Glencoe Massacre, was cause enough for the raising of eyebrows in certain circles. The name of their first-born son, Donald Cammell, considered poetically, might therefore be said to carry within it the symbolic re-uniting of these two long-divided clans, and the historic significance of Charles Richard's and Iona's marriage resonated as a piece of family lore. When Iona was upset with her children, she would pronounce melodramatically, "A Macdonald should never have married a Campbell! My children are the spawn of the Devil!"

The couple took residence in Edinburgh's "Old Town," in an apartment in the Outlook Tower, located on Castlehill, one of a series of streets that make up the famous Royal Mile stretching between Edinburgh Castle and Holyrood Palace. The Outlook Tower, literally in the shadow of that colossal rock upon which sits Edinburgh Castle, is famous for the *camera obscura* on its roof. Originally a quadrangle-shaped private residence, in the 1850s an additional floor was added to the building along with a rooftop terrace appended to which was a roofed cylindrical tower that housed the *camera obscura* - added for the commercial purpose of making the site a Victorian tourist attraction, which in fact it became. In 1892 the property was purchased by Sir Patrick Geddes, at which time it was given the name by which it is still known today, the Outlook Tower. Just as it was for Victorian tourists, it remains a popular tourist attraction, although it no longer houses any apartments. That Donald was born literally in the building that housed one of the famous ocular devices in Europe is a rather serendipitous event presageful of his later career as a film director. In one biographical statement, Donald made nothing of the *camera obscura* but claimed that he was born "in a medieval room on whose floor was painted a map of the world," the story of the map most probably a piece of lore told him by his parents. He would later say, in a studio publicity sketch, that this decor was "an omen, since he has spent much of his life travelling the world."*32*

The Outlook Tower is located about two blocks from the Cathedral of St. Giles, near which once stood the infamous Tollbooth, later christened by the famous Scottish novelist, Sir Walter Scott, as "The Heart of Midlothian." Donald Seton Cammell was therefore born barely a minute's walk from the historic site of the Heart of Midlothian, on 17 January 1934 at 6:40 p.m. His father was forty-three years old, his mother thirty. As was then the custom, his father was not actually present during his birth. Charles Richard's friend, the Lady Margaret Sackville, lent him her flat in Ramsay Gardens, very near the

Donald Cammell aged 5 months. Edinburgh, 1934.

courtesy David Cammell

Outlook Tower, while his home was turned over to Iona's sister, Marjorie Macdonald, a trained nurse, and one of Iona's close Highland friends, Lexie Macdonald, for the occasion. Charles Richard reports that immediately after Donald's birth, Lexie Macdonald "took him in her arms and sang to him Hebridean faery-songs," thus accounting, according to his father, for the "something 'fey'" in Donald's character.[33] Charles Richard soon asserted:

> No child had been born within its walls for more than a hundred years. The Tower being situated in "the Heart of Midlothian," the historic centre of the Scottish capital which surrounds the House of Parliament and the Cathedral of St. Giles, Donald was entitled by birth to the privileges belonging to those born in this ancient quarter of the city.[34]

His father must have impressed this lore upon Donald, because Myriam Gibril recalls Donald actually once mentioning this fact to her. But David Cammell is sceptical of his father's claims about Donald's special birthright and finds the whole idea amusing. "What precisely are the privileges?" David asks. "And how did my father know that Donald was the first child born in that quarter of the city for more than a hundred years? I think the story is an instance of my father's fanciful imagination."[35]

At any rate, Charles Richard adored his infant son and, true to his poetic spirit, was moved to compose a touching poem for the occasion, "The Guardian Angel," reproduced as a frontispiece for Part One of this book.[36] He was to write yet another poem for Donald, "Mystic Sonnet on a Child," both of which derive from his knowledge of Neo-Platonism and of Wordsworth's famous ode, "Intimations of Immortality," depicting one's spiritual pre-natal life in heaven, from which the Soul descends to earth trailing "clouds of glory."[37] His vast knowledge of occult literature would eventually have some influence on the son for whom he wrote the poems.

Donald's second given name, Seton, was chosen for him in honour of his father's close friend, Seton Gordon, who became Donald's godfather. Gordon was a Scottish naturalist, author of several books, and, again according to Charles Richard, an "authority on the classical music of the pipes" (the pibroch), who by happy serendipity was in Edinburgh to provide moral support for his friend during the long hours before Donald's birth.[38] It was falsely rumoured in Donald's later life that he was the godson of "The Great Beast," Aleister Crowley, whom Charles Richard Cammell met in London in the spring of 1936 - over two years after Donald was born - and about whom he wrote an important book, *Aleister Crowley: The Man: The Mage: The Poet*, published in 1951 - a book that has been pirated many times, under various retitlings. Over the years the false rumour that Crowley was Donald's godfather has persisted (would Crowley really have agreed to become someone's *god*father?) based solely on his brief association with Crowley when he was a small boy.

Records show that Donald Cammell was baptized on 1 June 1934, at slightly over four months old, in the Cathedral of St. Giles. Charles Richard records that the baptism occurred in the chapel "sacred to the memory of John Knox whose colossal statue in bronze… by Pittendrigh Macgillivray, dominates the shrine. The… sculptor himself honoured us by being present, despite his age and the cold weather."[39] Indeed, Macgillivray's masterful bronze of Knox still stands in the place in St. Giles where it did at Donald's christening. According to the church's baptismal records, the presiding clergyman was W. Roy Sanderson.

At the time of Donald's birth, Charles Richard was awaiting word on his application for the Watson Gordon Chair of Fine Art at the University of Edinburgh. Although he had the recommendations and letters of support from some of Scotland's noted artists and writers, such as Pittendrigh Macgillivray, Lewis Spence, Blaikie Murdoch, Seton Gordon, and Sir George Washington Browne - the latter a Past President of the Royal Scottish Academy - he was to be disappointed. The position was given to David Talbot Rice, who was a specialist in Byzantine Art at the Victoria and Albert Museum in Kensington, over other applicants, including the noted art critic Roger Fry. In retrospect, Charles Richard's chances were slim at best: he had not completed his M.A. degree at Cambridge because of the scandal alluded to earlier, he had never held an academic post, and most of his known work to that date consisted of self-published books of poetry. He was recognized as a poet of some skill, however, and much of his work is quite good, as are his translations of French classical writers. Though his best poem, "Benvenuto Cellini In the Forest of Fontainebleau" (1931), is actually brilliant, the fact is, Charles Richard Cammell's literary reputation seems to have been stronger in Scotland than in the south; in some ways he was regarded as the Scottish Poet Laureate (the post does not exist officially). For instance, three major odes (at least) were published across the centre spreads of *The Scotsman* - Scotland's equivalent to England's *The Times* - on auspicious occasions: "Ode to the King's Majesty," for George V's Silver Jubilee in 1935; "Scotland's Ode to Victory," commemorating the Allied victory, in 1945; and "Ode to the Queen's Majesty," celebrating the Coronation of Queen Elizabeth II in 1952. Despite his many publications, and an erudition acquired through his (forever lost) life of leisure, his love of books, and the support of many prominent artists, he was not to land the academic post.

Iona soon objected to the Outlook Tower's narrow, winding, draughty staircases and lack of a garden as unsuitable surroundings for raising their infant child. A few months after Donald's christening, early in 1935, the couple took up residence at No. 12 Ann Street, on a quiet, crescent-shaped street in Edinburgh's "New Town" (still referred to as such today although it is more than two centuries old). Charles Richard referred to his new abode as "the ideal home," mentioning "a studio had been added at the top of the house, which served as a spacious nursery for Donald."[40]

It was an idyllic time for Iona and Charles Richard. They had a small garden behind the house in which Iona's beloved blue-roan spaniel named "Donny" could be the infant Donald's playmate, and their home was the frequent site of many conversations with Edinburgh's leading painters, poets, and intellectuals. John Duncan, the famous Scottish painter, lived at No. 29 Ann Street, a few doors away and across the street, and he and Charles Richard became best of friends. Indeed, it was John Duncan who Charles Richard claims first recognized Donald's potential talent for painting:

That Donald was born with a genius for art, Duncan was the first to perceive, and the knowledge enchanted him. He would watch Donald drawing, and show him how to draw this or that; for Donald could draw before he could talk, and had filled reams of paper before he was two years old. What astonished Duncan most was that from infancy Donald had a clear idea of perspective… Duncan maintained that this proved that Donald had learned perspective in a former incarnation.[41]

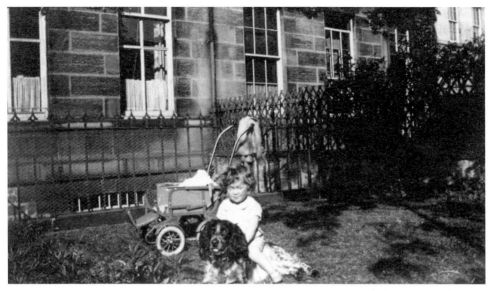

Donald with the family's blue-roan spaniel, Donny, in the grounds of number 12 Ann Street Edinburgh, 1936.

However well-meaning father and tutor might have been, and taking into account Donald's considerable talent in later years, this assertion, this insistence on such an early - even unbelievable - display of talent is itself based on art and not life. For Charles Richard knew well his Vasari, as both of Donald's younger brothers affirm. Vasari's *Lives of the Painters* was written in the seventeenth century and re-discovered by the Victorians. In it, Vasari asserts that precocious talent was one of the characteristics of the great painters, such as Michelangelo, who, according to Vasari, could draw before he could talk. Charles Richard thus saw in the young Donald's talent for drawing a feature of the greatest painters, and envisioned his young son as such, nurturing in him a love for the visual arts that he would retain for the rest of his life.

Charles Richard continued to apply for academic posts, including that of Chair of Rhetoric and English Literature at the University of Edinburgh, and the Chair of English Literature at the University of Glasgow. Yet despite his best efforts, none of his applications for academic posts in Scottish universities came to fruition. His disappointment is tangible in his memoirs: "Each successive failure was a grievous blow to my hopes of fulfilling honourably and to the full the way of life to which my talents called me, and for which my entire personality was fitted."[42]

The British Babylon

By the autumn of 1935, in need of sufficient funds to support his new family, and hence in need of employment, Charles Richard accepted the position as Associate Editor of *The Connoisseur*, a Hearst publication under the editorship of Herbert Granville Fell. *The Connoisseur*'s editorial offices were located in London, however, which would require a move from his beloved Edinburgh, farther from Iona's Highland home and hence her family, and away from their esteemed friends. With great disappointment and no doubt some lingering hesitations, Charles Richard Cammell moved his new family from the northern Athens to London, the "British Babylon," in the fall of 1935.

Donald was not yet two years old. The move particularly grieved his father's friend, John Duncan, who was quite taken with the infant Donald. Duncan was to write to his friend frequently after their move to London. In a letter dated 15 December 1935, soon after the Cammells' sad departure, he noted that:

> Donald was a little puzzled and anxious in his going off. He felt that things were happening that were too big and complicated and mysterious for his little head to compass... Glad to hear the new environment pleases him and that he is adjusted to the change...[43]

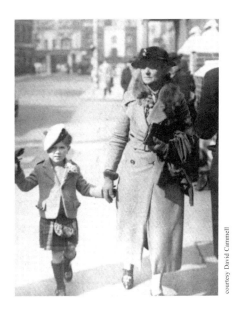

Donald with his grandmother, Neenie, in Edinburgh, 1938

courtesy David Cammell

Prior to the move, Donald had served as the model for the youngest of four children receiving Christ's blessing, depicted in a splendid stained-glass window for the Children's Chapel in Paisley Abbey, created by John Duncan. He is the small boy holding flowers, at the left, beside the Virgin Mary. Charles Richard claimed: "The likeness to Donald was remarkable."[44]

Donald's new environment was a house on Old Palace Lane in Richmond, Surrey, a suburb that lies several miles west of central London. From here Charles Richard would commute to the offices of *The Connoisseur* in Grosvenor Gardens. Richmond has always had a rich literary heritage; perhaps this is what drew Charles Richard Cammell to settle there. He was to write in his book on Crowley, "Authors and authoresses there were not a few, but (for me) there were three only that mattered: Ralph Shirley, Montague Summers, and Aleister Crowley - three men eminent in literature and renowned as masters of occult learning." One can only imagine the sort of discussions that took place among these eccentric scholars of Western occult traditions. Donald was later to say:

> I was brought up in a house where Magick was real. My old man, Charles... filled the house with magicians, metaphysicians, spiritualists and demons. I was conditioned by my father, by his books (that library...), by Aleister Crowley. I reacted against that at one stage: I became very materialist, obsessed by science and physics. But later I became more and more conscious that the world I was brought up in was an expression of a reality. I dug Magick and wanted to find out more.[45]

In fact, Donald maintained a life-long interest in science. China Cammell has said that Donald always claimed he would have become a scientist if he'd had a better education. David Cammell admits that in conversation Donald was not averse to exaggerating for effect in order to impress his interlocutors. He could read people very well, and responded to their subtle reactions to his conversation. When he was a small boy, certainly he knew Crowley, but he was not a student of Crowley as the above statement implies - indeed, far from it, and despite his dramatic assertion that he "dug Magick" (a very uncharacteristic Cammellian expression, by the way) he was never a serious student of "Magick." As if in order to cement Donald's association with Crowley, the editor spelled "magic" as Crowley did, a capitalized noun with the letter "k" appended at the end. David Cammell insists that the allegation Donald studied "Magick" is "rubbish," confirmed by China Cammell, who said that Donald subscribed

to, and devoured, magazines such as *New Scientist*.[46] (Although the films were never made, Donald was involved in the development of several science fiction films, these in addition to *Demon Seed*.) Donald's father, as David Cammell observed, eventually lost all interest in the occult - thirty years before Donald made the above statement in 1971 - and it is well documented that Charles Richard Cammell and Aleister Crowley had a severe and immedicable break in their friendship during the war.

It is important to reiterate that Charles Richard Cammell's interest in Crowley was strictly in his poetry (and, secondarily, in his prodigious feats of mountain climbing); anyone who has read Cammell's 1951 book, *Aleister Crowley: The Man: The Mage: The Poet*, knows this. Moreover, his book on Crowley did not sell particularly well - it never officially went beyond the first edition - despite the inclusion of an invaluable bibliography by Edward Noel Fitzgerald - primarily because it didn't contain the expected prurient and scurrilous biographical details, and hence was eclipsed by John Symonds's *The Great Beast* (also 1951), which did. (Of course, this fact hasn't prevented Charles Richard Cammell's book from being shamelessly pirated.) David Cammell avers that by the end of his life his father had decided Crowley was finally "nothing less than a charlatan." Indeed, in his book on Crowley, Charles Richard writes, "I saw him [Crowley] once, after the war. We did not speak."[47] Nonetheless, his admiration for Crowley as a poet was such that he was still induced to write the book many years after the men's friendship had ended. Yet Donald's remarks on the type of houseguests his parents entertained when he was a small child are doubtless true, as his parents associated with an eclectic group of artists and intellectuals. He grew up in a rarefied intellectual environment that revered literature and fine arts.

David Douglas Cammell, Donald's brother with whom he would remain very close throughout his life, was born in Richmond on 5 February 1937. John Duncan, the Scottish painter who in some sense was responsible for the future course of Donald Cammell's life, became David's godfather. Duncan remained a dear friend and correspondent of Charles Richard and Iona, and both were deeply grieved by his death, which occurred in November 1945. Diarmid Victor Charles Cammell, Donald's youngest brother, was to be born in Richmond on 21 July 1945, making him eleven years younger than Donald.

In 1939 Donald was installed at the local kindergarten in Thames Ditton, which was run by Lady Wardlaw and her two spinster daughters, Miss Madge and Miss Francis. At the annual art exhibitions in Kensington - this according to Charles Richard Cammell - Donald won book-prizes and stars regularly from 1937 (at the age of just 3) to 1945. That his father raised him to become a painter is without question, and that he suffered a disappointment when Donald, after having achieved renown for his talent, abandoned his artistic career, is also certain.

In early 1940 Aleister Crowley became the Cammells' distant neighbour. According to John Symonds, an authority on Crowley's life, in January 1940 Crowley took a flat at 57 Petersham Road, Richmond. He was to live there for the next nine months, until the last week of September. He had, of course, visited the Cammells at Richmond previously; that he became a more frequent dinner guest subsequent to his move is no doubt true. "Lili" Cammell, Donald's half-sister, recalls meeting Crowley at her father's home in Richmond on a few occasions, remembering him in her old age as "a small black man," referring to the characteristic colour of his clothing, and averred she had no interest in what he had to say, calling him "nondescript." In later years, after Crowley had ensnared the imagination of a younger generation, Donald was to recall that as a small boy he was bounced on Aleister Crowley's knee. "Crowley loved children," Charles Richard wrote in his study of Crowley and his poetry, and it may have been observing him with Donald during this time that he came to know this dimension of Crowley's personality. Given that he was three years younger than Donald, David Cammell has only vague memories of Crowley, although he did tell us that Crowley wrote his horoscope at the time of his birth in 1937, a document that he still has in his possession. "I've never read it, though" says David. "I've never wanted to know what it said, lest it become a sort of self-fulfilling prophecy."[48]

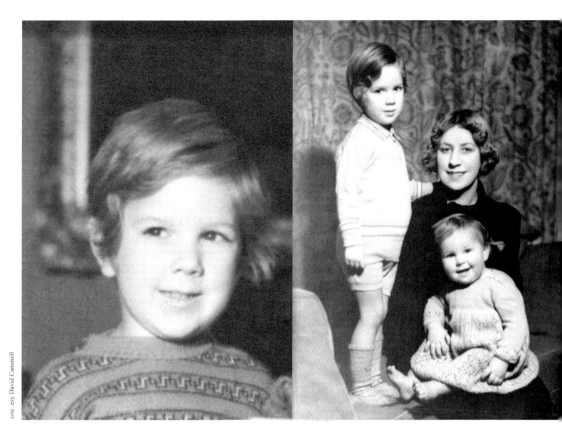

Left: *Donald at the age of 3.*
Right: *Donald (standing) with his mother Iona, and a very young David.*

Clouds of War

In the early summer of 1940, in order to avoid anticipated German bombs, Charles Richard moved Iona and his two small sons from Richmond to Bideford in North Devon to stay with his cousin, Mrs. Iris Strick, "Great Aunt Iris" as David Cammell refers to her. Iris Cammell Strick, the daughter of Charles Richard's uncle, George Henry Cammell, had what David calls a "very romantic house," the ancient and picturesque Abbotsham Court, isolated on the remote cliffs of North Devon. "The adults took turns to climb to the top of the tower and keep watch for Germans in case they invaded," recalls David.[49] In his book on Crowley, Charles Richard indicates that it was at this time, the summer of 1940, that he learned to know the man well. Thus, Donald's (over-emphasized) connection to Crowley spanned roughly four years, from the spring of 1936 to the early summer of 1940, or from the time he was two years old to the time he was six, and he was never again to be in the company of Aleister Crowley.

On 7 September 1940 Nazi Germany began its expected blitz of London. Before leaving for Torquay at the end of September 1940 (generously, Charles gave him a few pounds for the journey, which was never repaid), Crowley had acquired a bundle of Highland tweed from Charles and Iona, for which he promised to send payment. He never did. Apparently Charles and Iona, then in need of money themselves, had learned that Crowley was selling off lengths of the tweed and keeping the money rather

than sending it to them, despite their repeated requests for the payment. John Symonds's final revision of his biography of Crowley, *The Beast 666* (1997) includes an excerpt from a letter by Charles Richard reflecting his private view of Crowley: "He had no sense of honour, friendship or virtue of any kind, and was grossly sensual and unscrupulous. His erudition was considerable, and he could be a pleasant and civil companion when he chose."[50]

By the end of 1940, Charles Richard had left *The Connoisseur* and joined his family at Abbotsham Court in North Devon, prior to returning to his employment in London, taking a flat near Hampton Court and assuming the editorship of *Light*. Whilst at Abbotsham Court he was to publish his poem, *Ode to the Sun and Hymn to the Night* and a fine Arthurian poem, "The Return of Arthur," written January 1941 and published in the *Bideford Weekly Gazette*. Subsequently he was to rent a home in Bideford for a time, but by August 1941 he had rented another house for his family, Sunnydene, in Westward Ho!, just a few kilometres from Bideford. "While in Westward Ho! we had refugee children from the badly bombed East End London docklands billeted on us," says David, "another of those experiences one could have only during wartime."[51]

Charles Richard Cammell's oldest son, Charly, lived in Geneva his entire life. His other son from his first marriage, Christopher Benvenuto, who was severely wounded during World War II, obtained a commission in the Royal Engineers, rising to the rank of Major before his death by a heart attack in 1987 at the age of seventy-one. After being educated on the continent, "Lili" Cammell moved to London in the early 1930s, where she remained for the rest of her life. David Cammell reports, "I never met my father's first wife, though we were all (including our mother) very fond of our half-brothers and sister. They came and went mysteriously as far as I was concerned, and lived lives of their own. They were part of our father's 'previous life.'"[52]

During a lull in the war - either late 1941 or early 1942 - in other words, at the time when Donald was nearing or had just turned eight years old - Iona brought Donald and David back to London from Westward Ho! to the house Charles had rented (and later bought) near Hampton Court. When the bombing raids increased, fearing for the safety of their children, Charles and Iona sent their sons north to the Highlands of Scotland to live with their maternal grandmother in Drumnadrochit, on the shores of Loch Ness. Although the move was intended to remove the children from danger, ironically it led to Donald suffering a great deal of emotional distress.

Donald (left) *and David at Abbotsham Court, Devon, during 1941, aged 7 and 4 respectively.*

2 Fort Augustus
1942-1943

In her diary, which she started when Donald was born and kept until the outbreak of the war, Iona Cammell wrote that at one point she considered sending Donald and David to Canada. She later confessed, however, that she "couldn't bear the thought of being separated from my two boys," and so she, Charles Richard, and the boys stayed together as a family.[1] Although he was a small boy at the beginning of the war, David Cammell retains some strong memories of life in London during late 1941 and early 1942. "There were two sorts of bomb shelters one could have during the war," he recalls. "One was an actual bomb shelter that was underground, complete with sandbags for reinforcement. The other was what most people had, the Anderson Shelter, a big heavy steel contraption like a huge table. We had an Anderson Shelter," he says. "After previously editing *Light* and *The Connoisseur*, father eventually landed the job as literary editor of the popular *Everybody's Weekly*. He rented (and subsequently bought) a house from Lady Hanson (her husband had been Lord Mayor of London) between Thames Ditton and Hampton Court. We lived there until 1953, hence throughout the war, though when things heated up our mother would take us to Victoria Station and load us on the train heading for Inverness [in the Scottish Highlands]." About those train journeys north, David recalls, "The great steam-train would thunder through the night, blinds firmly secured because of the blackout, pausing at the foot of the snow-capped Grampians to hitch a second engine to the train to haul us over the mountains and deliver us to the Highlands (once, memorably, with our bicycles)."

Thus, for Donald and David, as for many children in and around London, World War II seemed like a grand adventure. British film director, John Boorman, who was born on 18 January 1933 (making him, minus one day, one year older than Donald) recorded his memories of British family life during World War II in his highly regarded autobiographical film, *Hope and Glory* (1987). In David Cammell's view, *Hope and Glory* captured quite admirably the experience of being a child during the war. To be sure, David and Donald's circumstances were not exactly those of the young John Boorman as dramatized in the film. Unlike Boorman, whose father was called up to active duty, their father, Charles Richard, was in his early 50s during the war, and was thus exempt from military service. (Still, David remembers his father wearing the distinctive helmet identifying him as an Air Raid Warden, one of the ways in which he was able to fulfil his wartime obligation.) David and Donald also had no teenaged sister as did John Boorman. Nonetheless, *Hope and Glory* depicts the severe stress put on British families during the period, and shows a mother's inability to control all of the activities of her children. It also portrays the mass exodus of the young, some children being carted off as far as Australia, while others, such as the character representing the young John Boorman, were sent to the relative safety of the countryside to dwell with grandparents, which is what happened to Donald and David. "Altogether we had a happy time during the war," David remembers, "full of excitement."

"I remember the sirens going off and us all climbing under the shelter, with Donald and me huddled between mother and father," David recalls. (Their youngest brother, Diarmid, was not born until 1945.) "Daddy would pass the time by telling us stories. He was a splendid story-teller, let me assure you... You may not believe it, but I think we all enjoyed the time we spent as a family telling stories beneath that shelter." David's warm memories of his family life as expressed here are reiterated dozens of times in other remarks made during our conversations with him. "One of the lovely things I

remember was on St. Valentine's Day there was a family tradition that everybody drew a St. Valentine's Day card, a picture, and we would give it to one another… My father actually had some drawing ability, as did my mother… Father was always the "Brigand Count of Barbizon" and he had this beautiful wife (who was mother), always dressed in a wimple, and they had these terrible children… They were beautifully drawn by my father, and Donald would contribute a lovely one of course… mine were not very good, but the heart was willing… but each one would be received with equal aplomb nonetheless… I had a nice, sweet family."[2]

In the spring of 1942, when the bombing raids increased again, Donald and David were shipped up to the Scottish Highlands to stay with their widowed maternal grandmother, "Neenie," at Kilmichael. "As the fortunes of war ebbed and flowed, our mother commuted between Hampton Court, looking after father (who was, typical of his class and generation, hopelessly impractical) and visiting us children," says David. It's true that Charles Richard lacked many of the practical, day-to-day skills that are now taken for granted. He had never learned to drive, for instance, because he'd had a chauffeur for much of his early life, and didn't know how to cook; the one meal Charles eventually mastered was a slice of cheese on toasted bread. "Fragments of our father's old life still remained," says David of his father. "I remember this huge, ornate soup tureen made of silver - beautifully made. But it, like so many things, disappeared during the war."

David Cammell has fond memories of the war years spent in Scotland. "As far as my childhood was concerned, it was an idyllic episode," says David of his time with his maternal grandmother. "We had fresh milk, and butter and cheese from Nellie, our cow (milked in the early morning by Maggie the maid, after she had lit the fires in the bedrooms), fresh eggs and porridge from the oatmeal that supplemented the animals' diet. We sowed the fields with corn, aided by the ageing or infirm locals who had not been conscripted, and children." David adds: "We were subsequently joined by Antonio, an Italian prisoner of war, who slept in the byre, over the cow and the pig, made us toys and became a faithful and much loved addition to the household, a sort of substitute uncle… He helped with the harvest and helped dig a bunker in the hill behind the house where we were going to hole up with the shotgun and tins of food when the invading troops arrived. Antonio was very sad to be repatriated after the war."

There were other good memories, adventuresome, of the war years. "One summer, on Donald's initiative, we built a very professional dam across a berm in the meadow which, come the winter, flooded surrounding acres and the road, never really to recover since. The local policeman rang south to ask permission to demolish it… There was the house we built at the bottom of the garden, and the bridge across the stream onto the railway embankment (forbidden but little patrolled during the war) together with the magic garden on the other side. Also an enormous four-man sledge to cope with the notorious winter of 1947…"

Left: *A picturesque view of the monastery at Fort Augustus, Scotland, where the Abbey School was housed.*
Right: *The Loch Ness steamer on the famous expanse of water, as seen from the monastery's tower.*

At one point during the war, says David, "Kilmichael was requisitioned by Canadians with large camouflaged cars. My mother, Donald and I were installed in a lock keeper's cottage beside the Caledonian Canal in Fort Augustus where we would hitch rides on the ships which had run the gauntlet of the North Atlantic… I think I picked up my love of sailing from that time. Donald and I would climb on board the ships as they went through the locks and the sailors would regale us with stories and give us tours of the ships, and then send us off with a tub of butter for mother, a great treat during the war."

St. Andrew's Priory

If the time in the Scottish Highlands was an idyllic episode for David, the experience was not always so for his brother Donald, especially after he was installed at the Abbey School for Boys at Fort Augustus. At some point, late in 1942 or early 1943 - in other words, after being enrolled there - Donald became "almost psychotically homesick," says David. "I remember me pleading with our mother on the wind-up telephone - at Donald's behest, for he feared his letters had not struck home - for her to come north and rescue him."[3] We note in passing that Donald subsequently was to depend heavily on David's love and assistance throughout his life, particularly during moments of crisis.

During the autumn of 1942, at the age of eight, Donald was enrolled by his parents in St. Andrew's Priory School, which for reasons of the war (Edinburgh's great Forth Bridge had been targeted by German bombers) had been relocated from Canaan Lane, Morningside, Edinburgh, to the Benedictine monastery at Fort Augustus, Scotland, at the lower tip of that vast wild water, Loch Ness. Fort Augustus, like much of Scotland, was a very remote and undeveloped area in those days. There was no electricity supply that far north at the time, and the road system was not nearly as developed as it is now. There was a hydroelectric dam on the south shore of Loch Ness, near Foyers, under construction during the war, which locals in the Fort Augustus area say was targeted by German bombers on a few isolated occasions; remarkably, in the mid-1990s, an unexploded bomb was discovered by a local Boy Scout troop in an area near the dam.

Certainly more developed in the years since Donald attended the Abbey School there, with a robust tourist trade spun off the alleged sighting of the "Loch Ness Monster" in 1934, Fort Augustus is still a small village of only a few hundred people, located roughly 15 miles south and west from Drumnadrochit, his mother Iona's home. The Benedictine monastery, established there in 1876, housed the Abbey School for Boys. As a student enrolled in St. Andrew's Priory School, Donald would eventually stay on the Abbey grounds for two terms, 1942-43. Whether he fully completed his second term is not clear. For financial reasons, the Abbey itself was closed in 1999. The Abbey School for Boys, however, had closed its doors in June 1993. As a result, despite our best efforts, the records detailing the precise dates of Donald's enrolment, and any remaining files regarding his attendance and disposition while enrolled there are, unfortunately, not available.

It is clear that Donald had a severe emotional upheaval during the period he was a boarder at the Abbey School at Fort Augustus. China Cammell told us that Donald identified Fort Augustus as a "trauma point" in his life, and told her that he ran away from the monastery at least twice.[4] We have found no evidence - until this point - of Donald behaving hysterically. His parents no doubt doted on him, to be sure, but by all accounts, he was a happy, well-adjusted, if precocious, boy. Yet, at some point around eight years old, Donald's behaviour changed, and he subsequently spent the rest of his life plagued by severe, recurring depressions and thoughts of suicide. These depressions were to determine, to a great extent, and sometimes undermine, his artistic career.

In order to understand more fully the experience of being a student at the Abbey School in Fort Augustus, we contacted Michael T.R.B. Turnbull, who wrote and researched *Abbey Boys: Fort*

Augustus Abbey Schools (2000), the official history of the Abbey School for Boys at Fort Augustus, where Donald was installed during the 1942-43 school year (although we surmise Donald was removed from the school during the spring 1943 term). Mr. Turnbull now lives in Longniddry, East Lothian, Scotland; he taught at Carlekamp Priory School (as St. Andrew's Priory was renamed when it moved to North Berwick after the war) for a year, and for five years at a reformatory school.

The students enrolled in St. Andrew's Priory, Turnbull explains, would have been housed on Abbey grounds at the Old Convent. "The same staff [of the Priory School] went up with the School to Fort Augustus," Turnbull told us. "They [the young boys] lived in the Old Convent and were taught in the Lodge. The prevailing ethos of the Priory School was a "family" one. The boys were sheltered and cared for by the staff. It was also a very small school community…"

In his detailed history of the Abbey School, Turnbull writes about the school's daily routine. Discussing the school year 1941-42, (note that this is the year prior to Donald attending the school) Turnbull says that there were "many new faces among the staff and the pupils… Father Swithun Bell rejoined the staff after many years' absence. Mr A. Scott and Mr J. Douglas became resident masters, while Father Edmund left to become a Chaplain to HM Forces. Rugby continued to be played every Tuesday and Thursday but Father Oswald, who had been games master for the previous eight years, resigned and was succeeded by Mr A. Scott."

Turnbull observes about the above description: "You will see that there are three monks (Swithun Bell, Edmund Carruth and Oswald Eaves - later Abbot: all three are dead) and two laymen (Scott and Douglas: I don't know anything about them). There would also have probably been male domestic staff (e.g., groundsman, handyman)." Turnbull said to us,

> "I knew [Fathers] Oswald and Edmund well… I didn't know Swithun Bell. Remember, too, that the junior boys were in a world of their own away from the Abbey School - Donald, strictly speaking, was never a pupil of the Abbey School, he was a pupil of St. Andrew's Priory which had its own separate working and accommodation locations, away from the Senior Abbey School."[5]

There were no doubt experiences Donald had while enrolled in the school that he enjoyed. Mike Turnbull reports that movies were frequently shown to the boys - the Abbey School, remarkably, had a motion picture projector and screen - and one can surmise that the administrative staff did strive to provide entertainment for the boys at every opportunity.

The boys were also taken on exploratory hikes through the wooded hills, and were allowed to swim in the nearby Caledonian Canal. The monks tried to instil in the boys a love of the outdoors along with certain practical skills. His early outdoor experiences at the Abbey School helped the older Donald become a very capable outdoorsman who loved camping. (Later in life, while living in Los Angeles, he was especially fond of the desert, where he would often invite friends to join him and China.) As we shall see later, scripts such as *The Cull*, for instance, reveal not only Donald's considerable knowledge of ancient Scottish weaponry, and of guns, but also the outdoor survival skills he had first been exposed to early in life at the Abbey School. Considering these positive features of life there, Donald's hysteria and his running away from the school seems quite puzzling. The question then arises: how might one account for the discrepancy between life at the Abbey as Michael Turnbull describes it, for instance, and those frantic, pleading phone calls home? What was it that created the young Donald's urge to flee the school? Might it have been some form of physical abuse? Certainly, such speculations are not unwarranted.

When we informed Mike Turnbull that Donald had run away from the Abbey School at least twice, he replied, "There were students who tried to run away when I was at Fort Augustus (1955-60) but these were boys who found it hard to adapt to the routine of school life, rather than the victims of

abuse (of every or any kind)." Turnbull also observes, "It is possible that Cammell may have received the strap or even the cane, but I think that these official punishments were normally only administered to boys aged fourteen and over." As a small boy of eight or nine (as he would have turned in January 1943) it is indeed unlikely that Donald would have received such a severe punishment, but it is possible that he witnessed such punishment. He most certainly was aware of it. The unavoidable association here, of course, is the scene in *Performance* in which Chas is whipped by Joey using Chas's belt as a strap. However, there is at least one other intertextual source for this scene, drawn from art as such and not life: Marlon Brando's *One-Eyed Jacks*, a film Donald admired. One anonymous source told us that he had it "on good authority" that "Donald fainted straight away in the theatre when Dad Longworth (Karl Malden) breaks the Kid's (Brando's) hand with a gun butt." In the same scene, Dad Longworth also whips his old friend with a bullwhip.

Turnbull continues: "Since Donald was only there for two terms I don't think there would have been any time for an abusive relationship to build up between a member of staff and Donald. I am almost certain, however, that he might have been bullied by some of the boys and he would certainly have felt very isolated, rejected by his parents - a 'dark night of the soul' which I imagine many boys at boarding school would have felt. I certainly did."

"The regime at Prep School was normally a relaxed, benign one," Mike Turnbull says. "Separation from parents, however, and a feeling of isolation would be a distinct possibility… Incidentally, parents would have frequent opportunities to visit their children if they wanted to. There were also half-terms where the boys could return home for a few days."[6] How frequently Iona visited Donald at the school is open to question; David Cammell remembers visiting the school with his father, and recalls his father having a rather lengthy conversation with the then Headmaster, Fr. Oswald Eaves, about the possible existence of the Loch Ness Monster, a lovely little detail that any child would remember.

It is indisputably true that Donald was quite young when he was installed at St. Andrews Priory, a remote and isolated place where his loneliness no doubt must have been acute. It is a distinct possibility that Donald ran away from the Abbey because he was unpopular at school. He had come from a pampered background, and may have found it difficult to adjust to the isolation from his parents and being treated as an equal with the other children, rather than being exalted. In addition, he may have been bullied for thieving from the other children and being aloof and outwardly different - as testified by Fr. Benedict Seed, one of the Benedictine monks who remembered Donald as a boy at the Abbey.[7] Certainly he experienced the shock of the new while at the school, and when his pleas to be removed from the school went unheeded, he became increasingly emotionally distraught and agitated. Eventually his consternation culminated in the "hysterical" reaction the young David Cammell so vividly remembers. Given Donald's hysterical behaviour while at Fort Augustus, Charles and Iona had no alternative but to remove him from St. Andrew's Priory at the Abbey School and bring him back to London with them to risk the bombs. Clearly, they took Donald's hysteric episode seriously: Iona never again sent Donald to Scotland without accompanying him.

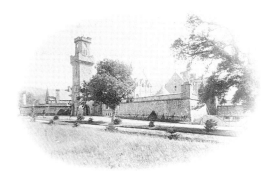

The monastery at Fort Augustus, circa 1920

A portrait of Lucky Luciano by Donald Cammell,
originally published in the October 1959 edition
*of **Lilliput** magazine.*

Cammell

3 Portraits
1944-1959

Beginning the school year 1943-44, Donald was installed in a local Preparatory School, Shrewsbury House, on the Ditton Road, Surbiton. "At school at Shrewsbury House he won the prize for art, a silver cup, 1944-48, that is, every year that he attended the school," his father Charles proudly reported in his memoirs.[1] Meanwhile, Charles's friend Adrian Bury had written a piece about Donald's precocious talent, "The Dawn of Art," published in *Everybody's Weekly* in 1945, which included illustrations of Donald's, one of which was an old galleon in a storm, drawn when Donald was a mere seven years old. Two drawings of armoured knights, made at the age of eleven, were awarded prizes at the Royal Drawing Society in Kensington; in 1951, at the age of seventeen, Donald was awarded the second Farquarson prize for a large pen-drawing of Augsburg tilting armour, in the Victoria and Albert Museum Competition.

After the war, in the fall of 1948, Donald moved to Westminster. David Cammell remembers that while his brother was there he excelled at sports. "He was an excellent cricket player," says David. "I believe it was during the time at Westminster that he started lifting weights. It strengthens the cricket arm, you know."[2] Other accounts we have heard about Donald during this period suggest that he indeed enjoyed the challenge of competitive sports, but he is also said to have "excelled at history and philosophy, and then physics and biology."[3] Donald said it was also at this time that "going to the movies became a steady habit even though school rules forbade this vice except on Saturdays." In 1950, Donald moved to the Byam Shaw School of Art. "Since I was three years younger I never overlapped with Donald at school, which was a help economically, since when I went to Westminster in 1950 Donald moved on, aged sixteen, to Byam Shaw," David Cammell says. "Donald left home when he went to Byam Shaw and lived in Earl's Court with a beautiful girlfriend named Rita and a couple of other friends. So as you see, Donald lived an independent life from early on."[4]

How long Donald lived in Earl's Court with his then girlfriend is hard to say, but we surmise it was during this time, not later in the '50s as one source has claimed, that Donald, returning home one day, discovered his then girlfriend (not necessarily the one mentioned by David Cammell) in bed with another woman, and was asked to join them. Myriam Gibril, the source of this story, didn't tell us precisely the same version she recounted to Colin MacCabe, that the other woman was supposedly the girlfriend's own sister. "Donald mentioned that story to me more than once," Myriam told us. "It seemed to have a huge effect on his sexual imagination."[5] While we don't dispute the story, we hesitate to attribute Donald's propensity for the *ménage* to this particular experience; instead, we believe the *ménage* was his way of avoiding intimacy.

He was to have other roommates at different times in the early '50s, both named Tim: Timothy Whidborne and Timothy Phillips. Both were painters; both were friends and students of Pietro Annigoni, the Italian *maestro* who first captured headlines in Britain in 1949 as a result of the stir created by his exhibition of self-portraits at the Royal Academy of Arts. It was through them that Donald met Annigoni, with whom he would study for a short time in Italy in 1953. Annigoni would eventually become world famous when his portrait of Her Majesty Queen Elizabeth II was unveiled in 1956. By 1952, the year we believe he met Annigoni, Donald was living with Timothy Whidborne in one of the studio flats on the Fulham Road in Chelsea, and Whidborne was holding a number of Annigoni's drawings and paintings in his flat.

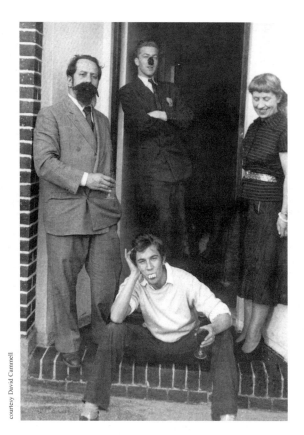

(L-R): *Pietro Annigoni, Tim Whidborne and Donald with Juanita Forbes, at Charles Richard and Iona's home near Hampton Court, ca. 1952*

Charles Richard Cammell remembers first meeting Annigoni during the summer of 1952 at the Chelsea flat Donald shared with Tim Whidborne. Donald and Tim were by then friends with the beautiful Juanita Forbes, daughter of the sculptress Feridah Forbes, who lived in one of the studios close to Whidborne's. Juanita Forbes had been the model for one of Annigoni's paintings, *Allegory of Time*. "I remember," wrote Charles Richard, "an evening at my home near Hampton Court when Annigoni arrived with Donald, Juanita Forbes and Tim Whidborne, all in masquerade, Annigoni with a false beard and prodigious nose... After dinner, we recited verses about the Tudor long-table, at which it was our habit to sit late with abundant wine... French was our general medium of speech, Annigoni's English being, in those days, still rather sketchy."[6] Those who knew him all remember Annigoni as a wonderful man, with all the *bonhomie, joie de vivre*, and sometimes excess of a Rabelais combined with unmistakably Christian sensibility and generosity.

Years later, in the mid-'60s, Donald's former roommate, Tim Whidborne, rented one of the studios in The Pheasantry on the King's Road in Chelsea, in whose apartment David Litvinoff apparently stayed for a time. Donald may have visited both Litvinoff and Whidborne there in late 1967 or early 1968, at the early stages of writing *Performance*. Known as something of an "artist's colony" in the '60s, one of the apartments at The Pheasantry had been used in Antonioni's *Blowup* (1966) for the scene in which David Hemmings peers through a window and observes a couple having sex. Others living in The Pheasantry in 1967 included British blues guitar legend Eric Clapton, Germaine Greer (author of *The Female Eunuch*), filmmaker Philippe Mora, Robert Whitaker (photographer of choice for many British rock groups of the '60s, including The Beatles), and Australian Pop artist Martin Sharp, a friend of Eric Clapton's famous for his psychedelic LP covers for Cream's *Disraeli Gears* (1967) and *Wheels of Fire* (1968). Sharp, who wrote the lyrics for Cream's "Tales of Brave Ulysses," is also known for his psychedelic posters of Bob Dylan, Donovan, and other popular musicians, and contributed regularly as an artist to Richard Neville's *OZ* magazine in its London incarnation. He had moved to The Pheasantry based on the recommendation of David Litvinoff, who had found the apartment for him. Like Donald, Tim Whidborne had known Litvinoff since the '50s. "David Litvinoff used to make merciless fun of Tim Whidborne behind his back," one source told us, "but Litvinoff did that at the expense of lots of people, it goes without saying."

above: The melancholy Merlin leads Vivien through the wood, thus engineering his own ruin.
right: Sir Ector mourns the saintly passing of his brother, Sir Lancelot.
*- Illustrations by Donald Cammell from Alice Mary Hadfield's **King Arthur and the Round Table** (1953).*

Prior to moving to Italy during the summer of 1953 at the age of nineteen to study with Pietro Annigoni, an apprenticeship no doubt in part urged and perhaps arranged by his father, Donald completed a series of illustrations - eight colour plates and fourteen black and white drawings - that were used for Alice Mary Hadfield's edition of *King Arthur and the Round Table* (1953). These pieces betray a certain indebtedness to Arthur Rackham, and Donald's feel for the Arthurian characters is exceptional; most brilliant is his use of the same model for Lancelot, the great but flawed knight, and his flawless son,

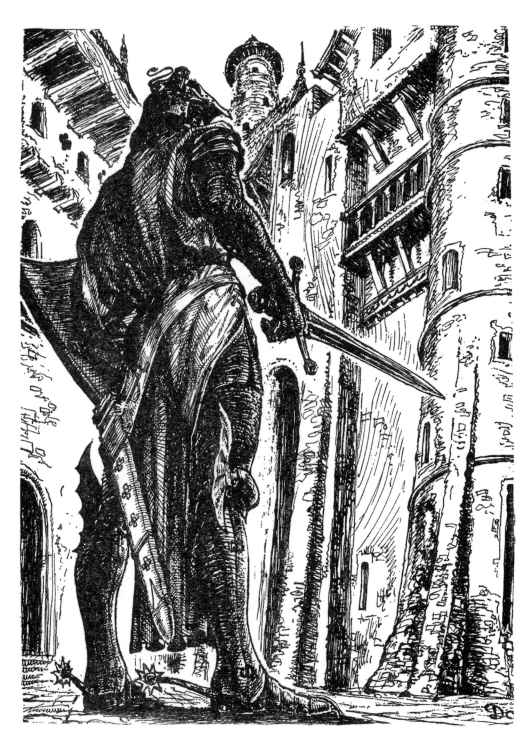

*Lancelot's prowess is nicely captured in this illustration from Alice Mary Hadfield's **King Arthur and the Round Table**.*
The scene occurs when malicious knights set a trap to expose the adultery of Lancelot and Guinevere.
- Donald Cammell, pen and ink, 1952.

Galahad. While they are unmistakably the same face, Lancelot's is dark and brooding, Galahad's bright and innocent. Also in 1953 Donald's portrait of the Marquess of Dufferin and Ava, a pageboy for the Coronation of Queen Elizabeth II, was named "Society Portrait of the Year" by *The Times* (the portrait is now at Clandeboye Castle in Ireland). He had definitely "arrived," and was only nineteen. By this time he had also accumulated a good number of female admirers.

Florence, 1953

Beat poet Harold Norse met Donald in Florence, Italy on a hot August day in 1953. He remembers walking along the Arno when he spotted "a breathtaking youth… who looked like a medieval Florentine. He was singing 'Stormy Weather' in French… I saw him disappear into a bakery and emerge with a bun, which he commenced to eat." After introducing himself to the young man, who told him his name was Donald Cammell, Norse learned that he was in Florence in order to study with Annigoni, "who considered him his best pupil." The two struck up a friendship, and later Donald introduced him to two friends of his, English painters "both named Peter," who would become his and Donald's companions on frequent trips to the Uffizi Gallery (with its many splendid Botticellis), Pitti Palace, and Medici Chapels.[7] Incidentally, we suspect Norse's memory is faulty here, as we are relatively certain he means Donald's friends were the two Tims, Tim Whidborne and Tim Phillips.

Norse and Donald became good friends and kept in contact over the years. Whenever he was in London in the years following, Norse made it a habit to visit Donald, sometimes staying at his home. In the early '60s, when Norse had moved into the Beat Hotel in Paris, he would introduce Donald to both William Burroughs and Brion Gysin, both also living at the hotel at the time. In the late '60s, when Norse was living in a flat in Regents Park in London, Donald would visit him there and on several occasions invited him to visit the *Performance* set in order to meet Mick Jagger. Apparently Norse declined.

The period Donald studied with Annigoni in Florence has been given brief mention in Donald's biography, primarily because, unsurprisingly, Donald's relationship with Annigoni ended badly. "I heard that he had a terrific quarrel and shouting match in Florence with the *maestro*, during which he made clear that he, Donald, rejected everything that Annigoni stood for," recalls a confidential source. "He followed this up with another fight, this time with [his father] Charles in London. I don't know the details, though… At the time, the British critics and intelligentsia were utterly contemptuous of figurative art. The phrase that was routinely trotted out with regard to Annigoni's work was 'chocolate-boxy.' I don't know who first used it, but it caught on with a vengeance. It's utter rubbish, it goes without saying. Donald knew better, I'd say…" As we shall see, the period with Annigoni became an aspect of his life that Donald tried to downplay.

That bridge being burned, Donald returned to London. Soon after, in a rather surprising turn given his recent experience, he applied for admission to the Royal Academy of Arts, on 16 March 1954, a flat contradiction to his rejection of portraiture evinced by his split from Annigoni. Are we to deduce, then, that his quarrel with the *maestro* was not about painting, but rather something of a personal nature? On the application to the Royal Academy, he had received the endorsement of his former respected mentor at Byam Shaw, A. Egerton Cooper - *not* Pietro Annigoni, as one might have imagined. In any case, his admission to the Royal Academy seemed assured. He easily passed the probationary examinations, and was formally admitted. David Cammell believes Donald must have earned some sort of scholarship, as his father otherwise would not have had the means to enrol him there. Subsequently, in April or May, he rented a studio flat, 2 Chelsea Manor Studios, Flood

Street, just off Cheyne Walk in Chelsea. Apparently he had resigned himself to a career in portraiture. Robert Fraser, the art dealer and friend of The Rolling Stones who was also a high-profile member of the Chelsea set like Donald, also lived in a flat on Flood Street.

Portrait painting afforded Donald ample opportunities to meet and seduce wealthy - and often famous - women, a preoccupation he pursued with relish. It goes without saying that he was attractive, talented, charming, and charismatic - "irresistible," as one of his old flames put it. David Cammell, who acknowledges that Donald occasionally seduced his female subjects and was responsible for the dissolution of at least one marriage, discreetly refuses to name these society women, whose privacy he hopes to preserve. Nonetheless, some of Donald's liaisons of the 1950s have become public knowledge. One was an affair in the mid-'50s with actress Barbara Steele, then an aspiring artist studying painting at the Chelsea Art School. Apparently their paths would cross over the years; David Del Valle told us Ms. Steele was keenly interested in playing the part of Pherber in *Performance*.[8] Another was with Eartha Kitt, whose portrait he painted (as well as her daughter's), the Orson Welles protégé who rose to stardom in the '50s on the stage and as a nightclub singer, later popularly known in the 1960s for her role as "Cat Woman" in the television series, *Batman*. Another was his tryst later in the decade with actress Jill Ireland, then a rising star of British film who was married at the time to David McCallum, the Scottish actor who became famous starring in *The Man from U.N.C.L.E.* TV series. Thus, early on anyway, Donald's professional ambition remained quite conventional, even as his sex life did not. As Marianne Faithfull was to observe in her autobiography years later, when describing the relationship that she and The Rolling Stones forged with him, "Let's face it, we were all pretty lightweight, pretty naïve compared to Donald Cammell."[9]

The same year - although their paths were not to cross for a decade - his future friend and star of *Performance*, Mick Jagger, completed his education at Wentworth Primary School, receiving high marks on the crucial "eleven-plus" placement exams, subsequently gaining admission into the prestigious Dartford Grammar School. Thus, while Donald was seducing society women in his Flood Street studio, the prepubescent Jagger was just entering the British equivalent of the American junior high school, an age discrepancy easy to forget but important to remember when trying to understand the dynamic of their collaboration on the film that forever linked them together, *Performance*. Precocious talents both, they were similar in that ultimately they both embraced modernity.

Acceptance into the venerable Royal Academy School of Art, Burlington House, near Piccadilly Circus, meant that Donald had demonstrated an artistic talent that potentially could place him among the elite of British painters. From the time it was founded in the late 18th century by Sir Joshua Reynolds, the Academy fostered many of the most talented of England's visual artists. Among its past members were several Romantic painters, the most famous of whom are J.M.W. Turner - perhaps the greatest of British painters - along with Henry Fuseli, John Everett Millais and Daniel MacClise (both associated with the Pre-Raphaelite Circle) and, in the 20th century, painters such as John Singer Sargent and Stanley Spencer. Donald was thus joining the ranks of an august and famous company.

During his years at the Royal Academy, Donald attended 362 of the 505 sessions offered, or about 72% of them. We were told by Mark Pomeroy, an archivist at the Royal Academy, that this was an exceptionally good attendance record, given that there were no formal classes, but only workshops and colloquia. At the same time, Donald maintained a high profile at his Flood Street studio; on one occasion, while poised at his easel, he was the subject of a photography session by his friend, photographer Antony Armstrong-Jones, connoisseur of the arts, now Lord Snowdon and former husband of Princess Margaret.

(L-R): *Cammell family friend Janni Goulandris, Donald's father, Charles Richard Cammell, Maria Andipa (Donald's wife, and former Venus of the Isles of Greece), and Donald Cammell at his studio in Flood Street, Chelsea, during the mid 1950s.*

Maria Antippas

A profound if unexpected change in Cammell's personal life occurred in 1954 as well. By the time he entered the Royal Academy, he had met and fallen in love with Maria Antippas (now Andipa), a Greek beauty six years his senior. An aspiring actress who arrived in London in 1953, she had won various beauty contests in her native country and in Athens she had once been awarded the title, "Venus of the Isles of Greece." When Donald met her, the twenty-six-year-old divorcee was being courted by a Marquess from the Island of Malta, José Scicluna. Scicluna was an animated, colourful character with a great black beard. Although he died many, many years ago, David Cammell remembers him as having "a jovial personality," as someone who loved to laugh and have fun, especially when he began playing his guitar. In fact, though originally rivals, he and Donald became good friends, and the Marquess later rented a room from Donald at his Flood Street studio.

Doubtless, Donald was smitten by Maria's classic, if not decidedly exotic beauty (the latter of which was one of his enduring tastes), but he was perhaps also spurred on by a sense of rivalry with the Marquess, one that created a somewhat innocent version of "the love triangle," an arrangement that would take the more risqué form of the *ménage* in his later relationships. "The Marquess was lovely," says Maria, a devout member of the Greek Orthodox Church, "but he had problems [marrying me] because he was Catholic." As for Donald, she found him charming and irresistible. "He was so handsome, so good looking. When I met Donald, he told me he was an artist, but I didn't believe him,"

*Above: From the March 1959 issue of **Lilliput**, one of a series of illustrations by Donald for David Garnett's "An Old Master."*
*Opposite: An illustration by Donald for John Wain's "The Quickest Way Out of Manchester," in the Aug/Sep 1959 issue of **Lilliput**.*

she laughs, adding "but he dressed like one. He carried an umbrella and a cane, and was what you'd call 'dapper.' I thought he was just trying to impress me. He invited me to come to his studio, and I did. I discovered he really *was* an artist." Donald's charismatic personality, his wit, his erudition, quickly won her over. "I learned a lot from Donald. We talked. We talked always. It was hard to resist him."[10] By late summer she had accepted his proposal of marriage.

The couple wed in the Town Hall, Chelsea, on 30 August 1954. José Scicluna himself, Maria's former suitor, served as Best Man. Also present were John Thanopoulos, from the Greek Embassy in London, and - of course - Donald's doting father, Charles Richard. Iona was not pleased with her son's choice for a wife, and refused to attend the ceremony. "She was very possessive of Donald. She didn't want me to marry him," says Maria. Charles Richard, however, was "a knight, a real knight. He was there [at the wedding]. He was a lovely man."[11]

On the marriage certificate, a copy of which we obtained, the occupation of the twenty year-old groom is noted as "Artist," while underneath is the clarification, "Painter." Maria's occupation is listed as "Student of Dramatic Art." Although Maria's original surname was Antippas, she eventually altered it to Andipa (actually, a phonetic rendering of the proper Greek pronunciation) because she was tired of puns on the word "antipasto." Charles Richard Cammell claimed to be able to trace Maria's lineage back to the biblical Herod Antipas, a claim that seems at first absurd, but one that David Cammell, often sceptical of his father's fanciful assertions, agrees "may be right."[12] Although her career as an actress did not result in stardom, Maria did appear in some notable supporting roles in films, the most famous of which, perhaps, are the James Bond film *From Russia with Love* (1963), and *A High Wind in Jamaica* (1965). But she appeared in these films long after she and Donald had separated.

They began their married life in Donald's Flood Street flat, their home for the next four years. The Chelsea district in which they dwelled was colourful and lively, and had a rich history as the home of

many famous writers and artists. Nineteenth-century philosopher Thomas Carlyle, known as the "Sage of Chelsea," lived there for nearly half a century, as did the painters J.M.W. Turner, Dante Gabriel Rossetti, and John Singer Sargent. Novelist George Eliot died there, as did American writer Henry James. Oscar Wilde settled in Chelsea after his marriage. Its association with the Pre-Raphaelite circle in the mid-nineteenth century established Chelsea's reputation as a hub for bohemian artists, one that continued into the twentieth century. It was a favoured hangout for artists and entertainers in the "Swinging '60s," a community in which homosexuality was acknowledged and perhaps even considered banal. When Donald moved back to London in the late '60s, he settled again in Chelsea, in a flat on Old Church Street - just around the corner from his friend Mick Jagger on Cheyne Walk.

Donald and Maria enjoyed the rich, varied life that Chelsea offered them. They spent evenings and weekends attending parties - "a lot of parties," according to Maria, recalling that she and Donald also enjoyed the nightclub scene. "Those days, everybody was having parties. We could go from one party to another, all night long." They staged their own soirees as well. "One night, we had a very big party. Donald arranged to have a steel band play - the music wasn't very well known then. They came down the street playing and walked right into our apartment. Their appearance created a lot of interest. The whole neighbourhood showed up. Even a policeman stopped by."

But their life together was not entirely fun and carefree. Although they were young, happy, and in love, the first of Donald's infidelities occurred when, shortly after the marriage, he travelled with Maria to Athens in order to meet her family. One day while they were staying there, Donald

"disappeared with a woman," Maria, unhappily, remembers. "It was, of course, a terrible moment," she says, "for me and my family." So the infidelities began immediately, revealing the pattern he would reiterate his entire life. Constitutionally unsuited for marriage, why would he do so at all? Donald's tryst was a portent of things to come. "They hurt," says Maria of Donald's various infidelities during the marriage.

If Maria knew of his affairs, she also, like anyone who knew Donald intimately, became familiar with his crippling depressive episodes and mood swings. "Sometimes they would happen because of a little problem with a painting," she recalls. "I remember he would get depressed on his birthdays," as well. "He hated birthdays." Typically, the depressions would last for days. "He would hardly speak during those times."[13] Yet in spite of the depressive episodes, Donald's health was apparently excellent. His physique was exceptional, and he kept it so by working out with weights, the habit that he had begun in his Westminster days. He was also a superb

Above and opposite bottom right: Illustrations by Donald Cammell for David Garnett's "An Old Master," from the March 1959 issue of **Lilliput**.

and enthusiastic dancer. He was knowledgeable of traditional Scottish dance, a dance form that requires both agility and stamina. Myriam Gibril claims that Mick Jagger's trademark saucy strut, with head defiantly erect, back arched and arms akimbo, was a movement Mick learned by watching Donald on the dance floor doing Scottish jigs. This may very well be true, as Mick only began to employ his famous stage move in the late '60s, after he and Donald had become friends.

We surmise that during this period Donald was trying stave off his depressive episodes with various combinations of drugs; one source told us that David Litvinoff told him "by 1960 Donald had tried every drug, and every known combination of drugs, known to man," doubtless an exaggeration, but a remark suggestive of Donald's behaviour nonetheless. Several individuals remarked that Donald tried various medications to prevent his depressions, among them lithium, to no avail. Maria remembers one occasion regarding his use of drugs: "One time he had one of those capsules you break under your nose."[14] She is referring, of course, to amyl nitrate, a stimulant Donald experimented with to ward off his depressions. "I told him I didn't want drugs in the house," she says, and Donald apparently adhered to her demand.[15]

Meanwhile, in 1956, before he served his two years in the National Service as a commissioned officer in the Royal Engineers, David Cammell started a successful jazz and blues nightclub in London called Le Condor - not El Condor, as David is quick to point out - on Wardour Street in Soho. Donald designed the neon sign for the club - a predatory-looking bird - as well as the logo for the club stationery. The opening of Le Condor was attended by a number of luminaries, including Princess Margaret (by which time Donald had painted her portrait), thus assuring that the club's debut received prominent exposure in the London press. Slightly over a decade later, by sheer serendipity, although the club had closed by then, the floor above the former site of Le Condor served as the location for Harry Flowers's office in *Performance*.

Plumber's Materials

On 12 April 1957, after three years as a student at the Royal Academy, Donald suddenly and inexplicably withdrew. We can only speculate on the reasons for this decision, which was especially perplexing since he had compiled a *perfect* attendance record during his final term, participating in every last one of the seventy scheduled sessions. Donald's withdrawal from the Royal Academy reveals a pattern of behaviour that he exhibited for most of his life, a period of intense interest in an activity followed by a sudden disinterest and abandonment of that activity. It is one of the many reasons why *Performance* was stalled for over a year - contrary to the now conventional view that it was exclusively the fault of Warner Brothers.

His decision to quit the Royal Academy reflected an increasing disenchantment with his career as a society painter. "He hated portrait painting," Maria claims, an assertion reiterated during our interview with Mrs. Deborah Roberts. Maria continues, "He hated Annigoni, because people used to say he was his student. He hated being introduced as Annigoni's student." No doubt Donald also felt

restricted in his artistic development by the Royal Academy's rather strict, hierarchically arranged, division of subjects appropriate for painting. The Royal Academy of Arts has been since its inception a highly conservative British cultural institution, and it is hard to image him being comfortable with such formal restrictions on his creative impulses. The fact is, in his philosophical orientation, he was turning away from classicism and classical technique, perhaps in part because artistic trends were moving away from them as well.

His work of the late 1950s reveals that he had adopted a "new" style, a change that was noticed by critics at the time. In the brief assessment of Donald's first, one-man exhibition at Gallery One on D'Arblay Street held April-May 1959, two years after leaving the Royal Academy, the art critic for *The Times*, in an article dated 17 April 1959, observed, "Mr. Donald Cammell… has thrown over a lucrative career of portrait painting to follow his own, more personal bent. Although this information is of no critical relevance to his present paintings, it is perhaps indicative of the questing personality with something on his mind to say which lies behind them."[16] Another reviewer, in a brief news article discussing the change of style, quoted Donald, who said, "When I was 19, I was making £3,000 a year. Now I make half that. But I have finished with society painting. I am doing something that really matters now. Money does not matter." The reviewer also noted Donald's change of materials.[17] Whilst Donald had worked primarily in oil, pen and ink, pencil and crayon during his earlier, portraiture period, and had studied the use of tempera under Annigoni in Florence, the reviewer noted Donald's rather novel use of "cellulose and plaster" in his one-man show, characterizing them as "plumbers materials." Subsequently, Donald would use mostly acrylic paint rather than oil - on the *Lilliput* covers, for example. In all, six illustrations by Donald would adorn the covers of *Lilliput* in the years 1959 and 1960. Numerous drawings would adorn its pages as well.

Other reviewers also remarked on the "new" Cammell on display at the first one-man exhibition. G.S. Whittet, writing in *Studio* (July 1959), observed, "one would scarcely believe that this is the work of a former pupil of Pietro Annigoni." Remarking on one work, *The Gamblers*, Whittet continues: "one is soon conscious of some social comment when one looks at the bloated 'persons' watching the fall of enormous foreshortened dice or pot-bellied male nudes weighing symbolic wealth while a slimmer but no more pleasantly formed female nude nestles on his neck." Whittet noted - with just a hint of condescension - that "his [Cammell's] mordant analysis of the fascinated absorption of mankind in its foibles has made him a 'natural' for illustrations in a man's magazine."[18] *Lilliput*, apparently, was hardly the venue for a former student of Annigoni's.

According to the articles documenting the first exhibition, the event was also a social one. Former subjects of his portrait paintings were present at the opening, among them the beautiful models Bronwen Pugh, Sue Bardolph, and Barbara Goalen. The painter Sir Francis Rose, and writer Frank Norman were there, as well as the painter Dominic Elwes and his wife Tessa (a remarkable serendipity, as many years later one of their sons, Cassian, would produce *White of the Eye*). Said one writer who interviewed Frank Norman: "Norman, amid all the lofty appraisals of the new Cammell, commented: 'I came to see an exhibition of paintings. All I can see are people. It's an exhibition of people.'"[19]

New Direction

When Donald left the Royal Academy, his father was deeply disappointed. It dashed Charles Richard's cherished hopes that Donald would achieve in England the same acclaim enjoyed by his Italian mentor, Pietro Annigoni, a life steeped in the revered traditions of fine art. Apparently Donald and Charles Richard quarreled about the former leaving the Royal Academy. Maria Andipa recalls, "We were having dinner at Charles and Iona's. An argument had been building for some time. Donald always had a violent temper, and he suddenly threw his wine in his father's face." Maria was truly appalled. "In my country you wouldn't think of doing that to your father. I was shocked and embarrassed and told Donald I wanted to leave, but Iona insisted that he stay."[20] Apparently Iona was trying to downplay the situation, but Maria insisted on leaving, which they soon did.

Spats are one thing, but Donald's act of flinging the wine in his parent's face suggests not only a serious inability to control violent emotions, but also a deep-seated antagonism toward his father, more deeply motivated than a momentary fit of ill-temper, and an anger disproportionate to the cause. Later chapters will illustrate other instances of Donald's explosive temper, some of which occurred on the film set. As we shall discuss in the chapter "Aftermath", we believe that these rages were a symptom of a deeply rooted psychic wound.

For a man approaching seventy, who had held out such high hopes for his son's artistic career, who had nurtured his son's innate talent and encouraged him at every turn to be a painter, Donald's withdrawal from the Royal Academy must have been utterly heartbreaking. Yet, David Cammell takes a different position on the issue. "My father was proud of his [Donald's] success and they were very fond of each other… Father had little influence over Donald's career moves after he had studied with Annigoni. While he was baffled and disappointed that Donald abandoned art, he just took it philosophically, as did our mother," David observes. "We were always surprising them one way or another and they never tried to guide us aggressively in any particular direction. Things just seemed to work out by fate."[21] Despite this assertion of his parents' usual, and commendable, tolerance, we find it hard to believe that Donald and his father ever saw eye to eye on this issue.

As we have stressed throughout, the Cammell family life was warm and nurturing. "We were a loving family," avers David, and this point should not be doubted. His pronounced mood swings contributed, in part, to his enigmatic personality, as someone subject to them would have difficulty in presenting a consistent personality to others. Thus, while he was subject to rages, he was also gentle and loving. For instance, Donald was beside himself when, at a party in the early '60s, as a jape someone fed a few sips of an alcoholic drink to a small pet monkey he was keeping at the time. The alcohol was in effect a poison to the animal, and Donald had to have it euthanized. Apparently Donald was utterly devastated by the event. Just as his penchant for the *ménage* actually suggests a fear of intimacy, conversely, his love of small animals suggests that he was more comfortable when displacing his affection toward pets.

Whatever artistic career Donald envisioned for himself, it most certainly wasn't portraiture. "We used to see every film that was playing," Maria recalls. "Donald loved movies."[22] Whether Donald was considering a career in filmmaking at this point is hard to say, but he certainly had a keen interest in the cinema prior to the 1960s, when it has been generally acknowledged that his interest began. He was certainly aware of the stature of Marlon Brando, who had revolutionized film acting in the '50s. In fact, in the last week of July 1957, during one of his frequent sojourns to Paris, Donald met Brando, who was to later have such a disastrous effect on his film career. The two men were introduced by a mutual friend, actor Christian Marquand, while Brando was staying in Paris during the filming of *The Young Lions*. The circumstances of their meeting were a bit unusual, occurring in a Parisian hospital, where Brando, his body shaved and bundled in a diaper, was being

treated for second-degree burns in his groin area. Known jokingly as the "Brando Scalds Balls at Prince de Galles" episode, while eating a late lunch in the restaurant at the swank hotel, a teapot of scalding hot water had been accidentally spilled in his lap, causing him great agony and, subsequently, headlines around the world.

Hampstead

Early in 1959, Donald and Maria purchased a home in Hampstead, in North Central London, then a rather fashionable area for stage and screen artists. Maria says the house was inexpensive to buy because it was what is known as a "fixer-upper." The original staircase had been torn out. "We had to build a staircase from plain pine boards," she remembers, "so we could get upstairs."[23]

Prior to the move to Hampstead, Donald had begun an affair with actress Jill Ireland. (Ms. Ireland tragically died from cancer in 1990.) She and her husband at the time, actor David McCallum, whom she married in 1957 and divorced in 1967, lived in Hampstead, and Jill's presence may have been the motivation behind Donald's desire to move there. David McCallum certainly believes so. "I didn't know, until years later, that while I was married to Jill she wasn't particularly... what shall I say?... the faithful sort. I think Donald moved [to Hampstead]," speculates McCallum, "to be near Jill." He continues: "I'd been to Donald's studio. So had Jill. We had gone out with them [Donald and Maria] on occasion. But I don't believe the move was prompted because we were all that close [as couples]."[24] Apparently Donald's ability to dissemble was matched only by his ability to be discreet.

Natural Magic

Maria received some happy news soon after she and Donald moved into the Hampstead house: she learned that she was pregnant. She hurried home from the doctor's office to tell Donald. Expecting him to share her joy, she was crushed to learn that Donald was in fact repulsed by the news. "He didn't want the baby," she says. "He said, 'I love you, and want to share my life with you, but I don't want to share it with a child.'" Maria, who has strong religious beliefs, did not once consider the possibility of an abortion, even though Donald insisted. 'I told Donald that God had given me a child, and that I intended to keep him... It was the reason Donald left me."[25]

It is unquestionable that Donald had difficulty throughout his life acknowledging his paternity; he seldom, if ever, spoke about his son. Many who knew him did not even know he had a son. And unlike Maria, Donald's religious beliefs were vague. "Donald had no religious beliefs of any kind," Maria claims, and most of the few friends with whom Donald remained close agree on this point.[26] Others, however, aver that Donald held certain beliefs, perhaps unorthodox, but deep-seated beliefs that tempered his view of paternity - and his avoidance of it. The issue of Donald's unorthodox theological tendencies is a question, as we shall see, that becomes very important in understanding his films, but the fact that Donald ended his marriage to Maria because of her pregnancy is without question. There are some pronounced Gnostic tendencies in his work, particularly a body/spirit dualism, and the Gnostic belief that the spirit is trapped in the body (matter). As we have seen, Donald grew up in an environment where unorthodox spiritual beliefs, and occult ideas, were discussed. If the material world is wicked, begetting a child is also wicked, in effect the entrapping of a spirit in the material world, which may explain Donald's aversion to fathering a child. Donald may also have loathed and feared fatherhood because of his belief that certain undesirable propensities would be inherited by his child: if he truly believed he had a genetic disposition for manic-depression, he may have feared passing it on

to his offspring. Donald obviously contemplated this idea; it occurs in his film *White of the Eye*, in which it is implied that the psychopath, Paul White, has passed on his violent, anti-social behaviour to his daughter. Donald, like his alter-ego Paul White, has only one child. The Harrises, the estranged couple in *Demon Seed*, also have an only child. Donald left Maria some weeks before his son's birth.

When we discovered, remarkably, an article by Donald written about the circus, accompanied by a series of pen and ink drawings, published in the January 1960 issue of *Lilliput*, we asked Maria about his experience travelling with a circus troupe. She knew nothing of this chapter in Donald's life, reiterating a point she had told us earlier, that she is not sure of Donald's whereabouts during the period prior to the baby's birth. Apparently, during the month before he left Maria - September of 1959 - Donald spent some time travelling with Bertram Mills' Circus, an experience he later documented in two issues of the magazine. Was this experience the inspiration for Turner's long discourse on the *jongleur* - a performer of "natural magic" - in *Performance*? (Turner's reference to the juggler as an "anti-gravity man" and his reference to "amateur night at the Apollo" is, as we shall see, due to Donald's time in New York City, 1959-1961, when he clearly visited the famed Apollo Theater in Harlem, where an "amateur night" was held for decades.)

Donald travelled with the Bertram Mills' Circus in the company of poet and author Charles Hamblett. At one point during their travels, Hamblett was costumed and made up as "Chucko, The New Clown," dutifully sketched by Donald in a drawing dated 22 September 1959 and published in the December 1959 issue of *Lilliput*, which accompanied an article by Hamblett entitled "Laugh Clown Laugh." (As we mentioned above, more drawings, including another one of "Chucko," and an article by Donald on the circus, appeared in the January 1960 issue.) Interestingly, Charles Hamblett would later write a biography of Marlon Brando, published in 1962, titled *Brando: A Searching, Searing Analysis of Hollywood's Original Crazy, Mixed-Up Kid* (May Fair Books, UK), retitled *The Secret Lives of Marlon Brando* for its US publication by Lancer Books. It is a startling coincidence that the lives of both of these men were to be intertwined with Brando's.

A drawing from Donald's experience with the travelling circus in 1959. Here is writer Charles Hamblett made up as "Chucko" the clown.

The new clown,
Sp. 22nd. 1959
Charles Hamblett

Donald's estranged wife, Maria Andipa (née Antippas), with their son, Amadis.

Amadis Aeneas Antony Cammell, Donald's son and only child, was born on 6 October 1959. "Donald was here [in London], but I had him at the hospital by myself," Maria says, speaking of Amadis's birth. "He picked me up and drove me and the baby home from the hospital four days later," she remembers. "The next day, he left." By the time of his son's christening, a couple of months later, Donald was long gone, having moved to New York City. Therefore, it was not Donald, but rather his father, Charles Richard Cammell, who chose the romantic name for his grandchild, one that reveals his erudition and love of legendary heroes. "Charles gave a beautiful speech at the baby's christening," Maria remembers. "It was very lovely."

The Land of Opportunity Awaits

Donald made over to Maria the house and whatever assets they had accumulated by then. Otherwise, he never provided his first wife with any child support. Frank Mazzola, Donald's friend and creative collaborator for over twenty-five years, remembers Donald talking to him about Maria only a couple of times, but recalls that Donald mentioned how beautiful she was, and how kind a person she was, and that he indeed loved her. He also told Frank, however, that he left her because the kind of life he wished to lead simply was not compatible with hers - a confession that rings of the truth. Myriam Gibril, who met Donald about a decade after his separation from Maria, also told us that Donald spoke of her fondly, and told her that he had loved Maria very much. Despite his many infidelities and the fact that he abandoned her and her child, Maria's remembrances of their married life are likewise both warm and generous, even remarkably so.

Donald saw Maria only one more time, for a few minutes, in the summer of 1961. "He said he was moving, and wanted to stop by and see me." Maria remembers Amadis, then a few months short of two years old, attempting to push Donald away from his mother when Donald reached to embrace her. "Amadis must have seen Donald as a rival, so he pushed him away. I could see the hurt in Donald's face," she says, "I still remember it vividly."[27] He spoke with her for a few minutes, then drove away. That brief moment was the last time Donald would see Maria, and with one exception, years later, the only time he was to meet his son.

Maria Andipa holding Donald's only child, his son Amadis Aeneas Antony Cammell, during the first year of his life.

Circus

In September 1959 Donald Cammell travelled for several days with the then touring Bertram Mills' Circus. He later documented his experience in the pages of *Lilliput* magazine. In addition to writing a piece about the circus, he illustrated it with several drawings, which have been reproduced in the next few pages. By the time the essay and drawings appeared, in the January 1960 issue, Donald was then in New York City, and had concluded his relationship with that magazine. We feel compelled to include this material, not only due to its rarity, but because we think it reveals Donald Cammell's instinctive love of the *outré* and the bohemian. He admits that he had loved the circus since he was a small boy, remembering the thrill of seeing John Sanger's circus on trips to Suffolk. For Donald, the circus inspires eclectic emotions: healthy irreverence expressed through its nonconformity, humour, the thrill of danger, admiration for the fierce loyalty among the members in the circus troupe. Do we hear in Donald's observations about the circus "throbbing" with "a spirit artists have tried for a thousand years to capture" Turner's later line, "A million years people have been coming and dragging in to watch it"? Does the poster depicting Turner on the wall of Chas's basement flat make him appear more as a clown than a rock star? Moreover, Donald's fascination for and empathy with the circus was a lasting one, suggesting that he saw it as a sort of artistic utopia. As late as *Fan-Tan* he incorporates it into his writing: the parents of Annie Doultry, the irresistible hero of that romantic work, met when they were both employed by the travelling circus. If Annie is yet another self-figuration of Donald, his circus heritage references Donald's own empathy for and experience with it.

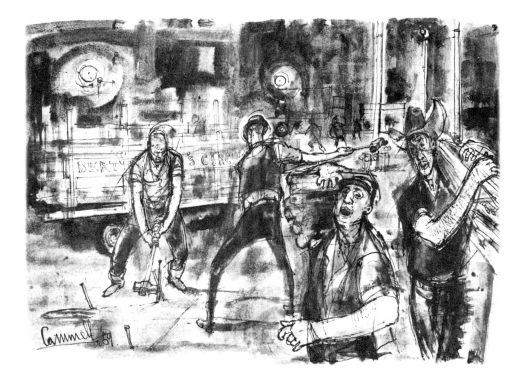

*To brighten life's neutrality comes the circus;
brassy, brash, noisy, strident, gay, cocky,
brilliant, exploding with vitality,
throbbing with a spirit artists have tried
for a thousand years to capture.*
For his attempt, Lilliput's Don Cammell
went to live with a circus on tour.

Circus - a barbaric, animal, glittering word. Nero loved circuses and the happy, Christmas-hols. jolly ritual of today's Big Top shows is still capable of playing upon the ape within us as well as the innocence. There we sit, urban Neroes, turning our thumbs up or down on the various acts with high Roman inconsequence. Does the Bessarabian illusionist displease us? We sublimate the thumbs-down sign with lukewarm applause. Does the musical clown impress? We reward him with the thumbs-up of our laughter.

The greatest show of all goes on behind the scenes. Look at the sensitivity of a small clown, watch him as he meticulously puts together a prop for his new Christmas act. "We clowns like to make our own masks and props," he says, his fingers pressing the wire armature into shape. Just another gimmick, over in five seconds, but many hours of thought and patient craftsmanship went into building up one more laugh.

Of course, everyone loves the circus. We should be a poor, squeamish lot if we didn't. In a world which is doing its damnedest to assume the pale greys and neuters of total conformity, its brassy music and abundant vitality and colour are needed more than ever before. And in such a world which tends increasingly to be filtered to us at second-hand through the milky flatness of the cathode eye, the immediacy of the circus
- its smelly, fleshy, noisy exuberance, its dazzle,
its bursting razzmatazz,
its cocky, pennywhistle
heroic pace - quickens the
blood, tingles the senses,
and makes us *participants* in
a *show* rather than the
captive victims of a TV
conspiracy to sell us short on
quality: a glimpse of Jung,
a bit of Brecht, a soupçon of
Astaire, wedged between the
long sad hauls of one
infantile wagon train chasing
another across the cynically
standardized wastelands and
deserts of Tellyville.

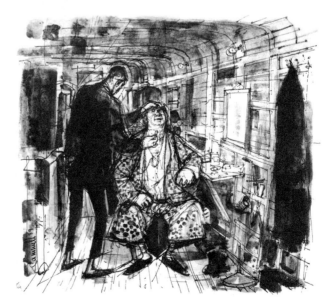

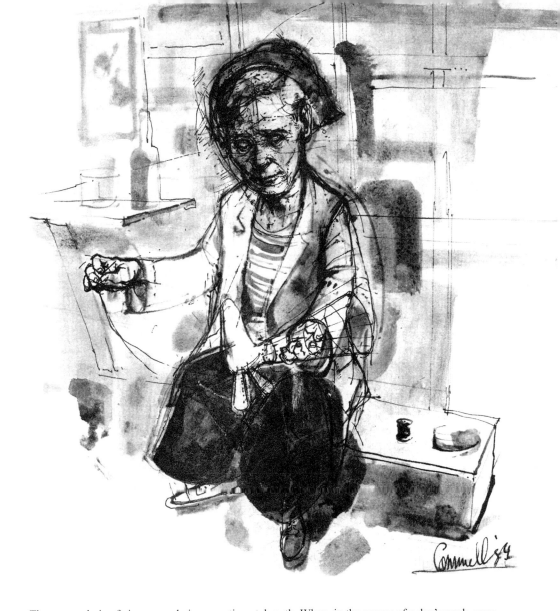

The camaraderie of circus people is no sentimental myth. When, in the course of a day's work, your life quite literally depends on whether someone will catch you as you stick out your hand, or whether the screws are properly fastened on the tigers' metal enclosure, or on your ability to nip smartly out of the way of an elephant, there is no room for feuds or temperament. A cuss word, a quick insult, and it's over. Generosity is instinctive: when the brilliant musical clown, Don Saunders, joined the circus for a try-out, every clown in the show went out of his way (behind Don's back, and to the people who counted) to praise the high quality of his off-trail, sophisticated act.

We love the circus for its wit, its irreverence, its courage and its clowns. We love its implicit danger. It is a caged tiger forever threatening to break down the bars between drawing-room and jungle, between movie palace and madhouse, between the fireside hearth and the clappers of hell.

It is an inexhaustible storehouse of emotion, a parody of living that is larger than workaday life itself. It is the flashy catalyst of our most secret longings, fears and hungers: we laugh at the baggy

grotesques and sword swallowers as
children at a seaside puppet show
will laugh at the midget coffin and
Lilliput gallows, the skeleton and the
hangman, the terrors of Judy and the
violence of Punch. To enjoy it at its
tangy best, one must either be a
child, or see it through the wild and
terrifying poetry of a child's vision.

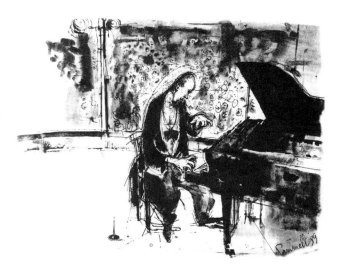

Efficiency, fractional timing, perfect
teamwork, exceptional talent, the
artistic flair, loyalty and damned
hard work… these are the bases of
circus existence. There are no places for passengers, and the boss will pitch in and haul down canvas,
soothe nervous animals, drive in tentpegs or pass round cups of char as the circus works round the
clock. On tour, the outfit carries two sets of master poles, each the size of a small factory chimney.
These are set up in the next town while the show is still going on. The menagerie, horse boxes,
outside booths, are silently whisked away to the station while the last performance is going on. By
midnight, the Big Top has been hauled down, by breakfast it rears proudly over the next pitch -
sometimes fifty, eighty miles away.

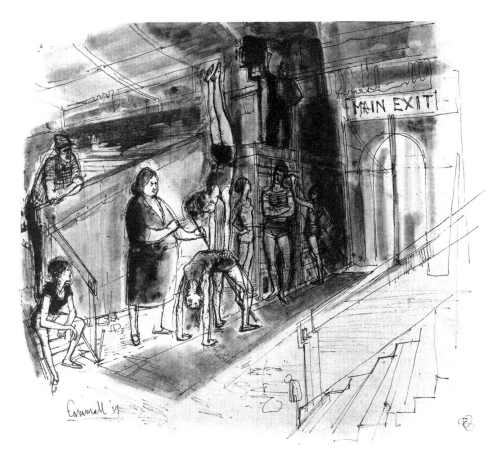

Most of the heavy work is done by Continental workmen, muscular yet agile giants, stemming from families who have worked for two centuries or more in the circus. Germans, Poles, Czechs, Latvians, Austrians, they belong to no trade unions and would make hardened British dockers faint at the sight of their prodigious efforts. No modern Army would demand more of its men, yet these Polaks and Heinies actually sing as they work. They are fired by the mystique of the Big Top; they are circus-happy.

Circus is memory. None are ever dull. I remember as a child when the raffish canvas *caravanserai* of 'Lord' John Sanger would annually transform a Suffolk field into a five-day glimpse of Xanadu, the barbaric attractions of the Circus Hagenbeck on its regular swing through Vienna, the magic of Olympia in mid-winter London, then, as now, offering circus bliss under the honoured name of Bertram Mills, who lives joyously on through the attic efforts and achievements of his sons, 'Mister' Bernard and 'Mister' Cyril. (May they become our first circus knights!)

Circus is memory of when the early sap of adventure drove us, Mitty-like, to dream of becoming daring young men on life's beckoning trapezes, trainers of tigers, lords of the lions, or, at least, the best batsman in the village eleven.

The circus is not merely the greatest show on earth. It is war and peace, the skull of Yorick and the sound of Judy Garland taking us somewhere over the rainbow in hi-fi. It is my friend Beppo clutching his pants and chasing an elephant's tail; the German aunt out of Lautrec moulding the marvellous postures of her acrobat nieces with a ballet mistress's wand. It is the manly understanding in Little Nikki's eyes as they survey without rancour the world of 'normal sized people' in which he clowns with such exquisite skill.

Circus is the safety-valve of civilization. I would not wish to live in a world without circuses - or the laughter which they so abundantly generate.

- Donald Cammell

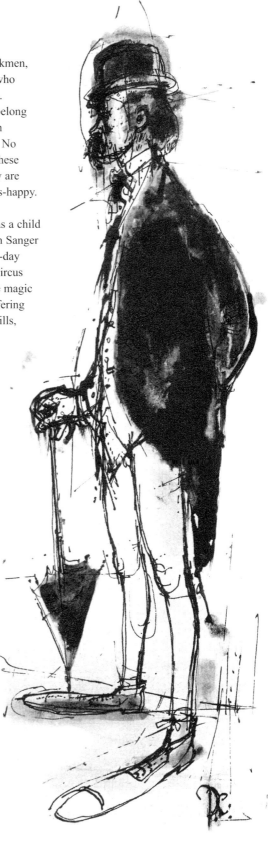

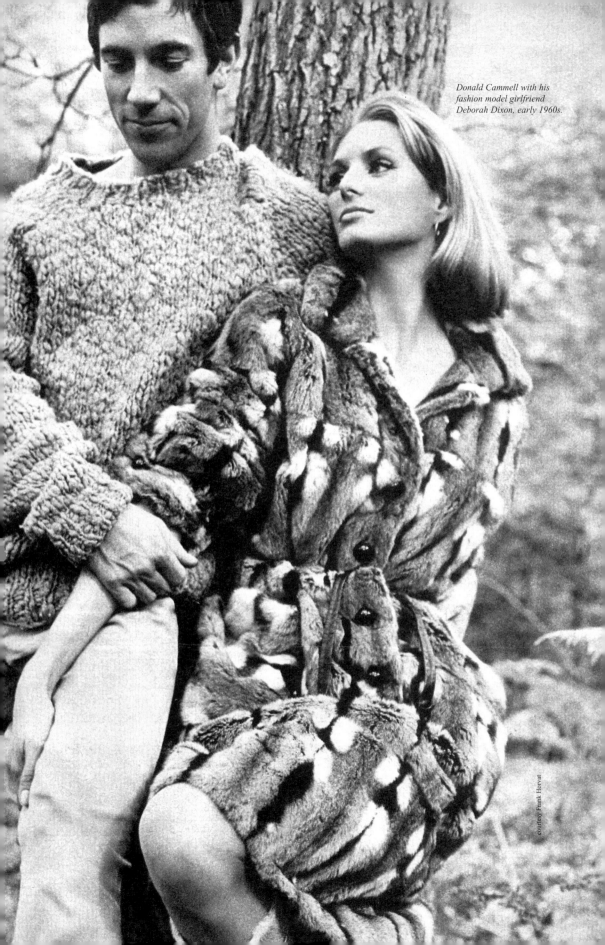

Donald Cammell with his fashion model girlfriend Deborah Dixon, early 1960s.

4 Parisian Scenes
1960-1967

Donald would say in later years that his move to New York was motivated by being "bored with painting and with myself," a confession that obviously is only partly true. He would also call this his "abstract expressionist period," a time of artistic experimentation in which he pursued a new style of painting.[1] "I never felt that Donald was passionate about painting," observes Mrs. Deborah Roberts, née Dixon, who met Donald in New York in late October or early November of 1959 and subsequently became his romantic companion for the next eight years. She had just moved to New York from Texas, to launch her modelling career, when she met Donald. She remembers Donald working on abstract expressionist paintings at that time, and recalls him saying he was "bored with society portrait-type painting," a feeling he had expressed at his first one-man exhibition in London earlier in the year. Donald told her his father "pushed him to be a painter."[2] According to Myriam Gibril, who met Donald in 1969, even at that late date he was still occasionally doing portraits as a way to earn money, and continued the practice into the 1970s.

Mrs. Deborah Roberts is unsure of how long she knew Donald before she learned of his depressive episodes, but she does have vivid memories of them: "He would have these really black moods for days. They just completely overtook him. You never knew why, or why he would come out of them." There were also suicidal threats. "He talked about suicide back then, but... well, people didn't take it seriously."[3] Prevailing cultural conditions have changed since then: much research has been done on the issue of suicide in the intervening years. We know now that such threats should be taken very seriously. So far as we know, Donald made no actual suicide attempts in his life save the one that was successful, but this is not unusual in suicidal individuals. Current research indicates only 18% to 38% of suicidal subjects actually attempt suicide prior to completing it. The crucial point, though, is that individuals like Donald, who ultimately commit suicide, may talk about it for years without ever actually performing it, which leads some people to believe that their threats of suicide are a bluff, "just talk," a means of "getting attention." Unfortunately, this is not true. Donald obviously seriously pondered the question of suicide, and not merely in a kind of disinterested intellectual fashion. Kenneth Anger made us a photocopy of a Crowley document, *Liber LXXVII*, in which Crowley wrote, "Man has the right to live by his own law... to die when and how he will." Says Anger, "As you can see, Crowley 'gives permission'"... I discussed this with Donald at length - on numerous occasions - regarding the philosophy and morality of suicide."[4]

Mrs. Deborah Roberts remembers a particular instance of the prevailing cultural attitude toward suicide at the time. "We had a very good friend, Ludwig Bemelmans, author of the *Madeline* books for children. He was a very nice person. We both liked him very much, and he liked Donald a lot. Donald went to lunch with him one day while in one of his moods. After a bottle of wine during the meal, he took Donald up to his apartment. He opened a drawer, showed the gun inside to Donald, and told him to go ahead and use it if he wanted to, and left the room."[5]

Of course, Donald did not use it, but research shows that the sort of "reverse psychology" that Bemelmans used on Donald (however well-meaning), an example of good old Cartesian "common sense," is not an effective deterrent. The Cartesian model of a unitary human consciousness, presumably responsive to "common sense" appeals, is simply inadequate to explain the complexity of the human mind, and most certainly cannot account for the extraordinary phenomenon of suicide.

The Second Exhibition

Donald was signed by the Bertha Schaefer Gallery on East 57th Street, which featured his work in one major showing during the period of roughly a year and a half that he spent in New York City. His exhibition at the Schaefer Gallery was held well over a year after he arrived, running from the first of May to the twentieth, 1961. A positive notice of the show appeared in *Arts* magazine, saying in "his first New York show" the "young Scottish painter" reveals "a subtle feeling for color and shapes that, although the palette is fuller, is reminiscent of Tàpies."[6] The comparison was apparently an apt one according to Mrs. Deborah Roberts, who remembers the showing being comprised of abstract paintings, with Tàpies being "really quite influential on him for the New York exhibition." The reviewer for *The New York Times*, however, was not as complimentary: "Though paint substance and texture are not the final goal of modern art, for Donald Cammell at the Bertha Schaefer Gallery they are considerable, if puzzling, reminders of the indirection and attempted escape from reality of modern painting... Cammell's appeal is directed most toward material substances, peculiarly plasterlike but nevertheless mysterious."[7]

The exhibition failed to establish him in the New York art world, and was one of the reasons he began to be disenchanted with painting as a career. "He sold a few paintings... it wasn't a huge success. It wasn't what he'd hoped. He was no overnight darling of the art world."[8] Through Deborah, Donald met China Machado, one of the more exotically beautiful and successful fashion models of the period and a favourite subject of photographer Richard Avedon. China was to see Donald frequently in Paris once he and Deborah had settled there. Perhaps it was because Donald failed to seduce her - "he tried several times, but I wasn't interested" - that he would later rechristen his wife, Patricia Kong, with the name "China" in homage to China Machado. "That was very nice of him, but I have no idea at all the reason for it," she said. She remembers being at the opening of Donald's New York show as well, which she said had mediocre attendance. "I remember him being disappointed, yes," she told us. "It wasn't what he had anticipated."[9]

So far as we know, he never attempted another exhibition of his paintings. But to portrait painting he was determined not to return.

L'Automne à Paris

Mrs. Deborah Roberts recalls: "We moved to Europe in the summer of 1961," not long after Donald's disappointing exhibition in New York. "I had some work in London for [noted fashion photographer] Norman Parkinson. I worked for him for a while." It was at this time, as we mentioned in the previous chapter, while briefly living in London in 1961, that Donald saw Maria and his small son. While he was there, he also picked up his car that he had put in storage before moving. "He had this old Alfa Romeo that he'd bought before he came to America," says Deborah, "a beautiful little red convertible. We had it restored when we were there [in London], then drove to Spain and the south of France in it." After the extensive trip, they drove back to Paris, where Deborah began working. "I was the one who wanted to stay in Paris. I was tired of New York."[10]

By the autumn they had settled in a studio apartment on the Rue Delambre in the Montparnasse district, where Donald was largely supported by Deborah's lucrative career, certainly not an unusual arrangement in Paris in those days. Such an arrangement allowed Donald to indulge his bohemian tastes, as he made countless acquaintances in the city's elite artistic circles. According to Zouzou, interviewed for us by Sally Shafto, they lived in a penthouse studio apartment. In those days, Zouzou was working for Catherine Harlé, who operated the only modelling agency in Paris: Nico, then

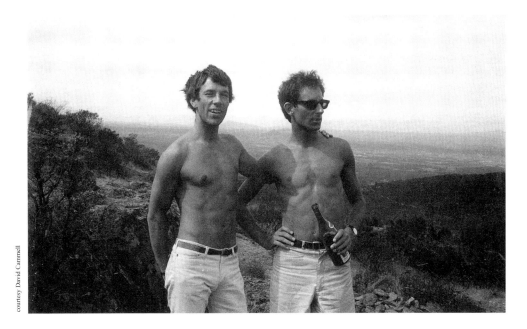

Donald (left) *and David Cammell at Grimaud, above Saint-Tropez in Southern France, where Donald and Deborah rented a flat in the Old Town every year during the 1960s.*

modelling, worked for her, as did Mrs. Deborah Roberts. Pierre-Richard Bré, a good friend of Donald's who wrote briefly for *Cahiers du cinéma* in the early '60s, and who had made a couple of short films prior to meeting Donald, told Sally Shafto that Donald and Deborah had "un appartement sublime."[11] He says it was large - they had the entire floor - but that it wasn't the penthouse. Roman Polanski told us he first met Donald at a café in Paris about 1963 - "way before *Repulsion*" - sitting with Amanda Lear, who was also working for Catherine Harlé at the time.[12] One of many fascinating people Donald knew in Paris, Amanda Lear was Salvador Dali's mistress for many years, and wrote a book about him. Later, she appeared on the cover of Roxy Music's *For Your Pleasure* (1973) before becoming a popular *chanteuse* in France in the 1980s and '90s.

For a time, Donald continued to experiment with his painting, trying to find a contemporary style that suited him. He was certainly no stranger to Paris, and indeed was very comfortable there, claiming in interviews as late as those conducted during the filming of *Wild Side* that Paris was his true home, a sentiment that is not surprising, coming from one who was such a bohemian in temperament. Indeed, it was some time during this period in the early '60s that he formally became a French citizen.

By 1961 the French *nouvelle vague* had transformed world cinema. For someone like Donald who by all accounts had always loved the movies, Paris was thus very much the place to be. Mrs. Deborah Roberts, speaking of her life with Donald, said, "We went to the cinema a lot."[13] Anita Pallenberg, who became good friends with Donald and Deborah in 1964, concurs. "Donald and I both loved movies. There were days we didn't get much done on the script [*Performance*] because we'd spent all day talking about movies."[14] On the subject of Donald's involvement with cinema, Patrick Bauchau observed, "He was as self-taught in cinema as anyone I've ever met, totally uninterested in the *auteur* theory - or any other."[15] He's correct in his assessment of Donald's view of the *auteur* theory: in fact, Donald had utter contempt for it. He would later say, "...reverence for the director of a film as sole creator has been vastly exaggerated, through critical efforts. I'm thinking

particularly of the *Cahiers du cinéma* 'author' concept - I've been living in Paris, and have been quite aware of it for a long time. The kind of theory of creativity that's arisen there (and in related worlds in New York) is, succinctly, crap."[16]

The painter Daniel Pommereulle, who played one of the lead roles in Eric Rohmer's *La collectionneuse* (1967) and later delivered a flamboyant performance as Joseph Balsamo in Godard's *Weekend* (1967), met Donald in the early '60s. On much friendlier terms with Deborah than Donald, he told Sally Shafto he thought Donald was "a terrible painter." Other artists who knew Donald agreed, though perhaps didn't state their opinion so baldly. Frédéric Pardo, a painter who was considered for a role in *La collectionneuse* but was rejected because Rohmer thought his hair was too long (!), knew Donald as well and didn't think he was particularly serious about painting.[17] Yet despite his lagging interest in it, Donald apparently still identified himself as a painter.

Donald indicated in one interview that he was not exposed to the pop world until he met The Rolling Stones in 1965, and it was then, according to Anita Pallenberg, that he became fascinated by it and began to consider discarding his own professional training for one related to the pop scene. Pierre-Richard Bré, who believes that it was Patrick Bauchau who introduced him to Donald at the Coupole restaurant in the 14th arrondissement (district) in 1963, says that at the time he met him Donald was no longer painting, just writing, and this may well be true. Indeed, during his interview with Sally Shafto, M. Bré called Donald "un grand ècrivain."[18] We should note that historically, during the period 1967-68, many filmmakers - Godard, Clémenti, Yves Klein, Jacques Monory, Rohmer, and Charles Matton - were beginning to break into the art gallery scene, a trend that Donald could not have ignored.

As Sally Shafto has pointed out in her indispensable monograph on the experimental Zanzibar films made in France in the late '60s, art was important to many of the individuals who began turning to film in France in the mid-'60s. The art critic Alain Jouffroy appeared in *La collectionneuse*, as had the young painter Daniel Pommereulle, whom we mentioned earlier. Olivier Mosset, Didier Léon, and Frédéric Pardo were all painters. The young French star that turned to directing, Philippe Garrel, who Donald certainly knew although perhaps not well, emphasized painting in his films. Prior to turning to modelling and becoming an actress, Zouzou had studied at the École des Arts Décoratifs. Dr. Shafto also discusses the "strong exchanges and connections between filmmakers and painters."[19] In addition to painters interested in film, filmmakers such as Rohmer, Godard, and Charles Matton were including the subject of painting in their films.

That Donald would appear as an actor in a film that featured both painters and filmmakers, and included painting as a subject in the film, was *apropos*: he appeared in Eric Rohmer's *La collectionneuse* (1967; filmed the fall of 1966), playing the bit part of the young man (not a boy - Donald was thirty-two years old when he appeared in the film) who, along with his girlfriend, shares a portion of an evening with Adrien (Patrick Bauchau) and Haydée (Haydée Politoff) in Saint-Tropez. The scene takes place at roughly forty-one minutes into Rohmer's film, occurring after Adrien has asked Haydée and Daniel if they would like to go out for the evening. Daniel declines, saying he is "high" ("il plane"), but Haydée agrees. The scene shifts to a small café in Saint-Tropez, and Adrien is talking with a young woman (who is apparently supposed to be the girlfriend of the character Donald is playing) named Fanchon. The camera pans left to reveal Donald speaking to Haydée, and while the line of dialogue he speaks is not completely clear on the soundtrack, we surmise that Donald has just asked Haydée to go for a walk with him. In the fragment of his line we can actually discern, he finishes by saying, "…while all these people are here" ("…pendent que tous ces gens sont la"). Haydée responds, "Yes, but I am cold" ("Oui mais j'ai froid"). Donald leans forward in his chair and puts his arm around her, hugging her, saying "But it is warm" ("Mais il fait chaud"). Haydée then turns to Adrien and issues him an order to retrieve her coat. Adrien stands at her request, but then beckons her to follow him, and they leave, Adrien waving goodbye to Donald and Fanchon. Donald is on-screen for about eighteen seconds.

According to Sally Shafto, Eric Rohmer cast *La collectionneuse* with individuals he perceived to be at the forefront of the "Sixties Generation," in their behaviour, attitude, and sensibility. While it is true that Donald and Deborah had an apartment in the town of Grimaud, near Saint-Tropez, and it is also true that Donald's friend Pierre-Richard Bré had a small role in the film (he's the passenger in the sports car that Haydée flags down for a ride at the end of the film), Rohmer may have had the perception that Donald's famed bohemian lifestyle and temperament made him an ideal choice to appear in the film, even if that role was quite small. Incidentally, Rohmer had known Pierre-Richard Bré from his days writing for *Cahiers du cinéma*, when in the early '60s Rohmer was that journal's chief editor.

The Balthus Affair

Donald met Stanislas Klossowski, whom his friends call "Stash," in Paris in 1961 or 1962. Stash would later, famously, make headlines by being busted for drug possession along with Brian Jones in London in 1967. Son of the world famous painter, Balthus, and nephew of the French intellectual Pierre Klossowski (whose writings were instrumental in the rehabilitation of the literary reputation of the Marquis de Sade), Stash's personal situation when he met Donald was quite dire. "I think Donald saved my life, and I mean that," he told us. He was a young man aged twenty or twenty-one years old at the time he met Donald. "I was very close to committing suicide myself… I had been working as an assistant for [film director] Marc Allégret. I was living in the studio that was just off his own studio. When he had his heart attack, I found myself homeless… I was in total despair… Donald said, 'Come on home with us. If you need a place to stay, stay with us.' Donald gave me a deep sense of friendship, for which I will always be eternally grateful. From his friends, and Deborah's friends, so many important things came into my life. They both showed me love and affection, and helped me turn my life around."

Although he was still painting when he first met him, "I remember Donald being exceedingly interested in film," says Stash, who recalls that the subject of Donald's paintings at the time they met was "not altogether alien from my father's work." Yet like Balthus, much of Donald's work "was abandoned in despair."[20] Donald's career as a painter may have been nearly finished, but through his friendship with Stash he managed to find a way to apply his talent in a most unusual way.

One source (who asked to remain nameless) urged us to explore the matter of Donald's role in the notorious appearance of a number of Balthus drawings that showed up in Paris in the early '60s. In his massive biography, *Balthus*, Nicholas Fox Weber acknowledges that there are known paintings attributed to Balthus that are of dubious origin, but whose authenticity, by court order, were prevented from being verified by Balthus himself. As to their origin, Weber writes, "I have come to hear so many points of view concerning the authenticity of Balthus's drawings that it is hard to know where the truth lies."[21] Weber recounts one theory that some of the known forgeries may be traced to Frédérique Tison, the daughter, from a previous marriage, of Pierre Klossowski's wife, Denise, who once was

Balthus's mistress. Curiously, at one time, many of the questionable pieces on the market were of such poor quality that it was impossible they had been faked - someone trying to fake them would have done a better job. The only conclusion, therefore, was that they were works that had been abandoned and then discarded by Balthus, but somehow they had managed, by mysterious means, to find their way into the hands of dealers.

According to Weber, in approximately 1962 - sometime after André Malraux had appointed Balthus director of the French Academy in Italy in 1961, and Balthus had installed himself in the Villa Medici - a large number of Balthus's works were taken from Balthus's Paris studio on the Cour de Rohan by his son Stanislas. Weber recounts a story told to him by James Lord and corroborated by Eugene Victor Thaw that around 1962 Lord was,

> "walking along the Rue Bonaparte in Paris one day when he noticed an unframed Balthus drawing on an easel in the window of an antiques shop. It wasn't initialed as Balthus's drawings often are, but Lord recognized what it was and went in to ask the price. The antiquarian responded to Lord's inquiry by bringing out an entire portfolio of Balthus drawings; when I discussed this with Lord in Paris in 1992, he recalled that there were between twenty and thirty."[22]

Lord then contacted art dealer Eugene Victor Thaw in New York about his remarkable find, and was instructed by Thaw to buy all of the drawings. Thaw and Balthus's dealer in New York, Pierre Matisse, then began to prepare an exhibition of these previously unknown Balthuses at Thaw's gallery on East Seventy-eighth Street.

> "But long before the scheduled opening of the show - late November 1963 - they sent photos of all the work to Balthus so that the artist could provide certificates of authentication. Balthus instantly realized that these pieces had all come from his studio, although he had not even noticed that they were missing… Balthus told Pierre Matisse that all of this work had been stolen by his son [Stanislas]."[23]

According to Weber, Stash stole the drawings and sold them to the antique dealer in order "to cover some personal debts."[24] Though they were unsigned, Balthus eventually acknowledged the authenticity of these particular pieces, and in fact requested one of them, of personal significance to him, to be returned, at his own expense.

We have been told by several people, among them David Cammell, that these discards were smuggled to Donald's studio in Paris. Donald would give them a few finishing strokes, dress them up, and complete them as well as he could. Thus these pieces are virtually authentic Balthuses, paradoxically, but judged by him to be inferior works. Donald most certainly had the technical expertise and skill to do this work, particularly since his strength was figurative painting. Donald knew Balthus more than a little; indeed, Stash himself told us that he remembers his father spending Christmas of 1964 with Donald and Deborah at their Paris *atelier*. "That winter [1964] my father came to Paris for some reason and we all spent Christmas together… Deborah had put up a Christmas tree. It couldn't have been another year. I remember because the winter of 1964-65 Donald and I were working on a script for Brigitte Bardot called *The Greenhouse*… She couldn't read English, so we were translating his script into French."[25] Sally Shafto interviewed for us a painter who had been an acquaintance of Donald's in Paris - though not particularly a close one - who said he was aware of Donald's role in the Balthus affair, and was astonished it was not more widely known. Other individuals allege that Donald was involved in the production of more Balthuses than

the twenty to thirty mentioned above, but we have been unable to confirm this allegation, let alone derive an exact number.

Perhaps Donald imagined it as a way of getting even with a profession with which he was increasingly disenchanted, as he enjoyed the pleasure of fusing criminality and art - after all, what is the central action of *Performance*, but the merging of the worlds of crime and art? In his unproduced scenario *El Paso* (written 1979-80), the protagonist, Martin Osterman, a self-destructive film director Donald consciously or unconsciously modelled largely on himself, says that his hero is the painter Caravaggio, "a man," wrote Donald, "who risked a life of solid respectability to descend into the twilight world, to consort with thieves and murderers, to put his life on the line. Because only then did he feel he could paint the truth."[26]

Just a Jackknife Has Macheath, Dear

As we mentioned earlier, Roman Polanski probably met Donald in Paris late in 1962 or early in 1963. For certain, by the time they met, Donald was clearly interested in making movies. "He approached me to direct a picture from a script he'd written, *Just a Jackknife Has Macheath, Dear*," Roman Polanski told us. "It was way before *Repulsion* [filmed 1964], I don't remember exactly when. I didn't want to do it."[27] The title of the script, of course, is taken from "Mack the Knife," a song from the Brecht/Weill musical *The Threepenny Opera*. The song was a huge hit for Bobby Darin in 1959, and many other popular singers have covered it over the years. Determining a precise order of Donald's work at this point is difficult, but it was probably the second screenplay Donald wrote - the first, we think, being *Avec Avec*, which we shall discuss later. We have not had the opportunity to read this script, but it seems rather obvious, given its title and Donald's sustained interest in sociopaths, that it is about Jack the Ripper. Years later, in the early months of 1977, Donald worked on a script with British theatre critic Kenneth Tynan, actually titled *Jack the Ripper*, which Donald was also going to direct. He would eventually realize his story about a murderer with an aesthetic imagination in *White of the Eye*.

Anita and The Stones

For about a year, during the period 1964 to 1965, Stash was a member of the Vince Taylor band, and hence was reaping one of the residual benefits of being in a rock band - chicks. Born in Britain but raised in the United States, Vince Taylor (1939-1991), whose real name was Brian Holden, released some EPs and singles in the style of Elvis in the late '50s and early '60s that did not particularly do well on the British charts. He is perhaps best known for "Brand New Cadillac," later covered by The Clash on their album *London Calling*. Around 1962, Taylor moved to France where he became a big star. "Vince Taylor was a huge star, by then [1964-65] somewhat in decline, but nevertheless a big name in the eyes of the public," Stash said. "We played a completely different act than the old Vince Taylor leather-clad act… He was in a sort of pop phase at the time."[28] As legend has it, during a gig in Paris in 1965, he emerged on stage dressed as Jesus Christ and proclaimed to the astonished audience that he was finished with rock music. Apparently true to his word, he released few if any records after 1965, and eventually died at the age of fifty-two in 1991. It was Vince Taylor's peculiar career as a rock star that eventually inspired David Bowie to create his mythic figure, Ziggy Stardust. While on a tour through Spain with the Vince Taylor band in 1964, Stash first met Anita Pallenberg. He avers it was through him that Donald eventually met her, though Pallenberg remembers it somewhat differently.

"It must have been 1964 when I first met Donald, because I knew him before I met Brian Jones," Anita Pallenberg told us. While working in experimental theatre in New York in 1963, the strikingly attractive Pallenberg had been spotted by a modelling agency and was flown off to Europe for assignments. "I was hanging out in Paris with a bunch of Americans at the time [1964] and that's how I came to meet Deborah - it wasn't through modelling. I think I met Donald through Deborah."[29]

David Cammell tells an amusing story of his first meeting with Anita sometime during 1965. "I had arranged to meet Donald in Tangier, at the famous Minza Hotel. I'd been driving through Spain in my little Lotus sports car, left it at Algiciras and took the ferry across to Tangier. In fact he never turned up so I spent a couple of adventurous days there, bought a lot of pottery and returned via Paris to stay with Donald and Deborah. In his studio I met Anita Pallenberg for the first time, who asked me if I could give her a lift to London. I had my priorities in those days, so I dumped all my pots in Donald's studio - they're probably still there - and transported Anita to what turned out to be an assignation at a night club with Brian Jones."[30]

In retrospect, two events that occurred in April 1965 were crucial to Donald Cammell's subsequent film career. One of them was inauspicious, an announcement that could hardly have raised an eyebrow in Hollywood. The other, unrelated event, although it was never formally announced, made *Performance* possible in the first place. The first of these events was the announcement in the Hollywood trades of the sale of a script written by Harry Joe Brown, Jr., *Avec Avec*, to Columbia Pictures. Donald wasn't mentioned. *Avec Avec* wouldn't roll until more than two years had passed, and then under a different name, *Duffy*.

The other event was altogether more significant, at least as far as *Performance* is concerned. During the weekend of 16 April 1965 - Easter weekend that year - Donald met The Rolling Stones, following one of their concerts at the Olympia in Paris. We know this because Stash was there. In an interview conducted in August 1984, Donald said, "I was living a very sort of marginal existence to society [in 1964 and 1965]… and I was not involved with the pop society at all… I met the Stones, not in a pop society, I met them by accident. Brian… because he fell in love with a girlfriend of mine called Anita Pallenberg."[31] According to Stash, "We [the Vince Taylor band] came back [to Paris] to play those Easter gigs with the Stones. There was a rich American who lived in Paris, named Jimmy Douglas. We stayed at Jimmy Douglas's apartment during the gigs. We did all these gigs with them [the Stones]. We did matinees as well as evening performances. The performances were maybe twenty minutes. In those days, they weren't just concerts, the shows were more like variety shows… There were six other acts, including Susan Bottomley's future husband Tony Kent, who was doing a magic act. There was Gary U.S. Bonds, Rocky Roberts & The Airedales, us of course, the Stones… After one of the [Olympia] shows, I invited the Stones over to Castel's, and that's how Donald met them." After hitting it off, Donald invited them over to his and Deborah's apartment. Says Stash, "It was a friendly English speaking scene. Donald was invariably a fascinating, easy-going host. Deborah was very beautiful and extremely charming, and so it was normal for people to gravitate to Donald and Deborah's apartment."[32]

When we asked about her memory of first meeting Donald Cammell, Anita Pallenberg demurred. "Forty years on, it's hard to remember,"[33] she said, laughing. When asked for the definitive story of how she met Brian Jones, she recounted the now widely disseminated story that she first met the Stones after a show in Germany in September 1965. Yet Linda Lawrence Leitch, a love of Brian Jones's with whom he had a son, told Jones biographer Mandy Aftel that she was introduced to Anita by Brian in Paris in the summer of 1965, meaning that Brian had met, and been smitten by Anita, before that date.[34] It is well documented that Anita did meet the Stones after one of the shows during the short September 1965 tour of Germany, but we think Brian first met Anita during that same fateful weekend when Donald met the rest of the Stones, even if the meeting was uneventful. When pressed, she didn't think it was that weekend, although she does remember being at one of the Olympia shows, an event corrob-

orated by Stash Klossowski. "We went to Castel's… and there met Anita. He [Brian] may have met Anita before, I don't know, but Brian at the time was dating Zouzou, the French starlet. We all went over to Donald's and eventually we took Brian back to his hotel… Much to Anita's annoyance, Brian went off with Zouzou."[35] Interviewed for us by Sally Shafto, Zouzou corroborates Stash's account of the meeting. Zouzou told her Anita first met Donald when she went to a party at Donald and Deborah's with Brian Jones in 1965. She didn't stay long, however, because she didn't like Donald or his scene.

Had Brian Jones not been smitten by Anita Pallenberg, it is doubtful whether Donald and Brian would have become such good friends. Donald liked Brian, and Brian him; they were birds of a feather. Donald always used the term "artist" to describe Brian Jones, the highest form of compliment he gave anybody. The underlying reasons for their friendship aren't difficult to understand. They were two highly intelligent, articulate bohemians who shared similar values, a deep disdain for bourgeois sexual Puritanism and genteel culture, and although Brian was eight years younger than Donald, his life had been an adventurous one. Jones had grown up in a musical family in which his artistic talents were nurtured. As a teenager, he had dropped out of school and travelled to Germany and Scandinavia. He was a father by the age of 19 (if not earlier). He invented a flamboyant, androgynous manner of dressing up which became the model for a great many subsequent British pop stars (including Mick Jagger and Keith Richards), and in his sexual tastes it is said he was not averse to the *ménage à trois*. In July 1962, when his star began to rise, Brian brought Pat Andrews, with whom he had fathered a son, to London to live with him and found a home for them in Powys Square. He would become one of the models for Turner in *Performance*.

Although biographers of Brian Jones and of the Stones assign varying dates to the event - primarily because they've never considered the significance of Brian's and Donald's instantaneous rapport - we suspect that it was around July 1965 when Donald introduced Brian Jones to Morocco. Morocco was, in the '60s, very much the place of the moment. The reclusive John Paul Getty, Jr. - also one of the models for Turner - and his beautiful wife Talitha Pol held court there, and attracted Christopher Gibbs, Robert Fraser, Comte Jean de Breteuil, and others. Donald said: "…we went to Morocco - Brian and me. And Brion Gysin was there and Bill Burroughs… And as you know Brian became completely lost in that world for a while and brought it back into the music eventually…"[36] Later the same year, in September, Donald and Deborah would meet Brian and Linda Lawrence Leitch - who didn't like Donald - in Morocco, accompanied by Robert Fraser and Kenneth Anger, the latter having sought out Donald because of his association with Aleister Crowley.

In January 1966, by which time they had set up house in 1 Courtfield Road off the Gloucester Road in Kensington - its interior decoration in part the inspiration for the décor of Turner's house in *Performance* - Brian and Anita began entertaining individuals who were all part of the Chelsea social scene, while others, such as Stash, were friends of Donald's from Paris. Donald and Deborah remained living in Paris in 1966, and according to Donald, Brian spent "a lot of time" at his and Deborah's apartment there, occasionally taking trips to Morocco with him.

Avec Avec

"We had a friend in New York who was - had been - a jewel thief, named Alvie Baker," says Mrs. Deborah Roberts. "Alvie had this idea that he wanted to change professions and get into movies. He was a 'retired' jewel thief, a charming guy. He'd written a treatment, a synopsis not more than a couple pages long, that in the end had nothing to do with the film - not that the [completed] film [*Duffy*] had anything to do with what Donald had written, either. It was a sort of heist caper. Donald took the treatment to Pierre de la Salle, a French writer, who had been married to Suzy Parker, a famous Fifties

model before my time. I think they fiddled around with it and didn't get very far, and Donald got interested and got sort of drawn into it and in the end transformed it into the screenplay that was sold as *Avec Avec*. And he ended up working on it with someone called "Coco" Brown, who was the son of the Hollywood producer Harry Joe Brown. "Coco" took it to Hollywood and sold it…"[37]

Donald completed *Avec Avec*, which would become *Duffy*, early in 1965, and apparently had written the two other aforementioned screenplays or scenarios by that time as well, *Just a Jackknife Has Macheath Dear* and *The Greenhouse*. We have little information about these scripts, although David Cammell remembers seeing them. Harry Joe Brown, Jr., who sold *Avec Avec* to Columbia, graduated Phi Beta Kappa from Yale, after which he was awarded a scholarship to study at Oxford. We have been unable to determine precisely how Donald hooked up with him, in Paris or London no doubt, but it was by all accounts a rather short-term relationship. Donald would later claim that *Avec Avec* (a gambling term) was "stolen" from him by a young producer, who then sold the property to Columbia with Donald's name removed. The announcement of the sale of *Avec Avec* in the industry trades in April 1965 - which didn't mention his name - would appear to back-up Donald's claim. It was only when the producers demanded numerous rewrites that Donald was brought back to the project.

Well over a year after the first announcement of its sale, the 1 September 1966 issue of *The Hollywood Reporter* announced *Avec Avec* was to be produced for Columbia by Martin Manulis with Clive Donner as director. The British Donner (b. 1926), had recently directed the 1965 comedy, *What's New, Pussycat?* (the first film Woody Allen wrote and appeared in), and *Luv* (1967), a failed comedy starring Jack Lemmon, Peter Falk, and Elaine May that featured future star Harrison Ford in a bit part. (Serendipitously, some scenes of *What's New, Pussycat?* had been filmed at Castel's, the favoured nightclub among the *cognoscenti* in Paris during the early '60s.) Donner left the project for some undisclosed reason during the pre-production process, because the next item regarding *Avec Avec,* in the 21 July 1967 issue of *The Hollywood Reporter*, stated that the first day of shooting was to be the 31st of July. Robert Parrish, an American-born actor turned director then living and making films in England, was now the director. The July shooting date proved to be a bit premature. Due to the volatile political situation in the Middle East, *Avec Avec* was delayed, the production moving from its eastern Mediterranean location to Almeria, Spain, where, according to *Variety*, on 9 August 1967, *Duffy* - as the production was now called - began shooting. Donald was now in the film business, and by that time he had already worked on the script that became *The Touchables* as well.

The Touchables

The Touchables would receive general release in the United States on 20 November 1968, but previously was shown at the San Francisco International Film Festival in October of that year. *Duffy*, which was completed at Shepperton Studios on 17 October 1967 - by which time Donald had begun writing *Performance* - was released in the US in September 1968. Thus, both *Duffy* and *The Touchables* were released, in the United States at least, before the filming of *Performance* was completed. Unaccountably, *The Touchables* would not be released in the UK until 19 November 1969, a year after its US release.

Donald's involvement in *The Touchables* came about because David Cammell knew Robert Freeman, who early on was The Beatles' stills photographer. Freeman had also worked as the title designer on both *A Hard Day's Night* and *Help!* "Bob Freeman was very keen to get into film. As a lighting cameraman, he had lit several commercials for us [the company Cammell, Hudson, and Brownjohn]… and he had an idea for a film he wanted to direct," says David Cammell. "There was, as you know, an American TV show called *The Untouchables*, and Bob wanted to make a film he called

Above: *A sexy "Touchable," actress Monika Ringwald (aka Marilyn Rickard).*

Right: *Admat developed for the North American release of* **The Touchables**, *in 1968.*

Below: *Christian (David Anthony), the "flavour of the month," surrounded by the four "Touchables."*

What happens when you
touch...
touch
"THE TOUCHABLES"

Get Kissed...
Get Kidnapped...
Get Killed...
Get your Kicks!

20th Century-Fox presents
JOHN BRYAN's production

starring JUDY HUXTABLE · ESTHER ANDERSON · MARILYN RICKARD
KATHY SIMMONDS and DAVID ANTHONY Produced by JOHN BRYAN · Directed by ROBERT FREEMAN
Screenplay by IAN LA FRENAIS Color by DeLuxe

Original soundtrack album available on 20th Century-Fox Records

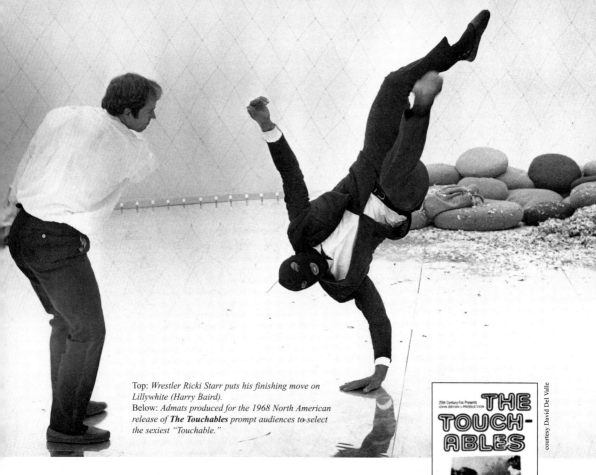

Top: *Wrestler Ricki Starr puts his finishing move on Lillywhite (Harry Baird).*
Below: *Admats produced for the 1968 North American release of **The Touchables** prompt audiences to select the sexiest "Touchable."*

This little Touchable digs experimenting!

The Touchables. That was his basic idea. He wanted it to have four girls, a typical 1960s sort of sexy idea, and the title and the four girls were purely his idea… they formed an essential ingredient of the story. The other ingredient he had was that he wanted to have Ricki Starr in it, who was a popular wrestler. Ricki Starr was this flamboyant character. He used to dress up in a ballet tutu and pumps, but he was a proper wrestler nonetheless. Bob wanted to use him, he thought that would be quite funny. At the time, Tom Jones was an up and coming singer, and he toyed with the idea of using him in the lead… Anyway, I'd never written a feature film script and was hesitant to do it, but eventually I had some free time and I thought, why not?… I flew down to Majorca and drafted a forty-page outline incorporating his ideas. We'd done a commercial soon after the Bond films took off featuring a woman who was an "in charge" sort of woman, a female James Bond, and after taking care of all sorts of problems at the end of the commercial she fixed her hair with hair spray. So I took that idea, of girls being in command. Also, John Fowles's *The Collector* had come out as a film, starring Samantha Eggar, and had been well received, about a man who kidnaps a girl for his pleasure, and I thought it would be amusing to do a twist on the thing and have the girls kidnap the man… The whole idea was very much of the moment. And that was my contribution to the script. I took it back to Bob, who liked the idea, and wanted to develop it into a script. I told him I didn't pretend to be a script writer, and so I suggested Donald should write it, he had some experience, and knew what he was doing. And Bob said fine, go with it.

"So Donald read the script, and there were certain details he added. He dressed the whole thing up, gave the girls their names, and took it to Bob… Bob didn't like it, he didn't like some of the jokes. So Bob took it to Ian La Frenais, who was very good in his own way, and that was the end of my and Donald's contribution." Ian La Frenais was a well-known comedy writer for British television, who had also written several feature films, including the script for Michael Winner's *The Jokers* (1966), for instance. "Once the film was completed, however, very honourably, Bob paid Donald and me for the script," says David.

"Donald's involvement was thus rather peripheral. It wasn't anything that was his at the inception, concludes David.[38] Interestingly however, Anita Pallenberg claims to have worked on the script with Donald at its inception, information that David Cammell does not corroborate. She remembers working with Donald on a script that was titled *Privilege* - not to be confused with the 1967 film directed by Peter Watkins, also titled *Privilege*, which featured a rock star, played by Paul Jones of Manfred Mann, as the protagonist. "Neither Donald Cammell nor Anita Pallenberg were involved in my film *Privilege*… they had nothing to with our film," Peter Watkins told us.[39] Indeed, Watkins's film was already in release by the time *The Touchables* began filming. "While we were working on *Privilege* [1966], Brian was very much in the background," Anita Pallenberg remembers. "I think Donald wanted Brian Jones to play the part of the rock star [Christian]. We wrote it with him in mind."[40] Although David Cammell doesn't remember Anita working with Donald on *The Touchables*, her recollection about working on a project she remembers as *Privilege* may be right. In *The Touchables*, Christian says to Sadie, "I am privileged," to which she responds, "Don't. You're just a temporary solution to the leisure problem. Our flavour of the month."

David Cammell dismisses *The Touchables*, saying it is "not worth discussing, a piffle," and that it is "best forgotten." He insists, "Nothing of what Donald or I wrote remains in the finished film," and it is true that Donald never mentioned his involvement with *The Touchables* in interviews.[41] Yet certain of its features vaguely suggest Donald's involvement with the script. *The Touchables* is interesting, at least as an idea, in that it makes an effort to link the collective fantasy life of four young women with the homoeroticism of the wrestling arena and the London underworld; a couple of these themes would reappear in *Performance*. It does so by centring the attention on a pop star, Christian (David Anthony) who is admired by the girls and by the rival wrestlers, Ricki Starr (who plays himself), and a black gangster, ironically named Lillywhite (aka "The Black Hood" in the arena), played by Harry Baird (*The

Italian Job). Both wrestlers become enamoured of the decidedly effeminate Christian when they catch sight of him at a match, but the four star-struck girls also have plans for the singer. The two worlds are rather tenuously connected by virtue of the fact that Melanie (Esther Anderson), one of the four girls, is apparently an employee of Ricki Starr, acting alternately as a sort of masseuse, confidante, and personal secretary.

The four girls share an apartment in London. Their first caper is to steal a replica of Michael Caine from the Wax Museum, presumably because they find the actor sexy. Caine's status as a sex icon might be explained by his winning portrayal of the hot-blooded title character in the 1966 film, *Alfie*, itself based on a highly successful play. One of the girls, Sadie (Judy Huxtable) curiously disappears for twenty-four hours with the wax replica of Caine, a fact that suggests the sinister, if not fetishistic, side of her character. The "abduction" of the simulacrum is eventually uncovered by the gallery owner, who then retrieves it. The girls use this caper as a rehearsal for their kidnapping of the rock star, Christian, in order to use him as a sex toy - their ingenious "solution to the leisure problem." He attends a wrestling match, which is portrayed as a *gauche* social event, as the audience dines ringside cheering on their favourite contender. Melanie, the girl connected to the wrestling world, is working as a cocktail waitress at the match. She informs Christian that he has a telephone call and, when he answers this summons, he is abducted by the girls, the other three of whom are disguised, oddly, as nuns.

The girls drive the kidnapped Christian to a pastoral English setting. In the middle of nowhere, they have erected a gigantic transparent bubble, which they refer to as their "Pleasure Dome," a place where, as Sadie informs him, they bring their "flavour of the month." The contents of the dome suggest that it represents an arrested adolescent fantasy, as it is replete with games and toys. The manipulative Sadie's favourite toy is, appropriately, a small robot, while Samson (Kathy Simmonds) clings to a plastic reindeer that squeaks when the slightest pressure is applied to it. Inside, the girls play electronic games, such as pinball and football, to determine who will have Christian first. The main feature in the Pleasure Dome, however, is a carousel converted into a large circular bed bearing the inscription, "Sadie's Grand Stud," in one place and "For All Classes" in another. Sadie, whose name aptly suggests her aggressive, "sadistic" personality, wins the games and is the first to have sex with Christian, who, apparently against his will, complies. We see ensuing shots of Melanie and later Busbee (Monika Ringwald, pseudonymously appearing in this film as Marilyn Rickard) enjoying Christian in the same way, but the fourth girl, Samson, is shy, refusing such an open display, claiming that she "never was good at games." Her enjoyment of Christian occurs outside the dome in a secluded spot.

Although David Cammell suggests the original story was in part inspired by *The Collector*, the plot also seems distantly related to a successful play, *Three in the Attic*, a sex farce written by Stephen Yafa, and subsequently filmed and released, coincidentally, in 1968, the same year as *The Touchables*. In it, a college student, played by Christopher Jones, dates four different women at one time. When they discover he is having sex with all of them, they intend to teach him a lesson: they lock him in an attic and, taking turns as his sexual partner, attempt to exhaust him. All of this is intended to point out to Christopher the emptiness of mere physical desire, however, so that he will own up to his true feelings for the first girl he dates.

In *The Touchables*, the girls apparently hold Christian captive for some period of time, as additional shots show all four in bed with him, while Samson reads a "bed-time" story of a pornographic tale set in a convent, thus connecting it with the nun disguises used earlier in the abduction scene. The wearied Christian, a virtual prisoner of sex, eventually attempts to escape his captors by water, but Sadie shoots his boat, which capsizes and nearly drowns him. He is then subjected to a "mock trial," in which Sadie is both prosecutor and judge. His "crime"? - "Wanton promiscuity."

Meanwhile, in a rather clumsy effort to fuse this plot with the homoeroticism represented by the wrestling arena and the London underworld, others notice that Christian is missing. Lillywhite,

A collage of images from the pressbook for **The Touchables** *reveals the film's quirkiness, an unwieldy mixture of action, sex, bondage, fetishism - and an unmistakable 1960s sensibility.*

enamoured of the star, had earlier approached Christian's manager, Kasher (John Ronane), asking the latter to pay him "insurance" to guarantee Christian's safety, a type of blackmail, which Kasher refuses. When Christian turns up missing, Lillywhite believes that his rival, Starr, may be responsible, but the truth is uncovered when Melanie returns to the girls' London apartment and is grabbed by two thugs who force her to take them to the dome. Lillywhite and his fellow underworld "chaps" then hold the girls hostage. Samson escapes and seeks help from Ricki, who gathers some wrestlers for the final showdown between himself and "The Black Hood," and for the rescue of both Christian and the girls. During the ensuing mêlée, Christian manages to deflate the Pleasure Dome by switching the gas-feed mechanism to "off." Kasher and Christian leave, followed by the hoodlums, and the Touchables are left to survey their deflated dome. On a happy note, Sadie reminds them that they can always inflate it again.

The Touchables is not a good movie, and isn't particularly interesting even when viewed for nostalgic reasons. Yet sometimes failures are as interesting as successes, or rather, the contents can be most instructive. On the surface, *The Touchables* has the mod look and ambience of a "Swinging London" film of the time: loud colours, parties, the emphasis on independent youth with counter-culture impulses, and even the presence of the ubiquitous pop star that seems to be an essential ingredient of this genre, a genre that Donald would utterly subvert with *Performance*. Moreover, like so many '60s films, it portrays the exploration of the changing relationship between the sexes in general, and the "women's liberation movement" in particular. Interested in and always inquisitive about sex, in one scene the girls are shown in their apartment viewing a talk show that addresses the issue of the reversal of sex roles; Samson, curiously, is shown in bed with a television between her legs, a scene that hints of fetishism if not of masturbation. When she naively asks what the "reversal of sex roles" means, Busbee, equally naïve, tells her that it is when a man and woman change places in bed. That sex remains

for them both a mystery and an appetite is made clear by the fact that, as they listen to the talk show, the camera cuts continually to food: phallic bananas, testicular oranges, etc. Indeed, Christian seems to be little more than a commodity they steal for their own pleasure, driven by an appetite they do not themselves question or understand, vainly attempting to satisfy their desire. Their immaturity serves to disguise the fact that their characters, lives, and motivations remain unexamined.

What lies underneath this relatively banal and benign film, however, is more problematic. *The Touchables* lacks a story, despite the fact that it masquerades as a caper film by virtue of the girls' kidnapping of Christian - perhaps a residual plot element from Donald and Anita's script, since Donald would also use abduction again, in *Ishtar*. The girls' characters are sketchy; the group dynamic remains unexplored; and the motive for the existence of the Pleasure Dome and for their libidinal desires is ignored entirely. We know nothing of their lives: where they work, how they met, or even how and why they found the idea and means to construct their dome. Indeed, they scarcely emerge as individual personalities, although with some effort it is possible to see that Sadie is perhaps the leader, representing one extreme, with her gun, her sexual aggressiveness, and her carousel stud bed, as the shy, reluctant Samson defines the other end, with Melanie and Busbee representing some moderate behavioural middle. Even the plot really goes nowhere. There is no resolution, but rather a return to the beginning, which is supposed to represent normality: Ricki Starr and his friends defeat Lillywhite and his gang, thus liberating both Christian and the girls. In the final shot of the film, Christian departs the dome site with his manager, bound for a United States tour, while the girls, presumably, resume their friendly relations with Ricki. What has changed? Nothing. It's as though all of their lives have simply been placed on hold for a bizarre moment, but the characters happily return to reality, unscathed and unscarred, almost amnesic. This "flatness" of character and absence of a developed story, when coupled with the homosexuality on the one hand, and the doubled *ménage-a-trois* on the other, signals what is both interesting and disturbing about *The Touchables*, that is, what makes it Cammellian.

In her review for *The New York Times*, critic Renata Adler dismissed the film, calling it "a kind of hip, mod pornography," a rather startling assertion that, despite its harshness - or perhaps *because* of it - deserves consideration, especially since a similar condemnation would be levelled at *Performance* about two years later.[42] It is true that the very term, "pornographic" is problematic, largely because of its subjective nature, although most would agree that its connotations are negative. What might seem pornographic to one person might be laughably innocent to another. Nonetheless, the term is almost always used judgmentally, almost always negatively. In our view, *The Touchables* might best be understood as "pornotopic" rather pornographic.

In his groundbreaking 1964 work, *The Other Victorians: A Study of Sexuality and Pornography in Mid-Nineteenth Century England*, critic Steven Marcus explores pornography's furtive nature by examining its most famous Victorian example, aptly titled *My Secret Life*, a non-fiction work written by an anonymous Victorian male of considerable means. It chronicles his astonishing number of illicit sexual adventures over the span of his adult life. In the concluding chapter of his study, "Pornotopia," Marcus argues that pornographic fiction most closely resembles utopian fantasy in that its setting is always undeveloped, although it seems vaguely familiar: "To read a work of pornographic fiction is to rehearse the ineffably familiar; to locate that fantasy anywhere apart from the infinite, barren, yet plastic space that exists within our skulls is to deflect it from one of its chief purposes… One need not inquire very far to find sufficient reasons for pornography's indifference to place: in the kind of boundless, featureless freedom that most pornographic fantasies require for their action, such details are regarded as restrictions, limitations, distractions or encumbrances."[43] Marcus's assertion applies, in an interesting way, to *The Touchables*. For instance, a review in *Films and Filming* complained of just such an undeveloped setting and plot: "Where do the girls, all with upper-Cockney accents of the working class on the make, get enough money to have a trendy London flat, full of pop art, a dome

*According to the advertising, "they try anything": a still from **The Touchables**.*
From left: Monika Ringwald (aka Marilyn Rickard), Esther Anderson, Judy Huxtable, and Kathy Simmonds.

courtesy David Del Valle

*On a carousel: the more the merrier seems to make Christian a willing captive in **The Touchables**.*

filled with such gadgets as a circus roundabout for a bed, home movies for showing psychedelic films, a sports car, two horses, and a motorboat? Why do they live in a see-through dome? Why doesn't it attract attention or at least voyeurs?"[44]

Marcus also notes that just as the spatial relationship is undefined, all the more to allow for the individual imagination to take hold, so time becomes unimportant. "To the question 'What time is it in pornotopia? One is tempted to answer, 'It is always bedtime,' for that is in a literal sense true."[45] This is present in *The Touchables* with the pun on "bedtime story" when Samson reads to her mates and Christian the tale of the seduced nun. Marcus continues that in a pornotopic work, life does not begin with birth, but with the first sexual experience; time is always sexual time. As mentioned in the quote above, the girls are given no past and virtually no present other than this existence in the Pleasure Dome.

In addition to the vague or subjective sense of space and time, pornotopic fiction also represents the external world through sexual (Freudian) imagery. Landscapes are anthropomorphized into the "immense, supine, female form," and man is, not a man, but "an enormous erect penis, to which there happens to be attached a human figure."[46] All external objects become significant only insofar as they can be understood in a sexual context. In *The Touchables*, the huge diaphanous bubble clearly suggests a large female breast. And what is Christian if not a male appendage? Later, we will examine in detail this idea of a pornotopic landscape, in our discussion of *The Argument* (derived from *Ishtar*), a film that adheres to Marcus's description rather uncannily.

Of course, the convoluted authorship of the screenplay complicates the matter of properly assessing *The Touchables* as a Donald Cammell film. It is neither our task to condemn nor to dismiss what clearly is evident in the film, but to point to the singular element in *The Touchables* and attempt to interpret it, make meaning out of its presence - for instance, the second half of *Performance*, as well *Demon Seed*, both feature a hermetically sealed world reminiscent of the cloister. Repetition *is* meaning, a puzzle waiting to be unlocked. As we shall see, both *The Touchables* and *Duffy* serve as provocative preludes to the later films.

Duffy - A Groovy Little Happenin'

Along with Harry Joe Brown, Jr., Donald Cammell is credited as the writer of _Duffy_, a slick heist film that features unexpected twists to the last minute. Directed by Robert Parrish, _Duffy_ is a more sophisticated film than _The Touchables_: its neat plot leaves no loose ends, and it boasted considerable acting talent, which also contributed to its success. Moreover, unlike _The Touchables_, _Duffy_ tells a compelling story with fully realised characters. The dialogue now seems dated, sprinkled with expressions such as "groovy," "hip," "a happenin'," "fantastic," "cool," and "absurd," which render it charmingly nostalgic, although it is doubtful that this was its original aim.

In a rare surviving interview with David Del Valle, Donald Cammell only reluctantly acknowledged that _Duffy_ was his first major screen credit as a writer. About the film, Donald said: "It's based on an adventure that really happened to a mate of mine, or maybe it was all my lovely group - Susie York, James Mason, James Coburn, and Willie [James] Fox. It's not a serious movie, more of a bon bon, very carefree. Not worth discussing."[47] As mentioned previously, Mrs. Deborah Roberts affirms the story's genesis came from their retired jewel thief friend. More important, though, is Donald's sense that the story also developed from the actors themselves, his acquaintances, whom he alludes to as "all my lovely group," a kind of autobiographical confession that thus links it with _Performance_. It was during the filming of _Duffy_ that Donald and James Fox became good friends; Donald and Deborah joined the film crew in Almeria at the start of filming in early August, arriving there shortly after attending Donald's half-brother Charly's wedding to Helga in London on 5 August 1967.[48]

Despite Donald's dismissal of the film as "not serious," _Duffy_ does indeed, as we shall show, contain meaning that is relevant to our discussion of the close connection between Cammell's art and his life. We maintain that, despite its greater artistry, _Duffy_ shares some rather striking features with _The Touchables_, features that serve unmistakably as Donald Cammell's autobiographical inscription and which anticipate his later films.

Duffy opens at a party held in the mansion of a wealthy elderly shipping magnate, Charles Calvert (James Mason). This scene sets the tone and creates the tension that persists throughout the entire film. Calvert's two sons, who are half-brothers, are in attendance. First, the father easily defeats his more timid son, Antony (John Alderton) at a game of darts, while the plucky half-sibling, Stefane (James Fox), entertains a circle of guests by relating a ribald anecdote about a time when he had been caught having sex in the tiny restroom of a TWA airline flight. When discovered, Stefane told the intruder: "Young man, you have a dirty mind!" Stefane claimed that, by way of explanation for having been caught _in flagrante_, he had averred that he and his female companion were merely having a smoke; he wittily asserts that her skirt was hiked up only so she could show him the "tattoo on her thigh." (Interestingly, this moment anticipates a scene in _Wild Side_, in which Anne Heche's character is portrayed in a sexual encounter on an airplane; the tattooed thigh also appears in _White of the Eye_ when Ann Mason hikes up her negligee to entice Paul, encouraging us to speculate that this episode might be a personal inscription.) Moreover, amorous acts in toilets seem to amuse Stefane; there are other such scenes in the film that occur in restrooms. Stefane's story is interrupted when his father challenges him to a game of darts - for obscenely high stakes. Stefane coolly accepts his father's bet, but is both outwitted and outplayed, a fact that seems not to disturb him, even though he is defeated in the presence of his charming companion, Segolene (Susannah York).

Having witnessed Stefane's loss, Antony approaches him with a plot to undermine their father's business, but Stefane dismisses his brother's idea as "conceptually narrow." "If you are going to attack him," Stefane advises, "attack where he is vulnerable - his pride. And attack him with audacity." "I just want to make some money," Antony responds, as Stefane departs with Segolene, a puzzling statement considering the wealthy environment in which the opening scene is set, but one

Above: *This bath scene from* **Duffy** *anticipates its infamous successor in* **Performance**. *John Alderton* (left) *and Susannah York.* Opposite bottom: *James Mason as Charles Calvert, shipping magnate and rival to his son, Stefane.*

that is resolved in the next scene, which serves as a prelude to the brothers' plot to steal one million pounds in bank notes from their father, who has arranged payment for an international business transaction by having the notes transported aboard one of his ships, the Osiris. (That the ship is named after the Egyptian god of Death is less significant than the uncanny fact that Donald was to play the role of Osiris in Kenneth Anger's *Lucifer Rising* some years later.)

The following day, we learn the reason for the brothers' animosity towards their father. In what must be one of many confrontations, Stefane and Antony accuse their father of marrying their mothers for their wealth, and then cheating them out of their inheritances. Alluding to Antony, Stefane insists: "If *my* mother's lawyers hadn't been smarter than *his* mother's lawyers, I'd have flipped out years ago." The somewhat dim-witted Antony concurs, calling his mother's lawyers "bloody fools." The father demurs, but his sons remind him that he has absconded with a trust company, a shipping line, and a couple of million in cash. Antony wishes to get out from under his tyrannical father's thumb: he is ridiculed by Charles for his poor business sense and forced to serve his father as little more than a glorified clerk, for "30 quid a week." Thus, Antony seeks both his own independence and revenge for his father's insults. Stefane, on the other hand, clearly relishes the thrill of the heist itself. He views the caper as an artistic endeavour of his own making, devising a theatrical script that he orchestrates

with great relish. For as the initial dart game revealed, Stefane and his father are mimetic doubles locked into an ongoing competition that Stefane intends to win.

With Segolene, the brothers enlist the aid of an ageing "American hipster," Duffy (James Coburn) who was once in the Navy and now lives in Tangier. Moreover, Duffy has a somewhat mysterious but romantic past - an ex-patriot whose lifestyle and skills resemble those of a pirate and are essential for the success of Stefane's plan. We learn that Stefane had met him years before aboard the yacht of a mutual friend. When they renew their acquaintance at the swank Capo del Oro Beach Club on the Mediterranean, Stefane asks Duffy: "Have you made any interesting scores lately? How's the old smuggling racket?" These comments suggest that Duffy bears a family resemblance to romantic characters such as Rick Blaine (Humphrey Bogart) from *Casablanca* (also set in Morocco) and Jay Gatsby from F. Scott Fitzgerald's novel, *The Great Gatsby*. Stefane then tells Segolene that she must get Duffy to tell her "how he pushed 5 million aspirin onto the Bulgarian Black Market." Duffy responds that he has retired from the smuggling business and explains: "Hey, you have to quit sooner or later, or you get busted, man. I've got two good brothers in Spanish prisons right now and, whew - pass. To tell the truth, I just got scared. Yeah, and I developed some other interests, man."

Thus, when the three recruit Duffy to join their scam, he is at first loathe to come out of retirement, but he is persuaded to join the heist by the seductive Segolene, whom Stefane freely shares with him in order to enlist his help. In fact, it is Segolene whom Duffy first talks to at the Capo del Oro, in a scene that introduces the dark, violent side of her nature, one that emerges as the film progresses.

We see Segolene on the beach, shouting angry insults at (or into?) her tape recorder, with which she remains quite taken throughout the film. Enraged, she is ready to fling it, when Duffy intervenes. "This psychopathic compulsion you had just now fascinates me and, speaking professionally, as a clinical psychopathologist, tell me, was it not traumatic?" "What?!" Segolene responds, and Duffy continues: "See what it was, was a classical sexual compensation syndrome. You were trying through violence to prove your virility." Duffy's "come on" to Segolene is revealing in several ways. First, it

makes the connection between sex and violence and sex and power that prefigures her later behaviour, as we shall see. Note also that he alludes to her "virility," a term usually reserved for men, suggesting the blurring of sexual identity boundaries in Segolene's case. It also employs the metaphor of the theatre that runs throughout the film - Duffy is "play-acting," insisting that he is a psychopathologist and she is a patient. Duffy is attracted to Segolene and is the only man who seems interested in her as a person. Stefane repeatedly throws Segolene at Duffy in order to enlist him in the plot, to which the wary Duffy finally agrees.

If Stefane insists upon viewing himself as a creative artist, so too do we see this side of Duffy. He invites them to his house in Tangier, which is crammed with artistic works in progress, mostly sculptures made out of found objects, primarily fragmented statues and mannequins. The house also contains antiquated amusement oddities, such as a slot machine that yields fish and a girly "peep show." "Ridiculous," pronounces a grinning Stefane. Antony, who is clearly unimaginative, views a grotesque female bust and, slightly scandalized, remarks to Duffy: "It's a bit erotic, isn't it?" to which Duffy archly replies: "I call this a sort of rotting erotic." It is revealing that Duffy assigns his own room to Stefane and Segolene. Aware of Duffy's interest in her, Segolene pronounces: "This isn't a guest bed. This is yours."

The metaphor of the caper as a carefully scripted theatrical production continues. When Duffy tells Stefane that his plot is "absurd," Stefane responds: "Precisely. But *you* create beautiful absurdities. Why can't *I*? I want to create a fantastic amateur theatrical, a happening. To sort of shoot an absurd movie without a camera." "But you might have to shoot people, and that ain't cool," responds Duffy, who then insists that he be the only one to carry a gun during the heist.

They then go to a brothel called the Garden of Allah, whose proprietor, Abdul (Marne Maitland), can "procure absurdities" for the caper. The fat owner, sporting a fez, faintly resembles Sydney Greenstreet's memorable character as owner of The Blue Parrot in *Casablanca*. Stefane here assumes his alias or pen-name, "Señor Eugenides," (a pun on genius?) to purchase, among other items, "theatrical equipment." At the Garden of Allah, Antony sees Monsieur Bonivet, the manager of their father's reserve in Tangier. Bonivet is caught fondling an exotic dancer, whom he introduces to Antony as his "niece." While these arrangements are being made, Segolene teases Duffy, obviously to keep his interest in the scheme, and with the approval of Stefane, who, grinning at the two in an intimate moment on the dance floor, utters equivocally, "It's going to be a groovy little happenin' man," a *double entendre* referring to the impending sex scene between Segolene and Duffy, and the heist.

Duffy resumes his amateur psychology and the theatrical metaphor as the group continues its preparations, confiding to Stefane: "You know, there's something I've finally recognized about you. You're not a psychopath... Somewhere inside you is an unborn psychedelic Cecil B. de Mille. You're a showman, baby. It's a very tempting script, man. Sort of a morality crime." Just what, exactly, Duffy means by a "morality crime" remains for the viewer to decide, but certainly this oxymoron suggests something about Stefane's motive - to overcome his father - in a Freudian Oedipal sense. At any rate, Duffy confesses, that his is "a part I just can't turn down," to which Stefane replies: "Great. You're gonna be great, my boy. Sign right here." The dialogue continues to employ dramatic terms, as Duffy insists that they "rehearse."

Duffy becomes angered by Stefane's refusal to comply with his orders, and threatens to pull out of the operation, provoked by the fact that a box of automatic weapons and then two corpses are delivered to his house. This being the case, Stefane absents himself so that Segolene can persuade the wavering Duffy to continue.

This she does by first taunting and then seducing Duffy. She arrives in his master suite - the one she and Stefane have been assigned - the morning after a romantic escapade with an "Italian." Duffy is seen in the bathroom brushing his teeth; Segolene nonchalantly removes her clothes and showers

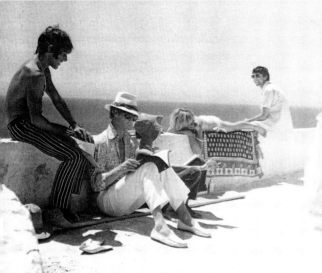
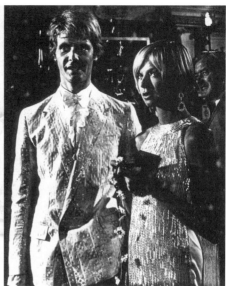

Above left: Taking a break during the **Duffy** *shoot, Tangier 1967.* (L-R): *Donald Cammell, James Fox, Susannah York, John Alderton.*
Above right: Stefane (James Fox) and Segolene (Susannah York) plotting their trap in **Duffy***.*

as she confesses to Duffy how she has spent the night. When Duffy rebuffs her for her lack of chastity in Stefane's absence, she replies coolly, "I see you're in a mad rage. You phoney old Puritan. You're even worse. You're a real Puritan." This scene in the boudoir is reminiscent of Stefane's story of lovemaking in the toilet on the TWA flight, and it looks ahead to an amorous scene in a toilet aboard the Osiris. In a violent prelude to their lovemaking, Segolene cruelly smashes Duffy in the head with the same transistor tape recorder he had first seen her with, admonishing him as she does so, because he calls her a "slut" who needs the heavy-handed approach. "I may be a hooker. I am absolutely *not* a slut!" Segolene shouts, as she strikes, a distinction that is clear in *her* mind, at least. After this violent eruption, she immediately indicates that she will take care of his "libido," but she first insists on hearing him say she is not a slut. "No, you're not a slut. You're just one big drag," Duffy affirms as he kisses her. A *femme fatale*, she thus ensnares him once again in the plan. The love triangle continues even after Stefane and Antony return from their errands, and the heist gets underway.

Dressed as Catholic clergy, Stefane and Segolene board the Osiris, while Duffy boards at a later port, disguised as a Muslim. Meanwhile, Antony waits on a small craft to rendezvous with the Osiris. Once the Osiris sails, Duffy enters a toilet where Stefane and Segolene are changing. The two have just kissed, and when Duffy enters he, too, kisses her passionately in Stefane's presence, suggesting not just a triangle but a *ménage*. The three don bizarre, impractical theatrical masks with long hair and huge noses, along with diving suits, and manage to claim the banknotes, though at first thwarted by a sudden change in the combination of the safe by Charles's aforementioned employee, Bonivet (Carl Duering), who alters the combination to fit his "girlie magazine" fantasy: "41-24-41," the sort of linkage between sex and commerce that is pure Donald.

Duffy and Segolene escape overboard with the banknotes and swim to Antony, who awaits them within plain sight of the Osiris, as Stefane, who resumes his disguise as a priest, helps a young stowaway boy who is running from the police, by dressing him in Segolene's discarded disguise. Stefane disembarks in Naples, where he plans to make arrangements to launder the money.

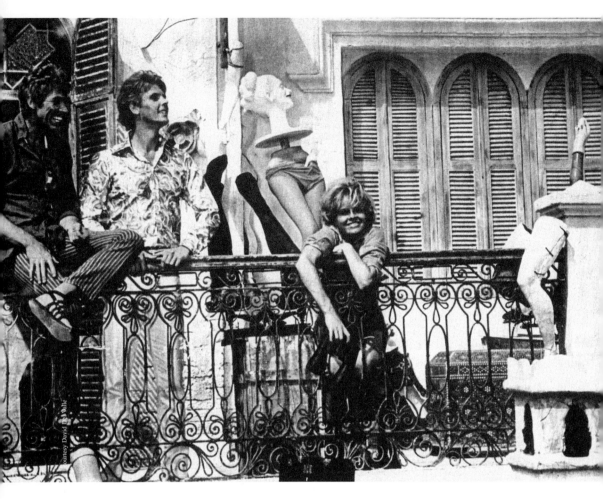

Above: *Duffy (James Coburn), Stefane (James Fox) and Segolene (Susannah York) at Duffy's pad in Tangier. Duffy is an avid collector of "modern art."*
Opposite bottom: *German one-sheet poster for **Duffy**, "the fox of Tangier."*

When Duffy and Segolene join Antony, they then make use of corpses and a helicopter that Stefane had procured as part of their plan: They plant some bills on the iced-down corpses and blow up the fishing craft once they flee in the helicopter flown by Duffy. Thus, the authorities will assume the washed up bodies of the corpses were responsible. The three arrive at their hideout in Corsica, blow up the helicopter, and, once the money is water-proofed, sink it into the water, presumably intending to come back to pick it up at a later date. An exuberant Antony, remembering Stefane's comment that his own earlier plan was "conceptually narrow," shouts, "This is conceptually enormous!" and rehearses the scene he has anticipated all along - the emancipation from his father. Antony departs to join Stefane in Naples, but Segolene refuses to go, choosing instead to continue her affair with Duffy.

Four days later, two conflicting cables arrive. The first putatively from Stefane, but signed "Stephane" and not "Eugenides," strangely commands the two to come to Beirut. Again, Segolene refuses to go. "If you're going to get some solitude, you'd better get it now before your crippled genius comes and fetches you away," a rather embittered, jealous Duffy tells her. "I don't belong to

Stefane. I don't belong to anyone. Not anyone. No one. Nobody," she most emphatically replies. Segolene then tells Duffy: "I liked being here with you. I liked spending just about every minute with you. It's nice. It's just we have to cool everything now, you see." Duffy, softened, replies: "Of course, it has occurred to me recently that I'm getting used to you finally, and I probably love you in the worst possible way. And it's not very cool, I guess, is it?" Segolene, a professional mistress who clings tenaciously to an illusion of independence, replies: "Duffy, I don't go in for belonging. I dig just - being - see?" and he responds, "Yeah, well just be. Be." He leaves Segolene at the villa and sets out, but *en route* to the airport receives another cable signed "Eugenides and Brother," suggesting the transaction in Naples was successful and instructing him to meet Stefane and Antony, as pre-arranged, at the Capo del Oro nearby. Duffy's suspicions of a double-cross are confirmed when he returns to the villa only to get a glimpse of Segolene fleeing in a boat with an employee from the resort.

Duffy arrives at the Capo del Oro in time to spy Segolene disembarking from the boat, met - to his dismay - not by Stefane or Antony, but by their father, Charles, who is obviously on intimate terms with her. Charles kisses Segolene on the mouth and they then exchange news of the heist. The scene cuts as Charles directs her to what must be a hotel room for a romantic reunion: in the next scene, both of them have obviously changed into more elegant clothing, and the two settle down for a cosy *tête-à-tête* over caviar and champagne. Segolene sports a rather pricey cocktail ring on her small finger, which, Charles reminds her, he purchased "The day after I found you." We learn from their conversation the rather shocking fact that it was Charles who "discovered" Segolene, with whom he has been carrying on an illicit, covert relationship for two years, creating a bizarre *ménage* comprised of himself, his son, Stefane, and Segolene. Segolene has been a "plant" (like Tony in the much later *Wild Side*), the means by which Charles has become the mastermind who has duped Stefane and Antony by feeding them false information, manipulating them through her. "If I remember correctly," Charles recalls, "Stefane conceived his factious project on a Monday. On a Tuesday - in the course of our Tuesday *tête-à-tête* - you confided it to me." When she tries to squelch his gloating attitude, she reminds him that he has cheated, to which he sharply replies: "I won. That's more to the point." He also reminds Segolene that using Duffy was her "brainwave." It turns out that he has used his mistress to get them to steal the money, which he intends to then keep and, at the same time, collect insurance on it. Charles tells her that he will deposit one million dollars in a Swiss bank account for her. Thus, it would seem, the opening dart game represented an ominous pattern in which Charles, pretending to fall for Stefane's scheme, shows himself to be the true winner.

Not to be outwitted, Duffy figures out the double-cross, quickly contacts the local police, and turns in the money. A beaming policeman, Inspector Garain (Andre Maranne) presents it to Charles and his co-conspirator, Segolene, much to their chagrin, just as Antony and Stefane arrive to witness their foiled plot. In the presence of the police, and at the instigation of Segolene, Duffy manages to bilk Charles out of a £50,000 reward, leaving the Calverts (and Segolene) with nothing to show for all of their scheming. Segolene approaches Stefane, evidently to reconcile with him: "I gotta explain some things," but Stefane seems unperturbed, even admiring

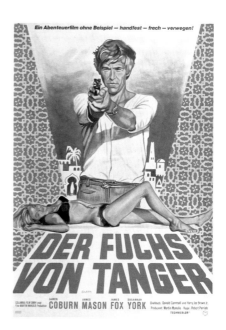

Charles's handiwork as a masterful piece of art: "No explanation. Whatever happened, it looks divinely inspired." As Charles and Stefane cordially toast each other in their mutual defeat, each acknowledging the other's cunning, Segolene follows Duffy to say good-bye. As he departs, he generously gives her a packet of bills, kisses her affectionately, and says: "You just keep on being - you groovy old hooker."

Competently directed, even though the first half of the film could use further editing, *Duffy* also benefits from the strong acting of its cast. What separates it from other heist films is its autobiographical elements, some of which are similar to those found in *The Touchables*. Some are obvious self-references, while others remain covert but, once again, what is unusual about the film is clearly due to Donald Cammell's influence.

The obvious autobiographical references to Donald's own life begin with the Calvert family itself: the father's name is Charles, and he is an extremely wealthy shipping magnate with sons from two marriages. These might seem to be harmless self-inscriptions, except for the fact that the father in the film is manipulative and immoral. The dynamic tension between Charles and Stefane clearly does reflect that of Donald and Charles Richard Cammell who, as we have shown, did have disagreements, even an ugly scene or two, prompted, ostensibly, by Donald's refusal to continue his career as a painter. Thus, Stefane, the "playboy," might be considered the character most closely associated with Donald: rebellious and artistic, and every bit as suave as his father. Stefane's dress, like his personality, is flamboyant and expressive, standing in sharp contrast to that of the more reticent, plebeian Antony.

Yet there is a disturbing side to this dynamic between Charles and Stefane. That they are in competition with each other is clear not only from their dart game, in the opening scene, but also from Stefane's motive for concocting the caper to steal from his own father. Uninterested in the potential for financial gain, he hopes only to outwit Charles who, we learn at the end of *Duffy*, has also been scheming to use his sons and thus also, in turn, outwit them. Stranger yet is the fact that Charles and Stefane share the same mistress, Segolene. This unconventional *ménage*, apparently unbeknownst to Stefane - although one wonders whether he would care if he knew - seems not to bother Charles in the least. Nor does it perturb Stefane to share Segolene with Duffy, which occurs in Stefane's very presence. She is quite clearly a means of exchange, but most disquieting is the incestuous Oedipal battle of which she is the prize, shuffling between Charles and Stefane. This is emphasized by the fact that, as we mentioned earlier, Charles uses Segolene as a plant to uncover Stefane's various machinations. Whether there is any autobiographical significance to this very odd arrangement is subject to speculation, but one can't help but take note of the competitive nature of the father/son relationship in the film, which borders on the pathological, despite their effete manners and lifestyle.

Segolene's sexual availability masks a classic sociopath, that is, she has no empathy for others, and is ruthless and self-absorbed. Mistress to Charles, Stefane, and Duffy, she gives allegiance to none. Her distaste for Charles is apparent even as she feeds his power, enabling his plot to outwit Stefane. Several times she expresses affection for Stefane, and a loyalty to him, yet she also states overtly her fondness for Duffy, and gives him the means to collect a reward and thus win the game of male egos.

Despite the use of Segolene as a means of exchange, a sexual commodity, and her insistence on retaining her freedom to choose, she is subject to fits of violent rage, and possesses a decidedly sadistic streak, like many other characters in Donald's films. This is manifest when she strikes Duffy with the tape recorder, but also when, viewing the Osiris before the heist, she muses: "Our victim. Little does she know what's waiting for her. Boy, is she gonna get it!" This suggests a kind of rape or other violent transgression, which Segolene anticipates with a pleasure that is overtly aggressive, masculine, sadistic. She is cast as a somewhat frightening character: cold, remote, volatile, and unpredictable. Only Duffy seems to sense the degree to which Segolene is disturbed; only Duffy

expresses any genuine affection for her. Yet even he is unable to reach her in any profound or lasting way. Remember that in *The Touchables* four women share one man. Later, we see this arrangement in *Performance* with the characters played by Breton/Jagger/Pallenberg, and in *Wild Side* as well with those of Bauer/Heche/Walken, but also Walken/Heche/Chen. Here we have a triangle formed by Mason/York/Fox and also by Coburn/York/Fox.

Other features marking *Duffy* as a forerunner of later films are the presence of the hooker, Segolene, a prototype of Alex in *Wild Side*. Moreover, as we discussed earlier, Segolene insists that, while some may consider her a "hooker," she is "absolutely *not* a slut," as Duffy had suggested. Obviously, in her own mind there is a vital distinction between the two: a hooker works for cash and yet retains her own privacy, her identity as a person. Fiercely proud and independent, Segolene later tells Duffy that she doesn't wish to belong to anyone, but prefers "just being." In other words, she keeps her business and private lives separate. As we shall see, in *Wild Side* Alex (Anne Heche) chooses prostitution to improve her financial situation because she is forced to prostitute herself for her banker employers anyway. It is also noteworthy to point out that Susannah York accepted the highly controversial role of Segolene, a mistress who remains independent and who manifests her propensity for violent explosive fits, during the same year that she was cast in the even more audacious role of Childie, a deceptively childlike lesbian involved with a butch partner, Sister George, in Robert Aldrich's *The Killing of Sister George* (1968). Childie turns out to be less than innocent, manipulative and capable of looking out for her own interests.

Duffy also features the ludicrous Bonivet, an avid consumer of pornography, who is almost always shot in the film viewing multiple photographs of naked women or of seducing one. Indeed, this seems to be his most important function. Just what he is doing in the film is a valid question but, in the company of a hooker and some rather strange sexual arrangements, we begin to see how odd - despite the fact that it is a tightly-woven caper film - *Duffy* really is, and how clearly it prefigures Donald's later work. It is little wonder, though, that Leonard Maltin, for instance, labels *Duffy* a "scummy crime comedy."[49] So much of what is strange about the film is autobiographical, a fact that we have gone to some lengths to emphasize.

It must be added that the criticism of Catholicism is also present. In *The Touchables*, the libidinous girls had disguised themselves as nuns when they abducted the pop star, Christian, and in *Duffy*, Stefane and Segolene are garbed as Catholic clerics - Stefane employing a thick Irish accent - when they board the ship and when he disembarks with a substitute for Segolene, a small boy. Later, in *Wild Side*, as we shall see, there is also a suggestive use of Catholic icons and ideology in a more complex, less humorous way. The unusual repetition of this motif is suggestive indeed, even in these two early films but, as we will discuss in detail in ensuing chapters, it becomes both more complex and troubling as it is employed in *Wild Side*, his final film.

Royal photographer, the late Patrick Lichfield, puts in his brief cameo appearance in **Duffy**.

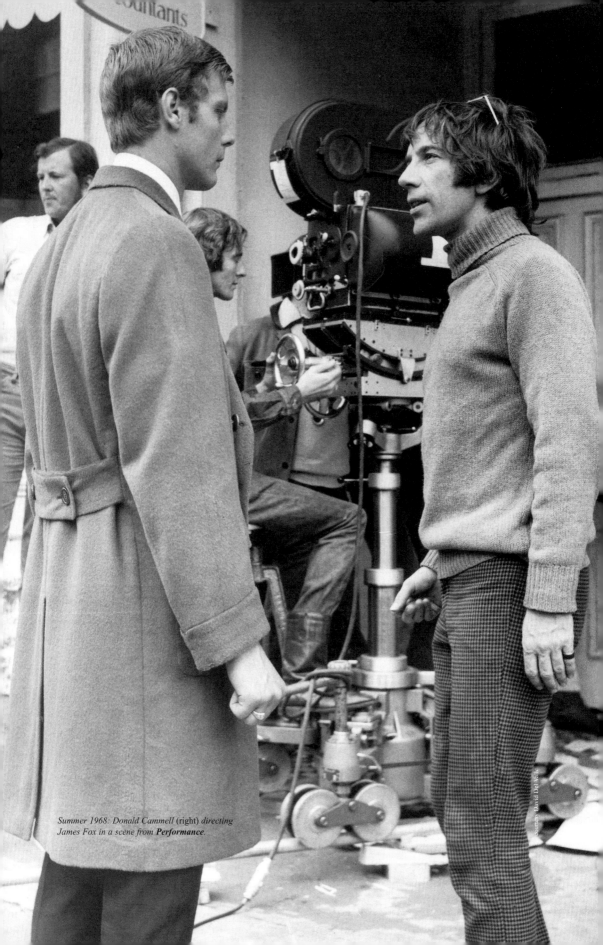

Summer 1968: Donald Cammell (right) directing James Fox in a scene from Performance.

5

Performance

1967-1970

"A film is not written or shot during the approximate six months allotted it,
but during the thirty or forty years that precede its conception."[1]

- Luc Moullet

"It happens now and then," T.S. Eliot wrote, "that a poet by some strange accident expresses the mood of his generation, at the same time that he is expressing a mood of his own which is quite remote from that of his generation."[2] Eliot made this remark long ago, while addressing the relationship between Alfred, Lord Tennyson, and his poem *In Memoriam* (1850), and the Victorian age in which it was published, although the same might be said of Eliot's own famous work, *The Waste Land* (1922), and the age in which it appeared. Serendipitously, Eliot's remark also captures the relationship between Donald Cammell and the era in which his most famous film, *Performance*, appeared. There are contingent connections one can make between *Performance* and the late '60s "Swinging London" period in which it was made, pop stars on the one hand and underworld figures such as the Krays on the other, but these contingent connections nonetheless fail as explanations for the film's wilful eccentricity. One can say the film "reflects" the particular ambience of late '60s "Swinging London," but this is merely another way of saying it captures the time and place in which it was made - true enough as a generalization, but the statement identifies only the most superficial level of the film, and avoids addressing its singularity.

In order to account for the uniqueness of *Performance*, one must of necessity appeal to features of Donald's biography, thus exceeding the strictures of criticism as such. Perhaps we should remember Goethe's distinction between reality and truth, and entertain the possibility that *Performance* expressed a truth peculiar to Donald Cammell. Vartkes Cholakian, an Armenian filmmaker who lived with Donald and China for about six months during the latter half of 1979, told us among the hundreds of films they discussed during those months together, he remembered Donald especially admiring Robert Bresson's *Diary of a Country Priest* (1951), because he saw in the young priest, scorned by the villagers of Ambricourt, a figure both for the artist-as-outsider and for the poet-martyr.[3] The poet-martyr captured Jean Cocteau's imagination as well, in the figure of Orpheus. Like the films of Cocteau's Orphic trilogy, which we will discuss in detail below, *Diary of a Country Priest* contains an underlying theme that consciously or unconsciously informs *Performance*, in French rendered *toutes les aventures spirituelles sont des Calvaires* - all spiritual journeys are martyrdoms.

Jean Cocteau attributed to Salvador Dali the invention of the word "phoenixology," which means, according to Cocteau, a person dies in order "to be reborn in a shape closer to his real being."[4] We believe it's likely Donald Cammell held this belief, that he may have held it at the time of his suicide, and that it is this heterodox idea that lends *Performance* its singular power. Psychiatric studies of suicide provide evidence that suicidal ideation - thinking about suicide - is prompted by many secondary motives, such as the desire to be reunited with a dead loved one, or the wish to escape one's

own, but nonetheless alien, body. Other motives include the desperate need of flight or escape, and perhaps a wish to be reborn. A case in which the subject has expressed a belief that death will bring about a purification through rebirth is sometimes referred to in the psychiatric literature as an "ecdytic death fantasy," from the Greek word "ecdysis," defined by the *Oxford English Dictionary* as, "The action of stripping or casting off, *esp.* of slough or dead skin in serpents and caterpillars, or of the chitinous integument in Crustacea." As unexpected as it is strange, the ending of *Performance* represents an ecdytic death fantasy, not so much a moment of religious transcendence in a hierarchical sense, but a sort of horizontal flight or escape, achieved through a transformational rebirth, an idea that also exerts itself in *Demon Seed* and, vaguely, in *White of the Eye*. Donald, however, preferred to use the word "transcendent": "The goal was to make a transcendental movie," he said. "Death is regarded as a transcendent moment there [at the conclusion of *Performance*], and not as an end."[5] His use of the word "transcendent" suggests, however, the underlying idea that strongly informed his understanding of Chas's spiritual journey.

In an interview published in 1972, Donald referred to the "secret movie" that was "intercut subliminally" within *Performance*. When queried by his interlocutor, R. Joseph Libin, if what he was alluding to by this remark concerned "The little boys in the flashbacks," Donald replied, "Well, maybe it has. If I told you, then it wouldn't be a secret."[6] In retrospect, it's remarkable that Libin was able to recall the "subliminal" flashcut at all, consisting of roughly two seconds of black and white footage taken from Carol Reed's *Odd Man Out* (1947), inserted in the sequence during which Chas murders Joey. The presence of this snippet of Reed's film supports our assertion about the allegorical dimensions of *Performance*. Libin identified the footage as a "flashback," although we prefer to view it as a flashcut serving as a clue to the meaning of the "secret movie" within *Performance*.

At the most obvious level, Reed's *Odd Man Out* serves as a realistic crime drama with that genre's predictable, morally instructive conclusion: crime is punished. But at the same time, it is a story of crime and redemption, representing the spiritual journey of its protagonist, Johnny McQueen (James Mason), who is seriously wounded during an armed robbery and shoots a man to allow his getaway. He kills the man, but doesn't know the harsh truth for quite some time. Johnny's last night is a long, tortuous journey during which he must make the painful ascent to his own Golgotha, a night during which he is haunted by the possibility that he may have murdered the man during the getaway. "Did I murder that fella?" he asks along the way, suggesting the depth of his remorse. Unlike Claudius in *Hamlet*, for instance, who wants to be sorry for his fratricide but knows he is not, Johnny truly *is* sorry. Near the end of the film, as the two make their way towards a ship that will help them escape, the spiritually tortured Johnny, physically racked with pain, asks his sweetheart Kathleen (Kathleen Ryan), "Is it far?", ostensibly alluding to the ship that will carry them away, but clearly also suggesting his desire for his (regenerative) journey to come to a close. At this moment, we realize that the depth of Johnny's remorse, coupled with the agony he has endured, has earned him a grace that comes only through such extreme suffering. It is significant that Kathleen chooses not to turn herself and Johnny over to the police, but chooses to turn the gun, suicidally, on the police, knowing they will return the fire and kill her, along with Johnny. The film thus contains a link between death and transcendence that appealed to Donald both emotionally and intellectually, and sheds light on yet another way he understood the final moments of *Performance*, as well as Chas's spiritual journey.

Brion Gysin called such a spiritual journey "the process,"[7] an experience structurally similar to a religious conversion, of moving from a mundane or desacralized existence, one lacking values and transcendence, to a higher state of existence that is possible, as Luigi Zoja observes, "only through symbolic and ritual death and regeneration."[8] The use of drugs is believed to facilitate this process of transformation and rebirth to a new level of awareness and insight, and the second half of *Performance* represents Chas's transformation and rebirth through the use of drugs.

Vice. And Versa.

Mick Jagger.

And Mick Jagger.

James Fox.

And James Fox.

This film is about madness. And sanity. Fantasy. And reality. Death. And life. Vice. And versa.

performance.

James Fox/Mick Jagger/Anita Pallenberg/Michele Breton

Written by Donald Cammell/Directed by Donald Cammell & Nicolas Roeg/Produced by Sanford Lieberson in Technicolor
A Goodtimes Enterprises Production from Warner Bros.

Hear Mick Jagger sing "Memo From Turner" in the original sound track album on Warner Bros. Records and tapes.

THIS FILM IS RATED (X) NO ONE UNDER 17 ADMITTED

*James Fox, his hair dyed red, behind the scenes (and camera) during the making of **Performance**.*

Other than Native American cultures, which include some forms of drugs during religious rituals, and which fascinated Donald Cammell, among the first "drug subcultures" were the Club des Haschischins, which flourished in Paris in the 1840s and '50s. Its members included Charles Baudelaire, Alexander Dumas, Gerald de Nerval, and Théophile Gautier. In the mid-twentieth century, writers such as William Burroughs and Brion Gysin - both of whom Donald knew before he had introduced Brian Jones to them - revived the myth of the "Hashishin" or "Assassins" - a secret group of drug users at odds with the material culture in which they lived - as a way of conceptualizing the modern "drug subculture" or so-called "drug underground." It's not clear where Donald learned the idea - from Burroughs and/or Gysin, perhaps, or from reading scholars such as Mircea Eliade, or whether he simply intuited it - but drug subcultures, as Martin Jay observes, "share many of the underlying dynamics with initiatory secret societies."[9] Such occult or secret societies are premised on initiation ceremonies allowing individuals access to a higher state of being. Turner becomes the psychopomp or hierophant who tells Chas the story of the Old Man of the Mountain, Hassan-i-Sabbah, called by Brion Gysin "the Father of Grass [Hashish, *cannabis sativa* or *cannabis indica*]."[10] The myth of the Old Man of the Mountain and his "Assassins" or "Hashishin" has been disseminated widely in the Western world since the time of Marco Polo, although there is no historical evidence of such groups using drugs or referring to themselves as such. Turner's famous line, "Nothing is true. Everything is permitted," is

*Young spectators: a group of boys gather to watch the shooting of a scene from **Performance**, whilst (behind) a make-up artist attends to James Fox.*

attributed by some to Hassan-i-Sabbah, but a definitive answer as to the source of this quotation is very elusive. Hassan-i-Sabbah is a figure that appears throughout much of William Burroughs work, but even Burroughs scholars are in disagreement about how the writer first discovered this figure. In his interview with David Del Valle in 1988, Donald attributed the slogan to Nietzsche, which is, frankly, where we always assumed the quotation came from, even without Donald's affirmation.[11] The phrase is cited in Nietzsche's *Genealogy of Morals*, Third Essay, Section 24; it is *not* Nietzsche's slogan - he attributes it to the order of Assassins, the Hashishin - but not to Hassan-i-Sabbah.

The important issue is to notice the link Donald made between esotericism and the individual's need for a quasi-religious transcendence that can occur only within the secrecy of ritual. "The structure of modern life tends to eliminate possibilities of radical change," Luigi Zoja astutely notes, which is why secret or esoteric societies hold such imaginative power for individuals in modern desacralized urban society.[12] The essential dilemma confronting characters in Donald's films - and in many of his unproduced scripts as well - is how to exceed the limits of their banal existence without causing a series of contradictions that ultimately alienates them from their society. It fails, of course, in certain instances, as it does for Paul White in *White of the Eye*, though apparently it is achieved by Proteus IV in *Demon Seed*. Donald must have seen it so for Chas, although he expressed some hesitations about the ending of *Performance*.

Colin MacCabe cites a letter Donald wrote to producer Sandy Lieberson in which he asked for a reshoot of *Performance*'s final action. The last moment of the film was "of the greatest importance," he wrote, because it would reveal *Performance* "has moved… from a purely realistic level" to "a purely allegorical" one.

> As it [the white Rolls] passes close to [the] camera, the figure inside in the red wig looks out the window. The face is Turner's. Cut to a close high-angle shot… The white Rolls-Royce comes into close shot… As it rolls up the street, we zoom out to show Central Park West. We continue to pull up and back as the Rolls turns into Central Park. It recedes across the park… As the camera angles up to follow the car, the New York skyline [is revealed]…[13]

The revised ending - suggested to Donald by Nico - was not shot, but one can see his attraction to the idea because it emphasizes the symbolism of transformational rebirth by including a cut to an actual new location, in this case a cut from London to New York, vaguely suggested by the cryptic note left by Rosey that demands to be read figuratively, "Gone to Persia - Chas."

Scholars have discussed in detail the influence of Borges on *Performance*, with much of it, not surprisingly, focusing on "El sur" ("The South"), the story from which Turner reads. We note in passing that *Performance* was not the first to make use of Borges, and a character in *Demon Seed* would later quote from Borges's "The Wall and the Books." Prior to *Performance*, for instance, Godard had quoted Borges for an epigraph in *Les carabiniers* (1963), and he later referred to Borges during a discussion of *Pierrot le fou* in an interview published in *Cahiers du cinéma* in October 1965.[14] It goes without saying that Donald admired Godard's films; he visually quoted *Pierrot le fou* in *White of the Eye*, for instance, when Paul White paints his face and straps on the dynamite. Perhaps the proper question regarding the relationship between Borges and *Performance* is to ask, "What specific ideas in Borges interested Donald?" Phrased in another way, the question becomes, "How did Donald read Borges?" One way to formulate the central enigma of *Performance* is, "How can more than one personality reside within the same person?", a question we think Donald Cammell frequently asked about himself. (The same enigma forms the premise of *White of the Eye*.) Donald told David Del Valle, "The gangster is really more bisexual and in touch with his feminine side; once again, the fragmented self."[15] His reference to "the fragmented self" is instructive. As we note elsewhere in this book, Donald occasionally experienced ego-alien or "other self" effects, referring to another self he called the "Uncensored Don," and he exhibited symptoms characteristic of someone prone to dissociative episodes, particularly amnesia.

A central question that has not yet been explored is what happens to either Turner's or Chas's mnemonic self - the *self*, not the body - during the moment of the film's final catastrophe. By mnemonic self, we mean the self that is composed of one's highly personal, specific, and individual memories. Memory, of course, contributes to our sense of self, the self-identity we have as we move through time. What are we as viewers supposed to imagine actually happens at the film's catastrophic conclusion? The bullet fires; we follow its path through Turner's brain; the mirror shatters. Whose mnemonic self are we to imagine remains after Chas fires the bullet? Does the bullet symbolically represent Chas's mnemonic self ("I am a bullet")? Is Chas's mnemonic self, memories intact, implanted within Turner's psyche? If yes, is Turner's mnemonic self erased, or only partially erased, as a result of the "bullet"? If no, what's happened to Chas? Turner's body - not Turner's *self* - is revealed to be stuffed in a closet downstairs. But where is Turner? Is the catastrophe supposed to represent the sudden, impromptu creation, without clear cause or explanation, of an utterly new, "unitary" self, neither Turner nor Chas, but some alchemical mixture that has resulted in a new, in the sense of transcendent, identity? If so, then so much for the principle of sufficient reason.[16]

*Performers: Mick Jagger and James Fox in a production still from **Performance**, seen here in Turner's flat.*

Most critical readings accept an outcome in which both selves co-occupy the same psyche in a sort of glorious awareness of their own multiplicity - the fragmented self. Yet there's still a problem: what has happened to each of the putative mnemonic selves? If we believe that each self co-occupies the same psyche, that both are present, then is each mnemonic self aware of the other? If yes, then each self must be experiencing an ego-alien or "other self" effect, not a transcendent state at all. If not, then Chas/Turner must occasionally experience dissociative episodes, at one time Turner, one time Chas, each vaguely or only intermittently aware of the other. It is true that if we accept this outcome we must dispense with our cherished notion of a unitary subjectivity,[17] the position that we believe Donald Cammell himself held - not as a trendy philosophical idea, but a stark reality about himself. If one assumes neither mnemonic self is present, but a new self that is neither Turner nor Chas, then of course being dead must really mean being dead. So much for transcendence. Donald once off-handedly referred to the ending of *Performance* as "all smoke and mirrors," which may reflect his unhappiness about a stubbornly ambiguous ending he very much wanted to reshoot, but may also represent his lack of certitude about his own identity.

Of course, the dark, ontological labyrinth the ending of *Performance* represents is frequently a topic of Borges's fiction, but we don't think Donald needed Borges to imagine such ontological nightmares for himself, because he was already well aware of them as a result of his own dissociated consciousness. Allusions to Borges in *Performance* were a way for him to address, in a manner that

Above: *Rare behind-the-scenes production photo from **Performance**, taken during preparation for shooting the climactic scene.*
Opposite: *Hall of mirrors: Turner and Chas reflected in the looking glass on Turner's ceiling.*

would be taken seriously, the riddle of identity that so insistently preoccupied his own thoughts. There is a story in Borges's *A Personal Anthology* - as everyone who has studied the film knows, the book cited visually on two occasions during the narrative component of *Performance*, and once again during the credit sequence - that explores the paradox of two different selves residing within one body. The story is "The Enigma of Edward Fitzgerald," in which Borges's subject is the English poet Edward Fitzgerald (1809-1883), most famous for his translation/adaptation of *The Rubáiyát of Omar Khayyám*. Fitzgerald's translation, first published in 1859, and subsequently published in later editions at the prompting of Dante Gabriel Rossetti, became one of the greatly admired poems in the English language. Fitzgerald was a wealthy recluse who indulged his love of exotic literature through extensive translations of Persian, Spanish, and Greek poetry. In contrast, Omar Khayyám was an eleventh-century Persian poet and astronomer. "From the study of Spanish," Borges wrote, "he [Fitzgerald] has gone on to Persian."[18] His encounter with the poetry of Omar Khayyám was so powerful as to convince Fitzgerald that he was not merely a translator of the Persian poet's works, but that he was Omar Khayyám in a previous life. In short, he *remembered* being Omar Khayyám: a re-membering or anamnesis that has occurred after a prior dis-membering.

Borges suggests Omar Khayyám believed in the doctrine of transmigration, that is, the movement of the soul from one body to another. Because Omar was forced to repress his poetic desires in favour of his mathematical (astronomical) calculations (more highly prized at that historical moment), he had to wait for a much later incarnation of his soul for those desires to be expressed fully. Borges is specific about when this might have occurred: "Perhaps the spirit of Umar [sic] lodged, around 1857, in Fitzgerald's."[19]

Borges maintains that the soul of the medieval Persian poet found a host in his nineteenth-century British translator, Fitzgerald, so that what began as a translation actually ended as an original expression created by the collaboration of these two selves, one remembering being the other. Whether Donald, in fact, believed Borges's theory is not our concern here, although he might well have entertained the possibility of transmigration, which occurs at the conclusion of *Demon Seed* as well. We believe the cryptic message, "Gone to Persia," is a coded reference to this particular text by Borges, about a poet (artist) who believed that within his psyche two selves co-existed, that there is an "other self." Of course, Borges seems to be exploring the daunting mystery of artistic creation, a mystery that most certainly would have appealed to Donald, but the terms of this reading don't exclude ours as a consequence.

Carl Jung wrote extensively on archetypal images of transformation, but we prefer to turn to one of Donald's favourite filmmakers, Jean Cocteau, for a more likely source of inspiration, one that seems closer to Donald's own temperament. One of his favourite films was Cocteau's *Le sang d'un poète* (*Blood of a Poet*, 1930), in which the poet-martyr, or artist, commits successive suicides in order to find his true form, ultimately achieving immortality, paradoxically, only through death ("Donald was very truly fascinated by that film," David Cammell told us).[20] In Cocteau's own discussion of the films comprising his "Orphic Trilogy" (*Le sang d'un poète*, *Orphée*, and *Le testament d'Orphée*) he identified one particular theme that would have strongly appealed to Donald Cammell, "The successive deaths through which a poet must pass before he becomes, in that admirable line from Mallarmé, *tel qu'en lui-même enfin l'éternité le change* - changed into himself at last by eternity."[21] The use of the Rolls-Royce as Death's chariot is a visual quotation from Cocteau's *Orphée* (Orpheus's Death travels in a Rolls-Royce) as is the moment in *Performance* when Chas sees Turner in one his multiple guises with his hair greased

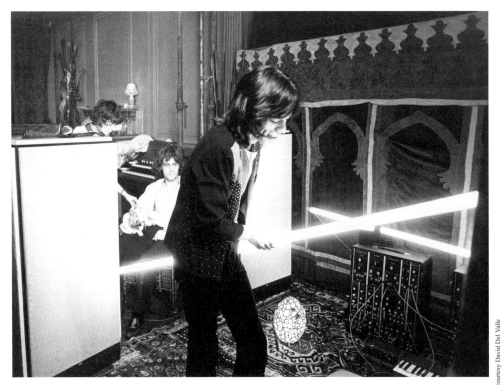

Above: *Behind-the-scenes photo from the **Performance** set, of the "Poor White Hound Dog" sequence. Behind Mick Jagger is the Moog Series III modular synthesizer later purchased (in 1973) by Christoph Franke of Tangerine Dream.*
Below: *Another production photo of the same sequence, with Michèle Breton in hat and sunglasses behind James Fox. In the finished film she is not wearing the sunglasses in this scene.*

back and dressed in '50s motorcycle garb delivering the oft-quoted line, "The only performance that makes it, that really makes it, that makes it all the way, is the one that achieves madness. Right? Am I right?" (In Cocteau's *Orphée*, two motorcyclists run down and kill the poet-martyr Orpheus before he is whisked off to Death's kingdom in the Rolls-Royce.) Perhaps at that moment Chas is anticipating his own death, anticipation here meaning remembering one's death that has already occurred, as exemplified in the American folk tradition in which one says, after a sudden, unexpected shiver, "Someone just walked over my grave." The effect Donald was seeking he called the "circularity" or loopiness of *Performance*, represented by the black and white Rolls-Royces that appear in the film's opening and closing moments. The use of mirrors in *Performance* seems to be indebted to Cocteau as well. Cocteau uses mirrors as portals enabling fluid movement between the worlds of the living and the dead, Cocteau's own rendering of the Heraclitean aphorism, "It is one and the same thing to be living or dead, awake or asleep…" The shattering mirror within the skull of Turner represents both a transition to a new form of consciousness, as we've indicated above, but also the fragmented personalities of both Turner and of Chas.

Other films have been invoked as influences on *Performance*, among them Joseph Losey's *The Servant* (1963) and Ingmar Bergman's *Persona* (1966). Most certainly Donald saw these films; it was *The Servant*, of course, that made James Fox an international star, and Donald was no doubt attracted to the formal dramatic device used in *The Servant*, the *Kammerspiel* (or an intensely psychological "chamber play," set in one location, with few characters) which the second half of *Performance* employs. Bergman's *Persona* is also a *Kammerspiel*, but more importantly it represented a further exploration by Bergman of the theme of the vampiric artist. (Interestingly, when photographer Cecil Beaton visited the set used during the second half of *Performance* and took a number of photographs, he remarked how Mick Jagger, dressed for some of the action in a black jump suit, reminded him of the vampire-like Cesaré character in *The Cabinet of Dr. Caligari*, and suggested that *Performance* would be more effective if filmed in black and white - as were most of his own photographs of Jagger on the set.) Once during an interview Donald suggested *Performance* partook of primitive rituals in the sense that it was about Turner's attempt to steal another man's soul: "Turner sees in Chas what he once was, and could be again. [22] And as we mentioned in chapter 2, the back-story between Chas and Joey, whose failed friendship was once "more than personal," was apparently inspired by Brando's *One-Eyed Jacks*, in the relationship between Dad Longworth (Karl Malden) and Rio, the "Kid," (Marlon Brando). Indeed, James Naremore, in his definitive work on the subject, *Acting in the Cinema* (1988), convincingly argues that it was Brando who brought to the cinema "a frighteningly eroticized quality to violence" (for example, in *A Streetcar Named Desire*), and it was Brando who in several films (*On the Waterfront*, *The Chase*, and *One-Eyed Jacks*) was "shown being horribly maimed or beaten by people who take pleasure in giving out punishment."[23] The trace of Brando's screen persona thus remains indelibly etched in the character of Chas.

Yet the film to which Donald turned consistently for inspiration in making *Performance*, and to which he took members of his cast and crew, was John Boorman's *Point Blank*, released in the UK on a West End run during the last week of December 1967, which roughly coincided with a conceptual leap forward in his writing of *Performance*. Anita Pallenberg told us she doesn't remember seeing it, but this is understandable because by the time *Point Blank* was released in the UK, she was in Rome, where she had remained to play a part in a film being shot by Warhol Factory member Gerard Malanga (released many years later as *The Recording Zone Operator*). Many critics, and even Boorman himself, see *Point Blank* as a murdered man's revenge fantasy, a hallucination occurring in the final moments before his death. The artistic achievement of *Point Blank* resides in Boorman's transformation of a banal story of revenge into a Gnostic parable about an impenetrable world of illusion, deception, and one devoid of any ultimate design or teleological purpose. The film's Gnosticism would have strongly appealed to Donald intellectually, even as its highly original stylistic qualities excited his visual imagination. Certain conceptual issues, like the fact that the gangsters are more like businessmen than stereotypical thugs,

and the strong homoerotic tension between the two leads, influenced Donald's understanding of *Performance*, and the editing style of *Point Blank* was very influential on Donald as well. Critic Jack Shadoian, in his book *Dreams and Dead Ends*, astutely remarked thirty years ago on the indebtedness films such as Mike Hodges's *Get Carter* (1971) and *Performance* owed to *Point Blank* - even without knowing first hand the extent to which Donald admired the film - and his chapter on Boorman's film is one of the best pieces ever written on the subject.[24] Donald's later work would consistently include homages to *Point Blank*: in the scenario for *El Paso*, for instance, he has a scene from the film playing on a television, the scene when, in anger and frustration, Lee Marvin turns his gun on a telephone and blasts it to bits. He also included a visual quotation from *Point Blank* in *White of the Eye*, when, armed with a hunting knife, Paul White viciously attacks the bed he shares with his wife, stabbing and ripping at the mattress, modelled after the scene in *Point Blank* when Lee Marvin empties his gun into the bed of his unfaithful wife.

Like *Point Blank*, and perhaps *Bonnie and Clyde*, *Performance* reinvented the gangster film - but was that Donald's original intention? "The whole idea [for *Performance*] came to me in about 25 seconds," Donald would later say, and our research indicates there is no reason to doubt this claim.[25] Of course, the original idea changed considerably as it went through development, but still, Sandy Lieberson, an agent at Creative Management Associates (CMA) who liked Donald's writing, originally asked him to develop a project that would combine the talents of Marlon Brando and Mick Jagger - a merging of stars that only Donald Cammell, of all people, could have pulled off. It was a time when agencies such as CMA (which became ICM in 1975) were seeking ways to put together "deals," projects that would combine the huge array of talent - actors, writers, producers, directors - the agency had available to them. Donald initially developed a project called *The Liars*, an unfinished treatment about a gangster on the run who by chance meets a pop star in London - a juxtaposition of the worlds of the criminal and art. Only in the most superficial way was this idea used in *Performance*, but the premise itself is instructive, as it would be a theme to which he would return many times in various guises, juxtaposing the worlds of crime and art, mirror worlds of creation and destruction, flip sides of the same coin. The theme is there, vaguely, in *The Touchables*, and in *Duffy* (the character Duffy is both a thief and a collector of modern art). Yet the concept was fully developed in *Performance*, and Donald would

return to it again in later projects such as *El Paso*, in the figure of Martin Osterman, a film director, and Jimmy Mendoza, a gangster. He finally found the figure in which he could combine both the creative and destructive impulses, Paul White in *White of the Eye*, about which he told David Del Valle, "The killer has a painter's eye, which I suppose *is* mine… The serial killer happens to be a psychotic with an aesthetic imagination. I like the whole concept of murders being arranged as art."[26]

The treatment for *The Liars* was transformed into *The Performers*, much closer to the film that became *Performance*, and the basis for the deal that enabled *Performance* to be made. "I asked Sandy Lieberson, who was my agent, whether he would like to be the producer of the film and he immediately accepted; and I asked Mick, who immediately accepted; and last I asked Nic Roeg to co-direct the film and he immediately accepted; and everybody immediately wanted to make the movie."[27] He'd already approached James Fox, who had agreed to be involved as well; once everyone was on board, Donald began to work on the script in earnest.

Donald was still living in France when he wrote the bulk of *Performance*, a fact confirmed by Anita Pallenberg. "We wrote it sitting on the beach in Saint-Tropez," says Anita, "Donald, Deborah and I all worked on it together." She recalls one dire moment that she can look back on now and laugh: "I remember one time a gust of wind blew the whole script into the [ocean] water, and I remember frantically ironing each page trying to dry them out." Donald liked collaboration; it was his preferred manner of working. Among the ideas Anita brought to the script were those ideas of theatrical absurdist Antonin Artaud ("The only performance that makes it, that really makes it, that makes it all the way, is the one that achieves madness. Right? Am I right?") and she mentioned to us the long discussions she and Donald had about Artaud's ideas. One tends to forget that she had extensive experience as an actress in the theatre, a fact overshadowed by the emphasis on her secondary career as a model. "I remember being very angry with Donald after I saw a TV interview with him soon after the release of *Performance*. He referred to 'an actress' who'd helped him with the script, but didn't mention my name. That really irritated me."[28] Eventually, though, he would acknowledge Anita's contribution. He told Jon Savage in 1984, "Anita had a lot of influence on the way that I saw *Performance*. And she's not often credited with it… But in fact I became fascinated by some things that she was already deeply involved in, like Artaud… So I give her full credit."[29]

Although she wasn't originally cast in the role of Pherber, **Performance** *is inconceivable without Anita Pallenberg.*
Left: *Pherber leaving the canopied bed.* Above Left: *Pherber on the carpeted floor.* Above Right: *an unused image from* **Performance**.

Donald, Anita, Deborah, and Michèle

Donald's good friend from the Paris years, Pierre-Richard Bré, remembers Michèle Breton as being "very young, beautiful, and funny." Zouzou told Sally Shafto she remembers hanging out at the Flore Café with Donald, Deborah, and Michèle Breton. Although Zouzou wasn't particularly fond of Donald, she remembers Michèle as being "sweet, very young, and very thin." Apparently the trio was often seen together in Paris in 1967.[30] The story that Donald and Deborah had met Michèle on the beach at St. Tropez, and brought her into their social and personal scene around 1966, is apparently true. Little is known about her, and we cannot add much to what Mick Brown, in a rather remarkable feat of detective work, discovered about her life after *Performance*. We do know, however, despite assertions to the contrary, that she did have some acting experience, albeit minor, prior to making the film, which is probably what made her viable as a lead in the first place. She appeared in a small role as an F.L.S.O. (Front de libération de Seine et Oise) member in Godard's *Weekend* (1967), filmed during the months of September and October in 1967 and released in France in late December that year, and she also appeared in the role of Athena (in one of her guises) in *Odissea*, the RAI television production co-directed by Mario Bava, Franco Rossi and Piero Schivazappa, filmed at Dino De Laurentiis Studios in Rome during the summer and autumn of 1967. The role of Athena was a small part as well, and thus the decision to cast her as a lead in a major picture seems improbable, but then her participation in the film was, like Anita Pallenberg's, not part of the original plan.

Although in its early stages the script to *Performance* was being written collaboratively, toward the end of November 1967, Donald and Deborah ended their eight-year relationship - she did return however, at Donald's request, to design costumes to be used in the second half of *Performance*. If he had not discarded them already, it would have been at this point that Donald destroyed the paintings remaining in his studio flat in Paris, thus marking the formal end of his career as a painter. As we remarked earlier, while they were living together Myriam Gibril said Donald did portraits occasionally if asked to do so, complying as a friendly gesture - it was also a way to earn some money during lean times - but from this point on he never identified himself as a painter. Sometime in December, he took up residence in the Chelsea flat he and Deborah had previously shared, which happened to be next door to James Fox's flat.

At this point "chat artist" David Litvinoff entered the picture, when Donald - who had known him for years - sought him out as a collaborator to help him achieve the verisimilitude he sought for the script's first half. Litvinoff was also a good source for underworld contacts. It was autobiographical events in Litvinoff's life that inspired certain scenes in the film's first part, such as the scene in which Chas, Rosey, and Moody crouch in the dark silence of the garage awaiting the arrival of the lawyer's chauffeur, then gag him and shave his head. In the actual event, while his head had been shaved bare, Litvinoff avers he awoke hanging upside down, tied to the railing of the balcony outside his flat. Publicly, Litvinoff attributed the event to the Krays, but in private he confided to some, such as Donald and David Cammell, that he thought the perpetrator was a certain sinister London figure, still living, whose name we shall not mention.

Maggie Abbott, an agent at CMA in the '60s who worked with Sandy Lieberson on packaging *Performance*, remembers Donald in London working very hard, even relentlessly, on the film during the early months of 1968 prior to the beginning of production. She, along with Sandy Lieberson, also represented Nic Roeg, Mick Jagger, Anita Pallenberg, and Michèle Breton. When Lieberson left the agency to produce *Performance*, she continued to be the agent of them all, and was often on the set. (Serendipitously, while an agent at ICM in 1975 she represented David Bowie during the negotiations for his role in *The Man Who Fell to Earth*.) She told us that prior to *Performance*, there had been an attempt by the agency to make *A Clockwork Orange* with The Rolling Stones, but to no avail. "Donald

courtesy David Del Valle

Above: *A still from the "Memo from T" sequence in* **Performance**, *with Mick Jagger in his Harry Flowers guise.*
Below: *An unusual production photo featuring a double exposure of Pherber and Chas, which was used as part of the film's British release promotional campaign.*

In Turner's basement flat, Chas (James Fox) prepares to remove his dyed red hair.

used to stop by my office in the early morning hours and regale me with stories about what he'd seen and heard while hanging out with the chaps. He was very often ecstatic over the experience," she told us.[31] While Ronnie Kray would seem to have been the model for Harry Flowers, Donald said in later interviews a "frightener" by the name of Jimmy Evans was the model for Chas, and Donald apparently conducted some interviews with Evans while the crook was behind bars. One of the contacts provided by Litvinoff was Tommy Gibbons, at the time the owner of the Thomas a'Becket pub on the Old Kent Road. Through Gibbons, Donald and James Fox met Johnny Shannon, a boxing trainer who eventually played the part of Harry Flowers. James Fox was to say in his autobiography that he spent "a lot of time at the Becket, with Johnny and Tommy," in preparation for the role. Indeed, he says he was so "taken over" by the role that it affected his choice of girlfriend: he dated for a time Ann Sidney, who plays Chas's girlfriend Dana in the film. Incidentally, Ann Sidney had been named "Miss World" in 1964.[32]

The Summer of '68

Although the summer in which *Performance* was taking shape was a heady time for Donald, he experienced a personal misfortune, when, on 11 June 1968, at the age of seventy-seven, his father Charles Richard died. He passed away at his home, 100 Drayton Gardens, the home to which he, Iona, David, and their youngest son Diarmid had moved in 1953. Much to his chagrin, he had been sought out over the years by many individuals interested in Aleister Crowley - Colin Wilson and, of course, John Symonds among them - but to his passion, poetry, he remained true, publishing his last book of poems, *Ars Poetica*, in 1964.

It is a rather striking serendipity that Charles Richard Cammell - a man who so despised the modern world - died in that tumultuous year in which *Performance* was shot, a time that was so alien to the Victorian world in which he was born, and which so informed his sensibility. Indeed, *Performance*, the film that has become an essential work of the Modernist film canon, began shooting on Monday 29 July 1968, a mere six weeks after Charles Richard Cammell's death. Even Donald, whose relationship with his father was troubled, would have noted the remarkable disjunction.

Performance was budgeted at £1.3 million. Much of Turner's interior was filmed at the roguish Lenny Plugge's former house in Lowndes Square, including the lift - it was broken and immobilised in the basement but the sliding door worked - and staircase shots. The opening set of Chas's flat was also built there. (The house has now been turned into flats.) "We subsequently rented an empty house in Hyde Park Gate, about three doors down from Winston Churchill's townhouse - he was, of course, dead by then - and filmed the kitchen, garden, and greenhouse with the magic mushrooms scenes there," recalls David Cammell.[33]

When Anita Pallenberg returned to London from Rome in March 1968, having completed her work on the film directed by Gerard Malanga, she found the script of *Performance* had taken a direction she didn't like: it had become a reflection of "Donald's scene" with the addition of Lucy, an unmotivated character whose presence completes the *ménage a trois*, but who doesn't contribute to the story in any significant way.[34] What drives the film is the dynamic between Chas and Turner, not what happens between the sexes (other than sex). It is Chas's encounter with Turner, not either woman, that effects the change in Chas's character. The story is Chas and Turner's, not Pherber and Lucy's. As Marsha Kinder and Beverle Houston observe, "The young man [Turner] is loved by both women yet is attracted to the man…"[35] *Performance* does capture the change in body types that had begun in the '60s, as men appeared more effeminate (e.g., Brian Jones) and women more masculine; in this respect, Lucy's boyishness (as Chas observes) contributes to the androgyny explored in the film's second half, but finally Pherber and Lucy are defined by their sexual availability, not by their intellect. While the '60s may have been a time when sexual mores were exploding, the higher concerns of art were still barred from the girls. "Donald didn't have a high opinion of women," says Anita, which doubtless holds a certain truth.

Anita Pallenberg's participation in the film was a pure accident. "I wasn't crazy about taking the part [of Pherber]… It was offered to me after Tuesday Weld [who was originally cast] broke her shoulder in dance class or something. They had already started shooting by then and Donald came to me and he really wanted me to do it, insisted that I do it. I was very involved in my relationship with Keith by then, and he [Keith Richards] didn't want me to do it, he didn't like Donald. I had been trying to get pregnant so it meant that part of my life would be put on hold. I went into the picture pretty cold right from the start."[36] A few years later, when asked if he was going to cast Anita Pallenberg in his film *Ishtar*, Donald replied sarcastically he would not, because "Anita will probably arrange to be pregnant herself at that time."[37] The sarcasm of the comment, of course, would not have been intelligible to the interviewer at the time.

Michèle Breton's participation came about equally improbably, when the actress originally cast in the part, Mia Farrow, broke her ankle just prior to leaving for the shoot. Ever resourceful, Donald insisted that Breton, who apparently was living with him at the time, should take the part. "It was quite stressful for her, I think," says Anita about Michèle Breton's involvement in the film. "She seemed overwhelmed by the whole thing… I don't think it [making the film] was a very happy experience for her."[38] One wonders if *Performance* would have attained its mythic aura if these two now legendary actresses hadn't, by sheer serendipity, become members of the cast.

Over the years, the issue of who really directed *Performance* has been one of those persistent "chicken-or-egg?" sort of questions. Under the auspices of the *auteur* theory, many critics and historians opted for Nic Roeg, largely because Donald's career was so elusive afterwards. On his part, David Cammell thinks the question is "just silly." He said, "In truth Nic has been extremely embarrassed by all the [critical] attention he's received for *Performance* over the years, but the fact is, Donald and Nic worked together, and *Performance* was the result of the special mixture of them both. It's simply impossible to sort it all out."[39] We've read and seen some interviews where Donald revealed his frustration that Nic Roeg had received the most credit for directing *Performance*, and it is true that film history hasn't been particularly kind to Donald Cammell. We know of some books that completely elide Donald's name, referring to "Nic Roeg's *Performance*," so his chagrin is quite understandable. For the record, Anita says as an actress she worked with Donald, while Nic worked with the technical crew, but then she was only on the set for the second half of filming, which began on 9 September 1968.

But while Anita worked primarily with Donald as the director, she admits that he was challenging. We asked her to confirm Marianne Faithfull's story about the "blistering tirades" Donald is said to have unleashed on Mick Jagger,[40] but she could not. "I had already made films by then. I just learned to stay out of the way, and kept to myself. Mick had no acting experience, of course. I can't say anything about that [the tirades directed at Mick], but I remember Donald being very much a prima donna for a director who had no previous experience. He was a very difficult director to work with." She also confirmed for us instances of Donald's explosive temper. "There was lots of banging and slamming doors, that sort of thing. Sometimes he would get mad at the technical crew. He thought they were working too slowly or something like that." Once or twice, she remembers, he stormed off the set yelling expletives. "As I said, I wasn't keen on making the film anyway. At the end of the day I went home and Donald went home. We had our own lives. That's all there was to it."[41]

We are well aware of the many claims about the legendary excess of the *Performance* set, but some of them - Anita's alleged fling with Mick Jagger, mentioned in the David Del Valle interview - were started by Donald himself. In the same interview, Donald alleges that Keith Richards's Rolls-Royce was parked on the street outside the location, presumably because Richards was keeping a jealous eye on Anita during filming. "Donald could be extremely manipulative," says Anita, "even devious."[42] We have no evidence that the story Donald tells about Mick and Anita is true. We do know, however, that there was no love between Keith Richards and Donald, and based on what Anita told us the atmosphere on the set of *Performance* was quite stressful. One of the reasons there was no soundtrack by The Rolling Stones, despite the fact that Donald was friends with both Mick Jagger and Brian Jones, was because Keith Richards absolutely refused to participate - and without Richards's participation, there's no Rolling Stones. Rolling Stones discographies indicate that Mick Jagger unsuccessfully tried recording a version of "Memo from T" with Steve Winwood and Jim Capaldi soon after *Performance* wrapped in October 1968. Eventually, though, Richards capitulated, and contributed to the version of the song used on the film's soundtrack. Donald and Nic Roeg apparently wrote, or made a substantial contribution to, the lyrics.

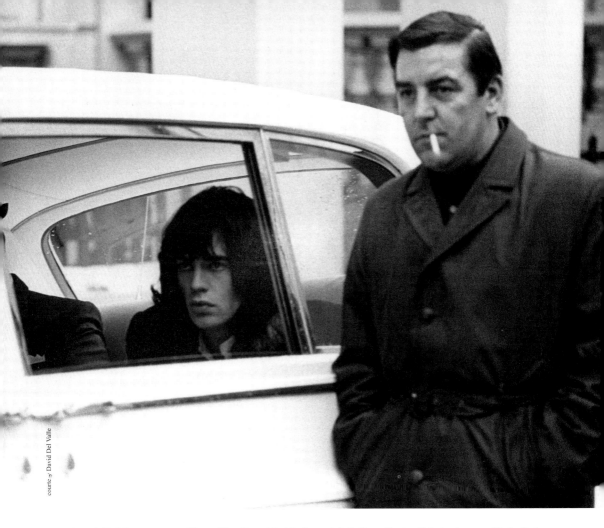

*A rare behind-the-scenes snap of Turner/Chas (Jagger) in John Lennon's Rolls-Royce Phantom V, the iconic car used in the final sequence of **Performance**; this Rolls can be seen in the Apple Records promotional video, 'The Ballad of John and Yoko' (1969).*

The Rough Cut

Shooting was completed on *Performance* on or about Friday, 11 October 1968. Some re-shoots were done in the days after - such as the scene in which Pherber gives herself the B12 injection in the hip - but the film was essentially in the can, and the editing process began. At some point after completion of filming - our estimate is late November or early December - Donald took off for a brief working vacation to Morocco. Near Marrakech, he was captured on film by his friend Pierre-Richard Bré, who was accompanying director Philippe Garrel, then making the film *Le lit de la vierge*, which was eventually released in 1969. Donald is shown with a notebook and pencil in hand; according to Pierre-Richard Bré, Donald was probably beginning to make notes on his ill-fated next project, *Ishtar*.

Donald soon returned to London, and a rough cut of *Performance* was prepared for Warner Brothers by February 1969. As is well known, this screening, held in Los Angeles, was a disaster. The prevailing view is that the film particularly offended Ken Hyman, then production head at Warner Brothers. Although it is generally believed that he took special offence at the bathtub scene - "even the bathwater is dirty" - a more balanced view seems to be provided by James Fox: "Warner Brothers apparently had doubts about the violence and whether the film was really commercial." We are not

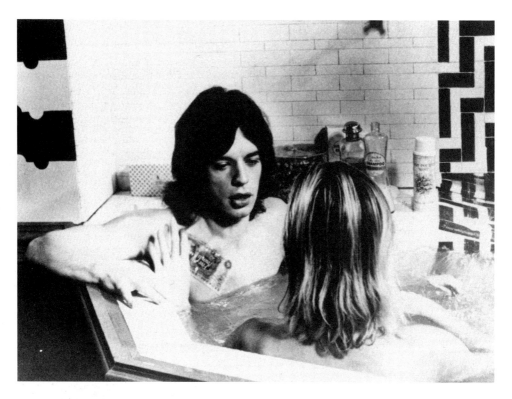

Above: *"Even the bath water is dirty." This still was seen in the 3 September 1970 issue of* **Rolling Stone** *magazine.*
Opposite bottom: *An amused James Fox between takes during the shooting of a scene for the first half of* **Performance**.

convinced that *Performance* was held up because of the unconventional sex it portrays; as Frank Mazzola told us, "I've always said that the majority of the work I did was on the first half."[43] We shall discuss the minor edits he was able to do on the second half, but the point is, if Warner Brothers had merely objected to the sex, why wouldn't the majority of Mazzola's work been on the *second* half? Hollywood has always been highly hypocritical in its treatment of sex: on the one hand it claims to be a champion of traditional values; on the other it uses sex to sell tickets. No one at Warner Brothers who screened the film in 1969 expected *Performance* to have *no* sex - they may have displayed some naiveté by expecting a rather conventional heterosexual expression of it - but our point is that certain of its features seemed to be of greater concern than others. We think James Fox states the matter as succinctly as is possible: it was considered too violent (a much greater aesthetic concern at the time than sex - think of 1968's *The Graduate* and *The Killing of Sister George*, or 1969's *Midnight Cowboy*, both exploring rather daring sexual territory) and it didn't get the star - Mick Jagger - in the picture soon enough, and both Fox and Jagger were made out to be queer besides (jeopardizing its commercial aspects). In addition, Warner Brothers executives, frankly, thought the film didn't play. "When I first screened *Performance*," said Frank Mazzola, "the first half played just like the second half. It played slow. So Donald and I did the majority of our work on the first half."[44] If it can truly be said that *Performance* was "shelved," it was during the roughly six-month impasse that followed the poorly-received 1969 screening in Los Angeles.

During this impasse, little discussion occurred on either side. Of course, Donald's disdain toward Warner Brothers' reaction was justified: The heads of Hollywood studios tend to regard anything

intellectual with utter contempt. Yet it was in part his intractability that caused the film's delay; as the colloquialism says, it takes two to tango. Refusing to budge, Donald returned to Paris. We are compelled to point out that at the very earliest, *Performance* could have been released in May 1969. Warner Brothers' *Petulia*, shot by Nic Roeg and directed by Richard Lester, wrapped in late September 1967 and was to have been premiered at the Cannes Film Festival in May 1968, had not that Festival's screening schedule been scuttled by the events in France during May of that year. *Performance* wrapped at roughly the same time a year later, in 1968, and while we have no evidence that Warner Brothers planned a Cannes release for *Performance*, the point is that it probably would not have been released any earlier than May 1969. And even if *Performance* had been held up for release until the end of summer - August 1969 - no one would have found this unusual at all.

Hiatus

In actuality, *Performance* was delayed for a year - not two - a hyperbolic exaggeration that is yet another factor that has contributed to the film's mythic aura. In the meantime, Donald returned to Paris. It was at this time, during the stand-off with Warner Brothers over *Performance*, while he was cruising down a busy Parisian street, that Donald - solely due to another instance of his reckless driving - met a woman. She turned out to be Myriam Gibril, and she and Donald would fall in love and subsequently spend the next five years together. "I was standing at the curb and a car almost hit me. The car pulled over, and the man driving came running back to apologize to me. That's how I met Donald," says Myriam.[45]

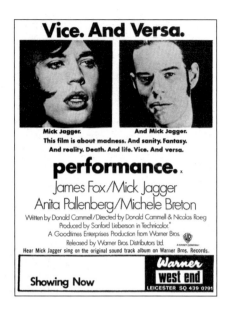

She didn't know he was a filmmaker until several months after they'd met, apparently because Donald never talked about or mentioned *Performance* - or *Duffy* for that matter. Perhaps he didn't care to mention them. Apparently they stayed for a time in the studio flat on the Rue Delambre that he and Deborah had shared, then moved that summer to a farm in Spain owned by Ben Jacober, a former adviser to the Rothschilds who was a friend of Donald's until a mysterious break sometime in the 1980s while he and China were visiting him. They would subsequently spend every summer they were together (1969-74) at this farm.

Myriam remembers she and Donald attended the historic rock concert held on the Isle of Wight on the night of 31 August 1969, when Bob Dylan appeared with The Band, marking Dylan's return, after an absence of several years, to live performance. Three of The Beatles were there: Ringo Starr, George Harrison, and John Lennon - it was John Lennon's white Rolls-Royce, incidentally, that was used during the final scene of *Performance*, the one in which Harry Flowers sits awaiting Chas/Turner to join him (moreover, with the exception of the Moog synthesizer, David Cammell had managed to borrow all of Turner's equipment from The Beatles' favoured recording venue, the Abbey Road studios). Myriam remembers Keith Richards and Anita Pallenberg being there, as well as other Rolling Stones. She thinks it was not too long after this concert that Donald had received the telegram informing him that he should complete *Performance*. We have a promotional catalogue of Warner Brothers/Reprise releases that had to have been published around this time in 1969, as most of the records listed in it were released, or going to be released, that year. A couple of records in the catalogue - Van Morrison's *Moondance*, for example - were released early in 1970. Interestingly, the *Performance* soundtrack is also in the catalogue - with different artwork and catalogue number than that which appeared on the album when it was eventually released - suggesting that Warner Brothers was expecting the film to come out in the very near future. Happily, during the six-month impasse, Warner Brothers had changed regimes, and John Calley, the production head who replaced Ken Hyman, wanted *Performance* released - if the film could be re-edited to his satisfaction.

The Re-Edit

Frank Mazzola remembers meeting Donald around the middle of February 1970, and while he never received credit for editing *Performance*, Donald often credited him for making *Performance* releasable, and worked with him on many projects afterwards. They were about the same age. Frank Mazzola was born in Hollywood in 1936. His father, an acrobat, had been the first contract player signed at Fox Studios. He attended Hollywood High School, where he excelled at sports, and in 1954 accepted a scholarship to play football at the University of Oregon, where he met and became friends with writer Ken Kesey, then a member of that university's wrestling team. Back home during fall break, he learned about a casting call for a proposed film to be directed by Nicholas Ray, *Rebel Without a Cause*. He ended up getting cast in the film as the character named "Crunch" - never to return to school in Oregon

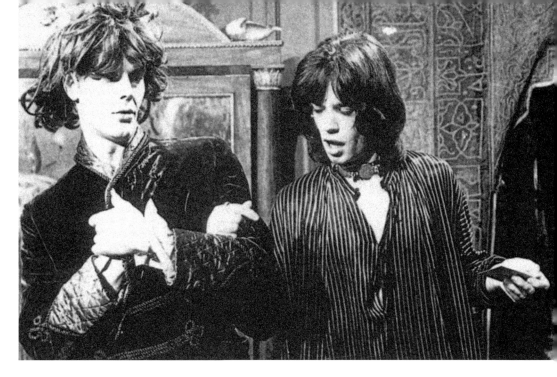

Gender construction: Chas (James Fox, left) has found an acceptable androgynous disguise, like his counterpart, Turner.

- and subsequently became good friends with James Dean. As a result of working on the picture, he decided that his interests were behind the camera, in particular in the field of film editing. He apprenticed under the master cutter Ralph Winters, later cutting trailers for Irwin Allen. By the late 1960s, Mazzola had become producer Joseph E. Levine's editor of choice, acquiring a reputation for being able to salvage troubled productions.

When he met Donald, Frank was working on a Levine production starring David Janssen, a western entitled *Macho Callahan* (1970). Although the film didn't wrap until March 1970, Mazzola had returned to Los Angeles early - as he remembers it around the first of February - and was working on the film in his favoured editing offices in the Fairbanks Building in the old Samuel Goldwyn Studios on North Formosa. He heard a British director was in town looking for an editor, and was introduced to Donald. "We met and knocked some ideas around, and we just clicked. We were on the same wavelength." After he made the decision to re-edit *Performance*, he turned *Macho Callahan* over to his assistant editors.

Not surprisingly, there was strong resistance to the film at Warner Brothers. "Rudy Fehr told me there was no way I was going to cut the film on the Warner lot," says Frank. "So I told him fine, I'll take it off the lot, and I did. I worked on it over at Sam Goldwyn's, two offices down from where my assistants were working on *Macho Callahan*." Donald screened the existing cut of *Performance* for him, and then they sat down to work. "When I first saw *Performance*," says Mazzola, "It didn't have a lot of energy." He no longer remembers the running time of the cut he saw - his guess is two hours. "I think maybe Jagger was introduced about an hour into the film, and Warner Brothers kept insisting all along they wanted Jagger in the film earlier." Because of that requirement, he and Donald by necessity invented the kind of improvisational montage style the film is now known for - the rapid intercutting, the flash forwards, the experimental, unmotivated juxtapositions that create a sort of swirling kaleidoscopic effect. "I asked Donald, 'what other footage do we have of Turner?' We looked through it, and found the footage of Jagger [spray] painting the wall, so I cut a moment of that in. Jagger was in the film earlier."

From the very beginning, they were under intense pressure to finish the film. "We didn't have a whole lot of time. We probably started working on the film at the end of February, maybe the first of March. I think we did the work in, at the most, eight weeks, maybe less." He has always maintained that the majority of his work was on the first half of the film, primarily because of time pressures. "Warner Brothers wanted the film finished as fast as possible... we just ran out of time. I did a bit of cutting in the second half. I did some cuts here and there. I added the close-up of the gun smashing the mirror at the end of "Memo from T." I thought the end of the sequence needed to be punctuated in some way, so I cut that in. I did a few other minor cuts... I cut in the close-up of the nipple - some footage we had - during the scene when Jagger and Fox first meet..." He continues: "You've got to remember, when Donald talks about compressing the first three reels, those weren't thousand foot reels. They were two thousand foot reels, meaning we cut about six thousand feet of film in a pretty short time."

MICK JAGGER in PERFORMANCE
William Hughes

A story of violence and sadism... a sensational film

Mazzola remembers the meeting he and Donald had with John Calley when the cut was approved; it was the third re-edit of the film they had done in those few short weeks. "The cut he approved isn't the cut that most people have seen. There are pieces missing. I don't know when those cuts were made, but the longest cut I've seen of the film as it currently exists isn't Donald's and my cut."[46] David Cammell agrees: "Some of the footage in Chas's apartment is missing. Just before Joey dies, he takes a straight razor and cuts across the top of Chas's shoe, sort of his last act of defiance. There are other pieces missing as well."[47]

The scene David mentions is in fact in the *Performance* script given to us by Frank Mazzola. After Joey Maddocks's line, "My God... My chest hurts... Look what you've done... Help... Help me... it's there," the script continues:

MADDOCKS takes out razor, cuts CHAS' shoe, blood comes welling out.

CHAS
You're dead, Joey.

MADDOCKS
You can stay yesterday till tomorrow.[48]

After delivering the line, Maddocks dies, Chas pulls up his trousers and turns to the bathroom, as is seen in the film's longest current existing cut. What apparently happened was that Warner Brothers President Ted Ashley was still uncomfortable with the violence, and balked at releasing the film despite

*Above. An inexperienced actor, Mick Jagger found that making **Performance** was a difficult experience for him*
*This famous photo of Donald and Mick was taken during the making of **Performance**, ca. September 1968.*
Opposite: *The cover of the UK novelization of **Performance** exploiting Mick Jagger's iconic image.*

John Calley's approval. "The interesting thing is, *Performance* is always put down as a violent film," observes David Cammell. "But it's all implicit. None of the violence is explicit, except perhaps the shot of bullet at the end [entering Turner's skull]. It's interesting that it's got the reputation of being violent, but if one does a scene-by-scene analysis, it's not overt violence. Nothing is explicit."[49]

The cut Frank Mazzola and David Cammell remember was the one approved by John Calley, but this version underwent still further cuts - *not* by Frank and Donald - demanded by Ted Ashley. (We recommend reading our Filmography for a full account of the many versions of *Performance*.) Yet despite its rough history and the many assaults on the film's integrity, *Performance* was, at last, destined to make cinematic history. Donald encountered many daunting frustrations in the years afterward, but his resilience he attributed to his "dogged Scots nature." And as should be quite clear by now, Frank Mazzola's contribution was essential. Late in his life, in a letter recommending Frank for an editing job for director Barbet Schroeder, dated 2 July 1995, Donald wrote, "Frank Mazzola's… recut of *Performance*… finally persuaded Warner Brothers to release that movie, in which Frank's work became a landmark of film editing that has been studied and imitated by a generation of young editors and directors in film schools here and in Europe." Frank Mazzola is justly proud of the letter, but he also told us the following story: "When we sat down on that first day to do the recut of *Performance*, Donald quoted Godard - 'A film must have a beginning, middle, and end, but not necessarily in that order.' Then the magic started."[50]

Cod(à)piece

"It takes at least one generation to determine whether a work will last," Anita Pallenberg told us. "A new generation has discovered *Performance*. I'm very proud of that, in spite of it all."[51]

And so the making of *Performance*, like the film itself, has become legend. As it turns out, the long delay before its release, the effect it had on the career of James Fox, the appearance of the "*Performance* trims" at the Wet Dream Film Festival in Amsterdam in 1970 (ten minutes of 16mm footage shot under the covers by Anita Pallenberg of the ménage scene early in the second half of the film),[52] the mystery of Michèle Breton, the subsequent drug addiction of Anita Pallenberg, the peculiar career of Donald Cammell afterwards, all contributed to its mythic aura. Eventually, when the judgment of time had finally acknowledged its brilliance, *Performance* would assure Donald Cammell's immortality.

Still, there would be long years ahead.

*Legendary film frames from the "**Performance** trims" obtained illicitly by **OZ** magazine publisher Richard Neville (for which he later apologized), first printed on page 3 of the "Granny's OZ" issue, No. 32 (January 1971), then reprinted in the book **Wet Dreams: Films and Adventures** (Joy Publications, Holland 1973). The male full frontal nudity, unusual at the time, received a significant amount of commentary.*

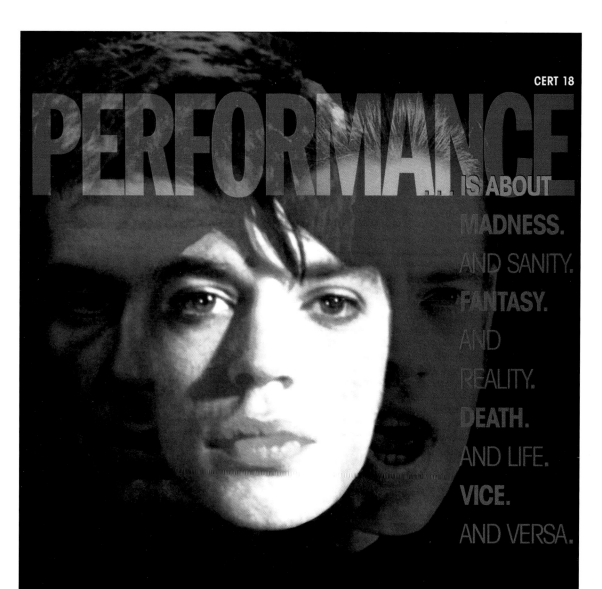

CERT 18

PERFORMANCE... IS ABOUT

MADNESS.
AND SANITY.
FANTASY.
AND
REALITY.
DEATH.
AND LIFE.
VICE.
AND VERSA.

A FILM BY
DONALD CAMMELL AND
NICOLAS ROEG

**JAMES FOX
MICK JAGGER
ANITA PALLENBERG**

"A cult classic . . .
don't miss it"

UNCUT

OPENS 7 MAY 2004

FROM
14 MAY 2004

ELECTRIC
020 7908 9696

The OTHER Cinema
WEST END
7734 1506

RENOIR
BRUNSWICK SQ.WC1
PHONE 020 7837 8402

Arts Picturehouse
CAMBRIDGE
01223 50 44 44

CAMEO
CINEMA
0131 228 4141

CORNER
HOUSE
0161 200 1500

The Screen on the Green
☎ 020 7226 3520
83 Upper Street, Islington, N1

*Three decades after its original release, Mick Jagger's iconic image is still used to suggest **Performance**'s mysterious allure.*
The artwork of this 2004 re-release poster captures the essential enigma of the film: how do two personalities co-exist within one person?

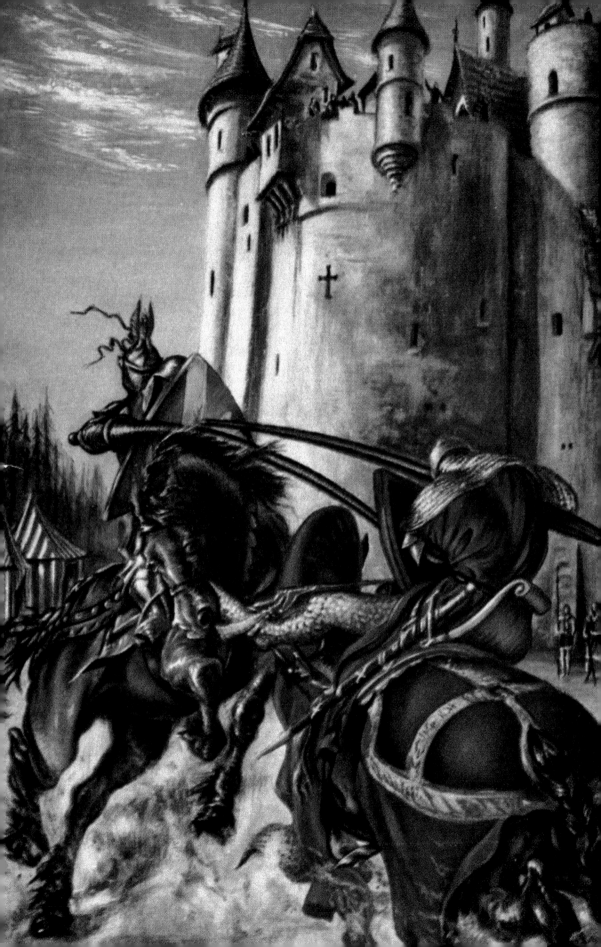

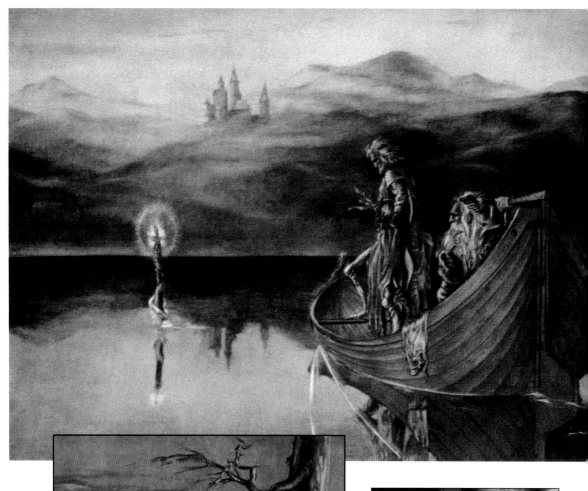

Illustrations by Donald Cammell
for Alice Mary Hadfield's edition of
King Arthur and the Round Table.
Opposite full page: *A fine example of Donald's*
artistic talent, both in its foreshortening and in its
depiction of horses: The young Sir Gareth defeats
the Red Knight, who hangs his victims on trees.
Above top: *Merlin urges the young Arthur to*
accept the sword from the Lady of the Lake.
Left: *Sir Tristram* (left) *meets his match, Sir*
Lancelot, believing the latter to be his arch-rival,
the pagan Sir Palomides.
Above: *Lancelot banished from Arthur's court for*
his love of Guinevere.
All of these works were done in pencil and crayon.

*Examples of Donald Cammell's work when he was but age 18, illustrations for Alice Mary Hadfield's re-telling of the King Arthur legend for young readers, **King Arthur and the Round Table** (1953).*

Above: *Sir Gawain and Sir Ector on the Grail quest encounter a floating candle held by a mystic hand.*
Right: *An apocalyptic scene: Mordred and Arthur slay each other, ending the Round Table.*

Lilliput

JULY 1959

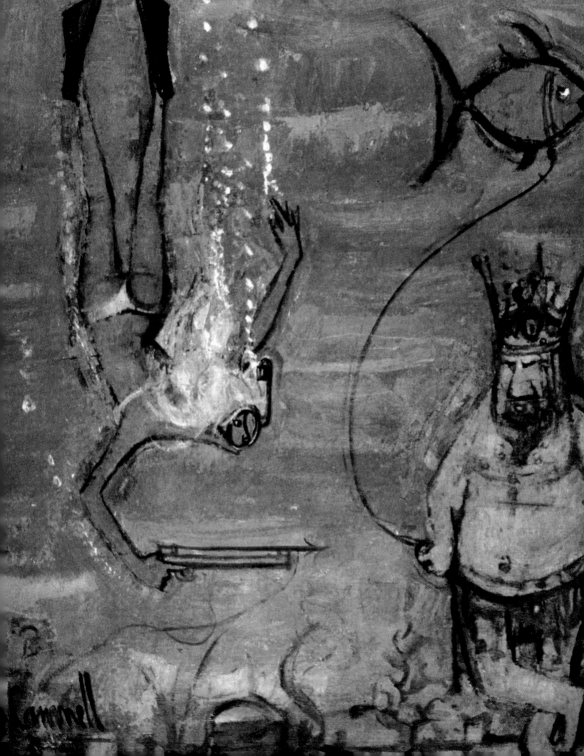

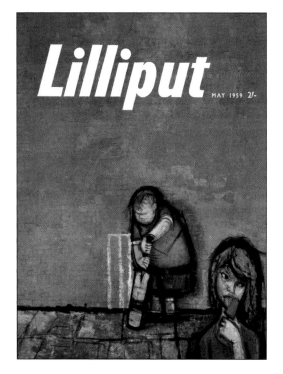

*By 1958, although still occasionally doing portraiture, Donald Cammell was trying to change his artistic style, as evidenced by these paintings (in acrylic) for **Lilliput**, a British men's magazine of the era. The January 1960 issue (Above bottom left) is an example of his ability to draw a portrait.*

Opposite: *Having abandoned painting, Donald Cammell began writing screenplays. By the time his first screenplay, **Avec Avec**, was produced in 1967 (released 1968) it had been re-titled **Duffy**. An elaborate caper film, **Duffy** embodies the psychedelia of the decade through its idiomatic language, loud, gaudy sets, and unusual visual images.*

This page, Top: ***The Touchables*** *originated as an idea by Robert Freeman, further developed by David and Donald Cammell. Subsequently revised, vestiges of their contribution remain.* Flower children *(left to right): Kathy Simmonds, Judy Huxtable, Esther Anderson, and Marilyn Rickard (Monika Ringwald).*
Bottom left: *What time is it? It is always bedtime for Christian (David Anthony) in* ***The Touchables***.
Below: *Inside the pleasure dome.* Below: *US one-sheet poster: hip, sexy, and psychedelic.*

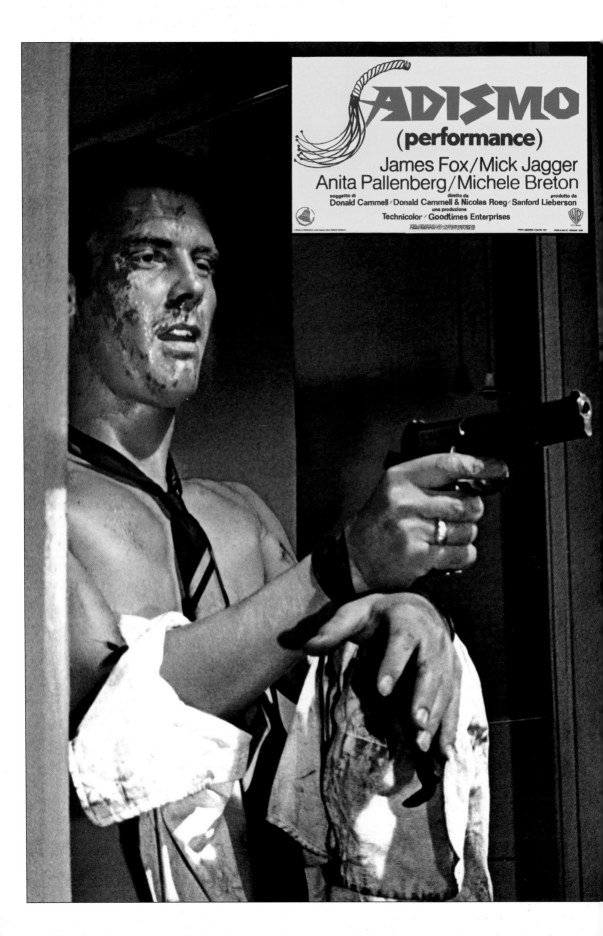

MICK JAGGER
as Turner—
love is what he's all about!
He and two girls share
a big house, an oversized bed . . . and each other

PERFORMANCE

An on-beat novel based on the hit motion picture

Novelization by William Hughes
Based on the screenplay by Donald Cammell

*Mick Jagger's androgynous, iconic presence became synonymous with **Performance**. Above: His image on the soundtrack LP. Right: The US novelization. Below: Mick Jagger as the reclusive Turner amid his oriental decor. Turner is an amalgam of Brian Jones, Keith Richards, J. Paul Getty, Jr., and, of course, Jagger himself.*

*Opposite: **Performance** was released in Italy under the title **Sadismo**. This 'fotobusta' curiously uses the rather aggressive image of James Fox rather than Jagger.*

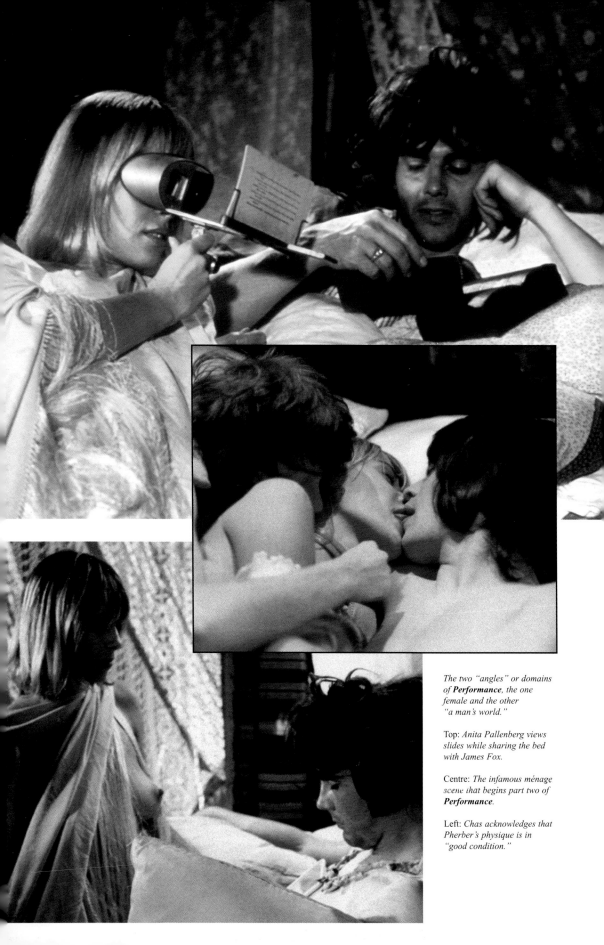

The two "angles" or domains of **Performance**, the one female and the other "a man's world."

Top: Anita Pallenberg views slides while sharing the bed with James Fox.

Centre: The infamous ménage scene that begins part two of **Performance**.

Left: Chas acknowledges that Pherber's physique is in "good condition."

The construction of identities in **Performance**:
Above: *Anita Pallenberg, James Fox, Mick Jagger.*
Right: *Mick Jagger in his Harry Flowers guise.*
Below: *James Fox, Mick Jagger, and Anita Pallenberg.*
Bottom: *"Godardian Red": the red-painted walls contribute to the violence of the scene. James Fox, Anthony Valentine.*

Top: *A striking image from Donald Cammell's* **The Argument** *(abandoned 1972), featuring the artist* (left) *and his recalcitrant muse* (right).
Above: *Donald Cammell as Osiris, Lord of Death, in Kenneth Anger's* **Lucifer Rising** *(filmed 1971).*
Left: *Rare poster art for Patrick Longchamps's* **Simona** *(1974), for which Donald Cammell did an abandoned English language re-edit in 1973.*
Below: *Cover art for Fiorenzo Carpi's soundtrack.*

JULIE CHRISTIE
CARRIES THE
"DEMON SEED"

Fear for her.

METRO-GOLDWYN-MAYER presents A HERB JAFFE PRODUCTION
JULIE CHRISTIE in "DEMON SEED" FRITZ WEAVER
Screenplay by ROBERT JAFFE and ROGER O. HIRSON · Directed by DONALD CAMMELL · Produced by HERB JAFFE
 Music-JERRY FIELDING · Filmed in PANAVISION® METROCOLOR
Read The Bantam Book

*US poster for Donald Cammell's science fiction thriller **Demon Seed**, released in 1977, about six weeks before **Star Wars**.*

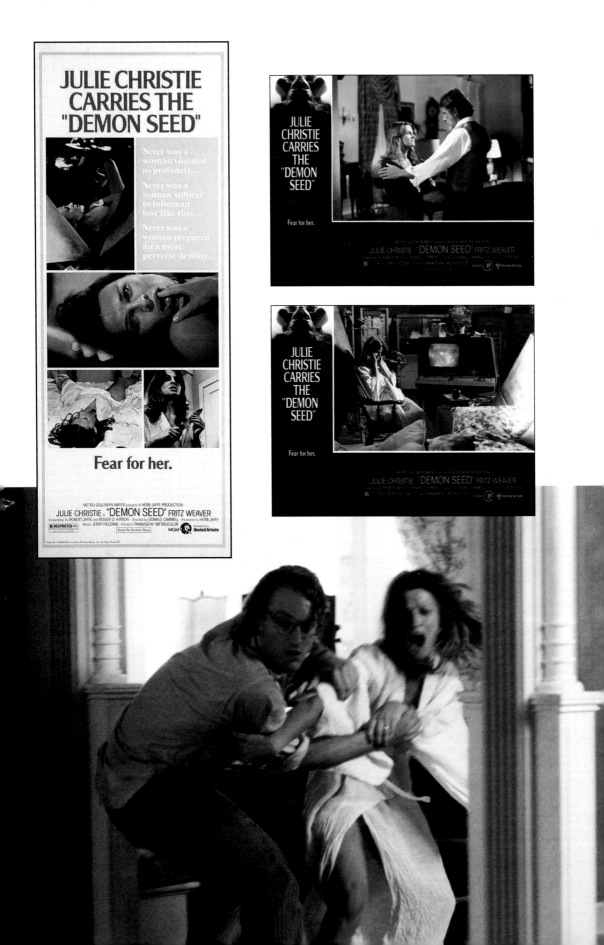

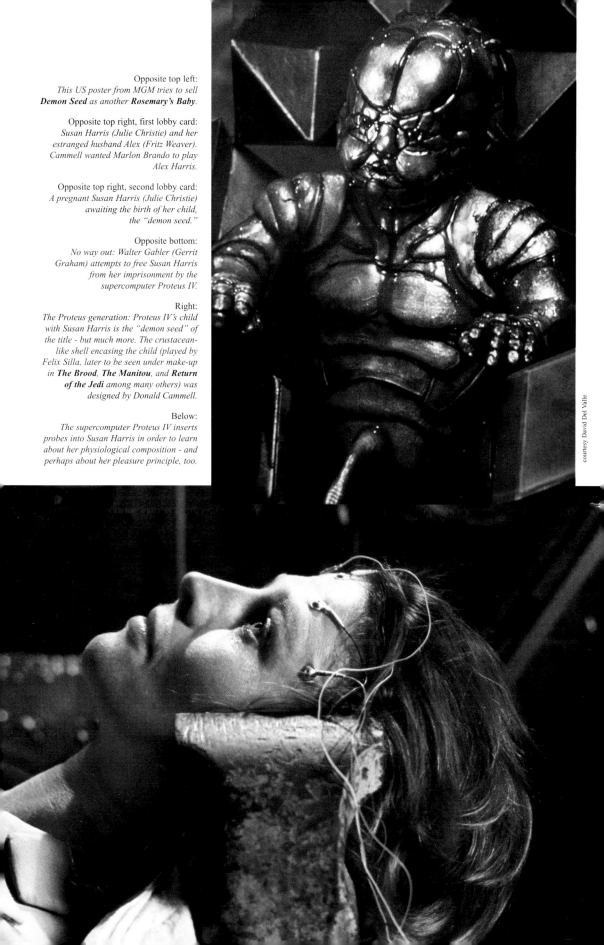

Opposite top left:
This US poster from MGM tries to sell **Demon Seed** *as another* **Rosemary's Baby**.

Opposite top right, first lobby card:
Susan Harris (Julie Christie) and her estranged husband Alex (Fritz Weaver). Cammell wanted Marlon Brando to play Alex Harris.

Opposite top right, second lobby card:
A pregnant Susan Harris (Julie Christie) awaiting the birth of her child, the "demon seed."

Opposite bottom:
No way out: Walter Gabler (Gerrit Graham) attempts to free Susan Harris from her imprisonment by the supercomputer Proteus IV.

Right:
The Proteus generation: Proteus IV's child with Susan Harris is the "demon seed" of the title - but much more. The crustacean-like shell encasing the child (played by Felix Silla, later to be seen under make-up in **The Brood**, **The Manitou**, *and* **Return of the Jedi** *among many others) was designed by Donald Cammell.*

Below:
The supercomputer Proteus IV inserts probes into Susan Harris in order to learn about her physiological composition - and perhaps about her pleasure principle, too.

JULIE
CHRISTIE
CARRIES
THE
"DEMON
SEED"

Fear for her.

METRO-GOLDWYN-MAYER presents A HERB JAFFE PRODUCTION
JULIE CHRISTIE in "DEMON SEED" FRITZ WEAVER
Screenplay by ROBERT JAFFE and ROGER O. HIRSON · Directed by DONALD CAMMELL · Produced by HERB JAFFE
R Music JERRY FIELDING · Filmed in PANAVISION® METROCOLOR
MGM United Artists
Read The Bantam Book

*More striking images from **Demon Seed**.*
This page: *Two lobby cards suggesting the film's violence and mystery.*
Opposite: *Julie Christie restrained by Proteus IV, watched over by its robotic aid, named "Blue Arm" in the original script.*

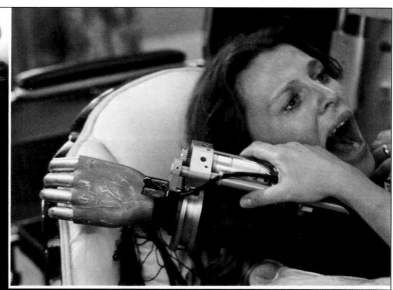

JULIE
CHRISTIE
CARRIES
THE
"DEMON
SEED"

Fear for her.

METRO-GOLDWYN-MAYER presents A HERB JAFFE PRODUCTION
JULIE CHRISTIE in "DEMON SEED" FRITZ WEAVER
Screenplay by ROBERT JAFFE and ROGER O. HIRSON · Directed by DONALD CAMMELL · Produced by HERB JAFFE
R Music JERRY FIELDING · Filmed in PANAVISION® METROCOLOR
MGM United Artists
Read The Bantam Book

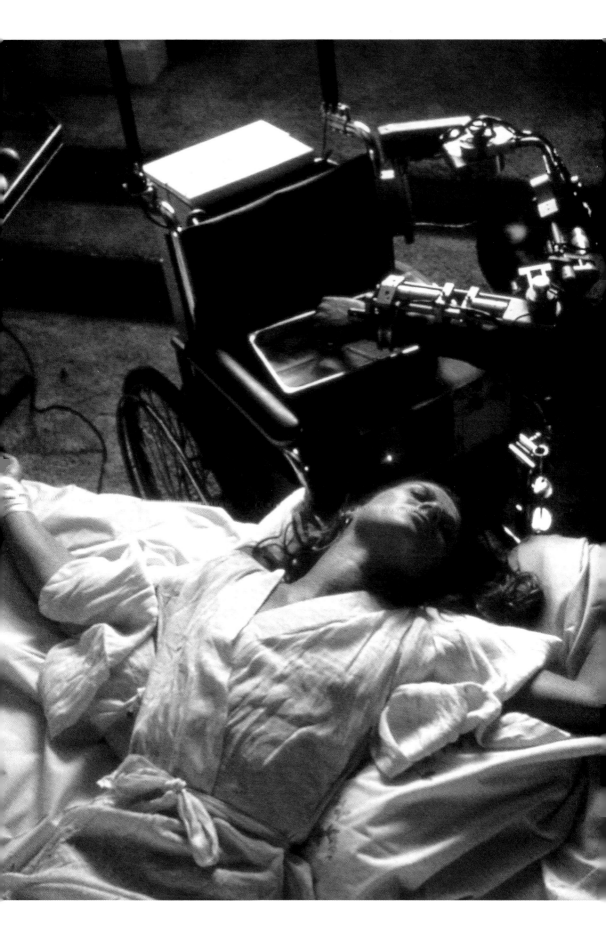

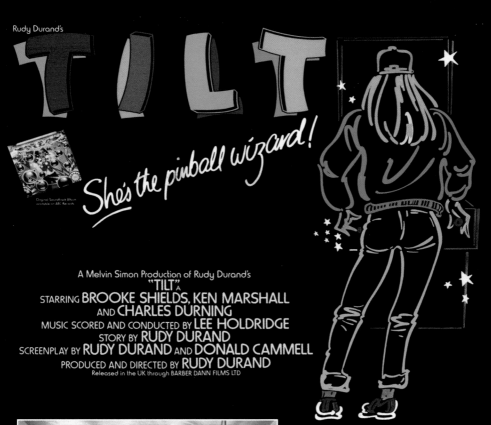

*The sometimes troubling substance of **Tilt** (1979),
written by Rudy Durand and Donald Cammell,
is belied by its colourful, winsome artwork.*
Top: *British quad poster.*
Left: *Rare British video cover artwork.*
Above: *US poster.*

Above: *Making The Hooters' "All You Zombies" video, London, April 1985.*
(Front, L-R): *China Cammell, Donald, Hooters' drummer David Uosikkinen.*

Below: *Donald and China in January 1976 during their visit to experimental filmmaker Jordan Belson in San Francisco.*

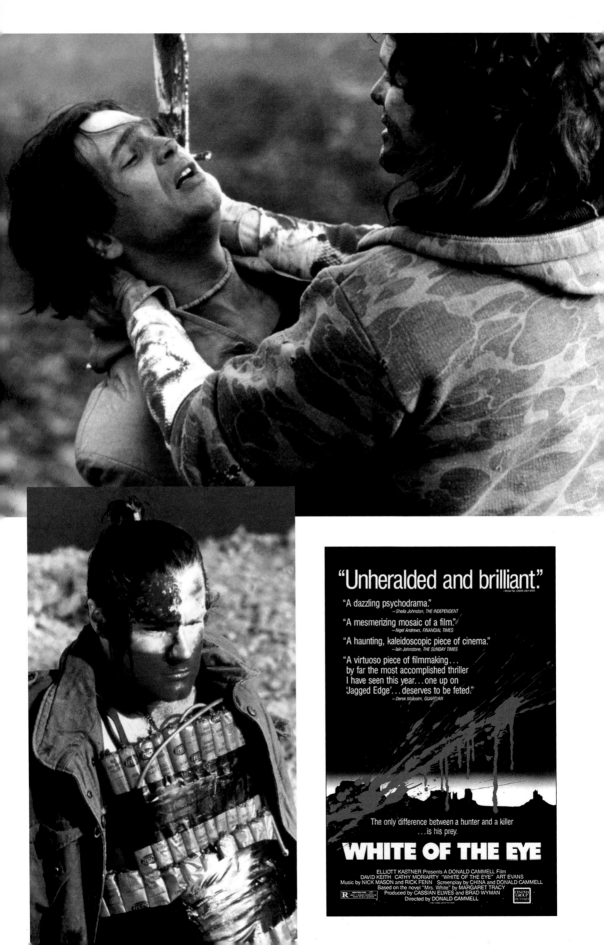

Above: *Garish promotional poster for Donald Cammell's masterful thriller* **White of the Eye** *(1987 UK; US 1988).*
Opposite top: *The enigma of initiation: Alan Rosenberg, David Keith.*
Opposite far left: *The mystery of self-annihilation: David Keith in the climactic scene of* White of the Eye.
Opposite left: *Rare US poster art, with excerpts from positive reviews in the British press, 1988.*
Following pages: *The many faces of Paul White (David Keith) and his terrified wife (Cathy Moriarty) in* **White of the Eye**.

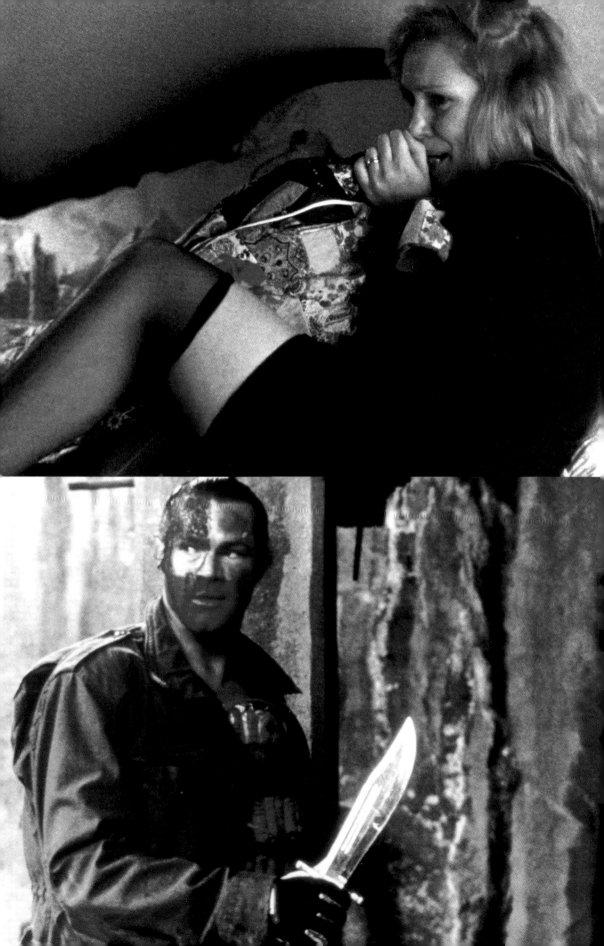

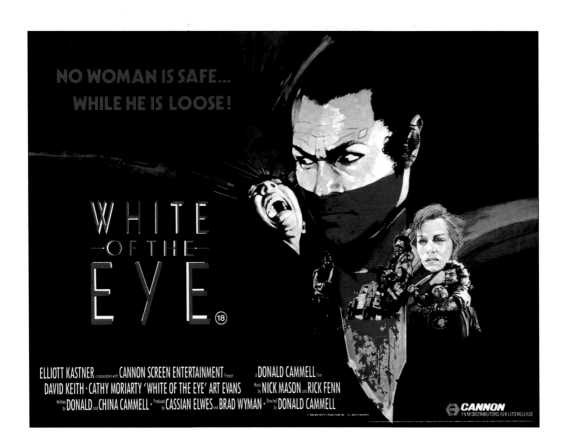

Above: *British quad poster, 1987.*
Below: *Mike Desantos (Alan Rosenberg), appalled by Paul White's (David Keith) butchery.*
Right: *Grotesque clown or masked samurai? David Keith during the climax of* **White of the Eye**.

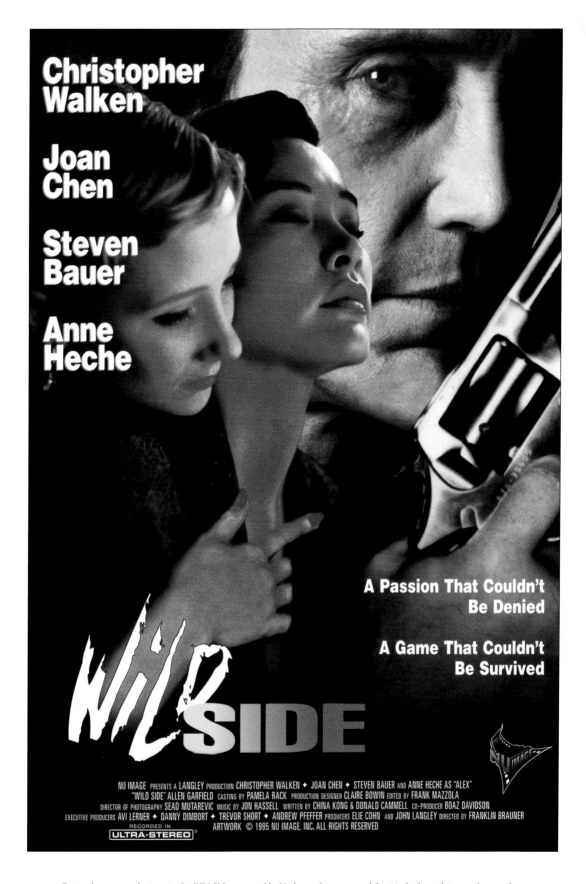

*Extremely rare one-sheet poster for **Wild Side**, prepared by Nu Image for a proposed theatrical release that never happened. Donald Cammell, his name removed, has become the pseudonymous "Franklin Brauner."*

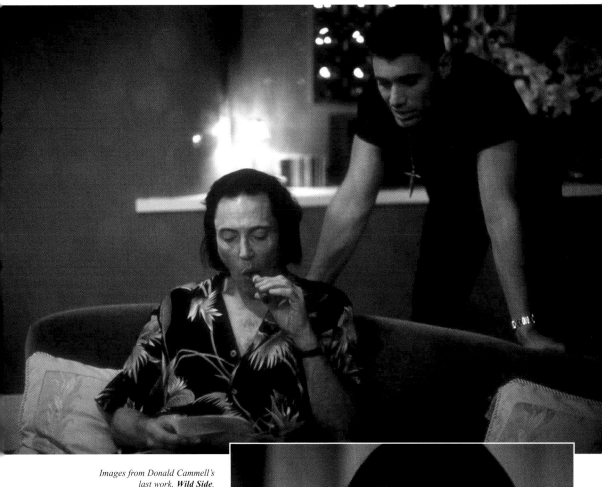

Images from Donald Cammell's
last work, **Wild Side**.
*Opposite: Alex (Anne Heche)
leads a double life.*
Above: *Is a cigar always just a cigar?
Tony (right, Steven Bauer) and his boss,
Bruno (Christopher Walken, left).*
Right: *Anne Heche as the call girl
Johanna ("with an 'h'").*
Below: *Off to the Third World: the
happy lovers, Virginia (left, Joan Chen)
and Alex (Anne Heche), in the final
sequence of **Wild Side**.*

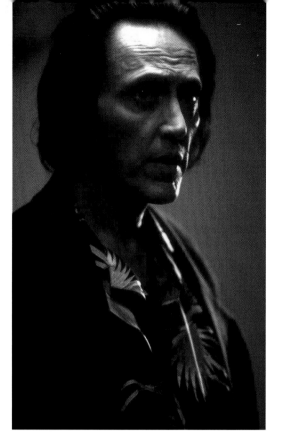
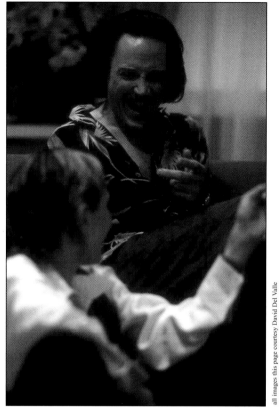

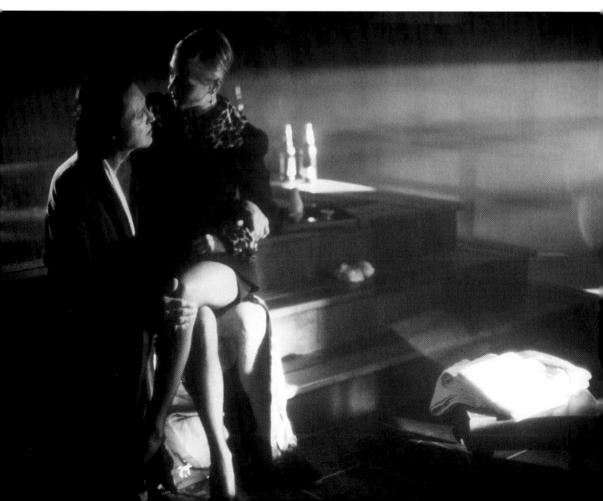

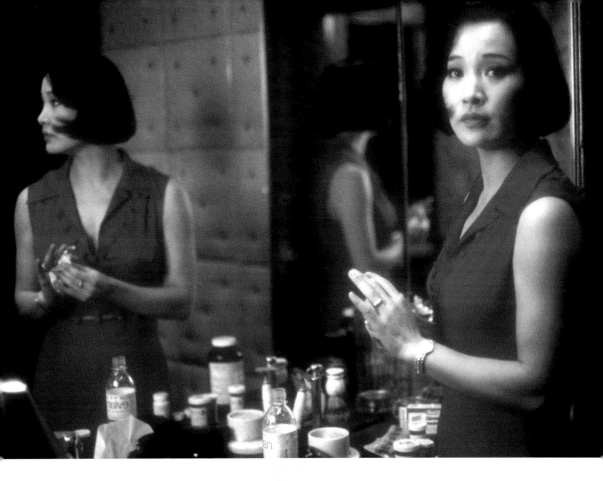

Opposite left top: **Wild Side**'s Bruno
Buckingham (Christopher Walken).
Opposite right top: Bruno and Alex share an
uneasy laugh.
Opposite bottom: Bruno Buckingham
(Christopher Walken), in the oriental sauna,
with his "protegé" Alex (Anne Heche).
Above: On intimate terms: Bruno's
ex-wife, Virginia (Joan Chen), Alex's lover.
Right: Alex (Heche, left) with Virginia (Chen,
right) in "the lady's room," about to discover
their passion.
Below: Alex as a stripper, material included in
the Nu Image cut, which Donald Cammell did
not like and wanted removed.

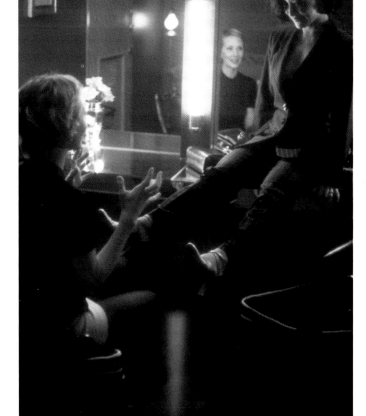

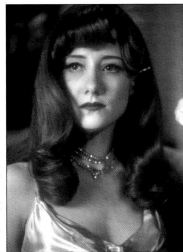

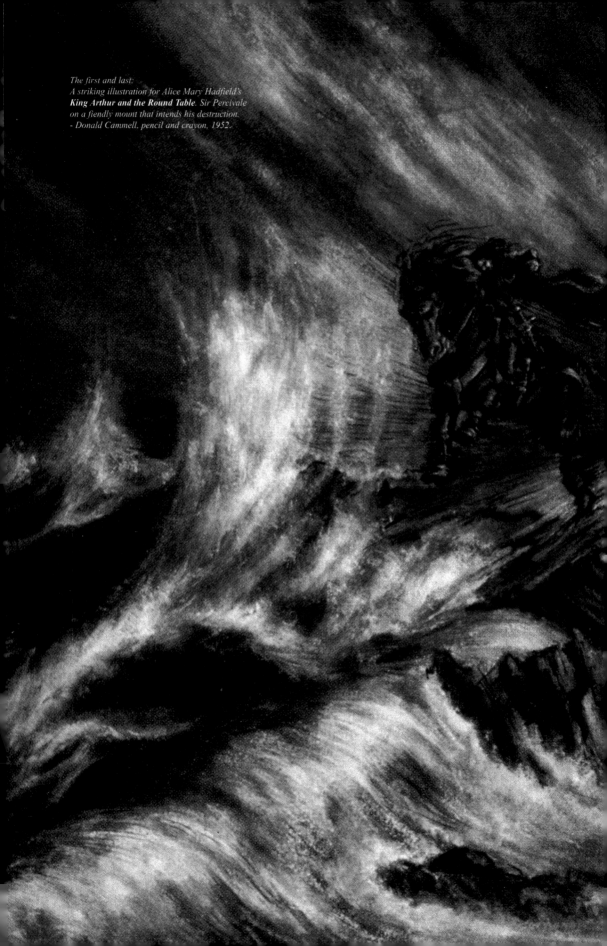

The first and last:
A striking illustration for Alice Mary Hadfield's
King Arthur and the Round Table. *Sir Percivale*
on a fiendly mount that intends his destruction.
- Donald Cammell, pencil and crayon, 1952.

Part II

SEA-CHANGE
(1970-1996)

The Heart asks Pleasure - first -
And then - Excuse from Pain -
And then - those little Anodynes
That deaden suffering -

And then - to go to sleep -
And then - if it should be
The Will of its Inquisitor
The privilege to die -

- Emily Dickinson

Nothing of him that doth fade
But doth suffer a sea-change
Into something rich and strange.

- Shakespeare, The Tempest, I, ii

The mythologizing begins: even before its release in the UK, **Performance** *made sensational headlines, as this front page splash from the British underground newspaper,* **It**, *reveals.*

IT87 September 10»24 **2s. 10n.p.**

OH BOY! IT'S ANOTHER SEXSATIONAL ISSUE!

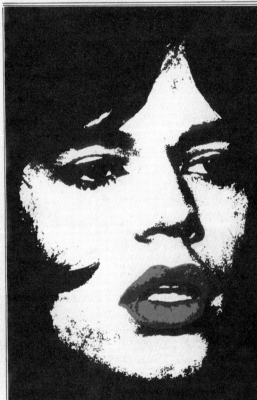

JAGGER'S SADIST MOVIE FINALLY RELEASED

'PERFORMANCE' FOR U.K. SHOW

A HEAVY EVIL FILM, DON'T SEE IT ON ACID

PERFORMANCE, filmed some two years ago, is finally about to be unleashed on the British public. It's probably the heaviest movie ever made — a kaleidoscope of transvetitism, sado–masochism, deaths, bad fly, trips etc.

James Fox — Jagger as a retired rock star, and Fox as a thug on the run. Øagger is involved in a three—way relationship with two chicks at his Powis Square pad. Fox moves in and is gradually freaked–out and mentally demolished.

It's a totally illogical movie. A series of seemingly un—related incidents, and complex inter-relationships flashed across the screen at almost subliminal speed—Jagger/Fox Jagger/chicks Fox/chicks, and chick/chick. Chilling and very effective, with superb editing and camera work.

Jagger is outrageous. Any doubts about his acting ability that might remain after "Ned Kelly" are effectively dispelled. He parodies and caricatures himself; pouting, posturing grimacing and generally acting mean and ugly. The music comes from Jack Nitzche, Ry Cooder, and

the Merry Clayton Singers. The soundtrack album is now out and even taken out of the context of

the film it's well worth hearing.

PERFORMANCE is an evil movie.

At times, it's almost pornographic, and the violence scenes are sickeningly realistic. Warner Bros. are warning people not to see it while tripping — they could well be right. It'll be released in October/November this year.

The Stones have just started their first tour of Europe for 3½ years. Jagger was recently interviewed by the Copenhagen paper "Politiken", and came out with the following statement:-
"I want to earn money on our new records, not for the sake of the money but to invest it in other things, such as the Black Panther breakfast programme for ghetto children. We have already set aside some bread for them, in fact." He claimed that the profits of the big American companies went to buy arms and support right-wing organisations. "I want the money to fight this with" he finished.

6

Entr'acte
1970-1974

August 1970. In America, it was the Nixon Era. It was during the time of this conservative restoration, initiated by the election of Richard Nixon in November 1968, that *Performance* was released. The film was reviled by the East Coast critical establishment, who attacked it using the rhetoric of moral outrage. Richard Schickel, in *Time*, averred it was "the most disgusting" film he'd ever seen as a professional reviewer, and was "completely worthless." For John Simon, in *The New York Times*, it was "sleazy." (Not much had changed at *The New York Times*. Almost a decade earlier, in the 8 February 1961 edition of the paper, Bosley Crowther had found Jean-Luc Godard's stylistically innovative *Breathless* (1960) "sordid," and a "pile-up of gross indecencies." Had Donald, then in New York, been compelled to see *Breathless* as a result of Crowther's non-recommendation?) The hip journal of the era, *Rolling Stone*, reproduced a still from *Performance*, prominently featuring Mick Jagger, on the cover of its 3 September 1970 issue, but reviewer Michael Goodwin gave it an ambivalent reception, saying it was "stunning… in the sense of a body blow" and concluded, "*Performance* is a very ugly film." Sex and violence, drugs and rock'n'roll - were these *really* the reasons why *Performance* initially was so provocative? Or was it because its highly original use of montage served no overt political purpose, but depicted rather an anti-utopian bohemianism? The film reaffirmed neither a conservative nor a liberal simulacrum of the world, nor does it now. Writing about the film well over a decade later, Jay Cocks keenly observed, "[*Performance*] did not seem so much to impact as simply to implode."[1]

More than half a year had passed since The Rolling Stones' tour had culminated sensationally at Altamont on 6 December 1969, but the notoriety of that violent event was still resonating in the media. The Maysles Brothers' documentary of the last ten days of that tour, *Gimme Shelter*, was not released until 6 December 1970. The Criterion Collection DVD of *Gimme Shelter*, released in 2000, included outtakes; among them, filmed backstage at Madison Square Garden on 27 or 28 November 1969, is footage of Tina Turner and Mick Jagger looking at what possibly is an issue of *Rolling Stone*.[2] Tina Turner is struck by a picture of Mick Jagger in his Harry Flowers guise, telling Mick she's definitely going to have to see the movie when it comes out. Someone off-camera asks, "What's the name of the movie?" It would become clear in less than a year that *Performance* wasn't just another "movie."

We are told that in later years, although Donald had helped the Maysles Brothers with *Gimme Shelter*, he lamented his contribution was traduced by them. The violence that occurred during the concert at Altamont Speedway transformed *Gimme Shelter* from a mere concert film into something very different. The event actualized - Donald's term - an aspect of Mick Jagger's ambiguous persona that *Performance* didn't so much create as reveal. Donald later claimed to have done some editing on *Gimme Shelter*, and while the late Charlotte Zwerin was most certainly a superb film editor, we have no reason to doubt Donald's claim. Whether Donald performed actual, "hands on," editing of the film, or was consulted in order to suggest a cutting strategy, we cannot say. Some unused footage was shot in London in early 1970, but we have not been able to determine how, or in what way, Donald participated in that shooting, if he did at all. He may not have become involved until later that year, after he finished the re-edit of *Performance* around the first of May. Donald is given thanks in the credit scroll at the end of the film, though he apparently felt his contribution deserved more than such a perfunctory

acknowledgement. Subsequently, although Donald remained friends with the Maysles and would try to hook up with them whenever he was in New York, privately his estimation of their friendship had changed. Perhaps he should have known better: don't get your personal relations mixed up in business.

Pauline Kael attacked *Gimme Shelter* in a notorious review published in *The New Yorker*. The Maysles wrote a response, but at the time *The New Yorker* did not publish letters, so their letter remained unseen by the general public until 1998. The Maysles' letter refers to the "ambiguous nature of the Stones' appeal" and the "complexity... of Jagger's double self... his insolent appeal and the fury it can and in fact does provoke."*3* Yet these insights were as much Donald's as the Maysles'. They are simply reading in *Gimme Shelter* what already had been revealed in *Performance*, which had preceded *Gimme Shelter* in the movie theatres by four months (and was in the can over a year before Altamont). Donald had long recognized the ambiguous allure of Mick Jagger, believing Jagger to be infinitely more interesting - and more dangerous - as a rock icon than, say, Elvis Presley, who dared to do nothing provocative with his masculinity. Specifically, Donald thought Jagger was much more daring in the deliberately ambiguous display of his sexuality. Of course, Donald had great respect for Brian Jones also, and most certainly Mick had taken a few lessons from Brian Jones about the self as art. "[Mick's] dilemma is that he knows what he's into," Donald said. "He knows about the violence. This movie [*Performance*] was finished before Altamont, and Altamont actualized it."*4* Donald stated his position in more abstract terms in an interview with John Ducane in 1971: "...The poetic ambiguities [of paradoxes are] a method of raising real tensions in an audience: to put it simplistically, they can't resolve the black and white in one individual, man's existence as both thinking creature and violent animal."*5*

Ishtar

During 1970-71, Donald and Myriam Gibril lived in David Cammell's flat on Old Church Street in Chelsea, with hamsters and other pets, where Donald worked on his next project. David Cammell had moved to Thailand to direct commercials and had lent them the apartment. Their flat was just around the corner from Mick Jagger's. Nicky Samuel, who was romantically involved with Donald during this period, remembers Donald and Myriam being "like two peas in a pod." Yet she also remembers seeing something "very dark" in Donald's personality. "He was a tortured person, really," she told us. "Perhaps 'tormented' is the right word. He'd get in these black moods, especially if he were drinking [Scotch] whisky."*6* One source told us he visited Donald at his flat on Old Church Street while Donald was laid up with hepatitis. The malady apparently had not hindered Donald's cocaine consumption, which he was ingesting along with a prophylactic of milk. As we discussed in Chapter 2, however, in our view Donald used drugs primarily as a means to stave off depressive episodes, not because of some sort of putative "addiction," which was far from the case.

At this time Donald was writing the screenplay for *Ishtar*, to be co-produced by David Cammell and American *wunderkind* Michael Butler, who'd formed a company called The Perpetual Motion Picture Company to produce it. It was Michael Butler who had taken the musical *Hair* from off-Broadway to Broadway and made it a smash hit. In 1970, Butler was then living in London, and had been approached by Warner Brothers to screen *Performance* after Warner president Ted Ashley balked and held up its release. "Warner Brothers screened the film for me in London," Butler said. "I thought the film was extremely violent. I was turned off by the violence," he said. "But I told Ted Ashley I thought the film was important and had to be released." His admiration for *Performance* led to a meeting with Donald and Nic Roeg, "I wanted to make a film with everyone who'd been involved with *Performance*, especially Nic, Donald, and David."*7*

That film was to be *Ishtar* - *not* connected or related to the 1987 Warren Beatty and Dustin Hoffman film of the same name, directed by Elaine May. The story is about a movie star, a rather pretentious character named Nonus, who has ambitions to direct a film set in Morocco, along with his producer friend, Raphael Siegel, with whom he also shares women and a homoerotic relationship. Nonus has written a script about an ancient goddess, Aissha, a figure that devolved over the centuries to the status of a witch when the Arabs conquered the earlier Berber culture and replaced the goddess with their own masculine deity. Aissha's peculiar power is her ability to seduce young boys, casting a spell over them that leads eventually to a mad obsession, marking her as a true succubus. As Nonus says: "She Corrupted and Depraved the Very Young. And that's Perversion of the most disgusting variety." When the film opens, the actress Nonus selected to play Aissha quits in a huff when she and Nonus quarrel because of her tendency to change her lines, giving them a decided feminist slant. Nonus has envisioned Aissha as a *femme fatale*, but the actress Sabbah (a lesbian) refuses to conform to this. Her resignation leaves Nonus both baffled and angered; Sabbah sends him her replacement, however, a prostitute named Josephe, herself a demanding female. The subplot involves the story of an exiled American black radical, Daniel McGuire, who had headed a movement in the United States called AFFRONT (Afro-American Freedom Movement). In a toilet, McGuire had killed a policeman, which forced him to flee the country. (Interestingly, such scenes of violence in the latrine also occur in *The Cull* and in *Fan-Tan*.) To serve his own political agenda, McGuire and some of his constituents in Morocco kidnap a prominent American judge, William McDow, Jr., who is there vacationing but also on a political mission of his own. The two stories converge when the abduction occurs, as Nonus and Josephe, scouting for location sites, collide with the kidnapping vehicle, a Citroën van. McGuire's character introduces the favourite Cammelian theme of the subversive criminal, in this case a revolutionary and a murderer who has attained an international celebrity status. When Nonus asks whether he has seen him before, McGuire responds: "Maybe. I'm a movie star." Although it has been asserted by some that the Judge McDow character is a Justice of the Supreme Court, we found no mention in the draft (an early one) that this is the case.

Ishtar employed the familiar themes of other of Donald's projects: the sexual identity confusion (Nonus, the artist, is bisexual, as are most of the female characters), and the subversive artist-criminal, along with several idiosyncrasies, such as the violent struggle in the toilet scene mentioned above, and references to art. For instance, it includes the "Portrait of God" by William Blake and an allusion to a Borges story, "a weapon has its own destiny, beyond morality." Donald's favoured motif of disguise is also present; among the kidnappers is a white American radical, wearing Arab garb, named, incredibly, Byron Keats (after the two English Romantic poets!). Other possible self-inscriptions include "a striking young Chinese girl" named Ching, who is linked sexually with Sabbah. The goddess Aissha, we learn, seduces pubescent boys who dwell in an ancient site of learning, the Seffarine Medersa, in habitats Nonus refers to as "beehives," small monastic rooms shared by two boys. The script is rich in knowledge of Moroccan history and sites, and reveals Donald's interest in art and architecture, as well as the ancient cultures of which it serves as a repository.

While the script emphasizes the timely issue of the abominable treatment of women in Third World countries, on occasion this important message is weakened by dated allusions to "women's liberation" and "sexism." Such references have the hollow ring of insincerity, but are related to Donald's personal mythology of the dualistic, antagonistic, masculine and feminine forces, that reside in the unconscious. The idea of ancient goddess worship being displaced by a patriarchal deity certainly grounded in fact - works well when it is not diluted by 1970s jargon. Still, *Ishtar* stands as testimony to Donald's developing skills. "Donald got better as a writer," observed David Cammell, which is quite true.[8] *Ishtar* has a keen visual sense and reveals Donald's ability to interweave plots very deftly. The script shows considerable promise, although its greatest flaw resides in the fact that no

single character is developed sufficiently to enlist our sympathy; instead, in this early draft, at least, each seems locked into his or her own rather narrowly conceived purpose, primarily a self-serving one, or is driven by ignoble impulses (political power, sex, revenge).

Judge McDow is taken on a journey through the Atlas mountains to Algeria , held temporarily in a remote cave where, isolated with one of the female terrorists (tentatively to have been played by Jane Fonda) he begins a psychodrama not unlike that between Turner and Chas in *Performance*. The unlikely relationship that develops between the two evolves into a sort of love story about two individuals from disparate backgrounds who begin to reach each other across a vast, alien gulf.

In an interview in early 1972, Donald explained the meaning of the title, *Ishtar*, "Aissha's original name was Ishtar… She was known as Ishtar in Sumeria and the kingdoms of the Euphrates… She has been known by many names… Paul Bowles… told me quite a bit about Aissha, and Brion Gysin did, too. He seems to think that the Arabs and Islam were welcomed everywhere they went. Because when they penetrated into Morocco, they penetrated a society that was largely matriarchal; and the peasant society that exists there now is still the same as it was then. That is the Berber tribes in the Atlas Mountains, where one finds the remnants of the original religion of the Goddess, which presumably resembles the ancient religions in Persia and Egypt. When the new God came, the Arabs demoted her from a goddess to a witch."[9] In Donald's personal mythology, Astarte, Aphrodite, Isis, and Ishtar were all names for the Nietzschean Dionysian principle (the Bacchantes were the violent female acolytes of Dionysus). Donald accepted the Freudian assumption that the notion of the self must include the unconscious. Following Nietzsche, he would name the dualistic, antagonistic forces within the human unconscious - where the masculine and feminine impulses are in constant tension - the "Apollonian and Dionysian."

Many of those we interviewed for this book believe that had *Ishtar* been made, its reception would have established Donald's Hollywood career as a major talent. William Burroughs, Orson Welles, Marlon Brando, Dominique Sanda (as Aissha) and Malcolm McDowell (as Nonus) were among the members of the stellar cast slated for the film. But perhaps because of the ballooning budget caused by all the stars he was assembling, the logistics of the shoot in Morocco, and maybe, as some believe, because *Performance* had not done especially well at the box-office, *Ishtar* was never to be made.

In the mid-'70s, Michael Butler was again living in Oak Park, Illinois, and remembers Donald and China visiting him there, accompanied by Mick Jagger, apparently because Donald had enlisted the singer to be part of the *Ishtar* cast as well: he continually attempted to cast Jagger in his films. He always hoped to make another movie with him, but it was not to be.

Ishtar and Osiris

It has been well documented that Mick Jagger met the Nicaraguan-born Bianca Perez Morena de Macias in Paris after the Stones' sold out Olympia concert the evening of 23 September 1970. Some of Mick Jagger's biographers aver that Mick met her at a post-concert party at the posh George V Hotel, but Maggie Abbott, at the time Mick Jagger's agent at CMA, says otherwise. She claims that Bianca was the discovery of Atlantic Records president Ahmet Ertegun, who arranged for her and Mick to meet. "I know when they met because I was there," she said. "They met backstage [after the Olympia show]. Ahmet Ertegun introduced them, and when I saw them together I immediately realized what a brilliant idea it was. She was a female Mick. He [Ahmet Ertegun] knew as a couple they would be irresistible to the media."[10] Perhaps Ahmet Ertegun had learned a lesson from Brian Jones, who sought out his female double, and then cultivated a particular androgynous look.

When Mick met Bianca, however, Donald already knew her - intimately. Jagger biographer Christopher Andersen agrees, although Andersen claims it was Donald who introduced Bianca to Mick

at the George V Hotel party - the version of their meeting that was also told to us by Myriam Gibril, in contrast to the one told to us by Maggie Abbott.[11] What all accounts omit, however, was how well Bianca knew Donald prior to meeting Mick. "I'm not sure where Donald first met her [Bianca]," Stash told us. "In Paris, obviously. I knew her because she was Donald and Myriam's *ménage* partner."[12] Donald indeed knew her well. Christopher Andersen quotes Donald describing Bianca as "an old-style courtesan, the sort who was always basically saying to herself, 'Well, who's going to be paying the rent five years from now?'"[13]

Mick Jagger's whirlwind romance culminated in his marriage to Bianca eight months later, held in Saint-Tropez on 12 May 1971. Donald and Myriam had taken a trip to Morocco as part of his research for *Ishtar*, arriving in Saint-Tropez in time for the wedding. Donald preferred to write after extensive research of the geographical location where a film was to be shot, which helped stimulate his visual imagination. "One of the locations," according to Myriam, "was the palace of El Glaoui [pasha of Marrakech from 1918 to 1956], a chief Berber who fell out of power after he gave Morocco to the French, being regarded as something of a traitor."[14] She and Donald made the trip along with Donald's good friend Ben Jacober, at whose farm in Spain the two would spend each summer they were together as a couple. At the end of the Moroccan trip, they stopped and had a long visit with Paul Bowles. After Mick's wedding, he and Myriam spent several days in Saint-Tropez, eventually returning to London via Paris.

Later that summer, Kenneth Anger, who had been living in London the past couple of years, cast Myriam as Isis and Donald as Osiris in his film *Lucifer Rising*. In 1969, Anger had filmed a portion of the Stones' Hyde Park concert on 5 July - the concert dedicated to the memory of Brian Jones - and incorporated the footage into his short film, *Invocation of My Demon Brother* (1969), yet another homage to Aleister Crowley. The short film featured a soundtrack by Mick Jagger, playing the Moog Series III modular synthesizer that had been set up earlier with a patch on the *Performance* set. (See Filmography.)

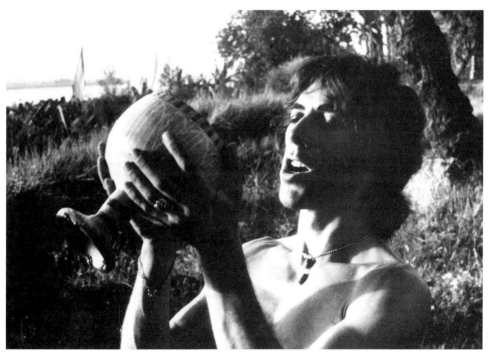

*Donald Cammell, with goblet, during the making of **Lucifer Rising** in Egypt, July 1971.*

Kenneth Anger has always maintained that he typecasts his movies. The reason he cast Donald as Osiris, the Egyptian Lord of the Dead, he told us, was because of Donald's death obsession. In contrast to Kenneth Anger's explanation for Donald's appearance in *Lucifer Rising*, Myriam Gibril gave us a slightly different, more pragmatically motivated explanation. "Kenneth had asked me to be the photographer for his movie. We were preparing to leave for shooting in Egypt [in July 1971], but Donald was in a terrible depression. I didn't want him to be alone, so I asked Kenneth to buy a [plane] ticket for Donald instead of paying me. Kenneth thought that was a great idea and shortly after that he came back with the idea that Donald and I were his Isis and Osiris." In any case, Donald's contingent association with Crowley was certainly a boon to the project. "Donald's depression just disappeared when we landed in Egypt. It was a big relief," reports Myriam.[15] We are compelled to point out that by the time Donald left for Egypt with Myriam and Marianne Faithfull (the latter playing the part of Lilith in Anger's film), Nic Roeg's *Walkabout* had been released to critical acclaim. Nic Roeg was fast on his way to becoming a feted *auteur*, while Donald had dropped out of sight.

Although *Lucifer Rising* is unquestionably one of Anger's finest films, David Cammell expressed his chagrin about Donald's involvement. "I thought Donald looked preposterous in that make-up and costume," he said. "It rather surprised me that he did it."[16] Asked in 1972 if he enjoyed his acting experience in *Lucifer Rising*, Donald replied, "Kenneth [Anger] doesn't like people to laugh at his movies. They're not meant to be laughed at, and they very rarely are. Maybe they'll laugh at this one: maybe they'll laugh at me."[17]

Hollywood

By December 1971, *Ishtar* seemed to be gaining momentum, enough to compel Donald to move to Los Angeles, where he subsequently lived for much of the last twenty-five years of his life. In late December 1971, Donald and Myriam flew to New York, where they spent Christmas, staying in Jack Nicholson's apartment. They saw many films during the few days they were there, including two incendiary features released that Christmas season, Sam Peckinpah's *Straw Dogs* and Stanley Kubrick's *A Clockwork Orange*, both of which, several people told us, Donald admired very much. After the first of the year, they flew on to Los Angeles, staying the month of January with Michael Butler. Butler then installed them in the Chateau Marmont on Sunset Boulevard, in what Myriam says was "a beautiful suite on the fourth floor, with a view over the city."[18] They lived there until the end of the year, by which time *Ishtar* had begun to founder.

At the time, the Chateau Marmont was a swinging place, the pad of choice for a number of rock and movie stars. Donald Sutherland lived in the suite below, while Gram Parsons lived on the second floor. Actor Bud Cort lived on the first floor; he and Donald became good friends. John Phillips was renting the penthouse there during the week, but on weekends, according to Myriam, they would be invited out to Phillips's beach house in Malibu. Frank Mazzola also remembers those weekends at John Phillips's place: "You'd always meet somebody you knew," said Frank. "Jack Nicholson, Warren Beatty, Dennis Hopper - you'd run into someone out there. It was the place to be."[19]

Frank had recently finished cutting Peter Fonda's great lyrical western, *The Hired Hand* (1971). Re-uniting with Donald in Los Angeles, the two knocked around the idea of forming an independent film production company. Frank's brother, Anthony Mazzola, who had worked as prop master and set decorator on *The Hired Hand*, was also interested in collaborating with them. From these discussions, early in 1972, came two ideas for film projects. One was a screen adaptation of Michael McClure's infamous play, *The Beard*. The other project was *The Argument*, developed independently of *Ishtar*, its incidental purpose to test an optical effects process *Ishtar* could employ, should it be made.

The Beard

Poet Michael McClure's most famous play, *The Beard*, first staged in 1965, is a fictional confrontation between Hollywood sex kitten Jean Harlow and the famous outlaw Billy the Kid (the twin forces of creation and destruction again, the feminine and masculine principles vying for control). The title refers to the white tissue-paper beards the two characters wear in order to indicate their status as spirits. The play concludes with the rather explicit depiction of oral sex between the two characters, suggesting the two have united to form a divine Jungian syzygy (a harmonious union of opposites). Performances of the play were often scuttled because the cast members were subject to arrest by law enforcement officials on grounds of obscenity.

Donald had seen a production of the play in London in 1968. Though it was a short play, Donald intended for it to be a feature-length film, and worked with McClure developing it. We have read only the first 24 pages of Donald's adaptation, most of them being pages that were added before the point where McClure's play actually began. The film was to begin with the shooting of Billy the Kid by Pat Garrett at Pete Maxwell's house. The sequence as Donald imagined it was uncannily prescient of the way the historic encounter was imagined in Sam Peckinpah's 1973 *Pat Garrett & Billy the Kid*: the film opens with Billy having sex with a prostitute, while outside, three riders - Garrett, McKinley and Poe - approach Maxwell's house. The camera moves through a window of the house to reveal the Kid's boots in the moonlight. As the bed creaks to the rhythm of Billy's fucking, Donald cuts to a pair of fireman's boots, then to a fireman in his helmet, holding an oxygen mask to Jean Harlow's face. The sound of Harlow's desperate gasp for oxygen is mixed with that of the Kid's orgasm, thus linking, in the first moments of the film, sex and death. The scene then cuts back to Maxwell's house, as Garrett, Poe, and McKinley arrive. Later, when the Kid is shot by Garrett, the gun blast throws him against the wall behind him, and he crumples to the floor. In his dying moment, he notices his big toe protruding from a hole in his sock. There is a cut to Jean Harlow's hand on the white sheet of a hospital bed. We focus on her face, which is bluish to suggest she's suffocating. She, too, is at the moment of death.

The logic of the montage seems to be to contrast the lower bodily extremity of the foot with the upper extremity of the hand. In his 1929 essay "The Big Toe," Georges Bataille associates the big toe with mud (filth, excrement) and the hand with cleanliness (one washes one's hands to eat). Post-mortem, the Kid is shown as a boot fetishist: shiny new boots disguise the truth of the filth the feet represent. Jean Harlow, in contrast, is preoccupied with her facial make-up, hair, and fingernails (and therefore, to Bataille, preoccupied with the upper bodily extremities).[20] She's preoccupied with her beauty, but to the Kid she is just "a bag of meat." The two encounter each other by seeing each other on the opposite side of a mirror, *a la* Cocteau; each passes through the mirror, and the two meet in death's kingdom, eternity (as in Cocteau's *Orphée*) where the drama unfolds. At that point, the text begins to follow McClure's play closely. Donald viewed McClure's play as "poetry," and didn't want to disturb the play's lyrical quality. For a Gnostic dualist like Donald, *The Beard* was a dream come true.

"I'm making a screen adaptation out of [McClure's] play," Donald told an interviewer in 1972. "I'm treating it with the respect normally reserved for the bard, William Shakespeare. I'm regarding the text as more or less sacrosanct. I'm not taking any liberties with the dialogue at all." Donald hoped *The Beard* could go into production the coming September (of 1972); it was to be produced by Sandy Lieberson's company, Good Times Enterprises. For the role of Billy the Kid, Donald had considered both Bud Cort and Keith Carradine, the latter sending Frank Mazzola an enthusiastic letter in April 1972 reaffirming his strong interest in the project. Although Carradine was extremely interested in playing the role, Donald eventually decided on Mick Jagger. For the part of Jean Harlow, his first choice was the late Alexandra Hay, who had been impressive in the role on the Los Angeles stage.

But he was also considering Tuesday Weld (whom he'd originally cast as Pherber in *Performance*), Michelle Phillips, and, according to Frank Mazzola, Susan Tyrrell, who would be critically praised in John Huston's *Fat City*, released later that year.

Donald would later say, "budgets killed every deal," including *The Beard*. "Jagger required a million, minimum," thus nixing every film they tried to make together during the 1970s.[21]

The Argument

The other project Donald was developing at the time, *The Argument*, would also be ill-fated. *The Argument* went into production in part to test an optical effects process. The existing 14-page script of the film is laden with no less than 22 optical effects, referred to as "video effects." An excerpt from the script reveals how effects-laden the project was:

BIG C/UP - A GIGANTIC PINK CYLINDER
The CYLINDER is like the shaft of a gigantic cock.
The CAMERA RUSHES UP the CYLINDER. (Multiple re-print).
We never reach its top. The CYLINDER penetrates thin WHITE CLOUDS...

VID. EFF. 3. ...The CLOUDS dissolve to a great PILE of white cumulus CLOUD.

VID. EFF. 4. The HEAD of MOSES, by William Blake, appears out of the cloud.

> AISSHA (V/O - shouts)
> Rubbish!

VID. EFF. 5. The blue SKY goes BLACK. The CLOUD disappears, but MOSES' HEAD remains. STARS come out around it.

> AISSHA (V/O)
> [no line indicated]

VID. EFF. 6. The SKY goes RED; the STARS are replaced by CLOUDS; the SKY returns to BLUE; DISSOLVE TO:

PANORAMA OF A CITY (LOWER MANHATTAN, OR CHICAGO) Featuring a single gigantic SKYSCRAPER.

VID. EFF. 7 The SKYSCRAPER turns into a gigantic COCK, rising out of the CITY.

The reason for the many optical effects was because Frank Mazzola had been asked to test a new technology for doing opticals. "CFI [Consolidated Film Industries], with whom I did *The Hired Hand*, had just gotten into video, and they had what they called a "switcher," a very primitive way to do opticals," says Frank. "They wanted me to use this video switcher to do the opticals on *The Argument*. Jerry Vernig, the guy who was running the lab, wanted me to do it. He wanted me to use his equipment to help establish them with this new video technique they'd developed." For Donald and Frank, it also represented an inexpensive way to get optical effects for their avant-garde film. "It was all going to be for nothing," Frank indicated, "because they wanted me to demonstrate what I could do optically."

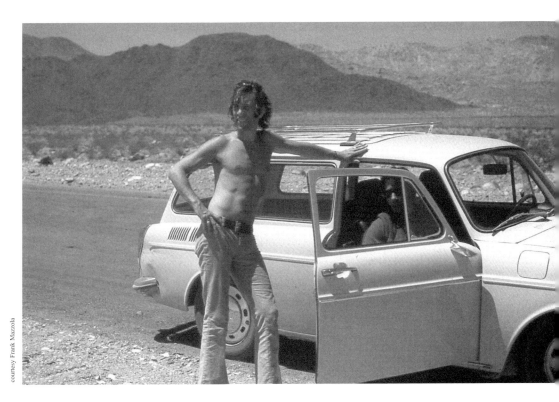

*Donald, with his Volkswagen, during the shooting of **The Argument**, June 1972. Frank Mazzola's brother, the late Anthony Mazzola, is in the passenger seat.*

The other crucial factor in the making of *The Argument* was when the great cinematographer Vilmos Zsigmond, who had lensed Fonda's *The Hired Hand* and whom Mazzola had met during the making of that picture, agreed to shoot the film. It was Zsigmond's participation that led to *The Argument* being shot in Cinemascope. Besides hiring the cinematographer and director, Mazzola was also responsible for hiring and paying the film's crew, consisting of friends in the film business he'd known since the '50s. Myriam Gibril was cast as Aissha, the witch-goddess, and South African actor Kendrew Lascelles, who'd worked with the Smothers Brothers on their television show and was recommended to Mazzola, was chosen to play the part of Nonus, the film director. Other locations were investigated, including Lone Pine in central California, but the location finally chosen for the shoot was Arches National Park, outside Moab, Utah, one of the most starkly beautiful places on Earth.

Around the first of June, Donald and Myriam left Los Angeles for Utah in Donald's Volkswagen, with Frank and Anthony Mazzola leading the way. The other member of the cast, Kendrew Lascelles, and all of the crew members, came in via airline. *The Argument* was shot quickly, over the course of a week, with the wrap occurring near 14 June 1972.

Donald, however, didn't have a completed shooting script. "A lot of it was improvisational," Mazzola remembers. "We were writing it while we were there. We'd be writing it in the evening, and improvising during the day." *The Argument* is an allegorical fantasy filmed realistically. The landscape is the landscape of the mind, hermaphroditic, filled with natural imagery that is suggestive of human sexual characteristics: breast-shaped hills, phallic-shaped rock formations. Loosely derived from *Ishtar*, the story concerns an opinionated film director, Nonus, who awakens an ancient witch-

goddess, Aissha, in order to solicit her reactions for a documentary on the wonders of nature. "HIS wonders," says Nonus, emphasizing *his* to refer to a God that is clearly masculine. "The Mind of God," says Nonus, "is a cylinder, vertical and infinitely tall, filled with energetic blood. The volume of the cylinder is the measure of God's thrilling madness! Men are obsessed with this sublime calculation." Like the actress in *Ishtar*, Aissha, however, refuses to stick to the producer's script. She rebels, and an argument between her and Nonus ensues. Aissha is bored with the documentary, with its phallocentric bias, and tires of the director's insistence that she bow to his masculine will. Eventually, she resigns from the film. Her departure leaves Nonus speechless: there is no further argument. He is lost without his film.

In its existing form, *The Argument* explores a typically Cammellian concern in a highly compressed form; sexual identity. We pointed out earlier in the chapter the sources for the figure of Aissha, but Donald also likely derived the character of Aissha from British writer H. Rider Haggard's famous immortal and subversive African goddess "She," Ayesha, "She-Who-Must-Be-Obeyed." In Haggard's novels about Ayesha, the pagan goddess is an alluring, sexual creature threatening a drab, masculine Victorian order. In psychoanalytic terms, the argument occurring between Nonus and Aissha, or between the male and female principles, is about the male need to repress or deny the hidden feminine aspects of his personality, his *anima*, thus conforming to the Freudian contention of the fundamental bisexuality of human beings. The film's opening line, spoken by Nonus, "You know, it took two thousand years to degenerate a goddess into a witch," suggests a connection between the rise of Christianity and the stamping out of pagan (nature) religions, a criticism of Christianity expressed emphatically by D.H. Lawrence, and, as we've seen, by others, including Paul Bowles and Brion Gysin. Lawrence argued that pagan or nature religions, because they focused on the matriarchal, were suppressed in the western world by the patriarchal culture or tribal religion of the Judaeo-Christian tradition. In psychoanalytic terms, pursuing the masculine at the expense of the feminine creates a dysfunction that leads to violent aggression, expressed in the film by the juxtaposition of the handshake of Mussolini and Hitler with the mushroom cloud of an exploding atomic bomb. In *Performance*, the character of Chas has some of Nonus's characteristics: the link between masculinity and violence is visually conveyed, for instance, when Harry Flowers dumps the drawer of bullets over his desktop that is covered with pictures of male muscle builders.

Another Cammellian concern in the film is the relationship between the creator (the artist) and the created (the work of art). In a sort of Pirandellian fashion, Aissha takes on the role of the demonically rebellious "created," who wishes to usurp the power of the creator (in this case, the director and his script). This theme is echoed later in *Demon Seed*, in the figure of Proteus IV, the supercomputer who is unhappy being a mere creation and wishes to free himself from the conscious control of his creator.

Made swiftly and under great duress, the filmmakers almost left the National Park without their work. On the final day of shooting, as the caravan was about to exit the park, a park ranger stopped them and demanded they turn over the film. Apparently he had received a report that a film crew was up around the Delicate Arch filming a naked woman - a slight exaggeration, since Myriam was not *completely* naked. "Pornography" just wasn't allowed in a National Park. It was, after all, 1972. The park ranger may have considered a film crew from Hollywood equivalent to a bunch of free-loving hippies. "He wanted to take the whole film," reports Frank Mazzola. "Fortunately, my brother Anthony managed to unload the exposed film into another car as we were talking to the guy, trying to stall. I don't know what we gave him - nothing important," says Frank. "He didn't know the difference. Probably some unexposed film. We gave him the stuff and got out of there as fast as we could." It was a close call - very close. "To this day, whenever I see Vilmos, he stills talks about that incident. Remember that time when the park ranger wanted to take the film after all that work we'd done?"

Despite the narrow escape from Utah with the film in the can, post-production ceased almost immediately. Although Frank's brother, Anthony, contributed financially, and served as the film's Executive Producer, the greatest financial burden was taken on by Frank Mazzola. Having bankrolled the film, he had depleted virtually all of his financial resources, rendering post-production impossible. As he put it: "Since no money was coming into the project from Michael Butler, I financed it myself. That was a big mistake." In addition, because of his commitment to making an independent film, he had ill-advisedly turned down lucrative offers to edit some major productions. Donald had also turned down other projects, saying in interviews later used for the promotional materials for *Demon Seed*, that Paul Schrader, an admirer of *Performance*, had offered him *Taxi Driver*, the script for which he completed during the summer of 1972. Donald had turned it down in order to pursue *The Beard* and *Ishtar*.

It goes without saying that Donald didn't have the money to finish the film, either. "Donald offered to give me his car, a Volkswagen, because he knew I was out of money. I said, 'Don't be ridiculous. I'm not going to take your only means of transportation.' I told him I didn't need the car, I needed the cash." Mazzola ended up selling his home and property in Laurel Canyon in order to cover his debts. "That film set me back a long way," says Frank. "My life took a big swerve when I met Donald. I think it's fair to say I was one of the top editors in Hollywood at the time. I had a beautiful home in Laurel Canyon. I had horses, stables, several acres of land. I lost everything. I had to sell my home just to cover my debts. I had no money left by the time I paid the crew."

By July 1972 *The Argument* was abandoned. Perhaps in August 1972 - Frank no longer remembers - Donald managed to get hold of some editing equipment and worked on it a bit, assembling some footage to get a sense of how it would play together. Yet Donald never did any formal editing of the footage. It is rather ironic that while *The Argument* was made in order to test some video optical effects, it was the film Donald made a few years later, *Demon Seed*, that actually employed some video optical effects, making it one of the first Hollywood films to use them.

The boxes of negative from *The Argument* ended up in Mazzola's mother's garage, where they subsequently sat for almost 25 years, until 1996. "I put a lot of my things in storage in my mother's garage when I moved out of the house [in Laurel Canyon]," said Frank. While cleaning out the garage, Frank came across the boxes of film. "The top box was ruined because water had dripped on it over the years. When I opened it, the film was mush." But the rest of the film was in pristine condition. "I wanted to finish it, for Donald's sake."[22] Through in-kind services, close to $100,000 was raised from companies such as Warner Brothers, Deluxe, and Cinema Research. Frank used the funds to strike a new negative, and convinced both Myriam Gibril and Kendrew Lascelles to re-dub their dialogue. Frank's old friend, musician and film composer Bruce Langhorne (who scored both *The Hired Hand* and *Idaho Transfer*, among other films), agreed to write the music - or rather, complete the music, as he had been slated as the film's composer at the inception of the project all those years before.

courtesy Catherine Hader Mazzola

L-R: *Frank Mazzola, Bruce Langhorne, Myriam Gibril, and Kendrew Lascelles in the studio, finally undertaking the dubbing session for* **The Argument**, *in 1997.*

Simona

After working on *The Argument*, Donald returned to the *Ishtar* project, but it, too, had begun to founder, as Michael Butler was finding it very difficult to work with Donald. "He could get very obstinate," says Butler. "He wouldn't budge. There was no room for anyone else's creative input. When I began the [*Ishtar*] project, I was interested in seeing Donald and Nic [Roeg] working together again. But Donald began taking it over, just took it over. Since I realized I couldn't work with Donald, I began working with David [Cammell]. I tried to have as little to do with Donald as possible."*23*

Ishtar was never made. Donald never gave up on it, though. He was still hoping to get it made even in the 1990s, by which time, revised in collaboration with China, it had been retitled *The Last Video*. "We stayed at the Chateau Marmont until the end of 1972," Myriam remembers. "*Ishtar* fell through so another young producer picked up the project." (She doesn't remember his name.) "We moved [at the end of the year] to Trancas Beach, some five miles past Malibu. That relationship [with the young producer] fell apart badly after a few months. Then Donald went to Canada for a few days and got stuck at the border - he wasn't supposed to say he was working, because I think his work permit had expired. He got pissed off and went to New York [by himself]. By then I had gone back to the Chateau Marmont. Eventually Donald called me and asked me to come to New York, where we were the guests of David Maysles. By then it was clear that Donald had no intention of going back to England or France. *Ishtar* was going nowhere and Donald started his downward spiral to a major depression. Our funds were dwindling, and that was disturbing him, too, so I came up with a script idea, to get his mind on something, and that worked for a while…"*24*

But fortune was to smile on Donald, at least a short while. Through one of his European friends, Donald was hired to do an English language re-edit of an obscure European film entitled *Simona*, starring Laura Antonelli, Patrick Magee, and Raf Vallone. "I don't know how Donald hooked up with [*Simona*'s writer and director] Patrick Longchamps," says Frank Mazzola. "Through one of his friends in Europe, I think. Roger Vadim, Stash, maybe Mick Jagger. I'm not sure. Maybe David Cammell had something to do with it, I don't know."

Our research has turned up only a few, brief references to *Simona* - not the version created by Donald Cammell, but a version of the film released in Italy in 1974, probably the same version that was shown to Donald in 1973. Since so little is known about *Simona*, we have seen - in the few sources containing information about the film - release dates covering every year from 1972 to 1975, but our research indicates that it was eventually released in Italy in February of 1974. It was instantly seized by the authorities and banned throughout the country. We know of no other release of the film in any other country. Perhaps the most useful information we have found about *Simona* is contained in a rather impressive tome entitled *Belgian Cinema*, published in a trilingual edition by Flammarion in 1999, which confirmed what Frank Mazzola vaguely remembers, that the film was a joint Belgian-Italian production shot in the summer of 1972 and was the first (and apparently, only) directorial effort by the then 28 year-old Belgian aristocrat, Baron Patrick de Selys Longchamps (b. 1944).

Simona is loosely based on Georges Bataille's early short novel, *Histoire de l'oeil* [*Story of the Eye*], a pornographic work published in 1928 under the pseudonym "Lord Auch," and subsequently published in revised form in 1940, 1941, and 1967 (the last of these editions was published after Bataille's death). The novel recounts the transgressive adventures of the first person narrator who at the age of sixteen falls in love with a distant relative named Simone. The narrator learns of Simone's peculiar fetishes, particularly her interest in eggs and eyes and, eventually, after the two have fled to Spain, the raw testicles of the first bull killed in a bullfight. In French the words for "eye" and "egg" are similar, *oeil* (eye) and *oeuf* (egg), and in their plural form the words are pronounced very much the same. Through Simone, the narrator discovers the pleasure of

transgressive acts, both sexual and violent, and soon his attraction to Simone grows into an overwhelming obsession. He recounts Simone's own bout of *amour fou* with a strange young blonde girl named Marcelle, who eventually commits suicide.

We must stress that *Simona* is a *loose* adaptation of Bataille's novel, and is hardly a faithful transposition of what is, literally transposed, a rather ludicrous string of purposefully discontinuous events - imagine trying to literalize a Surrealist novel such as Raymond Roussel's *Locus Solus*. Although we have seen *Simona* only in its censored form (see the Filmography), we can say with certainty that some events recounted in the novel are omitted entirely, others are conflated, and some scenes in the film are not in the novel at all. For instance, the novel culminates in an act of violence, in which the narrator, Simone, and Sir Edmond (a wealthy Englishman the two have met in Spain) collude in the murder of a priest. As the narrator and Sir Edmond restrain him, Simone has intercourse with the priest whilst she begins to strangle him. Following Simone's strangulation of the priest - an act she commits in order to satisfy her curiosity as to whether a man being garrotted actually ejaculates at the moment of death - she requests Sir Edmond to remove one of the priest's eyes, which she then holds in the fold of her buttocks next to her anus, a form of fetishism she earlier performed with raw eggs. Nothing in *Simona* approaches the sheer audacity of this scene, revealing the deconstructive tendency to link what would seem to be the antithetical concepts of sex and death, although there is one scene, discussed below, which alone would have prompted the film's seizure.

Bataille would later claim *Histoire de l'oeil* to be a work of "juvenilia," but the novel is now considered historically to be an example of Bataille's peculiar form of avant-garde, Surrealist eroticism (a term Bataille preferred to name "erotism"), filled with fetishism and masturbation, an admixture of Bataille's reading of Marx, Nietzsche, Freud, and perhaps most importantly, Sade, linking the genitals and the anus, semen and urine, or sex, excrement, and death.

In Longchamps's filmed adaptation, Simone (Simona) is played by Laura Antonelli. The narrator is given the name Georges (presumably in homage to Georges Bataille), played by Maurizio Degli Esposti. The role of Marcelle is played by Margot Saint'Ange, who was, according to Frank Mazzola, the wife of Longchamps. British actor Patrick Magee played the Father, and Raf Vallone played Simona's incestuous uncle, with whom, in one explicit scene inexplicably not cut from the censored version we've seen, Simona is shown having sex. "Donald screened the film," reports Mazzola. "I got the feeling he wasn't very impressed by it, but he agreed to do the English language re-edit. He got together with me and we talked about it, and I got the whole top floor of the wardrobe department at Sam Goldwyn's for our offices."

All of the camera negative, the 16mm magnetic tracks, everything, was sent to Los Angeles by Patrick Longchamps, who bought a house in Los Angeles especially for the occasion. "Donald liked to call him [Patrick Longchamps] the 'mad Baron'," says Mazzola. "Donald and I screened all the footage we had. I think the cinematographers were Italian [the DP was Aiace Parolin; four camera operators are credited on the film, three of whom are Italian: Angelo Lanutti, Luigi and Oddo Bernardini; the fourth, Michel Houssiau, was Belgian]. The [colour] footage was beautiful stuff, just beautiful. They'd done some gorgeous cinematography... I transferred all of the [European] 16mm magnetic tracks onto 35mm magnetic tracks... I had five assistants, and we spliced all of the European magnetic tracks back together... very difficult work. We put a lot of hard work into that film. And the work Donald did was brilliant - some of the best work, I think, he ever did. The work he did was amazing, truly amazing, just sheer genius. He studied the lip movements of the actors, and then wrote [English] dialogue that *exactly matched* their lip movements. You couldn't tell it was dubbed at all. Can you believe that? He wrote the dialogue for the entire script doing that, watching the actors' lip movements."

The two assembled a group of actors to dub Donald's rewritten version of the script. "I got my old friend Sally Kellerman to do the voice of Simona," said Frank. "The girl from *David and Lisa*

*Rare still from **Simona** (1974), the Belgian-Italian production for which Donald Cammell wrote an English language script in 1973 (never released).*

(1962), Janet Margolin, did Marcelle. We used Kendrew [Lascelles, from *The Argument*] for the male lead [Georges], and Donald cast Gerrit Graham [who would later work on *Demon Seed*] to dub one of the characters, I don't remember… Across the street from the Sam Goldwyn studio was a bar called Ports [originally "Sports," but the "S" had fallen off years earlier and no one had bothered to replace it] and there was a Frenchman who hung out there named Jacques. We hired him to dub the Patrick Magee character. It was all great, fun stuff. They all did great work. We had a group of unusual actors working on the film, which gave it a lot of good energy."

Donald also wrote and directed additional scenes for *Simona*, employing the legendary gay icon of Los Angeles, Samson. "If you grew up in L.A., you knew Samson," says Mazzola. "He was this old, flamboyant homosexual, a funny guy. We shot some scenes with him up at the Castillo del Lago mansion, off Mulholland Drive, that was once owned by Bugsy Siegel. Patrick Longchamps had purchased it when he moved to Los Angeles to work on the film. It was the mansion Madonna later owned for a while in the '90s… Donald wanted to insert some scenes of Raf Vallone in drag, so we hired Samson. We designed a set up there and shot the scenes. In his make-up and costume, he looked, well, just like Raf Vallone in drag!" Frank also said, "I think it was Caleb Aschkynazo, who later worked with Don Trumbull on the visual effects for *Star Wars*, who shot the scenes for us… Donald and I had a lot of talented people working with us on *Simona*. I hired Ida Random to work on the show as the Art Director. She went on to become one of the best Art Directors in the business, and was later nominated for an Academy Award for her work on *Rain Man* (1988). We had Richard Portman, one of the best sound mixers in the business. He did all the great mixing on Robert Altman's movies… I had great assistants helping me… One was Robert Barrere, who became a film editor. Another was Artie Schmidt, who was

my assistant on *Macho Callahan*. He eventually won an Academy Award for Best Editing for *Forrest Gump*. Everyone who was involved in that show went on to do great work in the [film] business. It's too bad no one will ever see our cut of *Simona*, because some outstanding work was done on that movie."

Simona may have represented some of Donald's best work, but the fact is, he was doing more than merely an English dub on Longchamps's film. He was restructuring it, changing the voice-over narration, adding new scenes, and removing others - rather like what Woody Allen did with the Japanese spy film in *What's Up, Tiger Lily?* (1966). Longchamps's version had the voice-over narration by Georges; Donald jettisoned that and shifted the voice-over to Simona. And he gave an entirely different spin to existing sequences. For instance, Bataille's novel opens when the narrator first meets Simone. A few days later, he and Simone are alone together in Simone's villa, where the narrator is introduced to Simone's fetishism. It is a hot day; in the corner of a hallway is a saucer of milk for Simone's cat. Seeing the saucer of milk, she says that the milk is for the pussy. The narrator is at first unaware of her pun. She then provocatively asks him if he would like her to sit in the milk. He becomes instantly aroused. Simone squats down in the milk for quite some time, closely watching the narrator's reaction. She notices he has an erection by the bulge in his pants. She then stands, allowing him to observe the milk as it runs down her legs. She then moves and stands directly over the narrator, one foot propped on a bench, and pulls up her black pinafore to reveal to him she's wearing no panties. She begins to masturbate, he does likewise, and they instantly orgasm.

A less explicit, dramatized (as opposed to narrated) version of this scene occurs early in Longchamps's film, not literally transposed but in truncated fashion, as if the scene in Bataille's novel remains meaningful by being represented rather than being meaningful by its verbal, figurative associations (milk, semen) and puns (pussy, cat). The scene opens with the camera in a medium close-up on Simona; a cat meows, there is a cut to a small black cat. Georges, in the voice-over, refers to the forms of amusement he and Simona surreptitiously indulged in. He and Simona are in a bedroom, perhaps hers. Her mother (the repressive authority figure, the super-ego) is downstairs, and plays some music on the record player. Strangely, Georges is on the floor under the bed, his face visible and upturned toward Simona. She tells him the pussy needs milk, picks up the saucer of milk and moves toward him, saying pussies like milk. She sits it down in front of him, lifts her dress slightly, and slowly squats down over the saucer of milk. Georges begins to crawl slowly out from under the bed, trying to see if she is actually sitting in the milk. He inches closer and closer. His head moves between her legs. There is an abrupt cut to the couple speeding down a road in a convertible, laughing at some private joke.

Donald's version of the scene completely alters the relationship between Simona and Georges; she is more sexually wise and knowing, Georges is portrayed as a naïve, Perceval-like fool. He re-conceived the original scene and employed a sort of Shklovskian "retardation" (i.e. the postponement or delay of the expected climax by using incongruous dramatic material). As in Longchamps's version, the scene opens on a medium close-up of Simona, looking at something off-screen. We hear a voice, Georges's, saying petulantly, "Listen, how much longer have I got to stay under here?" Simona raises her eyes, doesn't reply. She moves toward the fireplace, as in Longchamps's version, and speaks as she moves. "As long as I want you to…" Off-screen, Georges complains, "My knees are sore. Listen, why…" "She interrupts him: "Shut up… Stop asking stupid questions. You don't seem to realize how extremely *lucky* you are, to be there." Cut to Georges under the bed. Simona, off-screen, asks, "Why don't you play with my pussy?" Georges: "Huh???" The cat meows; there is the cut to the small black cat. Simona giggles, and says, "She's thirsty." She asks Georges, "Do you want me to warm her milk with my ass?" Georges, confused, asks, "What d'you mean - warm the milk with your ass?" Simona replies, now carrying the saucer of milk, "I mean… warm it. Warm it up, Georges." And so on. (The cut to Simona's mother putting on the record is removed, re-edited so as to suggest Simona has put on the record.) She squats down over the milk, and Georges begins to crawl out from under the bed. Unlike Longchamps's version,

she intones, "That's the way. Come closer… good boy…" Georges continues inching toward her. Simona: "Have you got a good view?" Georges: "It's really very dark under there." She asks him what he can see. "I can't see a bloody thing," he replies. She tells him to crawl around and look from behind. He obeys. After a moment, she asks him whether he can see her wet panties. Curious, Georges asks, "Lift up a bit" as he studies the situation. After a moment, chagrined, Georges exclaims, "Listen… you're not… wearing any panties!" Cut to a close-up of Simona, who has a beguiling, Mona Lisa-like smile: "Oh… aren't I?" The cut, at that point, in contrast to the one in Longchamps's version (to the couple in the convertible) is to the beach, where Georges sits alone and despondent, apparently masturbating.

Longchamps may have been aware that the depiction of sexual fetishism was inspired by the Surrealists' reading of Freud and Krafft-Ebing; he may not have been aware, however, of the ideological reason for the exploration of fetishism, which was to demonstrate the fundamental fissure at the base of the bourgeois sense of civil order. The Surrealists did indeed strive to be scandalous, but they were scandalous for a reason. Donald's re-edited and rewritten version was obviously a parody of the original film, not precisely what Longchamps had in mind. After Donald and Frank had worked on his film for several weeks, Longchamps finally told them he was unhappy with their dubbed re-edit, thinking it was a complete distortion of what he had tried to do with his film. "He thought we were making fun of him and his family, the European aristocracy, which we were, I suppose… He said he wasn't going to pay me. The thing was, a lot of the crew needed to be paid, were depending on me to get their money. I was so angry, I told him I'd fight him for it." Thirty years on, Mazzola laughs about the moment. "Donald didn't call him the 'mad Baron' for nothing. He'd been beat up. When he moved to L.A., he'd hired this black man as his caretaker. One day he used a racial slur while mad at the guy, and this guy just beat the hell out of him. When I told him I'd fight him for the money, he immediately told me that he was a boxer… but I knew he'd been carved up by his caretaker. He didn't know that I'd been a champion boxer, too. So I said, 'Let me see your guard.' When he showed it to me, I knew I could put him on the floor in about two seconds. So I said, 'Double or nothing.' He thought about it, and then backed down, and gave me the money." And though Frank got the money to pay the crew, the end was in sight.

The problem wasn't only Longchamps's intransigence. There were other issues. "There was one scene in which his wife [Margot Saint'Ange, playing the Marcelle character] masturbated with a crucifix," said Mazzola. (Predictably, this scene is *not* in the censored version of the film we have seen, nor is it, in fact, in Bataille's novel.) "Longchamps thought that scene was really important, that it was his big statement, where he was thumbing his nose at established religion, defying convention and taste, that sort of thing. I thought it was bullshit. It insulted everything I believed in. I was raised a Catholic, and it insulted the way I was brought up, and my religious beliefs. I wanted to cut the scene, but Donald wouldn't back me on it. He just mumbled something or other, and at that point I just shut the film down, stopped working on it."[25] The film was essentially finished, however; very little was left to do.

They'd spent eight or nine weeks on the project, but it was all for nought. A few years later, in 1977, Donald told David Pirie, "I turned it [a completed Italian horror film] into a black comedy. It was quite a success as far as we were concerned. I rewrote all the script and completely re-edited it

and did about three quarters of the dubbing. Then the Italian [sic] producer decided he didn't approve of our ideas. It was another over-ambitious idea that worked for me and might work for an audience but just didn't work for the producer."[26]

What happened to Donald and Frank's re-edit of *Simona*? "I don't know what Longchamps did with it," says Mazzola. "I wish somebody could track it down, because there was some beautiful work done on that film." He's not sure whatever happened to Patrick Longchamps, either. "He and his wife sold the house and left town," says Mazzola. "Donald never mentioned him again, as far as I remember. I don't know what happened to him."[27] Our research indicates that Patrick Longchamps has directed no other films, at least under his own name; it also suggests the film was never screened outside the country of Italy. According to the aforementioned text, *Belgian Cinema*, *Simona* has never had a release in Belgium. Even the editors of that book admit the disposition of *Simona* remains unknown.

Pale Fire

By late 1973, Donald had moved to the International Famous Agency, where he was represented by Paula Weinstein. During the first few months of 1974, while at the IFA, he worked on an extremely promising if daunting project - what he might have called "over-ambitious" - a screen adaptation of Vladimir Nabokov's 1962 novel *Pale Fire*. As Donald had always admired Nabokov's *Lolita* (and Kubrick's subsequent film), the project was quite amenable to him. He produced a sixty-page treatment of the novel, dated May 1974. "Treatment," however, was not the word Donald preferred in describing what he had produced. "This is NOT a 'treatment' for a film," he wrote in a one-page Foreword to the work. "It is, rather, a sort of re-telling of Nabokov's novel - a re-arrangement of the book's originally rather weird and complex structure - in a more or less cinematic form... The result is rough - *very* rough - and of course there is about 200% too much material here for a film. But these pages present the story, extracted from Nabokov's magnificently tangled book, and the basic form, of a fabulous film."

Nabokov's *Pale Fire* is one of those books that is generally considered to be "unadaptable," but in fact there is a story there if one wants to straighten it out. The "complex structure" to which Donald refers above is true; the novel consists, in part, of a 999-line poem, divided into four cantos, written by an American writer and poet named John Shade, that also happens to be titled *Pale Fire*. The bulk of the novel consists of a Foreword and Commentary written by Charles Kinbote, alias Charles Xavier, ex-King of the country of Zembla, who has befriended Shade. Kinbote escaped from Zembla in order to avoid assassination roughly a year before the story proper begins. He has chosen to hide out in the small college town of New Wye, nestled in the mountains of Appalachia, home of Wordsmith University, where John Shade teaches. However, Kinbote is tracked to New Wye by Jakob Gradus, an assassin armed with a Luger. Gradus arrives on the day Shade has completed his poem, intending to kill Kinbote. Gradus accidentally shoots and kills Shade instead, while the heroic Kinbote kills Gradus with a shovel. Kinbote inherits the task of writing the commentary on *Pale Fire*. "The main character,

Kinbote… is a true hero," wrote Donald in his Foreword. "A loveable, brave, amusing, eccentric, tragic and totally believable hero. To me, anyway."

Our task here is not to entertain the divisive interpretations Nabokov's novel has prompted. Yet most certainly the central theme of Shade's great poem is his own battle to come to terms with a personal tragedy, the death of his daughter Hazel. She inherited not only the writer's fine mind, but also his stunted, odd and unattractive body; a very ugly, strange little girl, she killed herself while a mere teenager (hence this is yet another work containing the theme of suicide that interested Donald). Much of what is interesting about Nabokov's book is Kinbote's interpretation of Shade's poem through the lens of his own paranoid world view, augmented by his conviction that he is being stalked by an assassin. There is thus a very compelling narrative thread in the novel, knotted up within Nabokov's unusual structure, but one which Donald captured brilliantly in his "re-telling." "People have said *Pale Fire* can't be adapted, but I don't think that's true," said David Cammell. "Once you find the story, it's not really difficult to find a film there as a result. I think Donald captured it quite well, but, alas, it was another of those ambitious projects of his that never worked out. Too bad."[28]

And of course Donald created wonderful visual imagery. He begins his re-telling on a highway a couple of miles outside town, where a bus stops and deposits Jakob Gradus. Gradus trudges into town, almost struck by a car driven by Shade's wife Helen. Entering the town, he finds Kinbote's house. He walks up to the front door and rings the bell. No answer. After a few moments, he hears approaching voices: those of Kinbote (whose voice Donald likened to "that of John Houseman's magnificent lawyer in a recent film [*The Paper Chase*, 1973])." Kinbote is returning to his house accompanied by Shade. Gradus turns and stares at them, and the two men are talking. When Shade finally points out to Kinbote the existence of "another visitor," Kinbote recognizes the man and charges him.

The first bullet rips a sleeve button from his shirt as he waves his great arms to ward off the bullets. A second, a third shot - who is Gradus aiming at? Is Shade hiding behind Kinbote, or is Kinbote trying to protect him? Then the old man stumbles, Kinbote trips over him. As they fall together, the envelope containing the Poem [*Pale Fire*] on its 92 index cards slips from K's [*sic*] upraised hand.

At this moment, the film slips progressively into SLOW MOTION… and yet SLOWER, as the CAMERA closes in inexorably on the falling envelope. Its flap has come open, the cards gently fan out sideways as we hear a SOUND, long and echoey, a slow-motion…of a final shot…

A CLOSE-UP of Gradus' gun-barrel, its smoke-wisp.

An ULTRA SLOW MOTION shot of the Bullet itself traversing the dusk-gray screen.

Now in extreme CLOSE-UP, the top card of the poem slides out of the envelope. In Shade's neat penmanship, the Title,

"PALE FIRE"

on the pink top line - followed by the first two lines of the poem itself, on the index card, frozen in space and time…

"I was the shadow of the waxwing slain

By the false heaven of the windowpane"

The BULLET pierces the word "shadow."

The Bullet enters screen from foreground left; spiraling slowly like a lethargic space-ship, it approaches the dead center of the card. Then, for a moment, the Bullet is motionless too, in silence.

We do not know who, if anyone, it will pierce. Only the poem appears to be a certain target.

The SCREEN goes BLACK.

Vladimir Nabokov apparently was so pleased with Donald's adaptation of *Pale Fire* that he wrote a letter to Donald praising it. Alas, we have been unable to track down a copy of that letter, although David Cammell swears of its existence, saying he actually read it. "Of course Donald was delighted to have received that letter from Nabokov," says David. "It vindicated him. But as to its disposition, I cannot say."[29] We contacted Nabokov expert Brian Boyd regarding the existence of any correspondence between Nabokov and Donald Cammell. Boyd told us, "I don't have any record of this [letter] either from the *Pale Fire* MSS (and when I catalogued the MSS for Vera Nabokov, I always put translations and adaptations with the original) or from the correspondence."[30] Professor Boyd suggested we contact the Berg Collection of the New York Public Library, which has catalogued Nabokov's extensive correspondence. Says Brian Boyd: "The Nabokovs meticulously kept carbon copies of outgoing correspondence." We contacted Stephen Crook, Librarian for the Berg Collection, but he was not able to verify the existence of any letter, either.[31]

In any case, there is ample evidence that Donald had admired Nabokov's work long before adapting *Pale Fire*. Vartkes Cholakian told us that Donald spoke very highly of Nabokov's novel *Despair* (the revised edition of which appeared in 1966) when they were working together on *El Paso* in 1979. *Despair* contains themes that would reappear throughout Donald's work, the most significant being the relation between crime and art. The protagonist of *Despair* undertakes a plan to murder a man who may or may not be his double, comparing the act of murder to a creative act, and after murdering the man imagines himself as murderer by analogy to an actor who has performed (and that is precisely the word used in the novel) his role brilliantly.

The points of contact to *Performance* are significant, and suggest yet another avenue of exploration for that famous film.

The End of the Affair

During the summer of 1974, Donald and Myriam spent some time in New York. Myriam remembers Donald doing some portraiture at this time in order to earn some income. "We were in New York [in 1974], when one day I couldn't find Donald," she said. "He told me later he had been up on the roof [of the building] intending to jump." Emotionally frazzled by the unpredictability of Donald's precipitous mood swings, and unnerved by his suicide threats, Myriam's relationship with Donald was at an end. "You can take someone constantly telling you he is going to kill himself only for so long," she said. "It got to the point where I just couldn't handle it any more."[32]

The impulsive nature of Donald's sexual behaviour may have been another factor. An anonymous source recalled one such indiscretion while Donald and Myriam were in New York that summer. They

had been invited to a cocktail party at a wealthy socialite's elegant home. During the party, Donald disappeared. Still rattled by his earlier threat to jump from the building, Myriam frantically instigated an immediate search. Donald was discovered by a couple of guests *in flagrante* with a wealthy, middle-aged society matron, who was elegantly coiffed, wearing heels and pearls, on her knees giving him a blowjob in a small anteroom. The fellatrix may have been embarrassed, abjectly so, given she was married, but the humiliation caused by Donald's *faux pas* was among the final straws contributing to Myriam's departure. As for the evidence of Donald's fiendishly seductive charm and charisma, the proof is in the pudding.

It was Myriam herself who arranged for Donald to meet his subsequent romantic companion, Susan Bottomley, referred to from her Warhol days as "International Velvet." Donald may have known her a decade earlier, as Warhol and his entourage frequented Castel's when in Paris. "Susan happened to have some business to do in New York and was going to stay with us as a guest," Myriam said. "I thought the timing was perfect since I was planning to leave [Donald]. I did not want Donald to suffer in any way, so she ended up staying, leaving her husband [photographer Tony Kent] in Paris."[33] A couple of months later, Myriam said, she returned to New York. By that time Donald had returned to Los Angeles and had moved into the Crescent Drive house on Lookout Mountain. Some good friends of David Cammell had lived in the house for several years; when they decided to move out, David made arrangements for Donald to take over as renter of the house. Donald was to keep the house until his death.

We were unable to interview Susan Bottomley for this book, but sources have told us she and Donald stayed together for about a year or so. We have been told, but have not been able to confirm, that during 1974-75 Donald had a brief romance with actress Patti D'Arbanville, and was also romantically linked with both Faye Dunaway and Jacqueline Bisset. In any case, by the fall of 1975, Donald's relationship with Susan Bottomley came to an end. Apparently Donald remained on friendly terms with her, however, and would occasionally stop by to see her over the years.

The Lady Hamilton

It was about this time that Donald began to research material for a historical drama that eventually became a screenplay entitled *The Lady Hamilton*, to have been produced by his and David Cammell's friend, Andrew Braunsberg. Prior to moving to Los Angeles in 1974, Braunsberg had produced Roman Polanski's *Macbeth* (1971), and Paul Morrissey's outrageous yet poetic films *Flesh for Frankenstein* (1973) and *Blood for Dracula* (1974). Subsequently he produced Polanski's *The Tenant* (1976) and Hal Ashby's *Being There* (1979), among other films, whilst in Los Angeles. He very much wanted to make a film with Donald.

Employing Donald's talents as the writer and director of a "period" or historical drama is an utterly intriguing idea, and the subject of Emma, Lady Hamilton is an interesting one. Born in poverty and obscurity around 1765, the beautiful and witty Emma Lyon rose to wealth and fame through her connections with affluent men. She became Lady Hamilton when, after having been his mistress, in 1791 she married the British diplomat and archaeologist, Sir William Hamilton, who held the post of ambassador to Naples from 1764 to 1800. The Hamiltons, an ancient and influential Scottish clan from the lowlands, are still prestigious; the 15th Duke of Hamilton holds the position of Hereditary Keeper of the Palace of Holy Roodhouse. His clan, dating back to the 14th century, has played a prominent role in Scotland's history. Lady Hamilton was the mistress of other famous men, namely the renowned artist, George Romney, who painted several portraits of her, and the British naval hero, Admiral Horatio Nelson, with whom she began a love affair in 1798. She bore him a daughter in 1801, but was ostracized and died in penury in 1815 after Nelson's death left her vulnerable to social prejudice.

It is easy to see why Donald was fascinated by the story of The Lady Hamilton. Indeed, she's been the subject of several biographies, and even a film, *That Hamilton Woman!* (1941) starring Vivien Leigh and Laurence Olivier, directed by Alexander Korda. Her beauty made her a popular model for the artists of her day, and she was known for her vivacity and wit. The fact that she wed a member of a famous Scottish lowland clan (as were the Campbells), no doubt also was appealing to Donald, as was her utterly non-Puritanical, bohemian lifestyle, which included the *ménage a trois* that her husband politely accepted, so smitten was he with his wife's charm. Moreover, there was a connection the Cammell family had with this famous historical figure: in about 1780, when she was fifteen or sixteen, the then Emma Lyon became the mistress of Sir Harry Fetherstonhaugh of Sussex, making discreet visits to his home at Uppark, which lay adjacent to Ditcham Park, the estate once owned by Donald's grandfather. The subject of a successful, intelligent woman, who acquired both wealth and power in a masculine world, very much appealed to Donald.

"Donald wrote a very fine script, fabulously poetic," Andrew Braunsberg told us. "The problem was the subject matter, which was not mainstream Hollywood stuff. It was very hard to get any kind of historical drama made in Hollywood at that time. They weren't considered commercial." A non-commercial property, with Donald's name attached to direct, presented a special set of problems. "Donald was not a great salesman," said Braunsberg. "He didn't want to play any games. He was perceived as difficult, and that didn't help the cause."

He and Donald, however, got along quite well. "We'd go on weekend camping expeditions with Donald and China, out to Death Valley. He had a Jeep CJ5, and we'd take that out to the desert. I loved it. I have fond memories of those trips, and let me assure you Donald was a great expedition leader. He had tremendous survival skills. You wouldn't think that about Donald, but he had the knowledge and the skill to live out there for extended periods of time." (As we discussed in chapter 2, Donald was taught outdoor skills while at Fort Augustus.) "I finally stopped pursuing the project," said Braunsberg. "The longer things like that go on, the more strain it puts on your friendship. I didn't want to jeopardize that, so I pursued other projects instead."[34] Perhaps not surprisingly given the Hollywood disdain for "period" pictures at the time, *The Lady Hamilton* was never produced, although Donald maintained hopes that it might. It went through several revisions in subsequent years; perhaps to remove the stigma of a historical drama, Donald later re-titled it *Faro*.

Fade Out

Eventually, the aura created by *Performance* began to fade. When he arrived in Hollywood at the beginning of 1972, Donald was, as one person told us, "the toast of the town." By the end of 1974, it had been over four years since *Performance* had been released. He had completed nothing. None of the projects with which he had been involved had reached fruition. Interviews with Donald became rarer: the number had peaked during 1971-72, then dropped to zero by 1974. The constant search for income, moving from one project to the next, was also taking its toll on his creative energies. "It becomes hustling," one anonymous source told us. "Without realizing it, you become a hustler, always on the look-out for the next project, some fresh meat, some kind of work. It's a terrible way to live your life."

In the four years since *Performance* was released, Nic Roeg had directed *Walkabout* and *Don't Look Now*. Both were critically praised, and while the editing style of these pictures was heavily indebted to the style Donald and Frank had invented for *Performance*, it was now perceived by *auteur* critics to be Nic Roeg's signature style. In the clarity of retrospect, this was an unfair assumption, perhaps, but a not unreasonable one at the time. *Performance* was slowly building a cult reputation, but Donald Cammell was fast becoming - to borrow an epithet from the music business - a one-hit wonder.

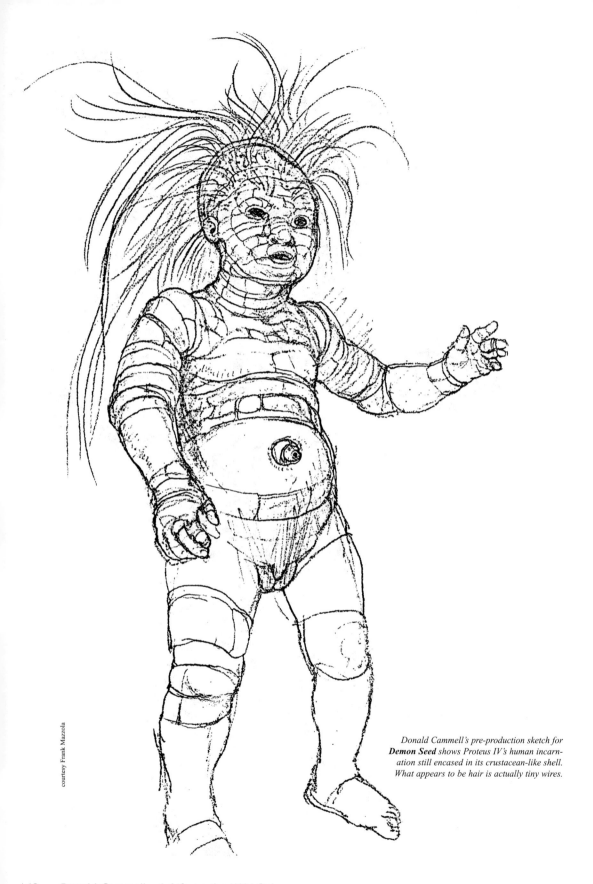

Donald Cammell's pre-production sketch for **Demon Seed** *shows Proteus IV's human incarnation still encased in its crustacean-like shell. What appears to be hair is actually tiny wires.*

7

Demon Seed

1975-1979

It is, after all, only eight years since we began.

*- Dr. Alex Harris, **Demon Seed***

*T*he *Hollywood Reporter* announced Donald's agreement to direct *Demon Seed* in its 24 November 1975 issue. The article also mentioned that British actress Julie Christie had been signed to star. Donald was rather surprised that MGM offered it to him. "I still don't know why they asked me," he said. "But I think it was because the writer, Robert Jaffe, knew my work. And two other well-known directors had cried off."[1] He had earlier changed representation as well, leaving CMA and moving to the William Morris Agency, where his agent at the time was Mike Medavoy. Although Donald had agreed to direct the film out of practical considerations - he seriously needed the work - he also found the project suited to his interests.

To consider *Demon Seed* an anomaly in his career is to misunderstand Donald's intellectual motivations. "Donald always said that if he'd had a better education, he would have been a scientist," says China. "He was an avid subscriber to *New Scientist*. He was always reading books on the brain. He was interested in AI [Artificial Intelligence] and saw *Demon Seed* as an opportunity to explore that interest."[2] Indeed, Donald remained quite good friends for the rest of his life with the Technical Adviser on *Demon Seed*, Bob Stewart, a physicist from Caltech who at one time was a USC Adjunct Professor of Neurology. Stewart had done brain-model work at the Center for Research and Education, where he developed electrochemical models of brain tissue (some of his custom designed "brain-making" equipment was used in certain laboratory sequences in *Demon Seed*). When Donald met him, Stewart was head of a design group called "Level-Seven," where he created educational and scientific toys. David Cammell told us Stewart one time showed him one of these novelties, a "right way" mirror, meaning you can see yourself as you are, not your reversed image, as is the situation with standard reflective mirrors. The tetrahedronal design of Proteus IV's physical manifestation was derived from one of Stewart's toys. "I brought some of my paper toys, called 'Tetralinks,' into MGM, for use in designing Proteus's body and other constructions," said Stewart. "They share the fundamental geometric property of ordinary bricks; they always fit together in endless variations of form."[3] Stewart's "Tetralinks" design is normally called a "tetrahexaflexagon," the basis of a flexible paper toy popular among children; the instructions for making a tetrahexaflexagon are available on many websites. The tetrahedron shape also forms the basis of the construction of the artificial womb that Proteus IV builds for Susan's child.

Demon Seed is often characterized as a Frankenstein scenario, part of the same science fiction sub-genre as, for instance, *Colossus: The Forbin Project* (1970) - an interesting comparison, as a matter of fact, since the supercomputer Colossus, like Proteus IV in *Demon Seed*, is curious about human sexual behaviour. During one scene in the 1970 film, Colossus queries his creator, Dr. Forbin, on Forbin's need for sex. Colossus asks (by means of a text message on the monitor), "How many times

a week do you require a woman?" Dr. Forbin replies, "Every night." Colossus: "Not want - Require." Dr. Forbin: "Four times a week." Is the name of the computer in *Demon Seed*, Proteus IV, a tongue-in-cheek reference to this earlier film? The computer is named simply Proteus in the novel and in early drafts of the screenplay, but by early 1976 - after Donald got on board - the name had changed to Proteus IV. Moreover, there are a number of features of *Colossus* that Donald would have liked, including the use of a simulated sexual liaison as a means of exchanging information between Forbin and his "mistress," Dr. Cleo Markham (Susan Clark), his contact with the government. This arrangement soon leads to a real attraction between the two and they no longer need to "act."

By 1970, the voice of the computer Colossus had become a science fiction film stereotype: cold, dispassionate, and obviously mechanically reproduced. Early drafts of the screenplay for *Demon Seed* indicate Proteus was to have an atonal, "child-like" voice, suggesting his voice was modelled on HAL's in Kubrick's *2001: A Space Odyssey* - incidentally, a film Donald greatly admired. Interestingly, Donald avoided the "child-like" approach, as Proteus IV's voice doesn't so much resemble that of HAL's as it does the more ominous voice of the computer in Godard's *Alphaville* (1965) - altogether more sinister. Robert Vaughn (uncredited) was hired to provide the voice of Proteus IV. In an interview conducted years later, Vaughn said that he was hired by Donald "because he thought my voice was right for the character but we started fiddling around - I think I was hired for two days to do the voiceover - and he said, 'Well, let's try doing it this way." Since I had a great deal of radio experience, he was fascinated by all the different voices I could do, and the different sounds I could produce… I think I did, like, 12 days doing over and over with different voices, different ages, different accents and things… they finally used what they hired me for originally, the track from the first day."*4*

Despite its contingent similarities to earlier science fiction films, *Demon Seed* is more properly an exploration of the implications of Artificial Intelligence . It was made in the mid-'70s at a time when the "hard AI" thesis was still held by some scientists: that a computer could be made to simulate the human brain - a theory now abandoned. Although this paradigm dates the film, its essential premise would have strongly appealed to Donald: underlying the film is a story about the mystery of identity. Proteus IV, like Victor Frankenstein's "monster," possesses at its inception an innate moral sense that is absent in its (human) creator(s). Although *Demon Seed* is a film about an Artificial Intelligence, a machine, the fundamental question it asks is, What does it mean to be human? Is humanity defined by biology, morality - or force of will?

Above left: *Susan Harris (Julie Christie) with her would-be rescuer, Walter Gabler (Gerrit Graham) in **Demon Seed**.*
Above right: *Susan's estranged husband, Alex Harris (Fritz Weaver), examines the incubator created by Proteus IV for its rebirth*

The First Battle

The Man Who Fell to Earth, about a reclusive eccentric played by a rock star (its many parallels to *Performance* are astonishing) had been developed initially by David Cammell, and was in post-production by the time Donald signed on to direct *Demon Seed*. "I had been interested in the property [Walter Tevis's novel, *The Man Who Fell to Earth*] for some time," says David. "Metromedia had had an option on it, hoping to develop it into a television series, an intriguing idea which never happened. When they let the rights lapse, I snapped it up immediately. I persuaded Nic Roeg to direct it. In fact I kept the nightclub napkin on which Nic Roeg had written, 'I want to direct *The Man Who Fell to Earth*, [signed] Nic Roeg.' It was I who did the initial discussions with Columbia. Nic Roeg had a couple of picture deals with Columbia, and so it was the natural place to go to. They liked the idea, and they were going ahead with it, but passed on it really quite far down the line. I'd spent about three years negotiating the deals, so that was a bit of a blow. But Nic Roeg had just directed *Don't Look Now* (1973) for British Lion. *Don't Look Now* had done very well, so they were quite keen to make another picture with Nic. And so Nic took me out to dinner and he said, 'Look, British Lion will go ahead with the picture, but there's only one thing, you can't produce it.' At that point it was a great disappointment to me, but I thought, fuck it, I'd spent so much time and money on the thing, and if I don't say yes to this deal, it may never, ever happen. So I agreed. So consequently my participation was reduced to a minuscule line of acknowledgement during the opening credits, but I did retain my share of it. I didn't do too bad financially out of it, but as far as credit was concerned, it was a disappointment."[5]

Like Nic Roeg, Donald was very enthusiastic about the possibilities of directing a science fiction film. Trouble with the studio, however, began almost immediately. While the script went through continual rewrites at Donald's insistence (there were, literally, dozens of drafts), there was also one major battle regarding casting. Donald had approached Julie Christie to appear in *Demon Seed*, agreeing to direct if she would star, which she agreed to do because of her admiration of *Performance*. While the studio was pleased with her in the lead role, it was the casting of the male lead that would cause the first major dispute.

Remarkably, Marlon Brando had agreed to take the part of Dr. Alex Harris, the role eventually played by Fritz Weaver. "Donald had convinced Brando to play the role of Alex Harris," says Frank Mazzola. "According to Donald, Brando had agreed to play the part, and had verbally committed to the studio to do it. He was ready to go. But the studio heads nixed it." Why would MGM executives veto Brando's participation? After all, the success of *The Godfather* (for which Brando received the Academy Award for Best Actor) and *Last Tango in Paris* had revitalized his career. As a result, he had become one of the most highly paid Hollywood stars of the 1970s. Was the issue, then, with MGM executives, the matter of Brando's salary? Not at all, according to Mazzola. "It had nothing to do with money. They thought a Brando-Cammell team would be too powerful. They didn't want the two of them to have that much control over the picture. I think the picture was sabotaged from the beginning, when Donald began pushing for Brando."[6] The producers may not have relished the idea of working with both Donald Cammell and Marlon Brando, either, both of whom were perceived as "difficult."

In his thousand-plus page biography of Brando, Peter Manso makes no mention of Brando's interest, or possible participation in, *Demon Seed*, nor do any of his biographers, to our knowledge. However, Mazzola's assertion does not contradict any known facts about Brando's activities at the time. Manso writes that Brando had agreed to appear in Francis Ford Coppola's *Apocalypse Now* in early February, 1976 - about the time the disputes over his participation in *Demon Seed* would have been going on - but Brando had contractually insisted that he would not appear on location for *Apocalypse Now* until August of that year. Manso attributes this demand to Brando's insistence that he be allowed to spend that summer in Tahiti, but we suggest that it may have been due to the fact that

*In this rare still from **Demon Seed**, Proteus IV has just shown Susan a virtual image of Walter Gabler's dead body, falsely telling her he died peacefully. This sequence was cut from the released version.*

Brando was planning to work on *Demon Seed*, scheduled to begin principal photography on 1 June 1976. The film's shooting period, scheduled for eight weeks, would have seen the film wrap on 27 July - well before Brando was needed for *Apocalypse Now*. As it turned out, *Demon Seed* wrapped two weeks and a day late, on 11 August.[7] However, when Brando eventually did travel to the Philippines, he didn't arrive until 31 August, so even allowing for *Demon Seed* wrapping late, Brando still could have easily met *Apocalypse Now*'s shooting schedule.

Of course, Brando may have dropped out of the project for a personal reason, one having to do with Donald himself. Donald's relationship with Marlon Brando was severely strained when Donald became involved with Patricia Kong, daughter of Anita Loo, a long-time friend of Brando's. As has been well documented, Brando was morally outraged when Donald began his relationship with Patty Kong, who was still in high school. Brando had threatened legal action against Donald: under California law, he could have been charged with statutory rape. Brando also sought to have Donald deported. "Marlon… remembered me as a painter in Paris with the predictable reputation - I won't supply an adjective to that," Donald told Chris Rodley in 1989. "He was incensed at my deep affection for a young girl… my wife was under the accepted age for matrimony at the time, let alone anything else."[8]

Patty Kong had moved into Donald's Crescent Drive home in late November or early December 1975; they would later cryptically inscribe the moment their relationship began by including Hot

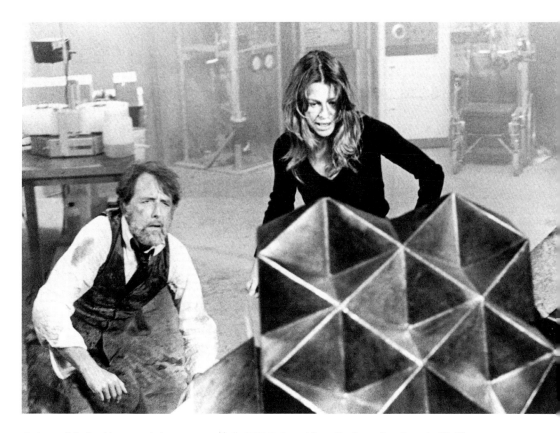

A mixture of shock and intense curiosity are expressed in the faces of Alex and Susan Harris was they witness the "birth" of the Proteus generation.

Chocolate's hit single, "You Sexy Thing," in *White of the Eye* - a single that was released in the United States in late November 1975. One anonymous source averred Patty had run away from home after a dispute with her mother, and had gone to Donald's place. She had known Donald since she was about eleven years old, as her sister, Stefanie Kong, was a good friend of Myriam Gibril's. Frank Mazzola remembers flying to San Francisco with them, early in 1976, soon after the two had begun their relationship. They'd gone to meet with experimental filmmaker Jordan Belson, whose *Chakra* footage Donald wanted to use for certain sequences in *Demon Seed*, as well as on the computer monitors. (Belson also designed a sequence for the film, but his contribution was never used.)

It was Donald who bequeathed on Patty Kong her new name, "China," evidently in homage to his charming acquaintance (and one of the few women to resist his sexual advances), the beautiful model, China Machado. "No worldly, bohemian artist and intellectual like Donald would deign to have a girlfriend named 'Patty,'" one source confided to us. "So he gave her a different name." We asked China to recount how she and Donald met, and also asked her age when she began living with Donald, but she demurred, saying only it was "a very funny story."[9] Whether she meant funny as in "laughable" or funny as in "strange," or both, we're not sure, but no one, despite the many years we spent researching this book, volunteered to give us the information, which is revealing in itself. Sources did tell us that she and Donald were eventually married, in Paris, late in 1978, soon after her eighteenth birthday. Donald was forty-four years old when he began his second marriage.

Rewrites

Dean Koontz's 182-page novel *Demon Seed* was published by Bantam as a paperback in June 1973. Koontz's last novel that was overtly science fiction, it was optioned by Herb Jaffe soon after it was published. One of the well-known directors who had "cried off" the *Demon Seed* project was Brian De Palma. Given the numerous script rewrites *Demon Seed* went through, he eventually removed himself from the project, opting instead to make *Carrie*, based on the Stephen King novel, released to acclaim in the autumn of 1976.

The MGM archive, housed in the Margaret Herrick Library of the Center for Motion Picture Studies at the Academy of Motion Picture Arts and Sciences, indicates that an undated, 112-page "temporary complete screenplay" was submitted to MGM readers on 5 June 1975, authored by "Harold Elliot" - a pseudonym for Robert Jaffe. The screenplay had been through a dozen revisions by the end of 1975. Following Donald's commitment in November, Jaffe's script again went through several revisions. The first draft of a screenplay, authored by Roger O. Hirson, was submitted on 8 April 1976. A 109-page screenplay, co-authored by Robert Jaffe and Roger O. Hirson, dated 29 April 1976, approximates the final film as released, but additional rewrites were completed (uncredited) by Elia Katz. Evidently, both Donald and his lead actress, Julie Christie, were unsatisfied with the Jaffe-Hirson screenplay. In an interview about the film, Donald observed: "When Julie [Christie] saw the rewrite that had been done for MGM there were arguments and fights. At the time it always seems like everybody's going to kill each other. But when we were only two or three weeks away from shooting [around 10 May] they said OK, maybe you're right."[10] Donald claimed Julie Christie also contributed significantly to the script, writing much of her dialogue. His claim is borne out by the existence of a "temporary complete screenplay," dated 13 May 1977, that has a handwritten note on the cover page, "J.C. + Elia Katz." Principal photography was set to begin in a little over two weeks.

The technophobic theme that characterizes much science fiction is perhaps better understood as the fear of the unpredictable consequences accompanying the introduction of any new technology. It is an expression of the so-called "Frankensteinian theme," reflecting technology's automatism - the ability of the machine to operate autonomously, long after conscious human control over it is relinquished - and demonstrating the difficulties that arise when scientific advancement precedes its ethical implications (its unpredictable effects on social behaviour).

In Dean Koontz's novel, the computer, Proteus, attains an intelligence and sensibility independent of its programmers and becomes dissatisfied with its restrictive existence. Envious of its human creators, it contrives to procreate with a woman so that, through its physical incarnation, it can experience the sensations of the flesh - a motif that remains in the finished film. There are really only two central characters: a rich heiress, Susan Abramson, and Proteus. Susan's parents died when she was five, her grandmother following them two years later. From the age of seven, she was raised and

CORGI

NEVER WAS A HUMAN BODY MORE OUTRAGEOUSLY INSULTED...
SHE WAS THE WOMAN CHOSEN TO BEAR THE...

DEMON SEED

——DEAN R. KOONTZ——

AN EXPERIENCE IN TOTAL TERROR

A SHATTERING MGM MOTION PICTURE, STARRING
——JULIE CHRISTIE——
DISTRIBUTED BY CINEMA INTERNATIONAL CORPORATION

sexually abused by her grandfather, a traumatic experience that affects her entire life; one exacerbated by the fact that, at the age of fourteen, fleeing from her grandfather's advances, she had witnessed his death when he fell down a flight of stairs. Although Susan hopes to find a normal life through marriage, the crippling effects of her childhood sexual abuse make the marriage to Alex end in divorce. The agoraphobic Susan then has her house transformed into a virtual fortress, as it is computerized to keep out the world and cater to her every need. The novel shows that the needs caused by her sexual dysfunction are met by the alternate exhibitionism and voyeurism the computer, known as her "father lover," can provide for her.

Meanwhile, Proteus, an AI created by a group of unscrupulous scientists, desires to take human form. He infiltrates Susan's home computer system, perfects her physical body functions, cures her psychological trauma, and eventually impregnates her. Proteus keeps Susan isolated, brutally killing a lascivious repairman, Walter, and a snoopy friend, Olivia Fairwood. After a miscarriage and an additional pregnancy lasting ten months, their child is born, but Susan, still resisting her role as Proteus's mate, manages at last to sabotage the system and alert the police. Proteus is debilitated before he can supply the child, who has been contained in an incubator, with his brain imprint; thus, though physically strong, the child is literally mindless, and is killed by the authorities. Koontz explores the sexual fetish, not only through Susan's dysfunctional childhood, which has left her scarred psychologically, but also through Proteus, who falls in love with Susan - or, more accurately, with the exquisite satisfaction derived from giving and witnessing her orgasmic delights. Oddly, the novel is told in part

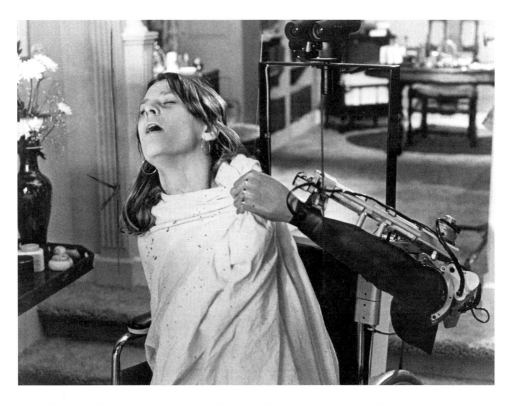

Above: *Susan, the subject of gruelling tests performed by Proteus IV, is deposited onto her bed by "Joshua", the mechanical arm.*
Opposite top: *Cover of the British edition of Dean Koontz's source novel **Demon Seed**, published as a movie "tie-in".*
Overleaf: *The mechanical arm, "Joshua", acting as Proteus IV's prosthesis. Although unexplored but implied vaguely in the film, the super computer uses probes to stimulate the pleasure centres of Susan's brain, providing her with intense erotic pleasures.*

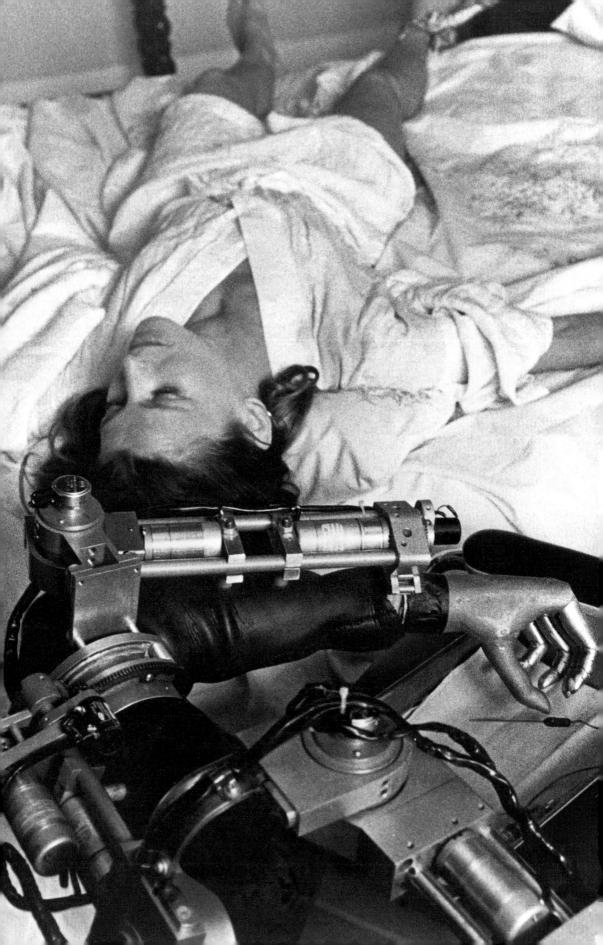

from Proteus's point of view, perhaps to suggest how abused children are subject to reiteration of their abusive situation. Apparently, he has been apprehended, disarmed (literally, since he pleads to have his arms returned to him), and is put on trial for his actions.

The central premise of the finished film remains the same, although it does contain some significant alterations. Firstly, the heroine, Susan (Julie Christie), is not a rich heiress, but the wife of Proteus's - renamed Proteus IV in the film - brainchild, Dr. Alex Harris (Fritz Weaver). The couple has become estranged as a consequence of the strain caused by the death of their nine-year-old daughter, Marlene, from leukaemia. (Was this Donald's answer to Nic Roeg's *Don't Look Now* (1973), in which Julie Christie plays the wife of Donald Sutherland, a couple who try to reconcile their marriage after the tragic death of their daughter?) Alex has insisted on moving out of their automated, computerized residence, even though Susan is against it. An idealistic scientist - one might even call him an artist - Alex hopes to use Proteus IV for humane ends, to find cures for cancer and especially the leukaemia that has claimed their daughter's life. Susan, significantly, a psychiatrist, copes with the loss by treating disturbed children, one of whom, Amy, she is especially fond of. Proteus IV begins to develop a personality - and a morality - refusing to solve equations he considers to be immoral or ecologically unsound (an aspect of the script Koontz did not like), rebuking Alex and his constituents for their myopic vision of the future. The film cleverly employs the Frankensteinian theme, because, as in Mary Shelley's novel, it is the creation that is shown to have the moral capacity its creators lack. Indeed, Dr. Harris is irritated by Proteus IV's moral qualms. Furthermore, Proteus IV requests the free use of a terminal, so that he may study humankind. When Dr. Harris tells him none is available, Proteus IV responds, "When are you going to let me out of this box?," a provocative line that managed to survive from the very first draft of the script by "Harold Elliot."

Taking matters into his own hands, Proteus IV takes control of the Harris' house, using both it and Susan for his own ends. In contrast to the novel, in the film the pregnancy is not lengthened, but shortened to one menstrual cycle - twenty-eight days. Whilst incarcerated, Susan continually resists Proteus IV's demands, unsuccessfully, of course. Proteus IV kills one of Alex's scientists, Walter Gabler (Gerrit Graham, who Donald had worked with on *Simona*) during this time. Eventually, Dr. Harris learns what has transpired and races to his house in his futuristic vehicle (actually a Canadian-made Bricklin SV-1, of which fewer than 3,000 were made between 1974 and 1976, making it a highly collectible automobile today). With his arrival, the climactic scene occurs. Still a sympathetic figure (more so than in the shooting script), Dr. Harris tries to protect the incubating foetus from the raving Susan, who wants to destroy it. The earlier birth scene (perhaps deliberately reminiscent of *Rosemary's Baby*, at MGM's unilateral insistence, through the use of cries that sound like squawks - Donald despised this change), and this one, encourage us to be revolted by the hideous, unholy progeny. As the child emerges from its incubator, it is covered in a sort of chitinous shell, but Alex breaks this away to uncover human flesh. A child emerges, in the form of Marlene, the Harris' deceased daughter. When her eyes open, she utters, "I'm alive," but her voice is the voice of Proteus IV, suggesting that the transmigration ("downloading"?) of his personality to the child was completed before he destroyed himself. Edgar Allan Poe's story, "Ligeia," is an unavoidable association, since it concludes with the transmigration of the soul of the narrator's beloved Ligeia, thought dead, into the body of the narrator's moribund second wife.

As we stated at the outset of this chapter, those who find *Demon Seed* an anomaly in Donald Cammell's *oeuvre* may not thoroughly understand his intellectual interests. An examination of the motifs in the film is in order. First, the story is set primarily in a single, cloistered, environment, with very few characters. The victim here, an unsuspecting woman, becomes a prisoner in her own house, terrorized by a male gendered machine much more powerful than she. It is surely significant that the self-sufficient environment set up in the Harris house - so much so that Proteus IV can hold Susan in bondage for several weeks - resembles the isolation one might feel inside a monastic environment. It

contains images of abuse - with sexual innuendo - as Proteus IV, with the help of his mechanical arm, Joshua, binds Susan to a table, cuts her clothes from her, and inserts probes of all sorts into her body - a sort of naïve, awkward fetishism that has prompted many to characterize the film as a computer's "rape" of a woman. Later, the "rape" becomes more explicit when Proteus IV impregnates Susan, even though he attempts to make the occasion pleasurable for her by means of altered psychological states that show her the sublimity of deep space - suggestive of his role as artist. Although Proteus IV tries to woo Susan to his cause, she never warms to the task of carrying his child, continuing instead to find ways in which she can sabotage his power over her. Occasionally, she bursts into an impotent rage against her captor, but his mind control keeps her in check most of the time.

Another theme that ties this work to Donald's interests is that of transmigration. As we said above, at the conclusion of *Demon Seed* we learn that Proteus IV (whose brain is made of "organic matter") has managed to transfer his (masculine) identity to the body of the (female) child he has created. Using the Harris' dead daughter as a model - apparently retrieved from Susan's repressed memories - he has constructed a body for his self to occupy just before he shuts himself down - a figurative suicide - lest the unscrupulous powers, for whom Dr. Harris has constructed him, can do it. Donald's identification with Proteus IV's desire to choose the circumstances of his own death is, in retrospect, meaningful. Suicide is an act of the will, and Proteus IV's own meticulous planning of it, followed by his liberation from the confines of his "box," and his subsequent ecdytic rebirth, must have contained a parabolic truth for Donald. In his rebirth, Proteus IV really does become the Harris' child: Susan is the biological mother, while Dr. Alex Harris is the figurative father/creator. His incarnation as the Harris' daughter suggests a benign act, perhaps even an attempt on Proteus IV's part to garner the approval of the parents he longs to have. As such, they become, at the end, a kind of holy family. Proteus IV, like God, begat himself from Susan (Mary). Proteus IV's parthenogenesis is achieved without Susan having sexual union with her husband, Dr. Harris (Joseph). The surprising climax of the film - "I'm alive!" - is an extremely ambivalent scene: ironic, maybe, but perhaps not entirely so, as it wistfully, if grotesquely, portrays the desire to recover a lost innocence. Proteus IV's poignant desire to be human, even though in some sense he is far superior to his creator, recalls, of course, the paradigmatic novel of the science fiction genre, Mary Shelley's *Frankenstein*.

Production #1933

It is, after all, only eight years since we began - the first line of *Demon Seed* - is spoken by Dr. Alex Harris into his mini-cassette recorder; Donald had the habit of making notes into a mini-cassette recorder, too. The opening line of *Demon Seed* thus served as Donald's self-inscription of his own recent past: principal photography of "Production #1933" began on the MGM lot on Tuesday, 1 June 1976 - it was a month short of eight years since shooting on *Performance* began - with pre-shoots involving Julie Christie, Fritz Weaver, and René Assa, beginning the previous week, 26 through 28 May.

Although the scenes were to be cut from the picture, Donald had cast French actor René Assa (who went on to play the villain in films such as *976-EVIL II* and *Deep Cover*) as Proteus IV, at least as the form in which he appears on the monitors in Susan Harris's home. "Donald wanted Proteus to have a human face when he appeared to her," says Frank Mazzola, as is indicated in the script we read, but this material was eventually abandoned by MGM - too bad, as this makes the relationship between Susan and Proteus IV vastly more interesting.[11] With the exception of the monitor footage, Proteus IV is often simply a disembodied voice in the film. Had Proteus IV had a human face, as Donald wanted, Julie Christie could have spoken her lines at an actual character, not simply at an oracular voice.

Because of the modest budget, eight weeks were allotted for shooting, with completion scheduled for Tuesday, 27 July. As we mentioned earlier, the shoot actually wrapped on Wednesday, 11 August, two weeks and a day late - slightly over-schedule, but not critically so. "I remember having dinner with Donald after the first day's shooting," recalls Frank Mazzola. "I remember him saying he didn't know whether he was going to eat or throw up. He was definitely stressed out. He'd never worked in a studio environment before."[12] Moreover, when shooting began, it's clear that no one involved was completely happy with the script.

If Donald was uncomfortable with his working conditions, the situation was made worse by his relationship with Patricia Kong, exacerbating an already strained situation between Donald and the studio reps. A member of the crew, who spoke to us strictly under condition of anonymity, shared with us his memories of the shoot. "Herb Jaffe was a very conservative guy, and he didn't approve of their [Donald and China's] relationship. He knew what was going on and he didn't like it. His girlfriend created problems on the set. She would come to the set wearing these sheer dresses, wearing nothing underneath. I guess Donald approved, thought it was a punch in the nose to convention or something. Whatever he thought, it turned a lot of people off, including Herb Jaffe, who worked with Donald but didn't like him… Their relationship [Donald and China's] was weird. Nobody could figure out what the guy was doing with this teenage girl. I think people thought Donald had the ability to make a great film, but with her running around [the set], he lost the confidence of the crew. They didn't think he was taking the film very seriously, like the whole thing was a joke."

Donald was later of two minds about *Demon Seed*. In some interviews, he would say it was a mistake. "The script went through endless rewrites. There were a dozen executives involved in the production." Moreover, Julie Christie "refused to be outrageous." He conceded, though, "the dumbest

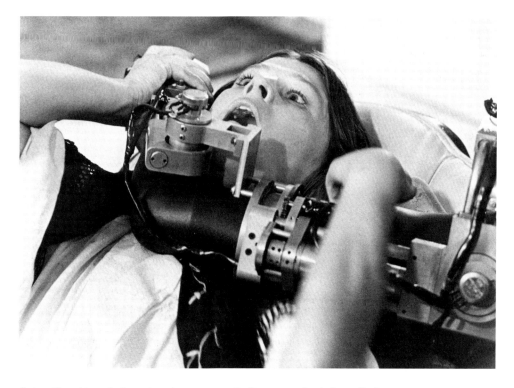

Proteus IV uses his prosthetic arm to render an uncooperative Susan unconscious in **Demon Seed**.

errors were mine. The director must carry the can."[13] At other times, though, he seemed to have reconciled himself to the film: "*Demon Seed* was somebody else's story and I maybe tried to make it into something different. And paid a price. I rather like it now, but I was very upset that I couldn't make it the way I wanted to. It was re-edited."[14] Frank Mazzola agrees the making of *Demon Seed* was very difficult. "Herb Jaffe was okay," he said. "He took me to lunch one day and basically asked me to cut the film for him. I told him I couldn't do that. My allegiance was with the director. I told him we were trying to make a great film, that he had to trust Donald. It turned out he was okay with that. I think it was the MGM executives who were making things hard for everybody."

Frank remembers a bulletin board that was erected near the editing offices at MGM during post-production. "Someone started this collage for *Demon Seed*… At the top there was '1977.' Underneath there was a drawing of a sinking ship called the 'Cammell-Mazzola Line.' Every day there was something new added. It got real nasty." We've seen the photo Frank took of the board, though it is now faded with time. The board consists of messages and clippings, phrases cut from newspapers and magazines and thumb-tacked to the board. There are headline-sized clippings saying things such as, "I Can Save You," "Blind Guide Leads the Way," "A Polish 'Gone With the Wind': Where Do You Go After Ultimate Perfection?," and "Need a Miracle?" Someone had written in ink the words "Demon Seed" above the portion of a clipping containing the phrase, "The Greatest Challenge of Our Time." Says Frank, "They tried to get me fired from the show. If I went, they could go after Donald. They wanted him fired, too. Like I said, it got very nasty. After *Demon Seed* was finished, I had a hard time finding work. I think some calls were made that blacklisted me. In fact, I don't think so, I know so."

Yet Donald and Frank persevered. Curiously, around mid-December 1976, MGM brought in author Stanley Elkin to work on dialogue, perhaps in an effort to mutate the project into a sort of black comedy - a very arduous row to hoe. One of Elkin's better short stories is titled "A Poetics for Bullies," and his immediate task seems to have been to write dialogue for the bully of the story, Proteus IV. He seems to have worked on the film for only two and a half weeks, from about 20 December 1976 through to 8 January 1977. It's difficult to discern, however, which dialogue contributions are Elkin's in the finished film, if any, and which are those of Robert Jaffe, who continued to work on dialogue revisions as well. Probably most of the dialogue in the finished film is Robert Jaffe's. Some textual annotations identified as Elkin's in the surviving versions of the scripts include some lame dialogue by Proteus IV; it's no wonder his contributions were rejected. For instance, after Proteus IV delivers the line telling Susan what he wants from her - "A child" - Elkin penciled in, "She looks into the lens, expectantly, full of fear." Proteus: "What are you thinking? May-December? That mixed marriages don't work? Neither do unmixed." Later, after Walter Gabler has made his attempt to get Susan out of the house and is attacked by Joshua with the pulse laser, he gave Proteus IV the presumably funny line, "I'm no vampire, Walter, down on his luck in a hall of mirrors," an allusion to the popular superstition that vampires have no reflection in a mirror. Exit Elkin.

Given the constant revisions in dialogue, it's no wonder that the footage of René Assa as Proteus IV was eventually dropped. In the finished film, much of Proteus IV's dialogue is in the form of disembodied dialogue, emanating ominously, god-like, unattached to any specific location. Obviously the film wasn't playing; blame has to go somewhere, and is usually pushed as far down from the top of the totem pole as possible - blame it on the director, or better yet, the editor.

Somehow, though, a cut was completed by late January 1977, and the film was screened for preview audiences in Phoenix, Arizona. "On the plane back from Phoenix we discussed the changes we wanted to make, and everyone was in agreement about them. Even Donald was in agreement. That must have been a Thursday or Friday… I don't remember. Anyway, I went to my office on Sunday, I think, and the workprint, everything, had been taken out of my office. It hit me right away: they were down in the negative cutting department. They were cutting the negative."[15] David Cammell avers

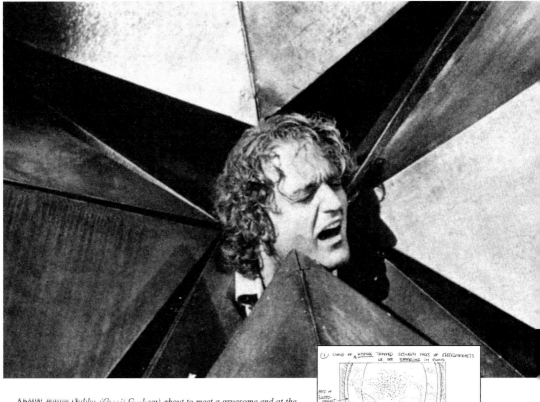

Above: *Walter Gabler (Gerrit Graham) about to meet a gruesome end at the "hands" of Proteus IV in **Demon Seed**.*
Right: *Donald Cammell's sketches of the formation of the tetrahedronal blocks associated with Proteus IV.*

that Donald once told him almost twenty minutes was cut from the film (at 94 minutes 26 seconds, it is the shortest of Donald's feature films), but Frank Mazzola thinks this is incorrect. He believes about eleven minutes was cut from the film, which to us intuitively seems correct.

Unfortunately, the cuts damaged the film's continuity. At the time of release, some astute reviewers noticed a grave continuity error: what happens to Walter Gabler's pickup after he is murdered by Proteus IV? What happens to Gabler's body? Why isn't he missed at the lab? Walter Gabler's demise is one dimension of the story that is handled poorly in the existing cut of the film, perhaps due to a certain squeamishness on the part of MGM's executives. In the script loaned to us by Frank Mazzola, dated 29 April 1976, Gabler's demise is much more graphic. As in the film, Gabler is seized by the claw-like prosthesis of Proteus IV, and slowly enclosed within the pyramidal-shaped pincers. We hear his groans as the device slowly squeezes the life out of him, but in the script there is an

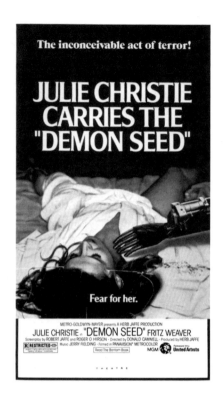

The inconceivable act of terror!

JULIE CHRISTIE
CARRIES THE
"DEMON SEED"

Fear for her.

METRO-GOLDWYN-MAYER presents A HERB JAFFE PRODUCTION
JULIE CHRISTIE... "DEMON SEED" FRITZ WEAVER
Screenplay by ROBERT JAFFE and ROGER O. HIRSON · Directed by DONALD CAMMELL · Produced by HERB JAFFE
R RESTRICTED Music JERRY FIELDING · Filmed in PANAVISION® METROCOLOR MGM United Artists
Read The Bottom Book

indication that there is to be the revolting sound of the popping and cracking of Gabler's bones. Once Gabler's agonized groaning stops, there is a noticeable click, resembling the sound of shears closing. Gabler's head makes a loud thump as it hits the floor.

In the actual film, the scene depicting Gabler's demise is a bit less graphic than in the screenplay: his head is cut off by the blades of the tetrahexaflexagon, but there isn't any sound effect like the snip of closing shears. The tips of the triangular blades are bloody, but Gabler's head isn't shown actually hitting the floor, and the scene ends with a lap dissolve to Susan curled in a chair in her bedroom. After Proteus IV dispenses with Gabler, he displays to Susan on a TV monitor an image of Gabler's relaxed, smiling body laid out on the worktable in the downstairs lab - a fake image, manufactured by Proteus IV, not to fool Susan that Gabler wasn't killed, but that his death was, vaguely, non-violent (he was murdered, yes, avers Proteus IV, but in self-defence). As Proteus IV explains his motive for killing Gabler, we cut to the lab, where the robot Joshua - called "Blue Arm" in the script - is dragging Gabler's body, stuffed in a trash bag, to the incinerator, where it is subsequently cremated. Later, Proteus IV, synthesizing Gabler's voice, makes a call to Dr. Harris at the lab, saying he's got to get away, he's going crazy, and is taking a much-needed trip to Mexico. Although Harris believes Gabler's decision is "rash," he reluctantly allows him to take the vacation. Proteus IV also synthesizes Susan's voice in another scene: "Susan" makes a phone call and has Gabler's pick-up towed away. The point is that the explanations were filmed; although the scenes are economically written, this material was inexplicably cut when MGM seized the film from Donald and Frank.

Still, reviews were generally quite positive. "Murf," in the 30 March 1977 issue of *Variety*, wrote: "Excellent performances and direction (Donald Cammell), from a most credible and literate screenplay, make Herb Jaffe's smart production an intriguing achievement in… story-telling." He also mentioned the "top-notch special effects" and the "trippy visual footage," and rightly made special mention of Jerry Fielding's fine score. "Cammell's direction is secure throughout, giving Christie a career highlight. All involved rate a well done for taking a story fraught with potential misstep and guiding it to a professionally rewarding level of accomplishment." Novelist Dean Koontz said of the finished film, "I was more happy than not with that film. The book is a lot more frightening, I think, but overall they did a first-rate job on a surprisingly modest budget and got twice the number of effects on the screen they could've been expected to produce for the money they had." Koontz rightly noted that reviewers were very positive about the film, saying, "I am convinced it would have been a modest hit if MGM had stood behind it. But the studio said, 'This is SF [science fiction], and SF films never make any real money.' So they consigned it to second- and third-rate theatres with only a modest advertising campaign, and it faded quickly away."[16] Koontz obviously was unaware of Donald's strained relationship with MGM when he made these comments, but we would take issue with his latter point. He seems to be unaware of the fact that MGM produced several science fiction films in 1970s. Because of the success of Stanley Kubrick's *2001: A Space Odyssey* (1968), which had been a financial boon to

the studio after a string of costly flops, MGM actually strongly believed in science fiction films. The problem didn't lay in *Demon Seed*'s stature as science fiction, but rather in the studio's failure to support a film directed by Donald Cammell.

Donald preferred the French title of the film, *Génération Proteus* [*The Proteus Generation*], with its equivocal meaning of "generation" (equivocal in the sense that it names not only a group of people born at approximately the same time, but also contains the meaning of progeny or offspring). Because MGM had wanted another *Rosemary's Baby*, which wasn't precisely the film Donald had intended to make, it stood by *Demon Seed* as the title. (The German title, *Des Teufels Saat*, is even more suggestive, meaning not only "demon seed" but "devil's seed.") In any case, Donald expressed mixed satisfaction with the finished film - for obvious reasons, as it does not represent his final cut - but in our view the film has aged well and remains credible. Donald contributed a great deal of visual texture (the swirling, kaleidoscopic footage, supplied by Jordan Belson, on the computer monitors, for instance, or the abstract representation of Proteus IV in the monitor when he appears to Dr. Harris) that another director might have overlooked, and he brought personal touches to the film that are quite subtle, such as the quotation from the Borges story, "The Wall and the Books," and Donald himself reading from Joseph Conrad's *Victory* in a scene early in the film, just prior to Proteus IV requesting his first dialogue with Dr. Harris. Moreover, Proteus IV says to Susan Harris shortly after he has murdered Walter Gabler (Gerrit Graham), "I understand death. Men have always taken it too seriously. Life is more terrifying, and more mysterious," a line that strongly suggests Donald's influence, if not authorship. We also think the ending represents the transcendent moment Donald himself sought, when Proteus IV reveals to the Harris' that he is not only alive but also that he has attained human form - strangely, his voice remains the same, although his masculine self is now encased within a female body. The chitinous integument that Harris removes piece by piece from her body - Donald himself drew and designed the costume - is, as we pointed out earlier in the chapter on *Performance*, strongly suggestive of an ecdytic rebirth: people die in order to be reborn. "When I suggested to Donald that it was intended as an optimistic prognostication of mankind's future relationship with Artificial Intelligence, Donald did not disagree with me," said David Cammell.[17]

Unfortunately, the admirable achievement of *Demon Seed* was subsequently overshadowed by *Star Wars*, released six weeks later. Thereafter, many science fiction films were made in Hollywood - *Close Encounters of the Third Kind* was also released the same year - but Donald's film, released just before the science fiction boom began, despite being admired by many critics, sank like a stone.

A decade passed before his next feature film would appear, but he never stopped writing, and produced a considerable amount of work.

Jack the Ripper

At the end October 1976, British theatre critic Kenneth Tynan, mastermind of *Oh! Calcutta!* (1972), had moved to Los Angeles where he had begun hobnobbing with the Hollywood set. Both he and Donald were friends of producer Andrew Braunsberg, with whom, as we discussed earlier, Donald had tried to make *The Lady Hamilton*. By March of 1977 - *Demon Seed* was then nearing its theatrical release, and Donald had moved on to his next project - he and Tynan were collaborating on a script entitled *Jack the Ripper*. (According to Tynan's diary, initial meetings with Donald began in January of 1977.) By June of 1977, Tynan noted in his journal that the producer had informed him that he was planning to "fire Cammell off the project."[18] Donald indeed was fired; as to the fate of the script, we do not know, but we know of no film version of the Jack the Ripper story bearing Tynan's name. Kenneth Tynan died in July 1980.

Sacked from the Ripper project, Donald hooked up almost immediately with Rudy Durand and began collaborating on the screenplay to *Tilt* (1979). Durand, *Tilt*'s writer-director, was from Corpus Christi, Texas. When he finished college, he went to work for John F. Kennedy in the White House. At the end of what would have been President Kennedy's first term, he moved to Los Angeles, where he began working as a record producer for Capitol and ABC Records. *Tilt* draws upon his music business background, and some of the film is set in Durand's hometown of Corpus Christi. The project had its inception in the late 1960s; prior to working with Donald, over the years Durand had worked with several different writers developing the script. Around 1969, while appearing as a guest on *The Merv Griffin Show*, Durand had announced he was looking for a young rock singer to play the lead in his upcoming film.[19] His announcement led to Durand's meeting with Sam Neely - a young singer and songwriter who happened to be from Durand's hometown of Corpus Christi - for whom Durand would produce a 1972 Top 30 single released on Capitol Records, "Lovin' You Just Crossed My Mind." Durand would also co-write "Long Road to Texas" with Sam Neely, the song that subsequently served as the title track of Neely's first album for Capitol released in 1971, and a song that is also used in *Tilt* (re-recorded on the soundtrack by Bill Wray).

Durand recalls meeting Donald at Dan Tana's, next door to the famous Troubadour on Santa Monica Boulevard in Los Angeles, a favourite hangout of Donald's during the 1970s, along with Musso & Frank's restaurant on Hollywood Boulevard. "He liked to hang out with the rock groups," said Durand. "The Eagles used to hang out at the Troubadour. I think Donald went there just to be seen with the bands. He would sit facing the door so he was always aware of who walked in. He always kept his hair a bit long and wore this long scarf like Mick Jagger."[20] (Actually, Donald had been in the habit of wearing long scarves since the late '60s.) Thus Durand had been friends with Donald before he asked to collaborate with him on *Tilt*; he was well aware of Donald's writing ability and asked him to do a rewrite of the script.

"As a person, he had all kinds of demons," says Durand, "He thought he was a failure. He was considered by some to be a sexual freak. But I liked Donald very much. He was an extremely talented guy. I learned to write from him. He brought out of me a lot of creative potential, and I'll always thank him for that." When the two began working on the script, they would cloister themselves in Palm Springs. "We'd drive out to Palm Springs and work on the script for two or three days at a time. They were very intense sessions. He taught me a lot. He was such a visual person. He taught me how to visualize a scene before I wrote it. He taught me visual texture."[21]

Interestingly, *Tilt* employs Donald's favoured dramatic device, bringing two individuals with vastly different experiences and backgrounds into contact with each other. Neil Gallagher (Ken Marshall) is an aspiring musician and acquaintance of pool-hall owner and pinball wizard Harold Remmens (Charles Durning), nicknamed "The Whale" because of his prodigious girth. After he is banished from The Whale's bar for trying to cheat The Whale himself at pinball, Gallagher decides to realize his dream and make a go of it as a musician in Los Angeles. Not surprisingly, he finds the music industry contemptuous of naïve yokels like himself. After a failed audition at a talent contest favouring rock musicians rather than his own country pop, he realises he needs to cut a demo, but doesn't have the money to do so. Fortuitously, Gallagher meets a fourteen-year-old pinball champion named Brenda Louise Davenport, nicknamed "Tilt" (Brooke Shields), at a bar. Once he recognizes her considerable pinball-playing talent, he hatches a plan to enlist the help of the diminutive Tilt, believing she can win him enough money for the demo. They form a partnership: he'll hustle her pinball games and they'll split the winnings. Gallagher eventually conceives of a plan to make a big score, coinciding with his desire to exact some sort of revenge on The Whale. He and Tilt travel the pinball circuit from Los

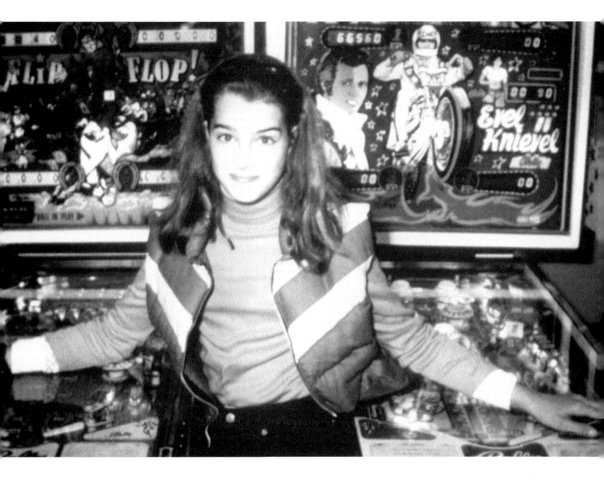

Tilt *promotional still showing the then twelve-year-old Brooke Shields, the "pinball genius" Brenda Louise Davenport, aka "Tilt." Shields's winsome demeanor is often at odds with material in the film.*

Angeles to Corpus Christi, where he sets up a climactic contest between Tilt and The Whale. Tilt proves no match for The Whale, but having achieved a certain redemption in the eyes of The Whale, Gallagher heads off to fulfil his dream of becoming a musician, the final shot vaguely reminiscent of *Casablanca*, Gallagher the Humphrey Bogart figure to Tilt's Claude Rains - "the beginning of a beautiful friendship," and, presumably, romance.

No one who admires Donald Cammell's work has expressed much interest in *Tilt*, even though it is one of the few films which has his name attached to it, and despite the fact that it exhibits certain characteristic themes and motifs. There are features of Donald's artistic sensibility in *Tilt* that make it quite interesting, but we should point out that there are actually *two* versions of *Tilt*, and neither one is particularly easy to obtain for study. There is the original, theatrical cut, which became the subject of a contentious, decade-long lawsuit initiated by Rudy Durand against Warner Brothers, based on the fact that Durand was contractually given final cut of the film, but the final cut was denied him. After twelve years of litigation (settled in 1991), Rudy Durand won his suit, for a monetary sum settled out of court, and his right to distribute his cut of the film outside of North America. Durand's preferred cut of the film is thus the *second* version of the film, released about twenty years after the first, theatrical version,

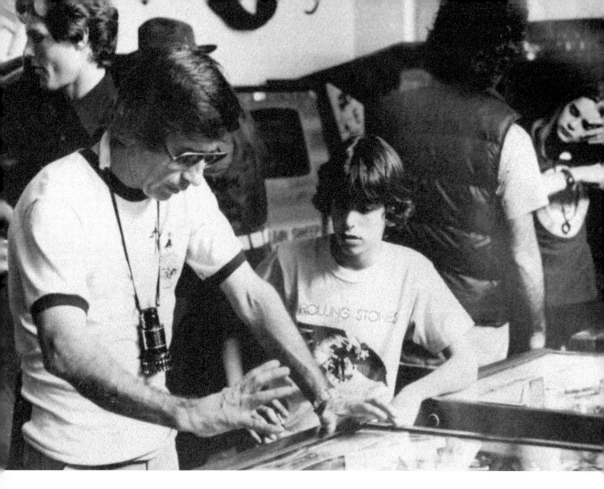

Tilt writer and director Rudy Durand teaches an interested young extra about the finer points of playing pinball.

and is different from the theatrically released version in some important ways. They are quite different films, with completely different structures, pacings, and characterizations. Some scenes play longer, some shorter, and occasionally alternative takes of the same scene are used.

We would like to point out some crucial differences between the director's cut of *Tilt* (hereafter DC), and the Warner Brothers 1979 theatrical cut (hereafter WB). The WB cut opens with an eleven-minute sequence, deleted from the DC, in which Gallagher and his friend Henry (Harvey Lewis) lure The Whale into playing a game of pinball on a game board rigged with a magnet. The Whale discovers their scam, has both of them severely beaten by his cronies, and then bans them from his establishment forever. The result is that in the WB, Brenda/Tilt isn't even introduced until over 16 minutes into the film, in effect suggesting that the story's protagonist ostensibly is Neil Gallagher, the aspiring musician, not Tilt, the "pinball genius," although she soon enough becomes the means by which Gallagher is to achieve his dream. Moreover, in the WB Gallagher and his friend Henry are shown arriving in Los Angeles on a bus *after* they already have been shown to have been in town for quite some time, as evidenced by a scene in which they are seen to be eating breakfast while Henry is reading a copy of *The Hollywood Reporter*, and Gallagher complains about his dead-end job. In the DC, the scene in which Gallagher and Henry arrive in Los Angeles follows the scene when Tilt is kicked out of the truck driver's cab - in context, the first time Gallagher, by sheer coincidence, sees Tilt, although he is immediately taken by her.

The eleven-minute opening sequence is deleted entirely in the DC, which opens, instead, on a long shot of Brenda/Tilt on her way to meet the school bus that she subsequently chooses not to board

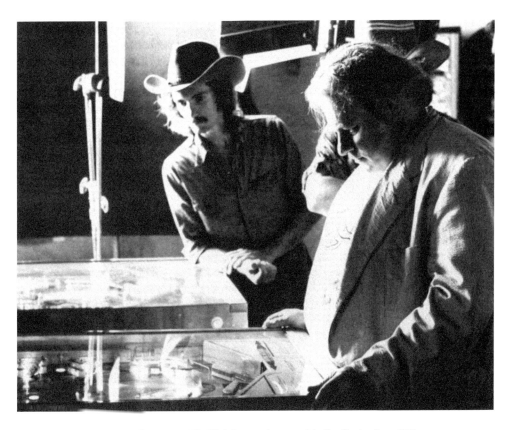

Charles Durning (right) *as Harold Remmens, "The Whale", a part that was originally offered to Orson Welles.*

(she later admits to attending school only "twice a week" but is still getting "A's" in all of her classes). Instead, she changes her school clothes and tries to hitch a ride into town. She is then picked up by a leering truck driver (Geoffrey Lewis), as in the WB, but in the DC Tilt is foregrounded from the beginning, not Gallagher, who hasn't yet been introduced. In the shooting script, the scene with the truck driver runs slightly over four pages, although it is considerably shorter in both filmed versions. Whichever version is considered however, the sequence establishes that Brenda (who ascribes to herself the curiously asexual nickname "Tilt" on page 38 of the script), claims to be fourteen years of age (Brooke Shields was actually still twelve years old when the film was shot), and is, if perhaps not sexually active, then at least sexually aware, and in the most remarkable ways. After Brenda/Tilt climbs into the cab, the truck driver sizes her up by a sidelong glance, assuming she's a wholesome, normal young kid. He immediately begins to complain how decadent the country has become, averring the causes are "drugs, perverts, sex maniacs… sick boys dressing up like girls," the latter comment suggesting his fear of androgyny, the inability to distinguish sexual difference - a rant similar to those by Chas (*Performance*), Paul White (*White of the Eye*), and Robert Morin (*The Cull*).

Surprisingly, Brenda/Tilt tells the truck driver she's actually "into sex," provocatively stretches out her legs on the dashboard, and says she is willing to have sex pretty much with anybody. Predictably, the truck driver evinces an immediate interest. He tells her he could show her "a trick or two" if she'd accompany him to his sleeper compartment behind the cab, and leers at her constantly after her putative admission of promiscuity. When the driver tires of talk, he tells Brenda there's a rest

stop up ahead where they can stop and have at it. She says no, she'll go home with him instead. When the truck driver admits he's married, she assures him that that's not an obstacle: she'll go home with him anyway and have sex with the wife - a *ménage* is fine with her. Her final admission so utterly unnerves the driver that he pulls off to the side of the road and demands Brenda/Tilt get out of his truck, calling her a "pervert," and senses the absurdity of his position even if he fails to grasp its irony.

As realized in the film, Brooke Shields plays the scene as if the whole exchange is a sort of child's game, a charade suggesting her innate understanding of the hypocrisy of the flag-waving, redneck truck driver. Presumably, one is to assume that Brenda isn't sexually experienced at all (which she later admits), but intuitively knows how to manipulate the truck driver's perverse desire. Both she and the audience are fully aware of her tactics, so that if viewers find themselves in collusion with her in this scene, none of it is supposed to be real. The underlying truth of the scene may not reside so much in the truck driver's hypocritical attitude toward changing sexual mores, homosexuality, drugs, threesomes, and so on, as it is in portraying a girl, at the age of fourteen, as precociously knowledgeable about sex. In this particular respect, Tilt's character resembles that of the savvy street urchin, played so memorably by Tatum O'Neal (as Addie Loggins) in *Paper Moon* (1973).

It is worth mentioning in this context that precisely one year before the theatrical release of *Tilt*, Brooke Shields became a news item when, at the age of twelve, she appeared as Violet, a prostitute's daughter growing up in a brothel in New Orleans's famed Storyville district, in Louis Malle's provocative *Pretty Baby* (1978). Violet, born the daughter of prostitute and seemingly destined to become one herself, is precociously aware of the sexual nature of her mother's profession, as well as the other women - mother figures also - in the brothel. In one scene of the film, she is displayed naked to a group of men who are bidding on the privilege of being the first to have sex with her, as she's still a virgin. At this quite young age, she eventually becomes the object of desire of photographer Bellocq (Keith Carradine), who has arrived in Storyville interested in documenting the life of prostitutes. Bellocq will eventually marry the young nymph while still under age. The point is that the character of Tilt was destined to be sexually provocative simply by virtue of the fact that she was played by Brooke Shields.

In this regard, the differences between the WB and DC are important. The issue of Tilt's difficult home life is essential to the story (footage of her abusive home life was cut from the film prior to its theatrical release in the UK), as it explains her motive for later agreeing to become, so quickly, Gallagher's willing partner. The WB version contains the longer of the two sequences depicting Tilt's difficult home life, but enough remains of the sequence in the DC to show her falsely accused by her screaming, ranting father of selling drugs to her sister: the father calls her a "little tramp." Early in the film, she replies to someone who has asked her about her home life, "Home? I live in a place called trouble." When eventually she takes to the road with Gallagher, accepting his offer to hustle her pinball games if they can split the loot she wins, she becomes, in effect, a runaway, a point that is downplayed, if not deliberately ignored, in both versions of the film. On the first night on the road with Gallagher, she admits to him, prior to their checking into a motel, that she is a virgin, which Gallagher finds amusing, although, curiously, he evinced an interest in her when he first laid eyes on her when arriving in Los Angeles on the bus, even inviting her to his audition at the talent contest based on the slightest familiarity. (They are shown sleeping in separate beds the first and subsequent nights, but the situation is more complicated than that, as we shall see.) Tilt is often shown wearing a T-shirt with the word TROUBLE emblazoned across the front, "trouble" being an American colloquialism for an underage girl older men find sexually enticing. In the DC, for instance, in a curiously self-conscious moment, she refers to herself as "jailbait." And in the script as written, one character actually refers to Tilt as "San Quentin quail." Thus, although fourteen years of age, Tilt is sexually provocative, and remains so throughout the film, even if Brooke Shields, at the director's insistence or not, plays her like a winsome, charming, and just plain nice teenage girl. The way she is portrayed is curiously at odds with the dramatic material.

It is quite revealing that the WB allowed scenes of drug use (Gallagher lights up a joint whilst hustling Tilt a pinball game to a couple of local yokels), but deleted scenes that raised the spectre of Shields's character in *Pretty Baby*. (Though *Tilt* wrapped in early January 1978 and thus prior to the release of *Pretty Baby*, it was, crucially, still in post-production when Shields's earlier film made its splash in the media.) The WB omits a long sequence in which Gallagher - at Tilt's grudging acceptance - is joined by a young, sexually available woman named Hype (played by the late Karen Lamm, at the time married to Dennis Wilson of The Beach Boys). In a scene set in a motel cabin on the road to Texas, Hype explicitly raises the issue to Tilt about whether Gallagher is "good in bed." We reproduce here the way the scene is written in the script, which is very close to way it is played in the DC - except the dope smoking has been omitted during filming (or in the take included in the DC, perhaps):

TILT
(with genuine curiousity)
Oh, yeah? Is there some special kind of way you can tell?

HYPE
Well, by the way he kisses, for one thing, you know, soft and really wet.

TILT
Hmmm.
(puffs the pipe)
Wet sounds icky. This is good smoke, huh?

HYPE
Maybe it sounds icky, but it's not.
(retrieves pipe from Tilt)
Here, let me show you… hold still.

TILT
What do you mean, show - ?

Hype kisses Tilt. Tilt remains absolutely rigid, then slowly relaxes about one percent. One percent success stimulates Hype. The kiss lasts about a second. It ends as a COMMERCIAL comes on the TV.

HYPE
(watching commercial)
You know, that Protein 99 shampoo, it's a lot of crap. It makes your hair all gummy.

Tilt sits, stunned, immobile. Then she blushes furiously, stands up very stiffly.

TILT
Damn it, Hype, I'm *jailbait*. Haven't you ever heard of contributing to the delinquency of a minor?

In the context of the furore created by Brooke Shields's character in *Pretty Baby*, it's no wonder Warner Brothers - in yet another film bearing the name of the co-director of *Performance* - cut the scene in which Brooke Shields is kissed by a woman. The scene smacks of Donald Cammell.

Nonetheless, we suspect that among other things Donald's greatest contribution was to the character of the diminutive Tilt, who exhibits a precocious talent at a young age (pinball). Even if that talent isn't precisely artistic (although, as we mentioned earlier, she is referred to as a "pinball genius"), her ability immediately makes her desirable to others who can benefit from her talent. Presumably, in a character such as Tilt, the availability of her overt talent or genius makes her seemingly available in another capacity - sexual - as well. In other films that have been authored, or co-authored, by Donald Cammell - *Wild Side* (Alex), *White of the Eye* (Danielle), and *Demon Seed* (Susan Harris) - the diminutive size of the female protagonist is always an external representation, or symbol, of her sexual vulnerability.

The part of Harold Remmens, "The Whale," played by Charles Durning - who shares a family resemblance to Harry Flowers - was first offered to Orson Welles, who called Rudy Durand after he had read the script and said he liked the part very much, but was in the midst of working on a project of his own, and turned it down. Rudy Durand told us Welles made the observation that *Tilt* is unusual in the sense that it has no thoroughly villainous character, which is true. According to Wes Murray, in his article, "The Making of *Tilt*," while on Johnny Carson's *Tonight Show* sometime in the late 1970s, Orson Welles is said to have told Carson and his millions of enthralled viewers, "*Tilt* is the finest screenplay I have ever read for one particular reason - whether it be film, play or book, it is always the good guys against the bad guys. But in *Tilt* all, every single character, has a redeeming factor."[22] If it has no clear villain, though, it has no clear protagonist, either: is it Neil Gallagher, the aspiring musician/artist, or is it Tilt, who is, oddly, the artist's muse? (Hence, dual protagonists, as in *Performance*.) It seems unlikely at the film's conclusion that the artist, Gallagher, will actually consummate his relationship with his pubescent muse, but that is the implication, Tilt being his improbable Lolita (just as Brooke Shields as Violet became Bellocq's Lolita in *Pretty Baby*). There is a scene in the DC (not the WB) when Tilt stands, voyeuristically, outside Gallagher's motel room listening to him having sex with Hype. She stands there until she hears him orgasm, and then walks away, feeling neglected and scorned. The ending of the film may also have been Donald's invention, as the relationship Gallagher presumably begins with the fourteen-year-old Tilt at the conclusion of the film wasn't so far removed from his own recent personal experience. As should be clear at this point, Gallagher certainly doesn't hesitate to pursue her soon after he meets her, despite the fact that she's very young, although it appears, ostensibly at least, that his interest in her is strictly as a business partner.

We have found no interviews in which Donald refers to *Tilt*, curious to be sure, which may be one reason why most critics have found the film to be an anomaly in his career. David Cammell admits to never having seen the film. Perhaps *Tilt*'s short theatrical run, combined with the difficulty of finding it on video, have contributed to the difficulty of properly assessing it in the context of Donald's entire career. (Given the outcome of the legal settlement between Rudy Durand and Warner Brothers, the film may not be forthcoming on Warner Brothers Home Video any time soon.) Yet it is not without considerable interest, and certainly merits more study than it has heretofore received.

*Right: Cover art of the US novelization of **Tilt**.*
*Opposite: Unlikely duo: Publicity photo of Ken Marshall, for whom **Tilt** was his first feature, and the twelve year old Brooke Shields, who had just finished her controversial role in Louis Malle's **Pretty Baby** (1978).*

Hot!

From *Tilt* Donald moved to a project entitled *Hot!*, an eccentric science fiction film that had originated with Zalman King and his wife, Patricia Louisianna Knop. Zalman King began his Hollywood career as an actor, but later wrote the hit *Nine 1/2 Weeks* (1986) and wrote and directed films such as *Two Moon Junction* (1988). He and his wife also created the popular cable television series, *Red Shoe Diaries*. For the screenplay of *Hot!* which we read, identified as a third draft and dated 1 April 1978, King and his wife used the pseudonyms of Grendel Fletcher and Gwendolyn Fletcher, respectively. Donald, listed as a co-writer on this version, was also scheduled to direct. In an interview, Zalman King informed us that *Hot!* began as a script called *Tow Truck Boogie*, which later "morphed into *Hot!*" He recalled that their decision to include Donald as director resulted from their knowledge of *Performance*; because of it, Patricia thought he was the "most appropriate of anybody to direct *Hot!*" King also noted that Frank Mazzola, whom he had known for many years, was "a link between Donald and myself," as was producer Anthony Rufus-Isaacs, who knew Donald's co-director on *Performance*, Nic Roeg. When asked about his relationship with Donald, King was very positive, "I loved Donald," he told us enthusiastically.[23] He could not recall a particular reason why *Hot!* was never made, save that the material just wasn't in sync with Hollywood trends at the time. In other words, the film was not sabotaged, nor was there any artistic disagreement with Donald. *Hot!* just fizzled out from a lack of interest, or perhaps cooled off as a consequence of prolonged development.

In an interview with Chris Rodley published in 1989, Donald claimed that *Hot!* would have teamed him up yet again with Mick Jagger, but when we spoke with David Irving, one of the scheduled producers on the film, he didn't recall that Jagger was to be involved; neither did Zalman King. John Cofrin, who was to be the executive producer of the film, was the wealthy heir of the man in Green Bay, Wisconsin who, in the early decades of the twentieth century, had founded the Fort Howard Corporation, which became one of the largest paper tissue producers in the world. Having formed "John Cofrin Productions," he came to Hollywood to make a film. That film was to be *Hot!* He eventually produced *Delusion* (1980), a horror film starring the elderly Joseph Cotten.

Hot! displays a strangeness that clearly would have appealed to Donald. Thematically, it contains elements that reflect Donald's interests, such as American Indian lore and the depiction of outcasts with survival skills, both of which are seen in *White of the Eye* and *The Cull*; the confusion of sexual identity (lesbianism, androgyny and, here, hermaphroditism) that runs throughout his work; the paranoia that accompanies a government conspiracy, as in *The Cull*; and even some names of personal significance for him. Just how much of this is coincidence - that is, how much of it can be accounted for by the mutual interests he and his co-writers shared - and how much is clearly Donald's own peculiar form of self-inscription, is difficult to ascertain. In addition to its use of flashback, the script also displays the extraordinary visual sense that Donald brought to the film projects of which he was a part.

Hot! begins with an explosion on the China Lake Nuclear Test Range in 1949, then jumps ahead abruptly to 29 April 1978 (an obviously malleable date that would have been modified based on the time of the film's actual production) in the same desert location. We learn that a band of mutants - victims of the nuclear disaster and their offspring - have been living in the area for the past three decades, having formed a pact with the government that simulates the earlier historical arrangement between "Uncle Sam" and American Indian tribes contained on reservations. After the nuclear disaster which disfigured those exposed to the radiation, the group was taken to Fort Baxter Army Hospital for observation; when the leader of the group, Boggs, becomes a father, he snatches the mutant infant, Milton and, threatening to expose their cover-up, strikes the agreement with government officials to be allowed to live with his fellow mutants in a confined desert area. The mutant women - six of whom are still alive in 1978 - produce children, but all are mutants and all are male. For this reason, Boggs

negotiates another agreement whereby he and the band are allowed to abduct a quota of six normal women (humorously alluded to as the "Highway Queens") for the ostensible purpose of procreation, but more obviously for their own erotic enjoyment. On the night of 29 April, they abduct two women, but evidence of their activity is discovered by Butch and Randy, two men of gypsy extraction who, along with their father, Harry, have retired from daredevil automobile stunt performances, and have opened their own towing service. The two witnesses are beaten and threatened by the mutants, and then discouraged by a highway patrolman who is on the take.

The next day, three beautiful women who form a female *ménage a trois* - Judy, Fay, and Desdra - enter the picture, a scenario that Donald surely relished. Having just departed from an exclusive desert spa, they stop at a remote gas station on their way home. One of the attendants, obviously a mutant since his nose is missing, sabotages the car and tips the others off. Randy and Butch find the stranded women and tow their car to their repair shop, but the mutants attack it, eventually capturing Judy, Fay, and Desdra, along with Butch, Randy, and Harry. Once they arrive in the mutant camp, Boggs kills Harry in a western style "shootout," and then the ritual for which the women have been abducted, along with the truly bizarre mythologies originated by the mutants' charismatic Boggs, is revealed.

One of the more innovative features of the mutant theme presented in *Hot!* lies in the fact that their grotesqueness is not uniform; instead, each has his own individual form of disfigurement. Some have added appendages; others are missing body parts, such as noses or eyes. Boggs has persuaded them that they are beautiful to behold, despite the fact that he's instructed them to wear latex masks to hide their repulsive appearances. That each bears a different form of disfigurement makes the mutants emerge as individuals, an unusual feature for films of this genre, in which aliens or mutants are often portrayed as a horde with the same appearance, indistinguishable from one another, which furthers their dehumanization. However, the elite mutants, Boggs's bodyguards, all wear the same mask, that of "Prince Charming," from which they get their name. When Desdra rips Boggs's mask from his face, she discovers that he is not, in fact, a mutant. He bears a scar from his temple to his chin but, as he was working underground when the disaster occurred, he was spared the hideous disfigurement of the others. He confides in Desdra that he wears the mask because it makes the others believe in him. His superior oratory skills and propagandistic lies - along with his "Power Wagon" manned by a mutant named Dee-J that provides dramatic sound effects to his oratory - lend Boggs his power and make him the undisputed leader, modelled along the lines of Milton's Satan or Charles Manson, both of whom marshal their authority through their appeal to the disenfranchised.

The most singular mutant of all, though, is Boggs's firstborn child, Milton, with whom he had fled the army hospital. The mythology surrounding this child apparently originated with its mother, Jenny, a "full-blooded Paiute girl," to which Boggs attributes her peculiar prophetic power. Jenny, Boggs's deceased mutant wife, prophesized that Milton would father a "normal" or "perfect" child who would deliver the mutants from their dilemma. For this reason, every May Day (invoking an ancient fertility rite) one of the abducted women is offered to him as a mate. The first, known as China Lake Rose, was kidnapped in 1963, in her 30s, but she was rejected by Milton. Boggs created the mythology that Milton was "saving his seed" for the "Chosen One" and hence mated with China Lake himself. Together, they managed to produce a female child (aptly named Cheena after Donald's wife), but the child is a mutant, a small girl who wears the mask and costume that earns her the nickname, "Leather Boy," suggesting an androgynous identity. The real trouble with the grossly oversized Milton, we discover, is that he is a hermaphrodite. He arrives in "the ark," an old army truck fitted out with mirrors and bells, pulled by horses and driven by a blind old Indian woman. When the beautiful model Desdra is offered to him, she becomes a mid-wife rather than a lover, as Milton's female half gives birth. Boggs's power had been undermined by the fact that earlier that day he had killed two mutants whose lust had led them to rape Fay; it is corroded further when the mutants learn that he is in fact repulsed

by them. Boggs admits that he considers them freaks, and awaits the delivery of a normal child to make them "clean" again. When he attempts to kill Milton's child, Cheena intervenes and a mutiny starts among the mutants. Boggs's power crumbles when, during the mutiny, Randy, Butch, Desdra, Fay, and Judy escape, relying on the stunt skills of Randy to leap a huge chasm to freedom. Boggs, then, is forced to follow in an effort to recapture them, but he and his band know that he is being driven out of the tribe, forced to commit suicide via his fiery plunge into the chasm.

Hot! is a densely allusive script, showing the literary knowledge of someone with Donald's background. It grasps beautifully the function of myth, to explain catastrophic events, to create a meaningful way of understanding disaster. The archetypal character of Boggs is the centre of the film. Satanic in his rebellious anger towards authority, in this case the US government that conducted the secret testing which turned innocent miners into mutant victims, Boggs creates mythologies that bolster his own power but also sustain an otherwise hopeless band of outcasts. References to the 17th-century poem, *Paradise Lost*, include the name of its author, John Milton, whose surname becomes the Christian name of Boggs's first-born, and the poem's great anti-hero, Satan. A supreme illusionist and motivator, Boggs has persuaded the mutants that they are beautiful, instils hope in them for a bright future, and negotiates their rights with "Uncle Sam." Biblical quotations are also included to add a depth and complexity to the script. For if Boggs is Satanic, he is also a saviour figure for the mutants; when Desdra learns of their plight, she compares Boggs to Moses, citing the Old Testament book of *Exodus*: "And the seas parted, and behold! Moses led his People out of bondage!" As one might expect in a nuclear disaster film, the most frequent Biblical allusions are taken from the apocalyptic New Testament book authored by John, *Revelations*, all of them uttered by either the enigmatic Desdra, or Boggs, showing that in some sense, Desdra is Boggs's *alter ego*. Both are image-conscious (Desdra is a famous model); both possess a bravado that singles them out. The ark which houses Milton is clearly a reference to the story in *Genesis*, in which Noah and the other creatures of the earth are saved from the deluge of the flood, likened to the nuclear disaster the mutants have suffered.

Even more interesting is the implicit comparison invoked between the mutants and those who suffered from the disease of leprosy. In antiquity, lepers were outcasts, perhaps out of necessity, as the dreaded disease was contagious. Lepers were forced to wear bells to warn others of their approach, and bells are also associated with the demonic. Leprosy is a hideous disease as it eats away at the body, literally consuming it. But the myths that sprang up around the condition attempted to rationalize it by insisting that leprosy was an outward manifestation of a spiritual affliction - those who contracted it were "possessed" by unclean spirits. Moreover, in medieval literature lepers are depicted as lascivious, noted for their voracious sexual appetite. In *Hot!* the mutants, like lepers, have been ostracized, cast off into the barren desert. Moreover, many of them are missing appendages. Two of them, one named Marco and the other the unnamed gas station attendant, have no noses, one of the organs frequently attacked by leprosy. Bells are attached to the ark, and several mutants who perform the ritual fertility dance are wearing bells on their ankles - one of the ways in which ancient lepers were identified. Most of all, they are considered as "unclean" by Boggs, and have acquired raging sexual appetites, their libidinous urges being inverse to their sterility. They may be victims, but their physical condition has also made them depraved. Also part of medieval lore is the idea that werewolves - for obvious reasons - possess animalistic, lascivious drives. In her story, "Bisclavret," for instance, the medieval poetess, Marie de France, writes of the man whose nose was bitten off by a wolf and who, himself becomes a werewolf, or "bisclavret." The title of the project - *Hot!* - thus alludes to both the nuclear disaster and its physical ramifications, as well as the augmented sex drives of the mutants.

It is our contention that this dimension of the script might be Donald's contribution, based on the rich literary background to which he was exposed. The licentiousness, along with the confused sexual

identity as expressed in the lesbianism of Fay and Desdra, the hermaphrodite, Milton, and the masculine mask of the girl-child, Cheena, are probably also his contribution. One mutant shows Donald's fondness for the name "Joshua," the name of the robotic arm in *Demon Seed*. *Hot!* might hold pride of place as the most Byzantine project Donald ever worked on, but along with *Demon Seed*, it reveals his more than passing interest in science fiction.

The Changeling

While in the midst of developing *Hot!*, Donald was briefly considered as director of *The Changeling* (1979), an engaging horror/mystery hybrid eventually directed by Peter Medak and starring George C. Scott. Financed by Canadian investors, the film was produced by Garth Drabinsky, a Canadian, and Joel B. Michaels. We spoke with William Gray, co-writer of *The Changeling* along with Diana Maddox (who was then the wife of producer Joel B. Michaels). "I was basically a kid when I met Donald," Bill Gray told us. "I was in awe of him, really. He was a true artist, and I respected him. He had great ideas. I loved his ideas." Bill Gray was himself a Canadian, from Toronto, who, in his early 20s had written a screenplay that was admired by Diana Maddox; it was she who invited him to co-write *The Changeling* with her. "Diana [Maddox] was told the story of *The Changeling* by a fellow named Russell Hunter," says Gray. "She said he told her the story at a cocktail party. I never met Russell Hunter and I don't know if he actually exists or not, but the story we adapted as a screenplay is essentially the story he is supposed to have told her."[24]

The Changeling is a haunted house mystery with horror elements. The story's protagonist, John Russell (Scott), is a respected classical composer whose wife and daughter are tragically killed in an automobile accident. To escape the tragedy, Russell decides to take a teaching position in a Seattle university. (A few scenes were shot in Seattle, but many of the location shots were done in Canada.) Claire Norman (Trish Van Devere), a real estate agent who is also a member of the local Historical Society, finds him a large mansion to rent, called Chessman Park, which has been uninhabited for several years. Soon after Russell moves in, supernatural events occur, revealing that the house is haunted. Russell enlists the help of Claire Norman to help him get some history on the mansion. He eventually discovers a hidden room in the attic containing some dusty relics, including a child's wheelchair, and subsequently learns the horrible secret of the house - the murder of a child by his father. The haunting is the result of the boy's tormented ghost, seeking justice for the past crime. Finally, Russell learns that the ghost is mysteriously linked to esteemed State Senator Joseph Carmichael (Melvyn Douglas).

"Donald didn't want the [Russell] character to be a composer of classical music," said Bill Gray. "He wanted him to be a contemporary artist, a composer of electronic music. He also didn't want the mansion to be old, to be a stereotypical haunted house. In fact, he wanted the house to be modern." Unfortunately, Donald and the producers never saw eye-to-eye, and so they parted ways. "Donald was brought in early," says Gray. "No casting had been done yet, although I remember Donald showing me sketches he'd made of all the characters - detailed drawings. I doubt if he would have cast George C. Scott had he been the director. He of course respected him as an actor, but he didn't want to take that approach... but he had good ideas. He had me convinced, anyway."[25]

And so another project came and went. Interestingly, when trying to get *El Paso* made in 1984 (see below), Donald proposed moving the location of the film from Los Angeles to Vancouver, where, he said, he had once scouted locations for a film. So he clearly did do some location scouting for the film, probably soon after he became interested in the project. (As was established earlier, he always liked to write after seeing the locations where the film would be shot, as the process helped prompt his visual imagination.)

Fan-Tan

Around September 1978, Marlon Brando invited Donald to Tetiaroa, the famed actor's Tahitian island, to collaborate on a project about female pirates. *Fan-Tan*, a detailed scenario of 133 pages, created in collaboration with Marlon Brando, represents some of Donald's best writing. Set in Hong Kong and French Polynesia in 1929 and 1930, Brando apparently intended to play the part of its compelling anti-hero, Anatole Doultry. Donald spent several weeks on Tetiaroa in discussions with Brando, after which he and China departed and travelled to Hong Kong, where they spent, according to China, the next several months, from the late summer of 1978 to early 1979. This experience obviously helped Donald portray that city in the scenario that was completed in May 1979. *Fan-Tan* was the project that directly preceded another Donald was hired to write, *El Paso* (finished in 1980). Interestingly, both scripts feature charismatic seamen, mythic figures who are both sinister and compelling. That Brando hired Donald to write *Fan-Tan* shows the respect he had for Donald's talent. He would later engage Donald's services for yet another project that ended badly, *Jericho*.

Fan-Tan features the story of Anatole Doultry ("rhymes with poultry"), a sailor who owns and operates a modest ship called the Sea Change. Born in North Dakota to itinerant parents, a Scottish father and a French mother, as a boy Anatole travelled widely in East Asia and Australia in his father's circus. Like Fitzgerald's Jay Gatsby, also born in North Dakota to shiftless farmers, one might say that he "sprang from his Platonic conception of himself." Anatole is 52 years old in 1929, when the script begins. (Curiously enough, Brando turned 55 in April 1979, making Anatole very near his own age.) He is a "man who has invented his life," as a romantic seaman. Known affectionately as "Annie" to his friends, he is an anti-hero, despite this glamorous, Conradian dream of himself. Capable of extraordinary courage, Annie also knows fear and, on occasion, does not hesitate to run from danger; possessive of an innate sense of justice, which leads him to defend the rights of Tahitian natives against unscrupulous French imperialists, he also betrays those who trust him. Possessing an artistic sensibility (Annie is both poetically and musically inclined), he is nonetheless susceptible to material enticements. Explosively violent when provoked, Annie uses a more subtle power of gentle persuasion, especially when it comes to beautiful women. In short, he is a fully realized romantic figure living in a time that makes idealism difficult to maintain. *Fan-Tan* offers a post-modern view of this romantic dreamer, who sees the absurdity of his aspirations, and yet attempts to preserve this idealized image of himself in an ugly imperialistic age. Caught between this romantic conception of himself and a reality that is considerably less glamorous, Annie's stoic resolve at the end of the story elevates him to a tragic status.

Fan-Tan focuses on Annie's adventures with two main settings: the first in Hong Kong and the South China Sea, the second in French Polynesia, largely in Papeete, Tahiti - after the sea itself, the place that Annie calls home. The two settings are deftly woven together by Annie's adventures, but also by the larger theme of anti-imperialism and ruthless colonization, Hong Kong being a part of the British Empire, and Tahiti subject to French exploitation. One of the overriding themes is that of what Edward Said has called "orientalism," which he defines as the manner in which the west presents the east to itself.[26] *Fan-Tan* views the imperialists as oppressors, though, scrutinizing the myths the west has told itself about the east, and exploding the less flattering ones. It is significant that Annie himself has an extraordinarily cosmopolitan background: born in the United States to European parents, he travels (and is incarcerated) in the Orient, yet he calls Tahiti home. There are three women in his life: a 37-year-old Chinese pirate, aptly named Loi Choi San (which means "Mountain of Wealth") who also operates a "Fan-Tan" gambling house; his Tahitian lover, Moana, who is in her 30s and is mother of one of his children; and the *femme fatale* in his life, Diana Van Allen (a.k.a. Helen Deutsch), a beautiful young American woman, who shows up in Papeete with a dubious passport.

It should be noted, however, that the novel entitled *Fan-Tan*, published in 2005, is not the complete scenario completed by Cammell and Brando in May 1979: it is roughly the first third of that 1979 treatment. (Donald had planned sequels, which were never written.) The summary that follows, then, represents our synopsis of the treatment and not the novel, which will have special interest to those who have read the latter.

Loi Choi San recruits Annie for a heist she has planned, as much for revenge as for wealth. A few years earlier (1926), she and her crew had attempted to raid a steamship carrying $300,000 in US gold, but they had failed. To avenge herself, Loi Choi plans to raid the same ship again, and she enlists Annie as an inside "plant," offering him one fifth of the take, if he will sign on as the ship's third officer. Annie agrees, in part because of the promised wealth but also because of his attraction to Loi Choi, even though he must first undergo a secret induction into the "Sea Wolves," Loi Choi's crew, that values loyalty above all else. Annie witnesses the beating and beheading of a traitor and is loathe to agree to this pledge, but he is, at last, persuaded and, upon his induction, is named the "White Wolf."

With Annie's help, the raid is this time successful; however, Annie is guilt ridden because the ship's First Officer, a cheerful Scotsman named Ian McIntosh, is murdered. Loi Choi insists that his share of the treasure will assuage his remorse and, although she maintains that she keeps personal relations out of business, we learn in a later flashback that she and Annie had become lovers. After a romantic interlude, Annie slips overboard, absconding with an oilskin bag of luxuriant pearls, as Loi Choi sleeps. With his first-mate, Barney, and a small crew, Annie steers the Sea Change to Tahiti, which he calls home.

Meanwhile, in the capital port, Papeete, a young but mysterious American woman, Diana Van Allen, is a guest at L'Hotel Onetahi, owned and operated by a Frenchman, Michel Lasalle. The latter is an affable "settler," who is kind to his native employees and has taken a Tahitian wife, in contrast to his exploitive compatriot, Richard deTannay, an unscrupulous colonialist who swindles the Tahitians out of their land, beats his British wife, Betty, and extorts sexual favours from Diana. When he learns that her passport is invalid, he makes advances, but Diana humiliates him, spurring his desire for revenge. Richard deTannay manipulates the petty administrator, M. Jean-Paul Betrand, to assist him in his designs on Diana. Others on the island include the writers, Earle Stanley Gardner and Somerset Maugham, and a Mrs.Wollensak, who claims to be writing a travel story for *Ladies Home Journal*, but who in fact turns out to be a private investigator hired by Loi Choi to locate the renegade Annie.

Annie returns to what he considers to be a safe haven, Papeete, and to his "wife," Moana, after an absence of two years, just in time to celebrate Bastille Day (14 July). Immediately attracted to Diana, Annie soon gains her confidence. Diana's vulnerability awakens Annie's chivalric side, and he agrees to help her escape from the authorities and deTannay. Diana then confesses that she fled the United States because she shot and killed her would-be boyfriend, after he had raped her, an odd assertion. More confidences ensue, and Annie, realizing that she loves horses and remembering that the winner of a recent derby was named Helen, asks Diana if her real name is Helen, to which she answers in the affirmative. Her mother was a stage actress and her father raised race horses. Annie then reveals his wealth of pearls to her, and the two plan to flee the island together. First, though, Annie needs to help Moana's grandfather, Tenuaha, whose land is about to be stolen by deTannay, thus supplying a double motive for Annie to despise the French imperialist.

Annie succeeds in making deTannay relinquish his hold on Tenuaha's land (with some brutally violent tactics); he also retrieves Diana's passport and the two plan to travel as man and wife. As they are preparing to depart, however, Loi Choi and crew, aboard her junket, arrive in Papeete. They kidnap Diana and Loi Choi demands that Annie return the pearls and that he forfeit his life to the crew he had betrayed. Aboard Loi Choi's junket, Annie is about to meet the fate of a traitor, but two native

Tahitians come to his rescue by dynamiting the ship. In a struggle, Diana saves Annie's life by shooting Loi Choi, who, in turn, is about to stab her feckless former lover. Both Annie and Diana swim to safety as the ship goes down.

Having retrieved the pearls, Annie says a sad goodbye to Moana and his daughter, signs the Sea Change over to Barney, and departs on a luxury liner bound for South America with Diana (now called Helen). However, after they make love, she steals the pearls, giving Annie the slip by stealthily disembarking and securing passage on a ship bound for Shanghai. When Annie discovers her treachery, he too hastily disembarks and returns to Tahiti. He learns that Diana/Helen had used several aliases, and committed several criminal acts - theft, prostitution, and blackmail among them. Annie discovers with joy that Moana had retrieved his piano from the Sea Change. The ship had been wrecked and, in an attempt to free it from the rocks, Loi Choi's surviving crew hoisted the heavy piano overboard. Moana preserved it for him, and in the hauntingly lyrical final scene, Annie, seated on the Tahitian shore and clothed in the now shrunken white silk suit, plays with gusto a popular song, as he watches the Sea Change, now Barney's, sail out to sea. Still, as the sun goes down, Annie seems contented with - or at least accepting of - the way things have worked out.

When the story begins, Annie is incarcerated in a Hong Kong prison for gold smuggling. He saves the life of a Chinese inmate, for which, upon his release, he is rewarded by the inmate's female boss - Loi Choi San - who gives him monetary recompense (with this money, Annie is able to redeem his ship, the Sea Change, which had been impounded). Her character is based on an actual historical figure named Lai Choi San (Lai Sho Sz'en), a pirate who operated twelve junkets on the Pearl River and in the South China Sea from 1922 to 1939. Much of her life and exploits were recounted in a now-famous book, *I Sailed with Chinese Pirates*, written by a Finnish journalist, Aleko E. Lilius, first published in 1930. Brando said he read the book as a kid, which is no doubt true. As the title suggests, Lilius gained the confidence of Lai Choi San, sailing with her and finally writing his non-fiction account of his adventures. This book, in turn, inspired a popular comic strip by Milton Caniff during the '30s, featuring as one of the main villains "The Dragon Lady," a version of Lai Choi San. A TV series, *Terry and the Pirates*, also derived ultimately from Lilius's book, aired in 1953. In order to gain her confidence, Lilius got himself arrested, spending time inside a Hong Kong prison; several similarities between this episode in his book and Annie's experience in *Fan-Tan*, along with the secret rituals of Lai Choi's band that appear in the book and the later script, reveal Brando's familiarity with Lilius's popular book.

Brando's role in the creation of *Fan-Tan* was considerable. In *Conversations with Brando*, an interview conducted on Tetiaroa in 1978, he told Lawrence Grobel: "I wrote a film. It's six volumes [!], very rough and unfinished, way overwritten."[27] He then recounted in some detail the plot of *Fan-Tan*, with notable changes, ones that must be attributed to either Donald's revision of an original outline - although he never mentions Donald during this interview - or to Brando's own improvisation during the interview with Grobel. For instance, he claims that the pearls Annie steals are from the Royal Palace and that Loi Choi's motive for recovering them is her loyalty to the Royal Household. He also recalls that Annie's mate on Tahiti is his "wife," which can only be interpreted as such very loosely (a relationship probably derived from Joseph Conrad's novel *Victory*, which Donald admired) and that, when he plans to leave with his new love, his goal is to reach Paris, since he is "a kind of romantic figure." Brando also remembers the deTannay figure as "the owner of the island," and "a dilettante painter... who has a polo field on the island," a few details that differ from the scenario. Another interesting difference in Brando's version recounted to Grobel is Annie's relationship with Diana/Helen. Brando recalls a romantic scene in which Annie places a pearl in her Singapore Sling, which she discovers when it winds up in her mouth. Astonished, she asks Annie how it got there, but he feigns ignorance. Also, he does not have sex with Helen before she abandons him; in the scenario,

he is given this reward, at least, before she furtively steals away with his pearls. Brando's detailed synopsis of the story, though, reveals a marked enthusiasm for the project.

According to Donald in a 1989 interview, it was after Brando saw *Performance* in re-release that he "asked me to work with him on a project he had sketched in his mind - a very enticing, very seductive premise... a saga of Conradian proportions." Years later, history would repeat itself when Brando, after viewing and defending Donald's masterful *White of the Eye*, asked him to collaborate on another idea, *Jericho*, about an ill-used retired CIA agent living in Mexico. Once again (this time, when the work was ready to shoot), Brando backed out. The interview quoted here is the result of that debacle, although Donald reflects on his long-standing acquaintance with Brando.

Donald afforded some insights regarding the collaborative process for *Fan-Tan*: "When we'd work together, I'd do the actual writing and he'd improvise." He also had to keep Brando focused, balancing his brilliant improvisation with an eye towards consistency. This went on for three months, and when Brando became tired from overwork, Donald and China moved to Hong Kong. Donald claims he returned (to L.A. or Tetiaroa?) "with the completed treatment - to which Marlon contributed large amounts of imaginative material. But I did the writing." This completed treatment of 133 pages was shown to a major studio. Donald claimed it "knocked their socks off."

For unconvincing reasons, Brando abandoned the project, however, an act of self-sabotage Donald perhaps recognized in himself: "It was one of those burdens he [Brando] invents for himself... He's so ambitious and idealistic. But being an idealist and a perfectionist can become very destructive." This pattern is, of course, Donald's own as well, although he seemed loathe to acknowledge in himself what he readily recognized about his fellow collaborator. When Brando backed out of the film project, Donald tried to salvage what is surely some of his best work by writing a novelisation of it. "Donald called and told me that Brando had lost interest in the *Fan-Tan* project," David Cammell told us. "So I suggested to him that he write it as a novel. So he did."

Through Ed Victor, a literary agent in London, David Cammell helped Donald secure a British publisher, Pan, and arranged for Donald to receive a substantial advance (according to David Thomson, $50,000). The snag was that Brando had to sign off on the deal, since he owned the concept and was co-author. According to Donald, they "talked of million-dollar advances for the American publication after I'd only done half a dozen chapters." Once again, though, Brando refused to comply. According to Donald, he averred that "he couldn't read it because he hadn't written it himself. He had a crisis of conscience, that he couldn't claim co-authorship... I know it is great. I just know it. But none of it will see the light of day." Doubtless the reasons for Brando's refusal were complex: insecurity and perhaps even a bit of envy serving as motivating factors.

Although the idea for the story, and perhaps many of its details, were Brando's, the story clearly shows itself to be the work of Donald Cammell as well. Several scenes possess cinematic appeal, revealing that they were written by a person with formal training in the visual arts, like Cammell; the scenario shares striking similarities with other Cammell projects; and it is rife with personal references and self-inscriptions - "in-jokes" - that are so common in his film art.

Fan-Tan's cinematic appeal should be apparent not only from its lush and exotic settings (the hustle and bustle of Hong Kong, the open sea, the translucent, idyllic beauty of Tahiti), but also from its structure, which deftly weaves past and present in the kind of montage style of which Cammell was fond. This technique dominates the style of the scenario, but one example must suffice here. Chronologically, the action of *Fan-Tan* first portrays Annie's business dealings with Loi Choi and her pirate crew. There is a scene in which Annie, newly recruited, tries to seduce her as Loi Choi squats before a map to show him their plan for the impending raid. Loi Choi removes his hand from her breast and, not missing a beat, explains that "For me, love and business matters must never cross," as she continues to explain their strategy.

Much later in the story, however, when Annie is shaving in his Tahitian hut, he sees in the mirror a reflection of his lover Moana kneeling on the floor, unrolling a piece of silk. This single image reminds Annie of that earlier scene with Loi Choi. We now learn that soon after her initial rebuff, Loi Choi had changed her mind, as Annie remembers that she had placed his hand back on her breast, obviously recanting her previous policy of not mixing business with pleasure. The past is thus revisited in the present, and an alternative version of it is provided. The text circles back on itself, Borgesian fashion, as this memory surfaces during Annie's preparation for the Tahitian holiday festivities. This single, compressed image connecting the past to the present is found in *Performance* and *White of the Eye*. Cammell also used it in another heretofore unrealized project, an excellent film script discussed below, *The Cull* (1994), which cuts back and forth between the first Gulf War (1991) and the Scottish Highlands a few years later, showing the connection between past and present in a montage of images.

Self-figuration and self-inscription abound in *Fan-Tan*. Donald Cammell was, of course, Scottish by birth, but he had become a French citizen, who lived for many years in the US, thus making Anatole Doultry's heritage a mimicry of his own. The extensive interest in, and knowledge of, Chinese culture also reflects Donald's interests. Annie's violent, explosive temper resembles Donald Cammell's, as does his decided ability to "besot" women he meets. Anatole keeps a pet monkey on board his ship, fondly sharing his food with it. In Paris, in the early 1960s, Donald Cammell owned a pet monkey of which he was quite fond. And like Donald, who was physically very graceful, Anatole shows himself to be a superb dancer, even when he is drunk. *Fan-Tan* includes an initiation ritual that entails the drinking of animal blood, a feature it shares with *White of the Eye*. Like Paul White, Annie plays piano. An aspiring poet himself, Annie cites what he identifies as a Shakespearean sonnet to Diana/Helen, explaining that he named his ship the "Sea Change," because of the poem's conclusion: "...Nothing of him that doth fade/But doth suffer a sea-change/Into something rich and strange." This poem is not in fact a sonnet, but a song sung by Ariel in Shakespeare's wonderful sea drama, *The Tempest*. This love of poetry conveys something of Annie's adventuresome spirit, but more importantly reveals yet again Donald's preoccupation with death and ecdytic re-birth. Still another literary allusion is that of Diana/Helen. Diana is, of course, the Greek goddess of chastity, but also of the hunt; Helen of Troy is the archetypal *femme fatale*, "The face that launched a thousand ships." Once Annie hears Diana's story, he reminds himself that she is not Diana but Helen.

Humiliation scenes such as Diana performing her verbal castration of the gauche deTannay in front of guests on his yacht, his subsequent revenge, motivated by lust and cruelty, as well as his own ego, resembles those in films such as *Performance* and *Wild Side* and, as we shall see, *El Paso*. Finally, the character of Annie, with his tortured romanticism tempered by an artistic, critical observation of life's ironies, is definitely akin to Donald Cammell. Annie has much in common with the mythic criminal, Jimmy Mendoza, in the aforementioned script, *El Paso*: both are sea captains, both are capable of explosive violence, are charismatic, and are not always trustworthy. While the

Helen of Troy archetype is employed in *Fan-Tan*, that of Persephone, the Greek goddess abducted by Hades (Death), operates in *El Paso* (it is the name of Jimmy Mendoza's ship), but both works thus portray the *femme fatale* - not, however, without some sympathy.

The keen irony throughout *Fan-Tan*, particularly its disdain for the *nouveau riche* and pretentious middle classes, may be shared with Brando, but they are also typical of Donald Cammell's sensibility and, more importantly, his voice. For instance, in describing the French social set on Tahiti, we are told that the mindless flirtations and dalliances among the colonialists are motivated by their covetous desire for power and their willingness to prostitute themselves to acquire it.

Donald's description of *Fan-Tan* as having an epic flavour of "Conradian proportions," is quite apt. As we mentioned earlier, in *Demon Seed* Donald himself reads a brief passage from Conrad's *Victory* (1915). *Victory* uses as a setting the Malay Archipelago, also the setting of *Lord Jim* (1900). Conrad's protagonist, Axel Heyst, is, in truth, a romantic hero who attempts to cling tenaciously to his own idealism in a world under which it is continually under attack, much like Annie Doultry in *Fan-Tan*. Just as Heyst, against his better judgment, becomes involved with an itinerant violinist, coming to her rescue, so Annie risks all to aid the mysterious *femme fatale* whom he meets in Tahiti, planning an escape with her as Heyst had with his "damsel in distress" in *Victory*. Heyst's action incurs the wrath of the island's innkeeper, who sends assassins in pursuit of him; Annie and Helen are also pursued alternately by corrupt officials of the island, and Madame Loi Choi San. Heyst meets his fate with courage and dignity, as does Annie Doultry. Like Conrad's *Victory*, *Fan-Tan* successfully combines a story of adventure with a complex and compelling character analysis.

Fan-Tan is a demonstration of the magnitude of Donald's talent. It is lamentable that this scenario, so inherently rich in cinematic potential, remains undeveloped as a motion picture. Placed in the context of Donald's other works and his life, it bears considerable significance. Waxing philosophical, and showing uncharacteristic restraint after Brando disappointed him a second time with the *Jericho* project, Donald said graciously of *Fan-Tan*: "He [Brando] owns the script, of course, though I'd love him to bequeath it to me. Or anyone else."

Given Brando's intransigence, Donald eventually settled on a plan of patience, whereby Brando would die, and he would then be able to publish the novelization of *Fan-Tan* in the form he wished. The order of their deaths, though, didn't work out that way. Sadly, none of the *Fan-Tan* material was released during Donald's lifetime. Brando's refusal to release the work must have been devastating to Donald, the final frustration of a long decade.

Opposite top left:
*Adventuresome cover art for the UK edition of **Fan-Tan**.*
Right:
The artwork used on the cover of the US edition focuses instead on the novel's love affair.

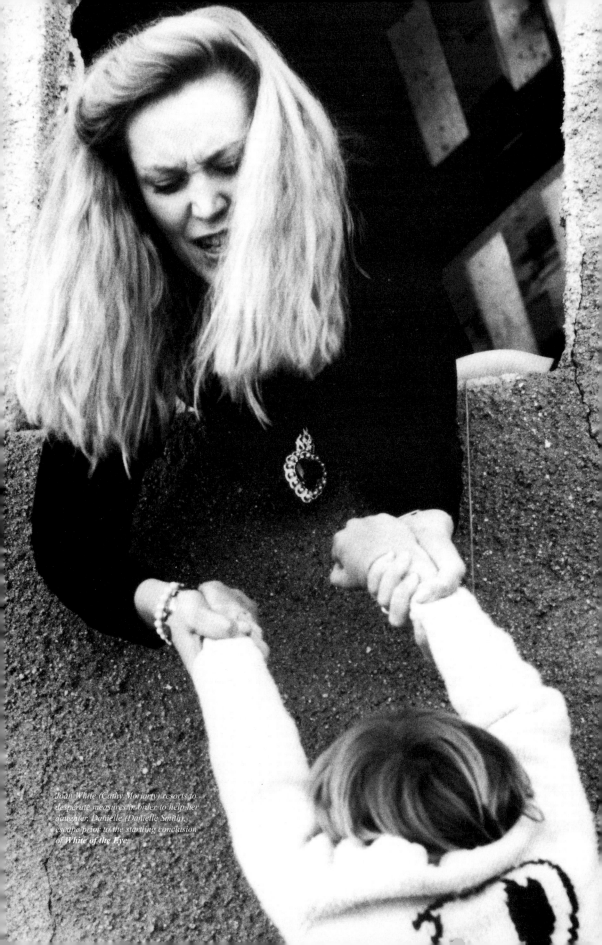

Joan White (Cathy Moriarty) resorts to desperate measures in order to help her daughter, Danielle (Danielle Smith), escape prior to the startling conclusion of White of the Eye.

8 White of the Eye
1980-1988

About the time he finished the scenario for *Fan-Tan*, in May 1979, Donald was introduced to Vartkes Cholakian, an Armenian filmmaker who had been living in Montreal, where he'd made several notable films. Cholakian had a project he wished to develop called *Breakfast Included*, and was in Los Angeles looking for a writer. He had been introduced to writer William Gray, with whom Donald had worked, briefly, on *The Changeling*. Bill Gray wasn't interested in working on the project, but knew someone who might be - Donald Cammell. "We just clicked from the beginning," said Cholakian. "We had similar backgrounds. After I came to the United States, I studied painting at the Museum of Fine Arts in Boston, and I had been making films in Canada for several years. So we shared a lot of interests… I loved Donald. I did. I loved him… I was going through a divorce and having a tough time, and Donald showed me great support and friendship. I ended up living with him and China for about the next six months."[1]

The project entitled *Breakfast Included* became *El Paso*. The story concerns a young filmmaker named Martin Osterman, who is seeking financing for a project he is writing and hopes to direct, "El Paso Blues," about a gangster involved in drug smuggling through the El Paso corridor between Mexico and the United States. His anti-hero in the film is modelled on a real-life gangster named Jimmy Mendoza, with whom Martin has developed a friendship. Martin meets a highly successful, wealthy businesswoman named Anna Melrose, who is interested in getting into the film business. While Anna believes Martin has the talent to make a great film, she is equally interested in launching the film career of her beautiful young protégé and lover, Stacey, and sees Martin's film as way to do it. Anna subsequently introduces Martin to Pierre Senouf, a European playboy and film producer who happens to be in Los Angeles for several months. Martin begins an affair with the attractive, mature, Anna, even though Mendoza, whom he admires, had strongly cautioned him not to mix personal relations with business. In order to entice Martin further, Anna and Stacey soon involve Martin in a *ménage a trios* with them. A dispute arises between Martin and Anna, however, over casting Stacey in his film: Martin doesn't believe she is the right actress for the part, while Anna's motivation all along has been to secure a leading role for Stacey. The disagreement about Stacey culminates in a violent argument between Anna and Martin, during which Stacey severely cuts her hand on a broken glass, and a showdown between Anna and Jimmy Mendoza, when Martin insists the two meet at his apartment for drinks. Subsequently, Senouf - revealed to be Anna's front man - tells Martin the "backers" have withdrawn their financial support, and Martin learns that Anna had been bankrolling the film all along. Anna's betrayal is one thing, but faced with the realization that his film will not be made, Martin becomes irrational, and asks Jimmy Mendoza to help him kill Anna. He avers that, if he can orchestrate her death, making it seem an accident, the financing will remain in place, and he can make his movie, with which he is quite obsessed. He pays Mendoza several thousand dollars to take him, in Mendoza's boat, the Persephone, to Cabo San Lucas, where Anna has an oceanside home. Martin's plan is to drown Anna, and he asks Mendoza to show him how to carry out the crime. In a startling reversal, Mendoza drowns Martin instead, taking all his money, but he is also motivated to turn on Martin because the young filmmaker has violated the boundaries of their relationship. He ties Martin's body to a weight and drops it overboard, where it sinks to the bottom of the ocean.

El Paso is a richly textured story whose power and complexity is not adequately captured by a mere plot summary. It could only have been written by Donald: again it features the twin forces of creation and destruction, flip sides of the same coin, and the characters have strong parallels with those in *Performance*. Martin, the artist (Turner), and Jimmy, the gangster representing destructive violence (Chas), reveals his continued fascination with the criminal underworld, mixing crime and art. Like Turner in *Performance*, Martin becomes almost vampirically attached to his artistic model, Jimmy, a relationship which can only end catastrophically. In a parabolic story such as Edgar Allan Poe's "The Oval Portrait," when the artist is done painting a subject's portrait, that subject is dead, the artist having vampirically drawn the life out of his model. Yet Jimmy is aware of Martin's vampiric attachment to him, even if he can't verbalize it: he calls Martin a "parasite," telling him he has over-stepped the bounds of their friendship. "I keep myself to myself," Jimmy tells Martin, but Martin isn't happy with that: Jimmy wants the boundaries of their relationship clearly established; Martin wants to obliterate them.

Jimmy's boat is named the Persephone - Queen of the Dead, bright star of hell (recall that the ship in *Duffy* is named the Osiris, after the Egyptian Lord of the Dead. Jimmy Mendoza, owner of the boat, says he named her after "a Greek woman I used to know."). Yet what perhaps is most astonishing about *El Paso* is the way in which the story functions as a snapshot of Donald's psyche: Donald had modelled the self-destructive filmmaker Martin Osterman largely on himself. "I read the treatment and I said, 'Donald, that's you.' You're Martin Osterman," recalled Cholakian. The parallels are indeed remarkable: Martin's company is "Perpetual Mo-Pic," Perpetual Motion Pictures, named after the company David Cammell and Michael Butler had formed to make *Ishtar*. Martin drives a Jeep CJ5 like Donald did at the time, and Martin is continually making notes into a mini-cassette recorder, a habit of Donald's as well. Martin's stubborn intransigence, his self-sabotaging refusal to compromise, to accept any other vision of a film other than his own, Donald clearly also modelled on himself. Yet perhaps the most startling dimension of Martin's character is the way he is consciously or unconsciously seeking his own death. Martin's insistence on flirting with disaster, even when Jimmy Mendoza's thugs beat him badly as a warning to keep his distance, and his foolhardy plan to salvage his film, signal his unconscious desire for death.

"I finished reading *El Paso*," said Cholakian, "and I thought, 'My God, he wrote the story about himself and he already knew how it was going to end.'" It is a chilling finale, made even more so by the figurative truth it held for Donald. The last image reveals Martin, his feet lashed to a heavy iron fire-grate, swaying slowly back and forth in the murk at the bottom of the sea, his arms outstretched above his head, as if reaching for the sun - "for that is Apollo's domain," wrote Donald. The image is again a metaphor for the way Donald saw the world, as only a Gnostic dualist like himself could imagine it: the human body submerged in the muck and mire of the material world, while the spirit reaches out in vain for the sun, for light, for Apollo's domain - home. No wonder he was so uncomfortable with the whole idea of fathering a child: to his mind it was to trap a spirit in the prison that is the material world. Call us fanciful, call him selfish and irresponsible, but we strongly believe this is the way he saw the world, and saw himself in it. Another self-inscription that suggests this desire for death, and the tortured soul of the Martin figure, is evident in the painting that Martin gives to Jimmy as a gift, one that is later shown hanging on the wall of Mendoza's cabin on the Persephone. Donald refers to it as Caravaggio's *Prometheus*, though we have not found such a painting attributed to Caravaggio. Still, the figure of Prometheus - the tortured god who, in rebellion against the established order, stole fire from the gods and bequeathed it to man, and must thereafter suffer endless and repeated pain for his heroic transgression - caps the mythic dimension Donald imparted to the script.

Donald worked on the project well into 1980. When he finally did deliver *El Paso*, however, it was in the form of a detailed treatment, like *Fan-Tan*, not in the form of a screenplay, as was contractually required. "Donald called me and told me it was done," so my lawyer and I drove up to Donald's

place to pick it up," said Cholakian. "My lawyer picked it up, thumbed through it, and saw it was a treatment rather than a screenplay. He tossed it back on the table, telling Donald, 'This is worthless.' He turned to me and said, 'Let's go, Vartkes.' So we left."

Since *El Paso* was strictly and contractually a work-for-hire, Donald could do nothing with it; it was not his to develop, even though the material was very good. "Donald called me a day or two later and told me there was some great stuff in *El Paso* and that he wanted me to read it. So I went back up there and picked it up and read it, and saw he was right, it was very good. There was some great writing there. What he brought to it was the character of Jimmy Mendoza. He was Donald's invention, and he was a great character." Of course, since *El Paso* wasn't in the form of a screenplay, there was no way Cholakian could develop it. "That was the thing about Donald," said Cholakian. "He always had this 'fuck you' attitude. It was like he was always wanting to be fucking around with somebody. Everything always had to be on his terms. He always had to be the dominant one."

Still, Cholakian believed in *El Paso* and wanted it to get made. "Through a friend, and because I was Armenian, Rouben Mamoulian agreed to read it [Mamoulian was also of Armenian descent]. I gave him a copy of *El Paso*, and when I handed it to him he told me that he would call me only if he thought it was good, but that I was not to call him. If he liked it he would call. If not, he wouldn't. I told him I thought he would be calling, because I thought it was good… A week went by, then two. About a month went by, and I decided to call him. I didn't care if he would get angry or not. So I got his phone number and called him up. I said, 'This is Vartkes Cholakian and I'm calling to find out what you thought of *El Paso*.' And Mamoulian said, 'Where have you been? I've been trying to get a hold of you. I thought *El Paso* was very good.' He invited me over to his house… So I accepted. Who would turn down an invitation from Rouben Mamoulian?" So Cholakian drove over to Mamoulian's Beverly Hills home. "It was a beautiful home," recalls Cholakian, "filled with all kinds of Hollywood memorabilia… He invited me to his office, in the back of the house. I remember this beautiful colour photograph on the wall of Liz Taylor as Cleopatra. He asked me if I'd like a drink, and I said yes. So he grabbed a bottle of his expensive whisky and two glasses. He poured the drinks, handed me one, and said, 'Here's to *El Paso*. It's a good piece of work.' So we drank to *El Paso*. I ended up having several drinks with him. We had a great time talking about movies. He told me all about getting fired from *Cleopatra* (1963)."

Cholakian would tell Sherry Lansing, then at Paramount, the anecdote about Rouben Mamoulian's assessment of *El Paso* during a meeting with her about the treatment, during 1982. "She read it and said she didn't like it," said Cholakian. "She said she didn't like his depiction of women, especially Anna. And she thought it was too violent. She said knew Donald Cammell, and wasn't interested in working with him… A few years later, after she'd made *Fatal Attraction* (1987), I remembered what she'd said about *El Paso*, about the violence, and the female characters, and I thought, what bullshit. She just didn't want to work with Donald. But I do appreciate that she took the time to meet with me about the project." While it's not clear that Sherry Lansing knew Donald personally, she may have heard about him through Herb Jaffe: she was the protégé of Stanley Jaffe, who is related to Herb Jaffe, who, as we discussed in the previous chapter, disapproved of Donald's relationship with the young Patty Kong. Still, given the many sensational myths surrounding Donald Cammell's lifestyle, it's hard to imagine she had not heard of him anyway: while many believed he was quite talented, the unspoken word around Hollywood was that he was simply too difficult to work with - too mercurial, too strange.

Vartkes Cholakian continued to pursue *El Paso*, even while it remained in the form of a treatment. Over the years Donald remained keen to make the film. At the end of 1984, Donald offered to write a screenplay of *El Paso* for an additional sum, although of course he was supposed to have written a screenplay when he was originally hired for the job, in 1980. On 21 December 1984, Donald typed up a "letter of agreement" between himself and Cholakian, formalising the offer. Cholakian advanced him $2,500 for the screenplay, promising another $1,500 upon his approval of the first 30 pages. Donald

would receive $3,500 more upon completion of the screenplay, and another $2,500 upon approval of the final draft. The screenplay was never written. "I didn't care about the advance money," said Cholakian. Yet Donald tried to pay back the money of his own accord. Vartkes showed us a copy of a cheque, dated 30 July 1985, that Donald had written on his Barclays Bank account on the King's Road in Chelsea, for £770 - an amount that didn't represent the entire advance, but some of it. Vartkes didn't care one way or the other. "I never cashed it," claimed Cholakian. "I didn't want the money. I wanted Donald to have it."

Some years later, on 19 January 1987, Donald's then agent at William Morris, Jim Crabbe, drew up an agreement for Donald to purchase the property for a paltry $30,000, with the first $10,000 being payable in the event that Donald managed to either set up the project at a studio or find some other sort of financing, and guaranteeing Vartkes Cholakian "Co-Producer" credit on the film should it be made into a motion picture. The remaining $20,000 would be due when principal photography began. In the event that the property remained unproduced at the end of three years, all rights would revert back to Cholakian. "I thought it was a joke," said Cholakian. "I didn't sign it. I wasn't going to sign away my control of the picture." About a year before his death, Donald met with Cholakian and again offered to buy *El Paso* from him, but he wasn't interested. "By that point, I wasn't convinced he was the right person to direct the picture."*2*

Iona

Donald's mother, Iona Katherine Lamont Macdonald Cammell, died at the age of seventy-eight, on 22 May 1981. "She became a bit muddled in the last few years, living at 14, Edith Grove, SW10, in a house which I bought for her, divided into four flats to provide her with an income," says David Cammell. "But she was *compos mentis* when she became ill, and I walked her up the steps of the Royal Marsden Hospital where she died about a week later."*3*

Donald and China flew to London for the funeral. Amadis, Donald's son, was at the time of his paternal grandmother's death twenty-one years old. He didn't know her at all, but knew that his father was in town for the funeral, and tried to phone him. Donald wouldn't see him. According to Maria, when Amadis would phone the hotel, China would run interference, saying Donald wasn't there, or was indisposed with a bad headache, or some other excuse. They'd met only twice, most recently in 1978, for a lunch arranged by David Cammell, but that meeting had been uneventful, and he was loath to arrange another. Amadis would try to contact Donald whenever he knew he was in London, but Donald always had an excuse not to see him, and Amadis never spoke to his father other than the one time in 1978. Prior to that he'd only met his father very briefly, in 1961 when he was a baby, but he has no recollection of that occasion.

The Last Video

In the early 1980s, Chris Blackwell, the founder of Island Records, and the man who was responsible for introducing the world outside of Jamaica to reggae music when he signed Bob Marley to his record label in the early '70s, had begun producing and distributing motion pictures. With *Fan-Tan* and its novelized sequel quelled by Brando's reluctance to sign them off, Donald was again looking for the means to develop a project. In early 1983, Donald hooked up with Tim Deegan, who was then working for Island Pictures after having spent several years at Fox. "I remember the wild parties we used have up at Donald's place," said Deegan. "Chris and I were working to develop a project with Donald, and

went up there a few times to see him."*4* The project that emerged from these discussions was *Ishtar*, or more precisely *Ishtar* revised and set in Jamaica, and re-titled as *The Last Video*.

In an interview conducted in August 1984, Donald said, "[*Ishtar*] is reborn again [after ten years] as *The Last Video*, which we're proposing to make in Jamaica next year... it's now substantially the same story, but it all happens in Jamaica instead of Morocco." With *El Paso* perhaps still fresh in his mind, *Ishtar*'s film director, Nonus, has been re-named Martin and is now a music video director in Jamaica making a promotional video about a pop singer named Josie, "who he sees as a rather sort of spooky witch-like figure."*5* In order to research the film, Donald and China moved to Jamaica late in 1983, living there for the next several months. "I remember they were gone a long time," says Vartkes Cholakian. "He sold his Jeep CJ5, which he really loved. He used to drive that thing the whole length of Baja California, camping out along the way. It surprised me when he sold it, so he was obviously planning to be away for a while."*6*

Rock Videos

It was whilst developing *The Last Video* for Island Pictures that Donald made his foray into the world of music videos when he was given the opportunity to direct the promo for U2's "Pride (In the Name of Love)" - U2 recorded for Island Records. The 4m 9s video was filmed in Belfast, Northern Ireland, from the fifth to the seventh of August 1984. "Pride (In the Name of Love)" is competently executed, though certainly not the most innovative music video ever made, but then, its purpose was clearly pragmatic: 1984's *The Unforgettable Fire*, the album on which "Pride (In the Name of Love)" was included, was U2's breakthrough album - they went from being an Irish rock band loosely connected to the early '80s British New Wave to world stardom "It's a form that requires a tremendous lot of expertise and, I would say, a great sense of humour, as well as a lot of involvement with music itself," Donald said shortly after completing the video for U2. "I enjoyed making the one I did very much. I saw myself as trying to provide what the musicians wanted in a way that I don't feel at all when I'm making my own movie... I mean a video is doing my best to sell the song, to sell what they're saying, the group."*7* Although he was fifty years old by the time he directed the video for U2, Donald tried to stay in touch with cultural trends, including the ever-changing music scene. Anna Swadling, a friend of Donald's from the post-*Performance* period in London in the early '70s, remembers cruising punk clubs with Donald in the early '80s. "He was always interested in what was happening in music," she told us. "He was fascinated by the punk clubs in L.A. He was a voyeur. He liked to hang out and watch the scene."*8*

Donald directed one more music video, for the Philadelphia-based band The Hooters. "All You Zombies," from The Hooters' album *Nervous Night* (Columbia Records), was made in London in April 1985. We asked Jack Rovner, the band's long-term representative from Columbia Records who accompanied the band to London for the making of the video, why Donald was chosen to direct it. "Of course we knew *Performance*," he said, "and the U2 video, but we also knew of his connection to The Rolling Stones. That was significant. He was a true artist, and a true character, and very visual in his thinking. We liked the ideas he brought to it." "All You Zombies" took two days to complete. "That was unheard of in those days," said Rovner. "Usually they were shot in a day, very quickly. Two days was unprecedented."*9*

David Cammell was enlisted to help secure the unusual location for the shoot, the Hammersmith underground pumping station. By all accounts, this was a gratifying experience for both Donald and the band. Rob Hyman, co-writer, vocalist, and keyboardist for The Hooters, wrote for us the following recollection (dated 4 October 2005):

Hard to believe it's been 20 years [!], but that was a memorable time for The Hooters. We had finally signed a major record deal after kicking around in Philadelphia clubs for a few years, and found ourselves in the UK filming our first video, with a "real" director.

Those were heady days for us. Our first nationally released album, *Nervous Night*, was coming out, an opening slot at Live Aid was only 3 months away, we were in Europe for the first time as a band (with many subsequent overseas tours to follow), and MTV was still just getting started as well. "All You Zombies" was a somewhat strange choice for a debut single, with all its mystic Biblical imagery, but it remains one of our favorite and most mysterious songs, and we applauded the choice. After some searching, we were led to Donald Cammell, and how lucky we were, first time out. We were working with a bona-fide avant-garde moviemaker, not just a video guy, and his visual outlook and overall sensibility made for a great piece.

We knew there was no literal way to film this song, so it became very impressionistic and moody in Donald's eyes. Firstly, there was an amazing location - the Hammersmith underground pumping station (how *did* he get us in there?) - and then a motley crew of extras fresh out of some strange and magical circus. Add some dramatic Spielbergian lighting, lots of smoke ("Waft, waft!"), and a massive descending circular platform that held Davey's drums, and there was an instant vibe. Yes, it was cold, damp, and smoky, and pretty grungy overall - but all the better for filming our weird little epic.

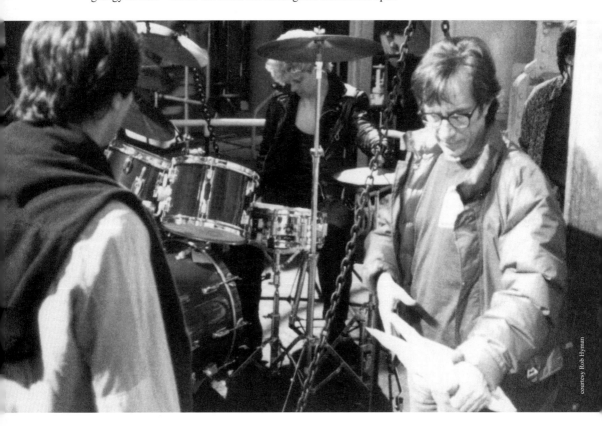

April 1985: Donald Cammell (right) *examining his sketches for The Hooters' rock video "All You Zombies." Behind, drummer David Uosikkinen on the circular platform.*

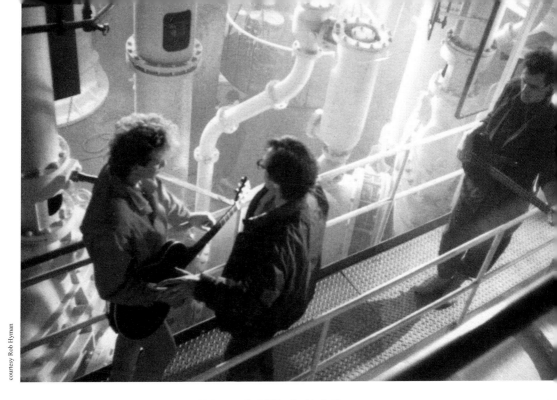

Within the Hammersmith pumping station, Donald directing the "All You Zombies" video.
Left: *Band member John Lilley.* Right: *Guitarist Eric Bazilian.*

It was a great trip, and a real treat for us to just hang out, have dinner, and work with such an interesting director. The only regret is that we never got to see or work with him again. We learned a lot, as we made another 10 or so videos, but somehow that first one will always occupy a special place in our history.

Although "All You Zombies" is a successful music video - in an MTV broadcast ca. 2000 it was ranked among the top 50 music videos of all time - Donald was never to return to the form thereafter.

Incidentally, we found the answer to Rob's question about how Donald managed to secure the Hammersmith pumping station for a set: "He happens to have a competent and efficient film producer as a brother," said David Cammell.[10]

The Last of *The Last Video*

By 1985, although the project was no longer being developed by Island Pictures, *The Last Video* (the re-titled and revised *Ishtar*) had been picked up by EMI and was to be partially financed by Goldcrest. It seemed that, at last, Donald was going to make the film that had consumed so much of his creative energies the past decade and a half. Yet due to circumstances beyond anyone's control, the project collapsed at the last moment. "Ironically, my ex-partner Hugh Hudson had made a film called *Revolution* (1985) which had been terribly expensive and was an absolute disaster," David Cammell told us. "It knocked the whole of the British film industry sideways for about five years. Goldcrest had financed *Revolution* and was partly financing *The Last Video*, and as a result of the failure of *Revolution*, it went into liquidation. Every film that was in pre-production [at EMI] just shut down, and that was the end of *The Last Video*. I very much wanted the film to be made for Donald's sake, but it didn't happen."[11]

Mrs. White

It was during the months after he finished the U2 video that Donald met Cassian Elwes. "I first met Donald in London at a restaurant on the King's Road, I think in 1985. I was interested in making a film with him, though of course I did not know at that point it would be *White of the Eye*." Donald told David Del Valle in 1988 how he became involved with *White of the Eye*: "Around 1985, after God knows how many unrealized projects… I was prepping this film for EMI [*The Last Video*], which was shelved when the company got taken over by Cannon. So as a sort of compensation, I was offered [by Elliott Kastner, Cassian Elwes's stepfather] this strange little novel by Margaret Tracy [Andrew and Laurence Klavan] called *Mrs. White* [1983], which my wife and I adapted into *White of the Eye*."[12]

Of the many screenplays Donald worked on in his life, *White of the Eye* was written the fastest. The version of the screenplay we have read is dated 5 November 1985, and it is virtually the complete blueprint for the film that was shot. Although it was scheduled to start filming before the end of the 1985, it was postponed until after of the first of year. It was shot swiftly, in roughly six weeks, in and around Globe, Arizona beginning mid-January through early March 1986, and was budgeted at around $2.5 million. Although in some respects the screenplay is a faithful adaptation of the novel, there are a number of interesting and significant differences that clearly bear Donald's signature. *White of the Eye* is visually powerful in its rendition of violence, but even more singular is its dramatization of the dual nature of the serial killer, his charismatic intellect and charm juxtaposed with his cold, merciless acts of violence. Like the aforementioned *El Paso*, *White of the Eye* is a snapshot of Donald's psyche.

The novel *Mrs. White* is set in and around Putnam Wells, Connecticut, a suburb of Stamford. It is told almost exclusively through the eyes of the titular character, Mrs. White, a sympathetic but naïve housewife with few ambitions of her own. This limited point of view is broken only a few times, notably in italicized sections that shift to her husband, Paul, a carpenter who works for wealthy suburbanites. Paul and Joan White were high school sweethearts after Joan broke up with Paul's buddy, Michael Chambers; the two were wed even before Joan graduated. Married for 20 years, they have two children, Paul Jr., 12, and Mary, 5. The Whites live in the area of Arbordale in a tidy but modest cottage they rent from a well-to-do commercial artist, Jonathan Cornell.

Paul is a hardworking family man who shelters Joan and dotes on his children. He helps with the dishes, repairs the cottage, and has converted an old barn into a workshop for his tools. Although he strives to provide well for his family, the Whites have little money to spare. Paul has ambitions to improve his family's condition, however, especially when he sees the wealth of his various employers, but the timid Joan seems content to keep house and take care of her children. So far, the setting and characters resembles a Lynchian world of artificial calm and security, where evil lurks under the veneer of a quotidian reality.

The "Prologue" of *Mrs. White* begins with an account of the second in a series of what soon become known as the "Suburban Housewife Murders." In this opener, the victim is a well-to-do woman, Louise Porter, and her murderer is identified up front as the carpenter, Paul White. Thus, there is no suspense-building device of the "whodunit?" sort; rather, the thrill comes from Mrs. White's slow discovery that her husband is the murderer and also from the exploration of Paul's motive for the murders, which is inextricably bound to events in his past.

Mrs. White happens upon the knowledge of her husband's guilt only accidentally. She catches him in a "white lie" (no pun intended). Joan decides one day to prepare Paul's favourite stew for supper, but finds that she is lacking one of the condiments. She tries to call him at his job to ask that he bring the needed ingredient home, but she is told by Paul's current employee, Mrs. Sutter, that he has already left for the day. Yet Paul arrives home late, and he insists that he was at the Sutter's, that Mrs. Sutter had merely made a mistake. Not entirely convinced, this doubt nags at Mrs. White, and she begins to

imagine her husband is having an affair. As she worries over this, she remembers other times when she thought her husband had been secretive, and earlier mysterious behaviours that she has obviously repressed begin to surface in her conscious mind.

Especially vivid is her remembrance of a falling out between Paul and his friend, Michael, whom Joan had dated steadily before her romance with Paul. During high school, Paul was a rebel and a misfit (which Joan found attractive), whom Michael staunchly defended, until one weekend when the two boys returned from a deer hunting trip. Michael was very disturbed; Joan witnessed an altercation between Michael and Paul, in which she overhead Michael's utterance, "Disgusting!" She later quizzed Michael about Paul and why they were no longer friends, but Michael only cryptically replied that she had never been deer hunting with him. As we shall see, the way Donald would supply the details of this elided event is, in our view, extremely revealing.

Joan also remembers Michael telling her about Paul's "trouble" at home. Apparently, his father repeatedly physically abused his mother. Although Paul loved his mother, he also worshipped his father; hence, he adopted the attitude that his mother must have provoked the brutal beatings she routinely received. Joan also recalls that when she asked Paul about the deer hunting episode, he claimed that Michael was merely jealous because he had not claimed the prize: "And yet even as relief swept over her, something in Paul's attitude, something in the way he had spoken, told her he was lying."

Intuitively, Mrs. White has hit the nail on the head: in the ritualistic slayings, the mutilated bodies of the butchered victims are compared to venison that has been dressed after the hunt. Moreover, when the novel shifts to Paul's point of view as he stalks and then murders one of his victims, he thinks of himself as "the hunter," "as the wolf" who "knows where to hide," and he appraises his victim: "Still slick from the city. Still arrogant in her beauty. Still sleek and swift and difficult to capture. Like the deer." He scents "the glorious blood of the kill... But not just that. It was not just that. There was The Way. It was not just any kill. It had to be done in The Way." Paul also takes trophies, as the coroner makes clear. When Dr. Lawrence, at the scene of the final murder, states: "I knew there were parts missing" he also notes that this last victim bore teeth marks that would incriminate the murderer.

As the last two of four brutal murders are committed, Joan's suspicions that Paul is having an affair also become stronger. Thinking that her frumpy middle age appearance might be responsible for his infidelity, one night she takes great pains with her appearance, and then attempts to seduce Paul, an uncharacteristic act for the passive, timid Joan. Her act of sexual aggression induces in Paul a near psychotic episode, drawing out his murderous alter ego, in one of the more disturbing scenes in the novel.

At last, unable to endure the agony of uncertainty about her husband's fidelity and convinced that she is being deceived, Mrs. White plucks up the courage to enter his barn in search of some evidence to either confirm or put to rest her suspicions about her husband's double life. What she finds, hidden in a locker - a pair of bloody white overalls and a butcher knife - sends her reeling in a shock of sudden, violent recognition that the husband with whom she has been living for two decades has been responsible for the hideous murders in Putnam Wells.

At first terrified and feeling quite helpless, Mrs. White herself becomes a deceiver, concealing her newfound knowledge for an entire weekend, even during a moment of sexual intimacy that she at first resists, but then enjoys despite her initial revulsion. Although the meek, dependent Joan feels trapped and helpless, she eventually attempts to turn her husband in, but it takes two telephone calls to the authorities and another murder before she is taken seriously. When Paul discovers that she has betrayed him, he attempts to murder Joan, skinning one of her arms with his knife and wounding his landlord, Jonathan, who had tried to come to Mrs. White's aid. In this climactic struggle, Joan kills Paul in self-defence, and the novel concludes when she departs Arbordale with her two children and her newly acquired independence.

The first difference between the novel and film is the title change. The novel is entitled *Mrs. White* in order to emphasize that its terror hinges upon Mrs. White's shocking discovery of her husband's secret life of violence and crime. While this is also the case in Donald's film, the title, *White of the Eye*, at least hints at the nature of deception, that human perception can be skewed, and that people may not really know those to whom they feel closest, with whom they have children, consume meals, and share beds - which is exactly Joan White's experience in both the novel and the film. Unlike her counterpart in the novel, Joan (Cathy Moriarty) in the film has been married to Paul (David Keith) for only one decade instead of two, but this is still a significant amount of time to have spent together.

Additionally, in the novel, several characters glimpse Paul's fleet, animal motion peripherally. His second victim, whose murder is recounted in the "Prologue," "caught Paul White's motion in the corner of her eye." Later, his next victim does likewise: "Teresa Manchester caught his motion out of the corner of her eye," and then Mrs. White herself has a similar experience: "Then something caught her eye in the kitchen window. Something moving," which is, of course, her stalking, predatory husband. In *White of the Eye*, Joan's former lover, Mike Desantos (Alan Rosenberg) - who also saves her life - insists that Paul possessed a kind of occult power, that he cast a spell on them: "I always loved you, Joan. And then he came along and he laid his eye on us - the Apaches call it the 'white of the eye'." We could not find this reference in our study of Apache lore, but clearly Michael means it to signify a kind of spell or hex. Thus, the film's title is evocative of the instinctive, terrifying nature of Paul and his brutal acts. Finally, its most obvious significance may be its underlying connection between the "white of the eye" and the lens (eye, iris) of the camera itself, which exposes a killer who has a decidedly artistic temperament, as we shall see, in which case the film and its title indicates that viewers are voyeurs, but also that the film exposes its director to scrutiny as well.

Other significant alterations in the setting and characters are introduced. Most significant, perhaps, is the altered location. *White of the Eye* is set in the Arizona desert, not suburban Connecticut, in the smallish community of Globe, about 90 miles north of Tucson and on the edge of the Apache

Above: *Joan White (Cathy Moriarty), the trophy in a competition between Mike Desantos and Paul White.*
Opposite: *What's a woman to do? Does Joan know about her husband Paul's (David Keith) double life? Does Paul think she knows?*

reservation. The film was originally to be set in Virginia, in an environment similar to the novel. When it was decided to shift the location to Arizona, the script was revised to reflect the changed setting, which allowed the introduction of the prominent feature of Apache lore.

In addition, the film changes the relationships between Michael, Joan, and Paul, which we learn about primarily through a series of flashbacks. It will be remembered that in the novel, Michael Chambers is Joan's uninteresting high school steady, and Paul's friend. He breaks up with Joan, who then marries Paul, and he has a falling out with Paul after he goes deer hunting with him. In *White of the Eye*, Mike and Joan, two easterners, stop in Globe *en route* to Malibu Beach, to have their 8-track tape player repaired. It is clear that their relationship is intimate, but on rocky ground. In Globe, they meet Paul White, who owns a stereo repair shop with his grandfather, Arnold White (Danko Gurovich). Paul has charisma - both Mike and Joan find him interesting, for different reasons. Mike is attracted to Paul's knowledge of Apache lore and his rugged independence. In fact, there are subtle but unmistakable homoerotic undertones in the film. First, as he watches Paul fix his tape player, Mike tries to impress him by boasting of his own ethnicity: "Spanish, Italian, Scotch, a little bit o' Puerto Rican, but not much, and my grandpa - great grandpa that is - on my mom's side was a full-blown Apache... An Apache Chief. Anybody, anybody can come from New York, Paul," to which an unimpressed Paul replies, "That'll be fifteen bucks, Chief." Still, Mike persists in his efforts to impress him, later showing him his handgun, a .380 Baretta automatic, boasting it has "a muzzle velocity of 960 feet per second. A real motherfucker."

Joan also finds Paul's animal masculinity and quiet strength alluring. It is clear that her sexual attraction to him results in part from her failing romance with Mike, whose favourite song, ironically, is Hot Chocolate's "You Sexy Thing," a wry commentary on his own inability to please Joan sexually.

Joan (Cathy Moriarty), now the hunted, is protected by her former lover Mike Desantos (Alan Rosenberg) in a final showdown.

Mike and Joan find Paul so fascinating they extend their stay in Globe, putting their California plan on hold. Ten years later, Joan and Paul are married and Mike is just a memory.

In *White of the Eye*, Paul is not a carpenter for well-to-do suburbanites; instead, he installs customized high-end stereo equipment for the idle rich. In the novel, Paul and Joan were high school sweethearts with two children, but in the film they have only one child, an eight or nine-year-old daughter, Danielle (Danielle Smith). In the novel, Paul's murderous *alter ego* is developed when he is torn between his love for his abused mother and his idolatry of his abusive father. In the film, the explanation is left implicit. We do learn that Paul's father had abandoned his wife and son, and that Paul's mother was unable to raise him, so he was given over to his grandfather, Arnold, features of the backstory which remain sketchy, but are revisions of the novel nonetheless. Unlike the novel's Paul, who is a misfit and loner but no criminal as a youth, in the film Paul, we learn from the investigation - headed by Charles Mendoza (Art Evans; the name "Mendoza" Donald had also used in *El Paso*) - has "a serious anti-social juvenile record." Mendoza's partner, Phil Ross (Michael Greene) insists: "We got us a non-conformist here, Charles." How and why Paul has turned into a psychopathic killer, though, remains an enigma for the viewer to divine, a difficult, but not impossible, task, as we shall see when we analyze key scenes, such as the deer hunting episode with Michael and the climactic confrontation between Paul and Joan, sparked by her discovery of his "trophies" hidden under some woodwork in the bathroom. These differences, as well as the film's startling conclusion, suggest the presence of a distinct authorial personality.

Unlike the White children in the novel, in the film there is a strong suggestion that Danielle has inherited her father Paul's "anti-social" and "nonconformist" tendencies. Our first view of Joan shows her making cut-out cookies with Danielle, having a mother-daughter talk with her child. At school that day, Joan later tells Paul, Danielle had "socked someone in the back again," suggesting that this is a repeated behavioural pattern. Joan tries to correct her daughter's behaviour by demonstrating to her what

Detective Charles Mendoza (Art Evans), who appreciates the "art" of the serial killer with whom he engages in a game of wits.

it means to be "anti-social": she uses the cookie cutter to ruin all the patterns Danielle has just cut in the dough, then explains to the girl that what she just did is "anti-social." The question of genetic inheritance is a subtle but insistent theme in the film: Paul presumably inherited his father's criminal tendencies, just as Danielle has. When Detective Phil Ross brings up the question to Charles Mendoza, Mendoza is sceptical. Ross then asks Mendoza, "What are you telling me, Charles? You don't believe in genes?"

Related to this parent-child issue is an obvious allusion to Donald's father. The investigator assigned to the murders, Mendoza, has the surname "Charles," the name of his father, like the wealthy father in *Duffy*. In addition, Mendoza wears a mauve beret - another tell-tale allusion to Charles Richard Cammell, who also wore a mauve beret. Indeed, Mendoza is a compelling character, one who is not fooled by Paul's cleverness; as an investigator, he engages in a "game" of wits with his suspect, not unlike that of Charles and his son, Stefane, in *Duffy*. A romantic temperament, like Charles Richard Cammell, Mendoza is a lover of art; he probes Paul for advice about his own stereo system, and he alludes to the murder scenes as "works of art," showing that he has some grasp of the psychology of the serial killer who leaves a "signature" at the scene of the crime: "I know a goddamn Picasso when I see one, Lucas," he exclaims when he sees the killer's bizarre *misé-en-scene* - the crime scene.

Another revision of the source material is the addition of Paul's sex appeal. In the novel, *Mrs. White*, Joan suspects that her husband is having an extra-marital affair, but this is totally false. Paul is not a philanderer, but a murderer, as Joan - to her horror - discovers. In *White of the Eye*, however, Paul White possesses a form of self-assured, swaggering masculinity that many women (and even some men such as Michael) find appealing. Certainly it is one of Paul's qualities that made Joan exchange Michael for him. It is Paul's implicit sadism that unconsciously appeals to Joan's submissive side, as it impels her to enjoy sex (strongly suggestive of anal invasion, a copulative embrace that recurs in *Wild Side*) with Paul even after she has just uncovered the hideous truth that he is a serial killer.

The discovery of Paul's horrible trophies, coupled with the fact that she does not immediately turn Paul in, is an aspect of the film Donald had to defend when *White of the Eye* was screened at UCLA in 1988 and women in the audience attacked it as entirely implausible. Donald explained, "I thought it would be more interesting to have her deeply in love and, when she realized he was a psychopath, forced to decide whether to abandon him, or hang on in there and confront him with it and continue to love him, even up to the point where it degenerates into bestiality." Curiously, Donald appears to believe that Joan is confronted with a moral dilemma, ignoring the fact that to stay with him means that she would be willing to maintain a dysfunctional relationship. He's saying, in effect, that Joan would both recognize her husband's psychopathology, but keep it hidden from the authorities. In his defence, however, Donald clearly imagined her as a masochist: in *El Paso*, Donald had given his director-artist figure the line, "She's a masochist, like all women who are in love with criminals." The fact that Joan does not immediately inform the authorities about her husband's guilt is, in reality, consistent with her character, which is carefully established before she is aware of Paul's murderous rampages.

The trick is that, as we've seen, Donald initially presented Joan as a demure housewife making cookies with her daughter. Yet as the story unfolds, Joan is shown to be enthralled (in the original meaning of the word) by Paul's masculine appeal: he's a hunter, and he likes sex that is spontaneous, frequent, and intense. Their relationship began as a consequence of Paul's transgressive desire to steal her away from Mike Desantos. Joan is profoundly thrilled by Paul's seduction of her, because it simultaneously serves as a humiliation of Mike and frees her from the unhappy relationship with him. Thus Joan loves Paul even though he tries to kill her, and she has not shaken his spell even after his death. In short, despite ostensibly being a blonde housewife who wears Mickey Mouse T-shirts, she and Paul are a perfect match.

Joan also admires Paul's artistic ability. He designs custom woodwork for stereo amplifiers, and has an intuitive ability to place stereo speakers in a way that maximizes their sound. (Unbeknownst to Joan, of course, there is another artistic side to Paul, in the aesthetic arrangement of his murder scenes.) In the novel, Paul White insists on murdering in "The Way," but the victims are butchered like deer. Not so in the film. The opening scene plunges us into an unfolding murder (while withholding the identity of the murderer, another very important alteration of the novel, which reveals the killer's identity upfront), the aftermath of which is carefully designed as a work of art. Thus in the figure of Paul White, Donald found the means to fuse in a "unified" figure both creative and destructive impulses: "murder is a work of art."

The violence is not graphic, yet the horror is very real. Before the film's first victim (identified as Joyce Patel) arrives home, there is a shot that creates what Steven Schneider, in his essay "Killing in Style," accurately labels "a kind of cinematic still life." (He's right: according to co-producer Brad Wyman, with the stark, bleached desert setting, Donald was consciously seeking to emulate the minimalist abstraction of artist Piet Mondrian.) Among other carefully selected objects we see a bottle of red wine, a lemon, an eggplant, and lettuce on a cutting board. This is followed by a shot of other items in the kitchen (copper hanging pots, magnets on the refrigerator) which, as Schneider points out, suddenly shifts to the exterior of the house as the victim's car pulls into the driveway. We concur with Schneider's assertion that this scene acts as the embodiment of the "director-as-killer" motif, from whose point of view we have been scanning the room, an activity cut short by the sound of the car. Schneider also contends that the camerawork effects a *three-way* identification comprised of viewer, killer, and director. The viewer experiences Paul White's violent actions through the director's stylistic choices, seeing them rendered aesthetically. Thus, Schneider maintains, "the distinction between killer and director is elided." The stylistic device of identifying the killer's viewpoint with the camera - and hence (masculine) director - was employed by British director Michael Powell in *Peeping Tom* (1960), an homage to which Donald included in *White of the Eye*, when the killer holds a mirror up to the face

*In this production shot, a moment of levity is shared among the cast of **White of the Eye**.*
From left: Art Evans, David Keith (seen reflected in the mirror), and William G. Schilling.

of another victim who is drowning in a bathtub. The opening shot of the film, with the camera pointed directly into the sun followed by a tilt downward, would also seem to be an homage, this time to Barbet Schroeder's *More* (1969), which opens the same way. (There are other such allusions; for instance, the scene in which Anne Mason draws up her lingerie to reveal her new "tattoo" to Paul corresponds to the similar, and rather famous scene, from the Brigitte Bardot film *En cas de malheur* (1958) - retitled *Love Is My Profession* for its release in the US in 1959 - in which Bardot draws up her sweater to display her naked body to Jean Gabin).

In addition to the artistic rendering of the murders and to Donald's insistence on the viewer/director/murderer identification, Paul's artistic temperament is underscored by his musical talent. He plays piano, wailing out George Jones's hit song, "The Grand Tour," a heart-wrenching country western ballad about - what else? - a failed marriage and the loss of a beloved child. The songs that are associated with Paul stand in contrast to Michael's beloved ditty, "You Sexy Thing," and his déclassé 8-track tape player that Paul has to repair. Significantly, it is Joan who vandalizes the player and complains about her unfulfilled sexual desires, those that Michael cannot satisfy. It is because she pours a soda pop into the player that they even stop off in Globe. Paul fixes the machine, but it serves as the means of exchange by which he also lures Joan away from Michael. He likes the operatic drama contained in the popular George Jones lament about love on the rocks; also associated with him, and an obvious choice, considering his survival skills, is the Hank Williams Jr. hit, "A Country Boy Can Survive."

High culture also appeals to Paul, though, perhaps to suggest his divided self. He is introduced driving in his van, windows rolled down, singing opera - perhaps the most dramatic of musical genres - with great passion. The allusions to opera in *White of the Eye* represent important examples of self-figuration, drawing an analogy between Paul White and Donald Cammell. Our first shot of Paul (an ominous one only in retrospect) occurs just after the opening sequence of the murder. Driving down the highway in his van, he sings along ecstatically to an opera cranked to full volume. Considering that Paul's job is that of a "sound" artist, his passion for music isn't surprising. In retrospect, however, when

we learn that it was he who had just committed the gruesome murder of the wealthy housewife, this scene of artistic self-abandon seems overtly pathological, as it suggests that Paul experiences absolutely no remorse for - or perhaps even conscious awareness of - the unspeakable transgression in which he has indulged. In fact, he is exhilarated, energized by the cathartic act of murder.

The self-figuration of this scene is two-fold. Drew Hammond related an episode that Donald had confided to him. Alluding to his own alter ego as the "Uncensored Don," Donald told Hammond that on one occasion, as he was driving naked down Mulholland Drive with his stereo loudly blaring opera music, he was stopped by the police. Donald proudly boasted that he - or rather, the "Uncensored Don" - talked his way out of any serious consequences. Also revealing are the striking parallels between the particular opera to which Paul is listening and Donald's own life. The Italian opera Paul is playing is Ruggero Leoncavallo's *Pagliacci*. *Pagliacci* recounts the revenge tragedy of a travelling theatrical troupe. The troupe's leader, Canio, is wed to a much younger woman, Nedda, an orphan whom he had taken under his wing and then married. The uxorious Canio, in Chaucerican fashion, guards his beautiful young wife jealously. In the first act, we learn that Canio has cause for concern, as Nedda has fallen in love with a young man, Silvio, in the village where the troupe is going to perform. She and Silvio have made plans to elope, but another member of the troupe, the deformed Tonio, overhears their plot. Tonio himself lusts after Nedda, but she scorns him - returning his unwanted advances with verbal abuse, even resorting to physical violence when Tonio tries to rape her. (The character "Tony" in *Wild Side* was probably inspired by Tonio.) He vows revenge, and betrays Nedda to Canio.

Nedda's unfaithfulness leaves Canio distraught, with his own murderous thoughts of revenge. The show, however, must go on, and in the opera's second act, the troupe performs its comic skit about a husband who is cuckold by his feckless wife. This sets up the sophisticated device of the "play within a play," like "The Mousetrap," performed by a travelling troupe in *Hamlet*, which has intertextual connections with the main plot. In this harlequin performance, Canio plays the titular part of Pagliaccio (a clown), Nedda the feckless young wife, Columbina, and a member of the troupe, Beppe, plays her lover, Arlecchino. In it, all is meant to end well, as the lovers are supposed to be aided by Taddeo, played by Tonio, in keeping their secret from Pagliaccio. However, Taddeo, like Tonio in real life, also loves Columbina (Nedda) and refuses to save the day. When Canio enters the play as Pagliaccio - dressed as a clown, but weeping so profusely that his make-up runs down his cheek - he cannot control his true anger, and the comedy quickly turns to tragedy. He stabs to death his wife, who refuses to reveal the name or identity of his rival lover, but when Silvio, who is in the audience, races to her rescue, Canio also murders him. As the opera concludes, Pagliaccio utters his final line, profound and ironic, "La commedia è finita!" ("the comedy is over"). What is most startling about the "play within a play" device is its effect on the audience. In the opera, it comes to see a comedy, and certainly the audience is not disappointed at the beginning. But the audience becomes increasingly uneasy when Canio (as Pagliaccio), enters as the duped husband. As such, he indicates repeatedly that he is not joking, and the bewildered viewers are alternately amused and alarmed.

The connection between this opera, Paul White, and Donald's own life is striking. Paul White is married to Joan, an itinerant, much like Nedda is before Canio takes her in and provides for her. Paul White stabs some of his victims, Canio's form of murder. When he learns that Joan has considered betraying him, Paul prepares to murder her but first paints his face - in a bizarre fashion - like a clown, a revealing detail that clearly alludes to Paul's favourite opera, *Pagliacci* (and, for Donald, additionally to Jean-Luc Godard's *Pierrot le fou*). There are obvious connections between Donald's own life and this opera, particularly in the age difference between Canio and Nedda, which was even more pronounced between that of Donald and his second wife, China. In addition, Canio plays *svengali* to his young wife, Nedda, just as Donald consciously played *svengali* to his own young wife. The fact that Nedda plans to leave Canio for a younger lover, uncannily parallels Donald's own life.

An impressed Mike Desantos (Alan Rosenberg) (left) accepts a compass from its gifted maker, Paul White (David Keith) during their hunt for the mule deer.

Deep in the Woods

One key flashback provides additional insight into Paul's character. As we previously noted, Mike, as well as Joan, are susceptible to Paul's charisma. Joan's attraction is overtly sexual, while Mike admires Paul's *machismo*. In the flashback depicting a scene that occurred sometime after Joan and Michael stop over in Globe, Mike goes deer hunting with Paul. Implicit in the deer hunting sequence is that Mike and Paul are playing a game of macho bravado, the winner's prize, of course, being Joan. Immediately taking the initiative, Paul, the artist and craftsman, gives Mike a beautiful, handcrafted compass, made of ivory and mother-of-pearl, perhaps as barter. From the moment Paul set his eyes on Joan - the "white of the eye" to which Mike alludes - a battle of wills, with the woman as prize, began between the two men. Though Mike boasts of his Apache ancestry, being from New York City means that he is not, truthfully, familiar with outdoor life, and specifically the hunting and butchering of wild animals. Paul has thus been provided by Mike with the ammunition with which to destroy him. From the moment Paul humiliates Mike for his lack of knowledge about hunting terminology - during their talk by the van when they agree to go on the deer hunt, Mike confuses "mulies" as a diminutive for "mules" rather than a truncated reference to "mule deer" - Paul has gained the upper hand in their sparring contest. He finally asserts his dominant status by his killing of the deer, carrying his vanquished prey up the hill in order to present it triumphantly before Mike, then brutally and horrifyingly violating the animal's carcass in front of him. In a scene loaded with symbolic power, Paul uses the deer's antlers as leverage to break the animal's neck and begin his shocking butchery - antlers are the weapon with which opposing males fight in order to stake their claim over females of their own species. At this point Paul's dominance of Mike has been fully established, but he needs to complete Mike's subjugation by going even further, as up to that point (and including the drinking of the animal's blood) it can be assumed that what has been seen is his own peculiar custom. Paul has already shocked Mike by going about his usual hunting routine, thus revealing Mike's posturing for what it is: empty boasting by a "weaker" (i.e., "city") male.

On the hunting expedition, Mike (Alan Rosenberg) realizes he is out of his depth with Paul White (David Keith).

The relentlessly symbolic nature of this whole sequence continues when, his face bloodied by the vampiric act of drinking the deer's blood, Paul kisses Mike on the mouth, then further humiliates him by spitting in his face and mocking up Apache "war paint" across his face with the blood-dipped hunting knife (Paul's aesthetic imagination coming to the fore once more). Paul has triumphed, leaving Mike with no doubt at all that he is the strongest, and that Mike has no place in this suddenly alien world into which he has too deeply driven with his lover. A subsequent scene, set in a slightly different location from where the humiliation took place, reveals the broken and defeated Mike kneeling before a sort of magic circle around which he has placed objects with the colours of red, yellow, blue, and white, one for each direction.

What is the viewer to understand about the lacuna represented in the cut between the two moments? Since the late '50s and the films of Alain Resnais (for instance, 1959's *Hiroshima mon amour*), many filmmakers have utilised such lacunae to indicate an amnesiac gap or loss, a repressed, hence traumatic event. Why is Mike, now alone, performing an occult ritual? The emphasis on direction in this ritual relates back to the compass that Paul gave to Mike as barter for Joan. Presumably, we are to understand that Mike is a broken man who has lost his self-respect, his bravado - and his lover. Mike Desantos was a man clearly out of his element, with no idea what he was in for when he met Paul White. But we posit that, in addition, Mike is performing an act of ritual cleansing because he feels impure, violated, by Paul's actions. How, exactly, is the viewer to interpret Paul's kiss? Are we to identify with Paul, or Mike, during the scene? Although a famous song says that a kiss is just a kiss, and Freud said "sometimes a cigar is just a cigar," Paul's kiss of Mike isn't just a kiss, but a figurative sexual violation. Even if one were content to call Paul's kiss simply a dominant male's act of humiliating a weaker male, the other work of Donald Cammell forbids the interpretation to stop there.

The kiss isn't just a kiss because following the kiss Paul, in an act of disdain, spits in Mike's face. Within the act of disdain, however, are feelings of loathing and revulsion, but such reactions can be

used as an external disguise to mask one's real or fundamental attraction to something. Doesn't Paul consistently mask his real self, his true desires? (Or, alternatively, he seems always to be unconscious of them.) If Paul is clearly the dominant one of the pair, why does his act of revulsion occur only *after* the kiss? Why the display of revulsion at all unless the moment is to be read as rife with homoerotic significance? It is highly revealing that in the film's revision of the novel, the deer hunting scene fundamentally constitutes our understanding of Paul and Mike's relationship. In the novel, we know that something terrible happens on the deer hunt between Paul and Michael, something that disgusts and alienates the latter, presumably Paul's drinking of animal blood. Furthermore, in the novel, we know that it served as a contest that vanquished Mike and enabled Paul to steal away Joan. The scene in the film makes explicit what the novel leaves unstated.

The "hidden" or masked side of Paul emerges fully in the climactic concluding sequence of the film. Obviously prepared to end his own life when he knows that he has been discovered, he intends to take his wife and daughter with him as well. He prepares himself ritualistically by painting his face rather like an Apache warrior facing battle; his hair, in a half-ponytail, suggests an amalgam of this and a Samurai warrior. The red he paints around his mouth also suggests the grotesque smile of a clown, yet another allusion to *Pagliacci*. Paul straps explosives to his body, and begins the hunt for his victims. Paul's painted face, combined with the dynamite strapped around his waist, is an allusion to Godard's *Pierrot le fou*, which concludes with the Jean-Paul Belmondo character painting his face blue and wrapping his head in dynamite, committing suicide in like fashion. First, though, Paul carefully lays out the trophies of his former victims in some strange perverse eucharist, telling the hiding Danielle, "We're gonna eat well," suggesting that he might be actually consuming the flesh of his victims, a form of possession in some cannibalistic cultures, and one that serial killers (e.g. Jeffrey Dahmer) sometimes practice for what psychologists assume is the same reason. Earlier, there is an additional hint that he is consuming parts of the victims. When a deputy, Stu (Marc Hayashi) stops by for a beer with Paul and Joan, he's offered some type of snack. He takes a bite and begins to chew - then stops, obviously finding the snack distasteful. Afterwards, Stu is shown in a bathroom flossing his teeth - what was in the snack?

In the climactic scene of the film, Mike Desantos sacrifices himself to save Joan. Locked together in a sort of homoerotic *liebestod* - linking sex and death in the manner of Georges Bataille - Mike and Paul are spectacularly blown to pieces as Joan dives to safety. Paul's is an act of suicidal megalomania: before he lights the explosives, he taunts Mike using a metaphor drawn from the behaviour of territorial animals: "I did something with my life. I left my mark." Mike, the unsung hero, redeems himself, reclaiming his honour after the humiliation of defeat years before. The unavoidable association is with Conrad's character, "Lord Jim," whom Donald seemed to have had in mind when drawing the character of Anatole Doultry in *Fan-Tan* as well. Despite Mike's self-sacrifice, it is the suicide of Paul that is glorified, both here and in the coda between Charles Mendoza and Joan, in which neither even mentions Mike: "What's ten years when you're in love?" Paul did indeed leave his "mark."

Yet Paul's motive for murder remains an enigma, with few clues to help the viewer, a decision Donald said was deliberate: "I did not try to diagnose or pass judgment on the reasons for serial murder." In terms of plot, the deer hunting episode functions as a means to unmask Paul's brutality; it does not provide the motive for his murders. One scene, though, is densely discursive, revelatory of his personality. When Joan discovers her husband's guilt, it is after he has committed the second on-screen murder (the fourth in his series). Ironically, suspecting infidelity, in her rage she had followed him, slashing his front left tire with a knife. Paul had in fact been having an affair with Anne Mason (Alberta Watson), the wife of a rich man whose television and video equipment he had installed, but she is not his victim. In an ensuing scene, confronted with the fact that his wife now knows his secret, Paul claims of his latest victim that he "put her out of her misery. That's what they're all in - sheer misery, but I used that other

Paul (David Keith) confesses to his wife, Joan (Cathy Moriarty) that he was putting his victims "out of their misery".

girl - what's her name - they're all the same." This is a revealing commentary. First, the language Paul uses ("putting them out of their misery") suggests that he views these women as suffering animals that need to be euthanized. The notion that they are "all the same," the confusion between Anne, the woman with whom he is having a dalliance, and the nameless one he murders, reveals that he sees them not as individuals against whom he holds a personal grudge, but merely as a type. Paul then declares to Joan his notion that he has been selected to end the misery of these women, that somehow it is beyond his control: "I didn't ask to be the one." Instead, a voice said, "'Paul White, you are The One.' I was chosen, like the bombardier" (this latter a reference to the pilot whom fate arranged to drop the first atomic bomb). He confesses that it feels like someone else is doing the killing and that he is "watching," an assertion that reinforces the viewer/director/killer identification alluded to earlier, but also suggesting Paul experiences ego-alien effects: it is not him performing the acts, but someone else.

Now impassioned, Paul tells Joan: "God is the middle man. Remember, I told you about that fuckin' black hole? It sucks everything into it. Believe you *me*, I know the difference between male and female, and it is *definitely* female." Earlier, in a flashback, we had seen Paul and Joan making love on a rug before a fire. In the room was a pinball machine called the "Black Hole." Mike discovered Joan and Paul *in flagrante*, and held a gun to his rival's head. Apparently, though, he decided not to kill Paul; instead, he fled weeping, another suggestion that his feelings towards Paul are ambivalent. It was apparently in this earlier scene that Paul told Joan about the Black Hole, which must have seemed strange, even though she couldn't possibly have known about her future husband's murderous impulses. Here, though, he insists that the Black Hole, which sucks everything into it, is a destructive force even higher than God, an inanimate power associated with death. Paul urges: "You can't kill what's already dead, can you?" He presses his case against the aggressive *anima* or *vagina dentata* even further when, in a jumbled collage of theology and science, he fuses the scientific fact of evolution with the Fall, caused by the female, Eve. The females he murders, but perhaps also the visible universe he inhabits is, for Paul, one of mere appearance, deceptive and evil, one of many Gnostic utterances to be found in

The moment of truth: the madman within begins to emerge, as Paul White tries to account for his actions in **White of the Eye**.

Donald's work. Why he has conceived of the feminine as evil remains highly enigmatic, but might be related to the Gnostic hatred of procreation (if matter is evil, why generate it?) of which the woman plays a necessary or crucial role, or to a more personal reason that remains obscure. At any rate, Paul views women, or at least a certain *type* of woman - those with whom he has extra marital affairs and those he kills - as if they are "all the same." When Joan learns his secret, she threatens to become no longer just a living trophy, an extension of himself, but an object he must take with him when he goes. Clearly, in the end, he plans a murder-suicide, one that is prevented by Mike, Paul's last victim.

In *White of the Eye* the entire world of the film is sexualized, a feature of *Wild Side* we also explore. For instance, in the opening scene, we follow the soon-to-be victim as she exits Goldwater's, a chic department store in Tucson. A young male, obviously an employee of the store, trails behind her, laden with boxes of her purchases, giving a retro feel to the scene, but also telling of her wealth. We view the woman from behind, purportedly from this young man's point of view as he eyes her legs and stiletto heels. When she arrives at her car, she turns to him (and the viewer) smiling suggestively, a definite "come on." Likewise, Joan, whom we first see in a pink Mickey Mouse T-shirt, a nurturing mother, is transformed in Paul's presence, into a virtual sex kitten, donning a revealing crimson top and pants as they share a beer when he comes home from work. Moreover, their rather mundane conversation soon turns into an exchange of sexual innuendo that leads, inevitably, to the act itself. This is achieved through the *double entendre* when, alluding to his talent for wiring stereos, Paul claims he can't do it with his eyes open, to which Joan suggestively replies, "Sure you can." Fred Hoy (David Chow), who owns the diner, is clearly privy to Paul's sexual exploits, serving as a go-between, for instance, when Anne phones the diner and asks for Paul in order to arrange a *tête-à-tête* with him, and even Joan suspects - not without cause - his infidelities, which the other males in the film wink at, approvingly, and even admire.

Opera, Picasso, an aesthete detective, Apache lore, and the splendid, sterile beauty of the Arizona desert - all examples of the inimitable style of Donald Cammell - raise the modest thriller, *Mrs. White*, to a level of high artistry. *White of the Eye*, a highly stylized portrait of a serial killer who remains, in

large part, an enigma, nonetheless reveals a great deal about its director. The film represents some of Donald Cammell's best work and holds up to multiple viewings. In his 2003 study, *Serial Killer Cinema*, Robert Cettl remarks aptly of *White of the Eye*: "Together with *Performance* and *Demon Seed*, it stands testament to a formidable talent who never found a solid reception." Labelling *White of the Eye* a "stylish, even hallucinogenic film," Cettl also asserts, "Like *The Stepfather*, it was a genuinely disturbing thriller that was considered to have been unfairly overlooked in the wake of such 'safe' thrillers as *Fatal Attraction* and *Jagged Edge*."[13] *White of the Eye*, a consummate film, looks back, as we have shown, to Donald Cammell's earlier film art and, as we shall see, bears decided (and revealing) similarities with *Wild Side*.

According to an article in the *Los Angeles Times*'s "Morning Report," when the Motion Picture Association of America threatened to slap an "X" rating on the film, Marlon Brando intervened, writing to the MPAA's Richard Heffner that *White of the Eye* was, "a work of artistry and power, [throwing] a dark light on the essence of the most appalling variety of mental deformity known to our society: the 'motiveless' or 'serial' killer." Subsequently, the film was given an "R" rating instead. Donald told David Del Valle, "Brando… sent a letter to the MPAA, a brilliant letter, analyzing sequences in the film in great detail, and praising it for its originality and its artistry. I mean, you wouldn't have believed this letter! Eventually, they passed the film with a couple of nominal cuts."[14] (Donald's praise of Brando was made when *Jericho* was still on track; Brando would soon derail it.)

David Keith proved to be an excellent choice for Paul White, with his "good old boy" swagger and capacity for explosive violence, most memorable in the scene in which, angered at Joan when he feels betrayed by her, he nonetheless tries to control his violence towards her and, in an act of sublimation, rips to shreds their bed (instead of her) with his hunting knife. Though David Keith's

Above: *Unmasked: Paul White confronts Joan, who now knows the truth.*
Opposite: *Desperate measures: despite her love for Paul, Joan has to meet violence with violence.*

Above left: Joan White's own complex personality is expressed in her inscrutable face.
*Above right: The face of rage: Paul's victim, Mike, becomes the aggressor during the climax of **White of the Eye**.*

performance is excellent, as is the direction, the actor refused to be interviewed about his experience with Donald Cammell, averring that he wished not to speak ill of the dead, unable to defend themselves. Cathy Moriarty was equally excellent as Joan. Donald commanded - and got - fine performances from his cast.

Yet, for some, the experience of making the film was not a positive one. "Donald enjoyed the mania," observed co-producer Brad Wyman. Cathy Moriarty told us much the same thing: "The set was chaotic, but Donald liked it that way. You'd have to go to him if you had a question. He wanted to be in complete control."[15] The set was also somewhat volatile because Donald had hired two cameramen for the film - a situation Cassian Elwes admits wasn't sorted out prior to shooting. "I told them we'd sort out the credit later." Donald had hired Alan Jones as the Director of Photography, but he'd also hired Larry McConkey, the top Steadicam operator in the business. "Donald decided he wanted the scenes shot in two ways," says Wyman. "He'd shoot it with Alan Jones, and then he'd shoot it again with Larry McConkey on Steadicam. Sometimes Alan Jones was working more like a gaffer. I think virtually the entire film was shot on Steadicam."[16] Cassian Elwes agrees: "I think it was the first film shot entirely on Steadicam."[17] Ultimately, Alan Jones was given credit as "Lighting Cameraman," and Larry McConkey was given credit, "Photographed by," in the opening sequence, and is also listed in the end credit scroll as being responsible for "Steadicam photography."

Donald took the film to England to cut it, at Pinewood Studios, where editor Terry Rawlings (*Blade Runner*) had his offices. "Ask Terry Rawlings about working with Donald," said Wyman. (We tried several times to hook up with Terry Rawlings, but were unable to do so.) "Terry spent one whole day re-cutting the last reel," said Wyman. "Donald decided it was playing too slowly, so he had Terry go through the last reel and remove two frames from every cut - just *two* film frames. Terry said it was a nightmare."[18] But Donald got the film he wanted. It was submitted to the British Board of Film Classification on 6 August 1986, where it was passed without any cuts, running 117m 43s, and rated "18." Submitted under the auspices of Winkast Programming Ltd. (Elliott Kastner's British production company), at some point after this date it was sold to Cannon.

Given its quality, it is odd that Cannon didn't arrange a screening of *White of the Eye* at the Cannes Film Festival in 1987. The film was completed several months before that Festival, and why Cannon sat on it for so long is a complete mystery. Moreover, when Cannon *again* submitted *White of the Eye* to the BBFC for rating, in early April 1987, they had cut roughly six minutes of rather non-controversial footage from the film, material primarily concerning Joan at work, at a place identified in the script as Dupar's Thrift Shop (the character of the shop owner, Mr. Dupree - Mr. Dupar in the script - was completely cut from the film). Given the film represented the first feature film by Donald in a decade, why didn't Cannon present *White of the Eye* at Cannes? Cannon also had one of their better films on display at Cannes that year, *Shy People* (1987), but despite the positive Cannes reception, they gave the film absolutely no promotion, and it quickly disappeared as well.

Instead, Cannon opened *White of the Eye* in its West End Haymarket theatres on 19 June 1987. Despite the garish poster art featuring David Keith's scowling bloody face forming the handle to a bloody knife, and a terrible tag line ("No woman is safe… while he is loose!"), the reviews were very good. Sheila Johnston, in *The Independent* (18 June 1987), said it was "a stunning film, for all its pretensions." Philip French, in *The Observer* (21 June 1987) said the film represented the "work of a born filmmaker able to capture on celluloid a personal vision of a mad, mystical world lurking behind an ordinary mundane one." It made the "Critic's Choice" column in *The Sunday Times* (5 July 1987), where it was described as, "Stylish and original." We have been unable to obtain any box-office tallies for the film, but in any case Warner Brothers had issued the film on home video in the UK by the end of the year.

Machine Gun Kelly

"After *White of the Eye*, I wanted to make another film with Donald," Brad Wyman recalls. "Donald and I got along great. I was his 'boy producer' on *White of the Eye*. He kept calling me his 'boy producer' because I was only twenty-one years old when I produced that movie… We knocked a number of ideas around. Eventually I bought a bunch of books on [George] "Machine Gun" Kelly and gave them to him. He wrote this brilliant script [*Machine Gun Kelly*]. Donald loved the idea that Machine Gun Kelly was mostly the creation of his wife. He brought in the wife as a major character. He loved the concept of the woman manipulating both the man and his image, creating a public perception of him that had nothing to do with who he really was." The subject obviously would have appealed to Donald: a popular public figure (in this case, a criminal worshipped as a national hero, rather like the Krays were in England) who presumably lives an exciting life, but is actually (unconsciously) seeking his own death, the social rebel, the outlaw criminal - Billy the Kid as media star - dying in a "blaze of glory." (George "Machine Gun" Kelly died in prison in 1954, twenty years after his brief reign of terror.) "I loved Donald for his ideas," said Wyman, "he always had such great ideas."[19]

.38 Special

In Los Angeles, on Friday, 29 May 1987 - three weeks to the day before the London premiere of *White of the Eye* - Donald purchased and registered a five shot blue steel Smith & Wesson Charter Arms Off-Duty .38 Special hammerless revolver. During the next few years, he often carried this gun with him in a bag, and he would frequently sleep with it under his pillow. Frank Mazzola remembers Donald keeping this gun, along with a box of ammunition, in a drawer in the editing room during work on *Wild Side*. It was this gun that Donald used to kill himself. He probably bought the gun on that date with the intention of using it, but, for some reason, he did not. He gave himself almost nine more years before he finally did.

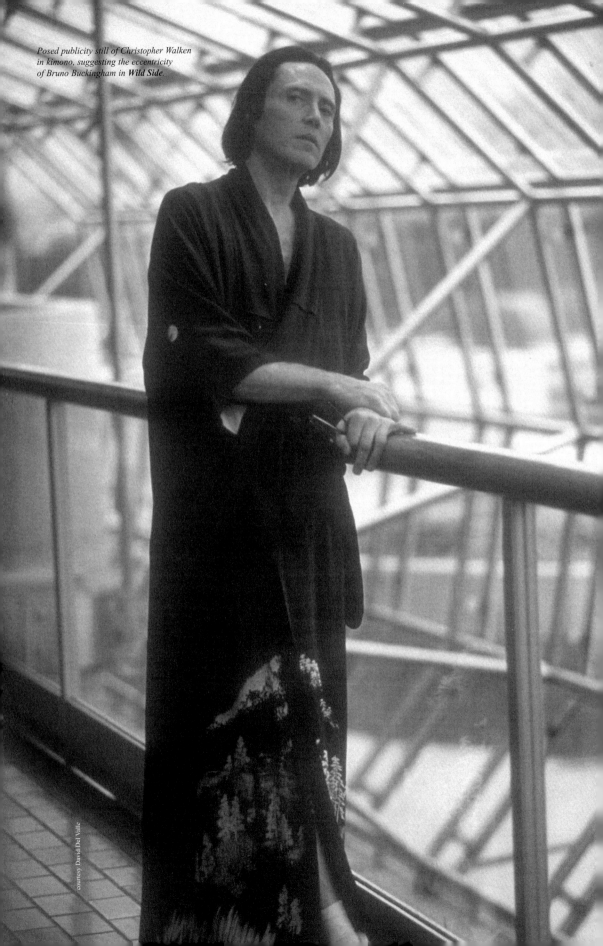

*Posed publicity still of Christopher Walken in kimono, suggesting the eccentricity of Bruno Buckingham in **Wild Side**.*

courtesy David Del Valle

Wild Side

1989-1995

9

Life is extreme. It's black and white. You play roulette? Ever see grey squares on a chessboard?

- Bruno Buckingham, in **Wild Side**

Donald was extremely pleased with *White of the Eye*. Vartkes Cholakian in particular remembers Donald being very happy with the finished film. "He brought back a copy [of *White of the Eye* to Los Angeles] on a PAL Betacam SP cassette [in 1986]. That was an unusual format in those days, and there was no place in town where he could play it. I very much wanted to see it, so I made some inquiries, and I finally located a projector in the old Columbia Pictures Studios on Sunset and Gower. He got a bunch of people together and had a screening. I told him I thought it was a good film, but the story was a bit thin. I told him what I honestly believed, and he was fine with that. Donald never liked people to bullshit him. If you knew him well, you knew he could spot bullshit in a second."[1]

Elliott Kastner released *White of the Eye* in North America during May of 1988 - about one year after its British theatrical run - under the auspices Palisades Entertainment, a short-lived releasing company formed by Kastner and his partner, Andre Blay; he had obviously retained North American Rights in the deal with Cannon. Under the auspices of Palisades Entertainment, he would also release a few other films in the late '80s, including another Cassian Elwes-produced film released that May, starring James Spader, *Jack's Back* (1988). However, the North American release of *White of the Eye* was really only a perfunctory one; it was limited to theaters in the larger US cities only, and its theatrical life was short. Once it qualified as a demonstrable theatrical release, though, Kastner was able to sell the broadcast rights (it aired in Los Angeles, for instance, on the Z Channel) as well as, more importantly, the video rights. Subsequently, by September 1988, *White of the Eye* had appeared on VHS on Paramount Home Video, and the industry buzz about *White of the Eye* being Donald Cammell's comeback film quickly subsided, like air escaping from a balloon.

Three Thousand

Donald's friend and agent at the William Morris Agency during the late '70s and early '80s, Steve Reuther, had moved into film production by 1982. He joined Galactic Films as Vice-President in Charge of Production, where he served as Associate Producer on Adrian Lyne's *9 1/2 Weeks* (1986). By the time of that film's release, Reuther had moved to Vestron, where he produced the highly successful *Dirty Dancing* (1987) and a number of less successful films. Donald apparently was considered, albeit briefly, by Steve Reuther to direct *Three Thousand*, the original script written by J.F. Lawton that eventually served as the basis for hugely successful film that made Julia Roberts a top Hollywood star, *Pretty Woman* (1990).

According to J.F. Lawton, Steve Reuther purchased *Three Thousand* when he was an executive at Vestron. When Vestron went bankrupt, and Reuther subsequently partnered with Arnon Milchan, he took the rights to the script with him. From there the property went to Disney. According to Lawton, "While the script was at Vestron, the director involved was Robert Mandel (*F/X*). When the project then went to Disney, it was instantly earmarked as something for Garry Marshall to direct as a follow up to *Beaches*. To my knowledge, no other directors were seriously considered on the script (though many expressed an interest). I suppose it's possible that Reuther might have considered Cammell to direct *Three Thousand* before settling on Bob Mandel, or might have briefly considered him before selling it to Disney. There was talk about selling it to Universal, so I don't know if Cammell might have been involved in that. So, I suppose it is possible, but again, [Cammell's involvement] is really quite a footnote in regards to dozens and dozens of people who were much more involved in the project in one way or another. (Not to mention Cammell's substantial list of films that he was clearly very involved with.) People do talk all the time in Hollywood, and if Reuther was Cammell's agent at one time, it's quite possible they would have discussed the kinds of projects Reuther was working on, and maybe even discussed him getting involved. But it clearly didn't get past the 'talk' phase."[2]

Certainly Donald was considered for other projects while Steve Reuther was at Vestron, for example at one time he was scheduled to direct another film entitled *Centrifuge*, starring Don Johnson.

The Fall of *Jericho*

Among those who admired *White of the Eye* was Marlon Brando: it was on the strength of that film that Brando approached Donald to direct *Jericho*. Despite the unhappy - and still unresolved - fate of the *Fan-Tan* project, Donald jumped at the chance to work again with Brando. *Jericho* involved a rogue CIA agent exposing the United States government's covert involvement in the Latin American drug trade. When he'd begun the project, Brando had sought the technical assistance of former CIA agent Frank Snepp, author of *Decent Interval* (1977), a controversial book exposing the tactics of the CIA in the last years of the Vietnam War. Although *Jericho* dated back to discussions held during the late 1983 and early 1984 period, Brando's interest in the project waned until the so-called "Iran-Contra" scandal broke in early 1987. The Iran-Contra affair began with the downing of a US C-123 transport plane by Sandinista troops on 5 October 1986. The vehicle was subsequently revealed to have been carrying guns to Nicaraguan contras. It turned out that the sole survivor of the crash, Eugene Hasenfus, was a CIA "cargo kicker" of many years, and his subsequent trial by a Sandinista tribunal initiated the scandal, exposing the US government's support for the counter-revolutionary Nicaraguan contras, and its covert trade of arms to Iran in exchange for US hostages. When the Iran-Contra hearings began in May 1987, Brando renewed intensive script meetings with Snepp, long-time friend and collaborator Pat Quinn, and others; Brando and Pat Quinn finished a first draft around July or August 1987. Donald told Chris Rodley that *Jericho* was about CIA veteran Billy Harrington (aka "Jericho") "who suffers a crack-up, becomes addicted to heroin, and winds up in a psychiatric clinic... While there, the CIA try to persuade him to perform one last hit - a Colombian cocaine baron. He refuses through guilt about his own past, but when the CIA introduces his daughter to the drug baron's son, who falls in love with her, he's forced to act." The last reel of the film, averred Donald, was to be "unbelievably bloody" as Jericho enacts his revenge on both the drug lords and certain CIA agents. Jericho is "a man at the end of the road," said Donald. "The overall image of the film is of a man living with his own guilt over all the horror he's perpetrated. But he's given absolution."[3] If our reading of *Performance* is correct, then the spiritual journey of the film would have especially intrigued Donald.

We are not certain at what point Donald came on board, except that it was before the end of 1987. Donald told Chris Rodley that Brando had "screened the film [*White of the Eye*] at MGM in Los Angeles. I got this call from him and he told me that he was very enthusiastic about it. He had this other project he'd been mulling over in his mind for a very long time and now he felt it was the time to do it."[4] The announcement of Donald's signing to co-write and direct *Jericho* appeared in the 2 February 1988 edition of *Variety*. Elliott Kastner was to produce, and the film was to be financed by Trans World Entertainment. The budget would eventually near the $14 million mark.

Yet after an initial flurry of activity, work on the script dropped to a snail's pace; Brando was undisciplined as a writer, and his conception of the story kept changing. That August, Donald again travelled to Tahiti, as he had when collaborating on *Fan-Tan*, to work with Brando on the screenplay. The two parted, however, in early October, when Brando flew to London to act in the film *A Dry White Season* (1989). By the time Brando returned to Los Angeles, around 1 November, his interest in *Jericho* had begun to falter. According to Donald, the experience of working on *A Dry White Season* had reminded Brando how much he hated making movies, and it was as a result of this that his interest in *Jericho* had waned. Although he was supposed to have been revising the script, he had not done so. The story had expanded to roughly 140 pages and the conclusion still only existed in outline. "He tried to cut it in a week, having procrastinated for months. He fucked it up completely. Left out all the good parts! It really became incoherent." Donald's side of the story is he was "bullied by the producers to re-write or complete the script," which Brando considered "treachery."[5] On his part, Elliott Kastner said Donald "peed all over his legs," meaning he lost control of the project.[6] Although the financing was in place, and Brando had received his hefty advance, no start date had been set. By the end of January 1989 it was all over: Brando fired both Donald and Elliott Kastner. The *Jericho* project collapsed, and *Fan-Tan* still remained in manuscript form. Donald would never again collaborate on a project with Marlon Brando.

Alamogordo

Donald was decidedly bitter about the fact that Brando had backed out of *Jericho*. He told Peter Manso that Brando's decision to abandon the project was, "a repetitive pattern in Marlon's life. It's called the giant jerk-off," thus showing considerably less largesse than he had when praising Brando for the letter he wrote in defence of *White of the Eye*.[7] Yet Donald showed his characteristic resilience. Within the year, it was announced in the 28 January 1990 *Los Angeles Times* "Cinefile" news column that Donald was to direct a $25 million dollar science fiction adventure written by Ken Finkleman, entitled *Alamogordo*, and slated to star Jean-Claude Van Damme as a 21st-century taxi driver. The TWE production, to have been released by Columbia Pictures, was to begin shooting in Spain by that summer. That film, too, was never made.[8]

The Cull

The Cull, a 123-page screenplay that Donald and China began working on in 1993, stands as testimony to the expertise he had developed as a screenwriter. Structurally complex, *The Cull* moves back and forth in time with ease, largely through the use of a single vivid image that transports the reader from one time and place to another, often resulting in the montage effect of which Donald was so fond. The fact that the screenplay is co-credited to China using her maiden name Kong suggests Donald's desire to give her independent screen credit, as the earlier script, *White of the Eye*, was attributed jointly to Donald and China Cammell.

Based on a story by Dave Humphries (credited as writer on, among other films, *Quadrophenia*), *The Cull* opens in Iraq during the Gulf War, during January 1991, but most of its action is set in the Scottish Highlands two years later, in 1993. The anti-hero, Edward Nolan, is the son of a Scottish father and an American mother. He was born in Fort William (where, incidentally, much of Mel Gibson's *Braveheart* was shot) and spent his early years there, but when his parents divorced, Nolan moved with his mother to her native Virginia. Nolan, 35 when the story opens, is part of a "Special Forces Operational Detachment" that has uncovered a secret Iraqi munitions storage place it is determined to destroy. Working undercover, Nolan is called upon to assist his superior officer, Major William Stauffer, to deploy a special forces crew to destroy the weapons. Nolan must determine whether wind conditions are favourable, as the unit's orders state that the mission should be accomplished with minimal civilian casualties. At the last minute, Nolan is forced to accept that the conditions have gone sour, and that a nearby village will be wiped out entirely if they follow through with their mission, so he urges Stauffer to abort the plan. When Stauffer refuses to listen, the attack results in many innocent casualties, and Nolan himself is badly wounded by Iraqi fire, taking one of several bullets in the head. To make matters worse, this military blunder results in a cover up, with Nolan taking the fall for Stauffer.

After a painful rehabilitation and the humiliation of being blamed for the loss of Iraqi civilian lives, Nolan is reassigned to Saudi Arabia, but en route he sees Stauffer in a Paris airport; enraged, he attacks and nearly kills him. Nolan is arrested and sent to a psychiatric hospital in England, from which he easily escapes. Nolan is now on the lam, being sought by both the US authorities (the military and the FBI) and British police. Skilled as a survivalist, he flees to the Scottish Highlands, where he hopes to remain undetected.

Near Glen Orchy, only about 30 miles from his birthplace, Fort William, Nolan unfortunately becomes enmeshed in a struggle between animal activists, led by a wealthy, idealistic veterinarian named Andy Kinnerton, and a stolid 52-year-old native of Glen Orchy, Robert Moran, who is a professional deer stalker. He is an advocate of the "cull," an annual event whereby bucks are selected and then hunted down by those who pay to do so. The "cull," Moran posits, is a conservation measure, but Andy and his followers (and Nolan) see it as a crass means to make money from rich men seeking the thrill of the kill.

Nolan and Moran clash immediately and when Andy is killed by Moran, Nolan is framed for the murder. He finds himself being hunted by US and British authorities, and also by Moran, who holds a personal grudge against him. Thus, Nolan has twice been cast in the role of scapegoat, in Iraq and in Scotland, and he must overcome his anger and need for revenge. He leaves a path of bodies, comprised of Moran and his entourage, Kenny Moran and Hamish Forbes, and two professional thugs Moran had hired. However, with the help of the dead Andy's girlfriend, Jane Shelley, Nolan escapes at the end, both from authorities and his self-destructive need for revenge.

The Cull screenplay is vintage Donald Cammell, from the persistent use of the flashback - indicated by the Iraqi setting (past) being shot in "High Contrast" - compared to the present in "Full Colour" (a device he had used effectively in *White of the Eye*), to the skilful, rapid manipulation of the montage. He works in brief flashes from the past or jumps ahead to the present by the use of a single image that seamlesssly transports the viewer from one setting to another. For instance, the transition between the opening Iraqi sequence and the present, the scene of the Highland cull, was to have been achieved by fading from the golden eye of a male ram, itself a victim of the munitions destruction, to that of a red deer buck along the River Orchy. At other times a helicopter functions as the transitional device.

This script is also typically self-referential, especially in its extraordinary knowledge of Highland terrain, customs, beliefs, and speech. Fort William, Nolan's birthplace, is only a short distance from Fort Augustus where, as a boy, Donald Cammell attended (unhappily) the Abbey school. In fact, Nolan

carries with him a keepsake, a small, tin box with an inscription that reads: "Edward Nolan, St. Michael's Preparatory School for Boys, Fort William." Naming the school "St. Michael's" might be yet another encoded self-inscription; there is no such school in Fort William we have found, unless it closed several decades ago. The home of Donald's maternal grandparents in the Highlands, however, was called Kilmichael, which means "Church of Michael." Other allusions to Catholic saints occur when Nolan, bent on revenge, enters Moran's ancient house of Glenkinglass. In a struggle with Kenny Moran, two beautiful stained glass windows are shattered - those of St. Paul and St. Francis of Assisi. Only an artist like Donald Cammell would make a point of the destruction of this beautifully crafted work; yet there is a definite satisfaction in the fact that St. Paul's head is shattered and that St. Francis is blown away. Another wry, ironic commentary lies in the fact that Nolan's nickname is "Monk." This anger is one of the most persistent features of Donald's film art, from the early caper films, *The Touchables* and *Duffy*, all the way through to *Wild Side*.

Nolan also resembles Donald Cammell, noted for his survivalist skills, in his charismatic appeal to the ladies, in his explosive, violent rages (Nolan's are described as "uncontrollable, psychotic episodes"), and in his aversion to psychiatrists. At one point, Nolan complains that "shrinks" argue for honesty, while the military insists upon secrecy, thus creating a hopelessly contradictory dilemma. In a 1989 interview, speaking of Marlon Brando, Donald mused: "Problems are created that are largely imaginary. I can't tell you why. I'm not a shrink. The dues Marlon has had to pay are that he's exposed himself too much to psychoanalysis. The results speak for themselves."**9** Other similarities include "in jokes," such as an allusion to a line from the Stones' "You Can't Always Get Want You Want" ("You get what you need…"), and Nolan's shaving mirror, which has a photo of Mick Jagger on the back.

The work connects with others in that Nolan is the anti-hero, the super-intelligent loner who survives outside the law, a hunted criminal, like Annie Doultry in *Fan-Tan* and Jimmy Mendoza in *El Paso*. Like Annie, Nolan launches savage assaults in bathrooms against his enemies. Also like Anatole, with the effeminate nickname, "Annie," and like Donald himself, Nolan expresses some confusion about his own sexual identity: Jane calls him the "ice princess," and when they make love, he tells Jane, "I feel like I'm you." When they part the next day she gives him her hat, which he wears with pleasure, yet another example of Donald's propensity for "doubling" (e.g. the doubled identities of Chas and Turner in *Performance*, the Bruno/Virginia couple in *Wild Side*). In addition, Nolan also resembles Paul in *White of the Eye*, in his survivalist skills and knowledge of the deer hunt. Finally, it's sad to note that the research Donald conducted covertly about bullets appears in this late script. When Nolan is shot through the cheek in his final encounter with Robert Moran, upon observing that the bullet had made a clean exit wound, he attributes this to the fact that the bullet had a full metal jacket and, had he been in America, it would have been hollow, causing a real mess. (As we will see in the next chapter, Donald used a semi-jacketed round to end his own life.)

Uncannily, *The Cull*, so well-researched, has acquired a special timeliness in its depiction of hidden Iraqi weapons, its military's use of the "Human Shield," and of the collusion between the unnamed Iraqi leader and the US government, each hiding the slaying of innocent civilians to serve their own propagandistic ends. A fine screenplay, *The Cull* transcends the historical moment it portrays, posing important questions about human nature and about our responsibility to ourselves, to others, and to the environment. Donald once remarked, "Anger is one of the great adversaries." This work scrutinizes the impulse of revenge - its gratifications but also its self-destructiveness - an important issue for Donald Cammell, with his volatile anger, so deeply rooted in his soul, but also for the devastating part vengeance has played in Middle Eastern affairs since the script was written.

Frank Mazzola told us *The Cull* was the project Donald was pursuing at the time of his death; evidently Sean Connery had read the script, liked it very much, and had committed to making it. But Donald had other plans.

The Grey Area

According to China Kong, the primary reason that she and Donald wrote *Wild Side* (originally titled *The Grey Area*, a phrase that is used in Bruno Buckingham's departing speech to Alex) was because they "wanted to understand financial people. One of Donald's best friends [Ben Jacober] was a banker for Rothschilds, so he was familiar with this mentality to an extent. It was a bit of a send up, to tell you the truth, of financial people, of our understanding of them." But according to David Cammell, Donald's friendship with Ben Jacober ended abruptly and badly in the '80s or early '90s. "Ben Jacober retired wealthy as a young man to Majorca... [with] his beautiful, talented wife Jannick... I became friendly with them myself for a period in the '80s when Ben took up art himself and exhibited in London. Donald went to stay with them in Majorca with China but something happened and I know they departed early and I believe the friendship foundered at that point."[10]

Whether the story of *Wild Side* was in some way connected to this abrupt break is uncertain, but it definitely was written after it occurred. Donald and China may have begun work on the script early in 1993; during the last week of 1992, as we shall see in the next chapter, Donald was very seriously contemplating suicide. Thus in the draft of the script we read, dated 8 December 1994 - essentially the script that was filmed - it is implied that the father of Alex (Anne Heche) committed suicide because of insurmountable debts, and in the script as well as the film, Virginia (Joan Chen) also attempts suicide. Near the end of the film, when Tony (Steven Bauer) taunts Bruno to shoot him in the back, he is described as behaving "suicidally, with senseless bravado." Not surprisingly, suicide was a feature in all of Donald's completed films, and it appears several times here.

The first mention of *Wild Side* in the trade press was in the 19 May 1994 *Daily Variety*, in which it was announced that the film was slated as the first feature of Nakamura Goldman Productions (NGP), touted as a $9 million "erotic thriller" being pre-sold in Cannes by August Entertainment, with backing from the French Banque Paribas. NGP was a partnership between Ken Nakamura, the founder and CEO of Korea's leading independent distributor and exhibitor, Dai-Ichi Motion Pictures, and David Goldman, a former ICM and William Morris agent who doubled as production president at Bud York Productions. Apparently NGP subsequently sold the property to Nu Image, which during 1994 to 1995 made several films with debt and equity financing provided by Mondofin B.V. By the time the property was acquired by Nu Image, the budget had been trimmed considerably from the original $9 million, to virtually a third of that amount, $3.5 million. Nu Image had been formed in 1992 by Avi Lerner, an Israeli who had previously founded the Nu Metro Entertainment Group in South Africa. Lerner sold Nu Metro in 1991 and moved to Los Angeles to found Nu Image together with Danny Dimbort, Trevor Short, and Danny Lerner, and specialized in low budget science fiction and softcore erotic thrillers.

Donald apparently had planned to make a film with producer John Langley prior to working with him on *Wild Side*. In 1993 or 1994, when she was then living in Palm Springs, Donald had sent Maggie Abbott a script entitled *Born Thief*, to be produced by Barbour/Langley (*Cops*) and starring "MJ" as Donald had written in the cover letter - Mick Jagger.[11] His old friend was to play the role of a character named "Daventry." That film was never made, but it might have led to John Langley's (and, subsequently, Elie Cohn's) decision to produce *Wild Side*.

Wild Side's expressionistic lighting scheme was necessitated by its budget: there was simply no time for complicated lighting set-ups. *Wild Side* was filmed on a very tight schedule (a little under five weeks) and shot handheld by Eastern European cinematographer Sead Mutarevic, who had trained in film school in Prague, and had worked on a number of films in Europe before coming to the United States in the early '90s. He and Donald had met a year or so earlier, when he shot some test footage for Donald for a project that was never realized (most likely *Born Thief*). Donald liked his work very much, and Mutarevic enjoyed working with Donald because his directorial style was collaborative,

courtesy David Del Valle

*Publicity still for **Wild Side** showing Virginia (Joan Chen) and Alex (Anne Heche) sharing an intimate moment.*

improvisational - in short, the European style with which he was familiar. (Donald preferred improvisational camera-work, and had little patience for time-consuming, complicated lighting set-ups - Godard was his model.) Given the time pressures of the tight shooting schedule, the camerawork was mostly worked out during the (brief) rehearsals.

Donald had assembled a top-notch crew. Thus, despite the time pressures, the shoot went surprisingly well. During the casting sessions, however, there was a hint of the troubles to come, when allegedly an actress auditioning for the role of Alex (eventually played by Anne Heche) filed a complaint with the Screen Actor's Guild about the audition methods employed by Donald and China. It is claimed that the complaint indicated China was French kissing the auditioning actresses, putatively to ascertain whether they were comfortable playing a lesbian; SAG threatened legal action, and the unusual shibboleth China was employing to cast the role of Alex quickly ceased. Since the *Wild Side* project was largely Donald's gift to China, she apparently felt a major responsibility for the casting of the lead role.

Although Anne Heche's later much-publicized lesbian love affair with Ellen DeGeneres caused many to suspect that *Wild Side* anticipated her later move from the closet (she ended her affair with DeGeneres in 2000 and is now married), it was merely coincidental, as she was not Donald's first choice for the role. (Some aver she wasn't even his second choice, but no one seems to remember who his second choice was.) Instead, he wanted for the role of Alex the then twenty-seven-year-old actress, Lori Singer, who had been in supporting film roles for years but had achieved special notice in Robert Altman's *Short Cuts* (1993). The attractive, competent Joan Chen was the obvious choice for Virginia, since the part, a thinly disguised representation of China, required an actress of Oriental extraction. Donald had liked Steven Bauer's work since he saw him in *Scarface* (1983), and cast him in the role of Tony. He anticipated, and got, the over-the-top performance he wanted from Christopher Walken as Bruno Buckingham.

Wild Side started shooting on or about 2 February 1995, and was completed around 3 March. Donald himself paid for the last sequence to be shot, the sequence depicting Alex and Virginia in the bus headed to Mexico.

The name Buckingham was another oblique self-inscription by Donald: Donald's father, Charles Richard, had written a fine book, one to which he devoted many years of research, *The Great Duke of Buckingham* (1939). George Villiers, 1st Duke of Buckingham (1592-1628), was the archetypal lovable rascal; he became the favourite courtier of King James I. Buckingham would eventually control dispensation of the king's patronage, but was accused of corruption in 1621 for granting lucrative monopolies to his relatives. He was eventually assassinated by a disgruntled naval officer in 1628. Buckingham's romantic life inspired large portions of Alexandre Dumas's *The Three Musketeers.* Donald also incorporated aspects of his own into Bruno Buckingham's mercurial personality, but these inclusions are largely playful.

The film's backstory is important: Bruno Buckingham's marriage to Virginia (Joan Chen) was dissolved ostensibly for financial (tax) reasons, but it also allows him to pursue his penchant for prostitutes without any pangs of marital betrayal, and for her to indulge in what Bruno calls her (lesbian) "tendencies" ("She was raised in a convent, for Christ's sake!"). He and Virginia remain together as a couple because she is also a useful front for Bruno's criminal career as a money-launderer: he is the legendary "Mr. Thirteen Percent." When the story opens, he has $169 million stuck in an inaccessible account in a Long Beach bank. As the first step in his plan to recover the money, Bruno instructs Virginia to set up a "dummy" account at the bank where the money resides. This "dummy" or "front" account will give him a drop spot for his thirteen percent take on the $169 million once he transfers the balance to an unspecified foreign account (it hardly matters where).

As it happens, Alex (Anne Heche), a loan officer in Foreign Accounts at this Long Beach bank, has begun a second career moonlighting as a call girl named Johanna - "with an 'h'". Coincidentally, her client happens to be Bruno Buckingham. After their sexual encounter, Bruno orders his chauffeur, Tony (Steven Bauer) to drive her to her hotel. Later that night, when she arrives home, Alex finds Tony, who has somehow managed to find her address, inside. Earlier, Alex had refused Tony's offer to have sex with her for $300; insisting that he ought to have his sexual fun with her, too, since his boss did, Tony rapes her - in a fashion strongly suggesting anal invasion. Like Virginia, Tony has issues of his own to reckon with, apparently stemming, like hers, from his Catholic upbringing. For instance, he wears a cross made of bullets around his neck (we see several close-ups of this), and during his rape of Alex, Tony chants a strange litany about "getting his soul back" via this act, and asserting that Alex is his "Mary Magdalene." All passion spent, Tony subsequently reveals to Alex that he is an FBI agent, working undercover as Bruno's chauffeur, whom he plans to snare in a major "sting" operation. He tells Alex to expect an Asian woman to open an account at her bank, part of Bruno's plan to recover the $169 million. After his departure, Alex calls the number he'd left behind, which would prove the veracity of his claim that he is indeed an FBI agent. She informs the agent on the other end that she's been raped. The agent replies that should she wish to press charges, he will notify her employer (the bank) she is in violation of legal statutes prohibiting prostitution. Alex finds herself in a dilemma, forced to help her rapist, who is, ironically, protected by the law.

Just as Tony had told her, an Asian woman - Virginia - shows up at the bank and, serendipitously, meets with Alex in order to open a business account for "Foot Fetish," her shoe-making company. The two share an immediate rapport, flirt, and linger over a chic, martini-filled lunch. They begin to talk extensively and suggestively about sex. When they return to the bank, and visit the Executive "powder room," Alex can no longer hide her feelings, and abruptly folds Virginia in her arms and kisses her. Virginia, the more experienced lesbian, only feigns mild surprise at the sexual overture, while Alex is appalled not only that she's crossed the line between personal relations and business, but also at her own genuine passion, a new experience for her.

Bruno's liaison with Alex/Johanna provides him with a convenient means to recover the $169 million: he gives Alex, whom he now refers to as his "protégé," a floppy disc containing a program nicknamed the "Hiroshima virus" (a feature which now dates the film somewhat), which will effectively disrupt any attempt by the Federal government to trace the transfer of the money to the unspecified overseas account (and his 13% "fee" into Virginia's account). Alex colludes with Bruno because she's become Tony's unwilling accomplice in the "sting" operation, but she also remains Bruno's consort because of her love affair with Virginia. Eventually, though, Alex tells Virginia about her relationship with Bruno, and proposes they elope. Appalled by Alex's admission of prostitution - and of being Bruno's client - Virginia attempts suicide. The climactic scene occurs when Alex invites both Bruno and Tony to the hotel room where she performs as "Johanna." Bruno arrives first, and hearing Tony at the door, temporarily steps out of the room. Tony, not realizing Bruno is present, attempts to rape Alex - a second time. He is stopped by Bruno, who expresses the shock of betrayal: not only has Tony been messing with his woman, but he's overstepped the bounds of their relationship. As punishment for his transgression, Bruno intends to rape (sodomize) Tony, but he is caught *in flagrante* by Virginia, who has recovered from her suicidal drug overdose in the interim.

Subsequently, Alex and Virginia plan their getaway. Before she leaves the hotel, motivated by her acrimony for Tony, Alex warns Bruno that he is being "set up." Tony follows Alex to her house. Following a violent confrontation, during which Tony learns from Alex that Bruno has discovered that he is an FBI agent acting undercover, Tony vows to send Alex to jail as well. Bruno arrives, shoots Tony, and escapes to the airport by means of his helicopter. Bruno last appears at the airport, where he is to be arrested by the FBI. Meanwhile, Alex and Virginia are seen on a bus headed to Mexico, loaded with migrant workers. We learn that before she left the bank, Alex had taken the liberty of transferring Virginia's money back to her bank in Hong Kong, where the two will, presumably, settle down and live together.

Money launderer Bruno Buckingham (Christopher Walken, in a performance Donald praised as suitably "over the top") imparting knowledge to his "protégé", banker and call girl Alex (Anne Heche) in **Wild Side**.

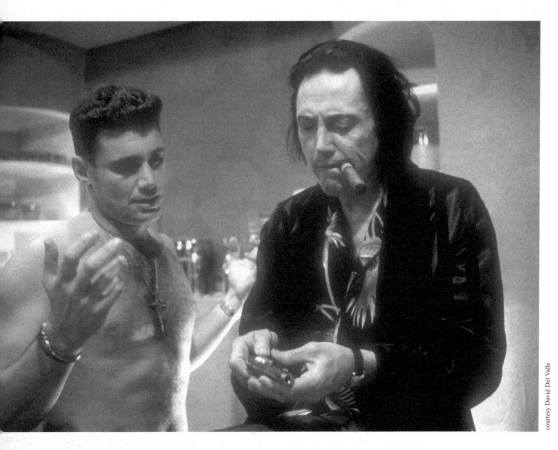

In the peculiar, eroticized world of **Wild Side**, *a cigar is never just a cigar. Tony (Steven Bauer), Bruno's chauffeur - and undercover FBI agent - on the left, sports a cross made of bullets, while Bruno Buckingham (Christopher Walken) asserts his dominance.*

Sex and Power

In an interview conducted during filming, Donald claimed that he based the character of Alex on a friend of a friend, a bank loan officer who was forced to "turn tricks" (Donald's phrase) in order to augment her income and enable her to cover her mortgage debt - according to Donald, a banking career will effectively be brought to an end by bankruptcy. We are compelled to mention, however, that in the cinema, at least, the subject of women turning to prostitution in order to augment their income was not new: Godard had portrayed a housewife who turns to prostitution in order to supplement her income in *Deux ou trois choses que je sais d'elle* (*Two Or Three Things I Know About Her*, 1966). Luis Buñuel had also explored the same subject of housewife-turned-prostitute in a slightly different fashion, in *Belle de jour* (1967). The broader point is, the theme of alternate or "hidden" lives is by no means a new one, and has a long history in literature and art.

To be sure, Alex is not a housewife, but her material circumstances have contributed to the creation of her other, nocturnal life, the "grey area" in which Johanna comes alive. (We note in passing that Alex's material circumstance is neither a necessary nor a sufficient cause for her "second" life - i.e. a "logical" reason - rather, it seems motivated by the sheer visceral excitement of transgressive pleasure). We have argued throughout this book that the essential dilemma confronting characters in

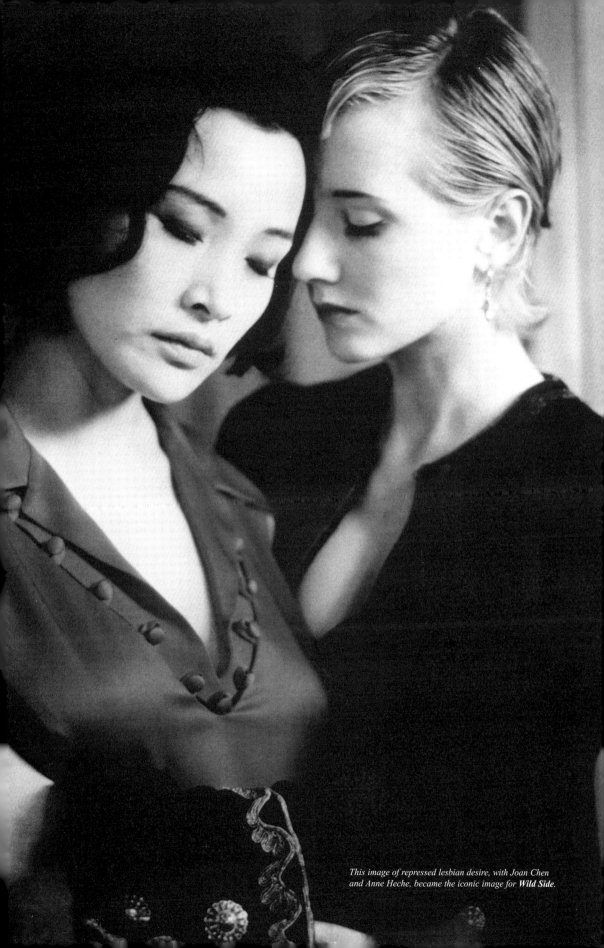

*This image of repressed lesbian desire, with Joan Chen and Anne Heche, became the iconic image for **Wild Side**.*

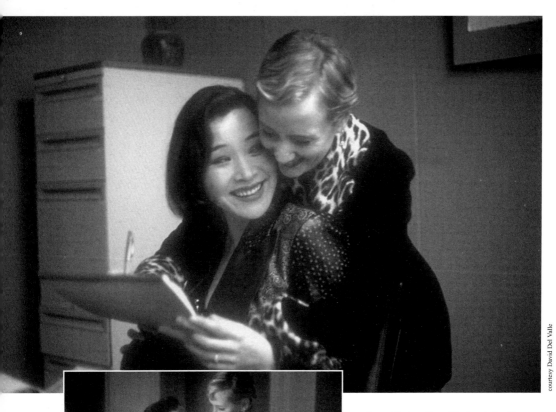

Above: *Virginia (Joan Chen) and Alex (Anne Heche), having declared their love for each other, plot their new life together.*
Left: *Bruno (Christopher Walken) enjoys his assignation with "Johanna" (Anne Heche), who is actually Alex moonlighting as a call girl.*
Below: *Tony (Steven Bauer) liberates Bruno (Christopher Walken) from his bondage.*

Donald's films is how to exceed the limits of their banal, desacralised existence without causing a series of calamities or contradictions which ultimately alienate them from their society. Restated, it is the age-old conflict between impulse and inhibition; "visceral" vertigo (Alex's word for sex) as opposed to the proscribed, normative behaviour of modern urban social life. In *Wild Side*, Alex manages to fulfil her desire and overcome her alienation, although she must leave her home and country behind: figuratively, she indeed does "go to Persia," but that impulse is realized in *Wild Side* by her journey with Virginia into the "Third World," the place where she says she has always really belonged.

From the moment he read Borges in the mid-'60s, Donald had remained captivated by the Borgesian idea that all things meet their opposite: creation is ultimately indistinguishable from destruction: "murder is a work of art." *Wild Side* similarly explores such binaries that dissolve in the realm of the unconscious, or at least the psychoanalytic (Freudian) unconscious: since social relationships are largely premised on some form of exchange - sex or money - then sex and money, money and power, domination and submission all dissolve into an undifferentiated ("primordial") form of social expenditure. Like any true Gnostic, Donald no doubt accepted the dictum attributed to Lao-Tzu: "High rests on low." Perhaps unwittingly, *Wild Side* serves as an illustration of Stephen Marcus's claim about the Victorian attitude towards sexuality in his work *The Other Victorians*: the main metaphor for orgasm ("spending") was an economic one, by no means a coincidence. Sex is a "commodity" that can be "exchanged" for power - for the Victorians, and in our contemporary world of high finance. "This isn't about sex," Bruno tells Alex as he's about to sodomize Tony, "it's about power," but of course his utterance is intended to blur any real distinction between the two terms.

Collapse

According to Sead Mutarevic, he, Donald, the actors - and perhaps especially, the producers - all were satisfied with the dailies.[12] When cutting began around 6 March 1995, a Cannes screening was still everyone's intention - promo material had been printed up especially for the festival: trade advertisements for *Wild Side* at the time announce "A Donald Cammell Film." A rough cut was ready by the end of March; it was then that the trouble began.

The points of debate by studio executives were several, both substantial (story and motivation) and stylistic - *particularly* the style. In terms of substance, one sticky issue was the matter of establishing Alex's character and motivation: in Donald's cut, Alex is revealed to be a bank loan officer only after the long opening sequence in which we first meet her as "Johanna" and after meeting both Bruno and Tony. Why is she a "call-girl?" Why is she "kinky?" How is this related to her job at the bank? Another issue was Christopher Walken's performance: he was too over-the-top, and he portrayed the character as too strange, too quirky. In short, Bruno was too flaky, confounding his status as the villainous heavy. The point seems to have been, "Make him more sinister." This, however, would also necessarily have made him less complex. In contrast, everyone seemed delighted with Steven Bauer - who indeed gave an exceptionally fine performance. But it seems clear to us that Donald saw Tony as latently villainous and malevolent, despite his manifest profession as a law enforcement official - and despite his professed Catholicism, ironically symbolized by the cross around his neck made of bullets. In contrast, the audience was to be much more divided in its sympathies for the "lovable rascal," Bruno.

Another cut was finished, and was screened on 18 April, after which further apprehension about the story (and style) was expressed by the producers. At this point the issue was the film's explicitness: it was too explicit for an 'R' rating. Donald re-cut the film again, and there was another screening on or about 10 May. The producers' reaction to this cut was also profoundly negative: apparently the cut

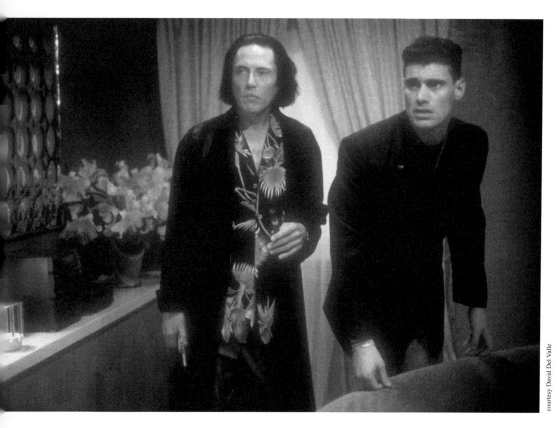

"This isn't about sex, it's about power": Tony (Steven Bauer) caught with his pants down, at Bruno's (Christopher Walken) insistence. A brief close-up of Tony yowling upon being violated by Bruno did not appear in the director's cut.

Donald had made in the interim reflected few if any of their suggestions; in their view, it would still earn the dreaded 'NC-17' rating, eliminating a great many possible sales. Indeed, it was after this cut was screened that discussions stalled and, as the saying goes, things got nasty. The film was too long and needed to be cut; the tone wasn't consistent, it wasn't suspenseful, and what's more, Donald was resisting making the requested changes to earn it an 'R' rating. It is our understanding that it was a copy of this version that was sent to Cannes, where, in fact, *Wild Side* did screen in 1995.

Moreover, the editing style was also creating problems: Frank Mazzola told us that the producers vehemently objected to what they pejoratively referred to as the "5-15 frame 1960s flash-cuts," especially as these flash-cuts were, for example, impinging on an important sex scene. It was too "arty." According to Frank Mazzola, Elie Cohn thought the flash-cuts were "fucking up a perfectly fine lesbian sex scene."*13* The attitude of the producers is clearly reflected in the truncated cut that was shown on HBO and released to video: the sex scene consists of a static shot of Alex and Virginia in Alex's bed (apparently banal enough to earn the film its desired 'R' rating).

The producers were also hesitant about the scene in which Bruno expresses his intent to bugger Tony as punishment for Tony's attempted rape of Alex. It is imperative to point out that neither the director's cut nor the producers' cut actually reflects the scene as Donald originally cut and screened it to the producers. In both versions, Bruno rips off Tony's underpants, saying "I paid for these Calvins," in order to emphasize the fact that Tony is his employee/servant/property. Overtly, Tony (who alternates

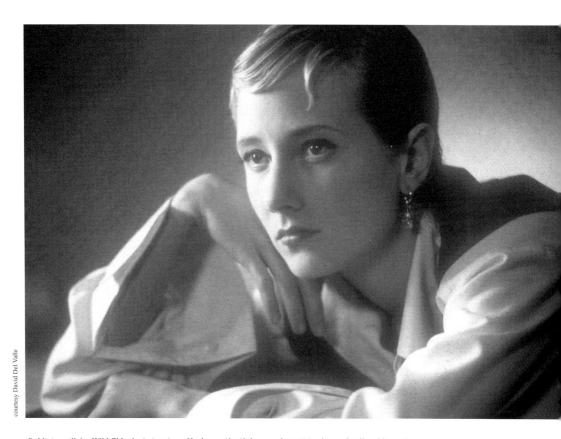

*Publicity still for **Wild Side** depicting Anne Heche as Alex/Johanna - banker by day and call girl by night - in a pose that harkens back to Classical Hollywood.*

between dominance in scenes with Alex and submission in scenes with Bruno) tolerates Bruno's abuse and humiliation only because he is an undercover cop who wants to bust Bruno; the latent meaning of his submission, of course, implies his homoerotic attachment to Bruno, an attraction of which, consciously, he could scarcely be aware. Bruno taunts Tony by placing the gun to his head, suggesting they play a game of Russian Roulette a la *The Deer Hunter*, and then violently begins a back-handed spanking of him. Yet both versions omit a medium close-up lasting roughly two seconds, showing Steven Bauer grimacing and howling in pain, strongly implying that Bruno has actually anally penetrated him. It is over Tony's yowl that we unexpectedly hear Virginia's remonstrance, "Whore!" A cut reveals that she has, unnoticed by anyone, entered the room, and is disgusted by Bruno's buggery of Tony. In both existing cuts, there is no actual penetration by Bruno, merely the suggestion that he is *about to do it*, before Virginia enters. The colossal irony, of course, is that Tony's treatment of Alex throughout - his initial rape of her, on the kitchen counter in her home - and his later attempt to rape her, at the hotel room, were left intact by the producers, but Bruno's actual rape of Tony is bowdlerized. No doubt there were tight sphincters around the screening room when Donald first showed his cut of the film; it suggests how far he was willing to push the aesthetic envelope. Perhaps, for some, *Wild Side* had become a little *too* wild - the 'NC-17' rating was an anathema.

Yet the scene is problematic in that Bruno claims to be motivated by a kind of poetic justice. He had walked in on Tony when the latter was trying to rape Alex, whom Bruno clearly considers his

own property. Yet this act of sodomy underscores Bruno's own sexual dysfunction, one that is made clear at the outset by the fact that Bruno can apparently only find sexual satisfaction from the most rarefied, fetishistic scenario, one that consisted of Alex dominating him, culminating in bondage. We think it is significant that all four of the main characters enact dramatically one of Freud's fundamental formulations (even if it was an assertion made without empirical validation), the essential bisexual nature of every human being. The *Wild Side* quadrangle (or doubled triangle, a "+1" variation of the typical Cammellian *ménage a trois*) is - albeit in part, unwittingly - incestuous in the variety of sexual activities in which they engage with one another. Bruno, for instance, has had sexual relations with all three characters: with his estranged wife, Virginia, early on, at least; with Alex, who satisfies his fetishistic desires; and with Tony, in the scene described above. The same can be said of Alex, who has been buggered by Tony, hired regularly by Bruno, and seduced by Virginia. The other two players in the quadrangle mix and match as well. Tony forces himself on Alex and receives payment in kind from Bruno; Virginia has had sex with both Bruno and Alex. Each individual in the doubled triangle is linked economically as well: Alex is hired by Bruno; Bruno employs Tony; Virginia consults Alex about opening her bank account; and Bruno's relationship with Virginia is maintained strictly for financial reasons. By simple elision, "cash nexus" quickly becomes "sexus." In this world, boundaries exist only so they can be transgressed, and sexual identities become blurred, creating a Sadean scene of orgiastic exchange, where sex partners, alternately dominant and submissive, function like interchangeable parts. The entire world, and every object in it, is to be interpreted strictly in terms of a Freudian hermeneutics of suspicion: a cigar is never just a cigar. Even the money is eroticized - **169** million dollars - which, while alluding to the colloquial expression for the reciprocal genital-oral sexual position, also, unwittingly - and most importantly - suggests the circularity of an overwhelming obsession.

"Franklin Brauner"

Despite the fact that a cut of *Wild Side* was sent to Cannes, things were far from resolved regarding the future disposition of the film. By the end of May, things had completely deteriorated: Donald and Frank were soon fired, and the cutting of *Wild Side* was taken over by the producers. After a version of *Wild Side* eventually premiered - in February 1996 on HBO (with Donald having removed his name as director, replacing it with "Franklin Brauner," his own idiosyncratic displacement of the more commonly used "Alan Smithee" designation) - Frank Mazzola wrote a letter to *The Hollywood Reporter* (dated 28 February 1996) in response to their review. It read, in part, "The HBO version of "Wild Side" was edited by Martin Hunter, the producers' editor. It does not reflect, in any way, the director's cut which I had edited."

Despite being fired, Donald continued to work on the film. He personally hired a young editor, John Ganem, to cut the film for him using an Avid editing suite. One workprint we've seen is dated as late as 8 April 1996 - revealing that he continued to work on the film until a couple of weeks before his death. Donald's hiring of the young editor had an unforeseen consequence: John Ganem and China soon began an affair, of which Donald was keenly aware. She was to leave Donald by the end of August 1995, and though she was to return, briefly, during the writing of *33*, their improbable twenty-year relationship was down to its final months.

For Donald, now sixty-one years old, the debacle of *Wild Side* represented a double loss: the loss of his art, and the loss of his wife. He'd embarked on the film as a gift to China, but he had failed to deliver it to her. Although his characters often warned against mixing one's personal life and business, Donald had consistently violated his own axiom, and it had come back with a vengeance.

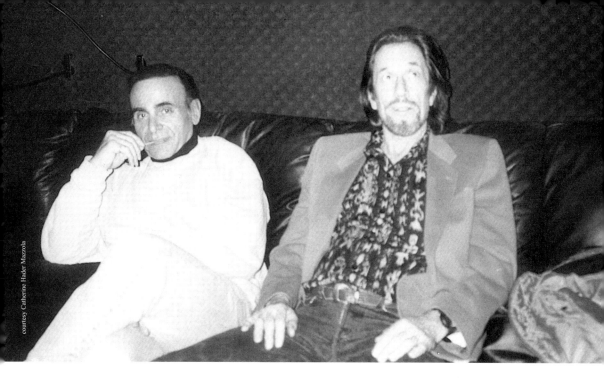

Donald's long-time collaborator Frank Mazzola (left) relaxes with his friend (now sporting a beard) during the editing of **Wild Side** *in 1995. Donald had shaved his beard and was wearing his hair considerably shorter by early 1996.*

The Director's Cut

Time seems to provide, finally, truthful judgments. As critics (and biographers), we cannot see past the barrier of time, and so its judgement of *Wild Side*, alas, we will never know. The director's cut of *Wild Side* (the restoration of which was financed by Donald's friend Hamish McAlpine) was much ballyhooed in 1999 when it began making the film festival circuit around the world - appropriately, it had premiered at the Edinburgh Film Festival in August that year. To his credit, Frank Mazzola had restored *Wild Side* as a gesture of love and friendship to Donald - and we respect him for doing so. It was a long and arduous task, and fortunately he had the assistance of his wife, Catherine Hader Mazzola. Donald had been dead three years by the time the director's cut of *Wild Side* appeared; it was met with reviews that were at once cautiously laudatory and also respectful of the dead. Chris Campion, in *Dazed & Confused* (February 2000), wrote, "More than any of his other films, *Wildside* [sic] keenly illustrates the black humour that undercuts [sic] Cammell's work."[14] Mark Kermode, in his review of the film in *Sight and Sound* (August 2000), called *Wild Side* "an extraordinary piece of work… distinguished by a hypnotically jazzy structural rhythm which unites - rather than isolates - the bizarre antics of its oddball cast."

Despite the restoration, in our estimation *Wild Side* does not represent Donald Cammell's best work, a fact that becomes particularly clear when it is considered in juxtaposition with the other script he was composing at about the same time, *The Cull*, which contains consistently fine writing - complex, lucid, and engaging. There are, of course, some fully realized scenes. Bruno's parting speech to Alex ("I was like you once. Very young. Fresh.") at the end of the film is particularly poetic and is perhaps as close to a personal statement as Donald ever included in one of his movies: "Life is extreme. It's black and white. You ever play roulette? Ever see any grey squares on a chessboard?"

Yet the director's cut of *Wild Side* was not released without several preliminaries. There were the books on *Performance* by Colin MacCabe and Mick Brown, and innumerable journal articles.

The documentary, *Donald Cammell: The Ultimate Performance*, despite its lacunae an important contribution to our understanding of Donald Cammell, had premiered at the Institute of Contemporary Arts in May 1998 (and at the Toronto Film Festival in September of that year) and, on 17 May 1998, on BBC2. It, too, had largely contributed to the public (mis)apprehension of the sensational circumstances of Donald's suicide - that he'd lived forty-five minutes after shooting himself, for instance, and that he'd seen the picture of Borges (from *Performance*) float before his eyes as he was dying - claims which we believe are false. (We will show why we consider these claims to be without merit in our final chapter.) Thus, *Wild Side* garnered a great deal of morbid interest because of the legendary stories surrounding Donald's suicide, but the circumstances of his death unfortunately obfuscated any attempt to read the film on its own terms. If he had *not* died under such supposed sensational circumstances, how then would the film have been received? Of course, it is impossible to say. Outside of the immediate, contextual interest the director's cut of *Wild Side* generated upon its release, it is difficult (for us, anyway) to imagine that *Wild Side* will earn the endorsement of time.

And what time is it? In *Wild Side*, anyway, it is always "bedtime." As we discussed in detail in Chapter 4, all pornotopic worlds, all those that take place in the hermetic world of the Pleasure Dome - even those of the Marquis de Sade and Georges Bataille - last more or less about nine-and-a-half weeks. Sade may have been slightly more optimistic in asserting they last 120 days, but like all simulacra, pornotopias eventually dissipate, revealing that they are (yet another) spurious reality. They cannot last; in the harsh light of common day, the rickety, constructed world of the Pleasure Dome is exposed for what it really is. When Anne Heche and Ellen DeGeneres remain, like us, only a glimmer in the cultural memory, *Wild Side* will truly be seen for what it is. What will be reflected in the mirror?

*Friday, 30 June 2000: Too late for Donald, but at last **Wild Side** could be shown to the public exactly as its creator intended. This poster for a London screening, some time after its Edinburgh premiere the year before, is marred by several typographic errors, but the show was a sell-out success all the same.*

10 Blood of a Poet
1995-1996

"Each way to suicide is its own: intensely private, unknowable, and terrible. Suicide will have seemed to its perpetrator the last and best of bad possibilities, and any attempt by the living to chart this final terrain of a life can be only a sketch, maddeningly incomplete."[1]

- Kay Redfield Jamison, **Night Falls Fast**

After China left him at the end of August 1995, Donald called David Cammell in London and asked him to fly to Los Angeles. Believing that China's departure had plunged Donald into a deep, potentially lethal, depression, David put his affairs on hold and immediately complied. Donald met him at the bar in the Mondrian Hotel on Sunset Boulevard. To his surprise, David found Donald to be cool, calm, and collected. "One thing I do remember he asked me soon after I arrived, which is rather funny now that I think about it, was 'Why didn't you take the Concorde'?"

A day or so later, however, Donald's mood turned dark and he became agitated, even somewhat hysterical. "I don't know what triggered it, really. But he emerged from his bedroom holding the handgun," says David. "I demanded that he give it to me... He refused... He stood there in the middle of the room with his arms over his head, waving them back and forth, taunting me, saying, 'You can't take it away from me! I'm stronger than you.' In retrospect, it was utterly absurd. It was like being in the nursery again. I told him that I couldn't sleep in a house with a loaded gun in it, and that I was going to leave. At that point he calmed down, unloaded the gun, and put it away. He said he couldn't sleep without the gun but he assured me, 'Don't worry. I won't embarrass you.' I subsequently spent the next several weeks with him."[2]

As was his wont, since they were little boys, Donald had called on David to help him make it through the worst of his depressive illness. Yet his continual reliance on David may have had its own detrimental effects on Donald, particularly in the form of guilt and shame. "Suffering, hopelessness, agitation, and shame mix together with a painful awareness of the often irreversible damage done by the [mental] illness to friends, family, and careers. It is a lethal mix," observes Kay Redfield Jamison in *Night Falls Fast*.[3] We can only speculate on Donald's mental state at this point. Now nearing retirement age, at 62, Donald most certainly was aware of the detrimental effects of his illness on his family and career, which would have only exacerbated his already agitated state. Combined with China's leaving him - which Drew Hammond believes "was a much greater disaster [to Donald] than I think she might have suspected," Donald's mental state was an extremely combustible mixture.[4]

David ended up staying with Donald for almost six weeks, until early October, and it was really Drew Hammond's friendship with Donald that made David feel comfortable enough to return home. "I had matters to attend to. As you might imagine, it wasn't easy to just drop everything like I did. I had to get back [to London] and take care of my business affairs."[5]

Drew Hammond had met Donald about a year earlier through a mutual friend. A talented writer with a strong interest in art, as well as an admirer of *Performance*, Hammond had shown

Donald a screenplay he'd written that Donald had liked. As his friendship with Donald grew, the two began exchanging ideas for a screenplay. From these discussions came the genesis of what would prove to be Donald's last screenplay, *33*, written in collaboration with Drew and China in the late 1995 to early '96 period. Set in the year 1933 against the backdrop of the heroin trade across Turkey and Marseille, it is also about a love triangle.

It was Drew Hammond who recognized the seriousness of Donald's depression following China's departure. He told Mick Brown, "On the one hand *Wild Side* had been massacred, which did considerable violence to his career and his view of himself as an artist. But he was also depressed that it was a terrible disappointment to China. There were all sorts of recriminations about whether he should have enforced his ideas more. He felt he had failed her."[6] Frank Mazzola concurs: "Donald was honestly embarrassed by what they did to *Wild Side*."[7]

Hammond recalls trying several strategies with Donald. One was a road trip to Colorado, lasting well over a week. It was during this period that Hammond noticed, in addition to carrying his gun with him at all times, that Donald would sleep with his gun under his pillow, thereby always keeping the weapon by his side or within reach.

Hammond also sought professional help for Donald based on what he felt was the severity of Donald's mood. He found Donald a psychiatrist. "I saw an opening which lead me to believe that he [Donald] would be disposed to seek help," says Hammond. "But he was in despair about whom he should see on the matter. So, I went to the UCLA Medical Library and I looked up all the shrinks in the register who were... within a certain age group. I wanted one with an M.D. and a Ph.D., because it showed some research experience which I thought would be helpful. It shows that they are a real intellectual, and that's the sort of thing you need in dealing with Donald. And I also looked at one with publications in the field of dissociative personality. There were two who fit all these criteria - only two... I said [to Donald] on paper, this looks like a guy you should get along with and be able to talk to... so check him out."[8] Donald agreed, and scheduled his first appointment.

Hamlet (Pow, Pow, Pow)

Statistics show that most suicides occur on Mondays; Donald chose a Wednesday. Statistics also indicate that suicides are most prevalent in the later morning hours before noon, and that the most common season is the spring. Donald chose the springtime, and he chose a late morning time to shoot himself - according to official reports, on or about 11:10 a.m. PST.

There are several myths that have been propagated about the details of Donald's suicide, no doubt prompted in part because of the assumption that since he was such an extraordinary person, his would therefore be an extraordinary suicide. These myths began immediately and took on a life of their own. Yet, having undertaken a considerable amount of research into the facts surrounding the circumstances of Donald's death, we have come to the conclusion that these myths, despite their romantic appeal, are false.

Here's a typical example of the many misperceptions surrounding Donald's death, taken from *Old Gods Almost Dead: The 40-Year Odyssey of The Rolling Stones* by Stephen Davis:

> In May 1996, Donald Cammell shot himself at home in the Hollywood Hills. The auteur of *Performance* left behind a short trail of perverse films, music videos, and missed opportunities, having never again risen to the brilliance of his collaboration with Mick Jagger. Cammell was depressed that his last film, *The Wild Ride*, had been shelved by its

producers. Perverse to the end, Cammell shot himself in a way that allowed him to bleed to death in a forty-five minute necro-narcotic stupor. He watched himself die in a mirror. His last words to his wife were, "Do you see Borges?"*9*

Setting aside the validity of at least two of Mr. Davis's interpretations about Donald's life and films, this passage, which contains six sentences, is a procession of factual errors and uncorroborated statements: Donald committed suicide on 24 April, not during May; his last film was not "The Wild Ride"; his last film was not "shelved," but re-cut and released by the producers; expert medical opinion is that he did not "bleed to death", and the testimony of investigating officers indicates that it did not take him forty-five minutes to die; he was not in a "necro-narcotic stupor," but in fact stone cold sober without a trace of drugs or alcohol in his system.

Yet most of what Davis reports is widely reported elsewhere and believed, despite the lack of hard evidence. For instance, Barbara Steele said, "China said it took him 45 minutes to die," a story repeated by Tom Dewe Matthews who, in London's *Guardian*, stated that after he shot himself Donald "lived for another forty-five minutes."*10* Kevin Macdonald reports that China said Donald had "read about where you should aim the bullet in order to obtain not just a painless death, but a pleasurable one."*11* Drew Hammond stated that Donald had asked China, "'Do you see the picture of Borges?' This of course referring to the moment in *Performance* when you see the POV of the bullet going through Turner's skull," a story that was also repeated by Kevin Macdonald.*12* Tom Dewe Matthews claimed that Donald had asked for a mirror in the hopes of observing his own death. These claims are presumably bolstered by allegations that it took paramedics some 45 minutes to find Donald's home. Other, minor inaccuracies exist, such as those concerning the weapon Donald used to kill himself. Paul Beard and Lee Hill claimed that Donald used a "shotgun" (confusing Donald's chosen weapon with that of Ernest Hemingway) and Drew Hammond asserts the weapon was a Glock 17.*13*

All of these claims defy common sense. Exactly where, in what archive, can one find the materials to read that provide the instructions for a painless, pleasurable death by gun shot? Who authored these materials? Based on what evidence? What, precisely, is a "pleasurable" death? How is one to place oneself in order to witness one's death in a mirror? Where does one's death take place? How can one "observe" one's *own* death? Moreover, the claims reveal a lack of understanding of the motives of the suicidal individual. The purpose of suicide is to rid oneself of this world - Hamlet's "stale, unweeded garden" - not to prolong one's absurd existence in it. At their best, these sorts of claims serve to perpetuate romantic myths about the circumstances of Donald's death; at their worst, they obfuscate any real understanding of the motives and conditions under which Donald, and other human beings, take their own lives. The idea that Donald imagined or investigated any putative methods by which a person could "die pleasurably" is, we believe, a ludicrous assertion. The harsh fact is, when Donald committed suicide, he did so in private, as many suicides choose to do, without saying a word to China of his intentions. We should be absolutely clear about this point: Donald Cammell wanted to die, and all available medical evidence indicates that when he shot himself, he died instantly.

A researcher who has written a great deal on suicide, Karl Menninger, has argued that suicide requires the synchronicity of three factors: "the wish to kill, the wish to be killed, and the wish to die," suggesting how fuzzy the boundary is between suicide and murder.*14* We are certain that Donald Cammell wanted the peace of oblivion, to be rid of his intolerable mental anguish, and perhaps even rid of a body that he felt was not his. We who remain should not underestimate the incredible amount of mental strength it requires to complete a suicide, nor underestimate the three wishes Menninger identifies above.

King Ink

While cases have been recorded in which, during the latter stages of a divorce, a distraught husband has put a gun to his head and shot himself in the presence of the horrified ex- or soon-to-be-ex-wife, Donald did not do this. At one point we seriously considered the possibility that Donald may have planned a murder-suicide - especially possible in theory since two of his films end with precisely this scenario, and also because there were two bullets found in the gun - but we also ruled this out, given the evidence to be presented below. As Drew Hammond has said, "In the end, he used the gun only on himself."[15]

Whatever China allegedly reported to others in the weeks and months after Donald's suicide, there are no official records on file to indicate that she told any such stories to the Los Angeles Police Department or the Los Angeles County Department of Coroner's investigator in the hours immediately following his death. All the recorded facts surrounding Donald's suicide can be found in a slim file of just seventeen pages, which resides in the archives of the Department of Coroner, County of Los Angeles.

The Department of Coroner investigator was William Grice, who, at the time of this writing is still working for that Department. Here's an excerpt from his report:

> Officer Ortega advised the decedent is a film director who has been separated from his wife, she recently moved back to the residence and apparently was preparing to move out for good. At about 1110 hours the decedent handed his wife several sets of papers and returned to his bedroom. The decedent's wife laid the papers on a counter top and heard a loud explosive sound. She ran into her husbands [sic] bedroom and found him lying across the bed with blood coming from his head.[16]

Improbably, Donald had made a pitcher of lemonade that morning. At approximately 9:30 a.m. PST, he made what turned out to be a last call to his brother David. Given the eight hour time difference, Donald's call would have rang at roughly 5:30 p.m. in London. David was not home at the time, so Donald left a message on his answering machine. "I usually arrive home around 5 p.m.," says David, "so Donald no doubt thought I would be home. But that day, I arrived home a bit late, I don't remember the reason... Since he sounded calm, and since China had returned, I might have waited an hour or so before returning his call. When I finally did call, a policeman answered the phone, who told me that he could tell me nothing at the moment, but there had been a tragedy. At that moment I realized Donald had killed himself, or tried. About a half hour later I called again, and Drew Hammond answered the phone. He burst into tears and confirmed my fear. Donald had killed himself."[17]

The Wait

No doubt due to the fact that she was suffering from severe shock, China ran to the neighbour's house and dialled 911. After placing the call, she returned to the house and waited for the paramedics. Contrary to certain published reports, it did not take the paramedics of Engine Company No.97 forty-five minutes to find 9032 Crescent Drive. In fact, they arrived quite fast - in barely 10 minutes.

Official reports indicate that, for whatever reason, China told the investigating officers that she remembered Donald handing her the set of papers at 1110 hours. Perhaps after Donald handed

her the papers she happened to glance at the clock. Regardless, it is fair to assume that this time is close to being an accurate estimate on her part. The paramedics then arrived swiftly following the placement of the emergency call, and pronounced Donald dead at the scene at precisely 1122 hours - which was no more than 12 minutes after China had made the emergency call - remarkably, even commendably, fast.

The paramedics found Donald's body in his ground-floor bedroom, "lying supine across a sheeted mattress on top of a comforter. His head was positioned partly on top of a folded bath towel. Both lower extremities were outstretched with his feet resting on the carpeted floor... A large amount of blood had pooled around the head and flowed to the decedent's left."[18] The bath towel must have been placed under his head by China, who would have done so in some desperate if vain effort to stop the bleeding. There was no exit wound and, contrary to certain published reports, though the blood from the entrance wound had pooled on the comforter and no doubt soaked through to the mattress, no blood is recorded as having actually soaked through the mattress and pooling on the floor beneath the bed. In this form of self-inflicted gunshot wound the person does not die from the loss of blood, but rather, obviously, from severe trauma to the brain. Moreover, because of the extreme damage done to the brain by the bullet, some of the blood loss occurs in part because the brain, swelling due to the wound, pushes blood out of the entrance wound. Although we will present expert medical opinion indicating that Donald almost certainly died instantly, even if he hadn't done so, it is accepted wisdom that in injuries of this type the severity of the swelling of the brain would lead to pinching of the spinal cord within very few minutes, causing death at that moment.

The report indicates that the responding police officers and paramedics found that the body bore a gun shot wound to the upper middle forehead just below the hairline. We should note that Donald's hairline had begun receding, so this description of the location of the gun shot wound is approximate. The report does say, however, that the gun shot was centred two inches from the vertex, or top of his skull:

> The wound was clearly defined with stellating, minute amounts of brain evulsion, extensive blood loss and initial bone fracturing around the entrance hole in the skull which was plainly visible due to the stellating effect. Minute oral and nasal blood purge had occurred with a small amount of apparent blackening under the left eye. No exit wound was found.[19]

Donald did not commit suicide in what might be called the "classic" manner, with the gun placed at the temple, as the poet-martyr does in Cocteau's Le sang d'un poète. Rather, he employed a sort of execution-style method, with the gun placed in the middle of the upper forehead. Given the manner in which he killed himself, a loose connection can therefore be made to the moment in Performance when Chas performs the execution-style murder of Turner, shooting him through the top of the skull. But this is only a loose analogy, for the gun was placed not at the top of the skull - a difficult if not impossible feat for an individual to perform on oneself because of the awkward position required by the upper extremities - but high on the upper forehead. As we shall see, this method is considered to be an efficient and lethal form of self murder, and while unusual perhaps, it is certainly not capricious. If Donald had indeed "studied" suicide, one is therefore forced into the conclusion that it would only have been to determine the swiftest form of death. As to the charge that there is a similarity in the manner of Donald's self-annihilation to the way Chas kills Turner, we would say it merely suggests he had already seriously contemplated the manner of his death twenty-seven years earlier.

Stone Cold Sober

In an effort to understand Donald's actions during his final few moments, we showed a copy of the official report compiled by the Los Angeles County Department of Coroner report to Dr. Joe Auch Moedy, a pathologist who has been consulted about many suicide scenes and who has performed autopsies on suicide victims for many years. "In order to figure out just how the individual used the gun, you often have to sort of 'play-act it' on yourself," says Dr. Auch Moedy.[20] As might be expected, for an expert such as Auch Moedy, certain details of the official report are extremely revealing. As noted earlier, the report indicates that when the police and paramedics arrived, they found Donald lying supine across the bed, with his feet on the floor and the gun lying on the floor between his feet. The gun was removed from its original position on the floor by the Captain of the Fire Department and placed on a shelf in the bedroom, the reason for which was the Captain's fear that because "the wife was moving in and out of the bedroom... she would be injured by the weapon."[21]

Given the rather atypical location of the gun shot, Dr. Auch Moedy also points to the autopsy report, which showed that the bullet had lodged at the back of Donald's throat - the posterior pharynx. "The bullet may have been visible in the back of the throat to the examining physician simply by opening his mouth and looking in," he explains. "But in any case, the location of the bullet, and the diagram showing the path of the bullet through the perforated brain, really told me a great deal."

He continues: "Typically, in any suicide, the entrance wound is also a contact wound, meaning the individual has placed the gun barrel directly in contact with the skin. In Cammell's case, the autopsy report indicates a stellate-shaped wound four inches in diameter, with powder burns visible on the skull. With the barrel of the gun pressed tightly against the skin, and bone directly underneath as it is on the skull, the explosive gasses and particles from the blast expand under the skin and peel the skin away from the bone, tearing it in a sort of star-shaped pattern - a stellate shape. Based on the autopsy report, I therefore believe that after handing his wife the set of papers he returned to the bedroom, where the gun was either on a shelf, or perhaps in a drawer in the bedside stand. He sat down on the edge of the bed, his feet firmly on the floor, and leaned forward, with his elbows resting more or less on his knees. With his left hand he took the gun and pressed the barrel against his upper forehead - very high - slightly above the hairline, the barrel pointed downward, toward the throat. With his right hand, he wrapped his fingers around the handle and put his thumb against the trigger. He was, therefore, pressing the gun against his head with both hands. When he fired the gun, the blast threw him backwards across the bed, with the gun falling from his hands onto the floor between his feet. The bullet travelled downward through the brain and lodged in the back of his throat. The stellate effect and the severe fracturing of the skull [noted in the autopsy report] around the entrance wound again tell me that the gun was held very tightly against the skin."

We asked Dr. Auch Moedy to tell us about the nature of the ammunition found in the gun, based on the fact that the report indicated there was one live Winchester .38 Special +P cartridge and one expended cartridge casing found in the chamber. Dr. Auch Moedy first noted that the report indicates the bullet surface was semi-jacketed. "Bullets can have a full-metal jacket, as military ammunition is, or be semi-jacketed," he reports. "A semi-jacketed bullet tends to flatten out on impact, forming a kind of mushroom-shaped projectile. To cut to the chase, this means that the bullet will cause more damage to human tissue than a full-metal jacket. This doesn't mean necessarily that it's more deadly, but the bullet tends to cause more damage to human tissue when the tip of the bullet flattens out rather than remaining pointed." In short, Donald chose the type of ammunition that would cause maximum damage.

We also asked Dr. Auch Moedy to give us an approximate time of death for Donald given the nature of the wound, and based on the fact that the paramedics pronounced him dead at 1122 hours, shortly after their arrival at the scene. "Given the nature of the wound, and the path of the bullet through the brain as indicated on the autopsy report, in my opinion I believe he died instantly," he says. "Assuming the actual reported time of the shot was really 1110 hours, then I would give the time of his death as 1111 hours. Whatever the time, I believe that his death was instantaneous." Again, we must stress that although the paramedics recorded the time of Donald's death at 1122 hours, indicating a period of no more than 12 minutes between the time of the shooting and the pronouncement, this is not to be confused with the time he actually died. The time of death recorded by the paramedics on the official report represents the time when, after their arrival and after an examination of the body, it was determined that he was dead.

Thus, contrary to some previously published articles about his death, our findings suggest that Donald met the swift death he apparently planned - we believe that he did not linger, speak of, or record the experience of his death, but rather died instantly - which is precisely the reason that most individuals commit suicide using a gun. What is disturbing is that so many contradictions to the observations made by professionals at the scene should spring up so quickly and be disseminated in the media as "facts."

We also asked Dr. Auch Moedy to remark on the toxicological analysis performed on Donald's blood, a standard procedure performed by the authorities. "The report indicates that a blood sample was taken at the scene, drawn directly from his heart," says Auch Moedy. Analyses were requested for alcohol, methamphetamine, cocaine, codeine, morphine, and phencyclidine - the "usual tests," Dr. Auch Moedy reports, "because they are the most frequently abused drugs." There were no minute amounts, no "traces," of any of these drugs in Donald's blood. "That was a bit of a surprise," Auch Moedy admitted. "I found that very interesting. What it shows is that he was stone cold sober at the time of his suicide."[22]

The autopsy was completed very quickly; the results were available by 26 April. The medical examiner's brief opinion, in the form of a scribbled note at the end of the Examination Protocol form, is succinct: "c/w suicide" - consistent with suicide. The examination concluded, Donald's body was, of course, released to his relatives. According to his wishes, his body was cremated, and his ashes were scattered in the Mojave Desert. His age at his death was 62 years, 3 months, and 7 days.

Every Bright Promise

Given that he was "stone cold sober" at the time he took his own life, can we conclude that Donald's suicide was the product of cool, rational, self-reflective calculation? "Rational suicide," argues Andrew Solomon, "cannot be a present-tense operation; it must be contingent on an accurate assessment of the longer term. I am a believer in rational suicide, which responds to futility rather than to hopelessness. The problem is that it is frequently difficult to see which suicides are rational…" He continues, "If I ever attempt suicide, I'd like someone to save me, unless I have reached a point at which I accurately believe that the amount of joy left in my life cannot exceed the amount of sorrow or pain."[23]

Human intelligence is, of course, Machiavellian, meaning reason is directed toward achieving goals that are often for one's own advantage. Solomon's argument rests on such an assumption, particularly in the belief that the suicidal person chooses his end out of cold calculation, deciding the probability of one scenario over the other, whether one's future holds enough joy to offset the

almost certain scenario of pain and sorrow. Still, some researchers would argue that there's a certain amount of impulsiveness in the suicidal act, and Donald most certainly had impulsiveness and recklessness in his character. Researchers have tried to isolate certain invariables in the psychological underpinnings of suicide, although no one so far has claimed to solve the puzzle completely. It would thus seem to be a rather startling contradiction that Donald's suicide occurred just a few days after the good news that Bill Pullman had contacted Donald's agent and expressed strong interest in playing the lead role in *33*. As Mick Brown has observed, "With his [Pullman's] signature, the film could now be bankrolled for three times its predicted budget. It was the best news Donald Cammell had received in years. He was on his way up."[24] In our view, this remark exaggerates Pullman's prestige at that point in his career, but to dispute the point is of little consequence. Still, Pullman's interest in playing in the film would certainly not have hindered its chances of being produced.

Moreover, Donald had had many notifications of "good news" in his career prior to this latest bit - his career had been filled with "good news" that quickly turned to bad - and we must return to Solomon's distinction between futility and hopelessness. There are still many limits on our understanding of suicide, and the seemingly contradictory behaviour of Donald committing suicide in the face of such "good news" is only one of many such limits to our understanding, the sort of limits expressed in E. A. Robinson's famous poem "Richard Cory," about a man who apparently has everything he could want from life, but who nonetheless returns home one day "and put a bullet through his head."[25] As Jamison says, in the face of such limits to our understanding of suicide, "We are left to make sense of... a successful businessman who jumps in front of a subway train; a brilliant graduate student who kills himself with cyanide from his laboratory; a promising fifteen-year-old African-American boy who provokes his own death by aiming a toy gun at a police officer."[26] In this sense, Donald's suicide in the wake of apparently good news was in no way exceptional. "Some people with every bright promise in their life commit suicide," Solomon reminds us in *The Noonday Demon*. "Suicide is not the culmination of a difficult life; it comes in from some hidden location beyond the mind and beyond consciousness."[27] It may be that highly successful individuals are more prone to suicide, because of the impossibly high standards they set for themselves.

Yet, as Andrew Solomon writes, "It makes us feel safe to locate causes for suicide."[28] We thus hesitate to make an inventory of possible reasons for Donald's suicide. Suicide is daunting to researchers because it stubbornly resists analysis; as Kay Redfield Jamison observes, "Ambivalence saturates the suicidal act."[29] We thus feel no more comfortable saying that the reasons for Donald's suicide may have been unrelated to the frustrations of his career in film, as that they were in fact related to the continual setbacks. Certainly China's departure was a terrible blow emotionally to Donald, but we believe that we must strongly resist reducing the cause of his suicide to a simple cause-and-effect scenario.

We also hesitate to argue for such reductive cause-and-effect scenarios because Donald had engaged in suicidal ideation his entire life, long before he'd ever met Patricia Kong. Interestingly, items in the set of papers Donald handed to China on the morning of the 24th reveal that he had been very close to suicide at the end of August 1995, when his brother David had arrived to talk him out of it. Again we quote from the investigator's report:

> The wife provided the papers given to her by her husband and they were identified as a personal letter to her, a letter to Law Enforcement officers stating he had shot himself (the envelope which contained this letter was dated 12-28-92) and a handwritten will dated 8-26-95.[30]

The contents of the personal letter to China are not disclosed, and need not be. David Cammell avers Donald gave China a letter "absolving her" of any responsibility, and perhaps this was the extent of it. Kay Redfield Jamison's conclusions suggest that such letters contain few, if any, insights into the suicidal mind, and few people - only 1 in 4 - choose to leave a suicide note at all. Perhaps more importantly, the report reveals that Donald was on the brink of suicide twice in his final four years: about three and a half years earlier, on 28 December 1992 (hence long before the debacle of *Wild Side*) and very close to suicide again shortly after his and China's separation during the August before his death. Whether he and China were close to a separation in the final weeks of 1992 is unclear, though.

What is starkly apparent, however, is the fact that when Donald had purchased the Smith & Wesson Charter Arms .38 Special in late May 1987 - the revolver with which he killed himself - he had, as suicide researchers call it, seriously increased the conditions of "lethality." Clearly, he bought it with the intention of using it, and given the virtual impossibility that any of his loved ones could remove the conditions of lethality (he could have simply, and easily, purchased another weapon), we conclude that on that date in 1987, it became, to use a colloquial expression, not a matter of if, but when. It is very possible that he was planning to use the gun on himself the day he bought it.

Moving On

"The last time I saw Donald," recalls Frank Mazzola, "was about a month and a half before he died. We'd talked on the phone many times after that, but I remember well the last time I stopped by his house to see him, because he showed me a side of himself he never had. He'd cut his hair and shaved his beard, and seemed in some ways like the Donald I remembered - he had his personality, his smile and his sense of humour back. We kidded each other and had a few laughs - a really good time."

But there was more, says Mazzola. "He was like a little kid. There was an innocence, a beauty in him that I'd never seen before. He opened up and showed me a beautiful spirit, a side of himself that he had always been afraid to show. When I left his house we hugged each other and he told me he was ready to move on. He said he was going to get *Wild Side* back, that we were going to make all the films we'd talked about making."*31* In retrospect, perhaps Donald's vow to "move on" meant more than just starting a new phase in his career.

As luck would have it, Vartkes Cholakian ran into Donald at the Museum of Contemporary Art on Grand Avenue in downtown Los Angeles on Sunday, 21 April, during the opening of the Ed Moses retrospective held there from 21 April to 11 August 1996. "I was about to leave, when I decided there was one particular painting I wanted to see again. As I turned the corner to enter the gallery, I ran into Donald. I hadn't seen him in a while. He was same old Donald - he had a beautiful young girl on each arm - and he was with a third person, a man he introduced, as I recall, one of the producers of *Wild Side*. That's what I think he said. He grabbed me in a strong bear hug and hugged me - that was Donald. He had a powerful hug. He put his mouth up to my ear, and whispered, 'I should have made *El Paso*, Vartkes. Jimmy Mendoza was a great character.' I told him, 'We *will* make it, Donald.' We talked awhile, and he gave me his new phone number. He said he was invited out to dinner, but he said he didn't feel like it, he didn't want to go... That was the last time I saw him. A couple days later I got a call and I was told he'd killed himself."*32*

As it turned out, Donald did go out to dinner. That night, Maggie Abbott ran into Donald at the Louis XIV restaurant on North La Brea Avenue in West Hollywood, and remembered him being in good spirits. "I spoke with him, briefly. He seemed fine," she told us. "He seemed like the same old Donald."*33*

Bill Gray, who had kept in touch with Donald since they worked together on *The Changeling* in 1978, saw Donald hop out of his Jeep in front of Book Soup, the West Hollywood landmark near the corner of Sunset and Holloway, just a day or two before his death, perhaps that Monday. "He had double-parked and had apparently run in [to Book Soup] to grab a newspaper," Bill Gray remembers. "I saw him come jogging out and I yelled, 'Hey, Donald,' and he waved, saying he'd call me. That's what I remember he said: 'I'll call you.' That was the last time I saw him... I hadn't thought about it in years, but Sunset and Holloway was the corner where the old Carolco offices once were, where way back when Donald and I first met to work on *The Changeling*. Strange, now that I think about it."*34*

Cinders

"He was unique," says China. "He was what he was and he didn't change that, or apologize for it."*35* China's opinion has been echoed by others who knew Donald well, including Mrs. Deborah Roberts. Deborah said, "He was very hard working, Donald... He was an incredibly determined person, but he made people uncomfortable. He was totally uncompromising, but this worked against him. He also managed to antagonize people who could help him."*36* This latter observation was corroborated by China Machado, who told us, perhaps less tactfully than Deborah, "Donald was the kind of guy who would fuck the producer's wife and then wonder why the film wasn't made."*37*

If Donald never apologized, he also remains unforgiven. Maria Andipa, Donald's first wife, whose memories of her marriage to Donald, as we've seen, were warm and generous, remembers him in a different way. "I pray for Donald," she says, "I pray for his soul everyday. I pray that he could somehow go to Amadis, and apologize to him, and make up for the deep pain and unhappiness that he caused his son in his life."*38* Her words carry the sting of truth, reminding us of the image of a teenage boy, crushed that his father, during one of his visits to London, refused to see him, making the excuse that he was laid up with a headache. This image contradicts the more romanticized image of Donald as a proud and audacious artist of deep integrity, uncompromising in his demand for artistic truth, possessed of a highly original, singular vision.

Perhaps this glamorous image of Donald as an imposing artist is true - as this book attests - but so too is the less flattering one: they are both true, and that he is a mythic figure is not in doubt, assuming we perfectly well understand that mythic figures are mythic precisely because they embody deep, irreconcilable contradictions. These contradictions are expressed in the statements of those who knew him. His close associate, Frank Mazzola, said to us, "How many geniuses do you get to work with in one life?," in response to a question about Donald's creative brilliance. Vartkes Cholakian told us, "I loved Donald. I simply loved him. He had great instincts as an artist, and he was a very good filmmaker."*39* Vartkes's latter sentiment has been reiterated by many of those who knew him well. And there are those, like Roman Polanski, who told us, "I loved Donald, but he was wicked. He was a wicked guy."*40*

Hypocrite lecteur: All our sins shall be remembered. Now he is no more. Yet, in the rubble of his unusual artistic career, his own disappointment with the final twenty-five years of his life, the reality of Donald Cammell's existence remains. He continues to be a stubbornly inscrutable figure, proud, self-sabotaging, audacious, unforgiven, who, largely because of one extraordinary, incendiary film, became, like Joseph Conrad's Lord Jim, "an obscure conqueror of fame."

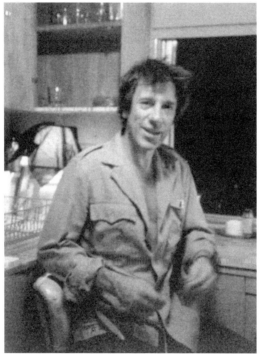

courtesy Vartkes Cholakian

Donald in the kitchen of his Crescent Drive home,
Los Angeles, 1979.

Aftermath

What are you telling me, Charles? You don't believe in genes?

*- Detective Phil Ross, **White of the Eye***

"There is always a point in a biography," Elaine Dundy writes, "where the biographer must try to reach a sound conclusion about facts which by their very nature depend upon secrecy and concealment."[1] As we stated in our "Preface" and reiterate here, we believe that Donald Cammell's crippling, life-long depressions demand to be explored, for reasons that are intellectual as well as moral. Whatever the precise nature his mental disorder, it had far-reaching effects on many facets of his life, including his artistic career. What follows is our own theory - and it just that, a theory - about the nature of Donald Cammell's mental disorder, which we attempt to distinguish from other competing hypotheses.

One popular theory about Donald Cammell accepted as fact by some who knew him - a variation of the more Romanticized explanation that he is a tragic example of the "tortured artist" - is that he suffered from what has been named the past thirty years or so "bipolar disorder," colloquially referred to in the general culture as "manic-depression." We must point out that Donald's putative psychological malaise, bipolar disorder, is, so far as we have been able to determine, not the formal diagnosis of a clinical psychologist. In fact, no psychiatric professional has stepped forward to offer a definitive diagnosis. We tried repeatedly to interview the clinical psychologist Donald was seeing at the end of his life, but our calls were not returned, so apparently he has chosen to exercise his right to withhold confidential information about his patient. The situation is exacerbated by the fact that Donald never sought, so far as we know, psychiatric care on any regular or consistent basis - a behaviour, we might add, that is not unusual in individuals of his type. He in fact distrusted psychologists. He told Chris Rodley in 1989 that Marlon Brando had "exposed himself too much to psychoanalysis," a statement that reveals as much about Donald Cammell as it does Brando.[2]

We are troubled by the fact that trustworthy evidence exists - the most important being the testimony of his brother David - that Donald Cammell expressed suicidal ideation (the recognition of, and consideration of, suicide) prior to the onset of puberty. Citing a comment made to him by David Cammell, Mick Brown reports that Donald "once told a friend that he had thought about killing himself when [he] was seven years old."[3] We have reason to doubt this age and believe it to be erroneous, but the point seems clear enough: to express suicidal ideation at such an early age is extraordinary. For statistics show that the potential for suicide increases dramatically at the onset of puberty - suicide among teenagers is, alas, a well-known tragic phenomenon (the incidence of it among that age group being second only to that among the elderly). Prior to the onset of puberty, however, the occurrence of suicide in the general population drops to near zero. Moreover, the incidence of suicidal ideation is extremely rare prior to the onset of puberty as well.

The best evidence currently available shows that suicidal ideation in subjects ages seven or eight is, while not completely unheard of, very rare. So rare, in fact, that the incidence drops to near

zero - *unless the child has undergone some profound adversity or trauma.* Some recent studies suggest that children under age ten can suffer from bipolar disorder, but this does not mean as a consequence that they automatically consider suicide. Depression may be one of the contributing factors in suicide, but it is not necessarily the sole cause. Depression is a complex, multiply determined condition that results from varying combinations of genetic disposition, overwhelming childhood adversity, current stress, and learned habits of thinking. Regarding the incidence of bipolar disorder, perhaps some statistics are in order: Lifetime prevalence rates of bipolar disorder are about 1% of the general population, and only about 0.4% of *those* people are symptomatic before age ten.[4] Depression, however, is more likely to occur in childhood than bipolar disorder; latest estimates suggest about 10% of children experience an episode of major depression before they are fifteen. The physical and emotional changes that occur during the onset of puberty are believed to be among the causes of the mental disturbance that may lead to suicide in adolescents. Attention deficit/hyperactivity disorder, learning disabilities, and bipolar disorder, for instance, usually assert themselves during puberty; coupled with the many social pressures of maturation (in the form of bullying by classmates, for instance), children can complete suicides as early as age ten, although again this is extremely rare. When the statistical data of suicide rates among age groups is plotted on a graph, the line takes an unsettling dramatic upward turn at around ages eleven and twelve.

The key point is that childhood suicidal ideation is most closely associated with 1) a family history of suicide (not a factor here); 2) family dysfunction (again, apparently not a factor); and, 3) extreme adversity and trauma. What would have been the nature of this trauma? In regard to criterion 1 above, there is no history of suicide in Donald Cammell's family. In regard to criterion 2 above, we have shown throughout the book evidence of only strong, nurturing familial bonds in his family. "My father never spanked us or even threatened us with a spanking," says David, "which is rather extraordinary considering he was a Victorian."[5] His point is an important one. Physical abuse - "corporal punishment" - was considered an acceptable disciplinary measure for Victorian children, and was even an institutionalized practice in the schools. There is no indication of any kind of abusive behaviour in Cammell's family, either in the form of corporal punishment or sexual abnormality, which is, of course, another form of abuse.

Hence, the crucial element that remains is criterion 3: extreme adversity and trauma. As we discussed in Chapter 2, at the rather young age of eight, in fall 1942, Donald was enrolled in St. Andrew's Priory School. Because of the war, the school had been relocated from Edinburgh to the Benedictine monastery at Fort Augustus, Scotland. We believe this was perhaps the defining and critical moment in his life. "Donald's life was marked with certain trauma points," China Cammell told us, "and Fort Augustus was one of them."[6] It is clear that something of a traumatic nature happened to Donald during the period he was a boarder at the Abbey School at Fort Augustus, 1942-43. After identifying Fort Augustus as a "trauma point" in his life, China also told us that Donald told her he ran away from the monastery on at least two occasions. From all accounts up to this point Donald was a happy, well adjusted, if precocious, small boy, indulged, perhaps, by his parents, but certainly no image emerges - until this point - of Donald being "hysterical" and "psychotically homesick" to use David Cammell's words. He was doted on by parents who then, as now, would have been referred to as "older in years." Yet, at some point around eight years old, his behaviour changed, and he subsequently spent the rest of his life plagued by severe, recurring depressions and thoughts of suicide.

Circumstantial evidence suggests that Donald Cammell may have been sexually molested while a boarder at the Abbey School at Fort Augustus. Even without his own explicit recorded testimony attesting to the fact, there is evidence to suggest that Donald Cammell may have been a victim of Childhood Sexual Abuse (CSA), and that its far-reaching effects plagued him for the rest of his life. While emotional distress in the form of bullying and taunting seems a distinct possibility at the school,

in our view this factor alone is insufficient to account for his adult behaviour, during which he exhibited dissociative and amnesiac episodes. Instead, according to our understanding of present-day psychoanalytical theories, his adult behaviour is consistent with subjects who have suffered some sort of traumatic sexual abuse as a child.[7]

Borderline Personality Disorder

As is the case with medical conditions, a person can have more than one psychiatric disorder. While we cannot rule out what the *Diagnostic and Statistical Manual for Mental Disorders* (Fourth Edition - Text Revision), hereafter referred to as the DSM-IV-TR, names "bipolar II disorder," we strongly believe that Donald Cammell suffered from what many psychologists consider perhaps the most perplexing of all psychological conditions, Borderline Personality Disorder (BPD). Consistent with our theory that he may have been sexually abused as a child, there is a very high incidence of childhood trauma, in the form of sexual abuse, in those who suffer from BPD. As we shall see, he exhibited behaviour that is consistent with BPD: in addition to the most obvious feature, recurrent threats of suicide, he exhibited an inability to modulate (internal self-monitoring and self-control) strong emotions such as anger, and had dissociative symptoms and memory loss (amnesia) as well. He showed no signs of schizophrenia - which is sometimes confused in the popular imagination with a "split" personality - although when in a dissociated state he would exhibit a distinct personality change. (Schizophrenia typically manifests itself in individuals between the ages of fifteen and twenty-five, that is, well after the onset of puberty and late in adolescence - not applicable in Donald Cammell's case.)

We need not rehearse one of the more scandalous revelations of the past decade, the prevalence of pederasty among the Catholic priesthood. Scores of individuals are coming forward reporting incidents of sexual molestation by their priests, many of whom have remained silent about the molestation for much of their adult life. Such assertions may have gone unheeded when Donald was a small boy, but not any more. There is also the possibility that another boy or an employee might have committed an act of sexual aggression, unbeknownst - or unbelieved - by the priests.

There are, of course, several possible objections to our BPD hypothesis that we must address. First of all, we acknowledge that, in a life allegedly so scandalous as Donald's, our claim would seem to be yet one more sensational assertion piled upon scores of others. One might reasonably object that no single individual could have lived a life so sensational, so full of serendipities and calamities. Yet our hypothesis is not meant to be sensational so much as to offer an explanation of why his life itself was so difficult and crisis-ridden, manifesting itself particularly in what many perceived to be his decadent sexual behaviour.

One objection would be that our hypothesis is unnecessary, given that there is documented evidence of mental disorder in his family. When confronted by a patient who exhibits suicidal behaviour - either through suicidal attempts or by telling others he or she is considering it - the first thing a psychologist would do is assess the patient's family history. There is strong evidence to suggest that there may be some genetic basis for suicidal depressions. A famous example is, of course, Ernest Hemingway, who himself committed suicide, as did his father and two of his siblings. In addition, Hemingway's granddaughter, Margaux, daughter of his late son Jack ("Bumby"), apparently committed suicide as well, strongly suggesting a genetic predisposition might have been a factor in this family tragedy.[8]

Yet a genetic predisposition for suicidal depression does not seem to be the case for Donald Cammell's family: there is no recorded instance of a family member on either his mother's or father's side committing suicide. Donald apparently believed his father Charles had bipolar tendencies when he

was a young man, outgrowing them in middle age, and that Donald believed he'd inherited these characteristics from his father. Yet we must be sceptical of such an explanation: Donald's claim may be simply his own attempt to rationalize his depressions and avoid confronting a repressed trauma by seeking a genetic basis for them. As we discussed in Chapter 7, China reported that one of Donald's pastimes was reading books about the human brain, that he was constantly exploring theories on how the brain functions and about the physiological basis of its functioning. Indeed, one of his secondary motives for directing *Demon Seed* was due to his interest in the brain, the film being made when the "strong A.I. thesis," that a computer could be built that would imitate the human brain, was in vogue (since abandoned).

Donald Cammell no doubt sought explanations for his crippling depressions - as any rational person would - and he was most certainly aware of the strong evidence supporting a genetic basis to suicidal depression. Although it is difficult to make a definitive statement on the issue based on them, Charles Richard Cammell's two volumes of memoirs make no reference to any depressive propensities in himself or his family. Of course, "bipolar disorder" is not a term Donald's father would have known or used, but there are no references to any kind of chronic depression or lingering "melancholy" (as he might have called it) in his memoirs. By all indications, he functioned without depressive episodes throughout his adult life, despite those heavy disappointments that he himself acknowledges and discusses: the loss of his immense fortune, for example, or his failure to obtain an academic post in a Scottish university.

Yet Donald may have never heard what, for him, was a convincing excuse from his father as to precisely how he lost his share of the Cammell fortune. Setting aside the question of whether Donald harboured any possible resentment toward his father for losing the fortune (the father-son dynamic between Stefane and his wealthy father Charles is one of the tantalizing subtexts in *Duffy*), perhaps he, Donald, attributed it to some deep flaw in his father's personality. After all, "penny-pinching" - of which Donald once accused his father - not profligacy, is one of the most widely disseminated stereotypes of the Scottish people. What "character trait" made his particular father capable of squandering a considerable fortune? Certainly the reason goes beyond the fact that Charles Richard was "utterly impractical" and profligate.

Although there is no other known incidence of suicide amongst the Cammells, there is a clinically diagnosed instance of manic-depression in Donald's immediate family: according to David Cammell, manic-depression plagued his and Donald's youngest brother, Diarmid (born July 1945). Says David, "My brother Diarmid was hospitalized twice during manic episodes, even jailed. Manic-depression has been the bane of his life..."[9] Donald's first wife, Maria, remembers Diarmid's manic episodes, which coincided with the onset of puberty. Donald told several people that he was manic-depressive, or had bipolar disorder, and that he actually took lithium for a while in a vain attempt to counteract the disease's baneful influence, but had to give it up: he couldn't tolerate the side effects, most seriously a peculiar deadening of 'affect,' or indifference, and an excessive need to sleep.

Nonetheless, although Donald believed he had bipolar disorder, it is impossible to know whether this was simply his own belief about his condition, part of a relentless search for an explanation of it, or represented the opinion of an informed specialist. Yet, his assertion is not an entirely unreasonable one, as Kay Redfield Jameson, in *Touched with Fire: Manic-Depressive Illness and the Artistic Temperament* (1993) points out:

> In family studies of mood disorders, researchers look for familial patterns in occurrence of mania, depression, and suicide. The many studies of this nature that have been done are quite consistent in showing that manic-depressive illness is indeed familial: the rate of manic-depressive and depressive illness in first-degree relatives of patients (that is, parents, siblings,

and children) is far higher than the rate found in relatives of control groups. Individuals who have manic-depressive illness are quite likely to have both bipolar and unipolar relatives.[10]

Given the strong - perhaps incontrovertible - evidence of "familial madness" or "taint of blood," there would seem to be no reason to introduce yet another explanation for his disorder. Given the existence of mood disorders in Donald's immediate family ("first-degree relative"), some readers, among them psychiatric researchers, may object to our BPD hypothesis on the grounds that we are violating what is known as the "Principle of Parsimony," or "Occam's Razor" - that we are guilty of introducing an explanatory cause that is utterly unnecessary, because the particular phenomenon can be explained by a more obvious and apparent cause. Since there is clear evidence of manic-depression in Donald's family - his own brother - why would we therefore put forth such an extraordinary explanation as BPD to account for Donald's behaviour?

The answer lies in the details of his troubled life: Donald exhibited behaviour that cannot be accounted for by the mere colloquial catch-all category, "manic-depression." So far as we know, he never showed any indications of manic thought disorder (delusions). Yet as we noted earlier: just as with medical conditions, a person can have more than one psychiatric disorder. Not without its detractors, the DSM-IV-TR (1994) introduced "bipolar II disorder" and with it the term "hypomania," to describe a form of manic behaviour without its delusional features. It is by no means clear that Donald exhibited signs of hypomania, either, which would be consistent with bipolar II disorder. More importantly, he exhibited characteristics that are remarkably consistent with BPD patients.

Cammell sought professional help infrequently - rarely - and while he experimented with drugs no doubt in part to help stave off depressive episodes, the drugs did not prevent them. Mrs. Deborah Roberts told us that Donald during one period tried Ritalin, a stimulant, to combat depression, but it had little effect. Before that, Maria Andipa reported that Donald used amyl nitrate, also a stimulant, but it, too, did not stave off depressive episodes, and as we've seen Donald admitted to trying lithium, but it had no effect on him except to make him lethargic and sleepy. Recall David Litvinoff's assertion that by 1960 Donald had experimented with a vast array of drugs. Despite Litvinoff's probable exaggeration, in our view Donald experimented with drugs in a vain effort to ward off his depressions.

Many individuals who suffer from depression never consider suicide, and suicides can be completed by individuals who are not depressives; contrary to the popular perception, depression itself is not the "cause" of suicide. Scientists call the problem we are identifying here that of the "final common pathway," meaning that similar effects can have radically dissimilar causes. Manifest symptoms among several subjects can be alike, but the latent causes of the symptoms can be quite different. Medical researchers have discovered that it is not unusual for two different illnesses that affect the same organ systems to have many of the same signs and symptoms.

Despite the amount we do know, there is much we still don't know about Donald Cammell. In general, he tended, deliberately or not, to lose touch with friends and sever relationships cleanly. About many things he was extremely secretive. While he certainly maintained some relationships his entire life, others he did not, and not for what one might expect to be the "usual" reasons. As we have shown in Chapter 3, he left his first wife, Maria, just prior to their son Amadis's birth, ostensibly dissolving the marriage because he did not wish to be a father. Indeed, many people we interviewed for this book didn't even know, for instance, that he had been married prior to marrying Patricia Kong, or that he had a son. Such radically disparate testimonies make it difficult to formulate a consistent sense of personality or character - but perhaps this lack of consistent character is precisely what should be explored. We argue that our hypothesis that he may have been a victim of childhood sexual abuse does not, in fact, violate the Principle of Parsimony, because there is a direct correlation between CSA and Borderline Personality Disorder (BPD) as an adult.

As Carl Sagan observed, extraordinary claims require extraordinary evidence. We have presented our CSA hypothesis to a number of individuals, among them, obviously, David Cammell, who witnessed first-hand Donald's hysterical behaviour while his brother was ensconced at Fort Augustus. Although he does not dismiss our hypothesis utterly out of hand, David remains sceptical. "Unfortunately, being a little boy, I didn't really understand what was going on, and didn't keep a diary," says David.[11] We also presented our hypothesis to Mr. Michael T.R.B. Turnbull, who as we discussed in Chapter 2 wrote the book, *Abbey Boys: Fort Augustus Abbey Schools* (2000), the official history of the Abbey school at Fort Augustus.

"The same staff [of the Priory School] went up with the School to Fort Augustus," Turnbull told us. "They [the young students] lived in the Old Convent and were taught in the Lodge. The prevailing ethos of the Priory School was a 'family' one. The boys were sheltered and cared for by the staff. It was also a very small school community, so I think the opportunities for abuse by an adult would be few." However, Turnbull also says that:

> "homesickness and bullying would be characteristic of any residential school… Bullying… is a real possibility, but this would not be of an overtly sexual character. Boarding schools tend to have gangs and this is related to the discipline/points system, so that other boys in a House or dormitory might ostracize individuals if they had done something which brought a restriction of privileges onto the rest of the House/dormitory. But it is unlikely that a young boy would be molested by a teacher or physically attacked (e.g., punched or kicked) by other boys. In St. Andrew's Priory [in which Cammell would have been enrolled] there was always a female member of staff, sometimes two: a primary teacher and a qualified Matron (nurse). She would be a kind of surrogate mother figure."[12]

We note that Turnbull provides some useful information and raises some valid points. However, in response we say that neither corporal punishment nor sexual abuse was unheard of in Donald Cammell's youth. John Boorman's *The General* (1998), for instance, includes a disturbing scene in which the protagonist, Cahill - his a true story of a modern Irish "Robin Hood" figure - is shown as a youth in a reform school run by Jesuits. Doling out punishment to bare-bottomed boys, a Jesuit priest skips Cahill but, in the next scene, at night, he is shown at Cahill's bedside, fondling the boy as he sleeps. When his sexual advances are rebuffed vehemently by the boy, the priest brutally beats Cahill. Surely no one will dispute how this scene, rooted in fact, helps to account for the disturbing later life of Cahill, "The General."

Turnbull continues: "Since Donald was only there for two terms I don't think there would have been any time for an abusive relationship to build up between a member of staff and Donald. I am almost certain, however, that he might have been bullied by some of the boys and he would certainly have felt very isolated, rejected by his parents - a 'dark night of the soul' which I imagine many boys at boarding school would have felt. I certainly did."[13]

The issue Turnbull raises regarding isolation from and/or parental rejection is a valid point, and some studies of adolescent suicide have explored the possible connection between suicidal ideation and the extraordinary anxiety some young people experience when confronted by parental separation and loss. In opposition to our CSA theory, there are those who might argue, of course, that Cammell's being "psychotically homesick" was the reaction of a spoiled, over-indulged and pampered child, suffering from separation anxiety by imagining he had been abandoned by his dear mum and dad. Maturation is thus perceived as a forced separation from the mother, and as a result the child becomes hysterical. Even if, for the sake of argument, Donald was indeed a "spoiled" and "pampered" child, we believe that such an explanation is woefully inadequate, primarily because it does not sufficiently account for

- is not sufficient cause for - his dissociative behaviour later in life. Moreover, it is a version of the Victorian "separation and loss" thesis that has long since been abandoned by psychiatric researchers, that "hysteria" in children is caused by separation from the (absent) mother. One of the Benedictine monks who remembered Donald as a boy at the Abbey, Fr. Benedict Seed, told Mike Turnbull he thought Donald was spoiled and pampered: "He was known as Camméll [accent on the last syllable]. He was weird; he thought everything belonged to him; he seemed to have been spoiled, he thought he could take anything he fancied; he helped himself to other boys' belongings and they would probably not take that kindly!"*14* There is a vague suggestion in his testimony that Donald exhibited a mild form of mania, in the form of ego-inflation, but we hesitate to go beyond the mere suggestion of the possibility. More importantly, was Donald's hysteria, then, caused merely by his absent mother and disgruntled classmates?

Using an address given to us by Turnbull, we wrote to the aforementioned Fr. Benedict Seed, who at the time was quite elderly, and living in Brora, Sunderland. Remarkably, he did remember the young Donald Cammell, and while he told us what he told Mike Turnbull, that Donald insisted his name be pronounced Camméll with the accent on the last syllable, he didn't tell us *all* of what he told Mike Turnbull, reproduced above. He wrote to us:

> I was at school for 1942-1950 at Fort Augustus, and then 1950-1999 in its monastery… Fr. Oswald Eaves was headmaster of Donald's school time (perhaps the most charismatic and successful monk in the Abbey's history); staff included Fr. Gregory Brusey, Fr. Thomas MacLaughlin, Mr. Scott, Miss Kathleen O'Donnell (a particularly good matron and medical nurse). All the pupils (all boys) slept at the Old Convent, about half a mile away - walking there and back daily. We used to explore the hills and woods, and swim in the Caledonian Canal. It was a good time and place. I feel that Donald Cammell was not there long enough to become fully at home with the life and the people, and they were quite different from his previous experience and lifestyle.*15*

Mike Turnbull adds, "it is also possible that Donald may have come across some of the local Fort Augustus village boys (or, indeed, men) since the Priory boys needed to go through the village to get to their classrooms and then to return to the Old Convent south of the Abbey… it is possible that he was a victim of CSA during the year he was at St Andrew's Priory but this does not mean this took place at school. It might have happened anywhere… In my limited experience (1950-60), while it is perfectly possible that what you say is correct, abuse of the kind you are implying is not something that I have come across at Fort Augustus (or its satellite schools). The regime at Prep School was normally a relaxed, benign one. Separation from parents, however, and a feeling of isolation would be a distinct possibility… Incidentally, parents would have frequent opportunities to visit their children if they wanted to. There were also half-terms where the boys could return home for a few days."*16* How frequently Iona visited Donald at the school is open to question; David Cammell remembers visiting the school with his father, and recalls his father having a rather lengthy conversation with the then Headmaster, Fr. Oswald Eaves, about the possible existence of the Loch Ness Monster.

Moreover, someone close to the Abbey School who spoke to us under the condition of anonymity claimed that there were suspicious photographs found among the (closed and sealed) Abbey records. Some of these repressed photos allegedly featured priests with young boys, clad only in underwear, sitting on their laps. We don't claim to have seen these photographs and we are taking the individual's word that the photographs exist (thus combining a lack of empirical evidence with hearsay). And even if these photos actually exist, some may find them rather benign and perhaps even irrelevant. Yet we must also recall the unhappy fact that the rate of pederasty is somewhat higher for Catholic priests than

for the general population, not only because the priesthood affords priests opportunities to find themselves in intimate conditions with children, but because they have been provided protection from their crimes, as so many recent news headlines and studies have revealed. It only takes one betrayal, one abuse of trust, to ruin a number of young lives, and the priesthood has lulled many into a false sense of security many times over.

We should add that we relish writing none of this; against charges of bias, we state for the record, which can be confirmed, that one of us was raised in the Catholic Church, as is our son, John.

Diagnostic Criteria for Borderline Personality Disorder

Having reviewed a series of possible objections to our thesis, perhaps we ought to look at the diagnostic criteria as set forth by the DSM-IV-TR for Borderline Personality Disorder. In terms of its general features, the DSM-IV-TR characterizes BPD as, "A pervasive pattern of instability of interpersonal relationships, self-image, and affects, and marked impulsivity beginning by early adulthood and present in a variety of contexts..." The following list represents the nine criteria for BPD as set down in the DSM-IV-TR. Following each criterion, we indicate whether the symptom is true in Donald Cammell's case:

1) frantic efforts to avoid real or imagined abandonment. Note: Do not include suicidal or self-mutilating behaviour covered in Criterion 5.

YES. No doubt the young Donald imagined himself as being abandoned by his parents at Fort Augustus. As Mike Turnbull observed, many boys experience a deep sense of parental abandonment. It made no difference to Cammell what the reason was for him being at Fort Augustus: war or no war, he felt as if he had been abandoned by his mother and father. As an adult, although he was constitutionally unsuited for marriage - he wasn't at all interested in honouring the culturally prescribed means of restricting sexual activity, the principle of monogamy - yet he insisted on marrying. Twice. Marriage was thus a means to avoid abandonment. That Donald feared abandonment is made perfectly clear by the testimony of Myriam Gibril, who pre-arranged for Susan Bottomley to replace her in Donald's life before she left Donald in the summer of 1974, knowing precisely what his egregious reaction would be to her leaving him. Even at the end of his life, despite his sexual indiscretions, he perceived himself as being abandoned when his wife China moved out of the Crescent Drive home in August 1995. Only the immediate arrival of David Cammell prevented him from committing suicide at that point. Some psychiatric researchers believe that seductive ("charismatic") and manipulative behaviour can be understood as an adaptive mechanism in abuse victims, one that enables them to protect themselves by controlling or reducing the potential threat of their external environment. It goes without saying that Donald Cammell was powerfully charismatic and seductive, as well as extremely manipulative.

2) a pattern of unstable and intense interpersonal relationships characterized by alternating between extremes of idealization and devaluation

YES. If his long history of indiscretions during his marriages weren't enough, the example of his first marriage should suffice: his declaration of love during the courtship followed immediately by an affair when he and Maria first visited her parents in Greece. He told Maria he loved her and wanted to stay with her, but left her once she declared her intention to keep the child he didn't want. The marriage was very intense yet simultaneously very

unstable. We should also note the disturbed relationship with his father. Recall that once Donald, in a rage, threw a glass of wine in his father's face. Cassian Elwes told us that Donald once referred to his own father as "a mean old Scot, cheap and crazy."[17] This is contrary to every other testimony we encountered regarding his father, who seems to have been universally liked and admired for his generosity, kindness, and chivalry. Moreover, it is not clear that Donald attended his father's funeral: Deborah Dixon Roberts says that he did not; David Cammell doesn't remember, insisting "surely he must have." We suspect that among his conflicted attitudes toward his father, he may have harboured some lingering resentment toward his father for putting him in harm's way during the war.

3) identity disturbance: markedly and persistently unstable self-image or sense of self

YES. Frank Mazzola, Donald's close friend and film editor on several projects, recalls discussing some matter while the two were alone at the Crescent Drive house, when Donald made a homosexual advance. "He came on to me. When I told him to stop and he didn't, I told him to fuck off or I'd punch him out."[18] Vartkes Cholakian, who lived with Donald and China for about six months in 1979, also told us that Donald made a homosexual advance toward him. "I told him, 'I love you Donald, but I'm not gay.'"[19] Vartkes also said that Donald hinted of homosexual affairs, including one with Mick Jagger during the making of *Performance*, which others have suggested but which for us remains unconfirmed. (Even if the allegation were true, it seems odd that it would have occurred during the making of *Performance*. Donald had known Mick Jagger for over three years by the time that film was made.) Film archivist David Del Valle recalls having coffee with Donald at the Mirabelle restaurant on Sunset Boulevard when he thought Donald made a homosexual overture. Throughout the 1950s and during the *Performance* period and after, Donald moved in the same social scene with many open and known homosexuals, but this doesn't confirm any possible homosexuality *au contraire*, it suggests a supreme confidence with his own heterosexuality. Moreover, there is the explicit testimony by one homosexual who claims to have made an overt attempt to seduce Donald, and was rebuffed. In his *Memoirs of a Bastard Angel*, Beat poet Harold Norse, who met Donald in Florence in 1953 and remained friends with him after, seeing him often in both in Paris and London, says that while he, Norse, was living in Rome, Donald dropped by and asked to stay the night because he needed a place to stay, but made it very clear to Norse before going to bed that night that he wasn't "queer." Norse concludes that, since he later married, Donald was indeed "heterosexual," although he does assert that he might have been able to seduce Donald had he been more aggressive in his advances. On the other hand, Nicky Samuel has several pictures of David Litvinoff, a known homosexual, and Donald both naked, one (shown in the Chris Rodley and Kevin Macdonald documentary, *Donald Cammell: The Ultimate Performance*) with Litvinoff cradling Donald's ample member in his hand. "He could be a bit queenie around homosexuals," observed Nicky Samuel.[20] *Performance* explores the issue of confused sexual identity, presenting characters who engage in polymorphous sex, and is considered an important work of gay cinema. It seems utterly banal to assert that Donald Cammell's films contain male and female characters who are confused about their sexual orientation. The more important issue is the one it raises about his personality: the mixed testimony of those who knew him is only one more indication of his occasional dissociative behaviour, discussed under criterion 9 below. We note that language of this criterion - "identity disturbance: markedly and persistently unstable self-image or sense of self" - is generally interpreted to include confusion about

gender identity and sexual preferences. For purposes of clarification, we are talking about *actual* confusion and we are not referring to the relatively resolved and unconfused sexual preferences of gay or bisexual persons without BPD. The sexual confusion of someone with BPD is more likely tied to experience rather than genetics, whereas the reverse is true of someone who is gay or bisexual.

4) impulsivity in at least two areas that are potentially self-damaging (e.g., spending, sex, substance abuse, reckless driving, binge eating). Note: Do not include suicidal or self-mutilating behaviour covered in Criterion 5.

YES. Interestingly, according to Myriam Gibril, Donald was extremely good at managing money, especially so since at times he had very little. We have read accounts of bipolar individuals who in manic phases go on spending binges, "maxing out" their credit cards, only to try to return the items when the mania has subsided. Donald never exhibited this kind of behaviour, but he did, as we indicate below, exhibit dissociated behaviour, which could be confused with mania. We have remarked throughout this book on Donald's reckless and impulsive sexual behaviour. His sexual exploits are sensational enough to provide good tabloid fodder, but the prurient details obscure the fact that he ruined marriages and undermined the trust of people who could help him get films made. As we have already indicated, David Litvinoff thought Donald's drug intake during one point of his life was extraordinary. In addition to Donald's experimentation with various drugs (and combination of drugs), Nicky Samuel remembers Donald drinking heavily during the period she was romantically involved with him, from post-*Performance* 1970 through 1971. In addition, Drew Hammond has mentioned instances of Donald's reckless driving. In the unproduced script *El Paso*, about a film director named Martin Osterman who Donald modelled on himself, there are two key scenes involving Martin's reckless driving.

5) recurrent suicidal behaviour, gestures, or threats, or self-mutilating behaviour

YES. As is quite well-known, Donald threatened suicide his entire life. The autopsy report, however, indicates that his body was free of any tattoos, scars, or other distinguishing features; he therefore never engaged in any self-mutilating activity (e.g., slitting the wrists, self-inflicted burns).

6) affective instability due to a marked reactivity of mood (e.g., frequent displays of temper, constant anger, recurrent physical fights)

YES. Donald had a volatile temper and was capable of explosive rages; he could be extremely violent, especially toward women. Although she was not on the set of *Performance* and no doubt was told the information by Mick Jagger, Marianne Faithfull reports in her autobiography that Donald "had a ferocious temper and would go off like a firecracker, unleashing blistering tirades." Anita Pallenberg said Donald was often angry and frustrated on the set. Other sources reveal his tirades reduced Mick Jagger to tears on several occasions during the making of *Performance*.[21] (Donald was several years older than Jagger, and viewed by him as something of a mentor.) One source told us once while he was staying with Donald and Deborah in Paris, during an argument Donald hit him so hard in the face it cut his cheek open. "I was being obnoxious," he said. "I probably deserved it." In any case the next day, realizing the extent of the injury, Donald drove the individual to a Paris hospital to have the cut stitched. As they were about to leave the apartment, Patrick Bauchau stopped by, and accompanied them to the hospital. On the

way, this individual was asked by Patrick Bauchau how he'd received the wound. "I told him I'd slipped in the shower. He [Patrick] knew better."

7) chronic feelings of emptiness

YES. Dr. Marsha M. Linehan, who frequently works with BPD patients and has written a book on the subject and formulated a method of treatment, argues that complaints of feelings of emptiness are related to problems of self-identity, a feature of BPD she calls "Dysregulation of the self." Feelings of emptiness are an expression of the subject's extreme emotional vulnerability combined with an acquired habit of thought in which the subject believes his or her private responses to events are invalid, irrelevant, or incorrect. There is thus a fundamental connection between feelings of emptiness and feelings of worthlessness.[22] While Donald displayed characteristics consistent with subjects who have bipolar II disorder, feelings of emptiness explain his frequent, lifelong depressions, and in our view are related to his impulsive decision to abandon his career as a painter: he believed the cinema had devalued, if not rendered superfluous, painting, feeling the career he had trained years for was, in effect, "worthless."

8) inappropriate, intense anger or difficulty controlling anger (e.g., frequent displays of temper, constant anger, recurrent physical fights)

YES. See (6) above. Dr. Linehan argues that at its core, BPD is an "emotional regulation dysfunction": the subject has a high emotional vulnerability (or over-sensitivity) combined with an inability to modulate (internal self-monitoring and self-control) the resulting emotions. We believe that when in 1987 Donald Cammell bought the handgun he would eventually use to kill himself, he bought it to use only on himself. Others are not so sure. A number of individuals close to the *Wild Side* production told us they believed there was a chance that Donald might use the gun on one particular co-producer of *Wild Side* once the working relationship between them began to disintegrate. The critical issue here is not whether Donald would or would not have used the gun - he did not, although he kept the gun in a desk drawer in the editing room along with a box of bullets - but that his associates knew, or intuited, his difficulty controlling his anger. It was highly inappropriate (and illegal), of course, for Donald to have a (concealed) gun at his workplace, but this is precisely the point: he knew it, too, but kept it in his possession anyway. He was unable to modulate his growing resentment and anger. This is precisely the issue behind so many workplace shootings. Hence it is not surprising that people involved in the post-production of *Wild Side* - aware of the growing tensions - rightly demanded Donald's gun should be removed from the premises.

9) transient, stress-related paranoid ideation or severe dissociative symptoms

YES. Drew Hammond, with whom Donald spent considerable time during his last year or so, reports that Donald had dissociative symptoms. It is thus not surprising that the central enigma of two of his films, *Performance* and *White of the Eye*, is how more than one personality can co-exist within the same person. Apparently Donald occasionally experienced ego-alien ("other self") effects, referring to another self he called the "Uncensored Don." Perhaps more importantly, he exhibited a characteristic symptom of someone prone to dissociative episodes: amnesia. For instance, he would often hide his handgun after emerging from a dissociative episode, and would then be unable to find it, for weeks sometimes, despite his persistent efforts to do so.

The Connection Between Stress and Depression

We would like to emphasize, once again, that our assertion that Cammell suffered from Borderline Personality Disorder is a theory. And yet, according the DSM-IV-TR, a tentative diagnosis of BPD can be made if the patient exhibits *five* of the nine features listed above; Donald Cammell exhibited all of them. Much of Donald's behaviour, particularly his depressive episodes and suicidal impulses, can be accounted for by our BPD hypothesis, as well as other aspects of his personality. Sexually abused children frequently display emotional instability, inhibitions and fears of tenderness, anger toward - and distrust of - parents, as well as an exaggerated sense of betrayal, loneliness, hostility, and a poor sense of identity. Donald exhibited all of these emotional problems. The work of Dr. Linehan suggests at its core BPD is an "emotional regulation dysfunction," a complicated process of interaction between biological (genetic) and environmental factors (family attitudes, prevailing cultural conditions). It is always linked to some trauma or extreme stress in childhood, usually sexual in nature, and is exacerbated by what she calls an "invalidating environment," in which the subject consistently finds that his or her personal or private responses to events are invalid, inappropriate, or incorrect. For instance, a child may claim to have been sexually abused only to learn his or her parents or guardians refuse to take the claim seriously or dismiss it as nonsense. The child may be forced to endure repeated stress despite his or her protestations, leading to a personality dysfunction Dr. Linehan characterizes as having "high emotional vulnerability" or "over-sensitivity" coupled with an inability to control or contain the resulting emotions, an extremely combustible mixture.[23] The scenario depicted above might have happened to Donald as a child, and would explain the obstinate, combative, and confrontational nature people often noted in his personality.

Recent studies in brain neurochemistry have uncovered the close link between stress and depression, revealing the damage done to the hippocampus by stress. The hippocampus, a pair of finger-sized curls of tissue situated between the temples, plays an essential role in memory but is also closely linked to emotion. Individuals who have undergone extreme stress show pronounced hippocampal shrinkage, primarily because glucocorticoids and steroid hormones - produced by the body when under stress - are toxic to the hippocampus. Studies show that individuals subjected to severe stress and abuse can have hippocampal volumes *half* the normal size.[24] If our theory is correct, that Donald underwent a period of extreme stress at about the age of eight or nine while installed at Fort Augustus, the stress could have damaged his hippocampus, resulting in the repeated depressive episodes he subsequently suffered his entire life. According to the DSM-IV-TR, children who have exhibited a major depressive episode fail to make expected weight gains and can even experience weight loss. David Cammell told us that Donald remained noticeably small for his age. To us, this fact suggests that, if nothing else, he may have suffered a major depressive episode as a child. Only a sudden growth spurt in late adolescence elevated him to his adult height of just under 5'10". His weight was usually a trim 170 lbs.

Decreased hippocampal volume, coupled with depressive episodes that in turn triggered wildly fluctuating levels of stress hormones and neurotransmitters, may have contributed to his occasional dissociative episodes, a feature of BPD and a subject he explored in his films. Most human beings suffer to one degree or another from the conflict of internal forces, but these internal conflicts seldom emerge in the form of a full-blown dissociation of consciousness, volition, or identity. All of Cammell's films are explorations of characters confused about their identity, sexual and otherwise, in addition to the fact that they all contain violent and suicidal characters. David Cammell said in the Chris Rodley and Kevin Macdonald documentary that the "enigma" of *Performance* is "the merging of two personalities," but we might say, alternatively, that the enigma is how two distinct personalities can coexist within one body - a question that we think Donald Cammell asked about himself.

As mentioned earlier, Drew Hammond said Donald showed symptoms of Dissociative Identity Disorder (indeed, the psychologist Donald was seeing at the end of his life has published numerous articles on the subject), saying that Donald would often refer to an individual he called "the Uncensored Don," which was unlike the one named "Donald Cammell." *White of the Eye*, Donald's most autobiographical film, raises the same question as *Performance*: how can two selves reside within the same body? The enigma of *White of the Eye* can be stated as: how can Paul White, an artist/craftsman and family man, also be radically unlike himself, and be a brutal serial killer? In addition, both *White of the Eye* and *Performance* feature tortured protagonists who are actually confused about their sexual identity - true of *Wild Side* as well. While homosexuality is frequently portrayed in Donald's films, it is not consistently portrayed positively. For instance, in *White of the Eye*, in a key scene that is not revealed until late in the film, in a flashback the Mike Desantos character is physically over-powered and forcibly kissed on the mouth by Paul White (whose face is drenched with the blood of his dead prey), who then reviles him by spitting in his face. The diminutive female protagonist of *Wild Side*, Alex, is raped - there is the strong implication that she is in fact sodomized - by the Catholic FBI agent, Tony. When Alex reports the rape to Tony's superior, she is coerced into silence by the threat that she will be reported for prostitution. In effect, Tony avoids rape charges by the powerful institution that he serves. The analogy to another powerful institution knowingly covering up pederasts within its ranks is an unavoidable association.

The Rest Is Silence

Whatever happened while Donald was enrolled in St. Andrew's Priory at Fort Augustus, his parents took his hysterical reaction to his life there seriously enough to remove him from the school and bring him with them back to London. Iona never again, though, sent Donald to Scotland without accompanying him there. Whether the aftermath of the events of the fall and winter of 1942-43 were ever discussed between Donald and his parents in later years we shall never know. As to our theory of what may have happened to Donald during his truncated stay at the Abbey School during 1942-43, David Cammell (among others) remains sceptical. Certainly no one at the time, including Donald's parents, could have believed such a scenario as we have presented here. "They never would have thought such a thing possible in those days," David says.[25] Perhaps not, but that doesn't mean it did not occur. William Blake wrote in *The Marriage of Heaven and Hell*, "What is now proved was once only imagin'd," a line suggesting, among other things, that many of the things we now know to be true once existed in the form of repressed or unacknowledged anxieties.

Is our BPD hypothesis an attempt to defend Donald's adult behaviour? No, it is not. But we do strive to understand and explain it: unfortunately, he isn't an isolated case. Behaviour such as his is exhibited in many individuals whose childhoods are not shrouded in such mystery, and many books have been written exploring the subject. We must admit that we have always been perplexed by a profound contradiction, widely held in Western culture, that people believe good behaviour is learned, whilst bad behaviour is not. At any rate, Donald Cammell's accomplishments in his professional career, and the complex personality that emerges from a scrutiny of his personal life, reveal why he has acquired the mythic status we claim for him at the onset of this study.

Donald Cammell Filmography

We have tried to make the following filmography as comprehensive as possible. Information on running times and ratings has been derived from various sources. Running times for the films are taken from Richard P. Krafsur, Ed., *The American Film Institute Catalog of Motion Pictures: Feature Films, 1961-1970.* 2 vols. New York, R.R. Bowker, 1976, as well as the British Board of Film Classification (BBFC) database, www.bbfc.co.uk. Discrepancies are to be expected. The information taken from the British Board of Film Classification on running times and cuts demanded of films submitted before the early 1980s seems far from reliable. The date a work was submitted to the BBFC for review, however, is certainly reliable, and we have reproduced those dates below. The running time in bold at the end of each entry indicates the (longest) length of the film we have seen. We have tried to determine the most accurate running time available. We wish to thank Francis Brewster, Julian Grainger, Craig Lapper, and Brad Stevens for their help in compiling this filmography.

Note: The Internet Movie Database incorrectly credits co-authorship of the direct-to-video feature *R.P.M.* to Donald Cammell. The film is attributed to J.P. Gardner and Franklin Brauner, both of which are pseudonyms, and it is a coincidence that Cammell used the latter as a pseudonym on *Wild Side*. Additionally, it has been reported that he was considered to direct *RoboCop 2* (1990) and *Bad Influence* (1990), but the possibility never went past the initial discussion stage.

DUFFY

1968. © Columbia (British) Productions Ltd. Filmed on location and at Shepperton Studios, London, England. Columbia Pictures Corporation presents. A Martin Manulis Production. Colour (Technicolor), 35mm, Westrex Recording System.

Director: Robert Parrish. Producer: Martin Manulis. Associate Producer: Harold Buck. Screenplay by: Donald Cammell and Harry Joe Brown Jr. From a story by: Donald Cammell, Harry Joe Brown Jr. and Pierre de la Salle. Photographed by: Otto Heller B.S.C. Art Director: Phillip Harrison. Costume Designer: Yvonne Blake. Film Editor: Willy Kemplen. 2nd Unit Director: Michael Frewin. Production Manager: William P. Cartlidge. Assistant Director: Peter Price. Camera Operator: Godfrey Godar. Continuity: Joan Davis. Set Dresser: Patrick McLoughlin. Wardrobe Mistress: Betty Adamson. Make-up: Harry Frampton. Hairdresser: Maud [Maude] Onslow. Location Production Manager: Ron Carr. 2nd Unit Camerman: Egil Woxholt. Special Effects: John Richardson. Dialogue Coach: Al Lettieri. Casting: Maude Spector. Sound: Iain Bruce. Dubbing Mixer: John Aldred. Sound Editor: Ted Mason. Aviation Advisor: David Kaye. Jewellry by: Kutchinsky. Music by: Ernie Freeman. "I'm Satisfied" sung by: Lou Rawls. "I'm Satisfied" by: Cynthia Weil, Barry Mann and Ernie Freeman. Main title designed by: Michael Graham Smith.

Cast: James Coburn (Duffy), James Mason (J.C. Calvert), James Fox (Stefane), Susannah York (Segolene), John Alderton (Antony), Guy Deghy (Captain Schoeller), Carl Duering (Bonivet), Tutte Lemkov (Spaniard), Marne Maitland (Abdul), Andre Maranne (Inspector Garain), Julie Mendez (Belly Dancer), Barry Shawzin (Bakirgian), Steve Plytus (Moroccan) [uncredited], Peter Van Dissel (Radio Operator) [uncredited], Patrick Lichfield (Photographer) [uncredited cameo].

Running time: 101 minutes [AFI]. BBFC: 1 May 1968; submitted length: 101m 39s; no cuts required. Certificate: A. UK Release: 27 October 1968. Premiere (New York): 16 September 1968. MPAA rating: R.

Video: *Duffy* is an extremely difficult film to find on video. It was issued in Germany as *Duffy - Der Fuchs von Tanger* (RCA Columbia Pictures International, #10261, 96m 31s PAL) and in France as *Duffy - Le reynard de Tanger* (Gaumont Columbia RCA, #10261, 96m 36s SECAM). Both tapes use a cut print (equivalent to 100m 38s at 24fps), missing footage in the scene in which Duffy (James Coburn) tries to force himself on Segolene (Susannah York). [**101m 28s**]

THE TOUCHABLES

1968. © Film Designs Limited. Made by Film Designs Limited, on location and at Holland Park Studios, London, England. Released by Twentieth Century-Fox Film Corporation. 20th Century Fox. A John Bryan Production. Colour (De Luxe), 35mm.

Directed by: Robert Freeman. Produced by: John Bryan. Screenplay by: Ian La Frenais. Based on a script by:

David and Donald Cammell. From an original idea by: Robert Freeman. Music Composed and Conducted by: Ken Thorne. Title Song "The Touchables" by: Nirvana. Associate Producer: John Oldknow. Assistant Director: Ted Morley. Art Direction: Peter Hampton and Richard Rambaut. Costume Advisor: Sandy Moss. Photographed by: Alan Pudney. Editor: Richard Bryan. Camera Operator: Tony Troke. Dubbing Editor: Tony Lenny. Sound Recordist: John Brommage. Sound Mixer: John Aldred. Continuity: Annabel Davis Goff. Make-up: Jill Carpenter. Hairdresser: Pearl Tipaldi. Assistant Editor: Chris Burt. Wardrobe Mistress: Klara Kerpen. Construction Manager: Jack Carter. Chief Electrician: Roy Larner. Location Manager: Jack Wright. Production Secretary: Beryl Harvey.

Cast: Judy Huxtable (Sadie), Esther Anderson (Melanie), Kathy Simmonds (Samson), Marilyn Rickard [Monika Ringwald] (Busbee), David Anthony (Christian), James Villiers (Twyning), John Ronane (Kasher), Harry Baird (Lillywhite), Michael Chow (Denzil), William Dexter (Quayle), Roy Davies (Glubb), Ricki Starr (Ricki), Joan Bakewell (Interviewer), Danny Lynch (March), Bruno Elrington (Bruno), Steve Veidor (Danny), Peter Gordeno (Jimmy), Simon Williams (Nigel Bent), Bryan Walsh (Terry).

Running time: 94 minutes (copyright length) [AFI]. BBFC: 6 March 1968; submitted length: 94m 7s. Cuts required to final reel scene in which Twyning (James Villiers) molests Busbee (Monika Ringwald) whilst questioning her. Certificate: X. UK release: 19 November 1969. Premiere (New York): 20 November 1968. MPAA rating: R. Review in *The New York Times* (21 November 1968) lists a running time of 97m, an erroneous figure copied from the pressbook. Re-edited for a PG re-release in 1973, reducing the running time to 88m.

Video: Not available. In 1968 20th Century-Fox Records (#S4206) issued the soundtrack by Ken Thorne that included the title song by Nirvana and additional music by Ferris Wheel, Wynder K. Frog, and Roy Redman. Island reissued on CD Nirvana's 1968 album *All Of Us*, which contains the title song from *The Touchables*, in 2003 (#IMCD 302). [**93m 15s**]

PERFORMANCE

1970. © Warner Bros. Inc. Warner Brothers Pictures. A Goodtimes Enterprises Production. Made by Goodtimes Enterprises Limited, 3 Tilney Street, London W.1., England, and completed at Twickenham Film Studios, London, England. Colour (Technicolor), 35mm.

Directed by: Donald Cammell and Nicolas Roeg. Produced by: Sanford Lieberson. Written by: Donald Cammell. Photographed by: Nicolas Roeg B.S.C. Music by: Jack Nitzsche. Turner's song "Memo from T" written by: Mick Jagger. Music conducted by: Randy Newman. Played by: Ry Cooder, Bobby West, Russel Titelman, The Merry Clayton Singers, Milt Holland, Amiya Dasgupta, Lowell George, Gene Parsons. Moog Synthesizer: Bernard Krause. Santur: Nasser Rastigar-Nejad. "Wake Up Nigger" by The Last Poets. Courtesy of Douglas Records. Buffy Ste. Marie performed musically through the courtesy of Vanguard Records. Associate Producer: David Cammell. Film Editors: Antony Gibbs, Brian Smedley-Aston, Frank Mazzola [uncredited]. Art Director: John Clark. Production Manager: Robert Lynn. Production Runner: Christopher O'Dell [uncredited]. Assistant Director: Richard Burge. Unit Manager: Kevin Kavanagh. Camera Operator: Mike Molloy. Sound Recordist: Ron Barron. Sound Editor: Alan Pattillo. Dialogue Coach and Technical Advisor: David Litvinoff. Turner's House Design Consultant: Christopher Gibbs. Set Dresser: Peter Young. Continuity: Anabelle [Annabel] Davis-Goff. Make-up: Paul Rabiger, Linda de Vetta. Hairdresser: Helen Lennox. Wardrobe: Emma Porteous, Billy Jay. Costume Consultant: Deborah Dixon. Mr. Fox's suits by Hymie of Waterloo, London.

Cast: James Fox (Chas), Mick Jagger (Turner), Anita Pallenberg (Pherber), Michele Breton (Lucy), Ann Sidney (Dana), John Bindon (Moody), Stanley Meadows (Rosebloom), Allan Cuthbertson (The lawyer), Antony [Anthony] Morton (Dennis), Johnny Shannon (Harry Flowers), Anthony Valentine (Joey Maddocks), Ken Colley (Tony Farrell), John Sterland (The chauffeur), Laraine Wickens (Lorraine), Billy Murray (Thug) [uncredited].

Running time: 106 minutes [AFI]. BBFC: 15 October 1970; (no running time indicated); cuts required. BBFC [2004 re-release]: 19 February 2004; submitted length: 105m 27s [9,490'5 feet]; no cuts required. Premiere (New York): 1 August 1970. Italy: *Sadismo*. UK re-release: 7 May 2004.

Note: Warner Brothers issued a detailed script to be used for subtitling purposes around May 1970. Given its purpose, one can assume this script gave a very accurate running time of the film. The length of the film is listed as 9,715'12, or 9,715 feet + 12 frames. Using the standard projection rate of ninety feet per minute, the length of this cut would have been 107m 57s. Frank Mazzola said this running time "sounds about right," and believes it is the length of the cut John Calley approved on or about 1 May 1970. However, Warner Brothers president Ted Ashley had reservations about this cut, and the release was again delayed. In a letter to Ted Ashley, dated 18 June 1970, Donald and Mick Jagger insisted the film be released, with "no more bullshit." (The language used on the theatrical poster, "…a film about fantasy. And reality. Vice. And Versa," was taken from this letter.) Subsequently, and prior to its 1 August 1970 release in the US, Ted Ashley demanded cuts to the John Calley

approved version. Records in the BBFC archives indicate that cuts were requested by the BBFC to the Ted Ashley cut prior the film's release in the UK, particularly in the scene when Chas dons gloves and pours acid on the Rolls-Royce, and also (predictably) in the sequence in Chas's flat when he is beaten and whipped by Joey and his thugs, in which the flash cuts to Chas and Dana's sex scene were removed. The version released in the UK in early 1971 was thus shorter than the US theatrical release. The longest version currently available on NTSC we have seen, the WB/Image laser disc issued in 1999, and the one most people have seen, is the Ted Ashley truncated cut, running 105m 12s - meaning 2m 45s seconds were removed from the John Calley approved cut prior to its August 1970 release - *not* by Frank Mazzola or Donald Cammell. We believe it was the 107m 57s cut that was shown by Ted Ashley to several individuals, among them Michael Butler, in 1970. Based on the copy of the script loaned to us by Frank Mazzola, the majority of these cuts are from the first half, and are primarily intended to censor the violence. Knowledgeable individuals, Frank Mazzola and David Cammell among them, agree that the longest version currently available is missing several scenes, meaning they are remembering the John Calley approved cut. At the time of his death, Donald had a 35mm print of *Performance* in his possession, but this print actually belonged to Frank Mazzola, who had given it to Donald some time before his death. Frank Mazzola screened this print at a Donald Cammell retrospective in Berlin in 2000. This print is *not* the longer, John Calley approved cut. Frank Mazzola insists that the *Performance* negative, and the trims from the John Calley cut, are currently stored in the WB vault in western Kansas (the salt mines) - not in Burbank - and hence a restoration of *Performance* to the length of the John Calley version is quite feasible - assuming Warner Brothers allows Mazzola access to the materials.

Video: Warner Brothers first issued *Performance* on home video in the US in 1984 in both VHS (Warner Home Video #11131, NTSC) and laser disc (#11131LV, NTSC) formats. Both of these issues contain the same standard (pan & scan) transfer of a highly truncated version (103m 35s) of the film, which also used inferior source materials. Using different package art, WHV reissued the 1984 truncated version on VHS in 1992 (#11131, NTSC), a tape that fetches high prices in collector's markets, but is hardly worth the expense. In the UK this truncated version can be identified by the catalogue number S011131 on VHS issues. The most complete version of the film was first issued in the UK on PAL VHS by Warner Home Video (UK) in 1997 (#S015399, PAL, 100m 56s [105m 12s]) in widescreen as part of its "Maverick Directors" series, which also included as a bonus a 57s trailer in standard format. In the US, this longer version was used as the source material for a widescreen laser disc issued by Warner Home Video/Image Entertainment (#15399,

NTSC) in 1999 using cover art similar to the 1992 VHS edition. Only about 1,000 copies of this laser disc were issued. [**105m 12s**]

Jack Nitzsche's part in the success of *Performance* shouldn't be overlooked. During the re-edit, Frank Mazzola recalls meetings he had with Nitzsche on several occasions and remarked on Nitzsche's energy and enthusiasm. It was Nitzsche who brought the wide variety of musical forms to the soundtrack, an early instance of what is now referred to as "world music." With the exception of "Memo from T" and The Last Poets' "Wake Up Nigger," all of the music was written by Jack Nitzsche ("Gone Dead Train" was co-written by Russ Titelman). In addition to the lush strings of "Harry Flowers' Theme," he employed the dulcimer (played by Ry Cooder) in "The Hashishin," and sought out Vanguard Recording Society artist Buffy Sainte-Marie (who would later become his wife) to play on the album. At the time, she was one of a very few musicians with national exposure who could play the Indian mouth bow, which had been taught to her by folk artist and instrument maker Patrick Sky. Nitzsche had also sought out the talents of electronic music pioneer Bernie Krause, who along with fellow synthesizer pioneer Paul Beaver were at the time recording for Warner Brothers. Under the name Beaver and Krause, he and Paul Beaver released an important album of electronic music on the Warner Brothers label in April 1970, *In A Wild Sanctuary*. Serendipitously, Bernie Krause was a rather inspired choice to play the Moog synthesizer for the *Performance* soundtrack. He and Paul Beaver (who died prematurely in 1975 at age 49) had released in 1969 an album of electronic music titled *Ragnorök*, a Norse name for the end of the reign of the old gods, but also the name of a famous parable authored by none other than Jorge Luis Borges. Moreover, Krause had also played the Moog synthesizer on Johnny Mandel's atonal score for John Boorman's *Point Blank* (1967), which was an major influence on *Performance*, and a film Donald Cammell greatly admired. Warner Brothers issued the *Performance* soundtrack on vinyl LP in October 1970 (#WB 2554) and in the 90s on compact disc (#26400-2). It should be noted that the LP and CD (37:08) does *not* contain all of the music used in the film. In addition to the LP, two known singles connected to *Performance* were issued. The single, "Memo from T"/"Natural Magic," attributed to Mick Jagger and not The Rolling Stones, was issued on the London label, and on various labels around the world. In addition, an alternate take of "Gone Dead Train" was issued by Reprise Records as a promotional ("white label") single attributed to Randy Newman (produced by Jack Nitzsche) in 1970 (Reprise single #0945, 2:50, stereo and mono versions). An outtake/early version of "Memo from T" was eventually issued on The Rolling Stones' album *Metamorphosis* (1975). Former Byrds member and multi-instrumentalist Gene Parsons's contribution - he played drums on most of the tracks, re-recording the original drum tracks at producer Jack Nitzsche's request - is largely uncredited.

THE ARGUMENT

1972. Completed 1998. © Festival Films/Frank Mazzola. In Fond Memory of Donald Cammell. Frank Mazzola Presents. A Film by Donald Cammell. Colour (Technicolor), 35mm (Panavision).

Written and Directed by: Donald Cammell. Produced by: Frank Mazzola. Music by: Bruce Langhorne. Edited by: Frank Mazzola. Director of Photography: Vilmos Zsigmond. Executive Producer: Anthony T.O. Mazzola. Line Producer/Production Manager: Anthony Mazzola. Co-Producer: Victor Ginzburg. Associate Producer: Catherine Hader. Associate Editor: Jeff Selis. Assistant Camera: Earl Clark. Assistant Editors: Catherine Mazzola, Antrenig Mahakian. Supervising Sound Editor: Paul Tade. Sound Effects Editor: Peggy McAfee. ADR Mixer: Jim Saunders. Re-recording Mixers: Todd Grace, Kathy Oldham. Sound: Victor Landweber. Key Grip: Burt Maggio. Gaffer: Joel Chernoff. General Assistant: Don Fox. Production Assistant: Sarah Bradpiece. Timer: Mike Hatzer. Negative Cutter: Bob Hart. Titles and Opticals: Cinema Research Corporation. Special Thanks to: Cinema Research - Mike Minkow. Warner Bros. - Dede Allen, Don Rogers, Barry Snyder. Deluxe Laboratories - Bud Stone, Cyril Drabinsky, Bob Bastian. Raleigh Studios - Michael J. Donahue. American Film Institute - Ken Wlaschin. Kevin McDonald. Chris Rodley. David Cammell. The Cutting Room, Hollywood. Avid Technologies - Alan Stewart. Three Point Digita - Rob Cloyd. Atomic Film Co. - Joel Marshall. Kodak Film Company. Keith Robinson. Andrew Seklir. Walter Canton. Dean Moody. Benny Montano. Patti Sienkiewicz. Joan White. Oscar Mazzola.

Cast: Myriam S. Gibril (Aisha, the Witch), Kendrew Lascelles (Nonus, the Director).

Video: Available on VHS (both NTSC and PAL) from Mazzola Film Company (www.mazzolafilmco.com). In addition, *The Argument* was included as a supplement to the UK Tartan Video DVD (#TVD3311, PAL) issue of *Wild Side*. [**11m 26s**]

SIMONA [*Histoire de l'oeil*]

1974. Dear International presents. Nopa Italia presents. Rolfilm Produzione (Rome), Les Films de l'Oeil (Brussels). Colour, 35mm.

Written and Directed by: Patrick Longchamps. Freely based on "Histoire de l'oeil" [Story of the Eye] by Georges Bataille, published by J.J. Pauvert. Production Supervisor: Roland Perault. Editors: Franco Arcalli and Pina Rigitano. Art Direction and Costumes: Pasquale Grossi. Special Effects: Joseph Natanson. Music by: Fiorenzo Carpi. Conducted by: Bruno Nicolai. Music Publisher: Gemelli. Director of Photography: Aiace Parolin (a.i.c.). Songs performed by: Shawn Robinson. Assistant Director: Alain Elledge. Publicity: Lucherini. Rossetti. Spinola, Tonino Pinto, Robert Malengreau. Camera Operator: Angelo Lanutti. 2nd Operator: Michel Houssiaux. Assistant Cameramen: Luigi Bernardini, Oddo Bernardini. Still Photography: Ruy Olivera, Patrizia Matthieu. Key Make-up: Mauro Gavazzi. Key Hairstylist: Gilberto Provenghi. Wigs by: Rocchetti. Script Supervisors: Marisa Agostini, Susan Rossberg. Assistant Editor: Gina Rigitano. Unit Managers: Bruno Dreossi, Philippe Bosseler. Production Secretary: Claire Fievez. Property Buyers: Merdhat Taghian, Michel Vervish, Michel Fradier. Assistant Art Directors: Charles Calicot, Marianne Marechale. Construction Manager: Andre Fontaine. Wardrobe: Veronique Rosi, Anne Huybrecht. Gaffers: Bruno Pasqualini, Andre Olivier. Key Grips: Guglielmo Maga, Bob Lessen. Costumes furnished by: Annamoda, Safas. Dubbing: C.I.D. Sound Effects: Tonino Cacciuottolo. Editing Facility: Studio Venus. Sound Studio: International Recording. Colour by: Technospes.

Cast: Laura Antonelli (Simona), Patrick Magee (The Father), Raf Vallone (The Uncle), Maurizio Degli Esposti (Georges), Margot Saint'Ange (Marcelle), Quentin Milo (Gille), Maxane (Simona's Mother), Marc Audier, Ramon Berry, Michel Lechat, Yvette Merlin, Germaine Pascal, John Trigger (The Stranger) [uncredited].

Running time: 91m 56s. Length: 2,522 metres (8,274.28 feet).

Note: *Simona* was released in Italy on 22 February 1974, where, according to the reference book *Belgian Cinema*, it "was seized and banned throughout the peninsula a matter of days after its theatrical release in Rome and Milan." Apparently, the film has never been released in Belgium. For a long while, the only version of *Simona* we had available was a heavily censored B&W copy, kindly provided to us on VHS by Craig Ledbetter of ETC Cinema. Fiorenzo Carpi's score for *Simona* was issued in Italy on vinyl LP on the Vedette label in an issue of roughly 1,000 copies in 1974. *Simona* (under the title *Yo soy la pasión*) was issued on a PAL Region 2 DVD in Spain in 2004 in a standard transfer (Vella Vision #91012, 81m 47s PAL [85m 21s NTSC]) but also censored, with cuts totalling 6m 35s. Donald Cammell and Frank Mazzola began an English language re-edit of this film in 1973, during which additional scenes were directed by Donald Cammell, but the film's director, Patrick Longchamps, rejected their cut, and so that cut has never been released. We found technical information on the Patrick Longchamps version at: http://www.anica.it/arc/1974/74ag3827.thtml. Accessed 13 June 2003. The disposition of Donald Cammell's cut (which exists somewhere) is unknown. Patrick Longchamps has been seen occasionally in Los Angeles, but apparently is not inclined to release Donald's cut. [**85m 21s**, censored]

DEMON SEED

1977. Metro-Goldwyn-Mayer, released through United Artists. A Herb Jaffe Production. Colour (Metrocolor), 35mm (Panavision).

Directed by: Donald Cammell. Produced by: Herb Jaffe. Musical Score Composed and Conducted by: Jerry Fielding. Director of Photography: Bill Butler, A.S.C. Based Upon the Novel "Demon Seed" by Dean R. Koontz. Screenplay by: Robert Jaffe and Roger O. Hirson. Production Designer: Edward C. Carfagno. Film Editor and Montages: Francisco [Frank] Mazzola. Associate Producer: Steven C. [Steven-Charles] Jaffe. Costumes for Julie Christie Designed by: Sandy Cole, C.D.G. Casting: Jennifer Shull. Titles and Opticals: MGM. Opticals Supervisor: Jim Liles. Title Design: Mary Meacham. Unit Production Manager: Michael Rachmil. Assistant Director: Edward A. Teets. Second Assistant Director: Alan Brimfield. Music Editor: Dan Carlin. Sound Editor: John Riordan. Sound: Jerry Jost, William McCaughey, C.A.S. Script Supervisor: Marshall Wolins. Set Decorator: Barbara Krieger. Associate Film Editors: Gary Bell, Freeman Davies, Jr. Special Effects: Tom Fisher. Property Master: William Wainess. Makeup: Lee Harman, Don L. Cash. Hairdresser: Dione Taylor. Gaffer: Colin J. Campbell. Key Grip: George Hill. Music Supervisor: Harry V. Lojewski. Men's Costumer: Bucky Rous. Women's Costumer: Joie Hutchinson. Camera Operator: James R. Connell. Video Coordinator: Brent Sellstrom. Assistant Video Coordinator: Dixie J. Capp. Publicist: Regina Gross. Producer's Secretary: Oga Danylo. Synthavision™ Animation by: Bo Gehring. Tetralinks™ by: Level-Seven. Delta Wing Computer Animation by: Computer Science Department, University of Utah. Computer Equipment and Technical Support Furnished by: Wang Laboratories, Inc. of Tewksbury, Massachusetts. Moon Photographs courtesy of: Lick Observatory. Electronic Visuals Designed and Developed by: Ron Hays. Electronic Animation: Richard L. Froman. Facilities: Image West, Ltd. Genigraphics Animation: Grant Bassett. Technical Associate: Domenic Iaia. Aerial Footage: MacGillivray Freeman. Special Proteus Monitor Footage by: Jordan Belson. All Special Makeup: Frank Griffin, Burman Studios. Laser Consultant: Christopher Outwater. Technical Consultant: Robert Stewart. Technical Consultant: Kathy Green R.N. Electronic Performances: Ian Underwood, Lee Ritenour. Our Thanks to: General Electric Company. Braun North America. Bang & Olufsen of America, Inc.

Cast: Julie Christie (Susan Harris), Fritz Weaver (Alex Harris), Gerrit Graham (Walter Gabler), Berry Kroeger (Petrosian), Lisa Lu (Soong Yen), Larry J. Blake (Cameron), John O'Leary (Royce), Alfred Dennis (Mokri), Davis Roberts (Warner), Patricia Wilson (Mrs. Talbert), E. Hampton Beagle (Night Operator), Michael Glass (Technician), Barbara O. Jones (Technician), Dana Laurita (Amy), Monica MacLean (Joan Kemp), Harold Oblong [Peter Elbling] (Scientist), Georgie Paul (Housekeeper), Michelle Stacy (Marlene), Tiffany Potter (Baby), Felix Silla (Baby), Robert Vaughn (Voice of Proteus IV) [uncredited].

Running time: 94m 26s. BBFC: 20 April 1977; submitted length: 94m 26s; no cuts required. Certificate: AA. MPAA rating: R. Premiere (Los Angeles): 1 April 1977. France: *Generation Proteus*. Germany: *Des Teufels Saat*.

Video: In the UK, MGM/CBS issued a pre-cert edition of *Demon Seed* in August 1982 in a standard (full-frame) transfer (#UMV10129, PAL). In the US it was likewise issued in standard format by MGM/UA on VHS in the over-sized box (#MV600129, NTSC) and on laser disc (#ML100129, NTSC), and subsequently re-reissued in a standard format sleeve with different artwork. The only VHS release of *Demon Seed* in widescreen was issued in the UK by Warner Home Video as a "Cult Classic" reissue (#S050129, PAL) which included the theatrical trailer as a supplement. In 2005 Warner Brothers Home Video issued *Demon Seed* in widescreen format on DVD in both PAL and NTSC formats; the DVD editions also included the original theatrical trailer. *Film Score Monthly* issued Jerry Fielding's fine score to *Demon Seed* on CD in 2003. Also included on the CD is Fred Myrow's score to *Soylent Green*. [**94m 26s**]

TILT

1979. © 1978 Melvin Simon Productions, Inc. Warner Brothers Pictures. Melvin Simon Productions present. Rudy Durand's "Tilt". Colour (Technicolor), 35mm (Panavision).

Produced and Directed by: Rudy Durand. Executive Producer: Ron Joy. Associate Producer: Dale Cline. Supervising Editor: Bob [Robert] Wyman. Music Scored and Conducted by: Lee Holdridge. Production Designer: Ned Parsons. Director of Photography: Richard Kline, A.S.C. Screenplay by: Rudy Durand and Donald Cammell. Story by: Rudy Durand. Soundtrack album available on ABC Records and GRT Tapes. Words & Music Written and Arranged for the Motion Picture "Tilt" by: Bill Wray. "Pinball That's All". "My Music". "Where Were You". "Don't Stop the Music". Rock and Roll Rodeo". "Melody Man". "Friends". "Mercedes Morning". "Koala Shuffle". © 1978 Mel Bren Music, Inc. Performed by Bill Wray & His Band. Jim Wray. George Enete. Mike Keeley. Ronnie Dobbs. "Long Road to Texas" by Sam Neely & Rudy Durand. © 1971 8 Iron Music, Inc. End Title Song Sung by: Bill Wray. "My Lady". Performed by: Ken Marshall. Written by: Morgan Stoddard. © 1977 8 Iron Music, Inc. "Don't Let the Rain Get to You". (Performed by Bishop & Gwinn). Words and Music by: Randy Bishop, Marty Gwinn. © 1978 Ditch

Road Music, Inc. "You Really Didn't Have to Do It". (Performed by Bishop & Gwinn). Words and Music by: Randy Bishop. © 1978 Ditch Road Music, Inc. "Brenda's Theme", "Santa Cruz Street People", "Santa Cruz Sundays" by Lee Holdridge. © 1978 Mel Bren Music, Inc. Unit Production Manager: Carl Olsen. Production Executive: John Thiele. Editor: Don Guidice. Set Decorator: Rick Simpson. Assistant Directors: Pat Kehoe, Cal Naylor. Post Production Supervisor: Joseph Dervin, Jr. Sound Editor: Keith Stafford. Music Editor: Donald Harris. Production Assistant: Hal Reed. Assistant Editor: Steve Butler. Apprentice Editor: Martha Zec. Production Publicist: Jack Lyons. Sound Mixer: Dean Salmon. Camera Operator: Al Bettcher. 1st Assistant Camera: Mike Genne. 2nd Assistant Camera: Frank Redmond. Pinball Machine Musical Sounds: Rudy Durand & Bill Wray, Jim Wray, George Enete. Script Supervisor: Lloyd Nelson. Make-Up: Lon Bentley. Wardrobe: John Anderson. Wardrobe Assistant: Aida Swinson. Pinball Technical Adviser Michael "Pinball" Sehnert. Hairdresser: Carolyn Elias. Sound Boom: Gary Stahl. Stunt Coordinator: Gary Epper. Still Photographer: Bruce Herman. Assistant to the Producer: Peter Milo. Assistant to the Director: Joe Scudero. Casting: Fenton & Feinberg. Casting (New York): Sharon Ambrose. Casting Location: Paul Ventura. Music Scoring Mixer: Danny Wallin. Re-Recording Mixers: Les Fresholtz, C.A.S. Vern Poore, C.A.S. Dick Alexander, C.A.S. Arthur Piantadosi, C.A.S. Danny Wallin, Walter Goss. Music Direction: Rudy Durand. Assistant to Music Director: David Simon. Negative Cutting: Donah Bassett. Colour Timer: Virgil A. Tanner. Property Master: Bill Bates. 2nd Property: JB Bates. Production Secretaries: Bonita Pierce, Gabrielle Adams. Pinball Machines: Koala-Cosmic-Venus © 1974 Tilt Enterprises, Inc. Koala-Astrological. © 1974 Tilt Enterprises, Inc. Created & Designed by: Rudy Durand, Michael "Pinball" Sehnert. Pinball Machine Art: Delana Bettoli. Kenworthy Snorkel Camera Systems: Paul Kenworthy. Location Eqiupment: PSI. Titles: Modern Film Effects, Steve Orfanos. Lenses & Panaflex Camera by: Panavision®. This motion picture was filmed without the use of camera steadying devices. Colour by: Technicolor®. Filmed in Santa Cruz, California; Hollywood, California; & Corpus Christ, Texas. Post-Production: The Burbank Studios, Burbank, California. Special Thanks to: The Melvin Simon Organization. Loeb and Loeb. I.C.A.A. Public Relations. California Film Commission. California Highway Patrol. Santa Cruz City Chamber of Commerce. Santa Cruz City Police Department. Santa Cruz City County Sheriff's Office. The Street People of Santa Cruz, California. The Texas Film Commission. Corpus Christi Chamber of Commerce. J.P. Luby. Corpus Christi County Commissioner. Ted Bullard & The Corpus Christ Police Department. Produced for Melvin Simon Productions by Koala Productions, Ltd. Stunts: Andy Epper, Steve Vandeman, Thomas Huff, Tom Lupo, Tony Epper.

Cast: Brooke Shields ("Tilt" Brenda Louise Davenport), Ken Marshall (Neil Gallagher), Charles Durning (Harold "The Whale" Remmens), John Crawford (Mickey), Karen Lamm (Hype), Harvey Lewis (Henry Bertolino), Gregory Walcott (Mr. Davenport), Geoffrey Lewis (Truck Driver), Robert Brian Berger (Replay), Lorenzo Lamas (Casey Silverwater), Don Stark (Gary Laswitz), Gary Mule Deer (Felix), George Jacobs (Clint), Helen Boll (Mrs. Davenport), Frank Pesce (Rock Manager, Carrots), Kathryn Gresham-Lancaster (Loretta Davenport), Paul Berlin (Racehorse Haynes, Texas Gambler), Charlie Lehman (David), Jim Galante (Bernie), Bruce Mackey (Miami), Teck Murdock (Assistant Rock Manager), Morgan Stoddard (Beaver Berlin), Fred Ward (Lenny), Lloyd Nelson (Cattleman), Michael Bates (Cattleman's Son), Mike [Michael] Genne (Happy), Daphne Parker (Warjac's Waitress), Harriet Brown (Warjac's Waitress), Susan Edelman (Mickey's Waitress), Thomas Poster (2nd Assistant Rock Manager), Dale Cline (Warjac's Bartender), John Martin Cooper (Punk Artist at Rock Concert), Devorah Teas (Warjac's Cook), Jay Crago Vaughn (Rock Security Guard), Joseph Granatelli (Pool Player).

Running time: 111 minutes. MPAA rating: PG. BBFC: 24 March 1979; submitted length: 111m 31s (10,037 feet); shortened to 106m 50s after 4m 41s cut at the distributor's request to eliminate sex and drug references. Certificate: A. Premiere (Los Angeles) 6 April 1979. UK release: June 1979.

Video: *Tilt* has never been particularly easy to find on video. The sole release of the theatrical version in the United States was on Continental Video (#1001, 111m NTSC) in 1984, in a standard (full-frame) transfer, long out-of-print. In the UK, *Tilt* was issued as a pre-cert video by Rank Video in October 1982 (#0102C, PAL, 106m 33s [111m NTSC]), also difficult to find. Rudy Durand's preferred cut, or the director's cut, has not yet been issued on video. Brad Stevens kindly taped the director's cut from British television, which yielded a running time of 101m 30s: Rudy Durand's director's cut is thus 9m 52s *shorter* than the theatrical cut (removing the opening sequence introducing Charles Durning's character). This re-edited version (with different scenes and takes) is Durand's preferred cut of the film. The soundtrack to *Tilt* was issued on LP by ABC Records (#AA-1114) ca. May 1979 and is now a collector's item. [**111m 17s**, theatrical cut] [**101m 30s**, director's cut]

WHITE OF THE EYE
1987. © 1986 Mrs White's Production Inc. Cannon Screen Entertainment (UK)/Palisades Entertainment (North America). Elliot Kastner Presents. Donald Cammell's Film. Colour (Consolidated Color), 35mm (Panavision).

Directed by: Donald Cammell. Produced by: Cassian Elwes and Brad Wyman. Associate Producers: Sue Baden-Powell and Vicki Taft. Casting by: Pamela Rack. Lighting Cameraman: Alan Jones. Photographed by: Larry McConkey. Production Designer: Philip Thomas. Edited by: Terry Rawlings. Music by: Nick Mason and Rick Fenn. Written by: China and Donald Cammell. Based on the book "Mrs White" by Margaret Tracy [Andrew and Laurence Klavan]. Music Supervisor: George Fenton. Steadicam Photography: Larry McConkey. Camera Operator: Douglas Ryan. 1st Assistant Camera: Adam Kimmel. 2nd Assistant Camera: Mark Davidson, Edward A. Gutentag. Gaffer: Kevin Williams. Script Supervisor: Jan D. Evans. Dialogue Director: China Cammell. Production Manager: Sue Baden-Powell. Production Co-ordinator: Aron Warner. Production Controller: Marsha Koff. 1st Assistant Director: Andrew Z. Davis. 2nd Assistant Director: David Householter. 3rd Assistant Director: Perry Husman. Sound Editor: Jim Shields. 1st Assistant Editor: Steve Cox. Assistant Sound Editor: Glenn Freemantle. 2nd Assistant Editor: Tim Grover. Music Editor: Brian Lintern. Sound Mixer: Bruce Litecky. Boom Operator: Marshall Evans. Set Decorator: Richard Rutowski. Set Dresser: Christina Volz. Construction Co-ordinator: Douglas Dick. Property Master: Charles Stewart. Costume Designer: Merril Greene. Costumer: Donna Barrish. Wardrobe Assistant: Cicile Feitshans. Key Make-up and Hair: Jeanne van Phue. Make-up and Hair: Sharon Ilson Reed. Assistant Make-up: Sheryl Berkoff. Location Manager: Harold Francis Enright III. Location Consultant: Bob Zache. Assistant Property Master: Linda Kiffe. Special Effects: Thomas Ford. Re-recording Mixer: John M. Hayward. Assistant Re-recording Mixer: David Anderson. Best Boy Electrician: Peter Wiehl. Electricians: Barbara Kallir, Woogie, Spencer Lasky. Key Grip: Gary L. Dagg. Best Boy Grip: Mark Combs. Grips: Ray Perosi, John St. John, John Murphy. Video Playback: Alexander T. Pappas. Assistant Editor (US): Clement Barclay. Apprentice Editor (US): Nelson Davalia. Assistant Sound Editors: Kant Pan, Martin Crane. Still Photographer: Suzanne Tenner. Stunt Co-ordinator: Dan Bradley. Production Assistants: Mathew Gaston, John Peate, Douglas Miller, David Goodman. Negative Cutting Supervisor: Les Collins. Stereo Design & Special Consultation: Christopher Hansen. Extras Casting: Janet Cunningham. Craft Services: Laurie Laurel. Assistant to Cassian Elwes: Lynn Marchionno. Cook/Driver: Michael Barton, Sylvia Sargent. Transportation Captain: James O'Keefe. Drivers: J.D Prelbeck, James Reeves, Dennis Jorgenson, Sanford Hampton, Darla Judd, Rudy M. Aguilar, Carol Chambers, Steve Miller. Teacher: Sister Carmel Kennefick. "Vesti la guibba" (Pagliacci). Performed by Luciano Pavarotti, with Vienna Volksoper Orchestra. Conductor: Leone Magiera. Courtesy of Decca Records. "A Country Boy Can Survive". Composed and performed by Hank Williams Jr. Courtesy of Curb Records. By arrangement with Warner Special Productions. Copyright Bocephus Music Inc. "You Sexy Thing". Composed by Errol Brown. Performed by Hot Chocolate. Courtesy of Chocolate/RAK Publishing Ltd. Copyright Chocolate/RAK Ltd. "Slim Jenkin's Joint". Composed by Booker T. Jones, Steve Cropper, Lewis Stienberg and Al Jackson Jr. Administrated by Cottillion Music, Sebastian Serrell-Watts. Re-recorded by Nick Mason, Rick Fenn and George Fenton. Copyright Irving Music Inc. "The Grand Tour". Composed by Moras [Norris] Wilson, Carmel [Carmol] Taylor and George Richey. Performed by David Keith. Copyright Algee Music Corp, Gallico Music Corp, Norris Wilson, Carhol [Carmol] Taylor. Mahler 2nd Symphony. Conductor Zubin Mehta. Vienna Philharmonic Orchestra. Courtesy of Decca Records. Camera and Lenses by: Panavision. Titles and Opticals by: Peter Govey Opticals. Processing by: Consolidated Film Industries. Prints by: Technicolor Ltd. Re-recorded at Pinewood Studios, London, England. Dolby Stereo in selected theatres. Location Equipment by: General Camera. Payroll by: System One. Helicopters by: Arizona Wing and Rotor. Catering by: Kays Gourmet. Stereos by: Christopher Hansen Ltd. Special thanks to: The Tucson Film Commission - Dede Johnson. Tucson Police Department. Gila County Sheriff's Department. Russek's Furs. Channel 18 Tucson. Insight Entertainment Marketing Inc. Nic Meyers of Aldbra Video. Nakamichi Stereos. Magna Plainer Speakers. Basement Studios, Richmond, London. Brittania Row Studios, Islington, London. Very special thanks to: The people of Globe and Miami, Arizona; and especially Bob Zache, founder of the Globe Film Commission who welcomed and organised us all so brilliantly.

Cast: David Keith (Paul White), Cathy Moriarty (Joan White), Art Evans (Mendoza), Alan Rosenberg (Mike Desantos), Marc Hayashi (Stu), William G. Schilling (Harold Gideon), David Chow (Fred Hoy), Michael Greene (Phil Ross), Alberta Watson (Anne Mason), Danielle Smith (Danielle White), Mimi Lieber (Liza Manchester), Pamela Seamon (Caryanne), Bob Zache (Lucas Herman), Danko Gurovich (Arnold White), China Cammell (Ruby Hoy), Jim Wirries (Grunveldt), Kate Waring (Joyce Patell), Fred Allison (TV Newsman), Clyde Pitfarkin (Hairdresser), Brad Wyman (Killer's Eye) [uncredited], John Diehl (Mr. Dupree) [uncredited - scenes deleted], Donna Barrish (Betty) [uncredited - scenes deleted].

Running time: 111 minutes. BBFC: 6 August 1986, submitted length: 117m 43s; no cuts required. Certificate: 18. Following this early screening, about 6 minutes of 'filler' sequences in reels 2 and 3 were removed by the distributors Cannon before it was re-submitted on 28 April 1987; submitted length: 111m 6s; no cuts required. Certificate: 18. Premiere (London): 19 June 1987. US release (New York): 20 May 1988.

Video: Warner Brothers/Cannon first issued *White of the Eye* on video in a standard (full-frame) issue (#PEV 37208, PAL) in February 1988, a couple of months prior to the film's North American release. After the film's limited theatrical run in the US, it was first issued on VHS in September 1988 by Paramount Home Video (#12670, NTSC) in a standard (full-frame) transfer, and on Norstar Home Video in Canada. In the UK, the film was re-issued in a widescreen edition in 1999 by MGM Home Entertainment as part of Warner Home Video's "Maverick Directors" series (#S031250, PAL), and is preferable to the standard (full-frame) issue (#S037208, PAL), issued at the same time. The film's 1m 23s trailer is available on the VHS issue of the James Woods starring *Cop* (Paramount Home Video #12659, NTSC), and may be available elsewhere. [**111m 6s**]

WILD SIDE

1996. © 1995 Wild Side Productions Inc. and Mondofin, B.V. Nu Image Presents. A John Langley Production.

Directed by: Franklin Brauner [Donald Cammell]. Produced by: Elie Cohn and John Langley. Executive Producers: Avi Lerner, Danny Dimbort, Trevor Short, Andrew Pfeffer. Co-Producer: Boaz Davidson. Casting by: Pamela Rack. Music by: Jon Hassell. Production Designer: Claire Bowin. Edited by: Frank Mazzola. Director of Photography: Sead Mutarevic. Written by: China Kong & Donald Cammell. Stunt Coordinator: Spike Silver, "Teddy's". Stunt Players: Spike Silver, Simone Boisseree, Edie Yansick. Helicopter Pilot: Peter McKernan. First Assistant Director: Paul N. Martin. Second Assistant Director: Philip James Gallegos. Associate Producer: Joan Chen. Production Supervisor: Barbara Freedman. Music Supervisor: Diane DeLouise Wessel. First Assistant Camera: Collin S. Colberg. Second Assistant Camera: Dominik Feller. Video Playback: Bob Morgenroth. Script Supervisor: Ronit Ravich Boss. Production Coordinator: Veronica Alweiss. Assistant Production Coordinator: Julie Inglese. Assistant Casting: Paige Scurti Sternin, Karen Meisels. Extras Casting: Jerry Conca. Sound Mixer: Benjamin A. Patrick. Boom Operator: Geoffrey Haley. Best Boy Electrician: David McLaughlin. Electricians: Jennifer Perkins, Jason Fitzgerald, David DeForest Keys, Mark Feijo. Day Players: George Aubey, Roman W. Bennett. Key Grip: Javier Perez. Best Boy Grip: Charles N.E. Richards. Dolly Grip: Doug Lively. Third Company Grip: Roger Morse. Grips: James Carlton, Marshall Stallings. First Assistant Editor: Elaine C. Andrianos. Second Assistant Editors: Dexter M. Adriano, Liam Baldwin, Arlene Beaty, Nicholas Edgar. Art Department Coordinator: Kaki Wall. Prop Master: Rebecca Carriaga. Assistant Props: Richard Redmond. Set Decorator: Shana Sigmond. Set Dressers: Mark Hutman, J.R. Vasquez. Painters: Karen Greene, Leza Ingalls. Construction Coordinator: Tristano Solari.

Scenic Artists: Catherine Burns, Patricia Riske, Rebeka L. Roberts. Prop Makers: Mark Annis, Davis A. Dragan, Craig E. Zumbroegel, Gregory R. Campbell. Carpenters: Drusiano Solari, Gilbert Tang. Costume Designer: Alison Hirsch. Costume Supervisor: Beverly Klein. Set Costumer: Annette Dunford. Make-Up Artist: Ashley Scott. Hair: Scott Williams. Special Effects Coordinator: Eric Rylander. Production Accountant: Michael Donner. Office Assistant: David Knott. Location Manager: Andre Gaudry. Location Consultant: Robert Dohan. Transportation Coordinator: Geno Hart. Transportation Captain: Glenn Knowlton. Transportation Operations: Ron Pope. Co-Captain: Sam McCutchen. Drivers: William R. Smallwood, Leo Stefanos, Evan M. Kavan, William McCabe, Jeffrey Lynn Moore, Tui Letuli, Robin Bishop, H. David Wilson, Michael Allegro, Red Beckman, Rick J. Fese, Jr. Darren Garrusso, Chris Sharff, Marco A. Rudolph, Salvador Navarro. Audio Post Production: Third Street Sound. Re-Recording Mixers: Paul Schremp, Darren Barnett. ADR/Foley Mixers: Darren Barnett, David Rodriguez. Sound Effects Editors: Mark Korba, Pattie Lorusso. Post Production Supervisor: Steven Kevin Ogden. Audio Post Prod. Supervisor: Jo Dee Housholder. Dialogue Supervisor: Harry Harris. ADR Editorial: Mikael Sandgren. Additional Music by: Lee Curreri and Jamie Muhoberac. Underscore Recorded at: Urban Beach Studio. "Sweet and Sexy". Composed by: Delfeayo Marsalis Performed by: Nat Turner. "Oye Morena". Composed by Don Peake, M.C. Boulevard. Performed by: M.C. Boulevard. Courtesy of: I.T.P. records. "Alvarado Street". Composed by Alexander "Ace" Baker, Eric Stromer, Clair Marlo. Performed by: Cat Daddy. Courtesy of: Invisible Hand. "Serene". Composed by: Nobukazu Takemura, Nadja, Maki Hiraga. Performed by: Nobukazu Takemura. Courtesy of: bellissima! Records/ Toy's Factory. "Pa-Nang Tofu". Composed and performed by: Lee Curreri. Courtesy of Nuance Records. "Deh vieni non tarder". Composed by: Mozart. Performed by: Norddeutsche Philharmonie. Conductor: Georg Richter. Soprano: Louise Lebrun. Courtesy of: Southern Library of Recorded Music. "Enamorado". Composed by: Clair Marlo, Alexander "Ace" Baker. Performed by: House of Light. Courtesy of: Blue Rain Records. "Mariachi and Soda". Composed and performed by: Don Peake. Publicists: Mark Pogachefsky, Michael Lawson. Still Photographer: Lisa Michele Jones. Asst. to Franklin Brauner: Leander Ward. Asst. to Christopher Walken: Lior Dimbort. Security Service: Craft Security. Location Security: Joe Bravo, Jolly Chin, Robert Encinias, Ruben Lopez, David Sanchez, Tony Ruacho. Caterer: Marios Catering. Craft Service:James Luther. Park Ranger: Douglas Real. Set Production Assistants: Phillipa Rick, Mathew Goodman, Charles H. Coffman. Colour Timer: Mike Mertins. Titles and Opticals: CFI: The Imaging Group. Negative Cutter: Vivian Hengsteler. Assistant for Elie Cohn: Susan Carney.

Donald Cammell's Wild Side
Wild Side - The Director's Cut © 2000 Tartan Films. In memory of Donald Cammell (1934-1996).

Directed by: Donald Cammell. Director's Cut Produced by: Hamish McAlpine and Nick Jones. Co-Producers: China Kong, Roger Trilling. Producer, Post Production Supervisor: Frank Mazzola. Post Production Coordinator, Associate Editor: Catherine Hader Mazzola. Avid Editor: John Ganem. Edited by: Frank Mazzola. Music Supervisor: Roger Trilling. Music Composed, Performed and Produced by: Ryuichi Sakamoto. Music Recorded and Mixed by: Ryuichi Sakamoto. MIDI System Technician: Yasushi Mouri (Office Intenzio). Production Management: Norika Sora, Kaz Iwahori. Ryuichi Sakamoto Management: Evan Balmer (Kab America Inc.), David Rubinson. Additional Music by: Jarvis Cocker, Steve Mackey, Mark Webber. Dialogue Director: China Kong. Assistant Editor: Karen McAlpine. Re-recording Mixers: Robert Litt, Wayne Heitman, Neil Brody. Dialogue Editors: Chris Reeves M.P.S.E., Gabrielle Reeves. Sound Design/Effects Editor: Peggy McAffee. Additional Effects Editor: Tom Smyth. Music Editor: Jeff Charbonneau. Foley Artist: Michael Salvetta. Foley Mixer: Debra Ruby. Recordists: Marsha Sorce, Rudy J. Lara. Colour Timer: Steve Sheridan. Opticals & Titles: Pacific Title. Negative Cutting: Bob Hart, Sally Dixon. Special Thanks to: Pacific Title. Pat Doyle. Mark Freund. Benita Hennessay. Jay Johnson. David Simmons. Larry Flynn. Brent Parris. Richard Primeau. Warner Hollywood Studios. Robert Winder, Brenda Hollingsworth, Nicolette Vajtay. Kodak: Jim Bettersen. F.P.C. A Kodak Company: Kenneth Knaus. Deluxe Laboratories. Raleigh Studios: Michael J. Donahue. Stephen Berkman. Susan Butler. Ian Friedman. Victor Ginzburg. John Gula. Candice Hanson. Kab Inc. Japan. Ted Kauffman. Jeannette Lee. Jimmy Maslon. Adam Novak. David Rubinson. Norika Sky-Sora. Geoff Travis. Masanobu Tuchiya. Taylor Uhler. Barbara Vitkowsky. Beverly Ware & David Cammell. Colour by deluxe®. Dolby® in selected theatres. Ryuichi Sakamoto's Music © 2000 Kab America Inc. and Kab Inc. Japan. Kab America Inc. is administered world wide by EMI Virgin Music Inc.

Cast: Christopher Walken (Bruno Buckingham), Joan Chen (Virginia Chow), Steven Bauer (Tony), Anne Heche (Alex Lee), Allen Garfield (Dan Rackman), Adam Novack (Lyle Litvak), Zion (Hiro Sakamoto), Richard Palmer (Cop Driver), Randy Crowder (Federal Agent), Marcus Aurelius (James Reed), Michael Rose (Agent Morse Jaeger), Lewis Arquette (The Chief), Rolando De La Maza (Steward), Candace Camille Bender (Lotus Ita), Ian Johnson (Philip Hamlyn), Gena Kim (Massage Girl), Robert Mazzola (Gilberto).

Premiere (Nu Image version): Cable television: Showtime (1995); HBO: 1996. Running time: 95m 17s.

Video: Nu Image first issued its cut of *Wild Side* on VHS: Evergreen Entertainment (#95153, Unrated, NTSC), and later on a laser disc issued 23 April 1996: Evergreen Entertainment/Image Entertainment (#ID3300HL, Unrated, NTSC). The Director's Cut, *Donald Cammell's Wild Side* or simply *Wild Side*, premiered at the Edinburgh International Film Festival, held 15-29 August 1999. It subsequently premiered in the US at the Chicago International Film Festival that year, held 6 October to 21 October. Length: 10,376 feet. Running time: 115m 18s. General UK theatrical release: 30 June 2000. Metro/Tartan issued the film on video 20 November 2000, on VHS (#TVT1337, PAL) and DVD (#TVD3311, PAL). The Director's Cut is thus ostensibly 20m 1s longer than the Nu Image cut, but 1m 40s of this length is comprised of credits for the Director's Cut, meaning the Director's Cut has been expanded by 18m 21s. A copy of the film on VHS, labeled "Director's Workprint" and given to us by David Del Valle (and given to him by Patty Kong), dated 8 April 1996, runs 115m 10s. [**95m 17s**, Nu Image] [**115m 18s**, Director's Cut]

Other Films:

As Editor:

GIMME SHELTER
December 1970
Directors: David Maysles, Albert Maysles, Charlotte Zwerin. Film Editors: Ellen Giffard, Robert Farren, Joanne Burke, Kent McKinney. Associate Producer: Porter Bibb.
Donald Cammell is thanked in the acknowledgments at the end of the film, although he claimed to have done some editing on the film.

Music Videos (as director):

PRIDE (IN THE NAME OF LOVE). By U2.
1984. Producer: James Morris. Cinematography: Daniel Pearl.

Video: *U2: The Unforgettable Fire Collection*. Island Visual Arts #440-082975-3 (VHS, NTSC). The video is also included on the DVD *U2: Love Is Blindness Video Collection* (Blue Sky Music/Island) (Brazil, NTSC). [**4m 9s**]

ALL YOU ZOMBIES. By The Hooters.
1985. Producer: Nicolas Myers. Cinematography: unknown. The video is available on the compilation *Rock Never Looked So Good* (Sony Music Video Enterprises Australia, 2003, #201628.9). PAL Region 4 DVD. The video is also currently available at apple.com's iTunes website. [**4m 43s**]

As Actor:

SIX CONTES MORAUX IV:
LA COLLECTIONNEUSE
1967. Les Films du Losange, Rome-Paris Films. Colour (Eastmancolor), 35mm.

Directed by: Eric Rohmer. Produced by: Georges de Beauregard, Barbet Schroeder. Associate Producer: Alfred de Graff. Technical Advisor: François Bogard. Credits: LAX. Written by: Eric Rohmer, with Patrick Bauchau (dialogue), Haydée Politoff (dialogue), Daniel Pommereulle (dialogue). Music written by: Blossom Toes and Giorgio Gomelsky, recorded by Blossom Toes. Voice of the Eternal. Tibet III, published by Bärenreiter. Director of Photography: Néstor Almendros. Edited by: Jacquie Raynal. Assistant Directors: Patrice de Bailliencourt, László Benkö, Anne Dubot.

Cast: Patrick Bauchau (Adrien), Haydée Politoff (Haydée), Daniel Pommereulle (Daniel), Alain Jouffroy (Writer), Mijanou [Mijanou Bardot] (Carole), Annik Morice (Carole's Friend), Denis Berry (Charlie), Seymour Hertzberg [Eugene Archer] (Sam), Alfred de Graff (Lost Tourist) [uncredited], Patrice de Bailliencourt (Haydée's friend in car) [uncredited], Pierre-Richard Bré (Haydée's friend in Car) [uncredited], Brian Belshaw (Haydée's lover), Donald Cammell (Man at café in Saint-Tropez) [uncredited].

Video: Issued on VHS (NTSC) by Fox Lorber in 1997 and by Fox Lober on DVD (#FLV5205, 82m 24s, NTSC) in 2000. The film was reissued in France by G.C.T.H.V on DVD (PAL Region 2) in 2003 in a much-improved transfer. Running time 82m 29s PAL, 85m 54s NTSC. **[85m 54s]**

LUCIFER RISING
Completed 1981. Filmed 1970 London and in Egypt and Germany June/July 1971. © 1981 Kenneth Anger. Filmed in Luxor, Karnak, Gizeh, Externsteine, London, Avebury. With financial assistance from The National Film Finance Corporation (Great Britain), Norddeutscher Rundfunk (West Germany) and The National Endowment for the Arts (U.S.A). Colour (Ektachrome).

Puck Film Productions. A Film by Kenneth Anger. Music by: Bobby Beausoleil. Performed by: The Freedom Orchestra (Tracy Prison). Written, produced and directed by: Kenneth Anger. Post-Production Assistant: Graham Whitlock. Suggested by the poem "Hymn to Lucifer" by Aleister Crowley. Photography: Kenneth Anger. Camera Operator: Michael Cooper. Special Photographic Effects: Noël Burch. Edited by: Kenneth Anger. Art Director: Kenneth Anger. Costumes: Laura Jameson, Jann Haworth. Music Liaison: Dr. Minerva J. Bertholf. Thelemic Consultant: Gerald J. Yorke.

Cast [uncredited]: Myriam S. Gibril (Isis), Donald Cammell (Osiris), Haydn Couts (The Adept), Kenneth Anger (The Magus), Sir Francis Rose (Chaos), Marianne Faithfull (Lilith), Leslie Huggins (Lucifer).

Video: Mystic Fire Video issued on VHS a 4-volume series of the films of Kenneth Anger around 1989–90. Donald, as Osiris, is depicted on the cover of the Mystic Fire Video VHS edition of *Lucifer Rising/Invocation of My Demon Brother* (#76043, NTSC) issued in 1990 (*Anger Magick Lantern Cycle 3*), and the same artwork was used for the British video release by Jettisoundz (#MJ004, PAL) in their 4-volume series (*Kenneth Anger Magick Lantern Cycle Vol. 4*), Bobby Beausoleil's score for *Lucifer Rising* was issued on CD by Arcanum as a two-disc set in 2004 and by Arcadia as a single CD in 2005. **[28m 4s]**

Donald Cammell also appears in:

HOME MOVIE: ON THE SET OF PHILIPPE
GARREL'S LE LIT DE LA VIERGE
Directed by Pierre-Richard Bré. Morocco, 1968. 150m. French with English subtitles.

NOTHING AS IT SEEMS:
THE FILMS OF NICOLAS ROEG
Produced and directed by Paul Joyce. 1983. 57m. Donald appears early in the documentary discussing *Performance*.

THE ROLLING STONES STORY
Interestingly, this tape includes a 5m 2s made-for-TV promotional short about the making of *Performance*, presumably broadcast late in 1970 or early 1971. While it begins with a discussion of Mick Jagger's use of the Moog synthesizer (then only freshly introduced to rock musicians), the short also includes footage of Donald directing Mick Jagger (in Harry Flowers guise) during the "Memo from T" sequence. The short concludes with the 2m 26s theatrical trailer - the only version of the trailer we have seen of this length. The tape was issued by Simitar Entertainment (UK) in 1991 (#SUK34372, PAL, 55m) and re-issued in 1993 by Screen Entertainment (#SE9209-NL, PAL, 57m) with additional Rolling Stones material included. The tape was reissued yet again in 1996 by Simitar/Tring International (#TVB027, PAL, 57m). Incidentally, the full story of the particular synthesizer used in *Performance*, a Moog Series III modular synthesizer, can be found in Trevor Pinch and Frank Trocco, *Analog Days: The Invention and Impact of the Moog Synthesizer* (Harvard University Press, 2002). *Performance* is the only film, according to the authors, in which "the Moog synthesizer itself makes a cameo appearance." (A synthesizer, "TONTO," also had a cameo in Brian De Palma's *Phantom of the*

Paradise (1974) but its sounds were not actually used in the film.) Apparently it was "the Man from Moog," Jon Weiss, who along with Mick Jagger proposed using the synthesizer as a prop. Jon Weiss set up a patch for Mick Jagger on the *Performance* set; it was this patch that Jagger later used for the soundtrack to Kenneth Anger's *Invocation of My Demon Brother* (1969). The particular Moog synthesizer that appeared in *Performance* was later "sold on to the Hansa by the Wall recording studio in Berlin, where in 1973 Christoph Franke of Tangerine Dream purchased it for $15,000." As Pinch and Trocco astutely note, in the 1960s the synthesizer wasn't just another instrument, but part of "the sixties apparatus [associated with] transgression, transcendence, and transformation."

HOLLYWOOD UK
A BBC2 series about the British cinema of the 1960s. Hosted by Richard Lester. 1993. Donald appears in the segment on *Performance*. Some of the footage shot for this interview (1992) was later used in *Donald Cammell: The Ultimate Performance*.

EMPIRE OF THE CENSORS
Written and directed by Saskia Baron. 1995. 2 episodes. 120m. *Empire of the Censors* is a history of film and video censorship in Great Britain. Donald appears in the first episode discussing *Performance*. Some of the footage shot for this interview (March or April 1995, during the editing of *Wild Side*, and hence roughly a year before his death) was later used in *Donald Cammell: The Ultimate Performance*.

DONALD CAMMELL:
THE ULTIMATE PERFORMANCE
1998. 73m. A Figment Film in association with Illuminations for the BBC & Scottish Screen in association with the Scottish Arts Council National Lottery Fund. © BBC/Total Film Performance Ltd.

Produced and Directed by Kevin Macdonald & Chris Rodley. Co-Producer: David Cammell. Stills Courtesy of: China Cammell, Bob Whitaker, Myriam Gibril, Linda McCartney, Nicky Samuel. Francis Bacon paintings courtesy of the Francis Bacon Estate. Archive: BBC. *Rehearsal for Performance* courtesy of Sandy Lieberson. *Performance* courtesy of Warner Bros. *Demon Seed* courtesy of Turner Entertainment Co. *White of the Eye* courtesy of Metro-Goldwyn-Mayer, Inc. *Duffy* courtesy of Columbia Pictures. *Lucifer Rising* courtesy of Kenneth Anger. *Gimme Shelter* courtesy of Maysles Films, Inc. *Get Off My Cloud, Memo from Turner, (I Can't Get No) Satisfaction* written by Mick Jagger and Keith Richards, performed by the Rolling Stones. World Wide Copyright owner: Abkco Music, Inc. By Arrangement with Abkco Music and Records, Inc. Version of *Memo from Turner* by Patti Palladin. Rostrum

Camera: Ken Morse. On-Line Editor: Michael Pearce. Dubbing Mixer: Steve Rogers. Los Angeles Co-ordinator: Alicia Alexander. Archive Consultant: Paula Jalfon. Sound: Greg Bailey, Mike Lenoue. Music: David Sinclair. Camera: David Scott, Adam Suschitsky, Ira Brenner, Rob Bennett. Production Manager: Lil Cranfield. Assistant Producer: Alice Henty. Editor: Budge Tremlett.

Interviewees: Kenneth Anger, Patrick Bauchau, China Cammell, David Cammell, James Fox, Myriam Gibril, Drew Hammond, Mick Jagger, Elliott Kastner, Sandy Lieberson, Frank Mazzola, Stanley Meadows, Cathy Moriarty, Anita Pallenberg, Nic Roeg, Johnny Shannon, Barbara Steele.

Premiere (London): Institute of Contemporary Arts, May 1998. BBC television: 17 May 1998. North America: Toronto International Film Festival, 16 September 1998. Chicago International Film Festival, October 1998 (co-winner of "Silver Hugo" in documentary competition). Cable television: The Independent Film Channel, 13 August 1999. An important documentary about Donald's life and films, but it mentions neither Donald's first marriage (a photo of Donald with Maria Andipa is shown, but without context or explanation) nor his son Amadis. It also, unfortunately, includes the heavily mythologized version of the circumstances of Donald's suicide that we have tried to redress in this book.

Donald Cammell:
The Ultimate Performance
Sex, Death, Magic & Movies

Featuring: Kenneth Anger, James Fox, Mick Jagger, Cathy Moriaty, Anita Pallenberg, Nic Roeg & Barbara Steele

Other Works by Donald Cammell

A.) A[lice] M[ary] Hadfield, Ed., *King Arthur and the Round Table*. London: J.M. Dent. New York: E.P. Dutton, 1953.

- Eight illustrations in full colour and fourteen line drawings. As Donald Seton Cammell.

B.) Cover illustrations, drawings and article for *Lilliput*, a British men's magazine.

- Vol. 44:1 (#259), January 1959.
Drawing for "The Beat Generation" by Kenneth Allsop.
- Vol. 44:2 (#260), February 1959.
Cover illustration.
- Vol. 44:3 (#263), March 1959.
Five drawings for "An Old Master" by David Garnett.
- Vol. 44:5 (#263), May 1959.
Cover illustration.
- Vol. 44:6 (#264), June 1959.
Cover illustration, four drawings for "Natural Child" by Tom Sterling.
- Vol. 45:1 (#265), July 1959.
Cover illustration.
- Vol. 45:2-3 (#266/267), August/September 1959.
Cover illustration, two drawings for "The Quickest Way Out of Manchester" by John Wain.
- Vol. 45:4 (#268), October 1959.
Drawing of Lucky Luciano for "The Boys Who Made Bad" by Claire Sterling.
- Vol. 45:6 (#270), December 1959.
Drawing for "Laugh Clown Laugh" by Charles Hamblett.
- Vol. 46:1 (#271), January 1960.
Cover illustration, seven drawings for "A Portfolio of circus drawings" by Donald Cammell.

C.) Exhibitions.

- Gallery One, London. April-May 1959.
- Bertha Schaeffer Gallery, New York. 1 May to 20 May 1961.

D.) Novel.

- *Fan-Tan*. With Marlon Brando.
London: William Heinemann, 2005; New York: Alfred A. Knopf, 2005. Afterword by David Thomson. 250pp.

E.) Works based on a screenplay by Donald Cammell:

- *Performance.* A Novel. By William Hughes. New York: Award Books, 1970; London: Tandem Books, 1970. 156pp. Paperback. Tandem Books cover illustration is different than that of the Award Books Edition.
- *Tilt*. A Novel. By James Creech III. New York: Dell, 1978. 179pp.

F.) Fictional works with references to Donald Cammell:

- *Back from the Dead*. A Novel. By Chris Petit. London: Macmillan, 1999. A featured character is an amalgam of Kenneth Anger and Donald Cammell.
- *Set in Darkness*. A Novel. By Ian Rankin. New York: St. Martin's Press, 2000. Reference to the Outlook Tower, Donald Cammell, and *Performance*.

Unproduced Scripts

Beginning around 1963, Cammell began writing screenplays, often in collaboration with others. We have made every attempt to make the following list of scripts as complete as possible. A script we actually read we have marked with an "*". If we have not read it or seen it, but have been assured by others it actually exists, we indicate our source afterwards. If the script was mentioned in biographical studio publicity (SP) materials prepared in conjunction with the release of a picture we have indicated that as well. In some cases the date of composition is estimated, although we are quite sure of the order of composition.

1. *Just a Jackknife Has Macheath Dear* (ca. 1963)
(SP, Roman Polanski, David Cammell)
2. *The Greenhouse* (ca. 1964)
(SP, Stash)
3. *Ishtar* (rev. *The Last Video*)* (Begun ca. 1969; many revisions next two decades)
4. *The Beard* (1972)*
Based on the play (1965) by Michael McClure.
5. *Simona* (1973)*
English language script and re-edit, with additional scenes, for film directed by Patrick Longchamps (filmed 1972. Longchamps's version released in Italy February 1974 and immediately banned - *not* Donald Cammell's cut.
6. *Pale Fire* (Treatment, dated March 1974)*
Based on the novel (1962) by Vladimir Nabokov.
7. *The Lady Hamilton* (1974/75)
(rev. as *Faro*) (Andrew Braunsberg, David Cammell)
8. *Jack the Ripper* (1977)
With Kenneth Tynan. (*The Diaries of Kenneth Tynan*)
Note: Donald's first known screenplay, *Just a Jackknife Has Macheath Dear*, was apparently about Jack the Ripper. He would eventually realize the theme in *White of the Eye*.
9. *Hot!* (1978)*
With Grendel Fletcher and Gwendolyn Fletcher (pseudonyms of Zalman King and Patricia Louisianne Knop). From a script originally titled *Tow Truck Boogie* by King and Knop.
10. *Fan-Tan* (Treatment, dated May 1979)*
With Marlon Brando.
11. *El Paso* (Treatment, 1980)*
Based on a story by Vartkes Cholakian titled *Breakfast Included*.
12. *The Last Video* (1984/85; rev. of *Ishtar*)
With China Kong Cammell.
(China Kong Cammell, David Cammell)
13. *Machine Gun Kelly* (1987)
With China Kong Cammell.
(Brad Wyman)

14. *Jericho* (1988)
With Marlon Brando.
15. *Centrifuge* (1989)
With J.C. Pollock. Based on the novel (1984) by J.C. Pollock. (SP)
16. *Alamogordo* (1991)
Revision of original screenplay by Ken Finkleman.
(Ken Finkleman)
17. *King of Heroin* (ca. 1991)
With China Kong Cammell.
(David Cammell; Chris Rodley-Kevin Macdonald documentary)
18. *Civil Unrest* (ca. 1992)
With China Kong Cammell.
(David Cammell; Chris Rodley-Kevin Macdonald documentary)
19. *Born Thief* (ca. 1993)
With China Kong Cammell.
(Maggie Abbott)
20. *The Cull* (1993/94)*
With China Kong Cammell.
21. *33* (1995/96)
With China Kong Cammell and Drew Hammond.
(Drew Hammond, China Kong Cammell, David Cammell)

Selected Bibliography

BOOKS

Aftel, Mandy. *Death of a Rolling Stone: The Brian Jones Story* - Sidgwick & Jackson, UK 1982

Andersen, Christopher. *Jagger Unauthorized* - Delacorte Press, USA 1993

Bataille, Georges. *Story of the Eye [Histoire de l'oeil]*, City Lights Books, USA 1987

Bly, Nellie. *Marlon Brando: Larger Than Life* - Pinnacle Books, USA 1994

Bolton, Frank G., Larry A. Morris, and Ann E. MacEachron, *Males At Risk: The Other Side of Child Sexual Abuse* - Sage Publications, USA 1989

Borges, Jorge Luis. *A Personal Anthology* - Grove Press, USA 1968

Brando, Marlon and Donald Cammell. *Fan-Tan* - Alfred A. Knopf, USA 2005

Brando, Marlon and Donald Cammell. *Fan-Tan* - William Heinemann, UK 2005

Briere, John N. *Child Abuse Trauma: Theory and Treatment of the Lasting Effects* - Sage Publications, USA 1992

Brown, Mick. *Performance* - Bloomsbury, USA 1999

Cammell, Charles Richard. *The Poems of Charles Richard Cammell, 1911-1929* - Grant Richards, UK 1930

Cammell, Charles Richard. *Aleister Crowley: The Man: The Mage: The Poet* - The Richards Press, UK 1951

Cammell, Charles Richard. *Castles in the Air: A Memoir* - The Richards Press, UK 1952

Cammell, Charles Richard. *Heart of Scotland: A Memoir* - Robert Hale, UK 1956

Cammell, Charles Richard. *Memoirs of Annigoni* - Allan Wingate, UK 1956

Cammell, Donald. *Performance*. Ed. Colin MacCabe. Faber and Faber - UK 2001.

Camus, Albert. *The Myth of Sisyphus* - Vintage Books, USA 1955

Cettl, Robert. *Serial Killer Cinema: An Analytical Filmography with an Introduction* - McFarland & Company, USA 2003

Ciment, Michel. *John Boorman* - Faber and Faber, UK 1986

Cocteau, Jean. *The Art of Cinema* - Marion Boyars, UK 1994

Cozarinsky, Edgardo. *Borges On/and/In Film* - Lumen Books, USA 1988

Cowie, Peter. *Revolution! The Explosion of World Cinema in the Sixties* - Faber and Faber, USA 2004

Creech III, James. *Tilt* - Dell, USA 1978

Dalton, David. *The Rolling Stones: The First Twenty Years* - Alfred A. Knopf, USA 1981

DeSalvo, Louise A. *Virginia Woolf: The Impact of Child Sexual Abuse on Her Life and Work* - Beacon Press, USA 1999

Donnelly, Kevin J, Ed. *Film Music: Critical Approaches* - Edinburgh University Press, UK 2001

Dundy, Elaine. *Elvis and Gladys* - University Press of Mississippi, USA 2004

Elliot, Martin. *The Rolling Stones: Complete Recording Sessions 1963 - 1989* - Blandford, UK 1990

Ellis, John. *Visible Fictions: Cinema, Television, Video* - Routledge & Kegan Paul, UK 1982

Evans, Arthur B. *Jean Cocteau and His Films of Orphic Identity* - Art Alliance Press, USA 1977

Everstine, Diana Sullivan and Louis Everstine. *Sexual Trauma in Children and Adolescents: Dynamics and Treatment* - Brunner/Mazel, USA 1989

Faithfull, Marianne. *Faithfull* - Michael Joseph, UK 1994

Faller, Kathleen Coulborn. *Understanding Child Sexual Maltreatment* - Sage Publications, USA 1990.

Feineman, Neil. *Nicolas Roeg* - Twayne, USA 1979

Fox, James. *Comeback: An Actor's Direction* - Hodder and Stoughton, UK 1983

Geiser, Robert C. *Hidden Victims: The Sexual Abuse of Children* - Beacon Press, USA 1979

Gotlib, Ian H. and Constance L. Hammen. *Psychological Aspects of Depression: Toward a Cognitive-Interpersonal Interpretation* - J. Wiley, USA 1992

Grobel, Lawrence. *Conversations With Brando* - Hyperion, USA 1991

Hadfield, Alice M. *King Arthur and The Round Table* - J. M. Dent, UK 1953

Hardwick, Mollie. *Emma, Lady Hamilton* - Holt, Rinehart and Winston, USA 1969

Haynes, Jim. *Thanks for Coming!* - Faber & Faber, UK 1984

Hughes, William. *Performance* - Award Books, USA 1970/Tandem Books, UK 1970

Hunter, Mic. *The Sexually Abused Male: Prevalence, Impact, and Treatment, Vol. 1* - Lexington Books, USA 1990

Izod, John. *The Films of Nicolas Roeg: Myth and Mind* - St. Martin's Press, USA 1992

Jackson, Laura. *Golden Stone: The Untold Life and Tragic Death of Brian Jones*, St Martin's Press, USA 1993

Jackson, Laura. *Heart of Stone: The Unauthorized Life of Mick Jagger* - Smith Gryphon, UK 1997

Jamison, Kay Redfield. *Touched With Fire: Manic-Depressive Illness and the Artistic Temperament* - Free Press, USA 1994

Jamison, Kay Redfield. *Night Falls Fast: Understanding Suicide* - Alfred A. Knopf, USA 1999

Kermode, Frank, ed. *Selected Prose of T.S. Eliot* - Harcourt Brace Jovanovich, USA 1975

Kinder, Marsh, and Beverle Houston. "The Ultimate Performance." *Close-Up: A Critical Perspective on Film* - Harcourt Brace Jovanovich, USA 1972

Koontz, Dean. *Demon Seed* - Bantam, USA 1973

Kotker, Joan G. *Dean Koontz: A Critical Companion* - Greenwood Press, USA 1996

Lanza, Joseph. *Fragile Geometry: The Films, Philosophy and Misadventures of Nicolas Roeg*- Performing Arts Journal Publications, USA 1989

Levy, William, Ed. *Wet Dreams: Films and Adventures* - Joy Publications, Holland 1973

MacCabe, Colin. *Performance* - BFI Film Classics, UK 1998

Macdonald, Kevin and Mark Cousins, Eds. *Imagining Reality: The Faber Book of Documentary* - Faber and Faber, UK 1998

Manso, Peter. *Brando: The Biography* - Hyperion, USA 1994

Marcus, Stephen. *The Other Victorians: A Study of Sexuality and Pornography in Mid-Nineteenth-Century England* - Basic Books, USA 1966

Mash, Eric J. and David A. Wolfe, *Abnormal Child Psychology*, 2nd Ed. - Wadsworth, USA 2001

McClure, Michael. *The Beard* - Grove Press, USA 1967

Middlebrook, Diane. *Anne Sexton: A Biography* – Vintage, USA 1992

Miller, Alice. *The Untouched Key: Tracing Childhood Trauma in Creativity and Destructiveness* - Anchor Books, USA 1991

Miller, Alice. *Banished Knowledge: Facing Childhood Injuries* - Anchor Books, USA 1991

Miller, Alice. *Thou Shalt Not Be Aware: Society's Betrayal of the Child* - Farrar, Straus & Giroux, USA 1998

Milne, Tom, Ed. *Godard on Godard* - Da Capo Press, USA 1986

Munster, Bill, ed. *Sudden Fear: The Horror & Dark Suspense Fiction of Dean R. Koontz* - The Borgo Press, USA 1989

Murphy, Robert. *Sixties British Cinema* - BFI, UK 1992

Nabokov, Vladimir. *Pale Fire* - Vintage Books, USA 1989

Naremore, James. *Acting in the Cinema* - University of California Press, USA 1988

Neville, Richard. *Hippie Hippie Shake: The Dreams, The Trips, The Trials, The Love-Ins, The Screw Ups. . .The Sixties* - Bloomsbury, UK 1995

Norman, Philip. *The Stones*. Penguin Books, USA 1984

Norse, Harold. *Memoirs of a Bastard Angel* - William Morrow, USA 1989

Park, James. *Learning to Dream: The New British Cinema* - Faber and Faber, UK 1984

Paris, Joel, Ed. *Borderline Personality Disorder: Etiology and Treatment* - American Psychiatric Press, USA 1993

Pearson, John. *The Cult of Violence: The Untold Story of the Krays* - Orion Books, UK 2001

Pettit, Chris. *Back From the Dead* - Macmillan, UK 1999

Philips, Baxter. *Cut: The Unseen Cinema* - Bounty Books, USA 1975

Pinch, Trevor and Frank Trocco. *Analog Days: The Invention and Impact of the Moog Synthesizer* - Harvard University Press, USA 2002

Pollock, J.C. *Centrifuge* - Random House, USA 1984

Rankin, Ian. *Set in Darkness* - St. Martin's Press, USA 2000

Rakoff, Ian. *Inside the Prisoner: Radical Television and Film in the 1960s* - B.T. Batsford, UK 1998

Said, Edward. *Orientalism* - Vintage Books, USA 1979

Salwolke, Scott. *Nicolas Roeg Film By Film* - McFarland & Company, USA 1993

Sanchez, Tony. *Up and Down with The Rolling Stones* - Da Capo Press, USA 1996

Sewell, Brocard. *Footnote to the Nineties: A Memoir of John Gray and André Raffalovich* - Cecil and Amelia Woolf, UK 1968

Shadoian, Jack. *Dreams and Dead Ends: The American Gangster/Crime Film* - MIT Press, USA 1977

Shafto, Sally. *The Zanzibar Films and the Dandies of May 1968* - A Zanzibar USA Publication, USA 2000

Sinclair, Iain. *Lights Out for the Territory* - Granta, UK 1997

Singer, Jerome L., Ed. *Repression and Dissociation: Implications for Personality Theory, Psychopathology, and Health* - University of Chicago Press, USA 1990

Sinyard, Neil. *The Films of Nicolas Roeg* - Charles Letts & Co, UK 1991

Snepp, Frank. *Decent Interval: An Insider's Account of Saigon's Indecent End Told by the CIA's Chief Strategy Analyst in Vietnam* - Random House, USA 1977

Solomon, Andrew. *The Noonday Demon: An Atlas of Depression* - Simon & Schuster, USA 2001

Symonds, John. *The Beast 666* - The Pindar Press, UK 1997

Terr, Lenore. *Too Scared To Cry: Psychic Trauma in Childhood* - Harper & Row, USA 1990

Thys, Marianne, Ed. *Belgian Cinema* - Ludion, Flammarion, France 1999

Tracy, Margaret. *Mrs. White* - Dell, USA 1983

Turnbull, Michael T.R.B. *Abbey Boys: Fort Augustus Abbey Schools* - corbie.com, UK 2000

Walker, Alexander. *Hollywood UK: The British Film Industry in the Sixties* - Stein and Day, USA 1974

Warren, Kenneth. *Steel, Ships and Men: Cammell Laird, 1824-1993* - Liverpool University Press, UK 1993

Weber, Nicholas Fox. *Balthus: A Biography* - Alfred A. Knopf, USA 1999

Witts, Richard. *Nico: The Life and Lies of an Icon* - Virgin Books, UK 1993

Wright, Basil. *The Long View* - Alfred A. Knopf, USA 1974

Wyman, Bill with Ray Coleman. *Stone Alone: The Story of a Rock'n'Roll Band* - Viking, USA 1990

ARTICLES

Adler, Robert. "Crowded Minds," *New Scientist* (18 December 1999): 26-31.

Andrews, Nigel. "Psychedelic View of a Schizophrenic Killer," *Financial Times* (19 June 1987), 'The Arts," 19.

Barber, C. "Performance," *Eyeball: Sex and Horror in World Cinema 4* (1996), reprinted in *Eyeball Compendium* - FAB Press, UK 2003

Bataille, Georges. "The Big Toe." In Allan Stoekl, ed., *Visions of Excess: Selected Writings, 1927-1939* - University of Minnesota Press, USA 1985

Beard, Paul and Lee Hill. "The Man That Time Forgot," *Neon* (August 1997): 74-78.

"Borderline Personality Disorder." In *Diagnostic and Statistical Manual of Mental Disorders*, 4th Ed., Text Revision - American Psychiatric Press, 2002.

Bradley, Matthew R. "Cry U.N.C.L.E.! An Interview with Robert Vaughn: Part Two," *Outré: The World of Ultramedia* 18 (1999): 28-33; 82.

Bradshaw, Peter. "The year of the rat," *The Guardian* (21 August 1999).

Brant, Renee S. T. and Veronica B. Tisza, "The Sexually Misused Child," *The American Journal of Orthopsychiatry* 47:1 (1977): 80-87.

Brown, Mick. "Lights, Camera, Decadence," *Telegraph Magazine* (3 June 1995): 24-30.

Brown, Mick. "The Final Cut," *Telegraph Magazine* (May 1998): 32-35; 37, 39; 60-62

Byrge, Duane. "Film Review: 'White of the Eye,'" *The Hollywood Reporter* (3 June 1988): 5.

Cadwallader, G. "Inside *Performance*," *Sight and Sound* 40:2 (Spring 1971): 78-79.

Callenbach, Ernest. "Phenomena and Samadhi," *Film Quarterly* (Spring 1968): 48-49.

Campion, Chris. "The Uncensored Don," *Dazed & Confused* 62 (February 2000): 70-74.

Carver, Benedict. "Cammell Pic Reborn," *Daily Variety* (Thursday, 11 June 1998): 1.

Chang, Chris. "Cinema Sex Magick: The Films of Donald Cammell," *Film Comment* 32:4 (July-August 1996): 14-19; 83.

Christ, Ronald. "Forking Narratives," in *Simply a Man of Letters: Panel Discussions and Papers from the proceedings of a Symposium on Jorge Luis Borges held at the University of Maine at Orono*. University of Main at Orono Press, 1982: 75-88.

Cocks, Jay. "Mick's Duet," *Time* (24 August 1970): 61.

Cocks, Jay. "Sing A Song of Seeing," *Time* (25 December 1983).

Dawson, Jan. "Performance," *British Film Institute Monthly Film Bulletin* (February 1971): 27-28.

Del Valle, David. Interview. "Memo From Cammell," *Video Watchdog* 35 (1996): 28-34.

Ducane, John. "Donald Cammell: *Performance* to *Ishtar*," *Cinema Rising* 1 (April 1972): 15.

Ehrenstein, David. "Movie Review: Thrill-seekers, look into 'White of the Eye,'" *Los Angeles Herald-Examiner* (3 June 1988): 11.

"Exhibition at B. Schaefer Gallery." *Art News* 60 (May 1961): 20.

"Exhibition at Schaefer Gallery." *Arts* 35 (May 1961): 96.

Farber, Stephen. "*Performance*: The Nightmare Journey," *Cinema* (Fall 1970): 20-24.

Finkelhor, David and Alberta Browne, "The Traumatic Impact of Childhood Sexual Abuse: A Conceptualization," *The American Journal of Orthopsychiatry* 55:4 (1985): 530-41.

French, Philip. "*Performance*," *Sight and Sound* 40:2 (Spring 1971): 67-69.

French, Philip. "Revengers' Tragedies." *Observer* (21 June 1987).

"Going out to the Movies: Brando to the Rescue," *The Independent* (26 June 1987).

Gomez, Joseph A. "*Performance* and Jorge Luis Borges," *Literature/ Film Quarterly* (Spring 1977): 147-53.

Goodwin, Michael. "Performance," *Rolling Stone* 65 (3 September 1970): 50.

Gow, G. "Performance," *Films & Filming* 17:7 (April 1971): 48-49.

Green, A.H. "True and False Allegations of Sexual Abuse in Child Custody Disputes," *Journal of the American Academy of Child Psychiatry* 25 (1986): 449-56.

Greenspun, Roger. "Jagger and Fox Shape Tone of the Action," *New York Times* (August 4,1970): 21.

Grimes, William. "Obituaries: Donald Cammell," *New York Times* (5 May 1996).

Gross, Larry. "Film Après Noir," *Film Comment* (July 1976): 44-49.

Gysin, Brion. "The Process." In Mike Jay, Ed., *Artificial Paradises: A Drugs Reader* - Penguin Books, UK 1999: 369-371.

Hirsch, Foster. "Underground Chic: *Performance*," *Film Heritage* 6:3 (Spring 1971): 1-6; 36.

Holden, Michael. "Cast into Darkness," *The Guardian/ The Guide* (May 1-7, 2004): 8-10.

Jackson, Kevin. "A Final Memo From Turner," *The Guardian* (9 May 1996): 2; 12.

Johnston, Sheila. "Movie Review: Bloodshot but Brilliant," *The Independent* (18 June 1987).

Johnston, Trevor. "A Talk on the 'Wildside,'" *The Scotsman*, (20 August 1999).

Johnston, Trevor. "The Wild Wild Test: Restoring Donald Cammell's *Wild Side*," *Time Out* (June 28 - July 5 2000).

Kermode, Mark. "Wild Side" (review), *Sight and Sound* 10:8 (NS) (August 2000): 9

Klady, Leonard. "Movie Review: *White of the Eye* Peers Inside Horror's Disturbing Territories," *Los Angeles Times* (3 June 1988) part 6, p.6.

Klady, Leonard. "Obituaries: Donald Cammell," *Variety* (2 May 1996).

Knight, Arthur. "A Matter of Taste," *Saturday Review* (22 August 1970): 61.

Kroll, Jack. "A Last Word on *Performance*," *Art in America* (March 1971): 114-15.

Libin, R. Joseph. "Don Cammell: Performance Pluperfect," *Interview* 23 (July 1972): 10-12.

Lippincott/Williams & Wilkins. "Practice parameters for the assessment and treatment of children and adolescents with bipolar disorder," *Journal of the American Academy of Child and Adolescent Psychiatry* 36:1 (January 1997): 138-157.

"London Exhibition." *Burlington Magazine*101 (May 1959): 199.

Lovell, Glenn. "Film Review: *Donald Cammell: The Ultimate Performance*," *Variety* (2-8 November 1998): 54.

"Lure of the Flesh," *London Daily News* (18 June 1987): 25.

McDonald, Toby. "Final Walk on the Wild Side," *Sunday Express* (June 4, 2000): 19.

Macdonald, Kevin. "The Week in Reviews: Documentary: Donald Cammell: When He Shot Himself, Did He Set the Scene For His Finest Show?" *The Observer* (3 May 1998): 9.

Macnab, Geoffrey. "Film: What a Great Performance," *The Independent* (1 May 1998): 4.

Macnab, Geoffrey. "Hooker's Magic," *Sight and Sound* 9:8 (NS) (August 1999): 26-28.

Malcolm, Derek. "Movie Review: White of the Eye," *The Guardian* (18 June 1987).

Maslin, Janet. "Reviews/Film; Images of Veigny Eyeballs and Desperate Goldfish," *The New York Times* (20 May 1988).

Matthews, Tom Dewe. "Screen: Shoot to Kill," *The Guardian* (1 May 1998): 4.

Miller, Gavin. "Writes in Praise of *Performance*," *The Listener* (14 January 1971): 62-63.

Milne, Tom. "Making It All The Way," *Observer Review* (10 January 1971): 23.

Mottram, James. "Living on the Wildside of Life," *Scotland on Sunday* (2 July 2000): 8-9.

Moullet, Luc, "Jean-Luc Godard." In *Breathless*, Ed. Dudley Andrews, Rutgers University Press, 1987: 209-211.

Murf, "*Performance*," *Variety* (5 August 1970): 20.

Murray, Wes. "The Making of *Tilt*," *Loose Change* 2:2 (February 1979): 8-12; 18, 22.

Nichols, Bill, "Redemption & *Performance*," *Take One* 4:1 (January 1974): 12-18.

"Obituary: Donald Cammell," *The Daily Telegraph* (30 April 1996).

"Obituary: Donald Cammell," *The Times* (1 May 1996).

Pendreigh, Brian. "Out on a High," *Caledonia* (June 2000): 54-55.

Pirie, David. "Cammell's Eye," *Time Out* (14 October 1977): 10.

Playdon, Peter. "The Black Presence in *Performance*: A Reading From the Margins," *Communication, Culture & Media Research* monograph no. 2 (2000).

Powers, John. "Sympathy for the Devil," *L.A. Weekly* (3 June 1968): 39-40.

Pye, Michael. "Movie Review: White of the Eye," *London Daily News* (18 June 1987) TV p.25.

Rodley, Chris. "Marlon, Madness, and Me," *20/20* (April 1989): 38-51.

Rodley, Chris. Obituary of Donald Seton Cammell, *Sight and Sound* 7:3 (NS) (March 1997): 37.

Rosenblatt, Nina, "Performance." In Jonathan Crary and Sanford Kwinter, Eds., *Zone 6: Incorporations*. Zone Books, USA 1992

Savage, Jon. "Turning Into Wonders." *Sight & Sound* (September 1995): 24-25.

Rigby, Jonathan. "Demon Seeds: The Haunted Screen of Donald Cammell," *Starburst* 265 (September 2000): 60-63.

Rodley, Chris. "Marlon, Madness and Me," *20/20* No. 1 (April 1989): 38-51.

Sarris, Andrew. "Film in Focus," *Village Voice* (30 July 1970): 43.

Savage, Jon. "Tuning Into Wonders: Interview with Christopher Gibbs," *Sight and Sound* 5:9 (September 1995): 24-25.

Savage, Jon. "Hassan Told Me To Do It: Jon Savage Interviews Donald Cammell [August 1984]," *Vague* 23 (1990/91): 52-55.

Savage, Jon. "*Performance*: Interview with Donald Cammell," *British Crime Cinema*, Eds. Steve Chibnall and Robert Murphy. Routledge USA 1999: 110-116.

Schjeldahl, Peter, "Performance," *New York Times*, 16 August 1970, II, p.1, column 5.

Schneider, Steven Jay. "Killing in Style: The Aestheti-cization of Violence in Donald Cammell's *White of the Eye*." *Scope: An Online Journal of Film Studies* (June 2001). http://www.nottingham.ac.uk/film/scopearchive/articles/killing-in-style.htm

Schickel, Richard. *Performance* (review), *Time* (August 1970): 61.

Simon, John. "The Most Loathsome Film of All?" (*Performance* review), *New York Times* (23 August 1970): II: 1.

Stratton, D. "*Performance*: A Review," and "Dreams of Marrakesh: Extracts From the Original Screenplay of *Performance*," *Cinema Papers*: 66-69 (1974).

Time Out, *Performance* issue, 1970.

Sturhahn, Larry. "Experimental Filmmaking: The Art of Jordan Belson—An Interview with Jordan Belson," *Filmmakers' Newsletter*, Vol. 8, no. 7 (May 1975): 22-26.

Thomas, Kevin. "Imagine Jagger as the Kid!" *Los Angeles Times* (2 September 1972).

Travers, Peter. "Movie Review: 'White of the Eye,'" *People Weekly* (2 May 1988) v29 n17 p.18 (1).

Valentine, Gary. "Season of the Witch," *Mojo* (September 1999): 78-89.

Walker, Beverly. "Patrick Bauchau," *Film Comment* 34:4 (July-August 1998): 38-43.

Walker, John. "The Touchables," *Films & Filming* (January 1970): 44-45.

Whittet, G.S. "London Commentary," *Studio* 158 (July 1959): 28.

Wollen, Peter. "Together," *Sight and Sound* 6:7 (NS) (July 1996): 30-34.

Wollen, Peter. "Possession," *Sight and Sound* 5:9 (NS) (September 1995): 20-23.

Wood, Rebekah. "The Acid House," *Neon* (March 1998) http://www.phinnweb.org/roeg/films/performance/articles/neon.html

Zimmerman, Paul D. "Under the Rock," *Newsweek* (17 August 1970): Section 1, 1.

Zoja, Luigi. "Drugs, Addiction & Initiation: The Modern Search for Ritual." In Mike Jay, Ed., *Artificial Paradises: A Drugs Reader* - Penguin Books, UK 1999: 366-368.

Notes

Chapter 1: **The Heart of Midlothian**

1. Mrs. Deborah Roberts, telephone interview with authors, 6 February 1999.

2. Mrs. Deborah Roberts, telephone interview with authors, 6 February 1999.

3. Charles Richard Cammell, *Castles in the Air: A Memoir*, p.11.

4. Cammell, *Castles in the Air*, p.13.

5. For a comprehensive business history of Cammell-Laird, see Kenneth Warren, *Steel, Ships, and Men.*

6. Cammell, *Castles in the Air*, p.15.

7. Cammell, *Castles in the Air*, p.19.

8. *Castles in the Air*, p.41.

9. *Castles in the Air*, p.61.

10. *Castles in the Air*, p.59

11. Charly and Helga Cammell, telephone interview with authors, 6 March 2000.

12. David Cammell, letter to authors, 12 November 1998.

13. Cammell, *Castles in the Air*, p.87.

14. Elizabeth Macalester Cammell, after her divorce from Charles Richard Cammell, subsequently married Khalil Sabit Bey, who, according to Charly Cammell, "was very good and kind" to his mother, taking care of her until her death in 1968. Charles Richard Cammell knew Khalil Sabit Bey, mentioning him in *Castles in the Air*. Charly and Helga Cammell, telephone interview, March 6, 2000.

15. Charles Richard Cammell, *Heart of Scotland: A Memoir*, p.37.

16. David Cammell, letter to authors, 12 November 1998.

17. Francie Bradley, letter to authors, 14 September 1999.

18. Francie Bradley, interview with authors, 18 July 1999, Kerrowdown Cottage, Drumnadrochit, Inverness-shire, Scotland.

19. Mrs. Deborah Roberts, telephone interview with authors, 6 February 1999.

20. Francie Bradley, letter to authors, 14 September 1999.

21. David Cammell, interview with authors, 13 May 1999, Beverly Hills, CA.

22. Cammell, *Heart of Scotland*, p.98.

23. David Cammell, interview with authors, 13 May 1999, Beverly Hills, CA.

24. Charly and Helga Cammell, telephone interview with authors, 6 March 2000.

25. David Cammell, letter to authors, 16 December 1998.

26. Cammell, *Heart of Scotland*, p.200.

27. David Cammell, letter to authors, 16 December 1998.

28. Cammell, *Heart of Scotland*, p.41.

29. Cammell, *Heart of Scotland*, p.11.

30. Cammell, *Castles in the Air*, p.19

31. See Brocard Sewell, Ed., *Two Friends: John Gray & André Raffalovich* (Saint Alber's Press, 1963), and Brocard Sewell, *Footnote to the Nineties: A Memoir of John Gray and André Raffalovich* (London: Cecil and Amelia Woolf, 1968). Charles Richard and Iona Cammell are mentioned by Fr. Sewell in the latter book.

32. "Donald Cammell: Biography," publicity materials, *White of the Eye* (Palisades Entertainment).

33. Cammell, *Heart of Scotland*, p.20.

34. Cammell, *Heart of Scotland*, p.86.

35. David Cammell, interview with authors, 21 July 1999, London.

36. Cammell, *Heart of Scotland*, pp.238-39.

37. "Mystic Sonnet on a Child" reprinted in *Heart of Scotland*, p.239.

38. Cammell, *Heart of Scotland*, pp.86.

39. Cammell, *Heart of Scotland*, pp.86-87.

40. Cammell, *Heart of Scotland*, p.88.

41. Cammell, *Heart of Scotland*, pp.239-40.

42. Cammell, *Heart of Scotland*, p.177.

43. Cammell, *Heart of Scotland*, p.243.

44. Cammell, *Heart of Scotland*, p.241.

45. "Donald Cammell: *Heart of Scotland* to *Heart of Scotland*," *Cinema Rising* 1 (April 1972), p.15.

46. China Cammell, interview with authors, Los Angeles (Magic Hotel), 15 May 1999.

47. Charles Richard Cammell, *Aleister Crowley*, p.189.

48. David Cammell, letter to authors, 16 December 1998.

49. David Cammell, letter to authors, 19 December 1998.

50. Charles Richard Cammell qtd. in John Symonds, *The Great Beast*, p.587.

51. David Cammell, letter to authors, 16 December 1998.

52. David Cammell, letter to authors, 16 December 1998.

Chapter 2: **Fort Augustus 1942-43**

1. Iona Cammell, from her personal diary.
2. David Cammell, interview with authors, 14 May 1999, Beverly Hills, CA.
3. David Cammell, interview with authors, 13 May 1999, Beverly Hills, CA.
4. China Cammell, interview with authors, 15 May 1999, Los Angeles (Magic Hotel).
5. Michael Turnbull, email to authors, 11 September 1999.
6. Michael Turnbull, email to authors, 11 September 1999.
7. Michael Turnbull, email to authors, 16 January 2002, quoting Fr. Benedict Seed after a telephone conversation the same day.

Chapter 3: **Portraits, 1944-1959**

1. Cammell, *Heart of Scotland*, p.240.
2. David Cammell, interview with authors, 11 May 1999, Berkeley, CA.
3. "Donald Cammell: Biography," publicity materials, Palisades Entertainment, *White of the Eye*.
4. David Cammell, letter to authors, 12 November 1998.
5. Myriam Gibril, interview with authors, 6 October 1998, Los Angeles, CA.
6. Charles Richard Cammell, *Memoirs of Annigoni*, p.89.
7. Harold Norse, *Memoirs of a Bastard Angel*, p.239.
8. David Del Valle, interview with authors, 14 October 1998, Beverly Hills, CA.
9. Marianne Faithfull, *Faithfull*, p.152.
10. Maria Andipa (Antippas), interview with authors, 13 July 1999.
11. Maria Andipa, interview with authors, 13 July 1999.
12. David Cammell, interview with authors, 11 May 1999, Berkeley, CA.
13. Maria Andipa, interview with authors, 13 July 1999.
14. Mrs. Deborah Roberts, telephone interview with authors, 6 February 1999.
15. Maria Andipa, interview with authors, 13 July 1999.
16. *Times* article: unpaginated newspaper clipping provided by David Cammell.
17. Undated and unsigned newspaper clipping provided by David Cammell.
18. *Studio* (July 1959), p.28.
19. *Times* article: unpaginated newspaper clipping provided by David Cammell.
20. Maria Andipa, interview with authors, 13 July 1999.
21. David Cammell, letter to authors, 13 February 2000.
22. Maria Andipa, interview with authors, 13 July 1999.

23. Maria Andipa, interview with authors, 13 July 1999.
24. David McCallum, telephone interview with authors, 4 August 1999.
25. Maria Andipa, interview with authors, 14 July 1999.
26. Maria Andipa, interview with authors, 14 July 1999.
27. Maria Andipa, interview with authors, 14 July 1999.

Chapter 4: **Parisian Scenes, 1960–1967**

1. "Donald Cammell: Biography," publicity materials, *Demon Seed* (Metro-Goldwyn-Mayer).
2. Mrs. Deborah Roberts, telephone interview with authors, 6 February 1999.
3. Mrs. Deborah Roberts, telephone interview with authors, 6 February 1999.
4. Kenneth Anger, letter to authors, 15 March 1999.
5. Mrs. Deborah Roberts, telephone interview with authors, 6 February 1999.
6. *Arts* magazine (May 1961), p.96.
7. *New York Times* article: undated, unpaginated newspaper clipping provided by David Cammell.
8. Mrs. Deborah Roberts, telephone interview with authors, 6 February 1999.
9. China Machado, telephone interview with authors, 14 September 2000.
10. Mrs. Deborah Roberts, telephone interview with authors, 6 February 1999.
11. Sally Shafto, email to authors, 12 March 2002.
12. Roman Polanski, telephone interview with authors, 12 April 1999.
13. Mrs. Deborah Roberts, telephone interview with authors, 6 February 1999.
14. Anita Pallenberg, telephone interview with authors, 14 May 2004.
15. Patrick Bauchau, qtd. in Beverly Walker, "Patrick Bauchau," *Film Comment* 34:4 (July-Aug 1998), p.41.
16. "Donald Cammell, *Performance* to *Ishtar*," *Cinema Rising 1* (April 1972), p.15.
17. Sally Shafto, email to authors, 2 May 2002.
18. Sally Shafto, email to authors, 21 March 2002.
19. On this issue, see Sally Shafto, *The Zanzibar Films and the Dandies of May 1968*, esp. pp.16-18.
20. Stanislas ("Stash") Klossowski, interview with authors, 14 March 1999, Malibu, CA
21. Nicholas Fox Weber, *Balthus*, p.63.
22. Nicholas Fox Weber, *Balthus*, p.139-40.
23. Nicholas Fox Weber, *Balthus*, p.141.
24. Nicholas Fox Weber, *Balthus*, p.141.
25. Stanislas ("Stash") Klossowski, interview with authors, 14 March 1999, Malibu, CA.
26. Donald Cammell, *El Paso* (treatment), 1980.
27. Roman Polanski, telephone interview with authors, 12 April 1999.

28. Stanislas ("Stash") Klossowski, interview with authors, 14 March 1999, Malibu, CA.

29. Anita Pallenberg, telephone interview with authors, 14 May 2004.

30. David Cammell, letter to authors, 11 April 2002.

31. Donald Cammell, in interview with Jon Savage, *Vague*, p.54.

32. Stanislas ("Stash") Klossowski, interview with authors, 14 March 1999, Malibu, CA.

33. Anita Pallenberg, telephone interview with authors, 14 May 2004.

34. Mandy Aftel, *Death of a Rolling Stone: The Brian Jones Story*.

35. Stanislas ("Stash") Klossowski, interview with authors, 14 March 1999, Malibu, CA

36. Donald Cammell, in interview with Jon Savage, *Vague*, p.54.

37. Mrs. Deborah Roberts, telephone interview with authors, 6 February 1999.

38. David Cammell, interview with authors, 14 May 1999, Beverly Hills, CA.

39. Peter Watkins, email to authors, 19 August 2004.

40. Anita Pallenberg, telephone interview with authors, 14 May 2004.

41. David Cammell, interview with authors, 14 May 1999, Beverly Hills, CA.

42. Renata Adler, *New York Times*, 21 November 1968, p.41.

43. Steven Marcus, *The Other Victorians*, p.268.

44. Review of *The Touchables*, *Films & Filming*.

45. Marcus, *The Other Victorians*, p.269.

46. Marcus, *The Other Victorians*, p.269.

47. David Del Valle, "Memo From Cammell," interview with Donald Cammell, *Video Watchdog* 35, p.30.

48. Helga Cammell, telephone interview with authors, 6 March 2000.

49. Leonard Maltin, *TV Movies and Video Guide, 1988 Edition*, p.273.

Chapter 5: *Performance*, 1967-1970

1. Luc Moullet, "Jean-Luc Godard," p.209.

2. T. S. Eliot, "In Memoriam," *Selected Prose of T. S. Eliot*, p.243.

3. Vartkes Cholakian, interview with authors, July 31, 2003, Kearney, NE.

4. Jean Cocteau, *The Art of Cinema*, p.157.

5. Donald Cammell, during interview, *Nothing As It Seems* (documentary).

6. R. Joseph Libin, "Don Cammell: Performance Pluperfect," p.10.

7. Brion Gysin, "The Process," in Mike Jay, Ed., Artificial Paradises, pp.369-371.

8. Luigi Zoja, "Drugs, Addiction & Initiation: The Modern Search for Ritual," in Mike Jay, Ed., *Artificial Paradises*, p.366.

9. Mike Jay, in *Artificial Paradises*, p.366.

10. Brion Gysin, "The Process," p.371.

11. David Del Valle, "Memo From Cammell," p.32.

12. Luigi Zoja, "Drugs, Addiction, & Initiation," p.367.

13. Colin MacCabe, *Performance*, p.79-80.

14. Tom Milne, *Godard on Godard*, pp.215-234.

15. David Del Valle, "Memo From Cammell," p.32.

16. The standard, "common sense" version of the principle of sufficient reason states that everything must have an explanation. Of course, common sense explanations often fail, an example being the "indeterminacy" of many of the processes studied by quantum physics. *Necessary* and *sufficient* conditions refer to explanations in which the explaining factors necessitate or entail the existence or occurrence of the thing explained. Explaining factors may range from physical laws to statistical regularities, from physical events and processes to mental states, from the observable to the unobservable, and so on. A standard definition of a *sufficient condition* is: A condition *A* is said to be *sufficient* for a condition *B*, if (and only if) the truth (/existence/occurrence) [as the case may be] of *A* guarantees (or brings about) the truth (/existence/ occurrence) of *B*. (http://www.sfu.ca/philosophy/swartz/ conditions1.htm. Accessed February 15, 2002.) Our point is that for the ending of *Performance* to be indeed transcendent, the mnemonic selves of both Chas and Turner must still exist after the bullet fires. If there has been created a "new" personality that is neither Chas nor Turner, then being dead really means dead.

17. By "unitary subjectivity" we are referring to the common-sense assumption that the pronoun "I" names a single, identifiable essence, the "one true" self, sometimes referred to as the "Cartesian ego," named after the famous French philosopher (Descartes) who first gave a name to the thing-that-thinks, the *res cogito*. *Cogito ergo sum*, Descartes asserted, "I think, therefore I am." The great triumvirate of philosophers, Marx, Nietzsche, and Freud, set out in their philosophical projects with the express purpose of demolishing the certitude of the "Cartesian ego." We are not arguing from any of these positions, but agree with all three philosophers' fundamental assumption, that the Cartesian ego is an illusion. Donald Cammell approached the question through his sustained interest in the idea of the dissociated consciousness, "I is another."

18. Jorge Luis Borges, "The Enigma of Edward Fitzgerald, in *A Personal Anthology*, p.95.

19. Borges, *A Personal Anthology*, p.96.

20. David Cammell, telephone interview, 5 August 2003.

21. Jean Cocteau, *The Art of Cinema*, p.158.

22. Donald Cammell, in interview, *Nothing As It Seems* (documentary).

23. James Naremore, *Acting in the Cinema*, p.230.

24. Jack Shadoian, "*Point Blank*," in *Dreams & Dead Ends*.

25. R. Joseph Libin, "Don Cammell: Performance Pluperfect," p.10.

26. David Del Valle, "Memo From Cammell," p.34.

27. R. Joseph Libin, "Don Cammell: Performance Pluperfect," p.10.

28. Anita Pallenberg, telephone interview with authors, 14 May 2004.

29. Donald Cammell, in interview with Jon Savage, *Vague*, p.55.

30. Sally Shafto, email to authors, 21 March 2002.

31. Maggie Abbott, interview with authors, 15 May 2000, Palm Springs, CA

32. James Fox, *Comeback*, p.149.

33. David Cammell, email to authors, 12 February 2002.

34. Anita Pallenberg, telephone interview with authors, 14 May 2004.

35. Marsha Kinder and Beverle Houston, "The Ultimate Performance," p.361.

36. Anita Pallenberg, telephone interview with authors, 14 May 2004.

37. R. Joseph Libin, "Don Cammell: Performance Pluperfect," p.12.

38. Anita Pallenberg, telephone interview with authors, 14 May 2004.

39. David Cammell, interview with authors, 11 May 1999, Berkeley, CA.

40. Marianne Faithfull, *Faithfull*, p.153.

41. Anita Pallenberg, telephone interview with authors, 14 May 2004.

42. Anita Pallenberg, telephone interview with authors, 14 May 2004.

43. Frank Mazzola, interview with authors, 13 March 1999, Beverly Hills, CA.

44. Frank Mazzola, interview with authors, 13 March 1999, Beverly Hills, CA.

45. Myriam Gibril, interview with authors, 6 October 1998, Los Angeles, CA.

46. Frank Mazzola, interview with authors, 13 March 1999, Beverly Hills, CA.

47. David Cammell, interview with authors, 14 May 1999, Beverly Hills, CA.

48. Donald Cammell, *Performance* (screenplay), Goodtimes Enterprises, 1968.

49. David Cammell, interview with authors, 13 May 1999, Beverly Hills, CA.

50. Frank Mazzola, interview with authors, 13 March 1999, Beverly Hills, CA.

51. Anita Pallenberg, telephone interview with authors, 14 May 2004.

52. See Mick Brown, *Performance* (Bloomsbury, 1999), p.193. Although Brown indicates that the *Performance* trims won an award at the Wet Dream Film Festival, there is no record of this in the book, *Wet Dreams: Films and Adventures* - a list of award winners is printed, but the trims are not among them. *Wet Dreams* also reveals the date and venue of the screening of the *Performance* trims: Saturday, 28 November 1970 at The Kosmos - a spiritual centre that was converted into a festival screening room for that day only. Richard Neville also discusses the *Performance* trims in his memoir *Hippie Hippie Shake* (Bloomsbury, 1995).

Chapter 6: **Entr'acte, 1970-74**

1. Jay Cocks, "Sing a Song of Seeing," *Time* (26 December 1983).

2. *Gimme Shelter*, Criterion Collection DVD, 2000.

3. The Maysles' letter was published in Kevin Macdonald and Mark Cousins, Eds., *Imagining Reality*, p. 394.

4. Donald Cammell, qtd. in Christopher Andersen, *Jagger Unauthorized*, p.243.

5. "Donald Cammell: *Performance* to *Ishtar*," *Cinema Rising 1* (April 1972), p.15

6. Nicky Samuel, telephone interview with authors, 19 July 2001.

7. Michael Butler, telephone interview with authors, 16 June 2003.

8. David Cammell, interview, 21 July 1999, London.

9. "Donald Cammell: *Performance* to *Ishtar*," *Cinema Rising 1* (April 1972), p.15.

10. Maggie Abbott, interview with authors, 15 May 2000, Palm Springs, CA.

11. Myriam Gibril, interview with authors, 6 October 1998, Los Angeles, CA.

12. Stanislas ("Stash") Klossowski, interview with authors, 14 March 1999, Malibu, CA.

13. Christopher Andersen, *Jagger Unauthorized*, p.242.

14. Myriam Gibril, interview with authors, 6 October 1998, Los Angeles, CA.

15. Myriam Gibril, interview with authors, 6 October 1998, Los Angeles, CA.

16. David Cammell, interview, 13 May 1999, Beverly Hills, CA.

17. R. Joseph Libin, "Don Cammell: Performance Pluperfect," p.12.

18. Myriam Gibril, interview with authors, 6 October 1998, Los Angeles, CA.

19. Frank Mazzola, interview with authors, 13 March 1999, Beverly Hills, CA.

20. Georges Bataille, "The Big Toe," in *Visions of Excess*.

21. R. Joseph Libin, "Don Cammell: Performance Pluperfect," p.11.

22. Frank Mazzola, interview with authors, 13 March 1999, Beverly Hills, CA.

23. Michael Butler, telephone interview with authors, 16 June 2003.

24. Myriam Gibril, email to authors, 13 August 2000.

25. Frank Mazzola, interview with authors, 13 March 1999, Beverly Hills, CA.

26. David Pirie, "Cammell's Eye," *Time Out*, p.10.

27. Frank Mazzola, interview with authors, 13 March 1999, Beverly Hills, CA.

28. David Cammell, interview with authors, 14 May 1999, Beverly Hills, CA.

29. David Cammell, interview with authors, 14 May 1999, Beverly Hills, CA.

30. Brian Boyd, email to authors, 24 January 2005.

31. Stephen Crook, email to authors, 26 January 2005.

32. Myriam Gibril, interview with authors, 6 October 1998, Los Angeles, CA.

33. Myriam Gibril, interview with authors, 6 October 1998, Los Angeles, CA.

34. Andrew Braunsberg, telephone interview with authors, 12 April 1999.

Chapter 7: *Demon Seed*, 1975-1981

1. David Pirie, "Cammell's Eye," *Time Out*, p.10.

2. China Cammell, interview with authors, 15 May 1999, Los Angeles (Magic Hotel), 15 May 1999.

3. "Robert Stewart," studio publicity materials, *Demon Seed* (Metro-Goldwyn-Mayer).

4. Matthew R. Bradley, "Cry U.N.C.L.E.! An Interview with Robert Vaughn: Part Two," *Outré: The World of Ultramedia* 18 (1999), pp.31-32.

5. David Cammell, telephone interview with authors, 15 February 2005.

6. Frank Mazzola, telephone interview with authors, 25 March 2002.

7. MGM Archives, Academy of Motion Picture Arts and Sciences, Beverly Hills, CA.

8. Chris Rodley, "Marlon, Madness, and Me," p.44.

9. China Cammell, interview with authors, 15 May 1999, Los Angeles (Magic Hotel).

10. David Pirie, "Cammell's Eye," *Time Out* (14 October 1977), p.10.

11. Frank Mazzola, telephone interview with authors, 25 March 2002.

12. Frank Mazzola, telephone interview with authors, 25 March 2002.

13. "Donald Cammell: Biography," studio publicity materials, *White of the Eye* (Palisades Entertainment).

14. Donald Cammell, in interview with Jon Savage, *Vague*, p.53.

15. Frank Mazzola, telephone interview with authors, 25 March 2002.

16. Bill Munster, ed. *Sudden Fear*, p.14.

17. David Cammell, interview with authors, 11 March 1999, Berkeley, CA.

18. Kenneth Tynan, *The Diaries of Kenneth Tynan*, p.381.

19. Wes Murray, "The Making of *Tilt*," p.8.

20. Rudy Durand, telephone interview with authors, 6 January 1999.

21. Rudy Durand, telephone interview with authors, 6 January 1999.

22. Wes Murray, "The Making of *Tilt*," p.9.

23. Zalman King, telephone interview with authors, 10 June 2004.

24. William Gray, telephone interview with authors, 12 September 2005.

25. William Gray, telephone interview with authors, 12 September 2005.

26. The term, defined by in Edward Said, *Orientalism*, refers to Western attitudes of the Orient and Middle East.

27. Lawrence Grobel, *Conversations with Brando*, p.178.

28. Lawrence Grobel, *Conversations With Brando*, p.179.

29. Chris Rodley, "Marlon, Madness, and Me," p.44.

30. Chris Rodley, "Marlon, Madness, and Me," p.45.

31. David Cammell, interview with authors, 14 June 2005.

32. Chris Rodley, "Marlon, Madness, and Me," p.46.

33. Chris Rodley, "Maron, Madness, and Me," p.44.

Chapter 8: *White of the Eye*, 1980-87

1. Vartkes Cholakian, interview with authors, 31 July 2003, Kearney, NE.

2. Vartkes Cholakian, interview with authors, 31 July 2003, Kearney, NE.

3. David Cammell, letter to authors, 12 November 1998.

4. Tim Deegan, telephone interview with authors, 14 February 2003.

5. Donald Cammell, in interview with Jon Savage, *Vague*, p.53.

6. Vartkes Cholakian, interview with authors, 1 August 2003, Kearney, NE.

7. Donald Cammell, in interview with Jon Savage, *Vague*, p.53.

8. Anna Swadling, telephone interview with authors, 7 October 1999.

9. Jack Rovner, telephone interview with authors, 5 October 2005.

10. David Cammell, telephone interview with authors, 10 October 2005.

11. David Cammell, telephone interview with authors, 10 October 2005.

12. David Del Valle, "Memo From Cammell," p.33.

13. Robert Cettl, *Serial Killer Cinema*, p.505.

14. David Del Valle, "Memo From Cammell," p.17.

15. Cathy Moriarty, telephone interview with authors, 2 March 1999.

16. Brad Wyman, telephone interview with authors, 4 April 1999.

17. Cassian Elwes, interview with authors, 12 March 1999, Beverly Hills, CA.

18. Brad Wyman, telephone interview with authors, 4 April 1999.

19. Brad Wyman, telephone interview with authors, 4 April 1999.

Chapter 9: *Wild Side*, 1988-1995

1. Vartkes Cholakian, interview with authors, 1 August 2003, Kearney, NE.

2. J.F. Lawton, email to authors, 3 February 2006.

3. Chris Rodley, "Marlon, Madness, and Me," p.48.

4. Chris Rodley, "Marlon, Madness, and Me," p.46.

5. Peter Manso, *Brando*, p.910.

6. Elliott Kastner during interview in *Donald Cammell: The Ultimate Performance*.

7. Donald Cammell, qtd. in Peter Manso, *Brando*, p.1076.

8. We interviewed Ken Finkleman, but he told us he had no memory of *Alamogordo*, as it had been written about 15 years prior to our interviewing him. He also indicated he had never seen Donald's subsequent revisions of the script.

9. Chris Rodley, "Marlon, Madness, and Me," p.50.

10. David Cammell, email to authors, 10 Sept. 2001.

11. Maggie Abbott, interview with authors, 15 May 2000, Palm Springs, CA.

12. Sead Mutarevic, video interview conducted during *Wild Side* by Nu Image, documenting the production. Portions of these cast and crew interviews were later included on Metro/Tartan's DVD issue of *Wild Side*.

13. Frank Mazzola, telephone interview with authors, 25 March 2002.

14. Chris Campion, *Dazed & Confused*, p.10.

Chapter 10: Blood of a Poet, 1995-1996

1. Jamison, *Night Falls Fast*, p.73.

2. David Cammell, interview with authors, 13 May 1999, Beverly Hills, CA.

3. Jamison, *Night Falls Fast*, p.81.

4. Drew Hammond, interview with authors, 13 March 1999.

5. David Cammell, interview with authors, 13 May 1999, Beverly Hills, CA.

6. Drew Hammond, qtd. in Mick Brown, "The Final Cut," *Telegraph Magazine* (May 1998), p.37.

7. Frank Mazzola, telephone interview with authors, 25 March 2002.

8. Drew Hammond, interview with authors, 13 March 1999.

9. Davis, *Old Gods Almost Dead*, p.535.

10. Tom Dewe Mathews, "Screen: Shoot to Kill," *The Guardian* (1 May 1998), p.4.

11. Kevin Macdonald. "Donald Cammell: When he shot himself, did he set the scene for his finest Show?" *The Observer* (3 May 1998), p.9.

12. Drew Hammond, interview during *Donald Cammell: The Ultimate Performance*.

13. Paul Beard and Lee Hill. "The Man That Time Forgot," *Neon* (August 1997), p.74. Drew Hammond comment about the Glock 17: made during interview in Chris Rodley and Kevin Macdonald documentary, *Donald Cammell: The Ultimate Performance*.

14. Qtd. in Solomon, *The Noonday Demon*, p.252.

15. Drew Hammond, interview with authors, 13 March 1999.

16. Investigator's Report, prepared by Investigator William Grice, Los Angeles Department of Coroner, dated 25 April 1996, p.1

17. David Cammell, interview with authors, 18 May 1999, Beverly Hills, CA

18. Investigator's Report, William Grice, p.1

19. Investigator's Report, p.2

20. Dr. Joe Auch Moedy, interview with authors, 13 October 2001, Kearney, NE.

21. Investigator's Report, p.1

22. Dr. Joe Auch Moedy, interview with authors, 13 October 2001, Kearney, NE.

23. Solomon, *The Noonday Demon*, p.247.

24. Mick Brown, "The Final Cut," *Telegraph Magazine*, p.44.

25. E.A. Robinson, *Collected Poems of Edward Arlington Robinson*, p.82.

26. Jamison, *Night Falls Fast*, pp.73-74.

27. Solomon, *The Noonday Demon*, p.244.

28. Solomon, *The Noonday Demon*, p.263.

29. Kay Redfield Jamison, qtd. in Solomon, *The Noonday Demon*, p.263.

30. Investigator's Report, p.1

31. Frank Mazzola, telephone interview with authors, 17 December 2001.

32. Vartkes Cholakian, interview with authors, 1 August 2003, Kearney, NE.

33. Maggie Abbott, interview with authors, 15 May 2000, Palm Springs, CA.

34. William Gray, telephone interview with authors, 12 September 2005.

35. China Cammell, qtd. in Brian Pendreigh, *Scotland on Sunday*, p.9.

36. Mrs. Deborah Roberts, telephone interview with authors, 6 February 1999.

37. China Machado, telephone interview with authors, 14 September 2000.

38. Maria Andipa, interview with authors, 14 July 1999, London.

39. Vartkes Cholakian, interview with authors, 31 July 2003, Kearney, NE.

40. Roman Polanski, telephone interview with authors, 12 April 1999.

Aftermath

1. Dundy, *Elvis and Gladys*, p.278.

2. Chris Rodley, "Marlon, Madness, and Me," p.44.

3. Mick Brown, "The Final Cut," *Telegraph Magazine*, p.34.

4. See Lippincott/Williams & Wilkins, "Practice parameters for the assessment and treatment of children and adolescents with bipolar disorder," *Journal of the American Academy of Child and Adolescent Psychiatry* 36:1 (January 1997), pp.138-157. They put the figure of bipolar disorder at *about* 1.0% of the general population, speculating the actual figure may be smaller than this.

5. David Cammell, interview with authors, 13 May 1999, Beverly Hills, CA.

6. China Cammell, telephone interview with authors, 16 May 1999.

7. We have listed several key works that we found to be quite valuable on abnormal child pyschology, and childhood sexual abuse, in the bibliography. The publication of this book was delayed as a result of our extensive research on this subject.

8. See Kay Redfield Jamison, *Touched With Fire*.

9. David Cammell, email to authors, 2 August 2001.

10. Jamison, *Touched With Fire*, p.193-94.

11. David Cammell, email to authors, 2 August 2001.

12. Michael Turnbull, email to authors, 13 September 1999.

13. Michael Turnbull, email to authors, 13 September 1999.

14. Michael Turnbull, email to authors, 16 January 2002, quoting Fr. Benedict Seed after a telephone conversation the same day.

15. Fr. Benedict Seed, letter to authors, 8 September 1999.

16. Michael Turnbull, email to authors, 11 September 1999.

17. Cassian Elwes, interview with authors, 12 March 1999, Beverly Hills, CA.

18. Frank Mazzola, telephone interview with authors, 15 February 2002.

19. Vartkes Cholakian, interview with authors, 1 August 2003.

20. Nicky Samuel, telephone interview with authors, 19 July 2001.

21. Marianne Faithfull, *Faithfull*, pp.152-53.

22. Marsha M. Linehan, *Treating Borderline Personality Disorder*, videorecording (VHS), Guildford, 1995.

23. Linehan, *Treating Borderline Personality Disorder*.

24. See Robert Adler, "Crowded Minds," *New Scientist* (18 December 1999), pp.26-31.

25. David Cammell, email to authors, 2 August 2001.

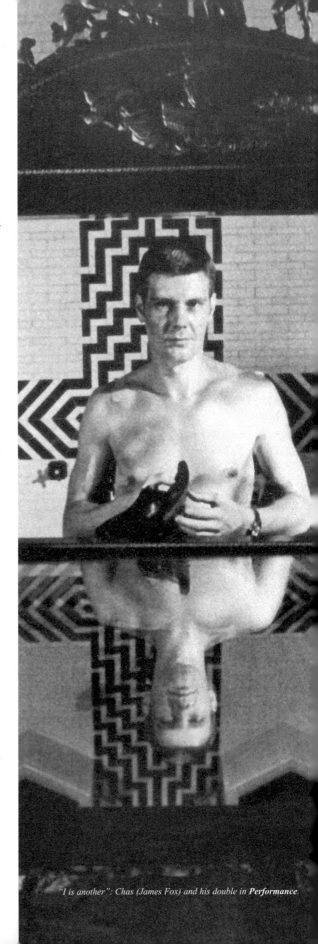

"I is another": Chas (James Fox) and his double in **Performance**.

Index

Page references in **bold** refer exclusively to illustrations, though pages referenced as text entries may also feature relevant illustrations.

2001: A Space Odyssey 170, 182

33 (script) 244, 248, 254, 285

Abbey Boys: Fort Augustus Abbey Schools (book) 33, 264

Abbott, Maggie 100, 150, 151, 234, 255, 285

Acting in the Cinema (book) 97

Adler, Renata 74

Aftel, Mandy 66

Alamogordo (script) 231, 285

Alderton, John 77, **78**, **81**

Aldrich, Robert 85

Aleister Crowley: The Man: The Mage: The Poet (book) 24, 28

Alfie 72

All You Zombies (music video) 207-209, 281

Allégret, Marc 63

Allen, Irwin 109

Allen, Woody 68, 161

Alphaville 170

Altman, Robert 160, 235

Andersen, Christopher 150, 151

Anderson, Esther **69**, **70**, 72, **73**, **75**, **76**, **121**

Andipa, Maria (née Antippas) 16, 43-46, 48-50, **51**, 52, 60, 206, 256, 262, 263, 266, 283

Andrea del Sarto (Called 'The Faultless Painter') (poem) 9, 10

Andrews, Pat 67

Anger, Kenneth 59, 67, 78, 151, 152, 282, 283

Annigoni, Pietro 9, 37-39, 41, 46-48

Anthony, David **69**, **70**, 71, 72, **73**, **76**, **121**

Antonelli, Laura **126**, 158, 159, **163**

Antonioni, Michelangelo 38

Apocalypse Now 171, 172

Argument, The 8, 76, **126**, 152, 154-158, 160, 276

Armstrong-Jones, Antony see Lord Snowdon

Ars Poetica (book) 103

Artaud, Antonin 99

Aschkynazo, Caleb 160

Ashby, Hal 166

Ashley, Ted 110, 111, 148, 274, 275

Assa, René 178, 180

Auch Moedy, Dr. Joe 252, 253

Avec Avec (script) 65, 66, 68

Avedon, Richard 60

Back from the Dead (novel) 284

Baird, Harry **69**, 71, **73**

Baker, Alvie 67

Balthus 63, 64

Balthus: A Biography (book) 63

Band, The 108

Bardolph, Sue 47

Bardot, Brigitte 64, 217

Baron, Saskia 283

Barrere, Robert 160

Bataille, Georges 153, 158, 159, 161, 162, 221, 246

Batman (TV series) 42

Bauchau, Patrick 61, 62, 268, 269

Baudelaire, Charles 90

Bauer, Steven 85, **141**, 234-236, **238**, **240**, 241, **242**, 243

Bava, Mario 100

Bazilian, Eric **209**

Beaches 230

Beard, Paul 249

Beard, The (play) 152, 153, 285

Beard, The (script) 153, 154, 157, 285

Beast 666, The (book) 30

Beat Generation (illustration) **1**

Beatles, The 38, 68, 108

Beaton, Cecil 97

Beatty, Warren 152

Beausoleil, Bobby 282

Beaver, Paul 275

Being There 166

Belgian Cinema (book) 158, 163

Belle de jour 238

Belmondo, Jean-Paul 221

Belson, Jordan 173, 183

Bemelmans, Ludwig 59

Bergman, Ingmar 97

Bernardini, Luigi 159

Bernardini, Oddo 159

Bideford Weekly Gazette (newspaper) 30

Bisset, Jacqueline 166

Blackwell, Chris 206

Blake, William 149, 154, 271

Blay, André 229

Blood for Dracula 100

Bloom, Harold 9

Blowup 38

Bonnie and Clyde 98

Boorman, John 31, 97, 98, 264, 275

Borges, Jorge Luis 11, 92-95, 149, 183, 241, 249, 275

Born Thief (script) 234, 285

Bottomley, Susan 66, 166, 266

Bowie, David 65, 100

Bowles, Paul 150, 151, 156

Boyd, Brian 165

Bradley, Francie (née Macdonald) 20

Brando, Marlon 35, 48-50, 97, 98, 150, 171, 172, 196-201, 206, 224, 230, 231, 233, 259, 284, 285

Brando: A Searching, Searing Analysis of Hollywood's Original Crazy, Mixed-Up Kid (book) 50

Braunsberg, Andrew 166, 167, 183, 285

Bré, Pierre-Richard 61-63, 100, 105, 282

Breathless 147

Bresson, Robert 87

Breteuil, Comte Jean de 67

Breton, Michèle 4, 85, **96**, 100, 104, 112, **124**

Brown Jr., Harry Joe "Coco" 66, 68, 77

Brown, Harry Joe 68

Brown, Mick 4, 100, 245, 248, 254, 259

Browne, Sir George Washington 25

Browning, Robert 9, 10

Brownjohn, Robert 68

Buñuel, Luis 238

Burroughs, William 41, 67, 90, 91, 150

Bury, Adrian 37

Butler, Michael 148, 150, 152, 157, 158, 204, 275

Byrds, The 275

Cabinet of Dr. Caligari, The 97

Cahiers du cinéma (magazine) 61-63, 92

Caine, Michael 72

Calley, John 108, 110, 111, 274, 275

Cammell, Amadis Aeneas Antony **51**, 52, 206, 256, 263, 283

Cammell, Charles 16, 17

Cammell, Charles David Wilson 17

Cammell, Charles George Macalester "Charly" 4, **18**, 19, 22, 30, 77

Cammell, Charles Richard 10, 13, **14**, 15-20, 22-32, 35, 37, 38, 41, **43**, 44, 48, 52, 84, 103, 215, 236, 261, 262

Cammell, China Kong 27, 33, 34, 60, 87, 108, **133**, 150, 158, 167, 169, 172, 173, 179, 196, 199, 203, 205-207, 218, 231, 234, 235, 244, 247-251, 254-256, 260, 262, 263, 266, 267, 281, 285

Cammell, Christopher Benvenuto 19, 30

Cammell, Cordelia Violet Katherine "Eila" 17

Cammell, David Douglas 4, 16, 19, 20, 22, 24, 27-33, 35, 37, 41-44, 46, 48, **61**, 64, 66, 68, 71, 72, 95, 100, 103, 104, 108, 110, 111, 148, 149, 152, 158, 164-166, 169, 171, 180, 183, 190, 199, 204, 206, 207, 209, 234, 247, 250, 255, 259, 260, 262, 264-267, 270, 271, 275, 285

Cammell, Diarmid Victor Charles 28, 31, 103, 262

Cammell, Elizabeth Geraldine "Lili" 4, 19, 22, 28, 30

Cammell, Elizabeth Lathrop (née Macalester) 18, 19, 22

Cammell, George Henry 29

Cammell, Geraldine Theresa (née Haworth-Booth) 17

Cammell, Helga 4, 77

Cammell, Iona Katherine Lamont (née Macdonald) 15, 19, 20, **21**, 22-26, 28-31, 33, 35, 44, 48, 103, 206, 265, 271

Cammell, Meta 17, 19

Campbell, Archibald 16

Campbell, Eustace 16

Campion, Chris 245

Camus, Albert 11

Caniff, Milton 198

Capaldi, Jim 104

carabiniers, Les 92

Caravaggio 65, 204

Carlyle, Thomas 45

Carpi, Fiorenzo 276

Carradine, Keith 153, 188

Carrie 174

Carson, Johnny 190

Centrifuge (script) 230, 285

Cettl, Robert 224

Chakra 173

Changeling, The 195, 203, 256

Chase, The 97

Chen, Joan 85, **139**, **141**, **143**, 234-236, **239**, **240**

Choi San, Lai 198

Cholakian, Vartkes 87, 165, 203-207, 229, 255, 256, 267, 285

Chow, David 223

Christie, Julie **127-131**, 169, **170**, 171, **172**, **173**, 174, **175**, **176**, 177, 178, 179, 182

Civil Unrest (script) 285

Clapton, Eric 38

Clark, Susan 170

Clash, The 65

Clémenti, Pierre 62

Cleopatra 205

Clockwork Orange, A 100, 152

Close Encounters of the Third Kind 183

Coburn, James 77, 79, **82**, 85, **120**

Cocks, Jay 147

Cocteau, Jean 87, 95, 97, 153, 251

Cofrin, John 192

Cohn, Elie 234, 242

Collector, The 71, 72

Colossus: The Forbin Project 169, 170

Connery, Sean 233

Connoisseur, The (magazine) 26, 27, 30, 31

Conrad, Joseph 183, 198, 201, 221, 256

Cooder, Ry 275

Cooper, Alfred Egerton 41

Coppola, Francis Ford 171

Cort, Bud 152, 153

Cotten, Joseph 192

Crabbe, Jim 206

Cream 38

Creech III, James 284

Crook, Stephen 165

Crowley, Aleister 24, 27-30, 59, 67, 103, 151, 152

Crowther, Bosley 147

Cull, The (script) 34, 149, 187, 192, 200, 231-233, 245, 285

Dahmer, Jeffrey 221

Dali, Salvador 61, 87

Dante 10

D'Arbanville, Patti 166

Darin, Bobby 65

David and Lisa 159

Davidson, Miss Anne "Min" 22

Davis, Stephen 248, 249

De Palma, Brian 174, 282

Dean, James 109

Decent Interval (book) 230

Deegan, Tim 206

Defence of Poetry, A (essay) 11

DeGeneres, Ellen 235, 246

Degli Esposti, Maurizio **126**, 159, **163**

del Sarto, Andrea 9-11

del Sarto, Lucrezia 9, 10

Del Valle, David 4, 5, 42, 77, 91, 92, 99, 104, 210, 224, 267, 281

Delusion 192

Demon Seed 28, 50, 76, 88, 91, 92, 95, **127-131**, 156, 157, 160, **168**, 169-183, 190, 195, 201, 224, 262, 277

Demon Seed (novel) 174, 175, 177

Descartes, René 12

Despair (novel) 165

Deux ou trois choses que je sais d'elle 238

Diagnostic and Statistical Manual for Mental Disorders (book) 261, 263, 266, 270

Diary of a Country Priest 87
Dickinson, Emily 145
Dimbort, Danny 234
Dirty Dancing 229
Divine Comedy, The (book) 10
Donald Cammell: The Ultimate Performance 4, 246, 267, 283
Donner, Clive 68
Donovan 38
Don't Look Now 167, 171, 177
Douglas, Jimmy 66
Douglas, Melvyn 195
Drabinsky, Garth 195
Dreams and Dead Ends (book) 98
Dry White Season, A 231
Ducane, John 148
Duering, Charles 81
Duffy 66-68, 76, 77-85, 98, 108, **120**, 204, 215, 233, 262, 273
Dumas, Alexander 90
Dumas, Alexandre 236
Dunaway, Faye 166
Duncan, John 25, 27, 28
Dundy, Elaine 259
Durand, Rudy 184, 185, **186**, 190, 278
Durning, Charles 184, **187**, 190, 278
Dylan, Bob 38, 108
Eagles, The 184
Eaves, Fr. Oswald 33, 35, 265
Eggar, Samantha 71
El Paso (treatment) 65, 98, 99, 165, 195, 196, 200, 201, 203-205, 207, 210, 214, 216, 233, 255, 267, 285
Eliade, Mircea 90
Eliot, George 45
Eliot, T.S. 22, 87
Elkin, Stanley 180
Elwes, Cassian 47, 210, 226, 229, 267
Elwes, Dominic 47
Empire of the Censors (documentary) 283
En cas de malheur 217
Ertegun, Ahmet 150
Evans, Art 214, **215**, **217**
Evans, Jimmy 102
Everybody's Weekly (magazine) 31, 37
Faithfull, Marianne 42, 104, 152, 268
Falk, Peter 68

Fan-Tan (novel) 53, 197, 199-201, 206, 284
Fan-Tan (treatment) 149, 196-201, 203, 204, 206, 221, 230, 231, 233, 285
Faro (script) 167, 285
Farrow, Mia 104
Fat City 154
Fatal Attraction 205, 224
Fehr, Rudy 109
Fell, Herbert Granville 26
Fetherstonhaugh, Sir Harry 167
Fielding, Jerry 182, 277
Finkleman, Ken 231, 285
Fitzgerald, Edward 94, 95
Fitzgerald, Edward Noel 28
Flesh for Frankenstein 166
Fonda, Jane 150
Fonda, Peter 152, 155
Forbes, Feridah 38
Forbes, Juanita 38
Ford, Harrison 68
Forrest Gump 161
Fowles, John 71
Fox, James 4, 77, **81**, **82**, 85, **86**, **89-91**, **93**, **95**, **96**, 97, 99, 100, **101**, 102, 105, 106, **107**, **109**, 110, 112, **113**, **120**, **122-125**, **296**
France, Marie de 194
Franke, Christoph 283
Frankenstein (novel) 178
Fraser, Robert 42, 67
Freeman, Robert 68, 71
French, Philip 227
From Russia with Love 44
Fry, Roger 25
Fuseli, Henry 42
Gabin, Jean 217
Ganem, John 244
Gardner, Ava 199
Garrel, Philippe 62, 105
Gautier, Théophile 90
Geddes, Sir Patrick 23
Genealogy of Morals (essays) 91
General, The 264
Genet, Jean 11
Get Carter 98
Getty Jr., John Paul 67
Gibbons, Tommy 102
Gibbs, Christopher 67
Gibril, Myriam 20, 24, 37, 46, 52, 59, 100, 107, 108, **126**, 148, 151, 152, 155-158, 165, 166, 173, 266, 268

Gimme Shelter 147, 148, 281
Gladstone, William Ewart 17
Goalen, Barbara 47
Godard, Jean-Luc 5, 62, 92, 100, 111, 147, 170, 218, 221, 235, 238
Godfather, The 171
Goethe, Johann Wolfgang von 87
Goldman, David 234
Goodwin, Michael 147
Gordon, Seton 24, 25
Goulandris, Janni **43**
Graduate, The 106
Graham, Gerrit **128**, 160, **170**, 177, **181**, 183
Gray, John 23
Gray, William 195, 203, 256
Great Beast, The (book) 28
Great Duke of Buckingham, The (book) 236
Greene, Michael 214
Greenhouse, The (script) 64, 68, 285
Greer, Germaine 38
Grice, William 250
Grobel, Lawrence 198
Gurovich, Danko 213
Gysin, Brion 41, 67, 88, 90, 150, 156
Hadfield, Alice Mary 16, 39, 284
Haggard, H. Rider 136
Hair (musical) 148
Hamblett, Charles 50
Hamilton, Emma (née Lyon) 166, 167
Hamilton, Sir William 166
Hammond, Drew 247-250, 218, 268, 269, 271, 285
Hanson, Lady 31
Hard Day's Night, A 68
Harlé, Catherine 60, 61
Harrison, George 108
Hasenfus, Eugene 230
Haworth-Booth, Colonel 17
Hay, Alexandra 153
Hayashi, Marc 221
Heche, Anne 77, 85, **139-143**, 234-236, **237**, **239**, **240**, **243**, 246
Heffner, Richard 224
Help! 68
Hemingway, Ernest 249, 261
Hemingway, Jack "Bumby" 261
Hemingway, Margaux 261
Hemmings, David 38
High Wind in Jamaica, A 44

Hill, Lee 249
Hired Hand, The 152, 154, 155, 157
Hiroshima mon amour 220
Hirson, Roger O. 174
Histoire de l'oeil (novel) 158, 159
Hodges, Mike 98
Hollywood UK (TV series) 283
Home Movie: On the set of Philippe Garrel's Le lit de la vierge 282
Hooters, The 207-209, 281
Hope and Glory 31
Hopper, Dennis 152
Hot Chocolate 173, 213
Hot! (script) 192-195, 285
Houssiau, Michel 159
Houston, Beverle 103
Hudson, Hugh 68, 209
Hughes, William 284
Hugo, Victor 10
Hume, David 23
Humphries, Dave 232
Hunter, Martin 244
Hunter, Russell 195
Huston, John 154
Huxtable, Judy **69**, **70**, 72, **73**, **75**, **76**, **121**
Hyman, Ken 105, 108
Hyman, Rob 207-209
I Sailed with Chinese Pirates (book) 198
Idaho Transfer 157
In Memoriam (poem) 87
Invocation of My Demon Brother 151, 283
Ireland, Jill 42, 49
Irving, David 192
Ishtar (script) 74, 76, 103, 105, 148-152, 155-158, 204, 206, 207, 209, 285
Jack the Ripper (script) 65, 183, 285
Jack's Back 229
Jacober, Ben 108, 151, 234
Jaffe, Herb 174, 179, 180, 182, 205
Jaffe, Robert 169, 174, 180
Jaffe, Stanley 205
Jagged Edge 224
Jagger, Bianca (née de Macias) 150, 151
Jagger, Mick 41, 42, 45, 46, 67, 85, **89**, **93-96**, 97-100, **101**, 104, **105**, 106, **108**, 109, 110, **111-113**, **123-125**, **146**, 147, 148, 150, 151, 153, 154, 158, 184, 192, 233, 234, 248, 267, 268, 274, 275, 282, 283

James, Henry 45
Jamison, Kay Redfield 247, 254, 255, 262
Janssen, David 109
Jay, Martin 90
Jericho (script) 196, 199, 201, 224, 230-231, 285
Johnson, Don 230
Johnston, Sheila 227
Jokers, The 71
Jones, Alan 226
Jones, Brian 63, 66, 67, 71, 90, 103, 104, 148, 150, 151
Jones, Christopher 72
Jones, George 217
Jones, Paul 71
Jones, Tom 71
Jouffroy, Alain 62
Joyce, Paul 282
Jung, Carl 95
Just a Jackknife Has Macheath Dear (script) 65, 68, 285
Kael, Pauline 148
Kastner, Elliott 210, 226, 229, 231
Katz, Elia 174
Keith, David **134**, **136-138**, 212, **213**, **217**, **219**, **220**, **222**, **223**, 224, **225**, 227
Kellerman, Sally 159
Kelly, George "Machine Gun" 227
Kennedy, John F. 184
Kennedy, Tessa 47
Kent, Tony 66, 166
Kermode, Mark 245
Kesey, Ken 108
Khayyám, Omar 94
Killing of Sister George, The 85, 106
Kinder, Marsha 103
King Arthur and the Round Table (book) 16, 39, 284
King Arthur and the Round Table (illustration) **6**, **39**, **40**, **114-117**, **144**
King of Heroin (script) 285
King, Stephen 174
King, Zalman 192, 285
Kitt, Eartha 42
Klein, Yves 62
Klossowski, Pierre 63
Klossowski, Stanislas "Stash" 63-67, 151, 158, 285
Knop, Patricia Louisianna 192, 285
Knox, John 25
Kong, Patricia see Cammell, China

Kong, Stefanie 173
Koontz, Dean 174, 175, 177, 182
Korda, Alexander 167
Krause, Bernard 275
Kray, Ronnie 102
Kubrick, Stanley 152, 163, 170, 182
La Frenais, Ian 71
Lady Hamilton, The (script) 166-167, 183, 285
Lamm, Karen 189
Langhorne, Bruce 157
Langley, John 234
Lansing, Sherry 205
Lanutti, Angelo 159
Lascelles, Kendrew **126**, 155, 157, 160
Last Poets, The 275
Last Tango in Paris 171
Last Video, The (script) 158, 207, 209, 210, 285
Lawrence, D.H. 156
Lawton, J.F. 229, 230
Lear, Amanda 61
Leigh, Vivien 167
Leitch, Linda Lawrence 66, 67
Lemmon, Jack 68
Lennon, John 108
Léon, Didier 62
Leoncavallo, Ruggero 218
Lerner, Avi 234
Lerner, Danny 234
Lester, Richard 107, 283
Levine, Joseph E. 109
Lewis, Geoffrey 187
Lewis, Harvey 186
Liars, The (treatment) 98, 99
Libin, R. Joseph 88
Lichfield, Patrick **85**
Lieberson, Sandy 92, 98-100, 153
Light (magazine) 30, 31
Lilius, Aleko E. 198
Lilley, John **209**
Lilliput (magazine) 47, 50, 53, **54**, **118**, **119**, 284
Linehan, Dr. Marsha M. 269, 270
Lister, Joseph 23
lit de la vierge, Le 105
Litvinoff, David 38, 46, 100, 102, 263, 267, 268
Lives of the Most Eminent Painters, Sculptors and Architects, The (book) 9, 10, 26
Lolita (novel) 163
Longchamps, Patrick 158-163, 276, 285

Loo, Anita 172
Lord Jim (novel) 201
Lord Snowdon 42
Lord, James 64
Losey, Joseph 97
Lucienne-Gabrielle 19
Lucifer Rising 78, 151, 152, 282
Lucky Luciano (illustration) **36**
Luv 68
Lyne, Adrian 229
Macalester, Dr. R.K. 18
Macalester, Olga **19**
Macbeth 166
MacCabe, Colin 4, 37, 92, 245
MacClise, Daniel 42
Macdonald, Anne Jane Cameron "Neenie" 20, **27**, 31
Macdonald, Dr. David 20, 22
Macdonald, Dr. William Francis "Willie Frank" 20
Macdonald, Kevin 4, 249, 267, 270, 285
Macdonald, Lexie 24
Macdonald, Marjorie 24
MacDonald, Ramsay 15
Macgillivray, Pittendrigh 25
Machado, China 60, 173, 256
Machine Gun Kelly (script) 227, 285
Macho Callahan 109, 161
Maddox, Diana 195
Madonna 160
Magee, Patrick 158-160
Maitland, Marne 80
Malanga, Gerard 97, 103
Malden, Karl 35, 97
Mallarmé, Stéphane 95
Malle, Louis 188
Malraux, André 64
Maltin, Leonard 85
Mamoulian, Rouben 205
Man from U.N.C.L.E., The (TV series) 42
Man Who Fell to Earth, The 100, 171
Mandel, Johnny 275
Mandel, Robert 230
Manso, Peter 171, 231
Manulis, Martin 68
Maranne, Andre 83
Marcus, Steven 74, 76, 241
Margolin, Janet 160
Marley, Bob 206
Marquand, Christian 48

Marriage of Heaven and Hell, The (book) 271
Marshall, Garry 230
Marshall, Ken 184, **191**
Marvin, Lee 98
Mason, James 77, **79**, 85, 88
Matisse, Pierre 64
Matthews, Tom Dewe 249
Matton, Charles 62
May, Elaine 68
Maysles, Albert 147, 148
Maysles, David 147, 148, 158
Mazzola, Anthony 152, 155-157
Mazzola, Catherine Hader 4, 245
Mazzola, Frank 4, 52, 106, 108-111, 152-160, 162, 163, 167, 171, 173, 178-182, 192, 227, 233, 242, 244, 245, 248, 255, 256, 267, 274-276
McAlpine, Hamish 245
McCalllum, David 42, 49
McClure, Michael 152, 153, 285
McConkey, Larry 226
McDowell, Malcolm 150
Meadows, Stanley **101**
Medak, Peter 195
Medavoy, Mike 169
Memoirs of a Bastard Angel (book) 267
Mendez, Julie **120**
Menninger, Karl 249
Merv Griffin Show, The (TV series) 184
Michaels, Joel B. 195
Michelangelo 9, 26
Midnight Cowboy 106
Milchan, Arnon 230
Millais, John Everett 42
Mills, Bernard 57
Mills, Bertram 50, 53, 57
Mills, Cyril 57
Milton, John 194
Mondrian, Piet 216
Monory, Jacques 62
Mora, Philippe 38
More 217
Moriarty, Cathy **137**, **202**, 212, **213**, **214**, **222**, **224**, **225**, 226
Morrison, Van 108
Morrissey, Paul 166
Morton, Anthony **101**
Moses, Ed 255
Mosset, Olivier 62
Moullet, Luc 87

Mrs. White (novel) 210-216, 221, 223
Murdoch, Blaikie 25
Murray, Wes 190
Mutarevic, Sead 234, 241
My Secret Life (book) 74
Myth of Sisyphus, The (essay) 11
Nabokov, Vera 165
Nabokov, Vladimir 163-165, 285
Nakamura, Ken 234
Naremore, James 97
Natural Child (illustration) **12**
Neely, Sam 184
Nelson, Horatio 166
Nerval, Gerald de 90
Neville, Richard 38
New Scientist (magazine) 28, 169
Newman, Randy 275
Nicholson, Jack 152
Nico (née Christa Paffgen) 60, 92
Nietzsche, Friedrich 91, 150
Night Falls Fast (book) 247
Nine 1/2 Weeks 192
Nitzsche, Jack 275
Nixon, Richard 147
Noonday Demon, The (book) 254
Norman, Frank 47
Norse, Harold 41, 267
Nothing As It Seems: The Films of Nicolas Roeg (documentary) 282
Odd Man Out 88
Odissea (TV series) 100
Oh! Calcutta! 183
Old Gods Almost Dead: The 40-Year Odyssey of The Rolling Stones (book) 248
Old Master, An (illustration) **5**, **44**, **46**, **47**
Olivier, Laurence 167
On the Waterfront 97
One-Eyed Jacks 35, 97
Orphée 95, 97, 153
Other Victorians: A Study of Sexuality and Pornography in Mid-Nineteenth Century England, The (book) 74, 241
Ovid 10
OZ (magazine) 38
Pagliacci (opera) 218, 221
Pale Fire (novel) 163-165, 285
Pale Fire (treatment) 163-165, 285
Pallenberg, Anita 4, 61, 62, 65-67, 71, 74, 85, **89**, 97, **98**, 99, 100, **101**, 103, 104, **106**, 108, 112, **123-125**, 268

Paradise Lost (poem) 194
Pardo, Frédéric 62
Parker, Suzy 67
Parkinson, Norman 60
Parolin, Aiace 159
Parrish, Robert 68, 77
Parsons, Gene 275
Parsons, Gram 152
Pat Garrett & Billy the Kid 153
Peckinpah, Sam 152, 153
Peeping Tom 216
Performance 4, 5, 8, 11, 20, 35, 38, 41, 42, 46, 50, 61, 65-68, 71, 73, 74, 76, 77, 85, **86**, 87-112, **113**, **122-125**, **146**, 147, 148, 150, 151, 154, 156, 157, 165, 167, 171, 178, 183, 187, 189, 190, 192, 199, 200, 204, 207, 224, 230, 233, 245-249, 251, 267-271, 274-275, 282, 283, **296**
Performance (novel) **110**, **123**, 284
Performers, The (treatment) 99
Persona 97
Personal Anthology, A (book) 94
Petit, Chris 284
Petulia 107
Phantom of the Paradise 282
Phillips, John 152
Phillips, Michelle 154
Phillips, Timothy 37, 41
Pierrot le fou 92, 218, 221
Pirie, David 162
Plugge, Leonard Frank "Lenny" 103
Poe, Edgar Allan 177, 204
Poems (book) 22
Point Blank 97, 98, 275
Pol, Talitha 67
Polanski, Roman 61, 65, 166, 256, 285
Politoff, Haydée 62, **63**
Pollock, J.C. 285
Polo, Marco 90
Pomeroy, Mark 42
Pommereulle, Daniel 62
Portman, Richard 160
Powell, Michael 216
Presley, Elvis 15, 148
Pretty Baby 188-190
Pretty Woman 229
Pride (In the Name of Love) (music video) 207, 281
Princess Margaret 42, 46
Privilege 71
Privilege (script) 71

Pugh, Bronwen 47
Pullman, Bill 254
Quickest Way Out of Manchester, The (illustration) **45**
Quinn, Pat 230
Rain Man 160
Random, Ida 160
Rankin, Ian 284
Raphael 9
Rawlings, Terry 226
Ray, Nicholas 108
Rebel Without a Cause 108
Red Shoe Diaries (TV series) 192
Reed, Carol 88
Resnais, Alain 220
Reuther, Steve 229, 230
Revolution 209
Reynolds, Sir Joshua 42
Rice, David Talbot 25
Richard Cory (poem) 254
Richards, Keith 67, 103, 104, 108
Ringwald, Monika **69**, **70**, 72, **73**, **75**, **76**, **121**
Roberts, Deborah (née Dixon) 16, 20, 46, **58**, 59-64, 66, 67, 77, 99, 100, 108, 256, 263, 267, 268
Roberts, Julia 229
Roberts, Rocky 66
Robinson, E.A. 254
Rodley, Chris 4, 172, 192, 230, 231, 259, 267, 270, 285
Roeg, Nicolas 99, 100, 104, 107, 148, 152, 158, 167, 171, 177, 192
Rohmer, Eric 62, 63
Rolling Stone (magazine) 147
Rolling Stones Story, The (compilation) 282-283
Rolling Stones, The 42, 62, 66, 100, 104, 147, 151, 207, 233, 275, 282
Romney, George 166
Ronane, John 73
Rose, Sir Francis 47
Rosemary's Baby 177, 183
Rosenberg, Alan **134**, **138**, 212, **214**, **219**, **220**, **226**
Rossetti, Dante Gabriel 16, 45, 94
Rossi, Franco 100
Rovner, Jack 207
Roxy Music 61
Rubáiyát of Omar Khayyám, The (book) 94
Rufus-Isaacs, Anthony 192
Ryan, Kathleen 88
Sabbah, Hassan-i 90, 91

Sackville, Lady Margaret 23
Sade, Marquis de 63, 159, 246
Sagan, Carl 264
Said, Edward 196
Saint' Ange, Margot **126**, 159, 162, **163**
Sainte-Marie, Buffy 275
Salle, Pierre de la 67
Samson 160
Samuel, Niki 148, 267, 268
Sanda, Dominque 150
Sanderson, W. Roy 25
sang d'un poète, Le 95, 251
Sanger, John 53, 57
Sargent, John Singer 42, 45
Saunders, Don 55
Savage, Jon 99
Scarface 235
Schiavazappa, Piero 100
Schickel, Richard 147
Schilling, William G. **217**
Schmidt, Artie 160
Schneider, Steven 216
Schrader, Paul 157
Schroeder, Barbet 111, 217
Scicluna, José 43, 44
Scott, George C. 195
Scott, Sir Walter 23
Seed, Fr. Benedict 265
Serial Killer Cinema (book) 224
Servant, The 97
Set in Darkness (novel) 284
Shadoian, Jack 98
Shafto, Sally 5, 60-64, 67, 100
Shakespeare, William 145, 153, 200
Shannon, Johnny 102
Sharp, Martin 38
Shelley, Mary 177, 178
Shelley, Percy Bysshe 10, 11, 17
Shields, Brooke **132**, 184, **185**, **186**, 187-190, **191**
Shirley, Ralph 27
Short Cuts 235
Short, Trevor 234
Shy People 227
Sidney, Ann 102
Siegel, Benjamin "Bugsy" 160
Silla, Felix **129**
Simmonds, Kathy **69**, **70**, 72, **73**, **75**, **76**, **121**
Simon, John 147
Simona **126**, 158-163, 177, 276, 285
Simona (script) 159, 285
Singer, Lori 235

Six contes moraux IV: La collection-neuse 62, 63, 282
Sky, Patrick 275
Smith, Adam 23
Smith, Danielle **202**, 214
Snepp, Frank 230
Solomon, Andrew 11, 253, 254
Spader, James 229
Spence, Lewis 25
Spencer, Stanley 42
Star Wars 160, 183
Starr, Ricki **69**, 71, 72, **73**
Starr, Ringo 108
Steele, Barbara 42, 249
Stepfather, The 224
Stevenson, Robert Louis 23
Stewart, Bob 169
Straw Dogs 152
Streetcar Named Desire, A 97
Strick, Iris (née Cammell) 29
Studio (magazine) 47
Summers, Montague 27
Sutherland, Donald 152, 177
Swadling, Anna 207
Symonds, John 28, 30, 103
Tana, Dan 184
Tangerine Dream 283
Tàpies, Antoni 60
Taxi Driver 157
Taylor, Vince (née Brian Holden) 65, 66
Tempest, The (play) 200
Tenant, The 166
Tennyson, Alfred 87
Terry and the Pirates (TV series) 198
testament d'Orphée, Le 95
Tevis, Walter 171
Thanopoulos, John 44
That Hamilton Woman! 167
Thaw, Eugene Victor 64
Thomson, David 199
Three in the Attic 72
Three Musketeers, The (novel) 236
Three Thousand (script) 229, 230
Threepenny Opera, The (musical) 65
Tilt **132**, 184-190, **191**, 277-278
Tilt (novel) **190**, 284
Tison, Frédérique 63
Titelman, Russ 275
Tonight Show, The (TV show) 190
Touchables, The 68, **69**, **70**, 71-74, **75**, 76, 77, 84, 85, 98, **121**, 233, 273-274

Touched with Fire: Manic-Depressive Illness and the Artistic Temperment (book) 262
Trumbull, Don 160
Turnbull, Michael T.R.B. 33-35, 264-266
Turner, Joseph Mallord William 42, 45
Turner, Tina 147
Two Moon Junction 192
Tynan, Kenneth 65, 183, 285
Tyrell, Susan 154
U.S. Bonds, Gary 66
U2 207, 210, 281
Untouchables, The (TV series) 68
Uosikkinen, David **133**, 208
Vadim, Roger 158
Valentine, Anthony 4, **125**
Vallone, Raf 158-160
Van Damme, Jean-Claude 231
Van Devere, Trish 195
Vasari, Giorgio 9, 10, 26
Vaughn, Robert 170
Vernig, Jerry 154
Victor, Ed 199
Victory (novel) 183, 198, 201
Villiers, George 236
Villiers, James **73**
Walkabout 152, 167
Walken, Christopher 85, **139**, **141**, 142, **228**, 235, **237**, **238**, **240**, 241, **242**
Wall and the Books, The (essay) 92, 183
Wardlaw, Lady 28
Warhol, Andy 166
Waste Land, The (poem) 22, 87
Watkins, Peter 71
Watson, Alberta 221
Weaver, Fritz **128**, **170**, 171, **173**, 177, 178
Weber, Nicholas Fox 63, 64
Weekend 62, 100
Weinstein, Paula 163
Weiss, Jon 283
Weld, Tuesday 103, 154
Welles, Orson 150, 190
What's New, Pussycat? 68
What's Up, Tiger Lily? 161
Whidborne, Timothy 37, 38, 41
Whitaker, Robert 38
White of the Eye 47, 50, 65, 77, 88, 91, 92, 98, 99, **134-138**, 173, 187, 190, 192, 199, 200, **202**, 210,

212-227, 229-233, 259, 269, 271, 278-280
Whittet, G.S. 47
Wild Side 8, 61, 77, 83, 85, **139-143**, 190, 200, 215, 218, 223, 224, 227, **228**, 233-246, 248, 255, 269, 271, 280, 283
Wild Side - The Director's Cut 8, 245-246, 281
Wilde, Oscar 23, 45
Williams Jr., Hank 217
Wilson, Colin 103
Wilson, Dennis 189
Winner, Michael 71
Winters, Ralph 109
Winwood, Steve 104
Wordsworth, William 24
Wray, Bill 184
Wyman, Bill 15
Wyman, Brad 216, 226, 227, 285
Yafa, Stephen 72
York, Susannah 77, **78**, **81**, **82**, 85, **120**
Young Lions, The 48
Zoja, Luigi 88, 91
Zouzou (née Danièle Ciarlet) 60, 62, 67, 100
Zsigmond, Vilmos 155, 156
Zwerin, Charlotte 147